MAGNUM
CONTACT SHEETS

MAGNUM
CONTACT SHEETS

EDITED BY KRISTEN LUBBEN

WITH 448 ILLUSTRATIONS, 240 IN COLOUR

Thames & Hudson

NOTES TO THE READER

Orientation, cropping and straightening of individual frames are
in accordance with images supplied by the photographers or their
estates.

All texts are provided by the photographers or the editor, unless
otherwise credited.

First published in the United Kingdom in 2011 by Thames & Hudson
Ltd, 181A High Holborn, London WC1V 7QX

This compact edition first published in 2014

Magnum Contact Sheets © 2011 and 2014 Thames & Hudson Ltd,
London

Magnum photographs © the photographers/Magnum Photos

Design by SMITH

Texts by Abbas, Antoine d'Agata and Jean Gaumy translated from
the French

Texts by Ferdinando Scianna translated from the Italian

Texts by Cristina García Rodero translated from the Spanish

British Library Cataloguing-in-Publication Data
A catalogue record for this book is available from the British Library

ISBN 978-0-500-54431-0

Printed and bound in South Korea by Pacom

To find out about all our publications, please visit
www.thamesandhudson.com. There you can
subscribe to our e-newsletter, browse or download
our current catalogue, and buy any titles that are in print.

CONTENTS

INTRODUCTION

Through the work of Magnum photographers, this volume traces the development and demise of a way of working that was so ubiquitous as to seem an inevitable and inextricable part of the process of photographing: the use of the contact sheet as a record of one's shooting, a tool for editing, and an index to an archive of negatives. The contact sheet, a direct print of a roll or sequence of negatives, is the photographer's first look at what he or she captured on film, and provides a uniquely intimate glimpse into their working process. It records each step along the route to arriving at an image – providing a behind-the-scenes sense of walking alongside the photographer and seeing through their eyes. Unique to each photographer's approach, the contact is a record of how an image was constructed. Was it a set-up, or a serendipitous encounter? Did the photographer notice a scene with potential and diligently work it through to arrive at a successful image, or was the fabled 'decisive moment' at play? The contact sheet, now rendered obsolete by digital photography, embodies much of the appeal of photography itself: the sense of time unfolding, a durable trace of movement through space, an apparent authentication of photography's claims to transparent representation of reality.

Organized chronologically, the book includes all analogue film formats – from the standard 35mm that was the core of photojournalistic practice in the twentieth century to panoramic to large-format – in both black-and-white and colour. Throughout, the intent has been to give the reader a sense of how each photographer initially encounters his or her own work, and to provide a window into their private editing and selection process. While editing programmes that create a simulation of the contact sheet from digital images are widely used today, they are a fundamentally different entity – a translation of what a photographer has seen, rather than its trace – and we have chosen to omit digital work from this volume.[1] In this sense, the book functions, in the words of Martin Parr, as an 'epitaph to the contact sheet'.

The images included – both celebrated icons of photography and lesser-known surprises – encompass over seventy years of history, demonstrating the role of photojournalism in describing events such as the World War II bombings of England, international political and cultural upheavals in the 1960s, and the wars in the Balkans. Weaving throughout this history are more inventive and experimental images, demonstrating the range and diversity of work produced within the community of Magnum photographers.

Beginning with photographs taken by Henri Cartier-Bresson, Chim and Robert Capa in Spain in the 1930s, the book corresponds with the rise of the illustrated press and the professionalization of photojournalism, within which an organized system for editing and storing images became necessary. It also parallels the introduction of small-scale cameras, which demanded the development of a system of editing for enlargement. One can see, however, how varied and unstandardized the approaches were in this early period. Cartier-Bresson famously cut up his negatives in 1939 as he would 'cut his nails', preserving individual images and sequences that he deemed successful or valuable and discarding the rest. While Capa did not intentionally destroy negatives, neither did he see the contact sheet as inviolable: along with his friend Chim and his working partner Gerda Taro, he cut up his contacts and pasted them into notebooks, occasionally editing or reordering the sequence of images. The contact sheets in the first chapter of this book, which also include personal projects by Herbert List, Philippe Halsman and Werner Bischof, demonstrate the idiosyncratic methods of storing and editing photographs in this early era.

The contacts from the decades following these initial examples – certainly after the post-World War II founding of Magnum – become more standardized, with 35mm black-and-white predominating, but no less fascinating or varied in subject. These chapters contain some of the high points of documentary photography and the mainstays of magazines such as *Life*, through which the enduring images of the period were most forcefully disseminated: from the 1950s and early '60s, René Burri's filmic sequence of close-ups of Che Guevara, Burt Glinn's coverage of the civil rights-era integration of Little Rock High School, or Eve Arnold's iconic portrait of the charismatic and image-savvy Malcolm X. Corresponding with the height of the magazine era in the mid-twentieth century, these sheets were a communal point of contact between photographer, editor, agency and magazine. They bear traces of the invisible steps of production between the photographer and the media; such intermediary tools were especially crucial in a collective enterprise like Magnum. At the same time, they remain highly personal and intimate glimpses into each photographer's way of seeing. In the late 1960s, 1970s and '80s, the multiple threads within Magnum become especially clear, with passionately engaged coverage of the wars in Vietnam and Central America alongside street photography, fashion work and humorous social documentary.

The work included from recent years is more open-ended and experimental in format, intention and approach, demonstrating ways in which the contact sheet has transitioned from a practical working tool to a source of creative inspiration. This is apparent in projects such as Jim Goldberg's 'Signing Off', a collaged contact sheet from his searing 1995 book about a group of street kids, *Raised by Wolves*. Rather than featuring images that reveal a moment unfolding in time, this work effaces the photographer's shooting sequence. Questioning and ultimately rejecting his images of a young, self-destructing couple in their most intimate moments, Goldberg decided to obscure the contact with images of static shot from a television, accompanied by descriptive text. The finished piece leaves the viewer to imagine the original sequence, but also raises a host of questions about representation. It is an early example of Goldberg's use of the contact as formal strategy, the most recent of which, 'Proof', a wall-sized installation of contact images, concludes this book.

OPPOSITE Henri Cartier-Bresson looking at contact sheets in the Magnum office in New York, 1959. Photo René Burri.

1 The one noteworthy exception is Mikhael Subotzky, who shoots in colour film but edits the film digitally; see p. 508.

Similarly, Antoine d'Agata's entry in the book is not actually a contact sheet. Instead, it is a sequence of video stills 'presented without any particular logic… I had no need to make a selection, or to believe that a single image should be privileged.'[2] In another of the most recent works featured here, Chien-Chi Chang shows an ongoing project in which he reserves one of his cameras to take single, isolated shots of a particular scene. 'Usually when you shoot, you work the image. You shoot a strip of film and pick the best. I work it, too, but in my heart or mind… I don't really care about the "before" and "after" anymore.'[3] Chang then sketches the image he has just taken in a notebook, later comparing his photographic vision with the more selective seeing involved in drawing. This quietly ruminative project has an entirely different relationship to time, sequence and narrative from the traditional contact.

Often compared to an artist's sketchbook, contact sheets are certainly more unrelentingly all-inclusive than that analogy would suggest. There is no removing or erasing the unsuccessful steps on the way to the final product – each twist and turn, each decision, is recorded, allowing viewers to see along with (or perhaps second-guess) the photographer. 'Contact prints are the proof that I did something wrong. Perhaps I could have moved the camera two feet this way or that, or waited until the sun was in a slightly different position. They show how difficult the medium can be.'[4] Here, Bevan Davies expresses an apprehension common to many photographers: that contact sheets reveal too much. The illicit quality of the contact sheet is the source of much of the viewer's fascination with it. Like reading someone's diary or looking in their closet, the contact is not meant for public consumption. As Cartier-Bresson noted, 'A contact sheet is full of erasures, full of detritus. A photo exhibition or a book is an invitation to a meal, and it is not customary to make guests poke their noses into the pots and pans, and even less into the buckets of peelings…'[5] A contact sheet is a diary of experiences, a private tool that records mistakes, missteps, dead ends – and lucky breaks.

Another frequently expressed concern is that contact sheets demystify the seemingly magical quality of photography, rendering it ordinary or even tedious in its workmanlike processes. Martine Franck reveals such qualms: 'I have certain misgivings about letting my contact sheet be published but in final analysis I realize that I am curious to see how other photographers work… One rarely expresses in words all the random thoughts that run through one's head except maybe on a psychoanalyst's couch, and yet the contact sheet spares neither the viewer nor the photographer. I feel that by allowing myself to be violated, and by publishing that which is most intimate,

I am taking the very real risk of breaking the spell, of destroying a certain mystery.'[6]

Many photographers also refer to the trepidation they feel in looking at their contacts for the first time, when the intention of what they were trying to capture is matched up against the reality of what is on the sheet. The constant fear of disappointment seems to shadow the editing process. Elliott Erwitt describes this hesitation: 'It's generally rather depressing to look at my contacts – one always has great expectations, and they're not always fulfilled.'[7] David Alan Harvey has a similar reaction to editing: 'I hate looking at my work. I delay it for as long as possible… I just know that it won't live up to my own expectations.'[8] And yet facing the task is inevitable and crucial, not only in order to arrive at the finished result – a print – but also in order to learn from one's mistakes or successes and incorporate those lessons into future work.

The experience of viewing contacts is almost invariably an intimate, even physical one. Because they are intermediary products rather than the finished result, they are used in the privacy of the studio or editing workshop, rather than displayed publicly. Their small size demands physical proximity, and they are often scrutinized with a loupe, a specialized magnifying glass held between the eye and the contact, bringing the sheet almost in contact with the face. Grease pencil or China marker notations in different colours indicate personal observations; throughout this book, one can see how unique these are to each maker, and how the physical trace of the photographer's hand can be felt on the contact.

Contact sheets only came into use when they became a necessary companion to small-scale negatives that required enlarging, in the early twentieth century.[9] Prior to this point, negatives were large enough to assess without an intermediate tool. In the case of daguerreotypes, tintypes and other positive processes, they were themselves the final product, incapable of being enlarged or otherwise altered. With the invention of the dry plate and flexible film, smaller, more lightweight cameras were developed. While these cameras had numerous advantages and freed photographers from the constraints of the studio and darkroom, they produced images of limited size. Rooftop enlargers that used natural sunlight had been around since the much earlier use of glass plates, but they were dependent on weather conditions and didn't deliver the sharp results required by serious photographers. In 1914, Kodak marketed its first enlarger with an artificial light source, paving the way for new possibilities with the smaller cameras. And with the advent of enlarging, the practice of selecting a portion of an image to print or crop out became commonplace.[10]

2 This volume, p. 504.
3 This volume, p. 510.
4 Ralph Gibson, John Flattau, and Arne Lewis, *Contact Theory* (New York: Lustrum Press, 1980), p. 26.
5 This volume, p. 18.
6 Gibson, Flattau, and Lewis, *Contact Theory*, p. 50
7 This volume, p. 70.
8 Interview by Sophie Wright with David Alan Harvey, 3 February 2011.
9 Precursors to the contact sheet include Edweard Muybridge's motion studies and André-Adolphe-Eugène Disderi's multiple-image cartes-de-visite. Neither represented actual contact sheets, but nonetheless share interesting similarities with later contacts in their gridded sequence of multiple photographic images.
10 John Szarkowski, *Photography Until Now* (New York: Museum of Modern Art, 1989), pp. 131–52.

The Leica, the camera that became emblematic of the new lightweight cameras, was introduced in 1925.[11] In 1932, Cartier-Bresson made it his camera of choice; the first entry in this book is from the following year. Clearly, the introduction of the contact is inextricably linked with a new way of working that comes into existence in the late 1920s and early 1930s. A Leica ad from 1935 says: 'The Leica is the fastest camera: the film winds on automatically and focusing is quick due to the built-in rangefinder. You can take three successive shots in five seconds…'[12] This emphasis on speed and on firing away at a subject also encouraged a new approach to photographing, less cautious with film and more reliant on editing after the fact than before pressing the shutter.

Around the same time that these technical innovations were occurring, new methods arose for the marketing and distribution of photographs in the press. The first photographic agency, the Illustrated Journal Photographic Supply Company, was founded in London in 1894.[13] Such agencies grew in number in the 1920s and '30s, attendant with the astronomical growth of the illustrated press, which required a steady flow of material for its readership. These agencies would send out packets of pre-selected images for the magazines to use. Photographers had little or no control over the use of their images, and were rarely credited, a situation that was not improved if they were under the direct employ of the magazines.

The establishment of Magnum in 1947 presented a new working model for photographers. Conceived by Capa and Chim with Cartier-Bresson and George Rodger, the organization was envisioned as a collective that gave photographers autonomy from the all-powerful magazines and control over their copyright, editing and choice of assignment. (They were initially joined by photographer William Vandivert and his wife Rita, but they parted ways with the organization not long after its founding.) Crucially, the photographers' partner in this fledgling enterprise was Maria Eisner, founder and director of the Paris-based Alliance photo agency, which had launched Capa's career. Eisner no doubt brought essential skills as to how to organize and market the work of multiple photographers, and may have been responsible for establishing the archives and working methods in the offices, including the use of contact sheets.

The free flow of support staff between *Life* magazine and Magnum in the early days may also have contributed to the adoption of the contact as the primary document for editing and organization.[14] According to John Morris, who worked at the New York office of *Life* in the early 1940s, staff photographers edited their work from negatives and had work prints made. It wasn't until he went to *Life*'s London office in 1943 that he saw the routine use of contacts in a magazine context, in part because of the need to have images cleared by the government war censor's office.[15]

Nearly from the outset, duplicate sets of contact sheets were deposited in Magnum's Paris and New York offices, with a set kept by the photographers.[16] When looking at contacts it is useful to keep in mind that there is often not one 'master' contact sheet; unlike negatives, there can be multiple sets of contacts, not only with different editorial markings but even printed in a different sequence or layout. Understanding each photographer's working process, or who made the contacts on their behalf, is crucial.

The complex behind-the-scenes operation of shipping, editing and distributing film in the analogue era – dependent upon a network of couriers, editors and other third parties – is also important to bear in mind. In the very early years, if the photographer was in the field and unable to edit their own work for immediate distribution to magazines, contacts were often edited by Robert Capa in the Paris office and Ernst Haas in the New York office.[17] In later years, if the photographer were unavailable, a fellow photographer or photo editor, such as Jimmy Fox in the Paris office, would do the edit on his or her behalf. In such cases, Fox recounts, the photographer might call in and debrief him, walking him through the roll of film to alert him to important events or people in the pictures.[18] Such a relationship was built on necessity and demanded both trust and a certain degree of surrender on the part of the photographer; some would later revisit the contacts and make a different edit for their own personal projects, one less tied to the marketability and newsworthiness of a story and made with a different eye. Ironically, as Peter Galassi points out, the more important and time-sensitive a story, the less likely the photographer would be able to have a hand in the editing.[19]

Fox was hired by Cornell Capa in 1966 to reorganize the New York office archives. His first project was to go through every contact sheet notebook in order to do an inventory of topics, countries, personalities and so on, which his assistant then typed up on individual subject cards kept on a Rolodex wheel. Up until then, knowledge of the contents of the contacts was dependent on the memory and expertise of the librarians, unrecoverable if they left the organization. In the effort to catalogue nearly twenty years of photographic production, the contact sheets were Fox's primary document. While the sheets are rarely, if ever, visited by the Magnum office staff in order to

11 A Leica prototype was invented in 1914 by Oskar Barnack, but not distributed commercially. After going through several iterations in the development process, the first commercial distribution occurred in 1925: http://en.leica-camera.com/culture/history/leica_products/.

12 Michel Frizot and Cédric de Veigy, *Vu: The Story of a Magazine* (London: Thames & Hudson, 2009), p. 16.

13 Frizot and de Veigy, *Vu*, p. 12.

14 Correspondence with Inge Bondi, February 2011.

15 Interview with John Morris, 28 October 2009. When Morris left *Life* in 1946 and became picture editor at *Ladies Home Journal*, the use of contacts for editing was normal practice. Later, as editor at the *New York Times* in the late 1960s, he relied 'hourly' on contact sheets, the first edit of which was done by the photographers themselves.

16 This process was in place by 1950, when Bondi began working at Magnum. In subsequent years, sets were made for the London office as well.

17 Inge Bondi, 'Early Magnum', Magnum blog post, 17 July 2007: http://blog.magnumphotos.com/inge_bondi.html.

18 Interview with Jimmy Fox, 19 November 2009.

19 On the Magnum distribution system, see Peter Galassi, *Henri Cartier-Bresson: The Modern Century* (New York: Museum of Modern Art, 2010), and Chris Boot, *Magnum Stories* (London: Phaidon, 2004).

re-edit stories, they remain a useful tool in other respects. The Halsman estate, for example, uses the photographer's original contacts to ensure that Magnum employs the exact cropping indicated by Halsman's hand.[20]

Until as recently as 2000, when photographers applied to Magnum, they needed to show contact sheets, not just finished prints. 'That's so you could see their thinking,' Morris said. He recalled looking at one 'hotshot' Blackstar photographer who had covered a big story and who 'overshot terribly… I saw fifty rolls, fifty contact sheets from him and there wasn't a good picture in the whole thing.'[21] Cartier-Bresson would apparently rotate contact sheets in his hands, looking at them from all angles, assessing the formal composition of the photographs (and no doubt alarming the photographer whose work was submitted to such scrutiny). According to René Burri, 'He always turned them all around and upside down. It became like a sort of dance. Strangely he didn't want to look at the picture!'[22] David Hurn and other photographers have described the thrill of being a new inductee into Magnum and staying up late in the Paris office to go through other photographers' contacts to see how they worked: 'When I first came into Magnum, I learned an enormous amount by perusing shelves of books of contacts from Henri Cartier-Bresson, Marc Riboud, René Burri, Elliott Erwitt, etc. A feast to be absorbed, night after night, in the Paris office on rue du Faubourg Saint-Honoré.'[23]

The contact sheets in the Magnum offices, while provisionally available to the community of fellow photographers, staff and occasionally clients or researchers, are personal archives.[24] They are ultimately the property of their photographers, and can be restricted in their usage or removed at any time (as has been the case with the Cartier-Bresson and Capa contacts). Some photographers, including Dennis Stock, have gone over their contact sheet notebooks, editing them with an eye toward their legacy.[25] Others, such as Harry Gruyaert, have taken a yet more radical approach, culling even their personal archives of variant or unwanted images, in a move that echoes Cartier-Bresson's ruthless early self-editing.

According to Jinx Roger, wife of George Rodger, 'When colour [transparencies] came along, everything changed, and most photographers did their own editing before giving the best to the office.' Susan Meiselas agrees: 'I do think that shooting in colour first changed our experience with the contact, before there was negative film. Colour transparencies would be edited and you immediately lost the trace of the original sequence, unless you kept the boxes intact. One tended to make sets: for instance, A for the Magnum distribution, B for the Magnum Library, C for information value … so the integrity of one roll was disrupted.' This was just a prelude to the sea-change effected by the introduction of digital images, which fundamentally changed the way that not only Magnum but the entire field makes, receives and understands the meaning of photographs.

Most of the images that come into Magnum today are digital, and very few photographers continue to generate analogue contact sheets (exceptions include Bruce Gilden, Chien-Chi Chang and Larry Towell). The real turning point for digital work within the organization seems to have been around 2001–02, when the younger generation of photographers began war reporting. As throughout the field, the shift to digital has been profound and game-changing, particularly for working photojournalists on assignment. Increasingly, photographers are called upon not just to cover a story, but also to edit their own work and manage a more and more sophisticated array of technological tools in order to transmit their images. Paolo Pellegrin describes the shift in his working process: 'The workload with digital has certainly doubled with fieldwork. You have now to photograph, edit and send your images on the same day. You go back to your car or hotel room to download, caption and transmit your work. It's much more immediate and it becomes much more difficult to revisit the work.'[26] One of the results has been more in-camera editing and editing in the field before work is uploaded to magazines, editors or agencies. The photographs that make the initial edit, those that seem newsworthy or valuable in their moment, are not always the most enduring images. Unless the effort is made to go back and archive outtakes, these images will be difficult to access – if not lost altogether – to future generations.

According to Meiselas, the move to digital has also cut out some of the shared experience of the process of working within Magnum. 'Digital photography can permit greater sharing in the field, but cuts out collectivity at the other end. Fewer people share the whole process. It used to be that you sent raw film in and often the Magnum editorial or another photographer would take a look at the contacts.'[27] In addition, what may have seemed analogue film's constraints – the limit on the number of photographs that could be taken before reloading, or the inability to see what had been captured – turn out to be some of the qualities that photographers miss about it. Jim Goldberg describes how the move to digital effects a change in the pace of photographing. Having to reload film forced one to pause or reflect at intervals in the shooting process – 'to reset, rewind your thinking. The opportunity for that forced pause has been lost', as has the 'containment of

20 Interview with Matt Murphy, October 2010.
21 Interview with John Morris, 28 October 2009.
22 This volume, p. 115.
23 This volume, p. 162.
24 Each photographer has his or her own policy regarding the openness of their contacts to outside scrutiny. Galassi quotes from a letter that Cartier-Bresson wrote on 11 February 1958 to a Magnum staffer who had shared his contacts with the editors at *Paris Match*: 'Contact sheets, which are so passionate, constitute an interior monologue but full of slag – inevitable slag, since we're not plucking petals in the drawing room. You can't just deliver that monologue out loud to any investigator who happens to come along. In the end, when one speaks, one chooses one's own words.' Galassi, *Henri Cartier-Bresson: The Modern Century* (New York: Museum of Modern Art, 2010), p. 74.
25 Interview with Matt Murphy, October 2010.
26 Interview by Sophie Wright with Paolo Pellegrin, 15 September 2010.
27 Interview with Susan Meiselas, 2 March 2011.

a roll of film'.[28] Meiselas adds, 'I still think not knowing what you "have" at the end of the day with film gives strength to the intensity when you work. It is a mystery and surprise. Now everyone spends more time looking at their screens, first on the camera and then the computer.'[29] According to Gilles Peress, 'with film you kept track in your head' of what you were shooting, and evenings could be spent on a mental recap of the work you had made: the technical demands of digital editing in the field, at their worst, mean 'less reflection, less intelligence, less thinking time'.[30]

The digital files that photographers now submit directly to Magnum (with some pre-editing more than others) create new challenges for the archiving of images. Magnum now uses digital editing software in-house, which essentially simulates the experience of looking at multiple images on a contact sheet. With the digital files, all of the meta-data (credits, captions, reference numbers, keywords, contact information) is embedded in the image file itself, providing a different sort of context for the image from that supplied by the conventional contact sheet.[31] While these systems may be highly functional for the short-term trafficking of images, it remains to be seen how enduring they will be. Will scholars of the future be able to pore through outdated digital files as they do through prints, contact sheets and paper files, and how will that fundamentally different experience of the archive shape the histories that are written of the current period of photographic production?

Despite the wealth of detailed information now embedded in digital files, the instinctive sense of authenticity or proof of an image provided by its context in a contact sheet – one of its most compelling qualities – is lacking. The traditional contact sheet, in its unaltered form, is inseparable from the notion of proof; indeed, they are also known as 'proof sheets'. Placing a photograph back within the flow of time from which it was removed, the contact sheet holds out the promise of substantiation that an image is truly what it claims to be, that an event unfolded in the way the photographer claimed.

Gilles Peress's contact sheets from Bloody Sunday – the 1972 massacre of unarmed protesters in Derry, which ignited a new movement in Northern Ireland toward violent resistance – are one of the most striking and literal examples of the use of contact sheets as evidence. Peress was first called upon to testify in 1972 at the Widgery Tribunal, the government inquiry that was called in the immediate aftermath of the killings. The hastily-arrived-at results of the report placed blame on the march organizers and absolved the army of wrongdoing.

In 1998, a second inquiry was established at the request of the victims' families, who had long protested the whitewashed results of the Widgery report. The second inquiry, led by Lord Saville, again called upon Peress to testify, this time attempting to subpoena his negatives. Concerned that the court was seeking to identify faces in the crowds and scrutinize the images for evidence that some marchers were armed, rather than seeking to establish which soldier killed which demonstrator, Peress refused to collaborate. Upon being threatened by the British government with lawsuits in both US and UK courts, Peress enlisted the assistance of the American Civil Liberties Union and of British attorney David Hooper. Instead of releasing his negatives, he provided access to his contact sheets, accompanied by detailed notations. The contacts show the sequence of events as they unfolded in a way that was damning to the army; they ultimately contributed to the outcome of the inquiry, which in 2010 overturned the results of the first tribunal in a watershed moment in Northern Ireland's history.

Another oft-cited example of the relationship between an image's veracity and its contact sheet (or, in this case, lack thereof) is Capa's 'Falling Soldier', the iconic 1936 image of a Spanish Loyalist militiaman falling to the ground. Symbolic of heroic resistance against fascism, the truth-claim of the image – that it depicts a man at the moment of his death by enemy gunfire – has been called into question at various points since the 1970s. The recent discovery and publication of variant images, incidental in and of themselves but for the mountain ranges seen in their background, have led to a reevaluation of the photograph's location, adding to the controversy.[32] Fuelling the ongoing questioning, no original negative exists for the image, and there is no contact sheet left as its trace. Neither of these facts is surprising, given the spotty organization and survival of Capa's contact notebooks, and the way in which negatives were often cut up at the time for publication. (Indeed, another famous Capa example in this book, his D-Day story, is also missing the negative for its most famous image.) But the absence of a contact sheet or intact negative sequence means that original sequences of images cannot be reconstructed, thereby thwarting the impulse to verify the truthfulness of the image.

Contact sheets became an independent subject of inquiry in the 1960s and '70s. No doubt the interest in process evident in conceptual art during this period spilled over into the photo world as well.[33] But other reasons for interest in the contact around the same time include the rise in photographic education in the 1960s

28 Interview with Jim Goldberg, 9 February 2010.

29 Interview with Susan Meiselas, 2 March 2011.

30 Interview with Gilles Peress, 11 March 2011. Peress also had qualms about the traditional distribution process, however, which by necessity cut the photographer out of the equation.

31 Interview with Matt Murphy, October 2010.

32 Published in Richard Whelan, *This Is War: Robert Capa at Work* (New York and Göttingen: ICP/Steidl, 2007). Basque historian José Manuel Susperregui has raised the most recent questions about the image's location in *Sombras de la Fotografía* (Bilbao: Universidad del País Vasco, Argital Zerbitzua, 2009).

33 This is explored in depth in an excellent unpublished essay on contact sheets by Yael Lipschutz, 'The Semiotics of the Contact Sheet: From Darkroom Worktable to Gallery Wall'. Lipschutz links this to the rise in the 1960s of interest in process and the aestheticization of work, as well as to Minimalism and the appeal of the grid. She argues, 'The reappraisal of the contact sheet developed within a general reevaluation of workshop processes, factual data and other anti-aesthetic aspects of art production. Suddenly, these previously marginalized art elements rose to the status of fetishized, free-standing forms.'

and '70s, within which the contact sheet became an essential tool of study and instruction. Increased attention to photography in museums and the market were also occurring at this time; within the context of greater notice of the medium in general, the contact was of interest because it was emblematic of the genre, and evocative of the relationship to cinema, storytelling, narrative and the traditional photostory. For the first time, contact sheets made it out of the workroom and were included in exhibitions, publications and even advertisements for books or shows.[34] For some artists and photographers (including William Klein, Duane Michals, Ed Ruscha and Ray Metzker) they became a formal device, even the final product.

In subsequent years, there have been a number of examples of museum exhibitions that have included contact sheets as part of an overall de-emphasis on the solitary masterpiece and increased interest in materials that show working process, photography in print and vernacular work. A notable early example of this shift was the 2003 exhibition *Diane Arbus: Revelations*, which included freestanding rooms of personal ephemera, including contact sheets, among the well-known prints.[35] More recently, *Looking In: Robert Frank's 'The Americans'*, the National Gallery of Art, Washington DC's 2009 exhibition, prominently featured contact sheets in its investigation of the editing and selection process behind that seminal photographic book. The International Center of Photography's 2010 exhibition, *The Mexican Suitcase*, structured entirely around contact sheets of recently rediscovered Spanish Civil War negatives, with prints playing a supporting role, has demonstrated viewers' fascination at the opportunity to read closely hundreds, if not thousands, of small images. Many younger viewers – loupes in hand – are encountering this way of looking for the first time.

Both exhibitions are part of a broader phenomenon of fascination with the archive, no doubt traceable in part to the dematerialization effected by the rise of digital culture. A subject of intense interest explored in exhibitions and publications, as well as artists' investigations, this fascination has generated renewed interest in contact sheets. An incomparable record of time, process and both the quotidian and monumental, contact sheets are uniquely suited to the discourse of the archive.

On the cusp of becoming anachronistic, they take on the aura of history and come to stand in for a bygone era in photography, with its manual cameras and whiff of darkroom chemicals. No longer an active working tool for most photographers, the contact sheet is relegated to the archive, of interest as a historic document. Its value there may yet prove even greater than its original workaday function: an enduringly accessible record of what and how photographers saw for nearly a century.

34 For example, the Museum of Modern Art in New York showed contact sheets in a 1965 exhibition, *The Photo Essay* (curated by John Szarkowski; John Morris was a special consultant), and in *Photography as Printmaking* in 1968.

35 The exhibition was organized by the San Francisco Museum of Modern Art and toured to multiple museums. One can reasonably question where interest in all aspects of an artist's working practice veers over into fetishization of their personal effects. Similarly, the interest in peeking over the artist's shoulder at outtakes, drafts and contact sheets puts into question the role of the author in determining the finished product. Lipschutz quotes Milan Kundera on this point: 'The ethic of the essential has given way to the ethic of the archive' and novelists must protect against the urge of 'armies of researchers' to look at drafts, rejected texts, etc. and include them as part of the writer's oeuvre, rather than accepting the final choices of the author.

OPPOSITE The archive at the Magnum office in New York, 2011. Photo Susan Meiselas.

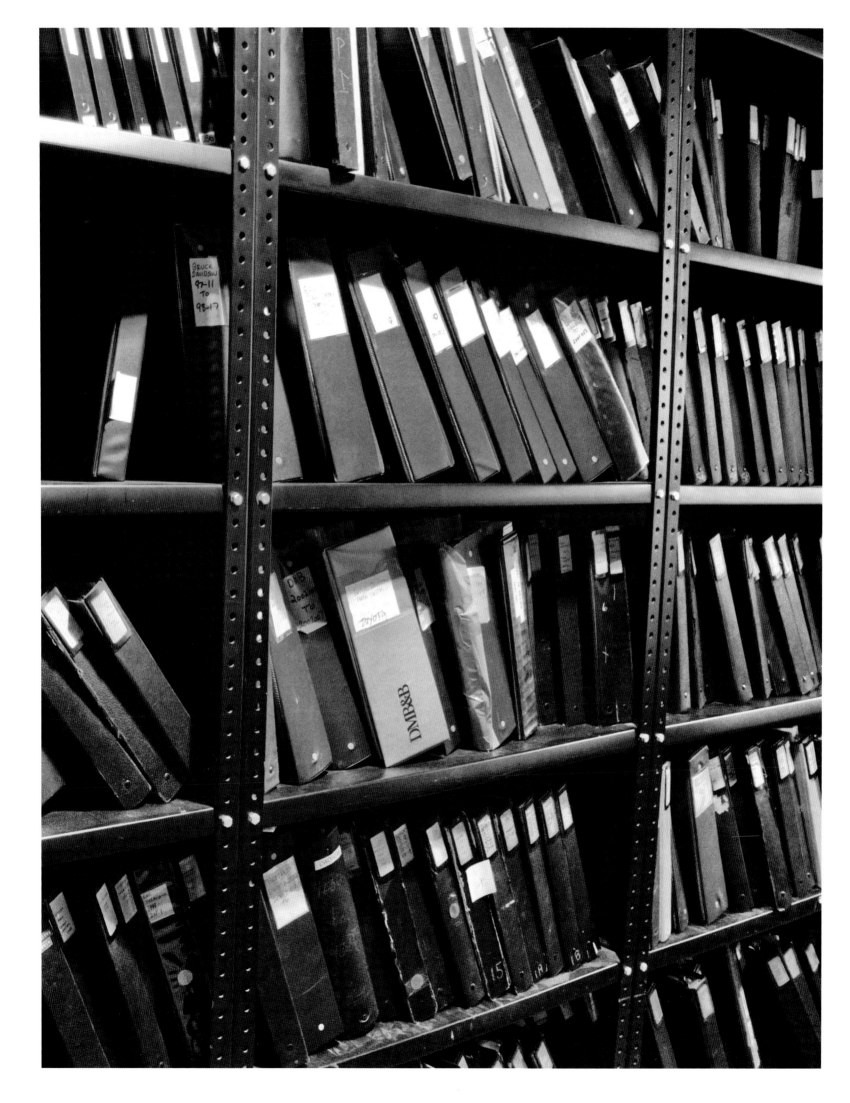

1930-49

1

2

4

5

7

8

Spain
April 1933

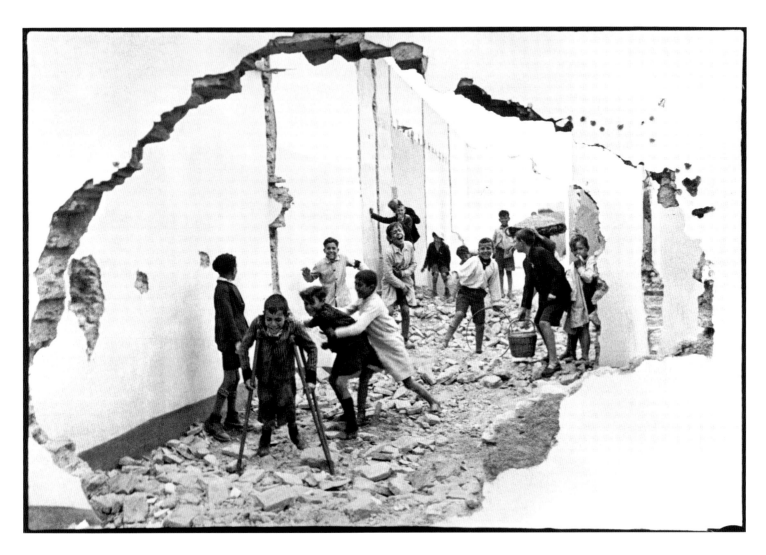

'When the war came (we had sensed its approach for quite a while), I took my negatives and destroyed practically everything, apart from what remains in *The Decisive Moment*. I likewise got rid of all my paintings when I left André Lhote['s art academy]. As to the reasons for this, I did it in the same way as one cuts one's nails: *allez, hop*! I kept the photographs I thought were interesting.'

'A contact sheet is a little like a psychoanalyst's casebook. It is also a kind of seismograph that records the moment. Everything is written down – whatever has surprised us, what we've caught in flight, what we've missed, what has disappeared, or an event that develops until it becomes an image that is sheer jubilation.'

'A contact sheet is full of erasures, full of detritus. A photo exhibition or a book is an invitation to a meal, and it is not customary to make guests poke their noses into the pots and pans, and even less into the buckets of peelings...'

'Pulling a good picture out of a contact sheet is like going down to the cellar and bringing back a good bottle to share.'

After touring Italy with his friends André Pieyre de Mandiargues and Leonor Fini in 1933, Cartier-Bresson embarked on a three-month journey around Spain. On his initial arrival in Avila on 4 April, he bought a third-class 300-km railway ticket for 300 pesetas and began his travels through the country. He visited Madrid, Cordoba and Seville before going to Spanish Morocco, where he spent nearly three weeks. Once back in Spain, he went to Granada, Alicante and Valencia. He rarely spent more than four days in any one city. He prepared his rolls of film and developed his photographs himself. As the writer Pierre Assouline has noted: 'No plans, no projects. Cartier-Bresson lets his footsteps guide him, he travels economy class, stays in low-budget hotels, eats frugally, but benefits beyond measure from the spectacle of life.'

OPPOSITE Individual unnumbered nitrate negatives, cut by Henri Cartier-Bresson before 1939; contact sheet reconstructed by the Fondation Henri Cartier-Bresson in the presumed order in which the photographs were taken.

Henri Cartier-Bresson — Séville, Espagne, 1933
Négatifs nitrates isolés sans numéro de vue, découpés par HCB avant
1939.

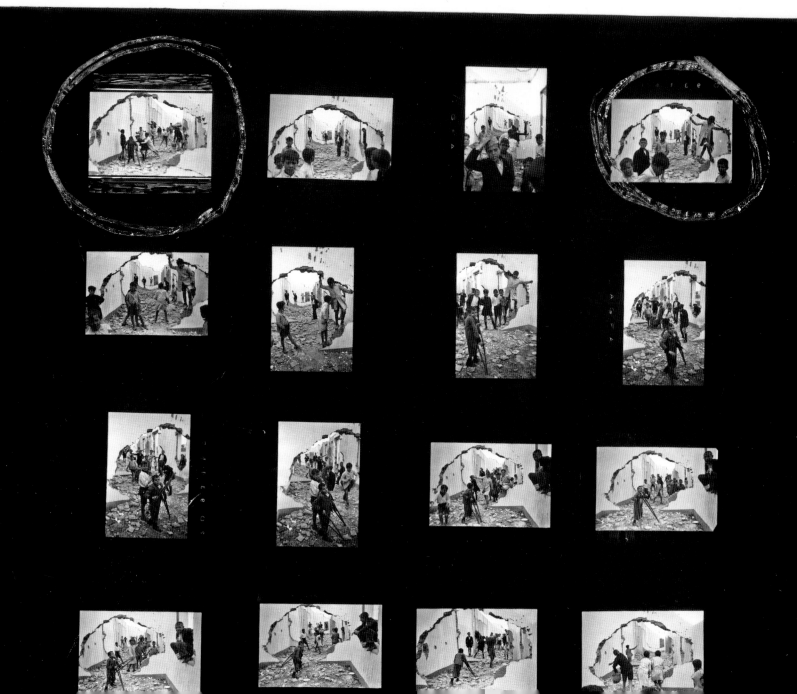

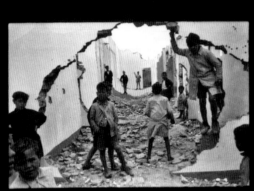
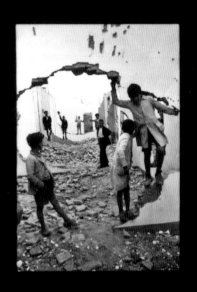
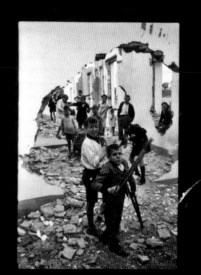
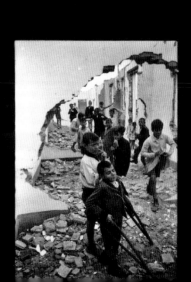

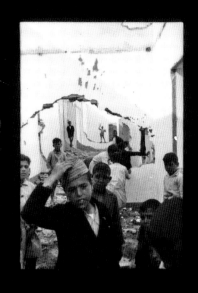
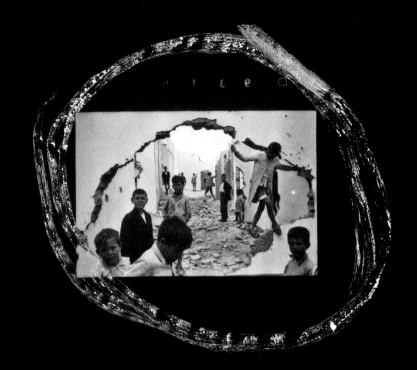
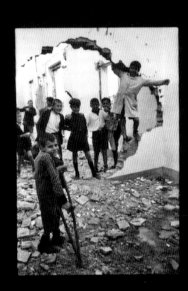
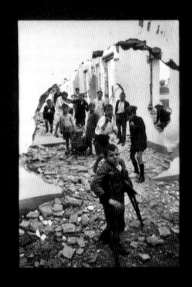
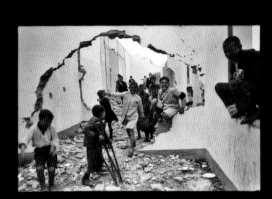
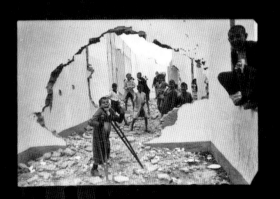

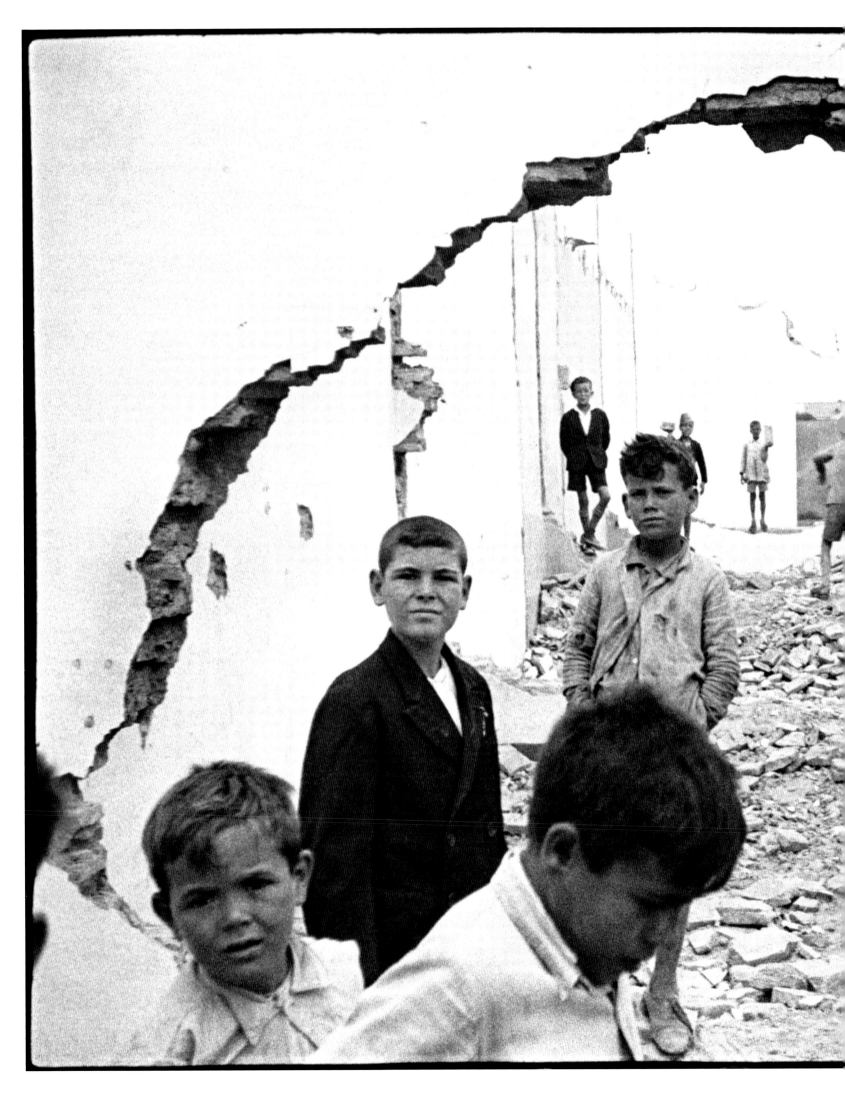

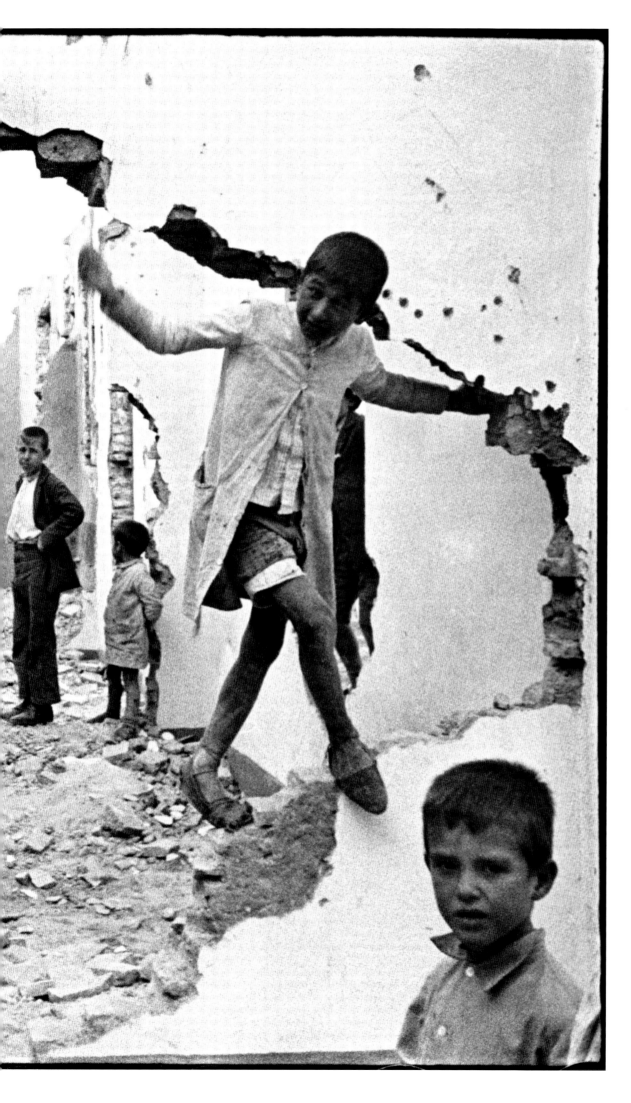

Extremadura, Spain
May 1936

In early May 1936, in a small town not far from Badajoz in the Spanish province of Extremadura, more than 2,000 peasants assembled in the Plaza de la República. They were there to attend a meeting organized by the workers of the 'Humanitaria', an 800-hectare piece of land whose owner had been obliged to rent part of it out to 526 labourers. The photographer Chim (David Seymour) was there to observe the meeting.

A drastic editor of his own work, Chim took scissors to his contact sheet, leaving us only the beginning and end of his film: frames 2, 3 and 4 and frames 31, 32 and 33. However, because his reportage was published in *Regards* magazine on 14 May 1936, we know that he had spent some time before the meeting photographing peasants in the fields, and then the village militia escorting the Socialist deputy to the meeting where he was to speak at six o'clock that evening. The editors' choice also included a frame, probably the first in the film, that focused on a group within the crowd, shot from a low vantage point. At the bottom of this horizontal image, the nursing woman on whom Chim will later focus is frowning, full of expectation.

Chim moves swiftly. In frame 2 he photographs from a medium vantage point, perhaps a wall of the enclosed plaza, then he moves up onto the town-hall balcony, beside the speaker, and focuses on a large number of people who pack the vertical frame. By the end of

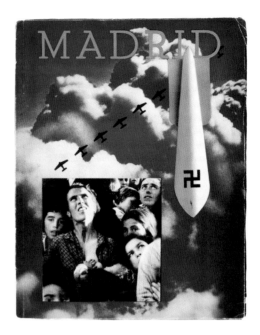

the contact sheet, he is mixing with the crowd and shooting from much closer, once with a tilted frame (32) that reminds us of his interest in Modernism.

In frame 33, Chim switches to a vertical format and focuses on the woman he has selected as his main subject. Her face is serious, caught up in concentration. The last rays of the day's sun fall on her left side, emphasizing both her tired features and the intensity of her gaze, directed not towards her nursing child but to the speaker whom we cannot see. Her rapt expression is echoed three times in the eyes of children piled up on her left. Faces fill the frame. The woman, absorbed in her listening, pays no attention to the photographer. Nor does the older woman in frame 31, with three men in caps aligned in a diagonal behind her. Chim's journalist colleague Georges Soria commented in the *Regards* reportage that was published together with Chim's photographs: 'I think that there is no country in Europe except for Spain, where an orator is listened to with so much fervour.'

Chim's picture became an icon. Editors often tightened the shot into a Madonna-like, cinematic, generic portrait, or repositioned the subjects, with new captions, as cutouts montaged under a blue sky, with Fascist planes dropping bombs overhead. What was a picture of empowerment and fervour became a public appeal to save victimized civilians. As of 1947, and for many years, Magnum distributed the photograph in the close-up version, as if editors were adding a zoom lens, which, during the Spanish Civil War, Chim did not own.

The surviving frames demonstrate Chim's intuition and his capacity to relate to unknown people, women and children in particular. In excluding the speaker, and preferring to photograph an event as reflected in the faces of the onlookers, he seems to suggest that it is not a single leader but the people themselves who are the real agents of their own history.

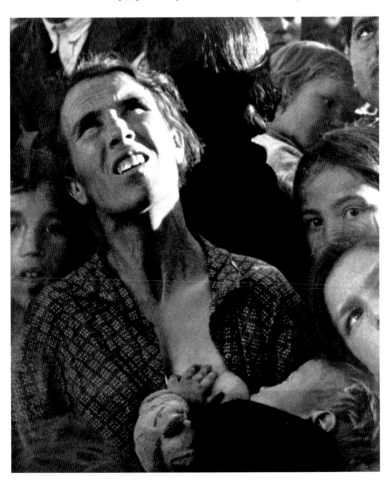

TOP Contemporary cover of *Madrid* magazine, showing a crop of the frame used as wartime propaganda with air-raid artwork added.

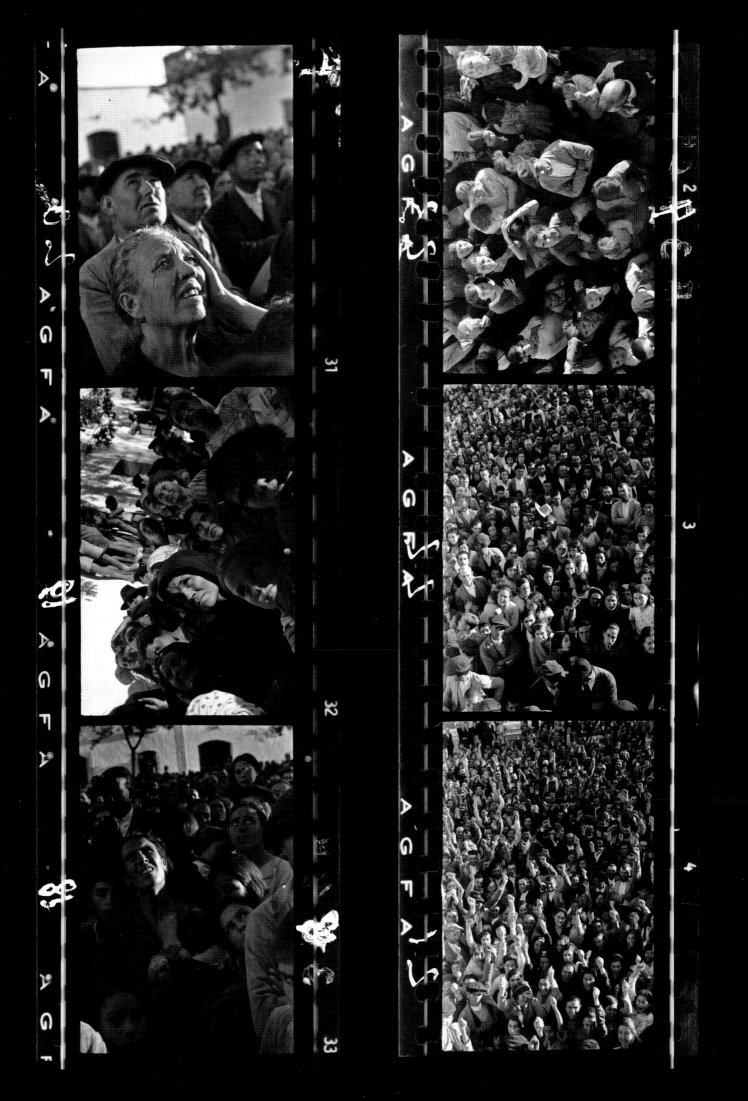

Portofino, Italy
Summer 1936

The image of a Dalmatian lying next to a pair of legs is probably Herbert List's best-known photograph. It has been described as both 'elegant' and 'subliminally erotic'. These are words more usually suited to the work of List's friends and colleagues George Hoyningen-Huene and Horst P. Horst – well-known fashion photographers, who created elegant tableaux in a studio environment.

List left Germany after his openly gay lifestyle and some disrespectful remarks he had made were reported to the Gestapo. Some of his friends had already been arrested, and his part-Jewish heritage also forced his decision. In London, he worked on some professional fashion shoots for *Harper's Bazaar*, but always found the work dull and unsatisfying. He preferred to photograph friends, people he met on his travels, and locals going about their daily business or enjoying leisure activities. Beach life was a particular favourite subject of this one-time nomad. As a young man, List had been part of a youth movement that aimed to overturn the stifling, conservative atmosphere of the turn of the century and make permissible the exploration of personal freedom and physical expression. List's works, with their homoerotic undertones, were a personal challenge to the general aesthetic and morality of his time.

The contact sheet of this series of beach shots reveals the playfulness with which the images were taken. One of List's friends even took the camera and snapped the photographer having a swim with the dog. The hierarchy of the traditional fashion shoot, with a model in a studio, is absent. List finds beauty and elegance not on a pre-arranged set in London or Paris, but in a sunlit cove off the Mediterranean Sea. No silk stockings, nail polish or artificial lighting are needed to turn a pair of legs into an icon – and male legs, at that. It is no surprise that photographers such as Bruce Weber and Herb Ritts have cited List as a strong stylistic influence.

List's private work is fascinating not only because of his pioneering exploration of the naked male body, outside of the realm of sports photography, but also because of his approach to remaining amateur, taking almost all of his images without a paid assignment. In declaring the images of his private life a significant part of his artistic oeuvre, List can be regarded as a predecessor of now-celebrated photographers such as Nan Goldin and Larry Clark. Since List did not see himself as a professional until the 1950s, he did not work with contact sheets; he cut his 6×6 strips into single shots and kept these with thumbnail prints. The sheet shown here is a recreation of the sequence in which the main shot was taken.

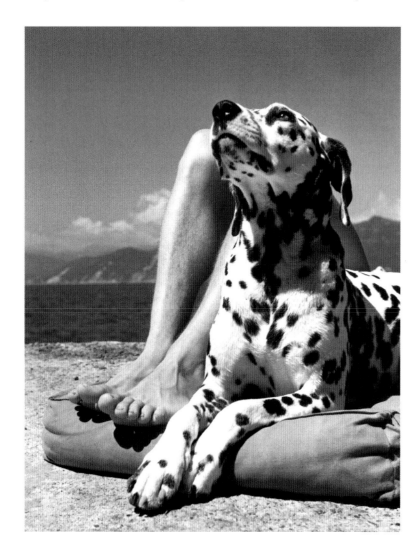

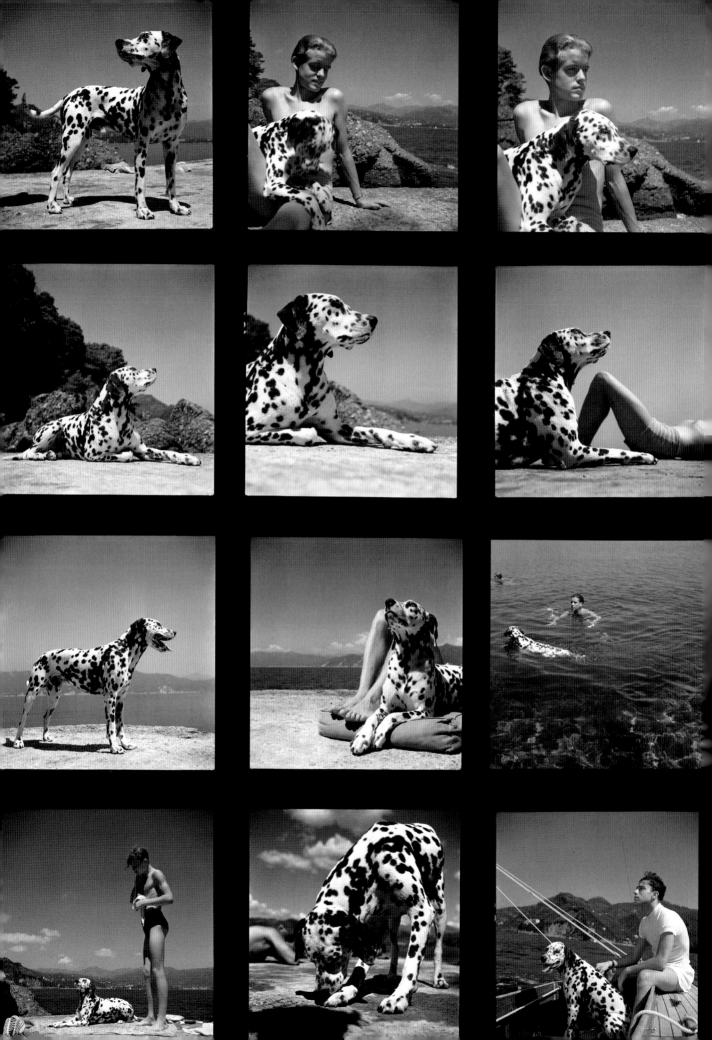

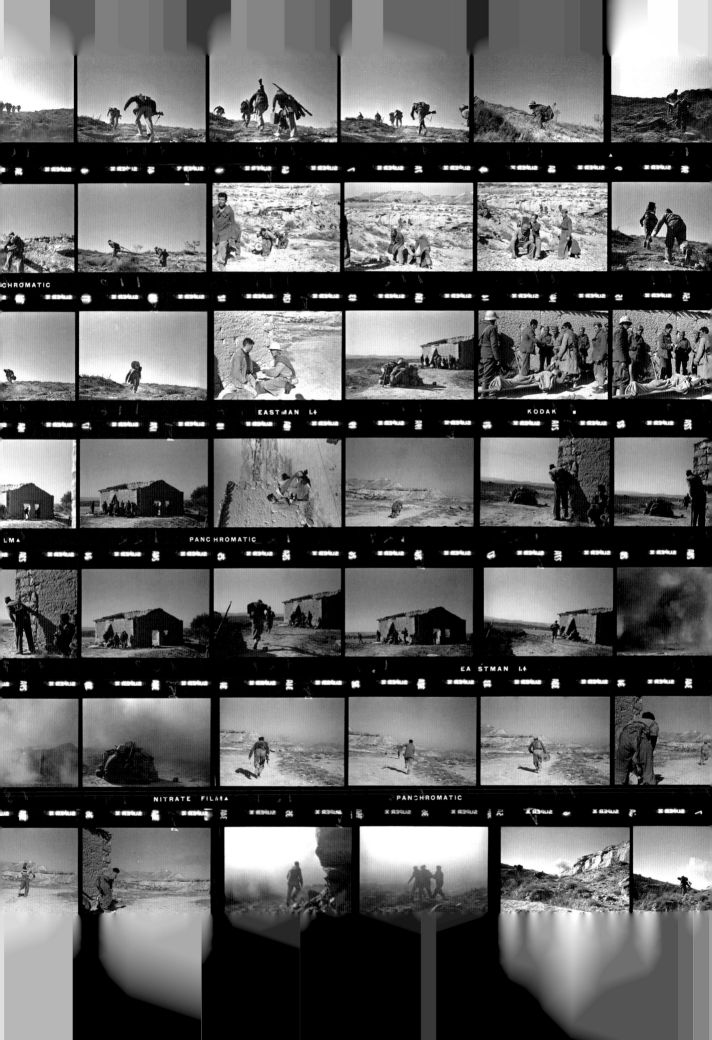

Near Fraga, Aragón Front, Spain
November 1938

Robert Capa's photographs of the Battle of Rio Segre comprise one of his most extensive and dramatic photo essays. Made towards the end of the Spanish Civil War, on 7 November 1938, the story was published in numerous international magazines and newspapers, including the French *Regards* and *Ce Soir*, American *Life*, Dutch *Katholieke Illustratie*, Swedish *Se* and Danish *Billed-Bladet*. The French *Match* and English *Picture Post* gave it an unprecedented number of pages and striking layouts, and *Picture Post* hailed Capa as 'The Greatest War-Photographer in the World'. To capture the images, the photographer essentially embedded himself with a group of Republican soldiers, who were launching an offensive across the Segre River, a tributary of the Ebro. The attack was a pre-emptive strike against the Nationalists to prevent them from crossing the Ebro and taking over Catalonia.

The roll of film featured here is one of the nine that Capa probably shot that day, known through contact print notebooks of the frames, made by Capa at the time the photographs were taken. These notebooks essentially functioned as contact sheets: they indexed all the photographs taken for each story, they included factual notes, they assigned film numbers, and they were shown to editors for image selection. Six of the rolls, including this one, were found in the so-called 'Mexican Suitcase' (three small cardboard boxes containing more than 4,500 negatives by Capa, Chim and Gerda Taro that were lost in 1939 and found their way to Mexico City; they were returned to the heirs in 2007).

This roll captures the climax of the battle and shows Capa's physical style of documenting action. He follows the soldiers as they run up the hill, taking stretchers and telephone wire to the front line, and dash between pillars of safety as explosions go off all around. Page 19 of one of the contact print notebooks respects the original sequence of the film, except for the last two frames, which are from another roll. In the notebook they anchor the page, and are even given sequential numbers. Capa, who was becoming adept at telling a story through his photographs, may have wanted to end the narrative with two frames of the soldiers in dust clouds, thus creating a more intense finale to the page. Indeed, these two images were used by several magazines to help portray the intensity of proximity to action. The photo essay that Capa developed through this story brought readers to the front line in a way that had never before been seen.

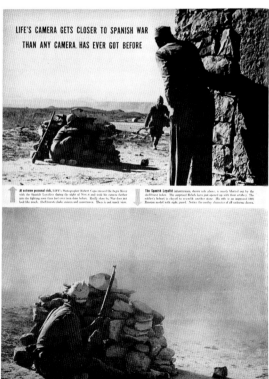

TOP The 3 December 1938 edition of *Picture Post* named Robert Capa 'The Greatest War-Photographer in the World'. Along with eleven pages of his Rio Segre photographs, the magazine featured a portrait by Gerda Taro of Capa holding a movie camera.

ABOVE *Life* magazine, 12 December 1938; the opposite page showed the two images of soldiers in dust clouds from the bottom row of the contact sheet.

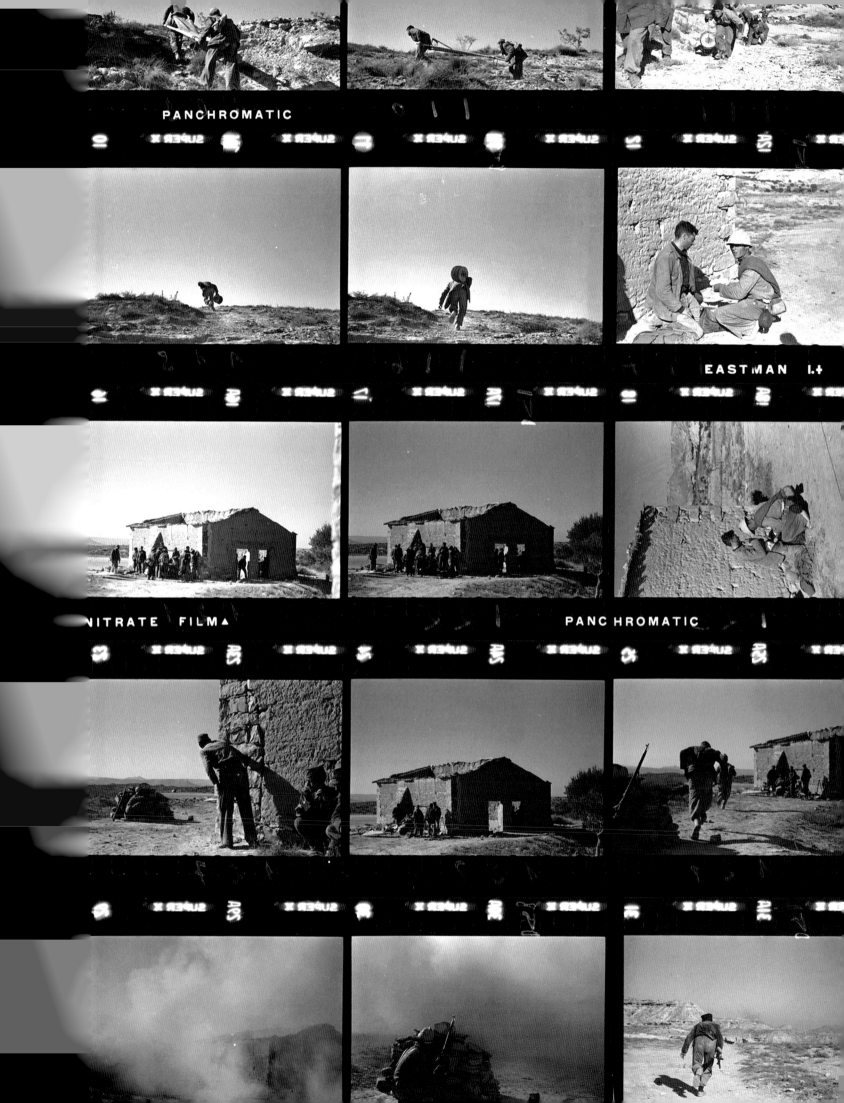

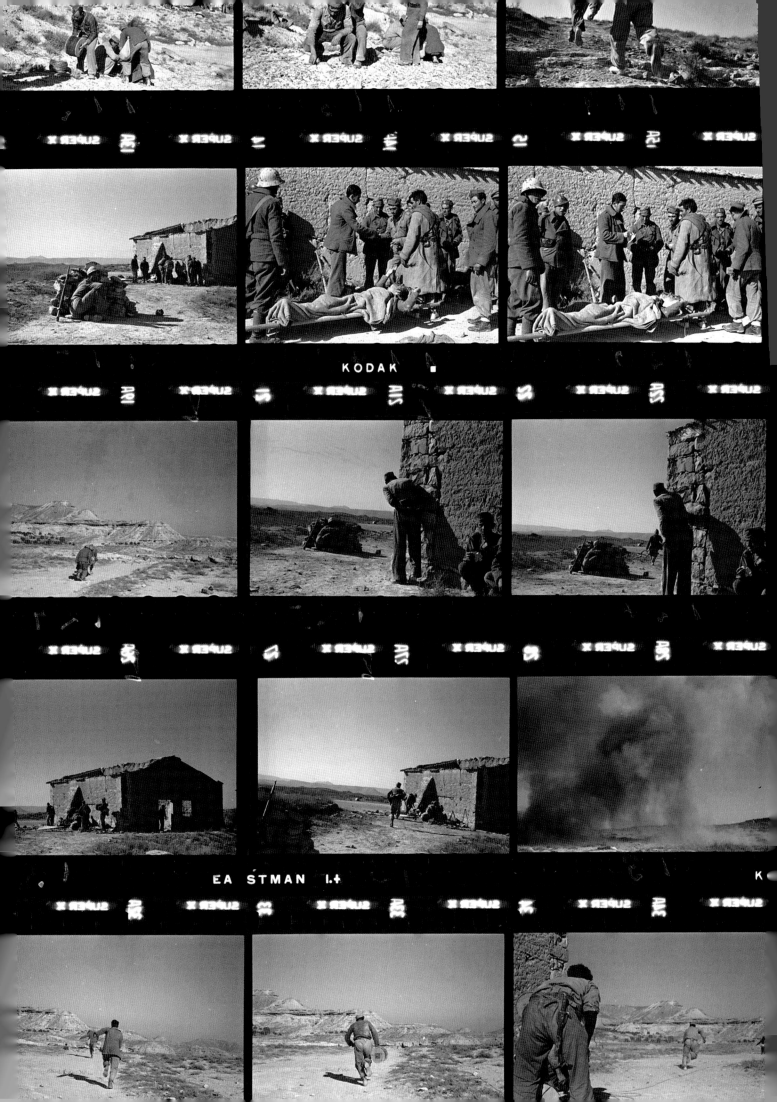

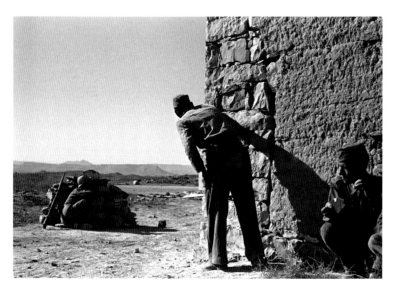 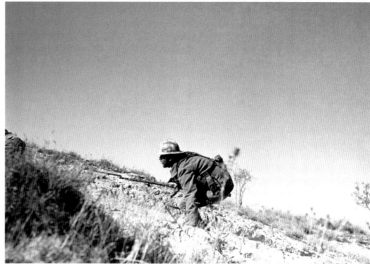

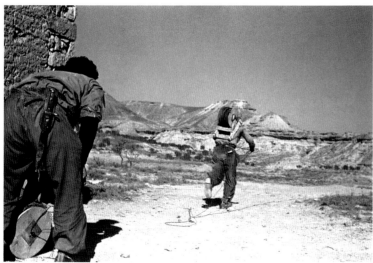 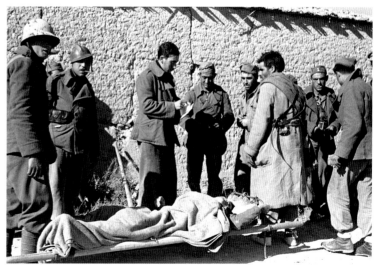

OPPOSITE Page from Capa's contact print notebook, dated 9 November 1938.

PHOTO ROBERT CAPA : ESPAGNE : 9 NOVEMBRE 1938 . V. REPORTAG
FRONT DE SÈGRE .

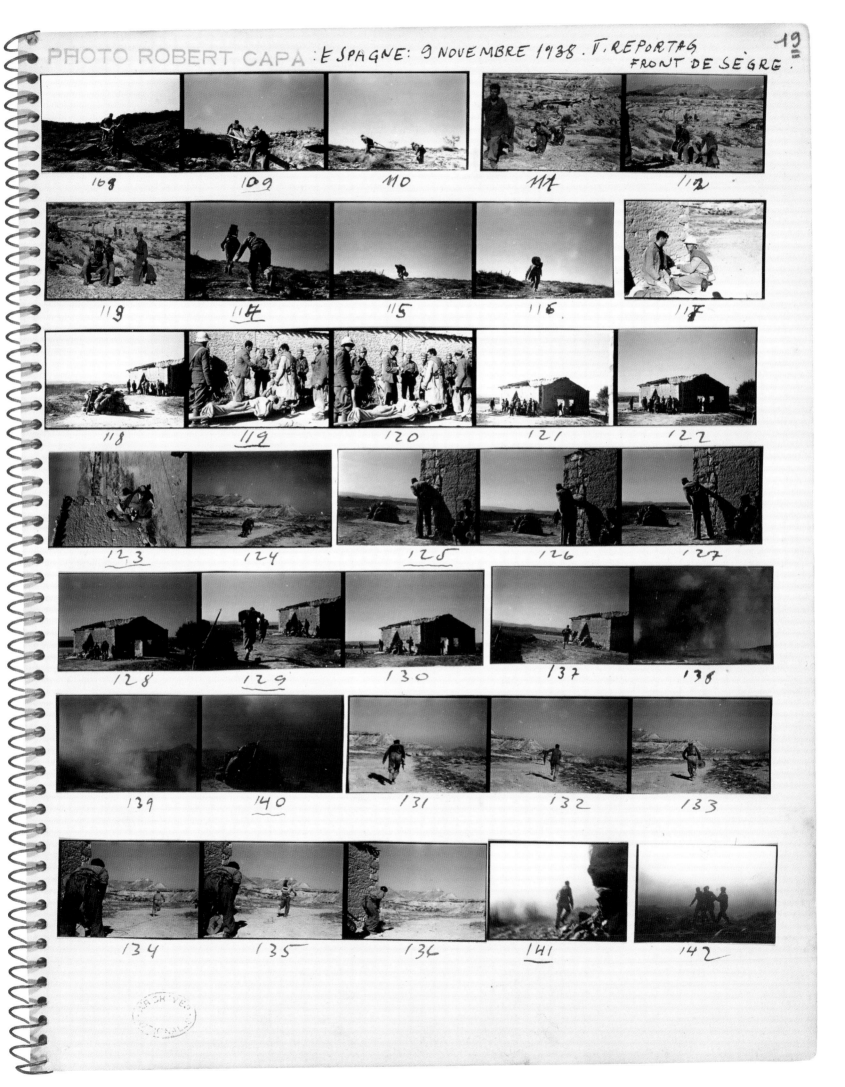

Switzerland
1940

'How serene and great nature is, quite removed from this world. The moon casts its pale face on the glacier below us – a mighty flow of ice with holes and crevasses, blackish-blue abysses signifying nothingness. So soft, so gentle, ennobling all, like a gentle hand the moonlight glides across the icy cold sheets. The shadows are not voids; they are full of life.

'In the blue-black sky a star shines unnaturally bright – Venus. The sparkling dome descends upon the Lauteraarhorn as we make our way, infinitesimal in this immense basin, surrounded by ice and snow. Two beings joined by a rope, silent, unspeaking, each lost in his thoughts. The sharp spikes of the crampons start to dig and without effort the first steep slope lies behind us.

'The first splinters of ice fly into my eyes, gleams of silver. I sense the power of the mountains. It is not the cold night air alone, nor the sound peculiar to ice axes cutting footholds; it is the space, the dimension about me, the freedom I need to live...

'The warming sun feels good. We are only a few metres below the cornice of the summit. What splendour will unfold before us when we look into the next valley, as yet unknown to us? Will it be a gentle snowfield? Will it have steep rugged rock walls? We do not know... Everything about this is wonderful: the anticipation, the enchantment of surprise, unbounded happiness for the person who sees and appreciates the mountains, who grows tired from looking, not from walking.'

This description of a dawn ascent of the Ochsen from the Strahlegghütte was found in Werner Bischof's diary, dated 19 August 1940. Nature came to Bischof's rescue, as did photography: on long mountain hikes, often alone, he relaxed from what would be a total of eight hundred days spent on active duty during the Second World War. His observations reveal the photographer's sensitive eye, and his longing for peace and harmony. To him the mountains were a kind of 'home'.

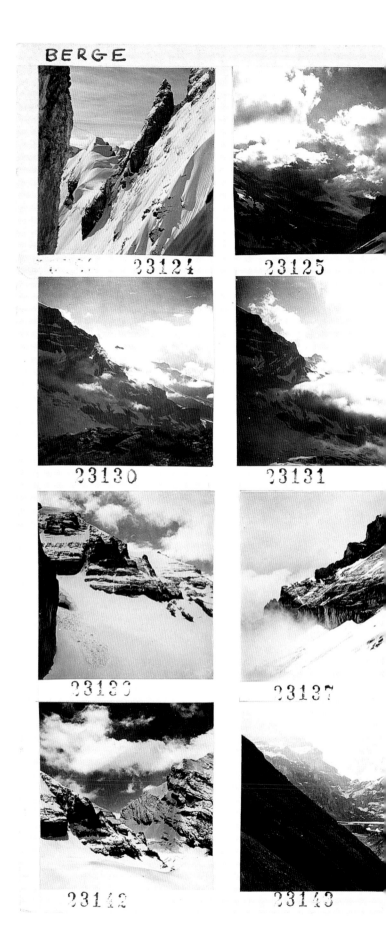

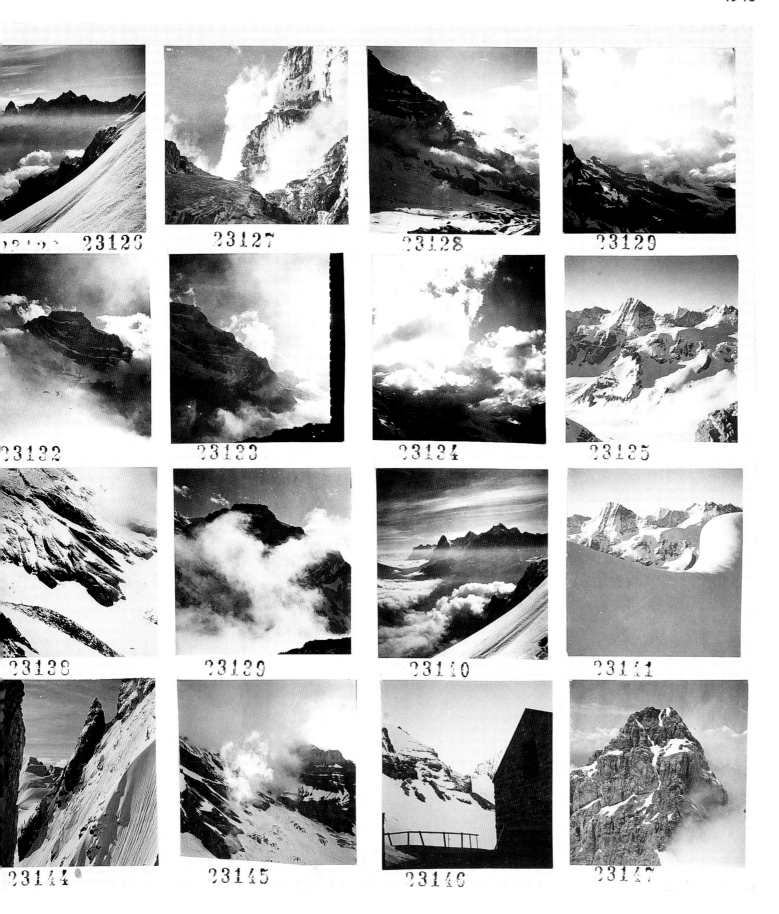

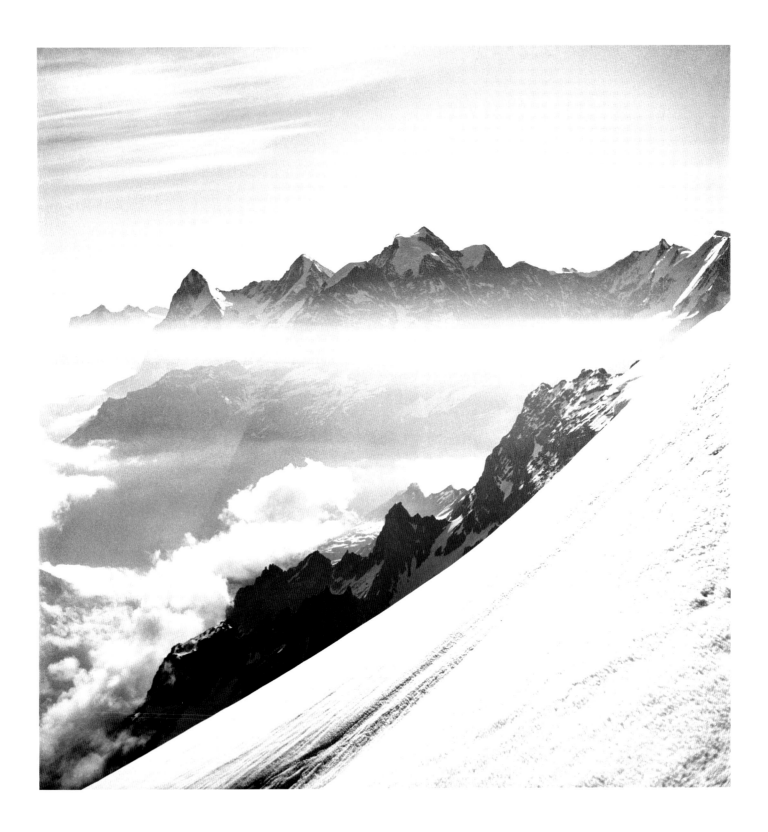

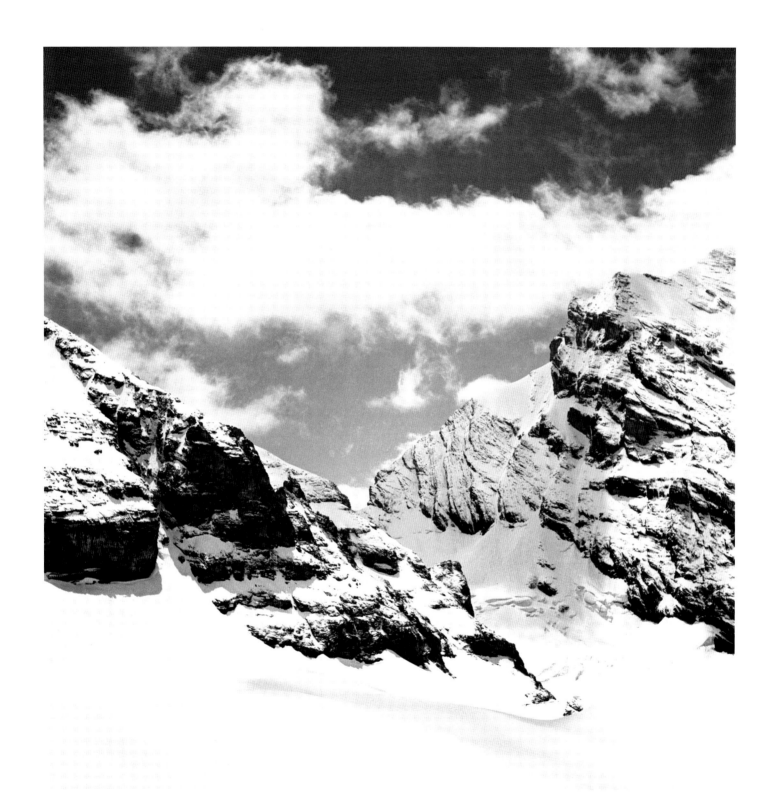

Coventry, England
November 1940

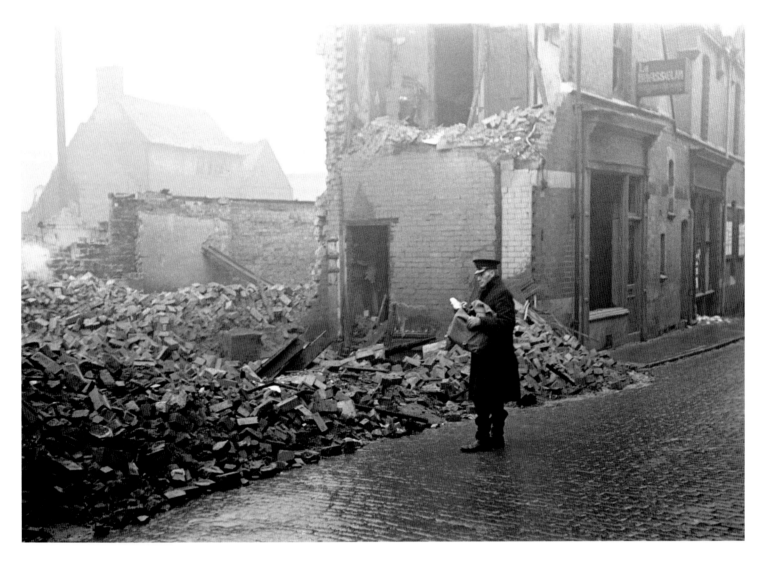

The Blitz contact sheet, made on the morning on 15 November 1940, covers a key moment in the bombing of Britain. As George Rodger wrote: 'Thursday 14 November was the night of the "Baedecker" raid, when German planes attacked five of England's cathedral cities, which were virtually undefended. The hardest-hit was Coventry – a prime target throughout the Blitz, since many of the local car firms had changed over to aircraft manufacture and the production of armaments. As the charred ruins continued to smoulder after the night-long raid, I watched the city slowly come to life again. Many bombed-out residents were evacuated; food supplies were rapidly organized for those who remained. Life had to go on – but postmen on their rounds found many addresses missing. Meanwhile, the pilots of the RAF were fighting back furiously. Over in Germany the

fat Reichsmarshall of the Luftwaffe huffed and puffed and declared: "This is the historic hour when our air force for the first time delivers its stroke right into the enemy's heart." But our Spitfires and Hurricanes and our guns denied him his knock-out blow.'

Rodger's stories captured the endurance and resilience of the human spirit. For *Life*, who wanted sharp images, Rodger used both Leica and Rolleiflex, while for European publications, such as *Picture Post* and *Illustrated*, he used only the Leica. Pierre Gassman, who re-edited and printed the Blitz photographs in 1990, noted that: 'In the 1940s George had been the victim of editors who chose "what the public wanted to see".' Despite this censorship, it was his war coverage that brought him to international attention.

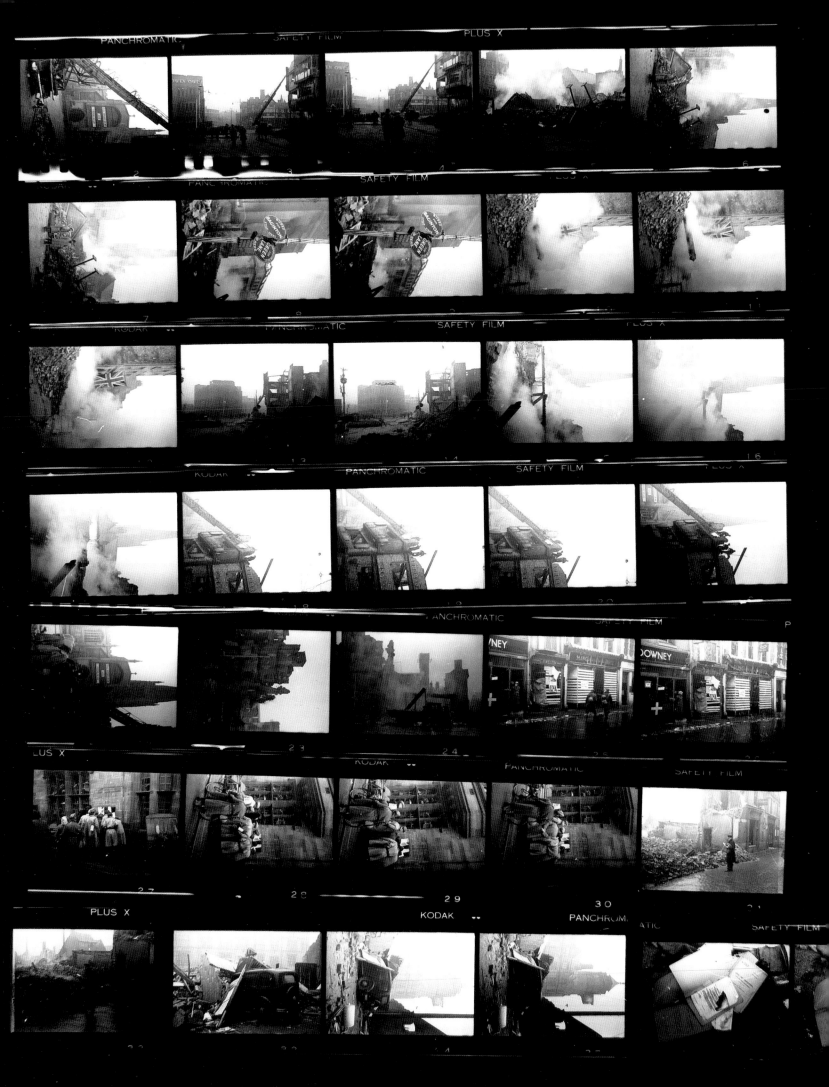

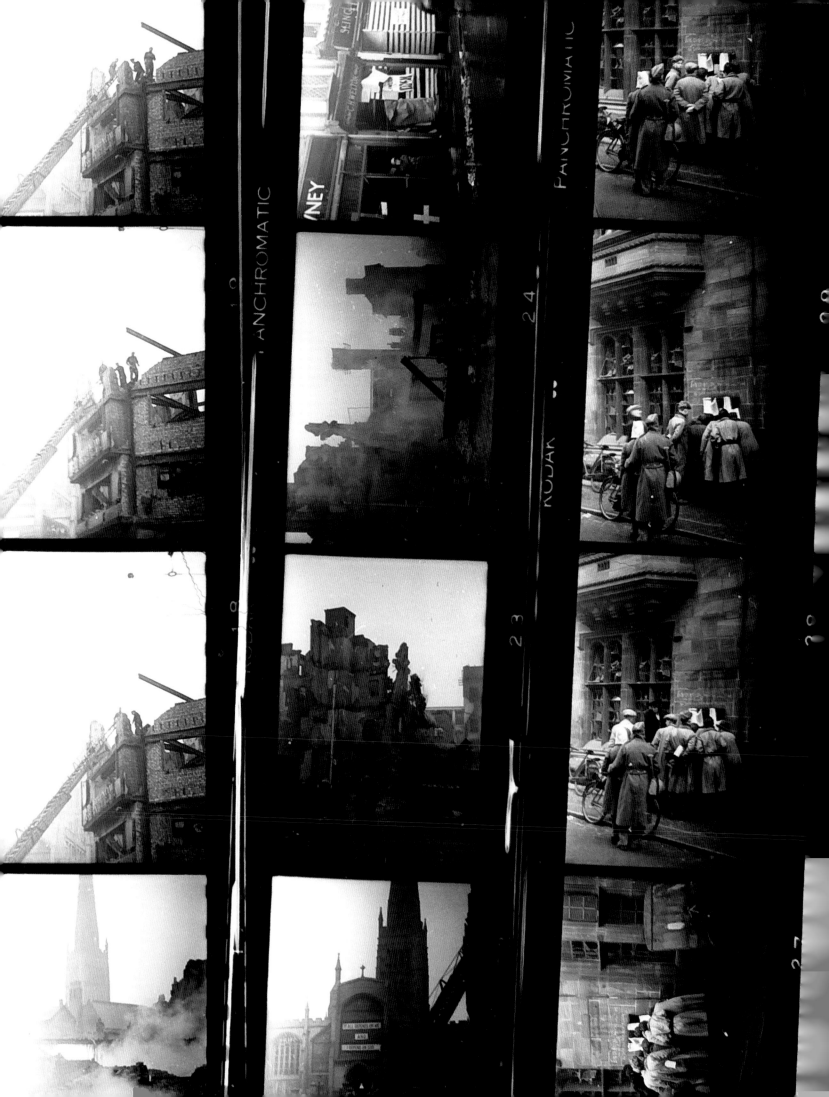

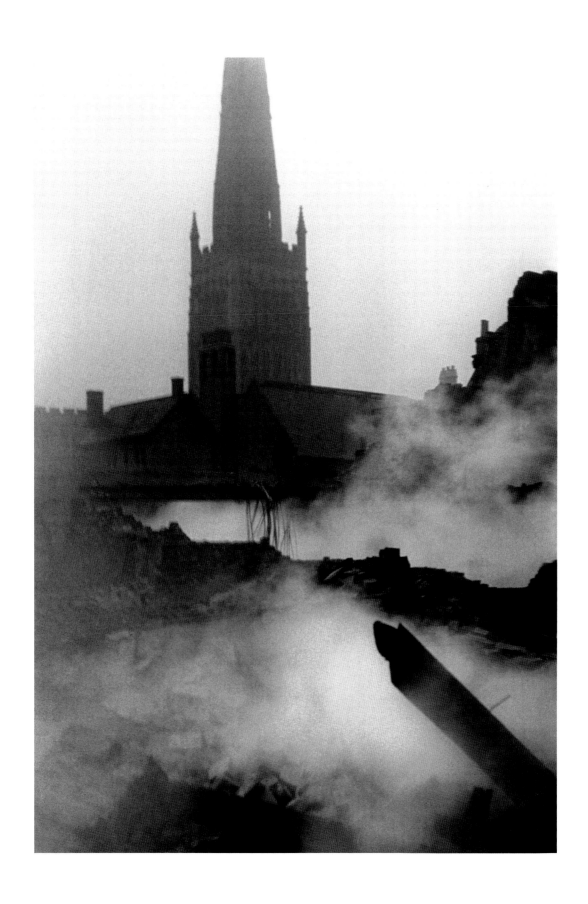

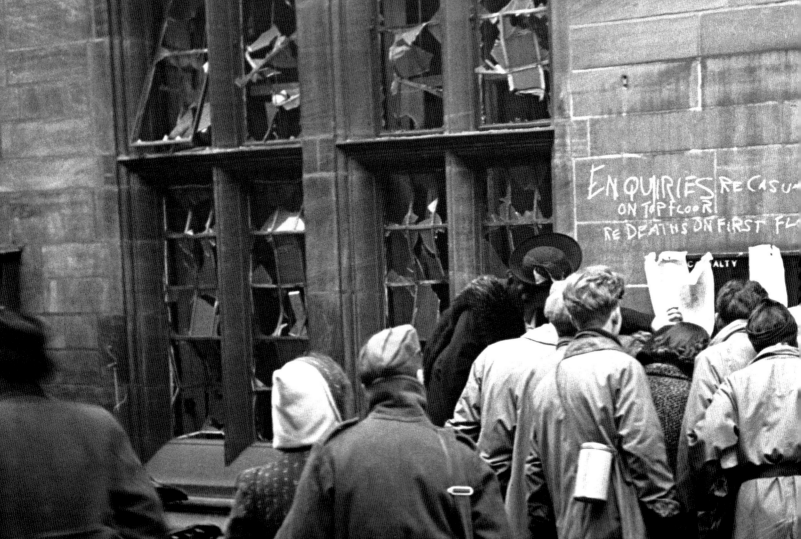

Egypt and Libya
June 1941

As a war photographer in the Second World War, George Rodger was one of only six English and American correspondents to be sent to cover the North African Western Desert Campaign. On assignment for *Life* magazine, he joined Charles de Gaulle's Free French forces, fighting the advance of Italian and German troops. His start, however, was not promising: 'I had already been four days in the desert without taking a picture of importance and began to despair of our "party" ever setting out. I went to the G.S.I. officer to find out for myself what the general situation was, so as to form my own operation plans.

'The actual position of the enemy seemed to be very doubtful… General Rommel with his 15th and 21st Panzer Divisions was swinging backwards and forwards across the desert to the south like a pendulum, in a series of retreats and counter attacks. His position, of course, changed daily, if not hourly. Along the coast were large pockets of enemy still holding out who had been left behind in the general retreat westward… Our general attack was a five-column drive spreading west, like the fingers of a gigantic hand, from the wire on the Egyptian frontier and curving to the north so as to scoop the enemy out of the desert and drive him to the coast…

'This, from the point of view of general photographic coverage, presented quite a problem. Firstly the distance, roughness of the ground, and unreliability of the P.R. transport, made it impossible for me to get from one column to another. The desert was very rough with no roads and was [more] often than not, either mined or covered by hidden pockets of the enemy… I decided therefore to stick to the coast road and meet them as they came up out of the desert.'

A further problem was the fact that Rodger was told his film had to be developed by Kodak and censored through the British embassy in Cairo. After a disastrous experience with a commercial photographer who ruined his films, he was left with only a few, badly scratched Rolleiflex negatives. He tried – not always successfully – to develop his own film in bathtubs. As he trenchantly recalled: 'The editors of *Life* were able to use only one double page from the vast stock of pictures which should have been available. I had sweated across 9,000 miles of Africa to get these pictures. It was a bit annoying.' However, he persevered, meticulously captioning his photographic materials and documenting each day's events in a diary, and in 1944 his work was published as a book, *Desert Journey*.

ABOVE Spread from George Rodger's *Desert Journey*, first published in 1944.

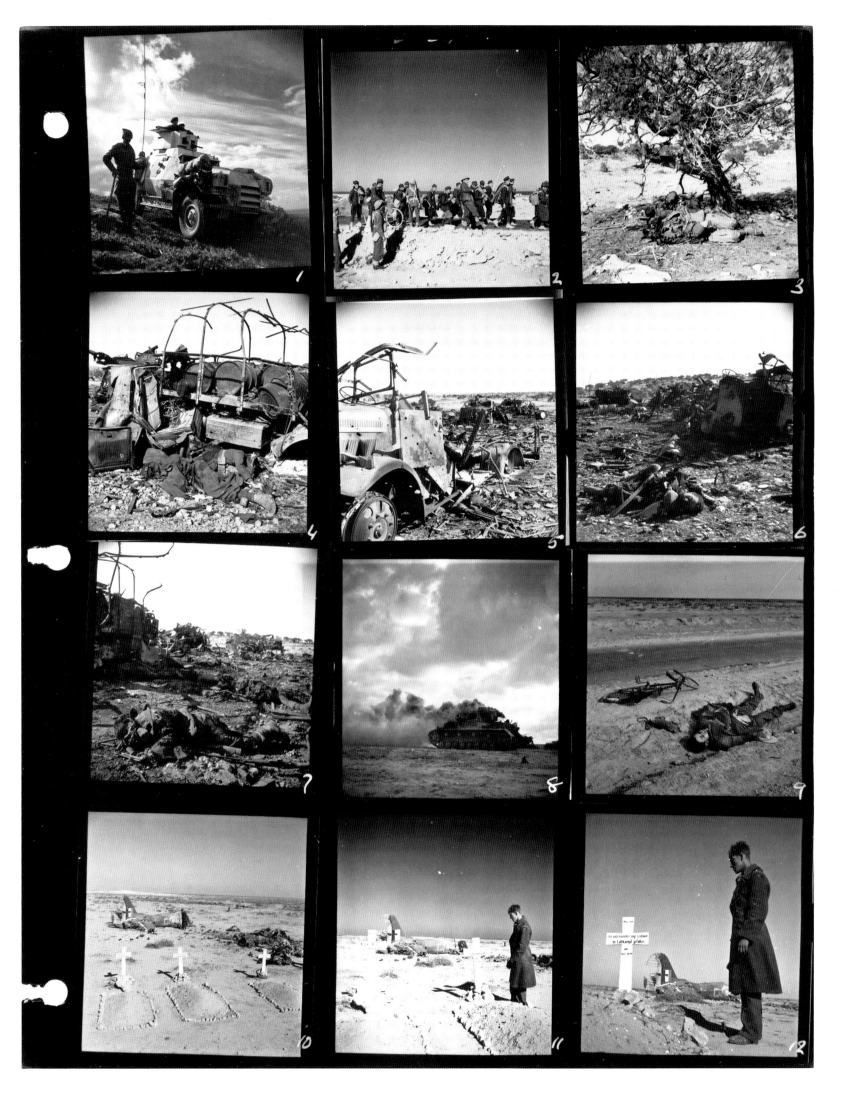

STORY NO. 20-X

ROLL NO. 5 R.

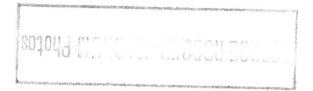

Roll 5
Advance into Western Desert 1941 --- the Benghazi Handicap

1. A South African armoured car picking a way through enemy minefield
2. Italian prisoners taken by the Free Polish Brigade being marched back to base from the perimeter of Tobruk
3. On the windswept escarpment above Derna a lone tree shelters the shot-ridden corpses of Italian soldiers
4. On the Coast Road leading East from Tobruk to Derna, an Italian supply column just ahead of our advance troops was straffed by low-flying planes of the R.A.F.
5. ditto
6. ditto
7. ditto
8. A German tank left in flames, over-run by the Westward drive of the 8th. Army
9. West of Gazala a young German soldier lies dead beside the bicycle he was riding
10. The graves of the crew of a British Bomber shot down in the Western Desert in June 1941. The wreckage of their plane lies beyond the crosses
11. ditto
12. ditto an example of the chivalry of Rommel's Afrika Corps The inscription reads " Here lies an unknown English Lieutenant who died in the air war."

OPPOSITE Back of the contact print, with Rodger's own typewritten, numbered captions.

Normandy, France
June 1944

D-Day – 6 June 1944 – was the beginning of the massive Allied invasion of western Europe to confront Hitler's forces. Two days previously, in the coastal town of Weymouth, England, American soldiers boarded landing crafts that shuttled them to their transport ships, anchored outside the tiny harbour. Capa shot numerous photographs of this operation and then accompanied the troops across the English Channel. The Allies were directing their forces toward Normandy, on the northern French coast, where they would attack along a fifty-mile stretch of beach, divided into five sections (the Americans would land on Utah and Omaha).

The invasion on Omaha beach was chaotic, and Capa nearly lost his life. Rough seas swamped all but a few of the amphibious tanks that were to back up the infantry, and many of the boats were driven off target by the wind and current, separating men from the officers with whom they had expected to rendezvous. The beach rockets intended to stun the Germans arrived too early and the aerial bombs landed too far inland. Many infantrymen deemed it suicidal to attempt to cross the open beach, so the waterline was soon mobbed with crouching, pinned-down men without officers to lead them forward. Capa photographed on the beach for about an hour and a half, shooting four rolls of 35mm film. He then boarded a ship to take him off the beach, but this was subsequently hit and sank, and he eventually made it back on another boat, where medics were treating the wounded. He arrived in Weymouth on the morning on 7 June, handed his film to the army courier, and returned to France.

That evening, Capa's films arrived at the *Life* offices in London. Picture editor John Morris told photographer Hans Wild and the young lab assistant, Dennis Banks, to rush the prints. When the film came out of the developing solution, Wild looked at it wet and told Morris that, although the 35mm negatives were grainy, the pictures were fabulous. A few minutes later, Banks burst into Morris's office, blurting out hysterically, 'They're ruined! Ruined! Capa's films are all *ruined*!' Because of the necessary rush, he had put the 35mm negatives in the drying cabinet with the heat on high and closed the door. With no air circulating, the film emulsion had melted. Although the first three rolls had nothing on the film, there were several images on the fourth. The film Capa had shot with his Rollei before and after the landings had not been put into the drying cabinet and so survived intact.

Although the few 35mm negatives on the fourth roll were usable, the emulsion on them had melted just enough so that it slid a little over the surface of the film. Consequently, sprocket holes – which would normally punctuate the unexposed margin of the film – cut into the lower portion of the images themselves. Ironically, the blurring of these images may actually have strengthened their dramatic impact, for it imbues them with an almost tangible sense of urgency and explosive reverberation. There are only ten images of the story known today, and the negative of the one soldier coming up on the beach is missing, probably lost around the time of the story.

When the pictures were published in *Life* on 19 June 1944, they changed the course of public sentiment for American involvement. They remain some of the most widely recognized images of war.

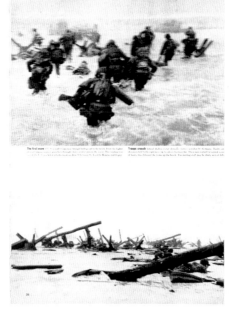

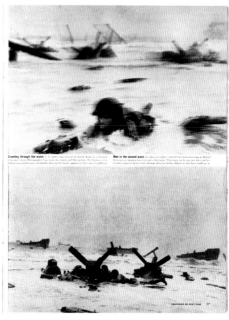

ABOVE *Life* magazine of 19 June 1944 reproduced a total of ten of the eleven salvageable frames from Capa's original 108.
OPPOSITE This digitally reconstructed contact sheet features the nine surviving negatives (two of the salvaged originals have been lost).

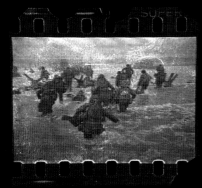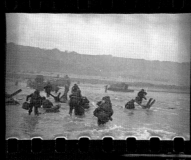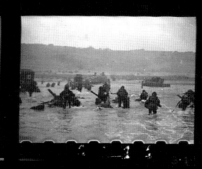
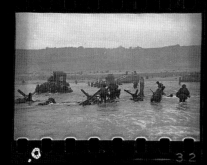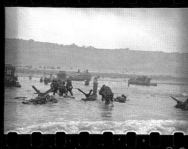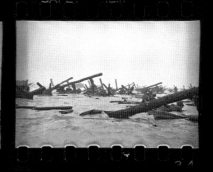
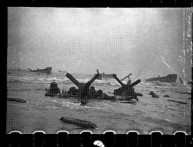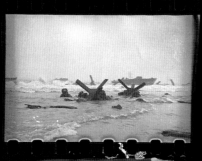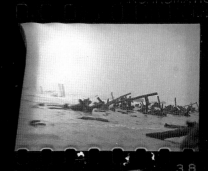

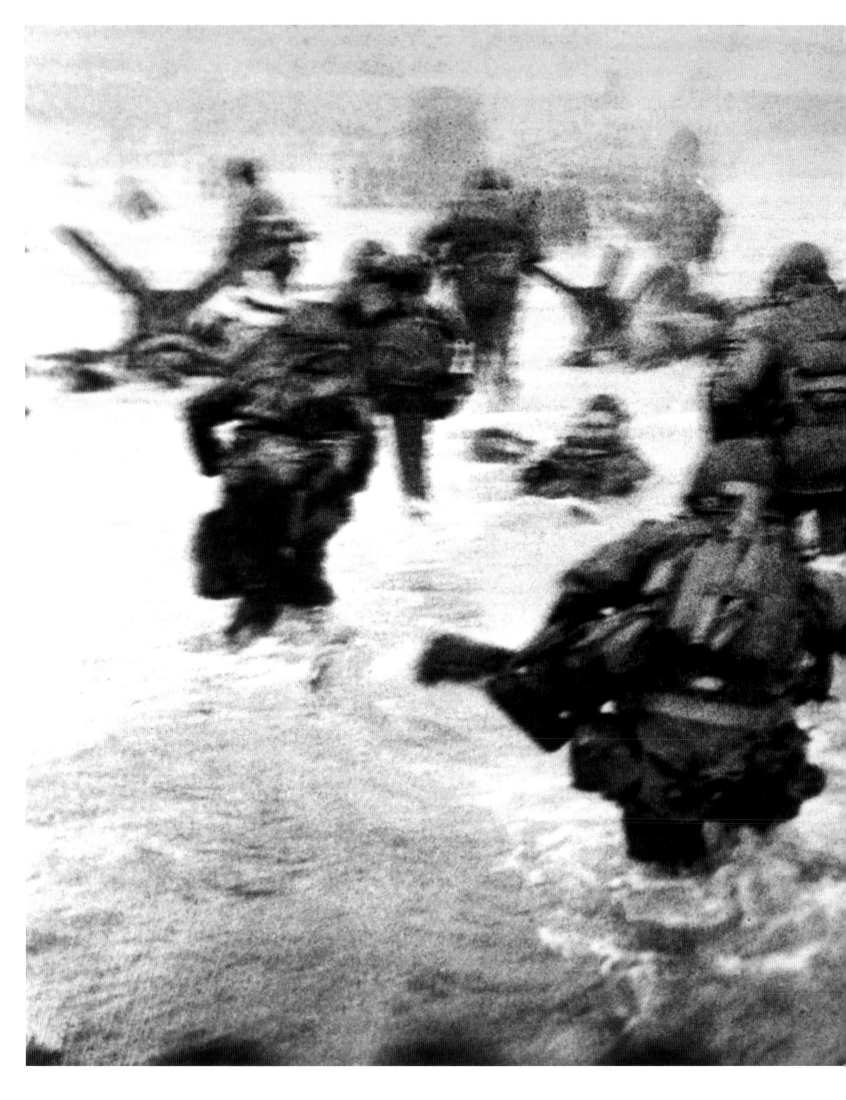

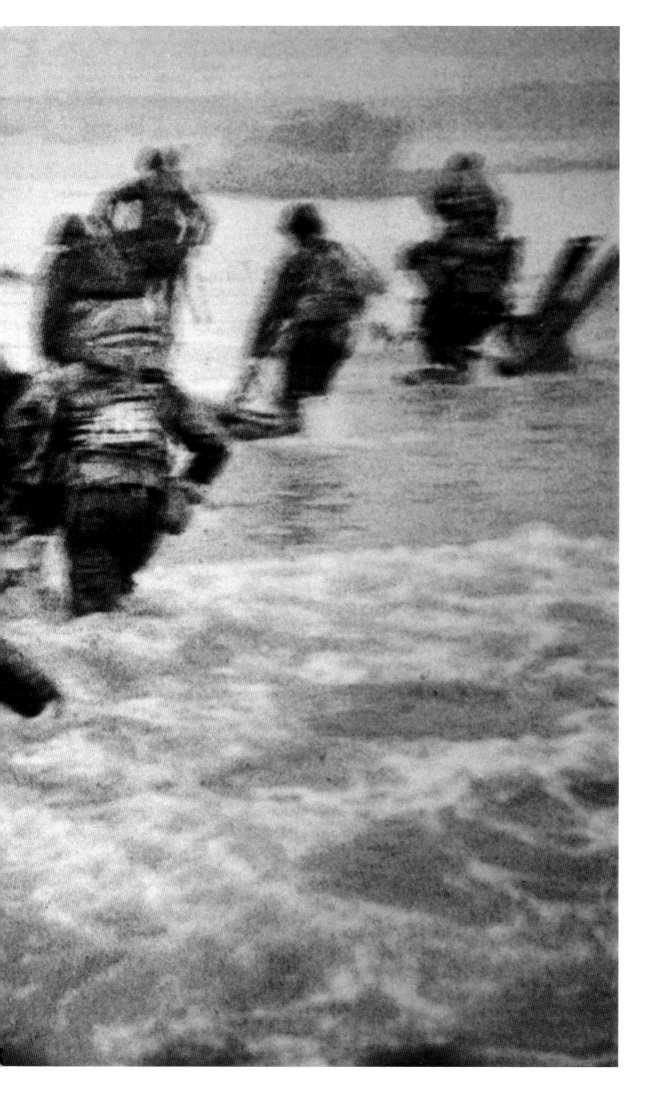

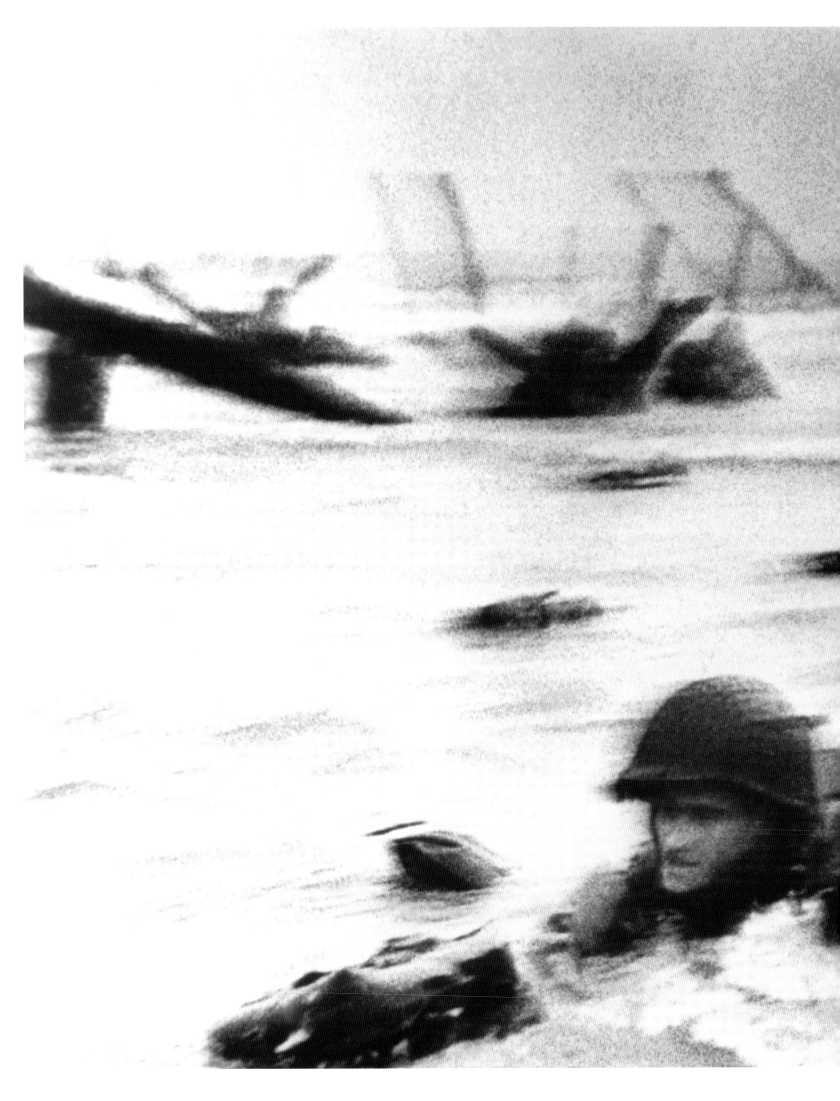

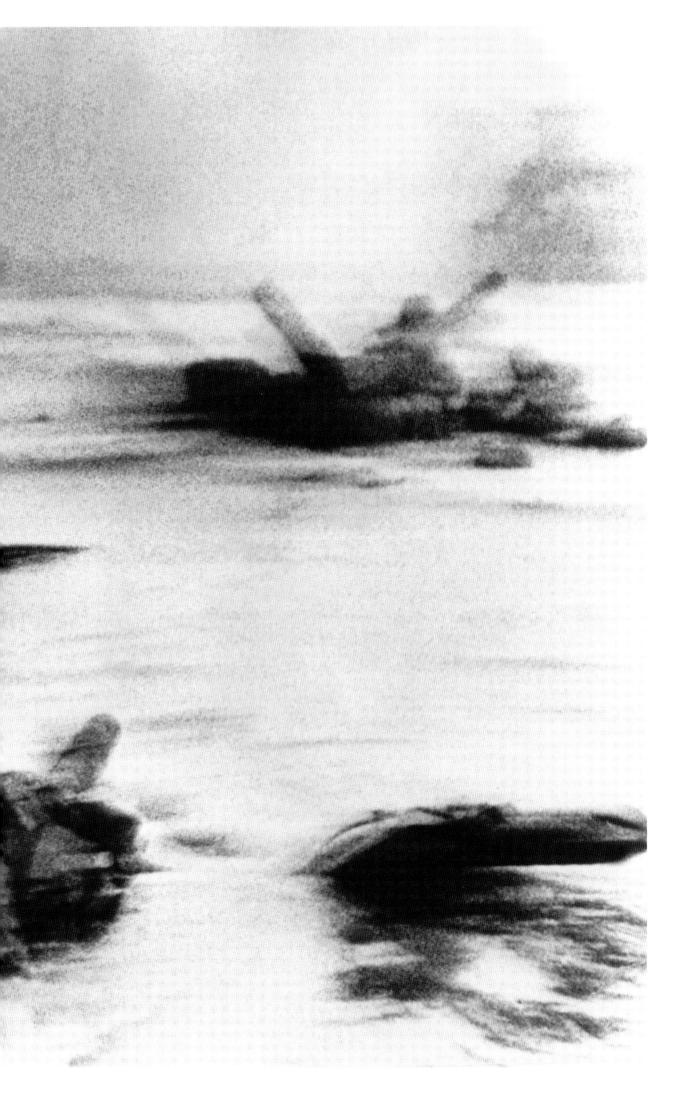

Germany
April 1945

By 17 April 1945, the Second World War was near a close. German defeat was imminent and the Allies were almost ready to declare victory. Capa had joined the First Army's 2nd Infantry Division as it fought its way through the western outskirts of Leipzig, then entered the city with little opposition. He accompanied a platoon of machine gunners into an apartment building at the corner of the main street that ran across the Zeppelin Bridge and into the centre of the city. In an open apartment on the fifth floor, two platoon members were shooting a gun on a table beside a window. The men then moved out to the apartment's open balcony, from which they had a clear line of sight along the main roadway over the bridge, to give adequate cover to the advancing troops. Capa hoped that from there he would be able to shoot an overview of soldiers on the bridge that could be, as he put it in his autobiography *Slightly Out of Focus*, 'the last picture of the war for my camera'.

Switching between two cameras, a Contax and a Rollei, Capa photographed the soldiers shooting through the window and then outside on the balcony. Then, in front

of his eyes, one of the soldiers was hit and killed by a German sniper. Capa shot several more frames in which the young man's blood pools into a spreading puddle on the floor. They are the most gruesome photographs of Capa's entire career.

Life did not publish the pictures until the 14 May issue, which heralded the end of the war in Europe, suggesting, as Capa wrote, that he 'had the picture of the last man to die', although the war continued with many deaths for an additional three weeks. *Life* covered the faces of the two soldiers on the balcony, so that the family would not read of their son's death before receiving official notification from the US Army. Above the photographs the magazine spread featured four lines from A. E. Housman's poem, 'The Day of Battle':

Therefore, though the best is bad,
Stand and do the best, my lad;
Stand and fight and see your slain,
And take the bullet in your brain.

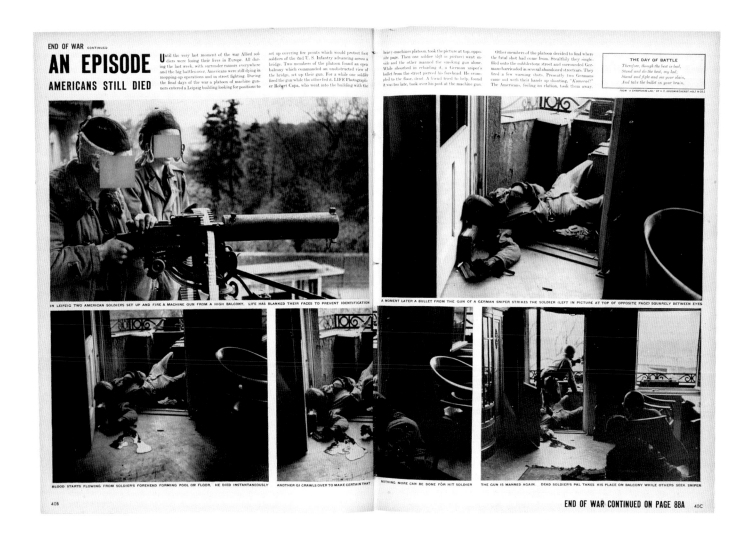

ABOVE Spread from *Life* magazine, 14 May 1945, with the soldiers' identities disguised.

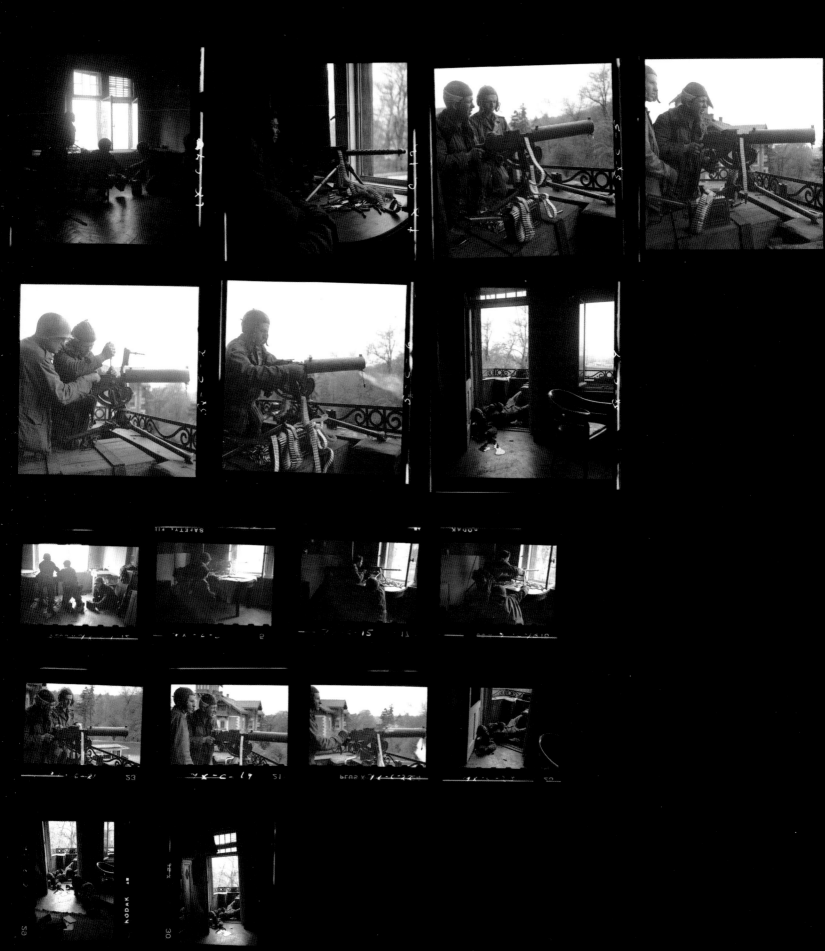

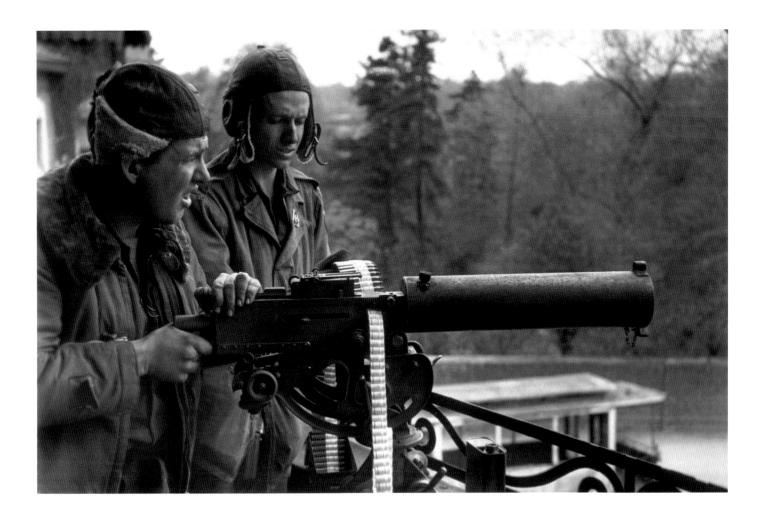

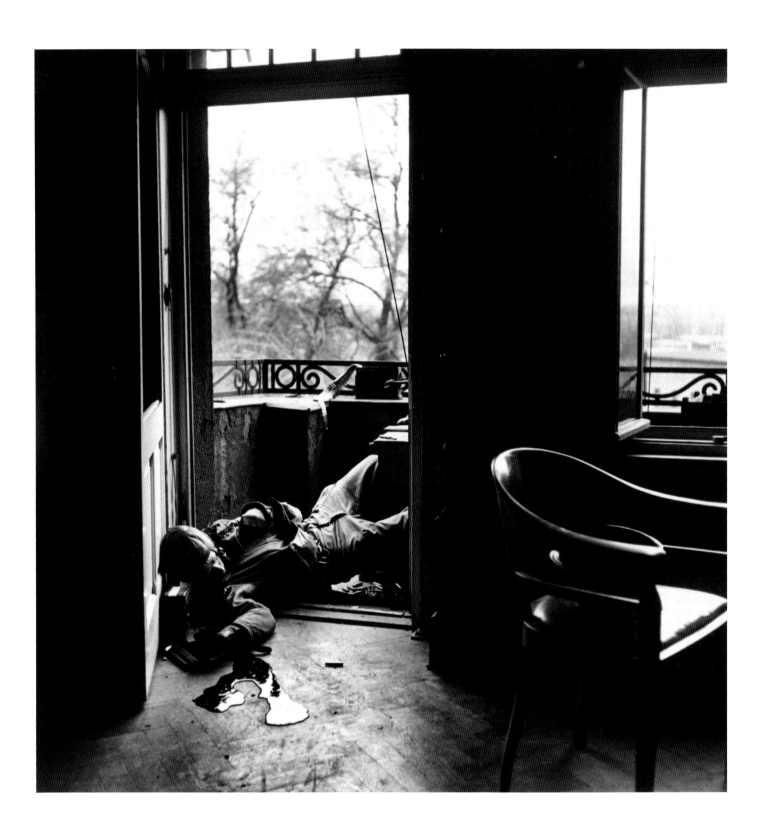

Munich, Germany
Winter 1945/1946

Herbert List's escape from Nazi Germany to southern Europe lasted only five years. Forced to return by the German occupation of Greece in March 1941, he made the city of Munich, with its many neo-classical elements, his home. List was not permitted to work as a photographer and was drafted by the German Wehrmacht to manage a map store in Norway. He returned to Munich in April 1945 to find the city in ruins.

The photographic documentation of destroyed German cities began straight after the war. German and international photographers alike mostly used an accusatory visual language that conveyed shocking impressions of horror and devastation. However, it was not long before photographs of reconstruction and the legendary 'Trümmerfrauen', war widows and survivors who cleared the streets and ruins of rubble, dominated the image of post-war Germany in publications.

List was not interested in journalistic documentation of loss, damage or reconstruction. Instead, he frequently turned his attention to Munich's cultural institutions,

exploring the skeletons of neo-classical buildings, such as the art academy, the Glyptothek and Pinakothek museums, and the state opera house. Inside the art academy, List came across plaster casts of classical sculptures: crippled representatives of a classical humanism that was short-lived and destroyed by barbarism.

List's more than four hundred sober images of a war-torn Munich remained almost completely unpublished, and it took another thirty years before this body of work was reconsidered. Since then, the image of plaster casts at the academy has often been named a key work of early post-war German art. It juxtaposes a model of a superhuman statue by Third Reich sculptor Josef Thorak with a plaster cast of its classical humanistic roots. List exports from Greece to post-war Germany his style of photographing ruins and sculptures as symbolic forms in dramatic light. The warm sunlight of Greece has been replaced with the snow and winter sun of Munich, creating a frozen moment of a collision of ideals.

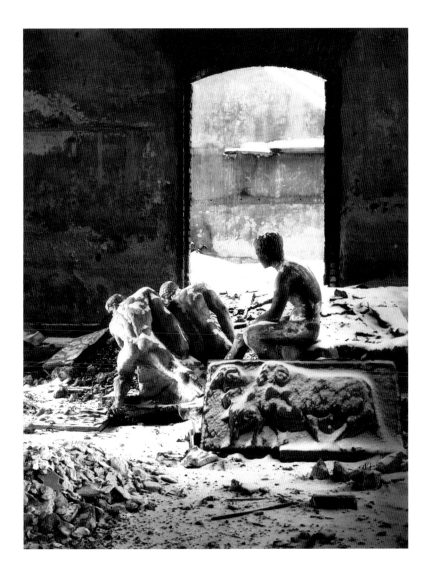

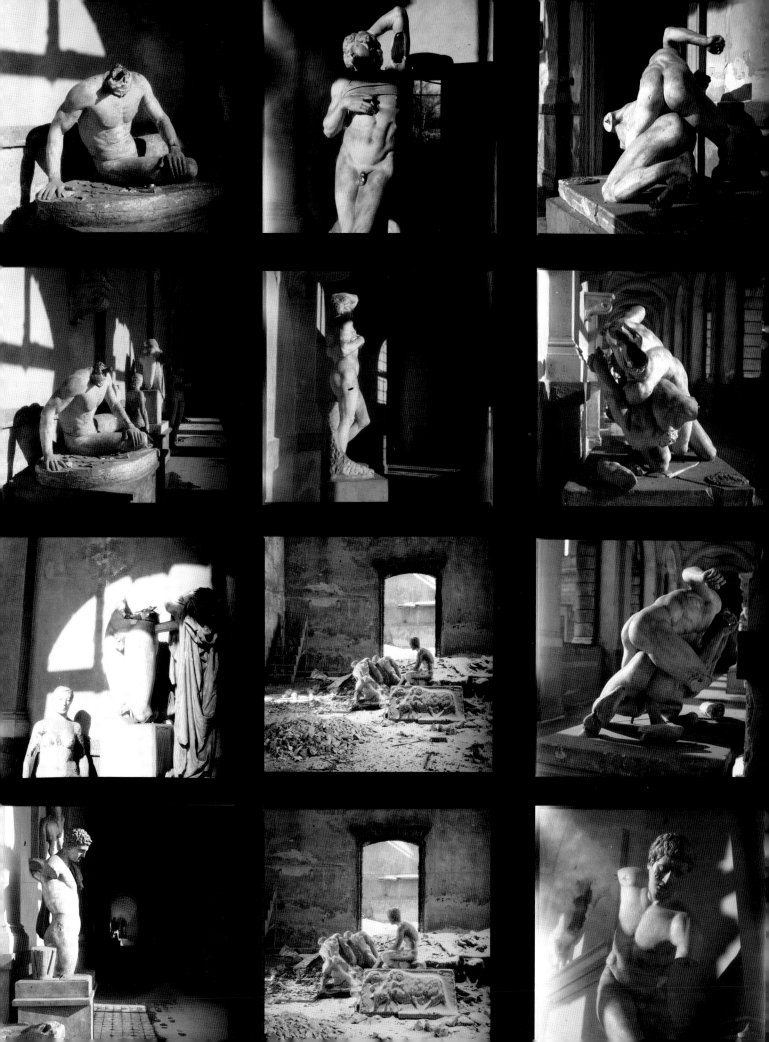

48-25-7

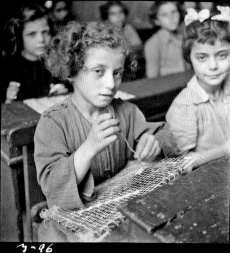

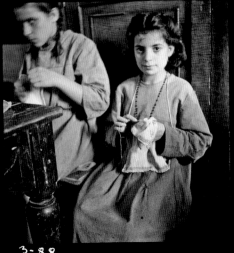

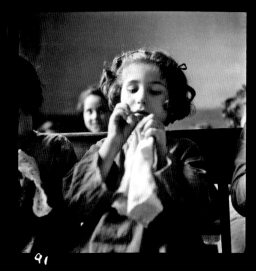

3-96

3-88

91

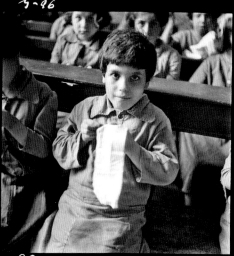

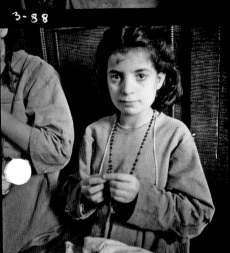

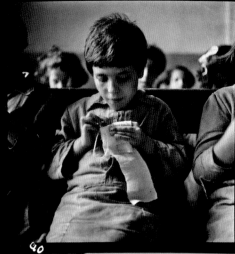

87

40

95

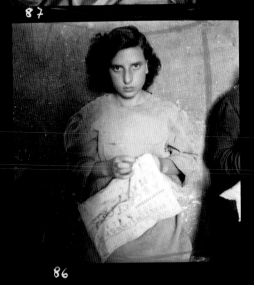

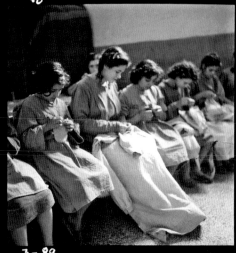

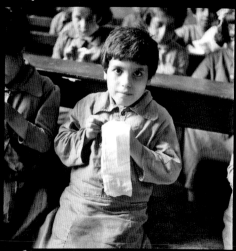

86

3-89

94

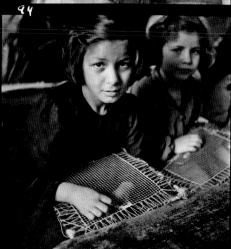

Naples, Italy
Spring 1948

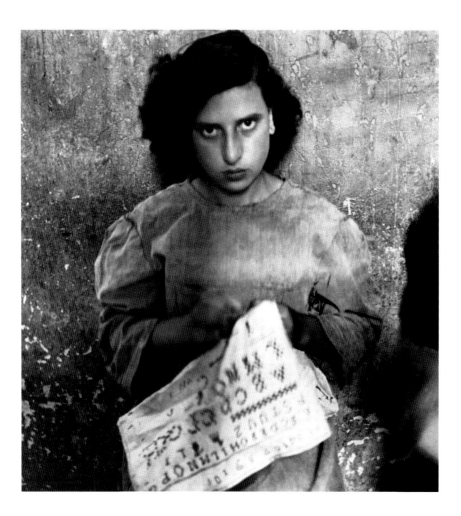

These photographs were taken in the spring of 1948 as part of David 'Chim' Seymour's work for UNICEF on Europe's children. In Naples alone, there were 75,000 street children, living mostly in groups, and active in the black market or pilfering in order to survive. The girls frequently had no choice but to sell cigarettes or turn to prostitution.

At the end of the war, the Albergo dei Poveri, a palatial building founded in 1752 by King Charles III of Naples and Sicily, was turned into a reformatory, where young vagrants, prostitutes and thieves were placed by order of the Juvenile Court. Boys and girls were kept in separate buildings, and the girls were taught embroidery by Catholic nuns, who saw this type of work as educational and redemptive.

On his assignment, Chim used a 35mm Leica and a medium-format Rollei. Working with the Leica, he followed the girls at recess to the yard, where they joined in a ring, then sat in a circle under the care of a nun wearing a full habit. Using his Rollei, he photographed the boys' orchestra and gymnastics session, and the children lined up in rows, as if – somewhat ironically – for a family portrait. In the room where the girls were sewing, Chim was drawn towards the oldest, an adolescent. According to the caption he provided, she had been raped, but subsequent captions often mistakenly identify her as 'a young prostitute'. Her beautiful face bears a haunted expression; a patch of light rests on her body as well as her embroidery, and briefly illuminates her left cheek. Behind her, a soiled wall marked with scratches speaks of lost splendour. The shot is slightly fuzzy and goes beyond the literal documentation: it has a dream-like quality. From each square of image to the next, we follow Chim as he walks around the room, slowly, silently, undoubtedly with his cat-like movements, exploring one face after another in tight frames. Though he was far from tall, he must have crouched to be at the children's height.

One photograph shows the girls seated in rows, as if in a classroom, clothed in loose and drab uniforms. Except for this frame, Chim chose to isolate his subjects, as if to echo their own solitude and alienation. None of them grins, but they return the photographer's attentive gaze with seriousness and maybe a hint of hope, perhaps feeling that they have been seen outside a penal system, recognized and respectfully singled out as individuals.

Each photographic square carves a hole into the scene and draws the viewer into the mystery of these young faces, as if the photographer had managed to open a brief window of light into the after-war darkness of the room, and of their souls.

New York, USA
1948

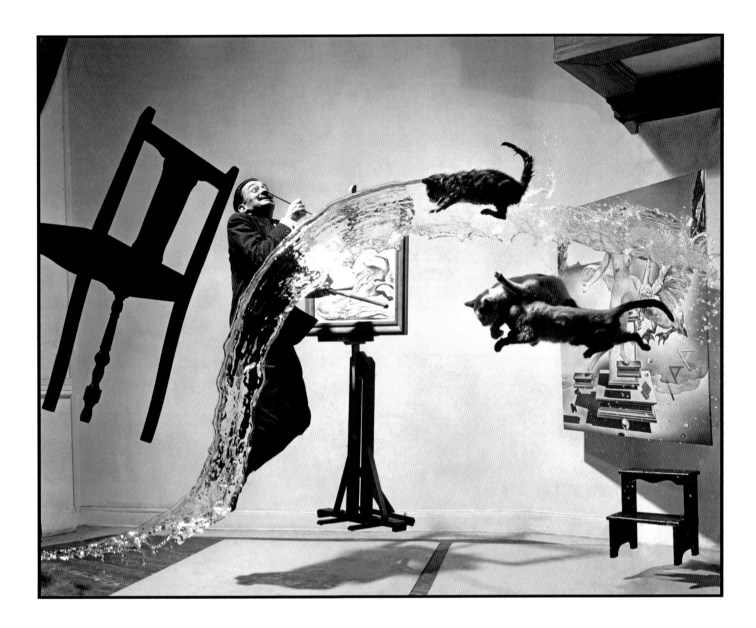

'If the photograph of a human being does not show a deep psychological insight, it is not a true portrait but an empty likeness,' wrote Philippe Halsman. 'Therefore, my main goal in portraiture is neither composition, nor play of light, nor showing the subject in front of a meaningful background, nor creation of a new visual image, but in order to be a portrait the photograph must capture the essence of its subject.

'Herein lies the main objective of portraiture and also its main difficulty. The photographer probes for the innermost. The lens sees only the surface.'

Halsman's portrait of his close friend, Spanish Surrealist Salvador Dalí, masterfully probes the psychology and the essence of its subject. The portrait was inspired by Dalí's 1948 painting *Leda Atomica*, which references an atomic-era fascination with the constant state of suspension created through the repulsion of protons and electrons.

Dalí and Halsman worked together in Halsman's New York studio with a 4×5-format twin-lens reflex camera (which he designed), four assistants and Halsman's wife Yvonne to achieve the perfect union of all the compositional elements in a suspended spatial explosion. The inanimate objects – chair, easel, stool, painting of *Leda Atomica* – were easily suspended using wires. The tricky part was to capture the simultaneously static yet mobile moment of animation of the fluid and living elements. With military precision, Halsman counted to three, his assistants launched three cats and a bucket of water into the air; then at four, Dalí jumped and Halsman took a picture before everything hit the floor. Immediately following each take, Halsman went into the darkroom to develop the film and check the result. 'Six hours and twenty-eight throws later, the result satisfied my striving for perfection,' he wrote. 'My assistants and I were wet, dirty, and near complete exhaustion – only the cats still looked like new.'

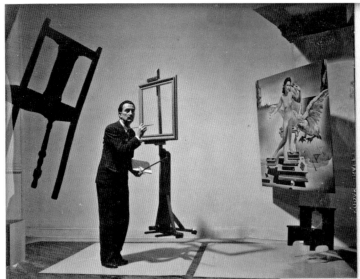

DALI GETTING READY

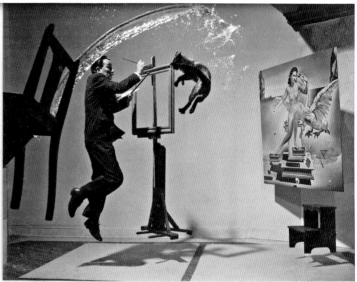

WATER SPLASHES DALI INSTEAD OF CAT

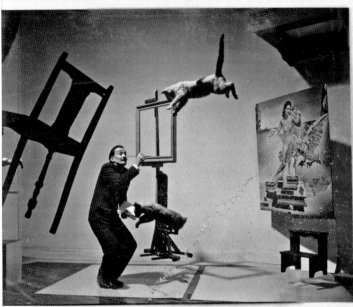

DALI JUMPS TOO LATE

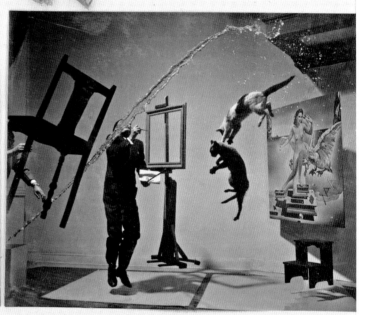

WATER COVERS DALI'S FACE

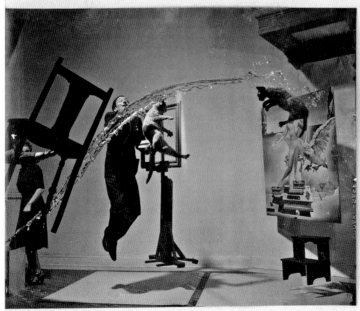

SECRETARY GETS INTO PICTURE

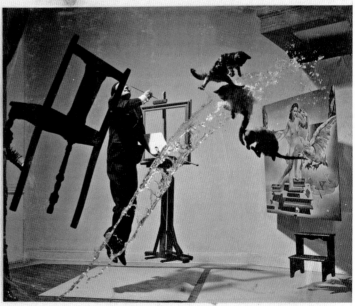

CHAIR COVERS DALI'S FACE, SPOILING PERFECT PIX.

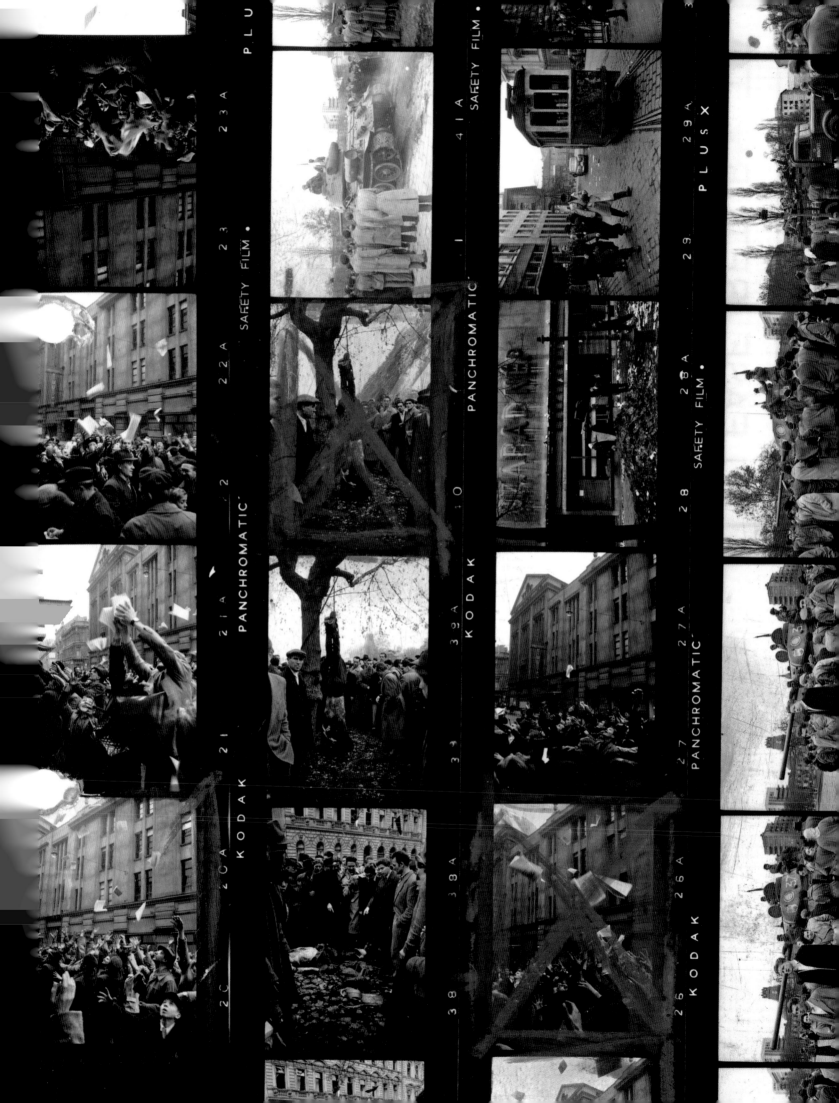

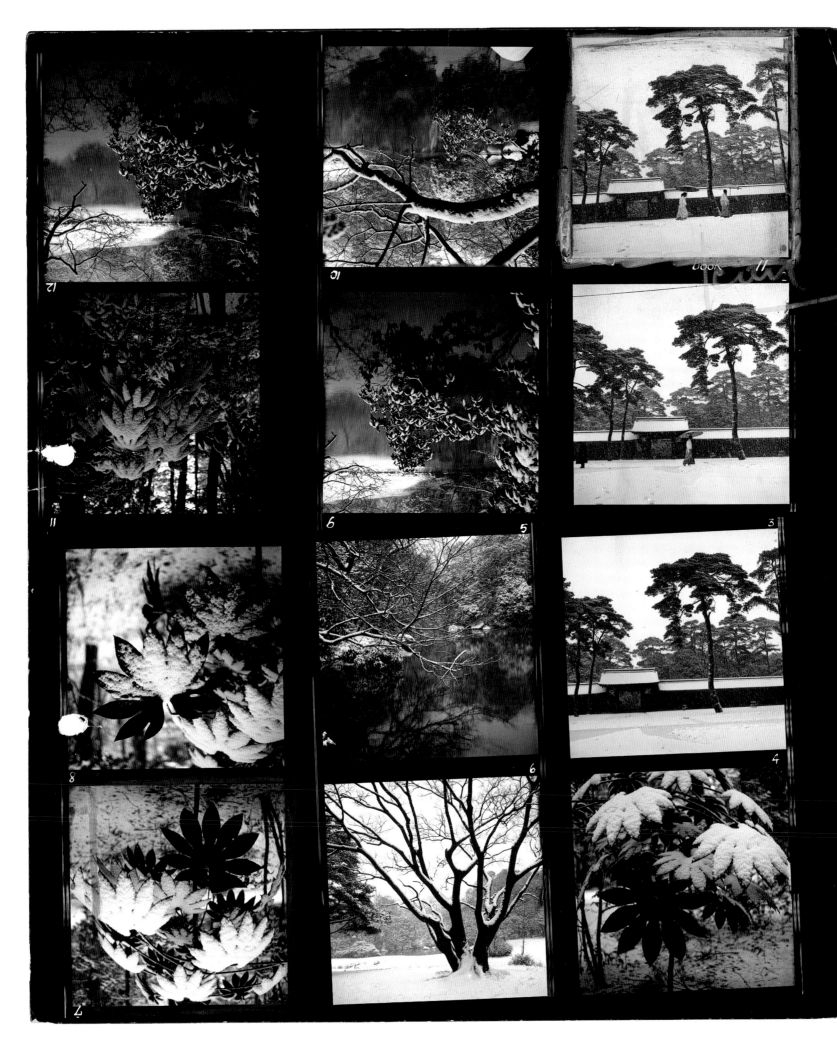

Tokyo, Japan
Winter 1951

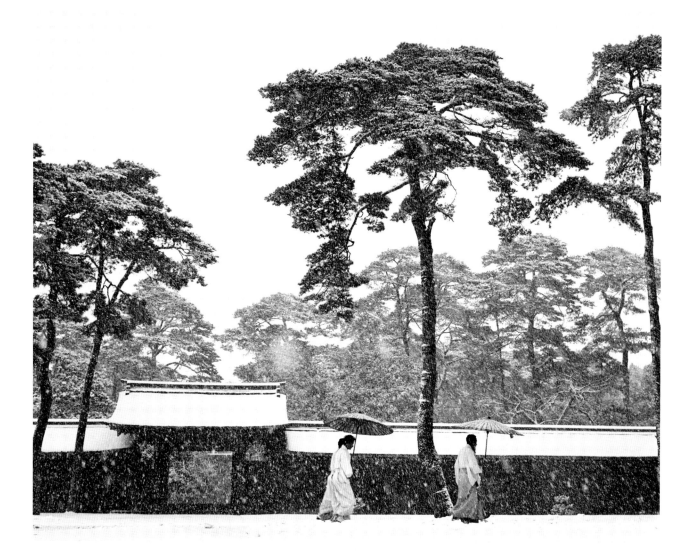

On 17 September 1951, while he was in Tokyo, Werner
Bischof wrote a letter to his wife Rosellina, telling her: 'The
trees are quite exquisite in Japan. You know the poems
that tell of the wind blowing through the trees and the
leaves. In the centre of the capital, with its ever-increasing
bustle, I have discovered some tree shapes of breathtaking
beauty, and have drawn them for you. I cannot believe that
these people will ever stop venerating nature, that a time
will come when they no longer shelter trees and flowers
in their houses as symbols of what is noble and pure...'

Rosellina joined Bischof in Japan for three months.
During that time, he took the photograph of the Shinto
priests in the garden of the Meiji shrine in Tokyo. The
story goes that he suddenly ran off and followed the
priests. When he returned, he told Rosellina: 'Now I have
the picture of Japan!' He realized the importance of his
photograph immediately. It is also possible that he had in
mind the famous screen painted by Master Hasegawa
Tōhaku with a depiction of pine trees.

New York, USA
1953

'These pictures were taken in 1953 and, as you can see, there is only one picture worth printing. They are all snapshots, including the one that's worth printing. It's a family picture: my first child, my first wife and my first cat.' Highlighting the dual perspectives of a new father snapping a picture of his young family and the professional photographer composing an image of a newborn child perfectly framed by her admiring mother on the right and the elongated form of a lounging cat on the left, 'Mother and Child' exemplifies Elliott Erwitt's ability to find the emotional balance between the personal and the universal. Since its inclusion in the seminal *Family of Man* exhibition and catalogue in 1955, Erwitt's often-reproduced image has become a classic representative of the transformative first days of a newborn's arrival in a family.

The roll is striking in its casualness. Among 26 'snapshots' of various aspects of young family life – including a sequence of a shirtless young Erwitt holding his daughter – there is only one frame of the signature scene. 'Mother and Child' captures a transitory moment, and exemplifies the thrill of finding one perfectly composed image on the contact sheet. Erwitt notes: 'It's generally rather depressing to look at my contacts – one always has great expectations, and they're not always fulfilled. But then eventually when you get to printing them and living with them, sometimes they become better. I don't always like to look at contacts because it's work and you can make mistakes, but it's part of the process. You have to do it … because very often you don't see things the first time and you do see them the second or third time.'

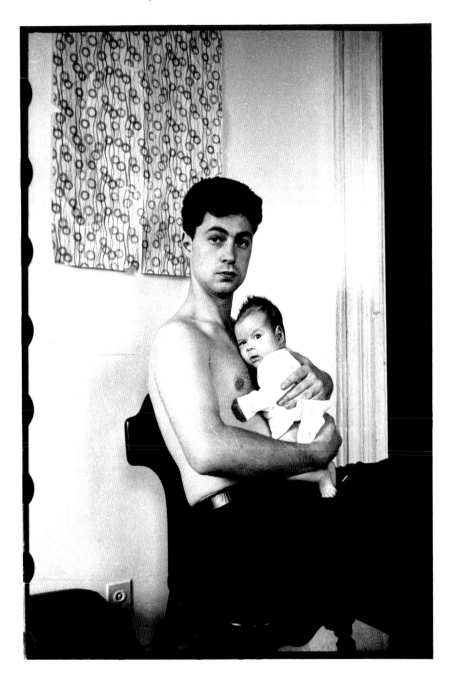

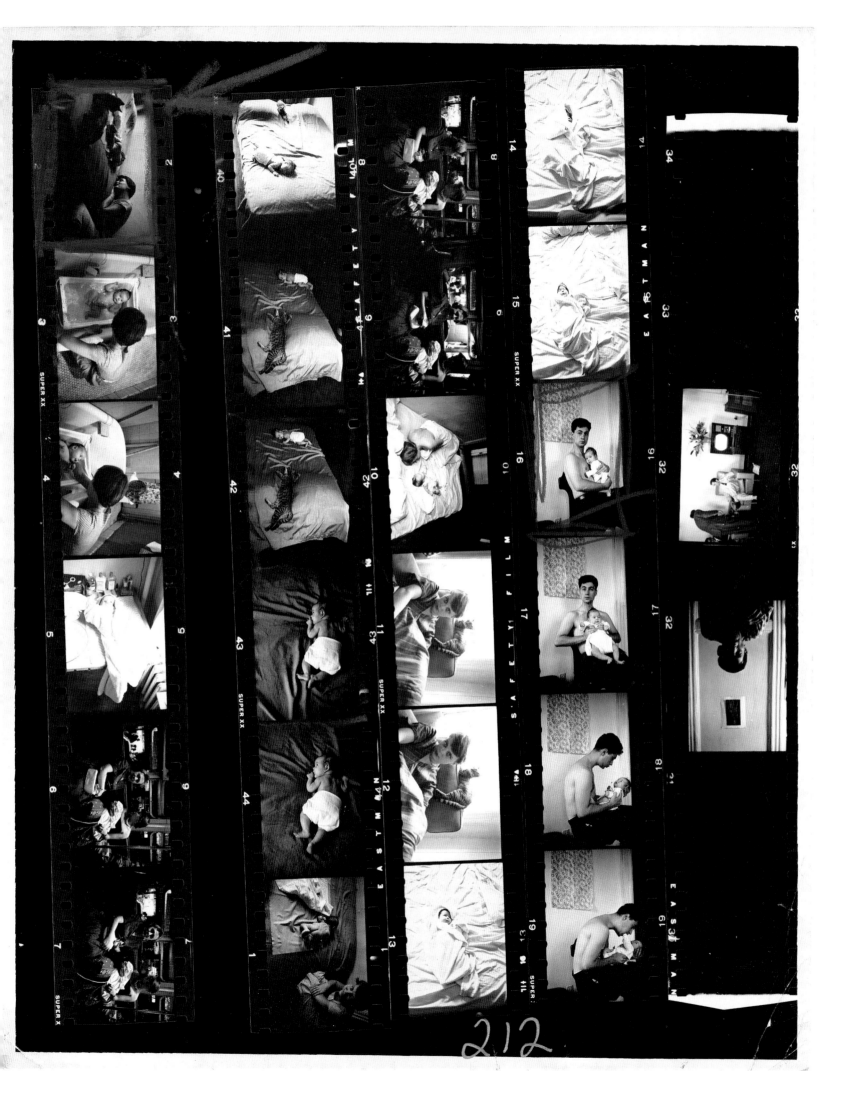

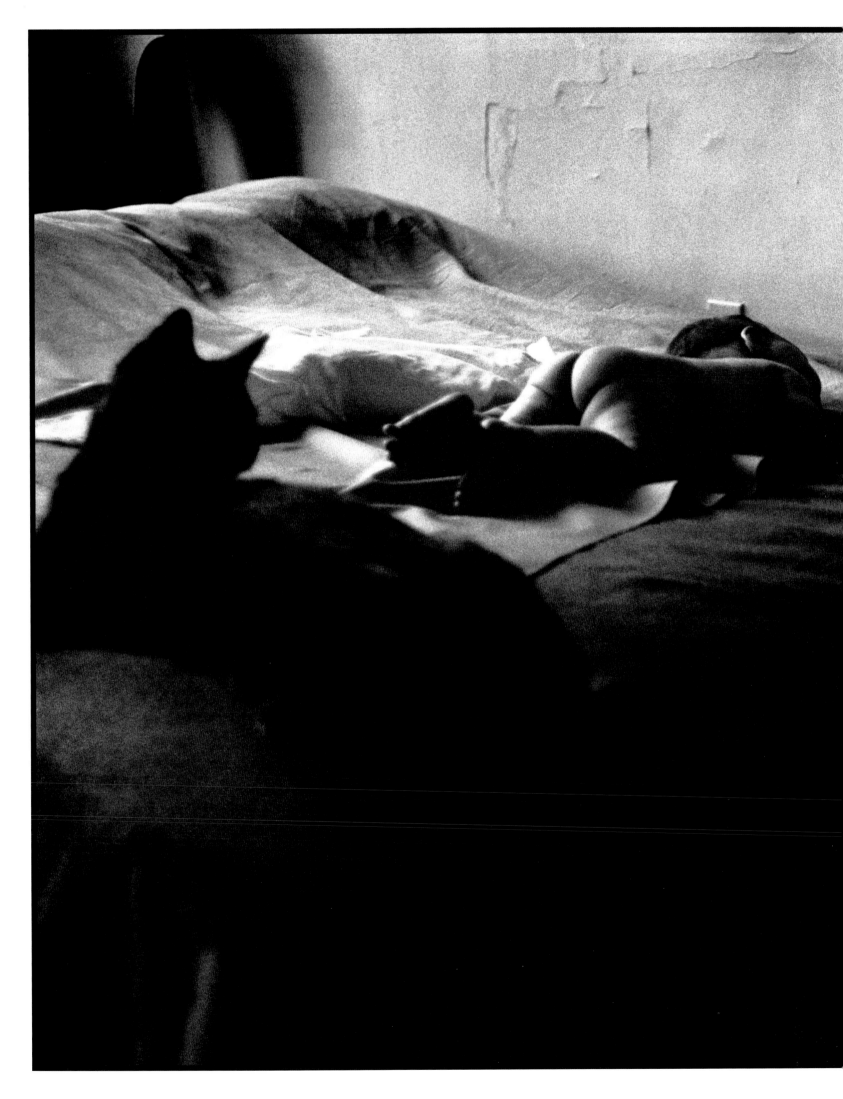

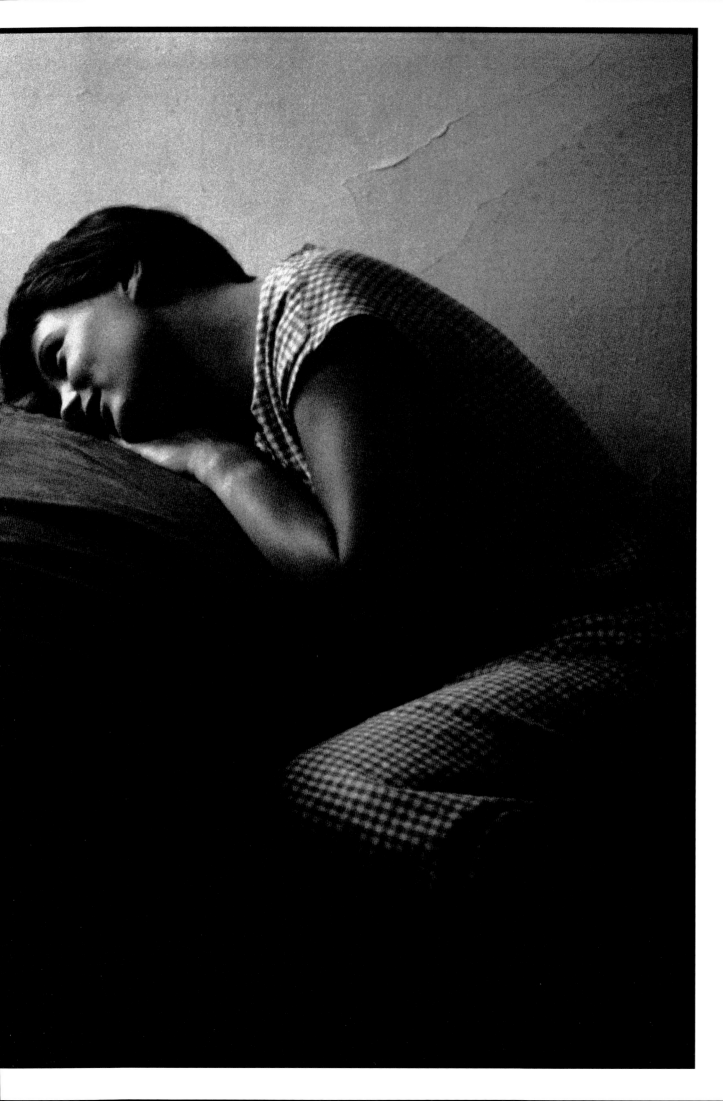

MARC RIBOUD Eiffel Tower Painter

Paris, France
1953

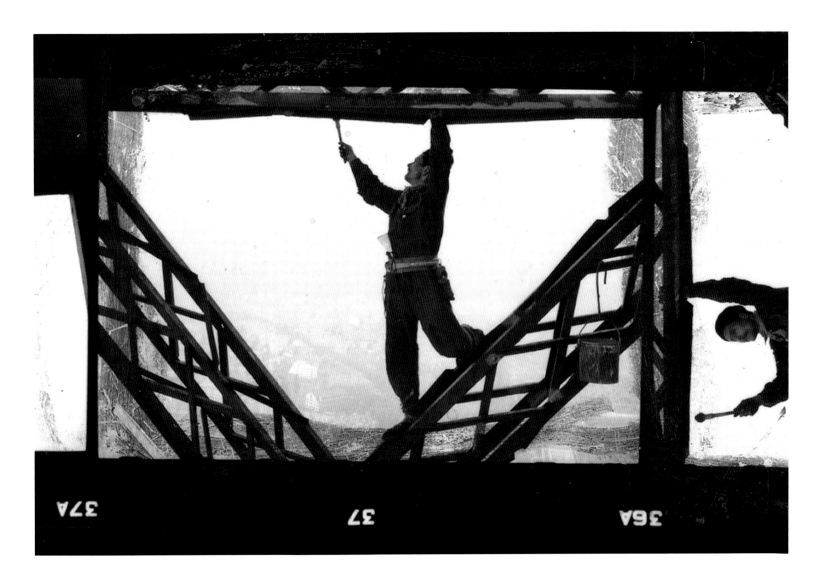

'In 1953, I leave Lyon for Paris. These are my first steps in the capital, and in photography. With my Leica and only one film, I'm strolling near the Eiffel Tower, which is being repainted. I suddenly notice these paintbrush-bearing acrobats, and wishing to see them more closely … I [walk] up the tower, maybe one hour of walking… Hanging onto the little spiral staircase with only my 50mm lens, I can't take close-ups or wide-angle shots, so I have only one choice left: that of the right moment. These constraints, these limited means, were my good luck in fact, and the choice was easy with this contact sheet, which isn't always the case. The best photo strikes the eye, as the right chord strikes the ear.

'Some people ask me, "Did you ask the painter for permission?" I said, "My goodness, no. To talk with them was to risk slipping and falling down." I've always been shy and I've always been trying to ignore the people I was photographing, so that they ignore me. I'm trying always to take a better picture than the one before but I was not sure of this one. I didn't think after I shot the picture that I shot something interesting. I learned from Cartier-Bresson what's called "geometry in photography". It's not dependent on what you'd call a good photograph, but good geometry.'

Impressed by the young photographer from Lyon, Cartier-Bresson and Robert Capa invited him to join Magnum Photos in 1953 and arranged for 'Eiffel Tower Painter', now regarded as one of the definitive Parisian images, to be the first picture Riboud published in *Life* magazine. Riboud noted how the painter's cheerful *joie de vivre*, framed by a hazy Parisian skyline, reflected his own photographic ethos of finding 'the rhymes and rhythms in my viewfinder… I think photographers should behave like him: he was free and carried little equipment.'

PHOTOGRAPHE

SUJET Tour Eiffel.

PLANCHE N° 53-3 (1) DATE 1953

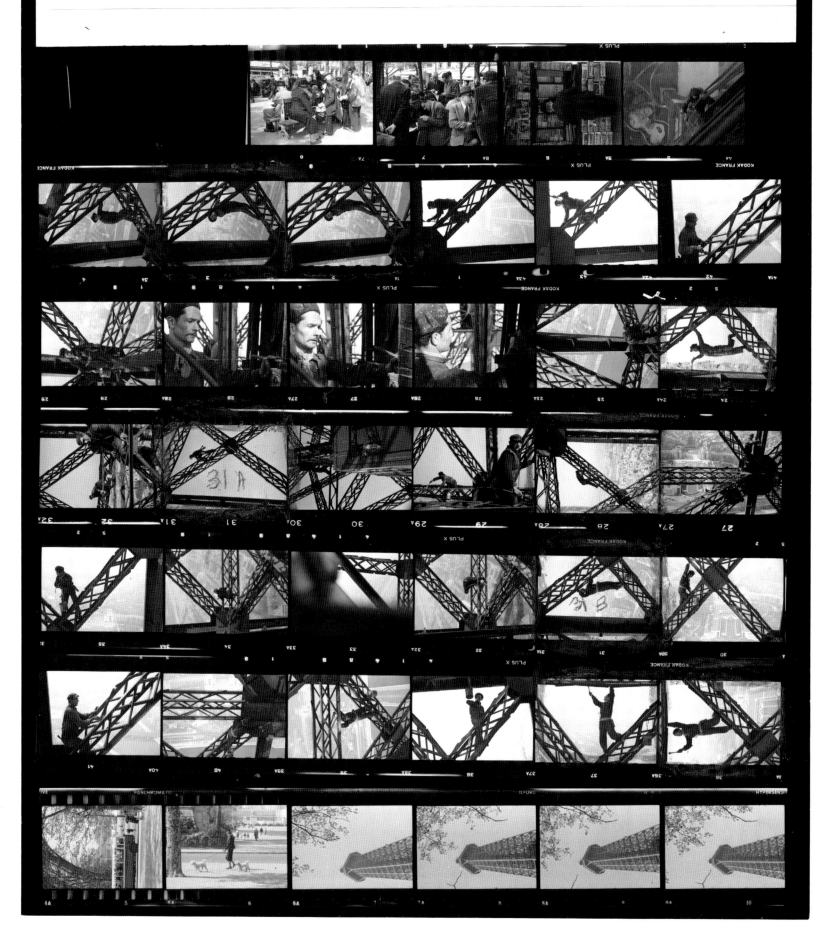

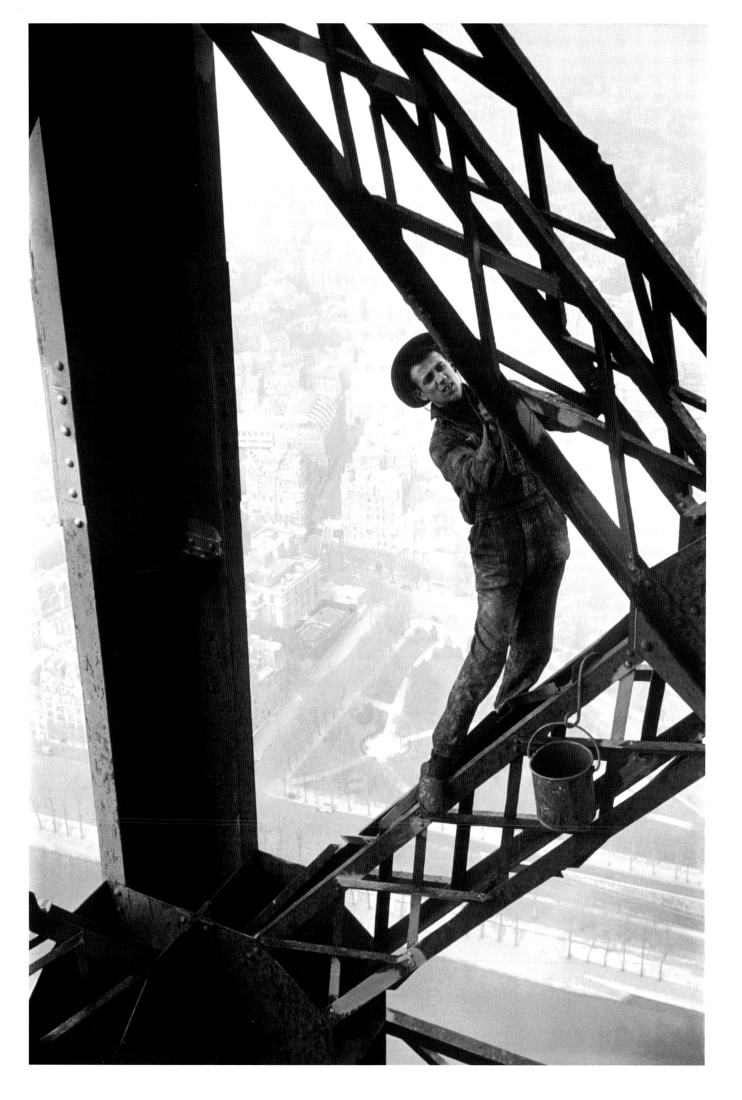

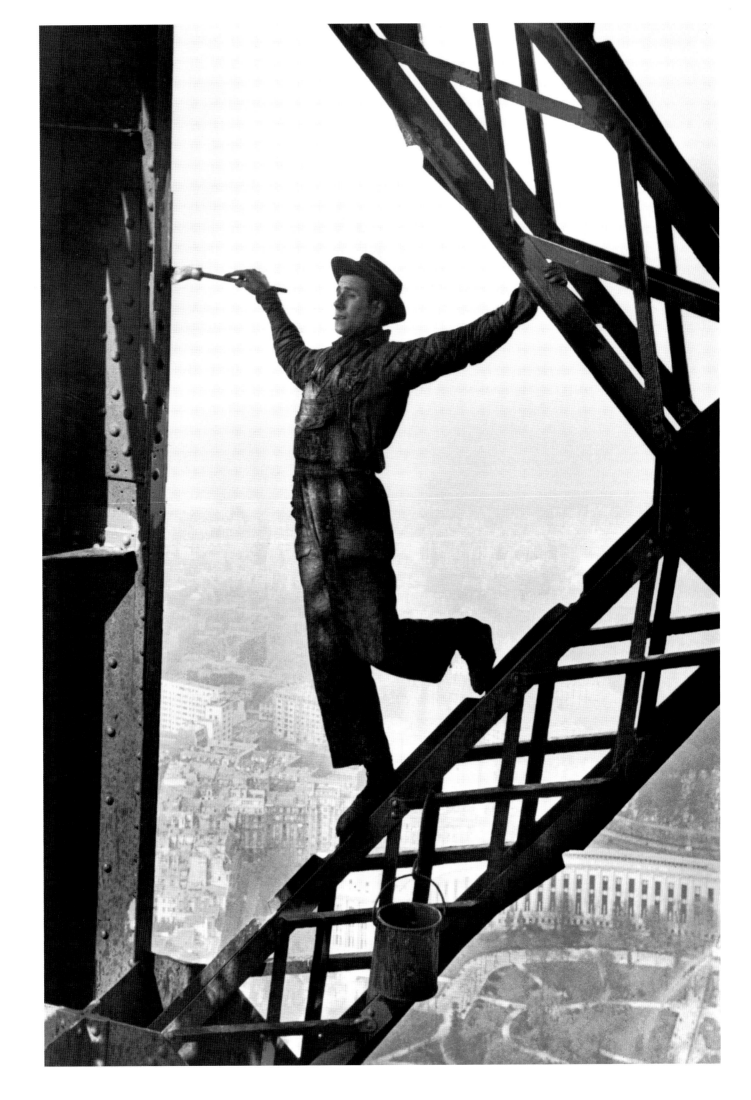

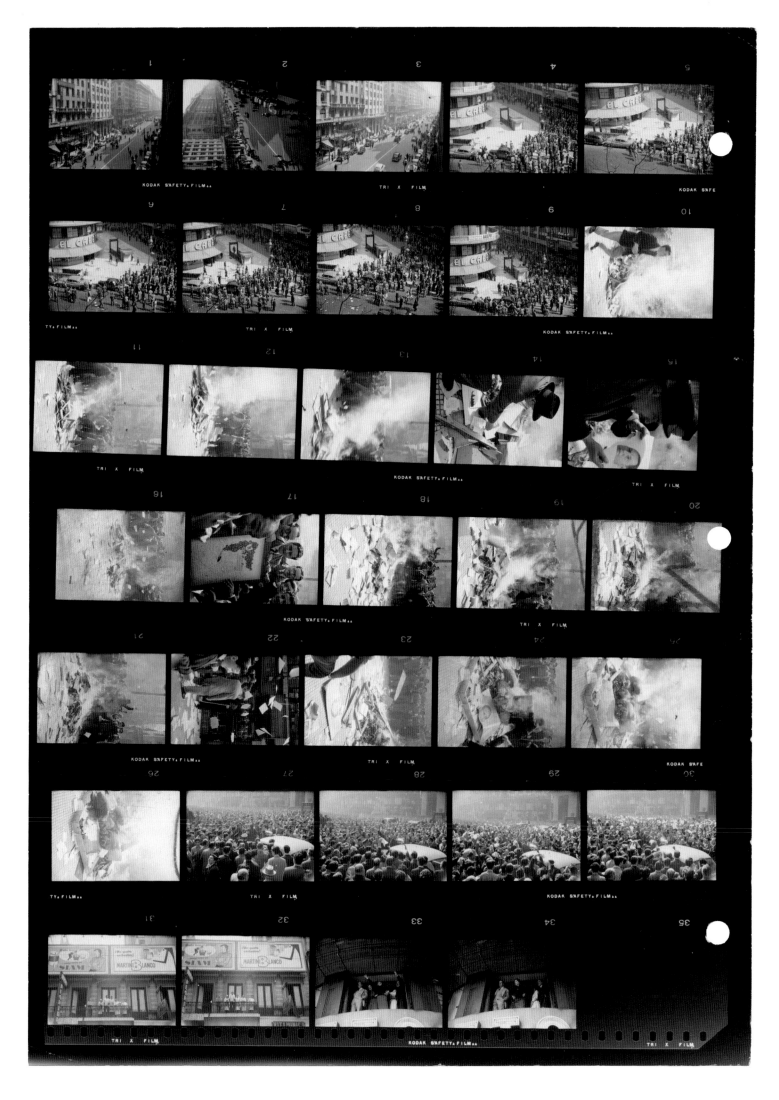

Buenos Aires, Argentina
September 1955

Capa's coverage of the dissolution of the Perón regime in August and September 1955 for *Life* consolidated his reputation as a major news photographer. Of this coverage, *Life* founder Henry Luce wrote appreciatively that Capa 'really made pictures tell the story as words never did'.

Capa arrived in Argentina at a tipping point in Perón's oppressive ten-year rule. On 31 August 1955, after Perón made a phony offer to resign, remaining supporters called for a general strike and crowded into the main square in Buenos Aires. Late in the afternoon, Perón retracted his resignation amid the cries and chants demanding that he stay. But this was the beginning of the end of Perónism, and, in the days that followed, the mood shifted against the strongman. Capa's photographs of those days convey all of the energy and compassion that hold people to their political beliefs. Tracking the rapid-fire changes and working relentlessly to produce captions, Capa scrambled to cover the whole story – Perón's last-minute attempt to seek support from students, his Farouk-like possessions,

his eventual escape to Uruguay, the inauguration of new president Eduardo Lonardi, and the return of exiled press. The pictures were published in *Life* in six issues over three months. Capa wrote to his photo editor that 'seldom if ever has a dictatorship dissolved in front of a photographer's eye. It would be quite beneficial for other people to see it, especially in this part of the world, where they have long been deprived of anything critical of the regime.'

This contact sheet shows the students and anti-Perónistas gathering in the streets and burning Perón images after it was certain that the old regime had gone and the mood had evolved from celebration to a more violent tone. The images reflect the intensity of the story and the quick sequence of events during those weeks. Capa worked non-stop to take the pictures, write the captions, send telegrams to his editors and follow the unfolding story. He wrote that the trip had been 'a most exciting and productive journey. The "team" covering the revolution was born welded under "fire".'

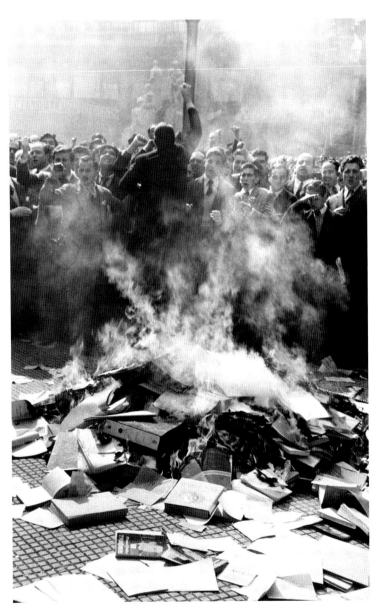

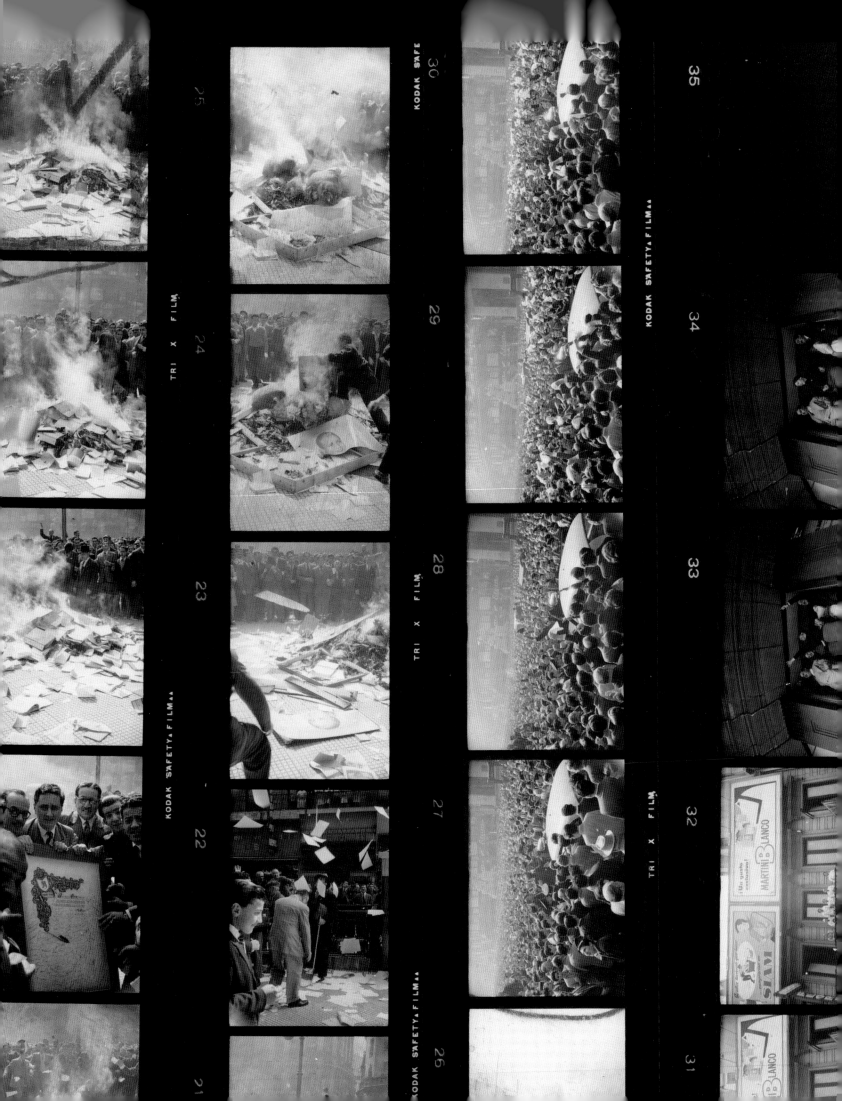

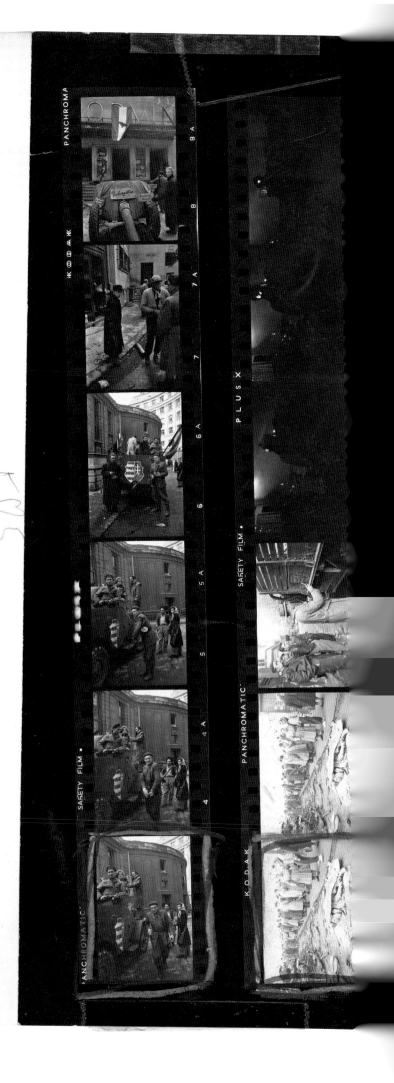

Hungary
October 1956

"The telephone rang early in the morning in our apartment in Geneva. Traudl took the phone, turned to me and said, 'They are shooting in Budapest.' I jumped out of bed and got on the next plane to Vienna. There I borrowed a car from an absent friend and, accompanied by a French journalist, set off for Budapest. The frontier between Austria and Hungary was open, and the Hungarian soldiers had taken the hammer and sickle off their military caps.

When we got to the city, the streets were very calm, but then we turned into a road and travelling towards us was a tank. As it began pointing in our direction, I made to turn quickly into the next street on our right. 'It's one-way,' said my companion. I drove down it anyway.

During the revolution I travelled in and out of the country, over the border, several times, driving from Vienna and spending the night en route. I shot this roll in one day – on the 25th of October – then left Hungary on the 26th, returning again on the 28th. At this time, they knew my car around Hungary, as I drove about the countryside, awaiting the Russians. It was a cream MG with red seats that before me had been the property of *Look* magazine reporter, Bill Edward.

This was a day fraught with activity. They were lynching secret police, and at the same time the printing presses had been taken over by the workers. On one of the contact sheets you can see the crowds outside the former central office of *Szabad Nép* (Freedom of the People), trying to catch the first edition of *Magyar Függetlenség* (Hungarian Independence).

So often, people ask me about my personal connection with my stories, but at this time I was working as a news reporter. My experiences were brief encounters. I believe Capa put it correctly when he spoke of how, as photographers, we have personal opinions that sometimes show in our images, but we are not supposed to interview; we are supposed to document.

I can't remember when I saw the contact sheets for the first time. The film was sent to Paris and I went there a few days later. I don't know who edited it, but in those days it would always have been me with a person in Magnum's Paris office: either Jimmy Fox or my wife, who would do it if she was not on a trip with me. The impact of this story at the time was such that the important pictures stood out."

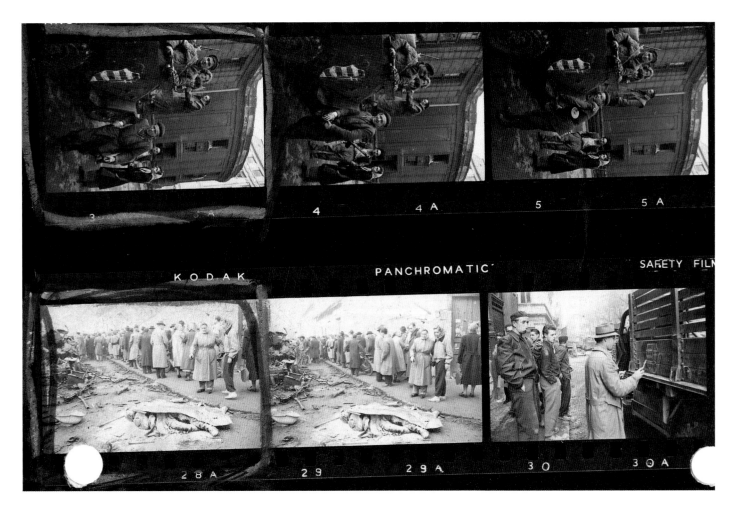

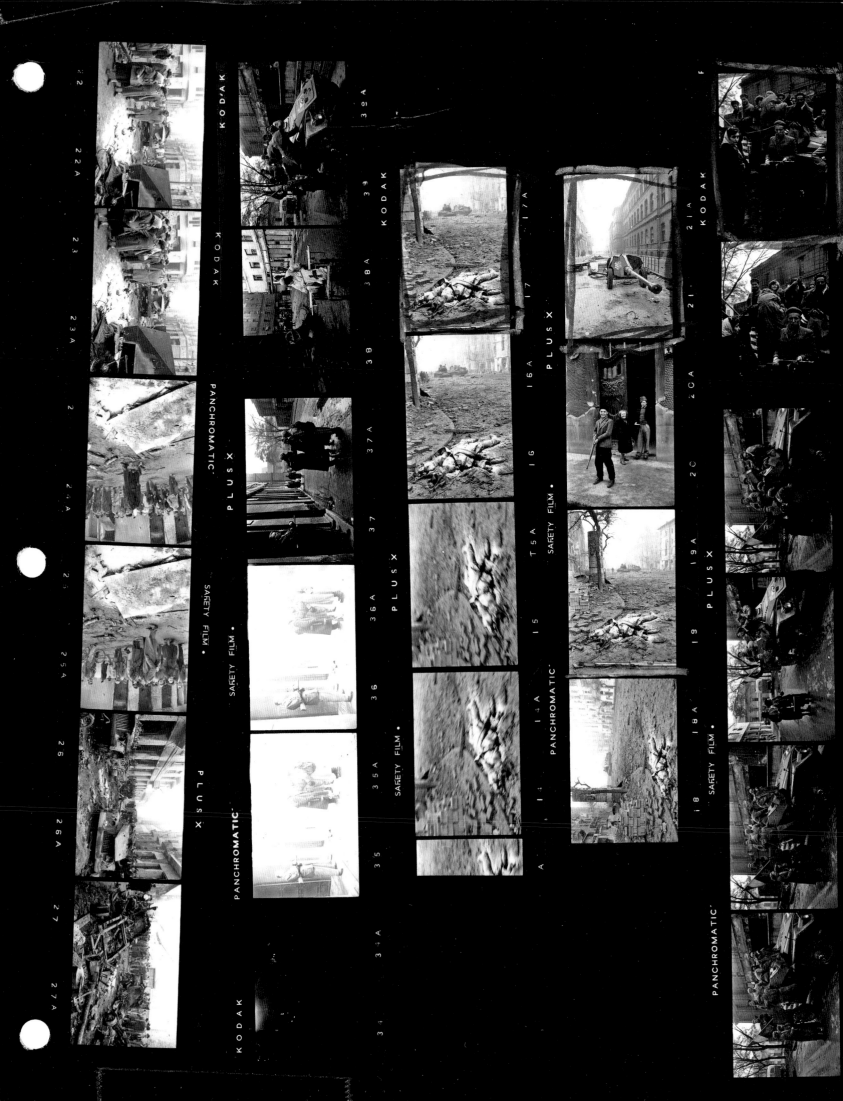

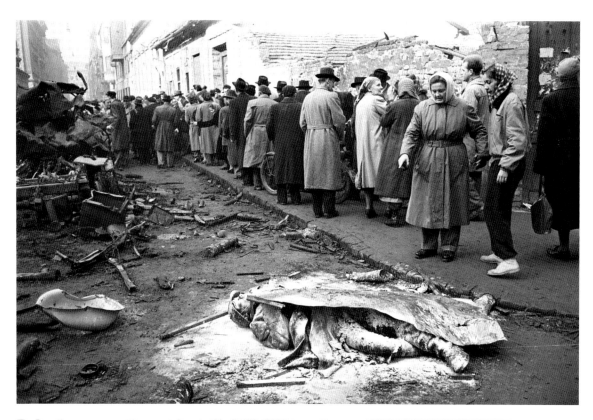

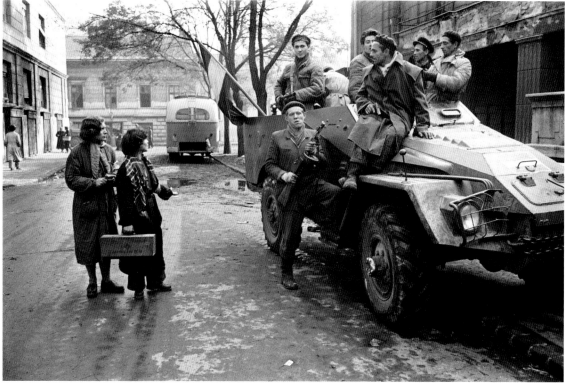

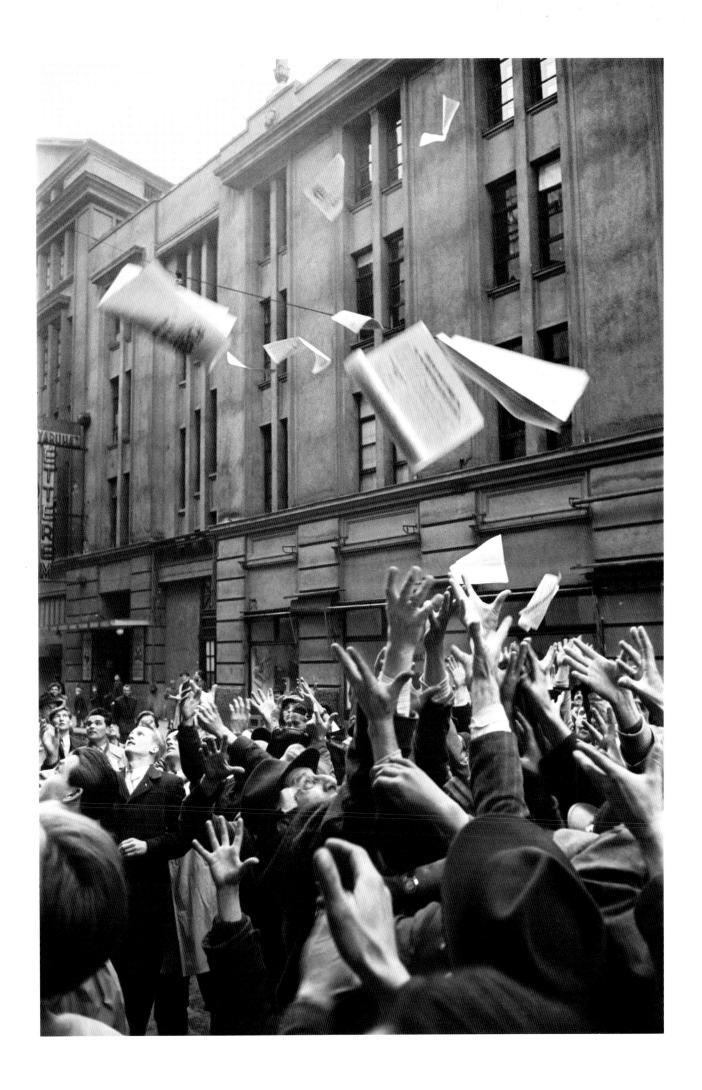

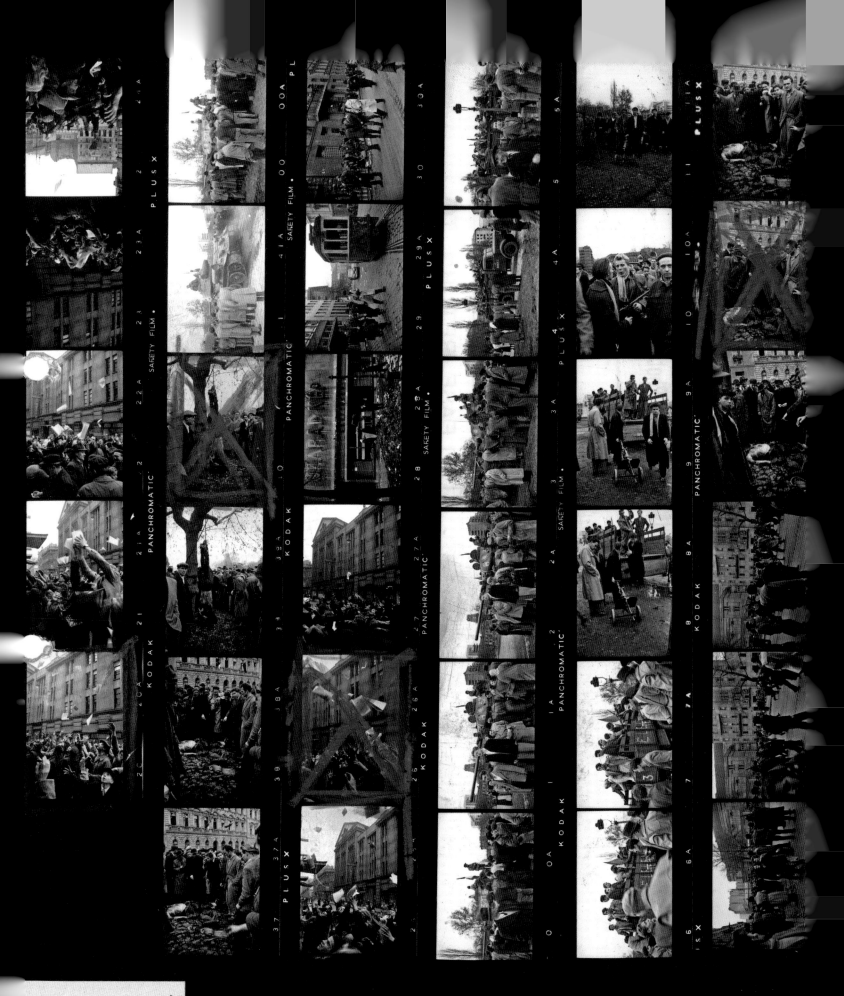

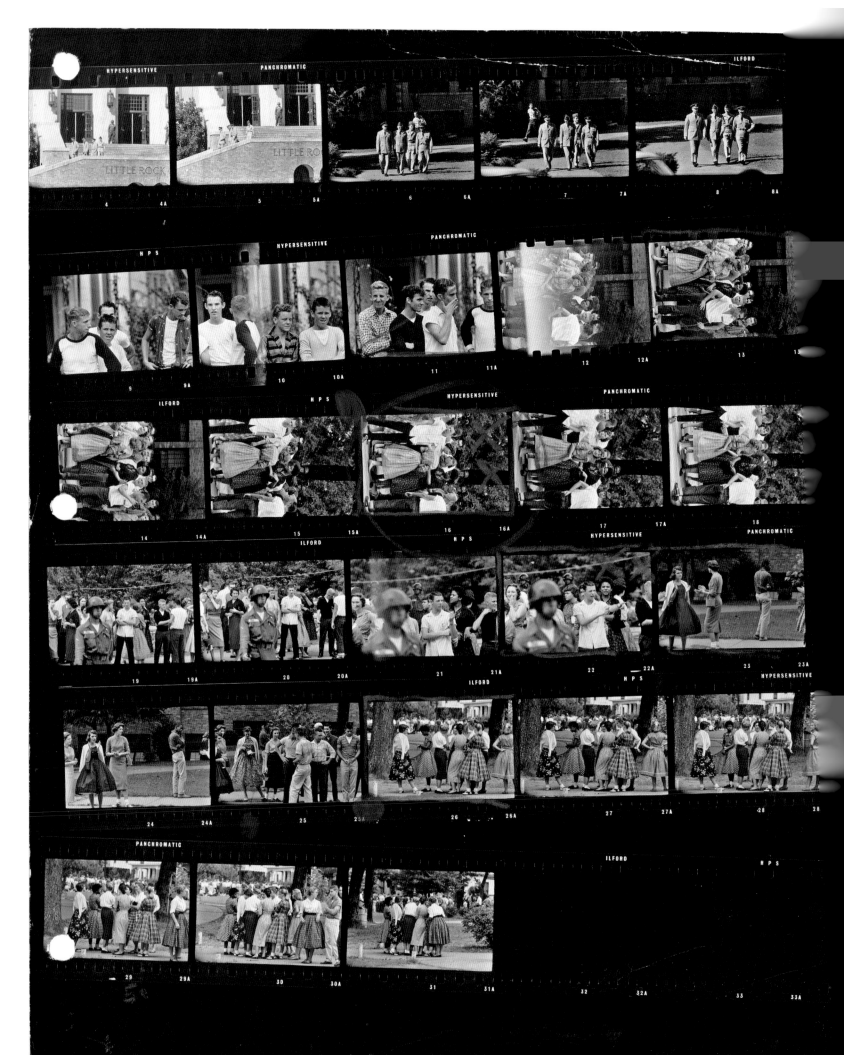

USA
September 1957

Little Rock Central High School in Arkansas was set
to begin the 1957 school year de-segregated. Then the
Governor of Arkansas, Orval Faubus, defied the Federal
Court's decision in the case Brown vs. The Board of
Education of Topeka, Kansas, which said that school
segregation was unconstitutional. Faubus ordered the
Arkansas National Guard to prevent the first nine African
American students, the 'Little Rock Nine', from entering
the school.

In the ensuing crisis an injunction was issued against
the governor, and the nine students returned to school.
This time, however, they were met by an angry mob of
townspeople, who prevented them from remaining at
school. Finally, after many diplomatic efforts, President
Eisenhower intervened and dispatched 1,000 paratroopers
and 10,000 National Guardsmen to Little Rock. The Little
Rock Nine finished the school year under federal protection.

Among the first nine African American students was
Minnie Jean Brown, who is shown in frame 16 speaking
with several white students outside the school during
a fire drill caused by a bomb scare on the first day of
integration at Little Rock High. Despite the girls' calm
interaction, the scene remains tense, as indicated by
the helmeted soldiers visible just beyond the students
in the background of the photo. Of frame 23, Burt Glinn's
typewritten captions note: 'To pass the time (30 minutes)
during the fire drill, students practice school songs and
cheers used at football games. This explains the girls
who appear to be clapping their hands while singing.
Negro student Terence Roberts stands off to one side,
in a world of his own. He does not sing or clap.' Of
frame 26, Glinn observed: 'Negro student Elizabeth
Ann Eckford stands with a group of white girls during
the fire drill. She has become a heroine of the Negro
fight for integration in Little Rock. During the first week
of school she tried to obtain admission, but was denied
entrance by National (really State of Arkansas) Guard
troops sent by Governor Faubus.'

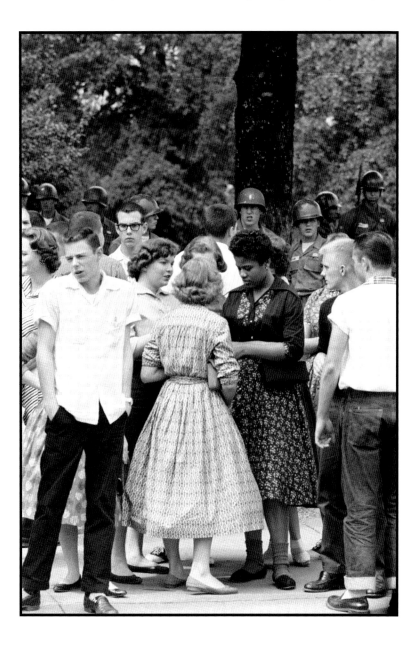

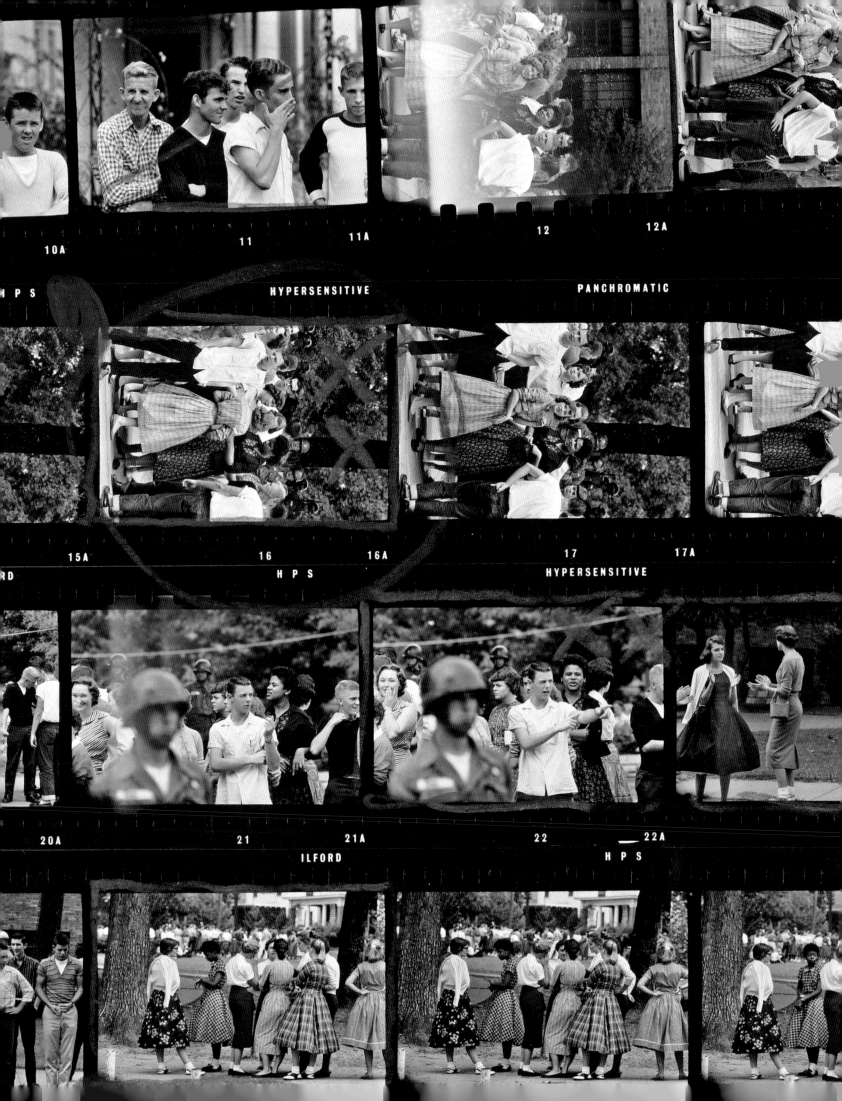

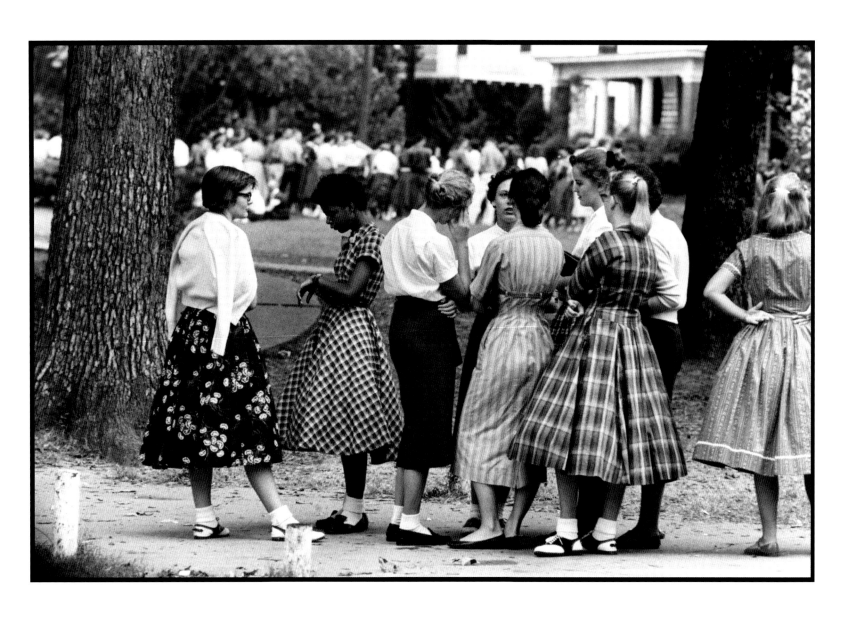

INGE MORATH A Llama in Times Square

New York, USA
1957

Like many of the iconic images for which Inge Morath is recognized, 'A Llama in Times Square' originated in a magazine assignment. In its 2 December 1957 issue, *Life* magazine published a one-page story, in its humorous 'Animals' section, entitled 'High-paid llama in big city'. The story was about a menagerie of television animals – including, in addition to the llama, large and small dogs, cats, birds, a pig, a kangaroo and a miniature bull – living at home with their trainers in a Manhattan brownstone.

The *Life* story featured three photographs by Morath, including a cropped close-up of Linda the Llama. Curiously, the caption accompanying the close-up describes the llama as ogling from the window of a taxi on her way to make a television appearance. In fact, she was in the back seat of her trainer's car, and, as Morath explains, on her way home from the studio when the picture was taken. Morath's full caption reads, 'Linda, the Lama, [sic] rides home via Broadway. She is just coming home from a television show in New York's A.B.C. studios and now takes a relaxed and long-necked look at the lights of one of the world's most famous streets.'

In Morath's work chronology, her contact sheets for the story are marked '57-1', indicating that this was her first assignment in the year 1957. On the back of a vintage work print of the iconic picture, Morath has inscribed the caption, '57-1. That's when that was – driving around with Linda the Llama.' Nevertheless, a selection of snapshots taken by an unknown photographer, showing Morath posing with the llama and her trainers, and photographing them on a New York City street, are all dated 1956 in Morath's hand. These indicate that she may have spent a great deal of time getting to know her subjects, and might even have been responsible for pitching the story to *Life* well in advance of the time it was published. This was Morath's typical working method.

Since its original publication, 'A Llama in Times Square' has been exhibited and re-published extensively, being seen everywhere from classrooms and calendars to museum walls and even Oprah Winfrey's *O* magazine. Viewed alone, it appears to have been a perfect example of being in the right place at just the right moment. In fact, as Morath's contact sheets show, it was the result of considerable forethought and work. The appearance of spontaneity, masking the reality of careful planning, reveals the degree of ease that Morath was able to establish with her subjects while working on their stories, and is one of the prime characteristics of her superlative work as a photojournalist.

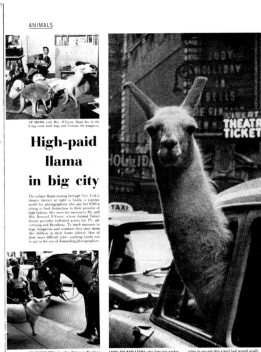

TOP The *Life* magazine story, as published 2 December 1957.

ABOVE A page of Inge Morath's typewritten, numbered captions for her animal story.

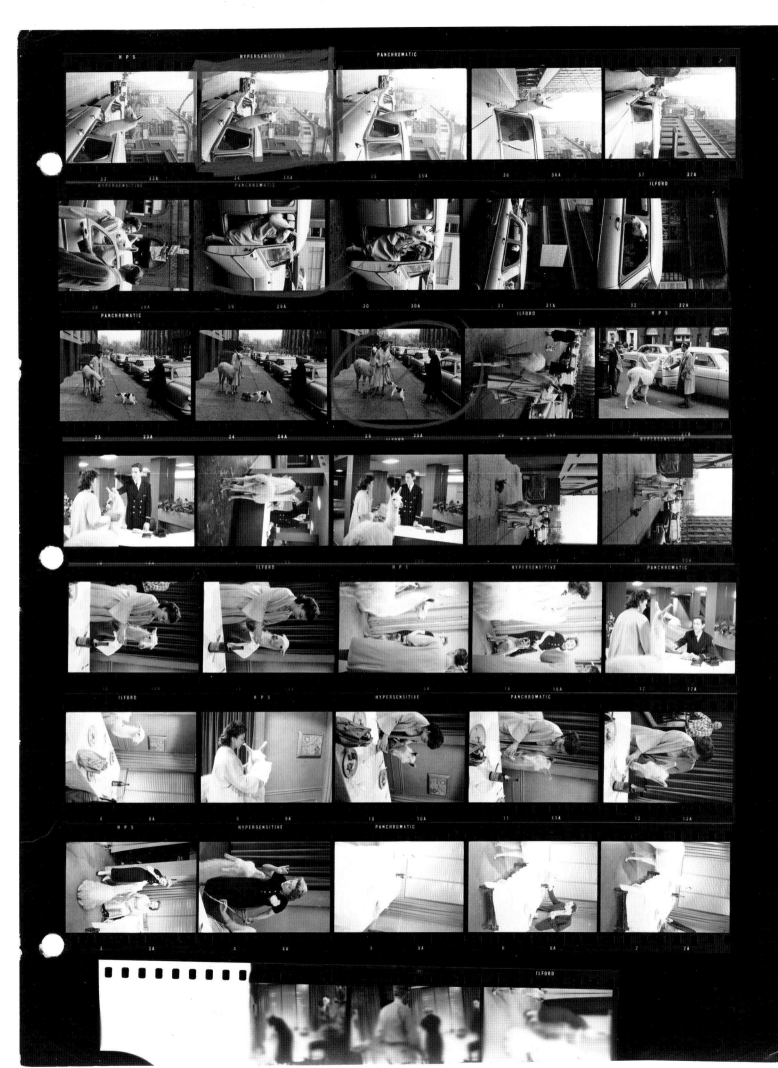

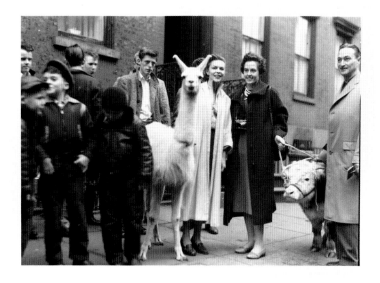

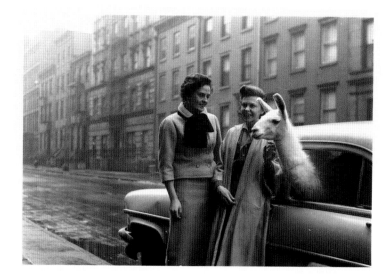

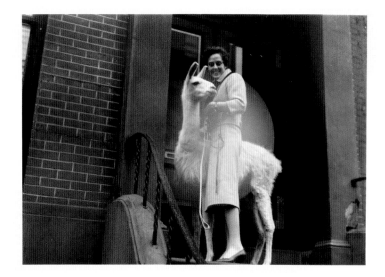

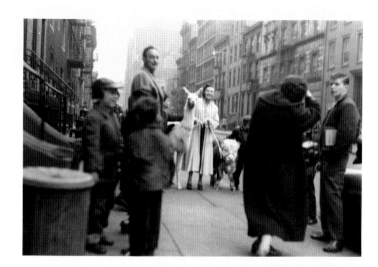

ABOVE Photographs of Inge Morath, with Linda the Llama and trainers, on location for the *Life* magazine story, dated 1956.

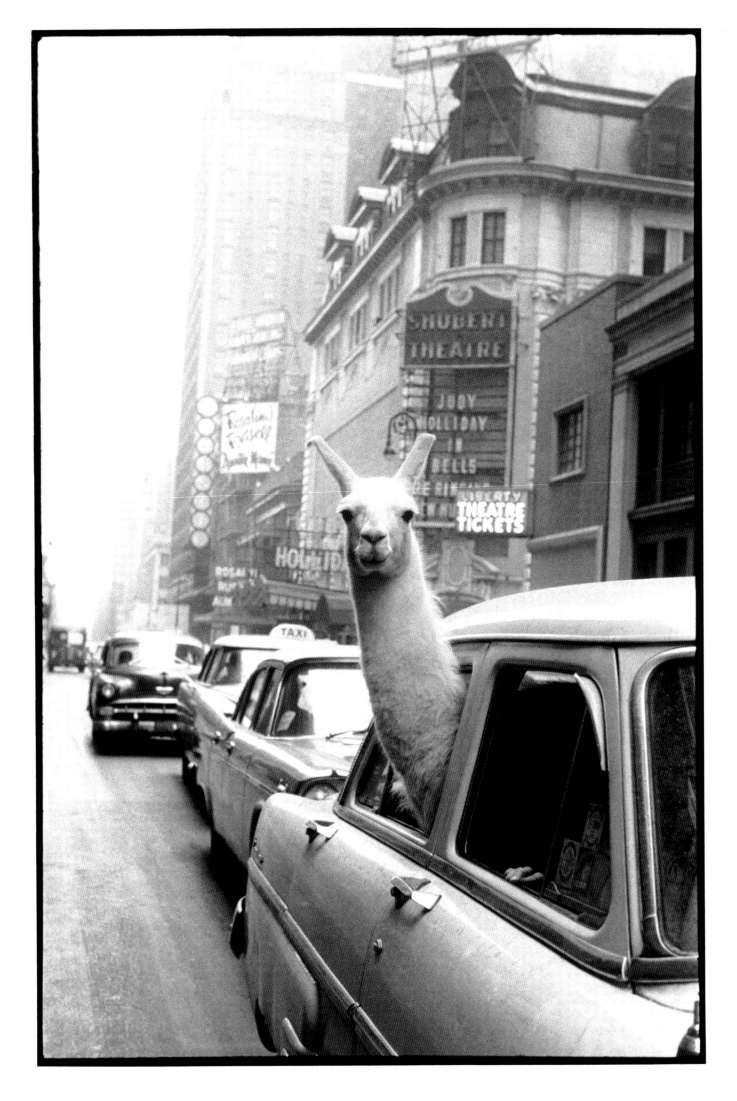

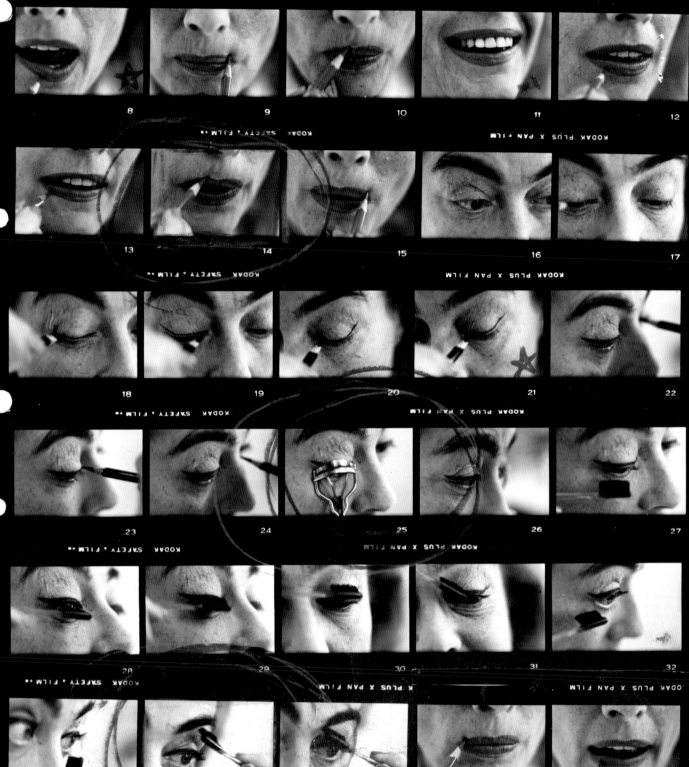

Los Angeles, USA
1959

During the 1950s, Eve Arnold often worked in portraiture. On one occasion she was sent by the *Woman's Home Companion* to photograph Joan Crawford. To Arnold's alarm, on the first day of shooting the intoxicated actress stripped nude and commanded Arnold to take her photograph, so Arnold reluctantly complied. Not trusting any lab with the sensitive job of handling the film, she taught herself to develop colour and processed the roll herself. When she eventually handed over the transparencies, the grateful actress kissed her, raised her vodka glass, and said, 'Love and eternal trust always.'

Arnold was to photograph Crawford again, in 1959. At her suggestion, *Life* magazine assigned her a photo essay on the actress. Arnold telephoned to confirm the shoot. 'Yes, she would love to be in *Life*; yes, she would love to be photographed by me. But there was one small favour. She would like to go into a darkroom with me, the way Marilyn Monroe had with Richard Avedon. Translated, this meant she wanted editorial control. I said I would ask the magazine and that we would get back to her.' Irate, Crawford rang *Life* to complain, but, as Arnold recalls, 'I played a hunch that in the sober light of day she might back down. At eight o'clock her time, she called me. "Yes," came her dulcet tones, "I agree," and still in that sweet voice, "but if I don't like what you do," and here [her] steely voice came through, "you'll *never* work in Hollywood again."'

'It was not the best way to start an assignment, but when I arrived in Hollywood she was welcoming. We discussed the story line. She wanted to show how dedicated she was to hang on to the top of the cliff of success for thirty years. We started with nothing off-limits and wound up after eight weeks the same way. In fact, so inventive was Joan – she would simply dream up situations and go ahead, waiting for the camera to follow after – that we could have filled an encyclopaedia instead of the twelve pages at our disposal.

'It was remarkable to see her on set made up and ready for a scene, surrounded by her retinue of hairdresser, make-up artist, wardrobe mistresses, security, chauffeur and stand-in. She would stand nervously, clutching her fingers and repeating her lines to herself. For big emotional moments the director would arrange for her to literally run into a scene. She would take off twenty feet from the lighted set, run, hit her mark perfectly and start to emote for camera.

'Weekends we would spend in her house in Bel-Air, photographing. Those would be her days for having her nails done, her hair coloured, her legs waxed, her eyebrows dyed, all of which she wanted me to record on film, to show her devotion to her public.

'The more I saw her, the more complex she seemed and the more perplexed I became. When the *Life* story appeared, she cabled me and said, 'Love and eternal trust always'. It was a tough intimate story, but she wanted it that way.'

Moscow, Russia
July 1959

Elliott Erwitt's iconic 'Kitchen Debate' image of US Vice President Richard Nixon getting tough with Soviet Premier Nikita Khrushchev was shot on 24 July 1959 at the opening of the American National Exhibition at Gorky Park in Moscow. As Erwitt relates: 'I was working on a commercial assignment on the fair. I was hired by Westinghouse Refrigerators, but I carried my private camera as well.' Surrounded by a large press corps, Nixon ushered Khrushchev through the exhibit designed to showcase the comforts and advantages of an American lifestyle through the display of American consumer items. Erwitt decided to move to a quieter location and, as he recounts, 'I just happened to be in the right spot at the right time. It's very difficult to work in a crowd, especially a huge crowd. You can't move. But by sheer luck I was able to get into the Macy's kitchen display, behind the fence that separated it from the crowd. I was in the kitchen, free to move, and they just happened to come right up to the fence. So it was like shooting fish in a barrel.' Erwitt's shot of a hard-hitting Nixon, jabbing his finger at Khrushchev's chest during a momentary adversarial encounter, comes towards the end of a contact sheet depicting mostly amicable exchanges between the two politicians. Also present was William Safire (at the right of frames 46–52), who according to Erwitt, 'got his job with Nixon as a consequence of my picture. He was doing PR for the Macy's kitchen at the time. Apparently he was instrumental in tracking down my picture, which was used for a 1960 Nixon campaign poster (mercifully Nixon lost). Safire then got attached to the Nixon campaign and became one of his speechwriters.' Taken at the height of the Cold War, Erwitt's 'Kitchen Debate' photo became a symbol of Nixon and the American people standing up to the Soviets.

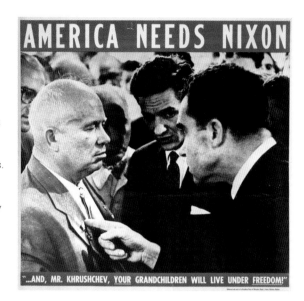

TOP Richard Nixon campaign poster, 1960, featuring Elliot Erwitt's iconic image.
ABOVE Erwitt's press pass, signed by then Magnum president Robert Capa.

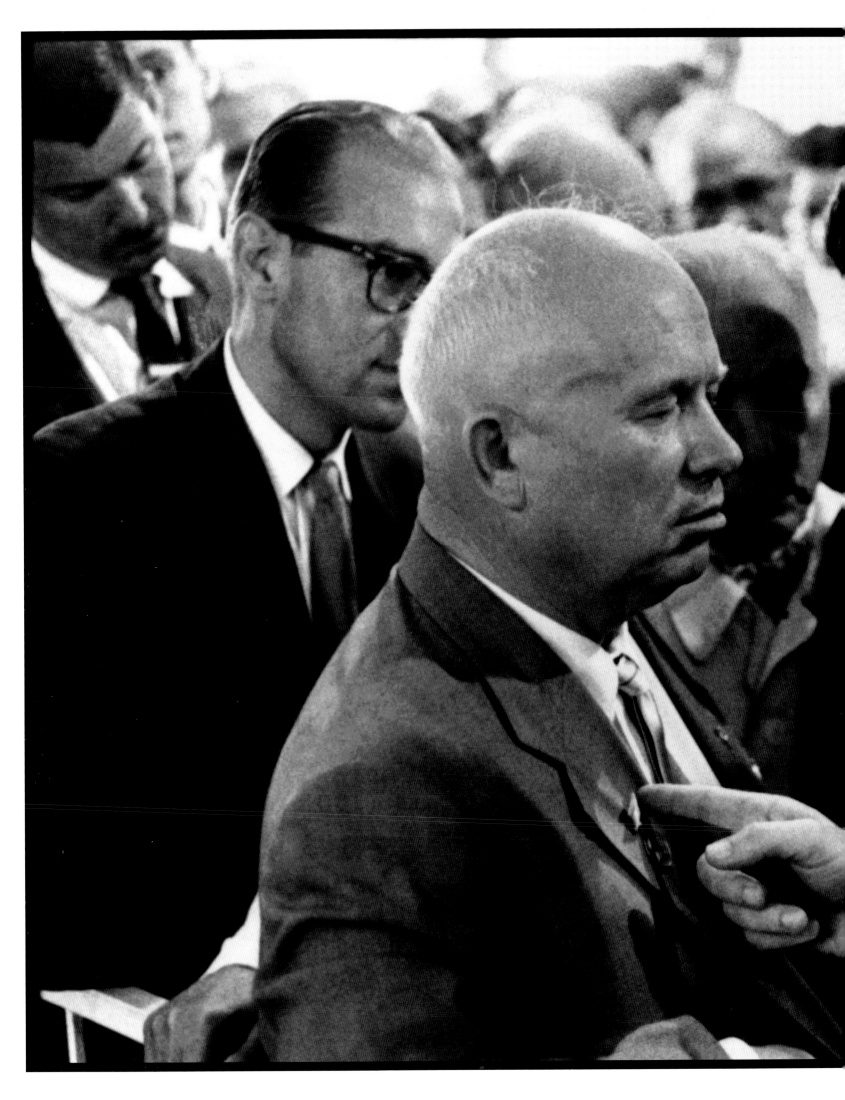

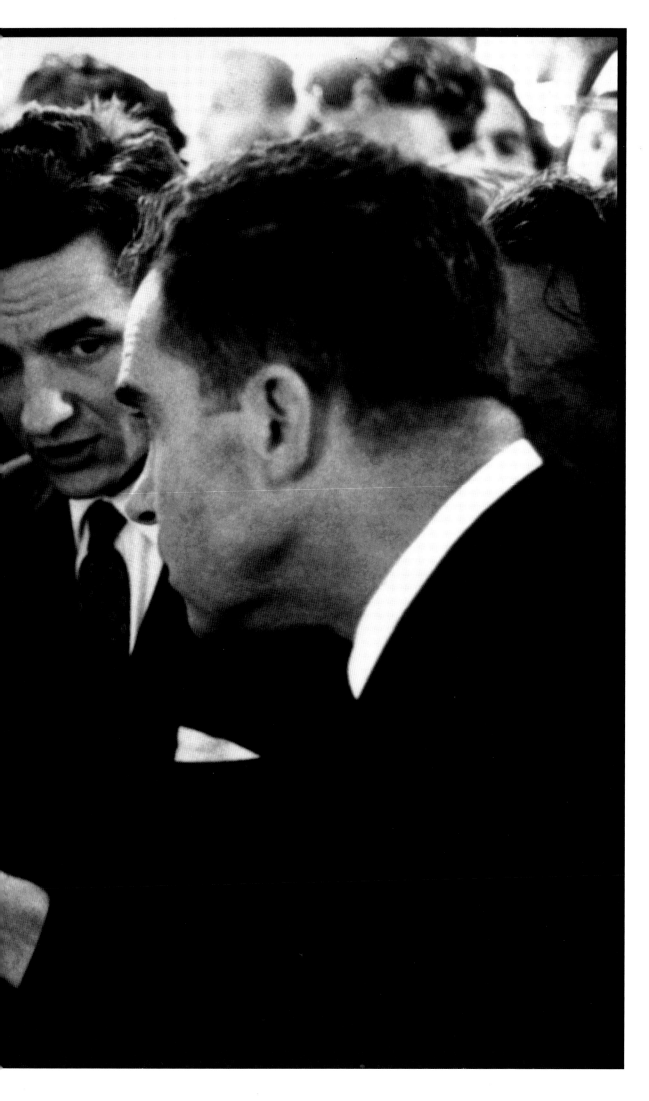

Havana, Cuba
January 1959

"By the time I arrived, it was past dawn in Havana. Batista had fled. Fidel was still hundreds of miles away, although nobody knew exactly where. Che Guevara was on his way to Havana. Nobody seemed to be in charge. The moment I got to my [hotel] room there was gunfire in the streets. Leaderless crowds were gathering, armed with whatever they had at hand – pistols, shotguns, machetes...

Everyone was calling for Fidel. But nobody knew where Fidel was. There was no press office, this was not a photo-op; it was a real revolution. In the meantime, the *Life* magazine team had organized their own transport and teamed with a Venezuelan photographer; everyone called him Caracas. It was Caracas who finally spotted Fidel on the road between Camaguey and Santa Clara.

After an all-night speech in Sancti Spiritus, the Castro group had dwindled momentarily to four cars, carrying Fidel, his aide Celia Sánchez and an escort of about eleven Barbudos, or bearded ones. We had made contact with Fidel, but it was hard to keep track of him. He had started in the Sierra Maestra without any official vehicles, but as he progressed through Santiago, Camaguey, Santa Clara and Cienfuegos toward Havana, the column grew. Somehow the rebel entourage acquired tanks, trucks, buses, jeeps, cars, taxis, limousines, motorcycles and bikes.

Castro kept changing vehicles and we kept playing tag with him, trying to spot him in the column on the road. As the caravan traversed the countryside, it would roar through towns where people lined the streets, cheering... In Cienfuegos he started speaking at 11pm and went on until 2 in the morning. He involved his listeners, asking them for advice on how to run the country. He climbed down from the platform into the crowd and discussed farming methods with them and exchanged jokes about the deposed Batista. It was an incredible demonstration of two-way faith. Considering the situation, his entourage was worried about an attempt on his life, but Castro was fearless... The euphoria was incredible and permeated the whole country.

After leaving Cienfuegos, the route became so unruly that we lost Fidel until we caught up with him on the entry to Havana. By now the crowds were so tumultuous and the ranks of the marchers so swollen that it was impossible to differentiate the procession from the audience. Arriving in Havana, the crush along the seaside Malecón was so great that I lost my shoes while struggling to get my pictures.

I remember the wild hopes and the ominous portents that filled those few brief days. I only wish in all those years since then that Fidel had done the Cuban people better and that we had been smarter. I think I would trade all of these, my favourite pictures, and all the great cigars I have had from Cuba, if we could all do it over again. Only better this time."

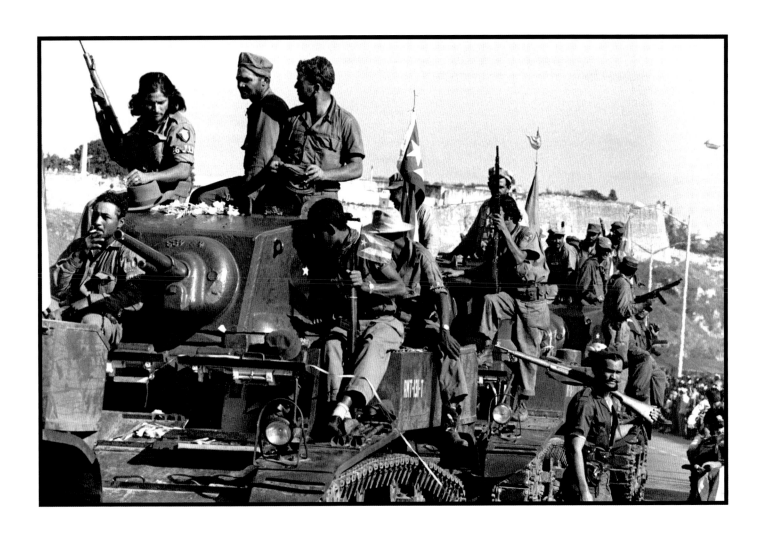

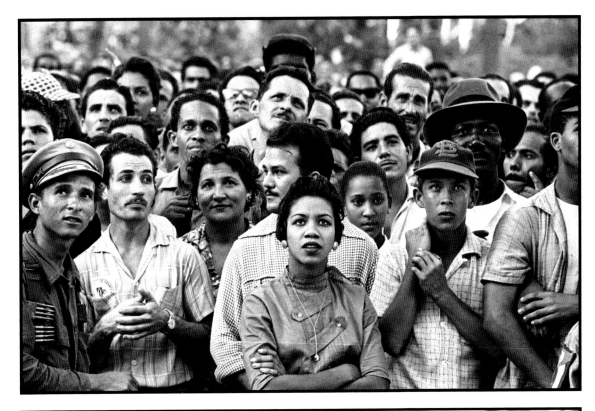

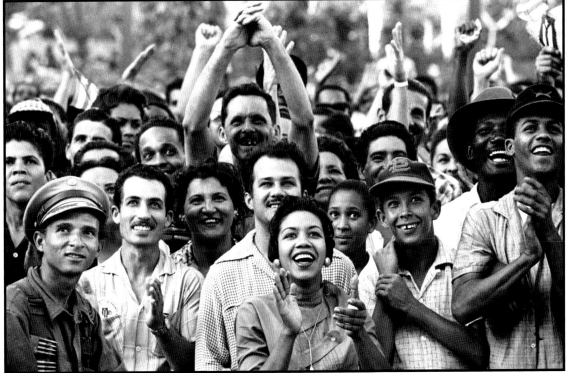

Siliguri, India
April 1959

Marilyn Silverstone was the only woman photojournalist to cover the arrival in India of the Dalai Lama, following his departure from Chinese-occupied Tibet. Silverstone was on assignment for *Life* magazine, having responded to a cable sent out by the Gamma Agency on 21 April 1959, announcing 'The Dalai Lama arrives in India'.

Notes from Silverstone's first communication after covering the story give an account of events: 'When I got the confirming cable from Gamma Agency, I booked myself onto the plane they were chartering to take us journalists to Tezpur and back. At Tezpur it was a madhouse – for six days, we sweated and ran around in circles – no one knew anything, and we were sure the Indian government would just sprint HIM (D.Lama) past us. There was nobody who would or could, tell us anything.

'Finally, on Friday, the plan was made known and we got our press cards. We piled into two buses and were driven to the Foothills camp of the Assam Rifles. There we found we were expected to stand way back from the scene. But at 07.45, the gate lifted open and THEY arrived. The stampede then began. It turned into a free-for-all, with all the Indian photographers practically smashed up against HIM so that no one could get a decent unimpeded shot.

'After all the suspense, it was very exciting to see them arrive in the Jeeps. HIMSELF was absolutely sweet – smiled and laughed delightedly at the photographers and stood for them to take pictures, then moved on into the house. The big moment was for Heinrich Harrer [the Austrian Alpinist who had previously been the boy lama's teacher in Lhasa], who was brought by the *Daily Mail*. The Dalai Lama did a "double take" when he saw him, and later kept saying: "old friend, old friend"…

'Off at the crack of dawn for Siliguri, where thousands of Tibetans from the hills waited with incense, banners, white scarves and a mournful Tibetan band, for the train to arrive. He came out in front of the station and mounted the usual podium – this time an enormously high one – and raised his hands in blessing, then came down and walked around it, re-entered the train which would probably carry him away from Tibet for ever…'

While the press were standing on the station platform, one of the party said, 'I wonder what would happen if YOU got on the train?' Silverstone, 'in a split-second decision', stepped aboard, with 'no money, no passport, and no toothbrush – nothing but cameras and film'. However, she was apprehended at the next stop and interrogated before being released. The story was published in *Life* on 4 May 1959 (though the train station photograph was not included). In later years, Silverstone became a Tibetan Buddhist nun and met the Dalai Lama on several occasions.

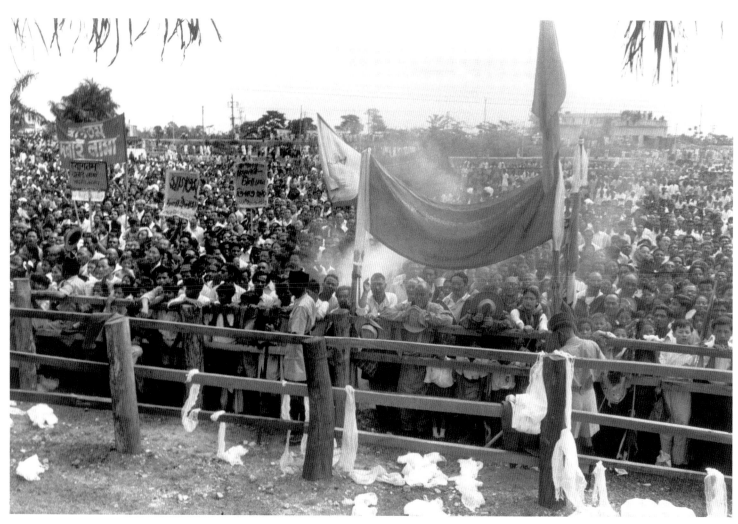

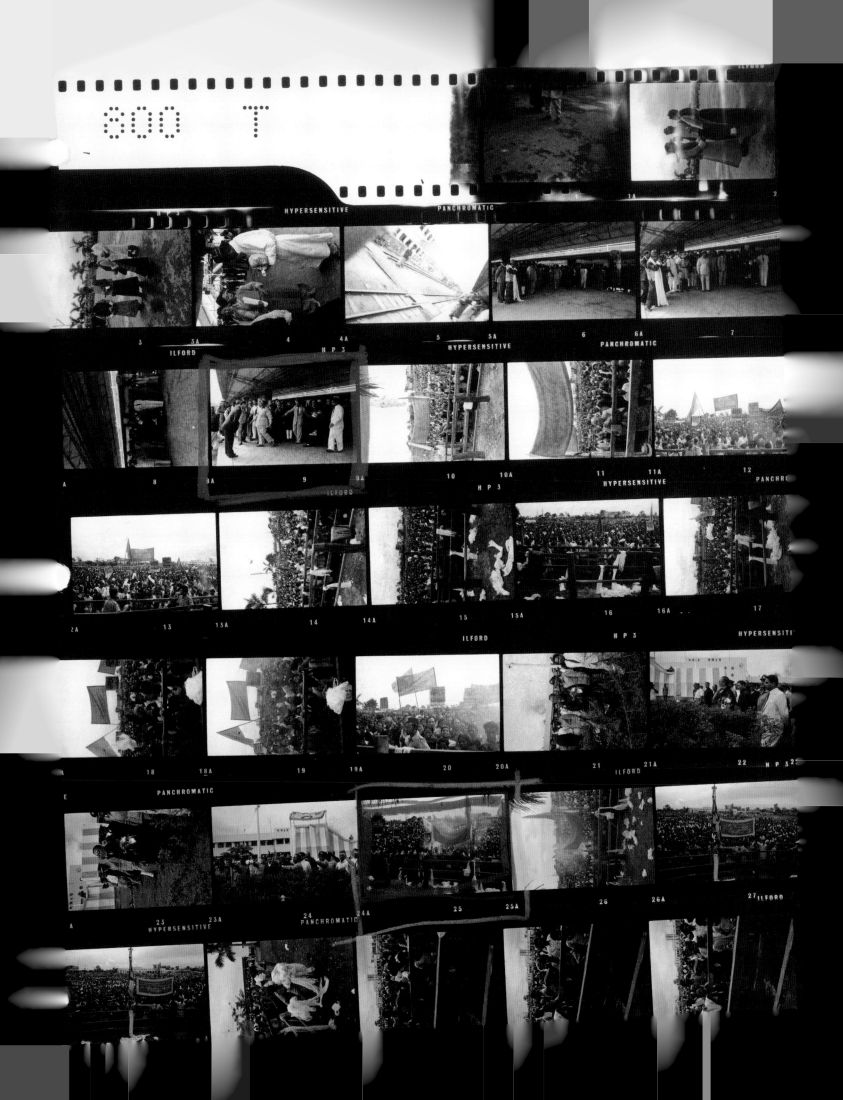

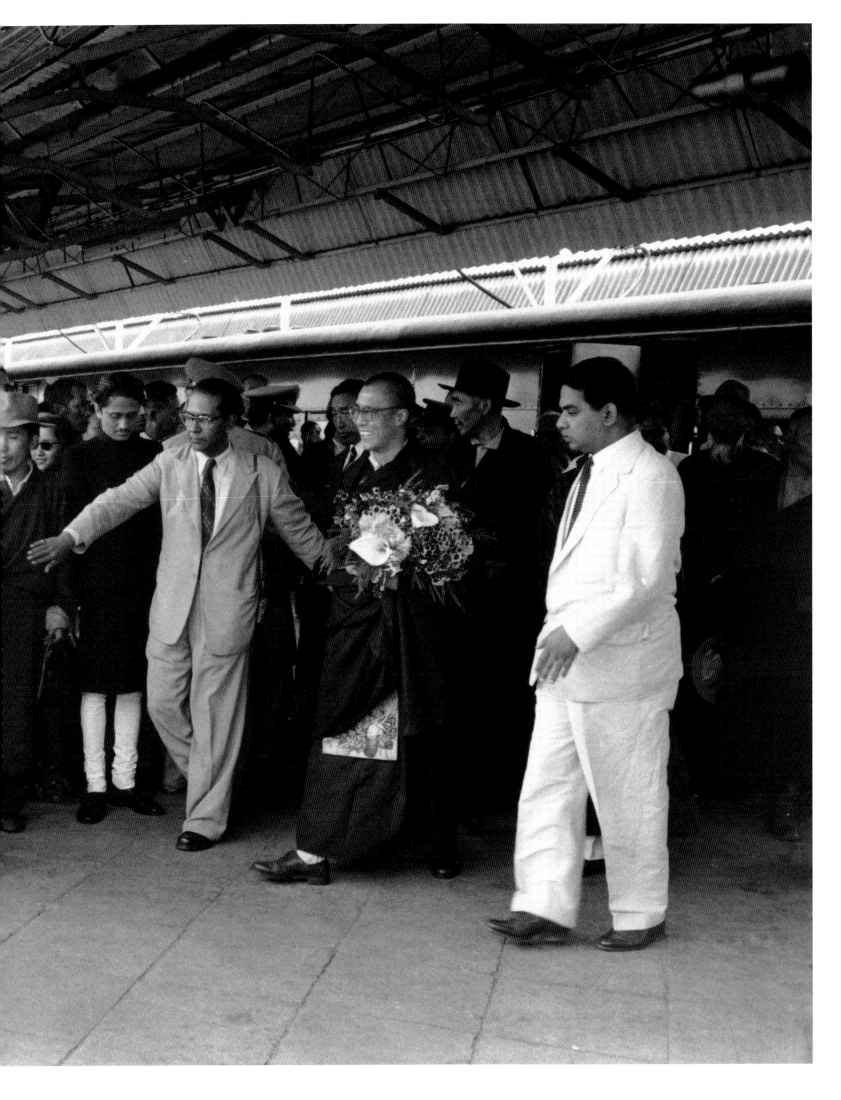

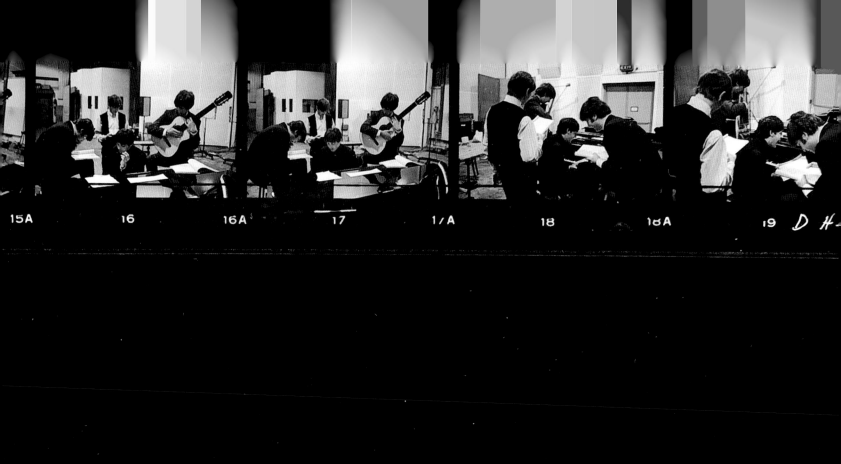

15A 16 16A 17 17A 18 18A 19 D H-

26 26A 27 27A 28 28A 29 D H-1

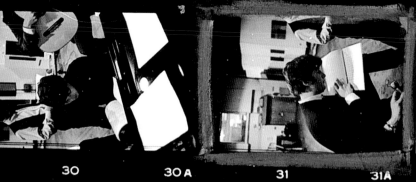

30 30A 31 31A 32 32A 33 D H-1 33A

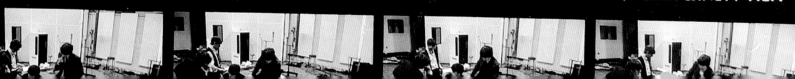

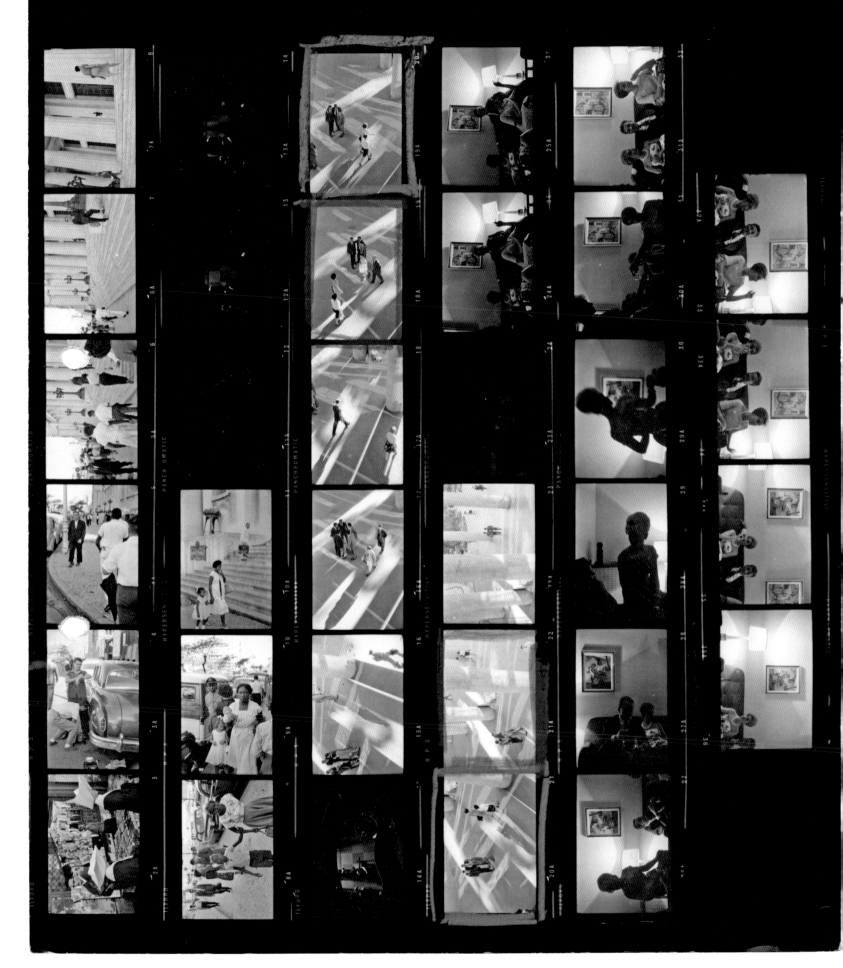

Rio de Janeiro, Brazil
1960

René Burri did not initially intend to become a
photographer. 'I went to art school, and then I was
interested in films, and then I wandered into various
classes – graphic design, interior design, and so on.
Then I walked into the photographic department and
it looked like a little mini movie studio, with all those
lamps and everything, and I said, "Yes, that's it!" And
I immediately got out a film camera and I said, "That's
what I want. To make this emotion…"'

Burri describes the editing processes that took place
when he began working in photography: 'In the old days,
we would have 100 rolls and go back through them and
get 60, 80, 100 pictures together and project them to tell
the story. You'd have one or two carousels of slides that
you would take to the picture editor of the magazine you
were working with, and edit your work with projections.
At Magnum, we'd send in our rolls and, once the pictures
got to the office, the editors would scribble a red mark:
you often didn't have time to do a selection yourself.
Cartier-Bresson would also examine our contact sheets.
He always turned them all around and upside down.
It became like a sort of dance. Strangely he didn't want

to look at the picture! I forget now, but he probably
did that with this sheet and with my "Men on the Roof"
story (photographed in São Paulo, also looking down;
I climbed everywhere in Brazil). If one picture was
not exactly framed, he would expect us not to use it.'

Burri worked in South America over many years.
He documented the growing confidence of Brazil,
encapsulated by its modern architecture, including
the founding of its new capital Brasilia, designed by
Oscar Niemeyer. The Ministry of Health, in Rio de
Janeiro – another example of Niemeyer's elegant
modernism – is the subject of this sheet. Of Burri's
iconic final image (the uppermost frame highlighted
on the contact sheet), the writer Arthur Rüegg noted:
'The room, with its criss-crossing shafts of light,
becomes a stage. Two women are walking across it
with a clear sense of destination, their path marked
by sunlight. Standing together in the shadows, three
men have turned around and are gazing after them.
It is a woven metaphor for the opposite poles of man
and woman, light and shadow, soft and hard, horizontal
and vertical.'

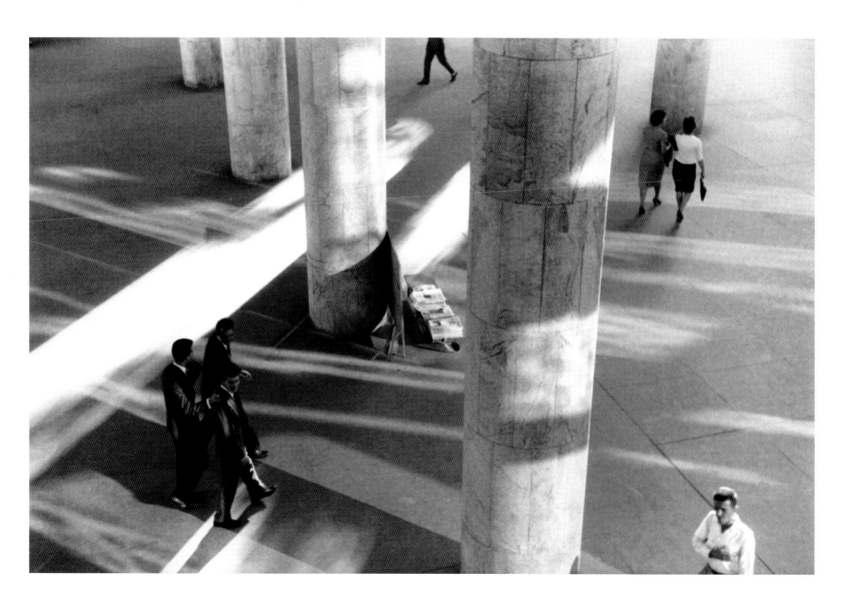

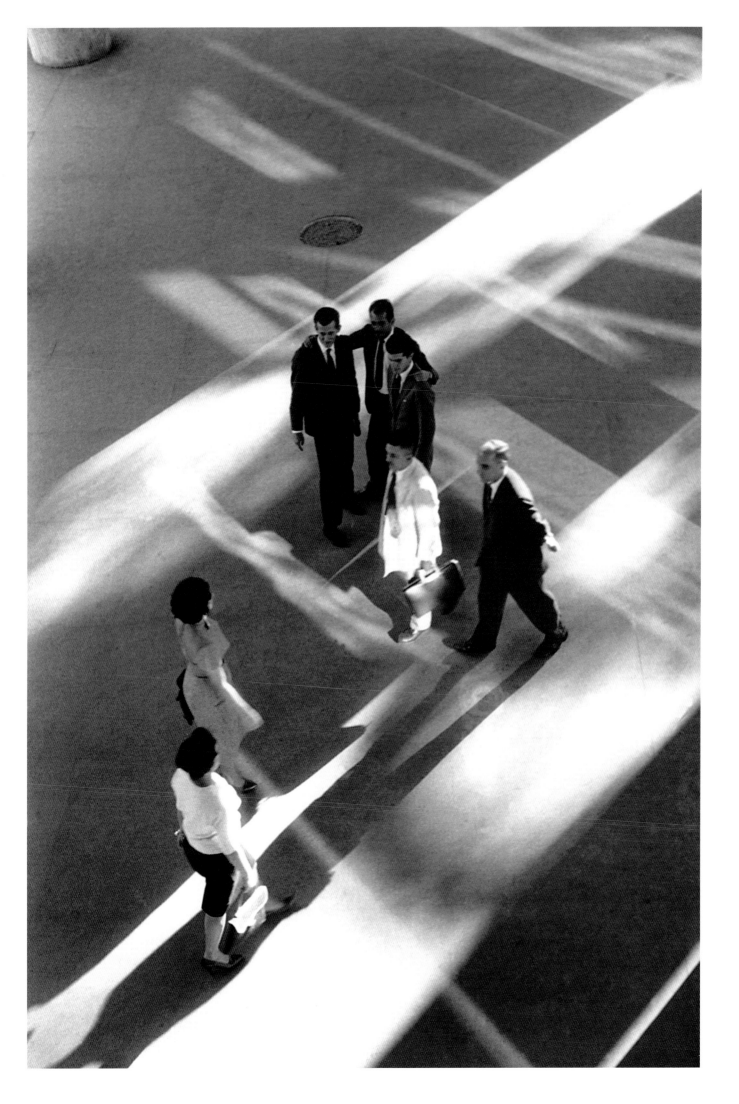

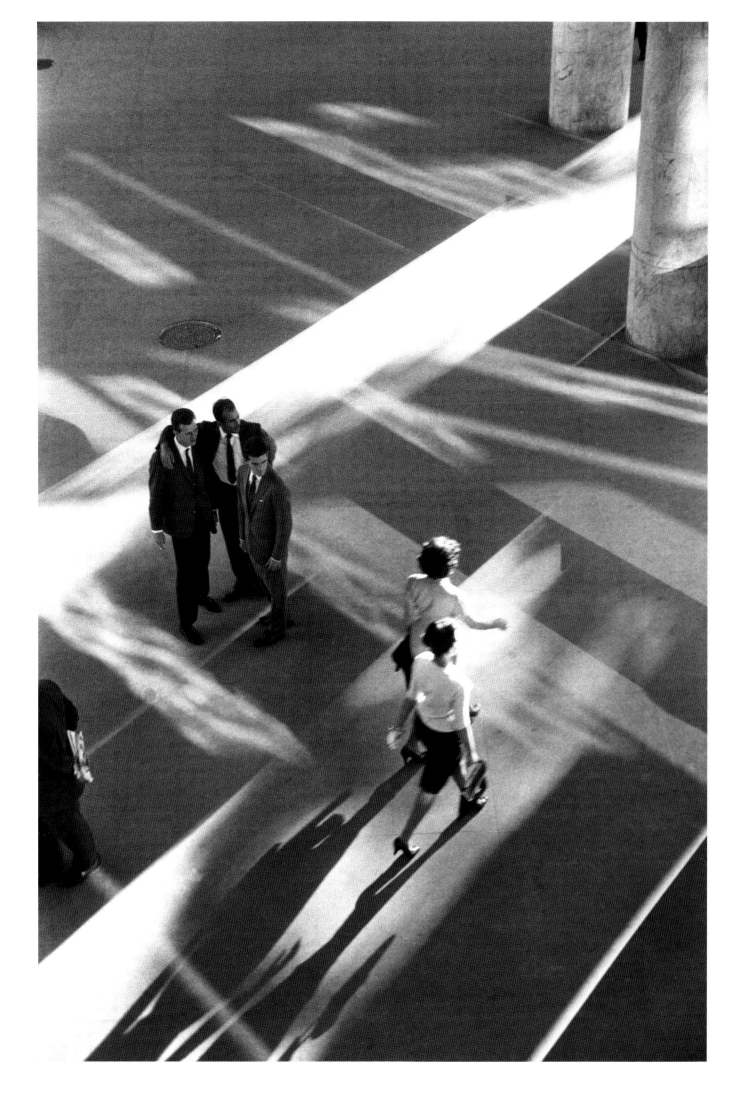

Gaza
1960

In 1957, Yul Brynner went to Austria to star in a film called *The Journey*, centred on the Hungarian Revolution. The cast included a group of refugees, who had been displaced from their homes during the conflict. Magnum photographers Inge Morath and Ernst Haas, both Austrian natives, were assigned to the set, and Morath made a series of compelling portraits of the refugee actors. Brynner later wrote that the film marked his first real encounter with refugees.

Two years later, the United Nations declared 1959 'World Refugee Year' and Brynner was appointed Special Consultant to the UN High Commissioner for Refugees. Himself a serious photographer (his pictures were distributed by Magnum Photos), Brynner invited Morath to travel with him to camps in Europe and the Middle East. In 1960, they published *Bring Forth The Children*, a photographic report on the plight of young refugees. They also collaborated on a related exhibition, and Morath published a story under her own byline in the periodical *Du*.

For Morath, the commission would have been particularly poignant. As a university student in Berlin during the Second World War, she had declined to join the National Socialist student organization and was therefore drafted for factory service, where she worked alongside prisoners of war. When the factory she had been assigned to was bombed, she joined the masses of refugees made homeless by the war, and she returned to Austria on foot. Many years later, at Magnum Photos, she refused to photograph war, preferring to work on stories that exposed its dire consequences.

In her documentation of European and Middle Eastern refugees – the source of whose plight she had experienced first hand – she went beyond the confines of her assignment, which was to photograph the hardship that refugees, especially children, endure. Morath showed her subjects actively rebuilding their lives and communities through family, work and education. Particularly in her photographs of camps in Gaza, she focused on the activities and relationships through which her subjects sought to mitigate the harshness of their circumstances, invoke their traditions and express their humanity.

Her colour photographs of Gaza were among a trove of more than 8,000 transparencies recovered after her death from a storage facility in Paris, where they had been lost for nearly fifty years. By comparing her slides with related materials that she kept in her archive – including black-and-white contact sheets and notes for captions – it has been possible to determine roughly the sequence in which she exposed them, and to begin the larger process of reintegrating her colour and black-and-white work on this personally and historically important story.

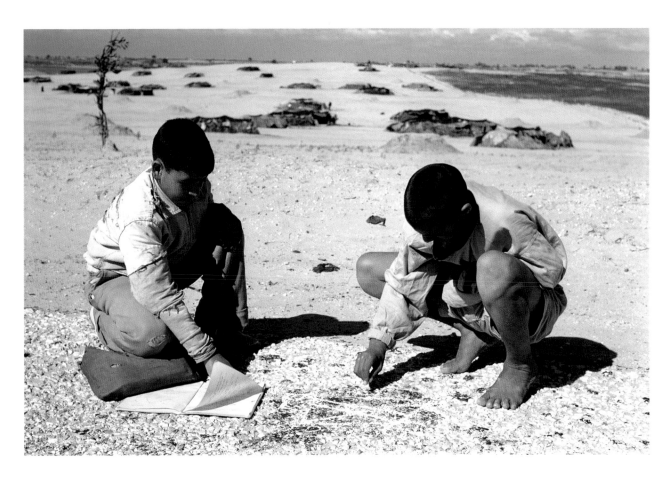

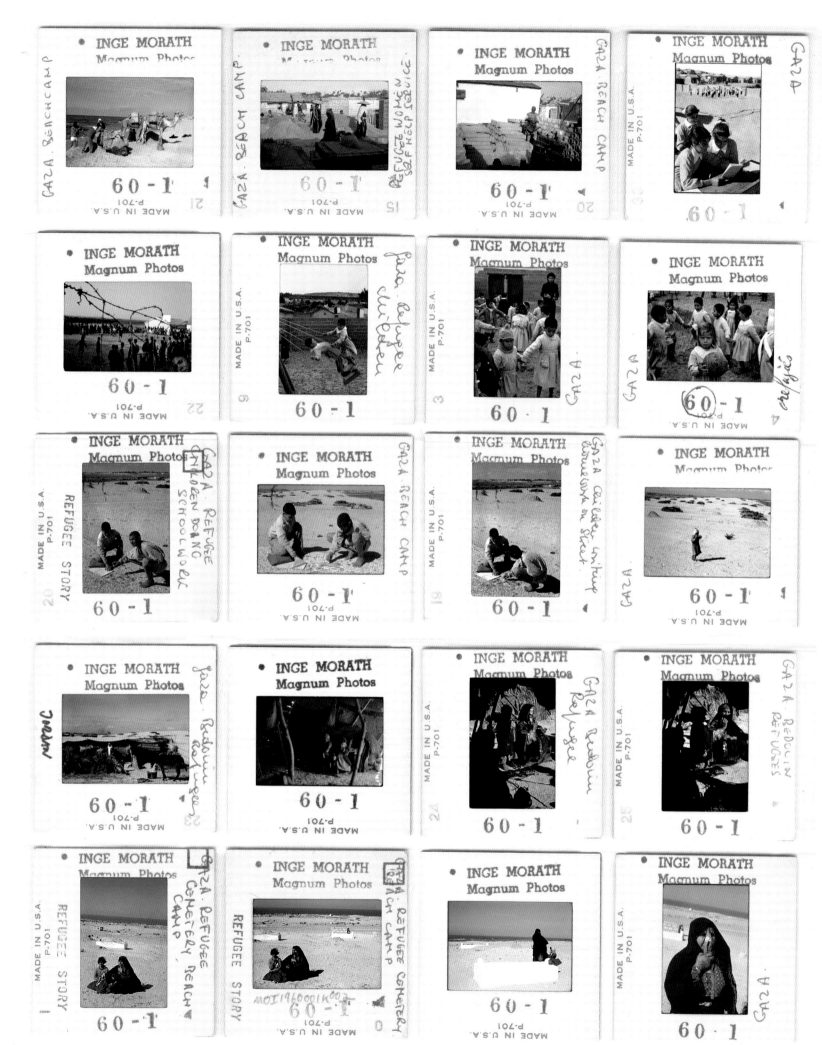

photograph by Inge Morath

photograph by Yul Brynner

YUL BRYNNER, *famed Broadway and Hollywood star, is an expert photographer as well as an arresting spokesman for this great humanitarian cause. He is donating all of his royalties from Bring Forth the Children to the Office of the United Nations High Commissioner for Refugees.*

INGE MORATH, *his pictorial collaborator, is a top magazine and book photographer. Her work was a notable contribution to Mary McCarthy's book,* Venice Observed.

cGRAW-HILL BOOK COMPANY, INC.
0 West 42d Street, New York 36, New York

a journey to the forgotten people of Europe and the Middle East by . . .

YUL BRYNNER

photographs by Inge Morath and Yul Brynner

BRING FORTH THE CHILDREN

Contactsheet Neg	Dummy Nr.	
60-1-86-44 Morath	53	**MUGHAZI CAMP, GAZA.** A few enterprising men among the roughly 10.000 refugees in this camp have created a small co-operative in which they manufacture soap. They made use of the UNWRA Self Help Flunxc Project, cared for by the Welfare Division. Amother Within this self help project Unwra provides a small capital for the realisation of a project, the rest is put up by the refugees themselves. Now tye co-operative of MUGHAZI has 8 members, the soap they produce is sold in the market in Gaza and in the camps. They manage to make a small profit, which they are confident to improve. In the photograph three members of the sopa co-operative mix the liquid for the soap in the big raixle kettle they made themselves for their little factory.
60-1-87-23 Morath	54	**RAFAH CAMP, GAZA.** All over the Gaza Strip, refugee boys use the road to figure out their homework and read their schoolbooks. There is neither room nor light for these things in their overcrowded homes in the camps. In the background the black tents of the Beduins that live in one part of RAFAHx camp.
60-1-87-18 Morath	55	**KHAN YUNIS CAMP, GAZA.** Crippled refugees doing cane work within a self help project financed by the NECC (NEAR EAST CHRISTIAN COUNCIL).

Contactsheet Neg	Dummy Nr.	
60-1-84-18 Morath	56	**GAZA TOWN.** One of the few things that can be produced for export by the refugees are ropes maxexoxt and mats made out of palm leaves. This is part of a group of projects by the Near Eastern Christian Council for the benefit of the refugees. In the backgrd cut up palm leaves ready to be made into ropes.
60-1-82-52 Morath	57	**GAZA TOWN.** Carpentry workshop for refugees, part of a group of projects run by the NECC for the benefit of the refugees.
60-1-75-18/19 Morath	58	**BEACH CAMP, GAZA.** UNWRA tries to help xrmatex build up recreation centres in each camp. The one in the beach camp has a ball court, a room with a small library, another one with a ping-pong table. Here the beach camp volley ball team plays against the Jabalia camp team. For a few moments the boys forget the barbedcxixexc ever present barbed wire.
60-1-90-4 Morath	59	Fishermen refugees from Haifa cast their nets into the Mediterranean at the shore of GAZA'S BEACH CAMP. All their big boats were left behind, but they managed to earn the money t get a couple of boats again to go out and fish at sea. All the fishermen in the Beachcamp are members of one family: the Hissi family. They form a kind of family cooperative. The whole Hissi family counts now 150 members, all refugees in GAZA.

TOP Cover of *Bring Forth The Children*, published in 1960, with photographs by Inge Morath and Yul Brynner.

ABOVE Inge Morath's typewritten captions for photographs shot in Gaza in 1960.

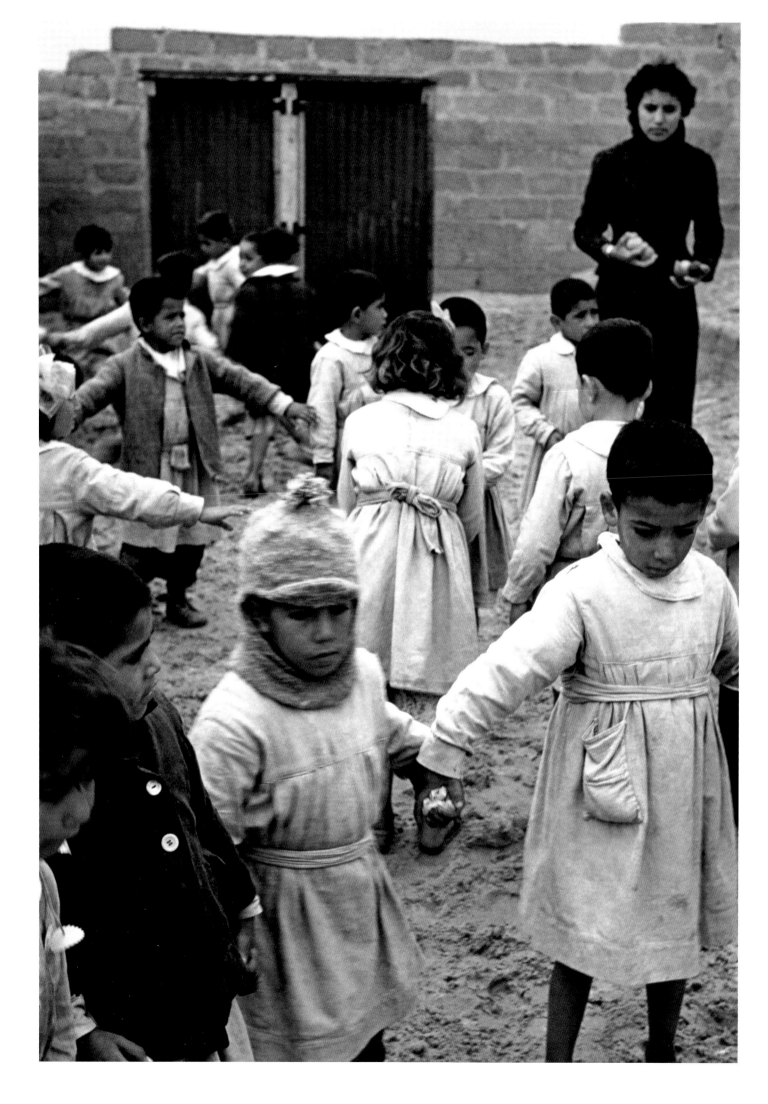

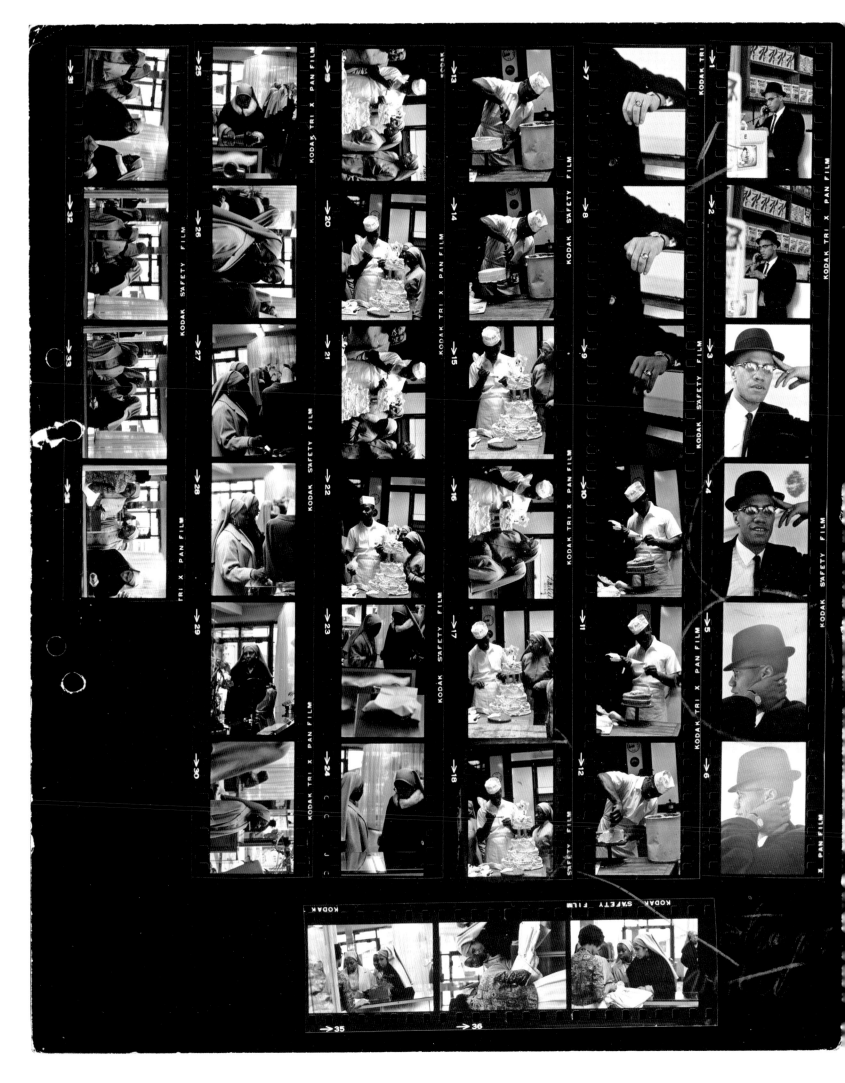

Chicago, USA
1961

"Photographing movie stars was child's play compared to the problems to be hurdled when *Life* magazine assigned a political story on Malcolm X, the emerging leader of the Black Muslims. There was a major research job to be done [though *Life* did not in the end run the story]. The Muslims were a virtually impregnable wall to broach. Through sources I no longer remember I contacted a man called Louis Lomax, who was a journalist with access to Malcolm X. We agreed that for a sum he would be the fixer for the story.

The first contact was at the Uline Arena in Washington, at a national convention of all chapters of the Black Muslims. People had come by the busload from all over America. The males were in black suits, white shirts and black ties, their boots highly polished. The females wore white dresses, and their heads were modestly covered in white scarves. There was an honour guard for the Prophet, Elijah Muhammad, the messenger of Allah, as well as an elite young military guard called the Fruit of Islam.

Over the next year I followed Malcolm from Washington to New York and Chicago and then back to New York. He was cooperative and considerate. As we worked together, he began to think of situations for me to photograph. When I went to Chicago, it was to see the way the Muslims dealt with 'whitey' through their economic boycott. The Chicago community was thriving, so Malcolm thought it should be photographed as part of my article.

He was a really clever showman and apparently knowledgeable about how he could use pictures and the press to tell his story. He set up the shots while I clicked the camera. I tried several times to get him in the act of framing a photo with his hands, but he was too quick for me. With the photos of himself, he was professional and imaginative. He obviously had an idea of how he wanted the public to see him and he manoeuvred me into showing him that way. I am always delighted by the manipulation that goes on between subject and photographer when the subject knows about the camera and how it can best be used to his advantage. Malcolm was brilliant at this silent collaboration. He knew his needs, his wants, his best points and how to get me to give him what he required."

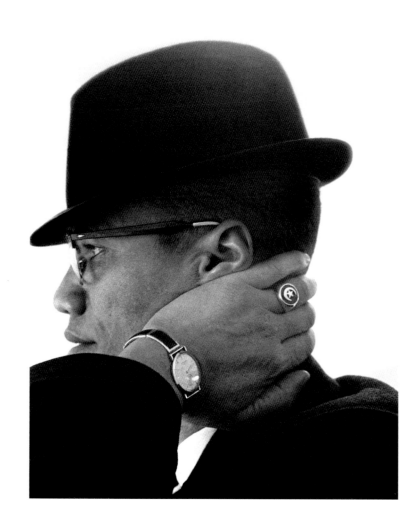

Washington, DC, USA
March 1961

Fascinated by American politics, Cornell Capa followed the three presidential campaigns of Adlai Stevenson, but it was not until John F. Kennedy's campaign in 1960 that the photographs culminated in a major project. At the inauguration ceremony in January 1961, Capa was struck by the new president's speech: the inspirational tone and adventurous spirit reminded him of the beginning of the Franklin Delano Roosevelt presidency, when FDR confronted daunting challenges and accomplished great things during his first hundred days. Capa decided to produce a book on the first hundred days of the Kennedy presidency and enlisted eight fellow Magnum photographers, Henri Cartier-Bresson, Elliott Erwitt, Burt Glinn, Constantine Manos, Inge Morath, Marc Riboud, Dennis Stock and Nicolas Tikhomiroff, and seven writers and historians to cover various challenges that the administration faced – conflict at the United Nations, famine in Africa, water crisis in Ecuador, war-torn Laos, civil rights and poverty. The title, *Let Us Begin: The First 100 Days of the Kennedy Administration*, was taken from Kennedy's inaugural address, in which he said, 'All this will not be finished in the first hundred days. Nor will it be finished in the first thousand days, nor in the life of the administration, nor even perhaps in our lifetime on this planet. But let us begin.'

The book is often cited as the first topical photojournalistic book, as it came out on Day 110, and *Time* magazine called it 'instant history'. Capa covered the White House, from official meetings to the Kennedy family at home. This contact sheet shows the start of a cabinet meeting in March 1961. Among those present are Vice President Lyndon Johnson, Secretary of State Dean Rusk, Secretary of Defence Robert McNamara, Special Counsel Ted Sorensen and Attorney General Robert Kennedy. Capa nestled in inconspicuously, from a low angle, on the seemingly casual small groups of men conversing before the meeting, capturing even the intimate whispers of political secrets. The portrait of George Washington hangs in the background of many images. Once the meeting begins, Capa's camera is excluded from the table and the tall dark backs of the studded leather chairs are all that can be seen. Capa's more humorous attitude towards some of the pomp of politics is seen in the several frames of the plaque on the back of Kennedy's chair, labelled: The President.

ABOVE Cornell Capa and Elliott Erwitt at the White House, working on the book *Let Us Begin: The First 100 Days of the Kennedy Administration.*

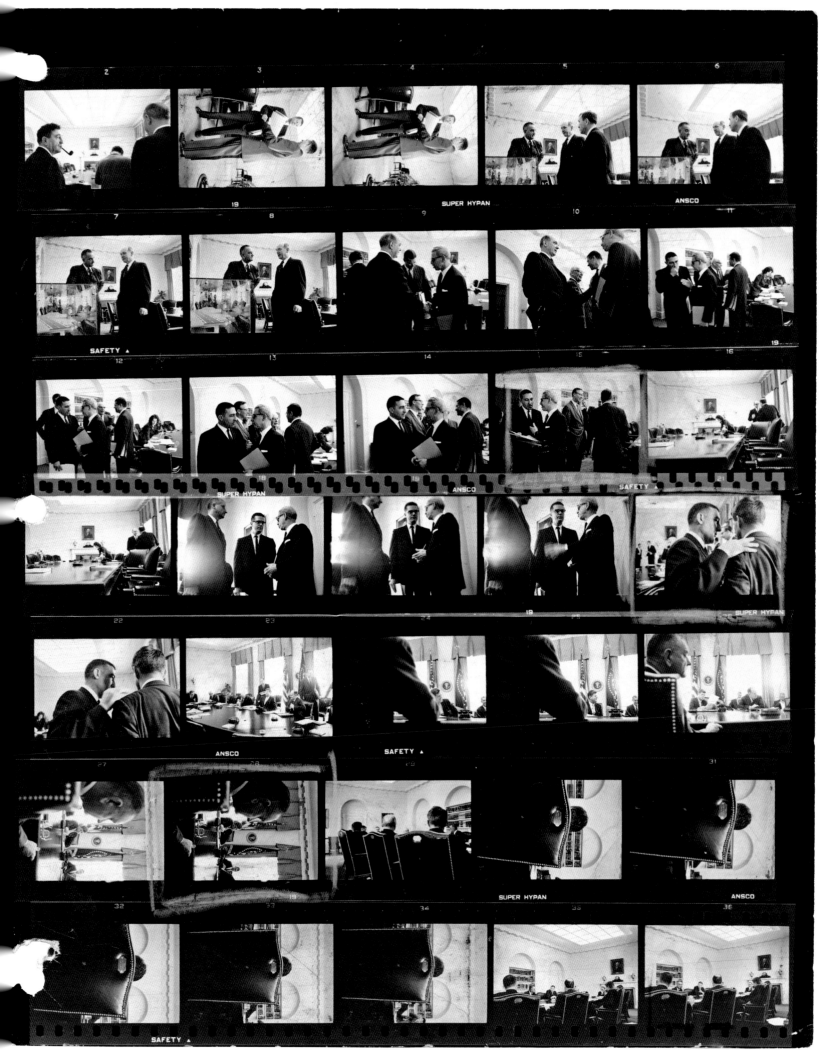

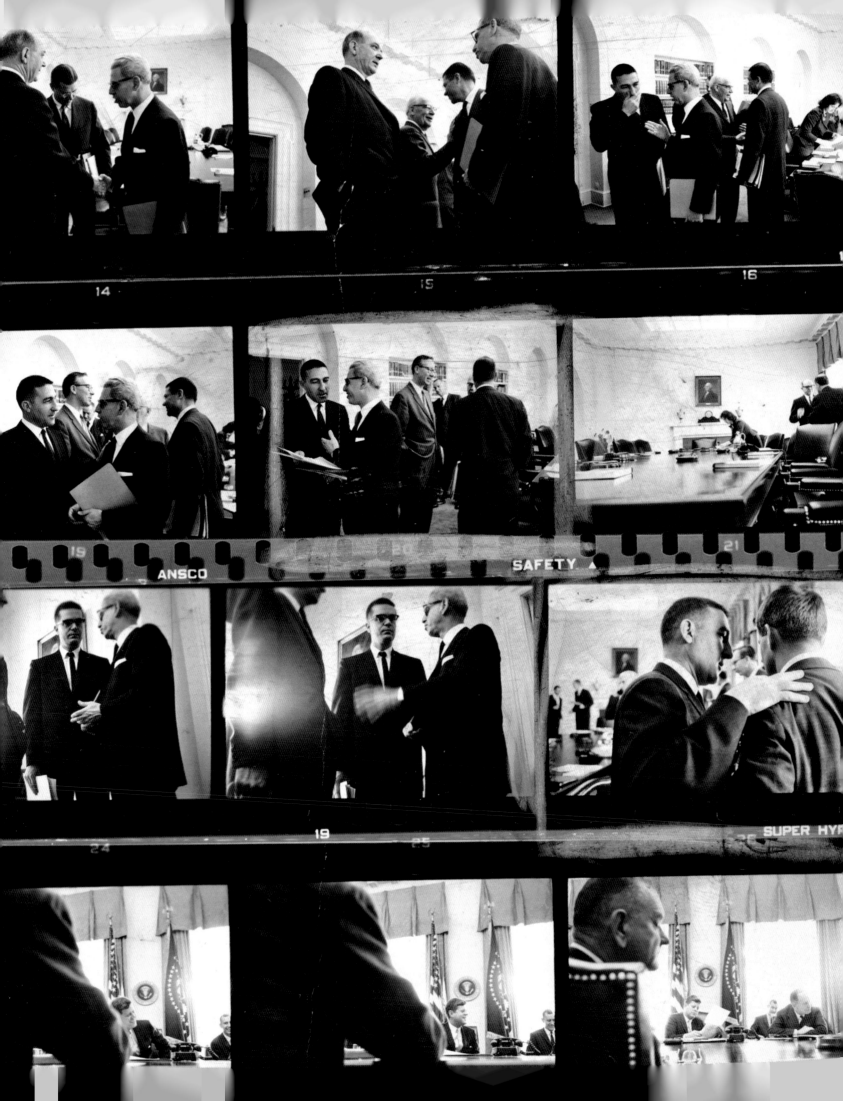

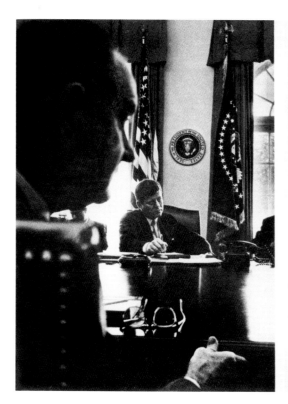
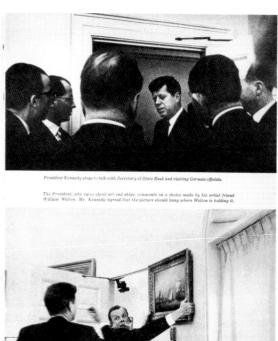

TOP Spread from *Let Us Begin: The First 100 Days of the Kennedy Administration*, published in 1961.

ABOVE Recording of President Kennedy's inaugural address, with a sleeve photograph by Cornell Capa; the record was included with the hardcover edition of *Let Us Begin*.

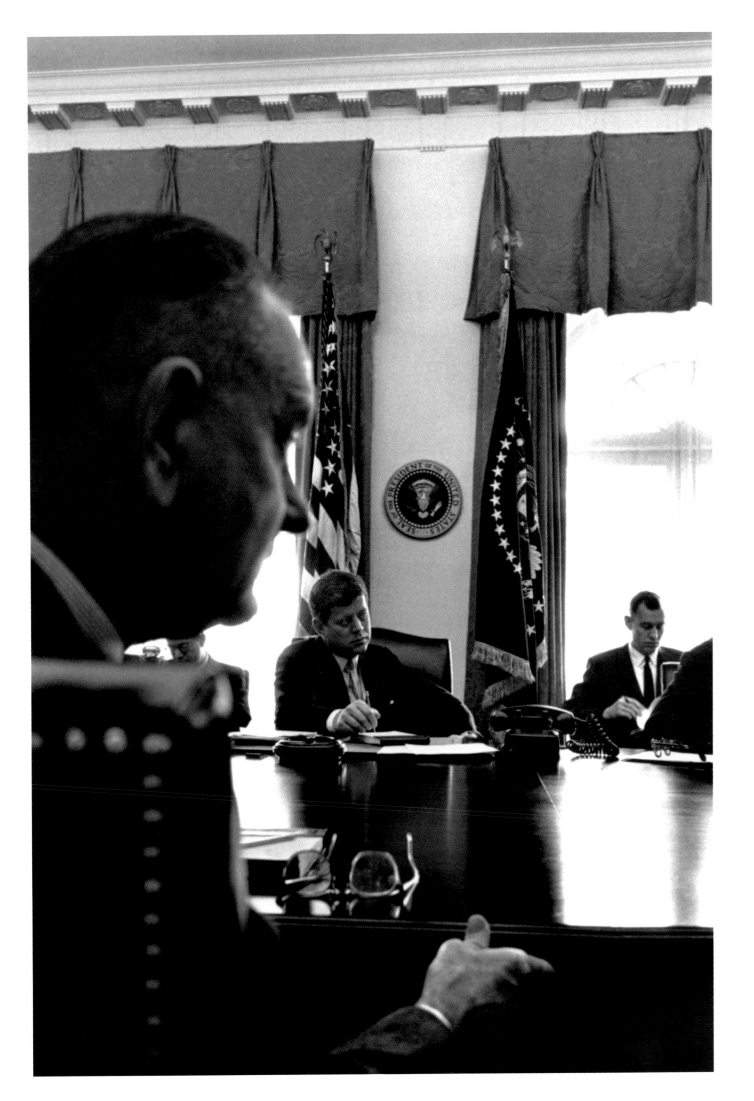

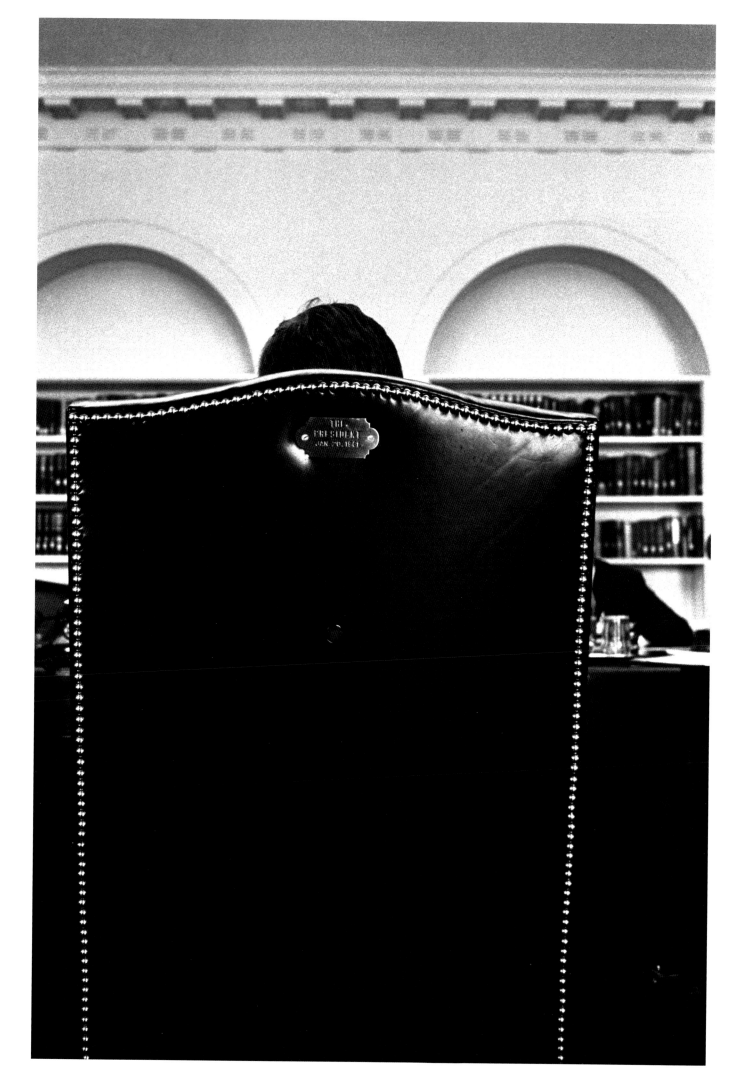

USA
1961–65

In May 1961, two buses filled with 'Freedom Riders' –
civil rights workers protesting segregation in interstate
travel – launched a trip from Washington, DC, to
Birmingham, Alabama. The first bus was firebombed
outside Anniston, Alabama; the second made it to
Birmingham, but was attacked on arrival by an angry
mob. When another Freedom Ride was attempted a few
weeks later, Bruce Davidson set out to cover the story.
He met the Freedom Riders in Montgomery, Alabama,
where they boarded a Trailways bus bound for Jackson,
Mississippi. Davidson recalled: 'This time there was a
police presence, National Guard troops were assigned
to the buses, and the press was out in full force.' He
photographed the activists as they sang songs and
watched nervously as seething crowds and cordons of
federal marshals formed outside the bus windows. Upon
arrival at the Jackson bus station, all of the Freedom
Riders were arrested by Mississippi police.

In 1962, Davidson received a Guggenheim fellowship to
document 'Youth in America'. He used the grant to support
his episodic, four-year project to document the civil rights
movement. He travelled to the South eight times, covering
protests that attracted international media attention but
also smaller, otherwise overlooked events.

In May 1963, he documented the clash in Birmingham
when the police used fire hoses and police dogs against
nonviolent protesters. Of his photographs of the arrest of
a young woman, he commented: 'I was moving around,
I was fast and fancy, so I could take a picture and move
to another moment before they became aware of me. I
knew when to stop so they wouldn't react to the camera.'

Davidson's last trip south took place in 1965, in the
midst of campaigns for voter registration and federal
protection of voting rights. He was introduced to Annie
Blackman, who lived close to Jefferson Davis Highway
80 in a three-room cabin with three of her nine children.
Davidson photographed Annie holding her youngest child,
Felicia (thirty-seven years later, he returned and located
the family, including Felicia, by now an insurance
representative for local farmers). On the same trip, he
also documented the Selma to Montgomery March for
universal voting rights. Driving fellow marchers back
home, Detroit housewife Viola Liuzzo was shot to death
in her car by four Klansmen. Davidson made haunting
photographs of the scene of her murder, visible on the
end of the roll with the portrait of Annie and Felicia.
'Before dawn the next morning, I located the car with
splattered bloodstains on the front seat, and was able
to take a few pictures before a trooper spotted me. I
hightailed it out of there. This gruesome murder made
the Selma March and its mission even more poignant
and powerful.'

At the same time that he was capturing images of
protest and strife, Davidson was documenting a broad
range of everyday experiences in African American
communities in New York, Chicago and the rural
South. 'It occurred to me a number of times that the
demonstrators were kind of invisible on our television
screens and in our newspapers as individuals, as
people… I was looking for a personal experience.'

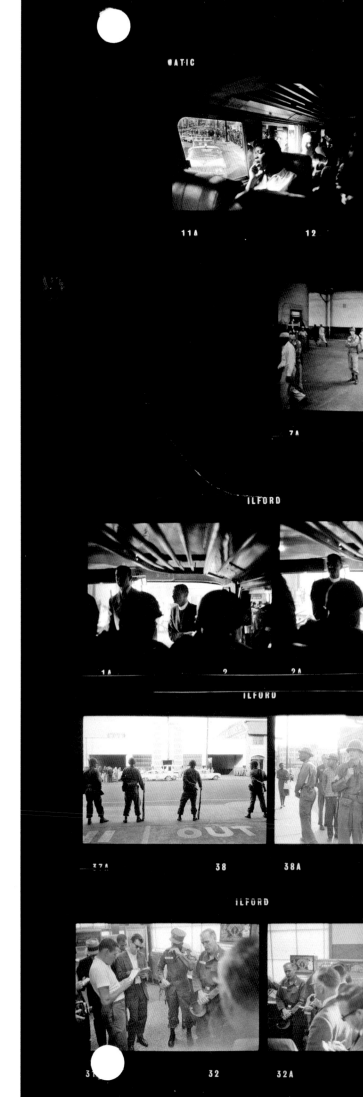

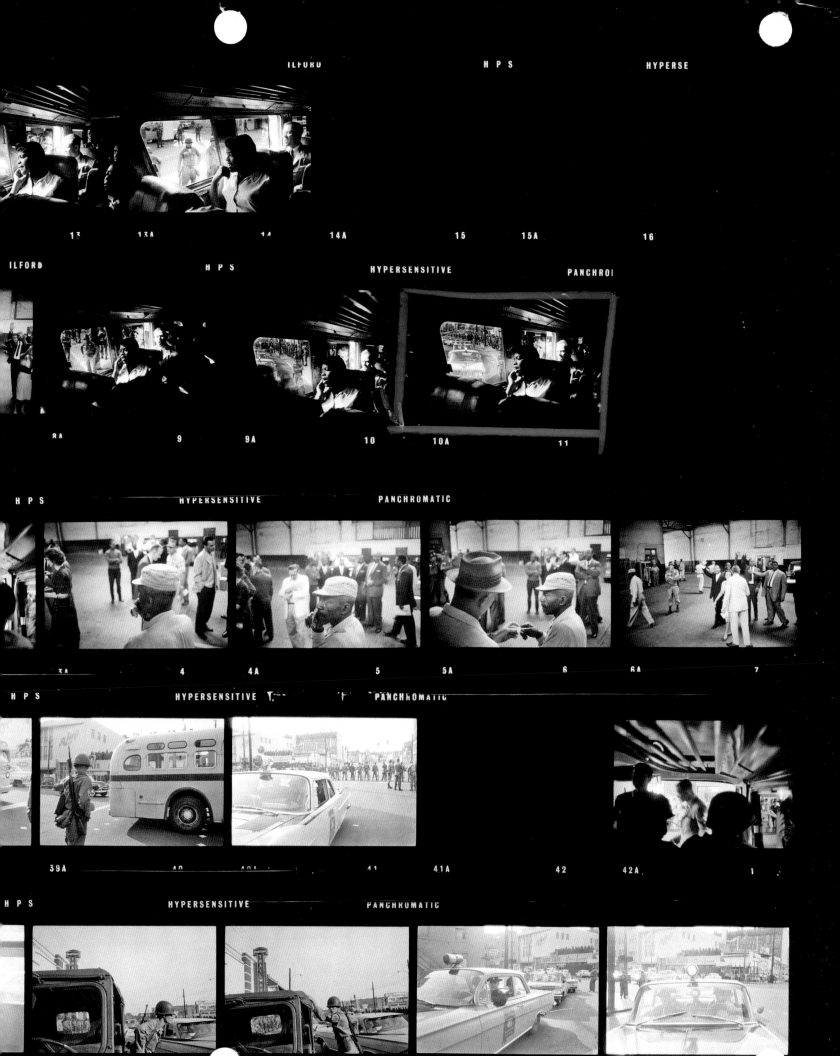

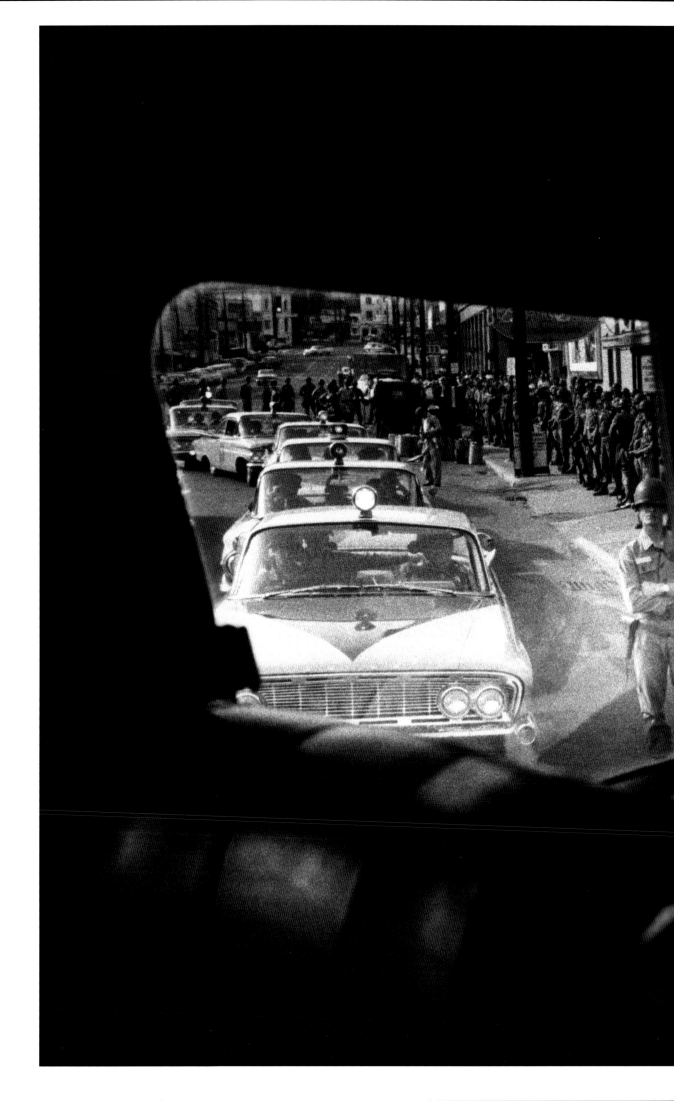

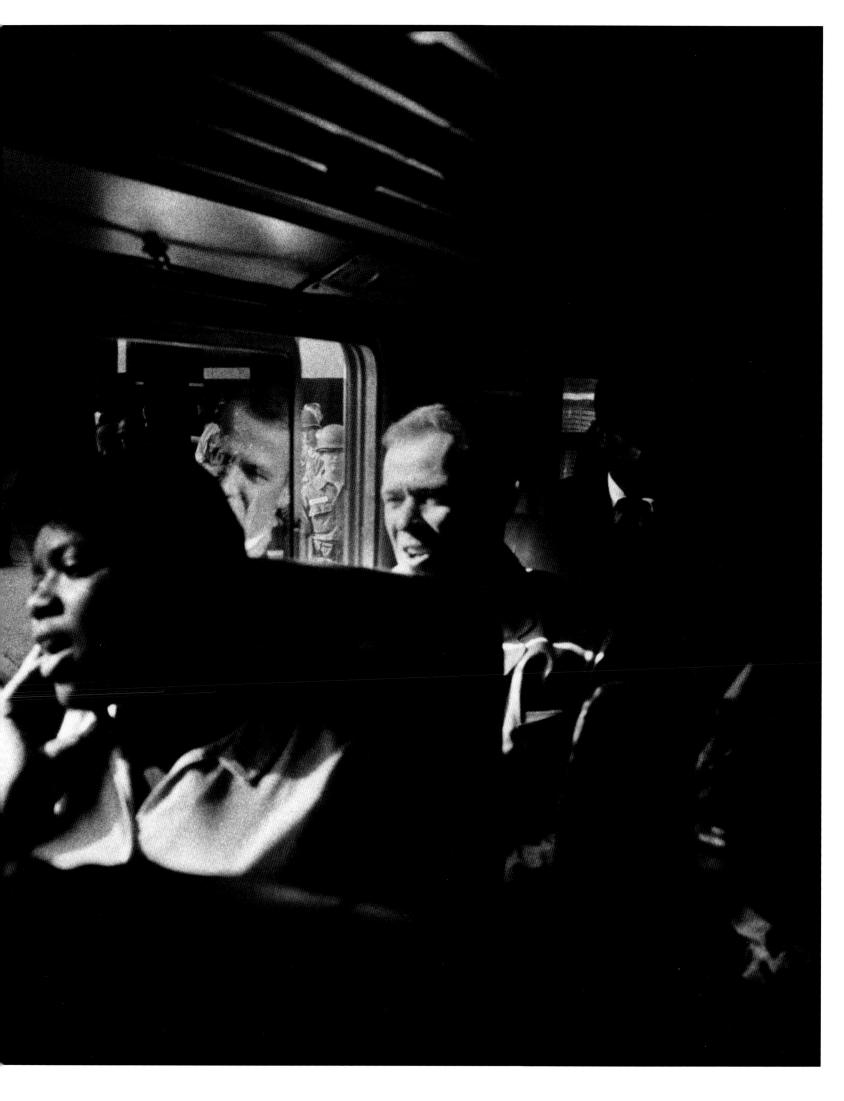

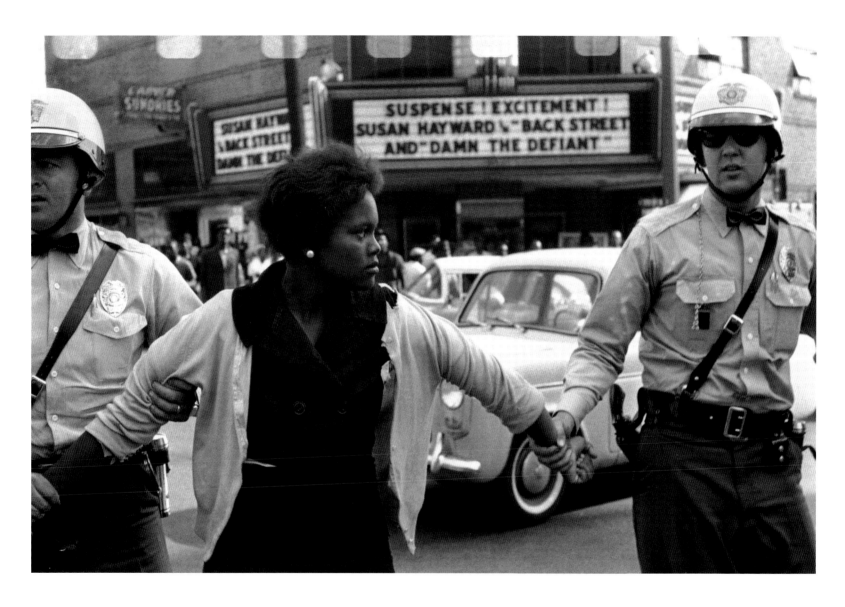

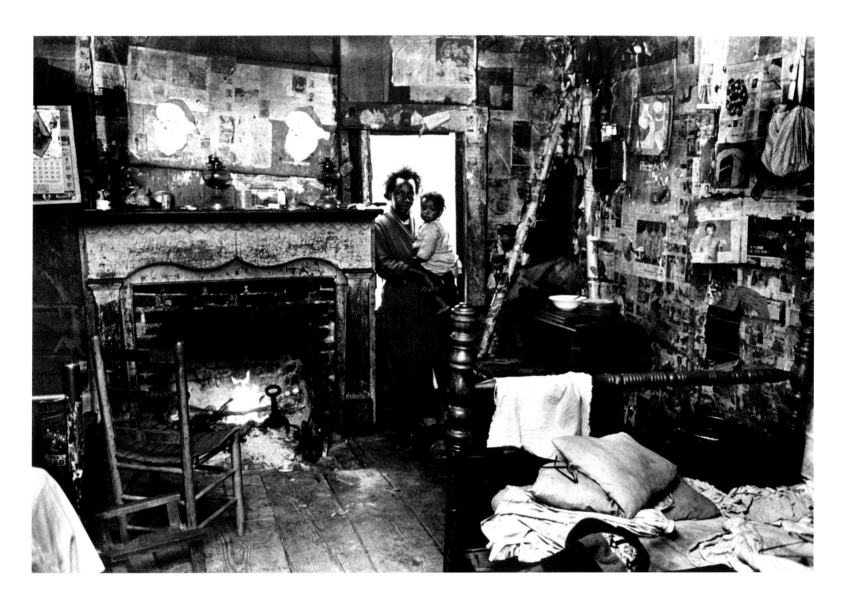

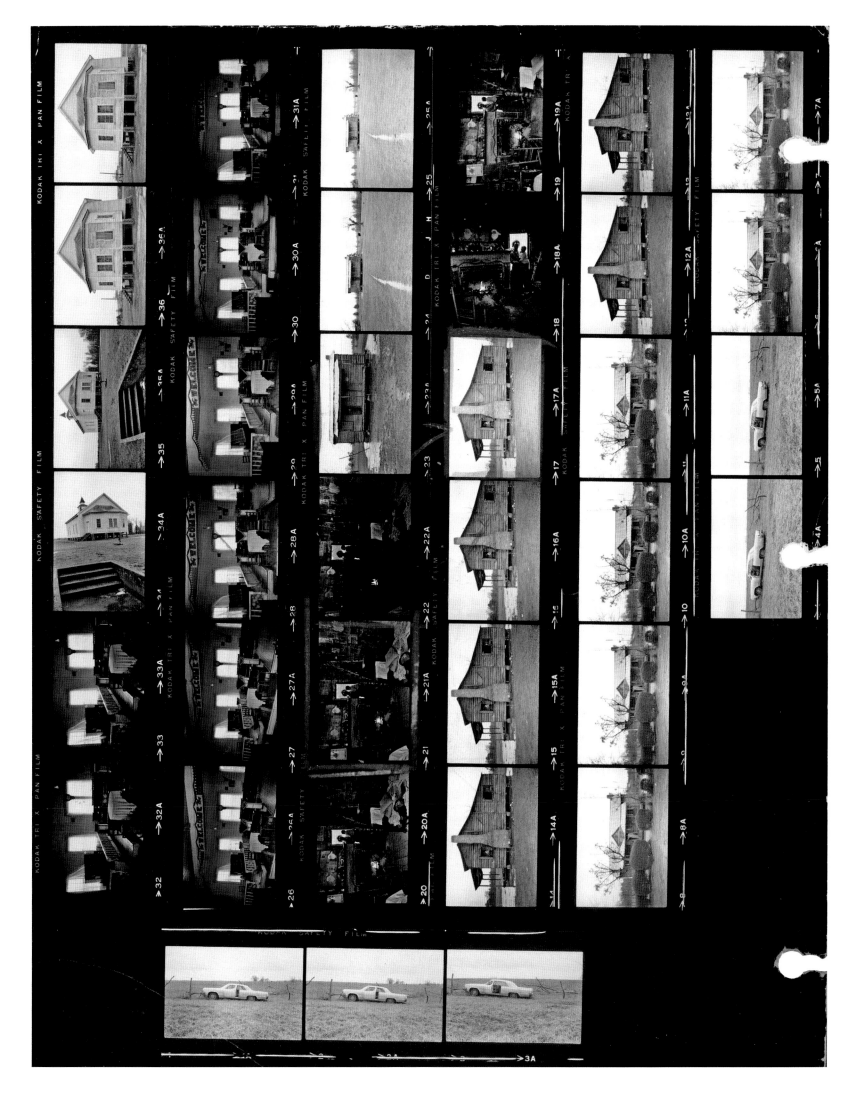

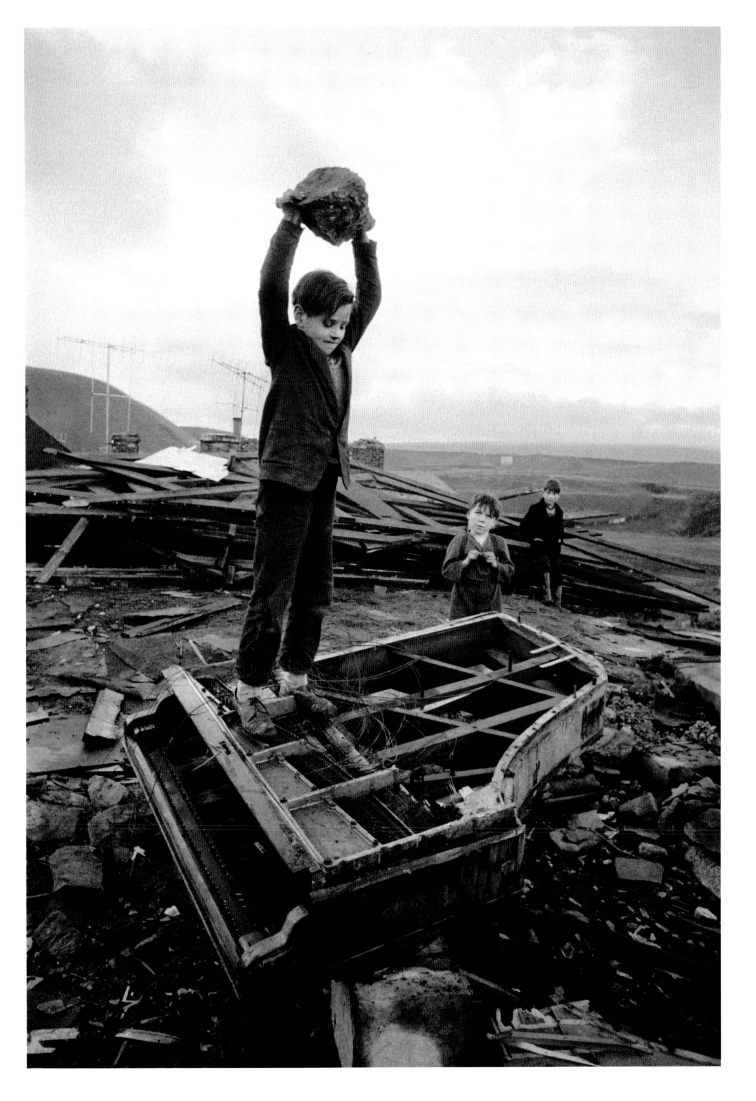

Pant-Y-Waen, Wales
1961

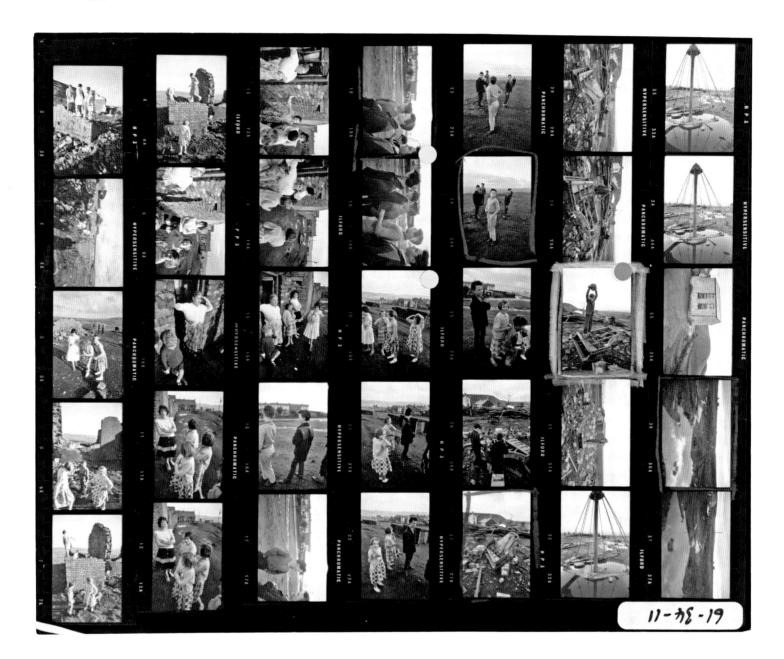

Philip Jones Griffiths's contact sheets are notable for
how few takes of the same subject appear on them; how
economical he was with his film, how little he shot. The
photograph highlighted here dates from 1961, the year
in which he turned professional, giving up his job as a
chemist and starting to travel all over the world. However,
he was fiercely proud to be Welsh, and he always returned
to his roots. The caption he gave this picture reads: 'This
place, Pant-Y-Waen, was once, in the 1930s, voted the
most beautiful village in South Wales. It has long since
been obliterated by open-cast mining. This young boy
epitomizes our ambivalent love for both rugby and music.
When I asked him what he was doing, he replied: "My
mother gave it to me to mend."' This was one of Jones
Griffiths's favourite pictures, and was used as the cover
photograph for his retrospective book, *Recollections*.

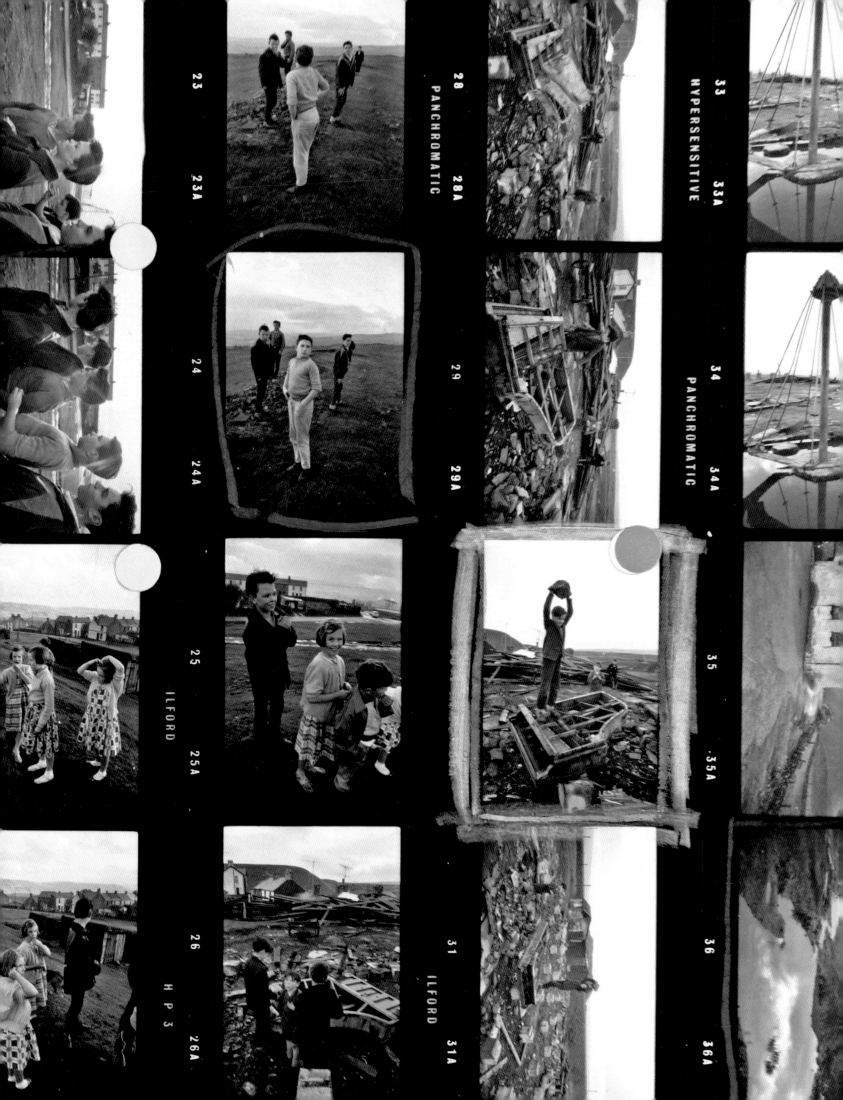

CONSTANTINE MANOS Women at Graveside

Peloponnesus, Greece
1962

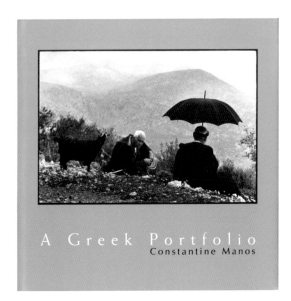

"When I went to Greece in late 1961 to make pictures for a
book, one of the regions I visited was the Mani – a rugged
and isolated peninsula in the southern Peloponnese.
During the five hundred years of Venetian and Turkish
subjugation of Greece, the Mani was never subdued,
and the people have retained their hardy individuality
to this day.

During my stay in a village I learned that an old man
had died. Having got permission to be present at the
funeral, I made this series of pictures at the graveside.
Everyone had gathered around the priest, who said a
blessing and left. Then the women began their keening.
It reached a peak and subsided within a few minutes.
It looked like a scene that could have taken place in
ancient Greece over two thousand years ago.

The frame numbers are not consecutive because
my film was bulk-loaded (I was operating on a budget).
What amazes me now, so many years later, is how few
frames I shot of the profoundly moving group of four
women (frames 29–34), one of whose picture was the
final choice. The roll of film was shot during the period
1962–63, although there are other dates on the back of
the contact sheet and negative sleeve.

The picture appeared in my book, *A Greek Portfolio*,
first published in 1972. At the time of publication the
picture entered the collection of the Museum of Modern
Art in New York, and exhibitions of photographs from
the book were held at the Bibliothèque Nationale in
Paris and the Art Institute of Chicago. This work was
the main catalyst for my being asked to become a
Magnum Associate in 1964."

ABOVE Cover of *A Greek Portfolio*, first published in 1972
(this edition 1999).

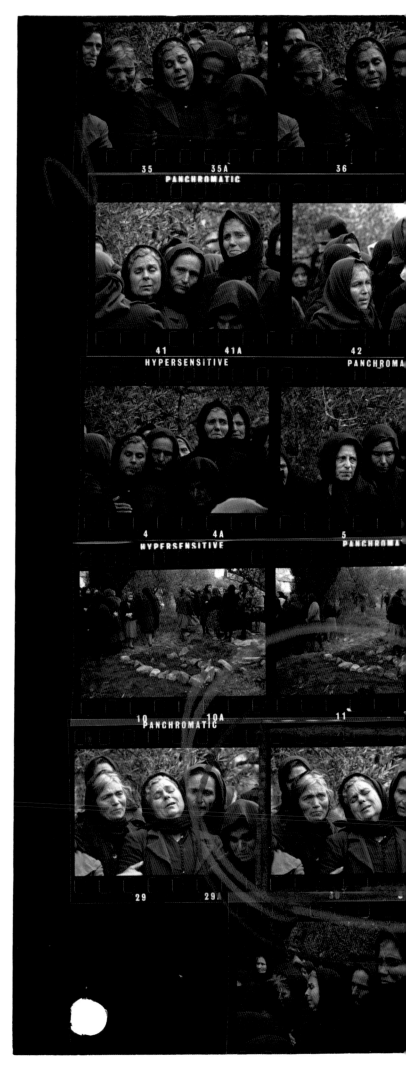

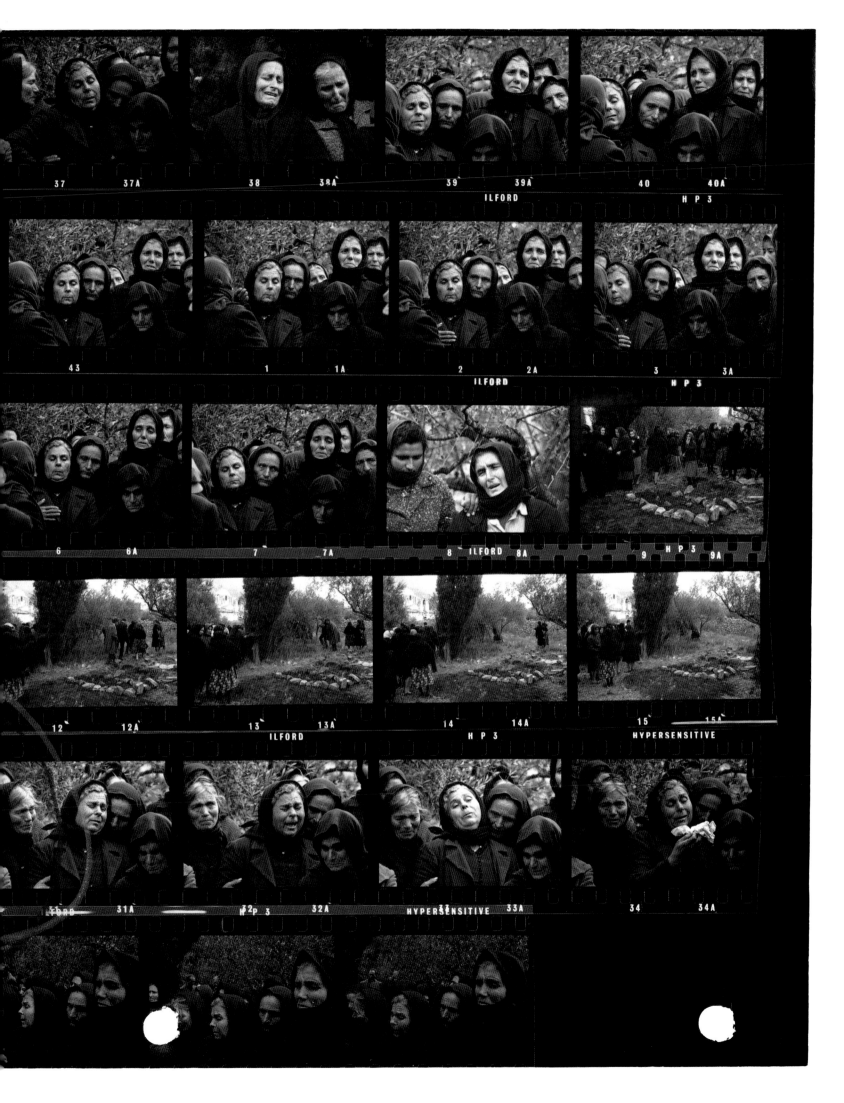

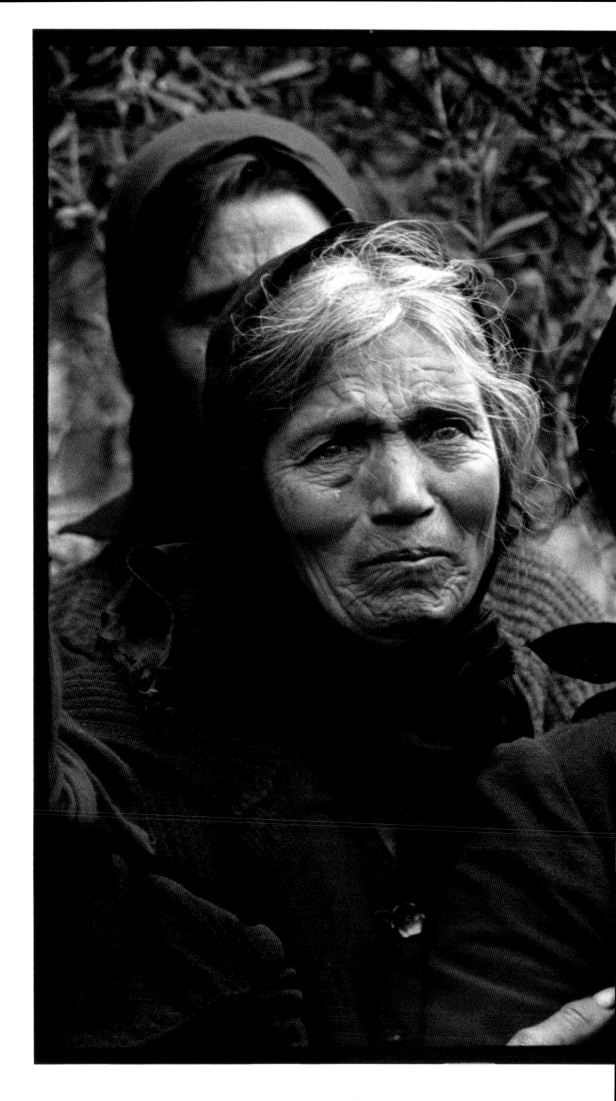

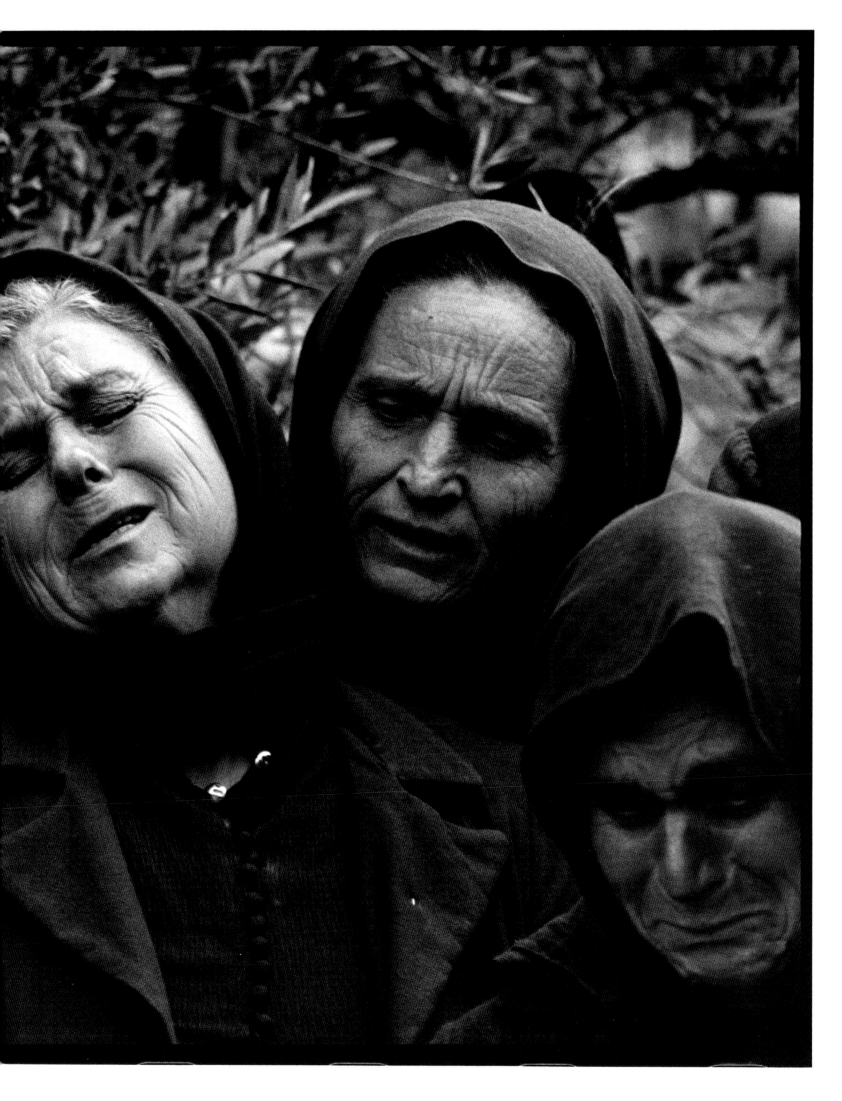

MAGNUM photos

Captions

Remarques

Story N° 63-1-

BUR63001 W000 74

Dist N°

Color

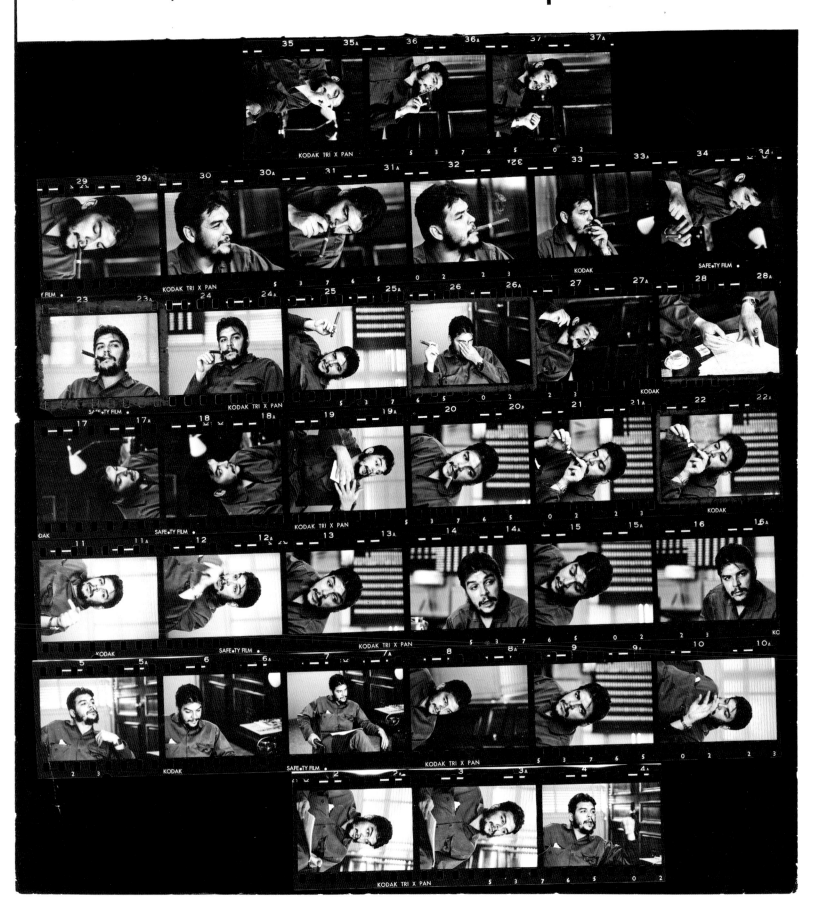

Havana, Cuba
January 1963

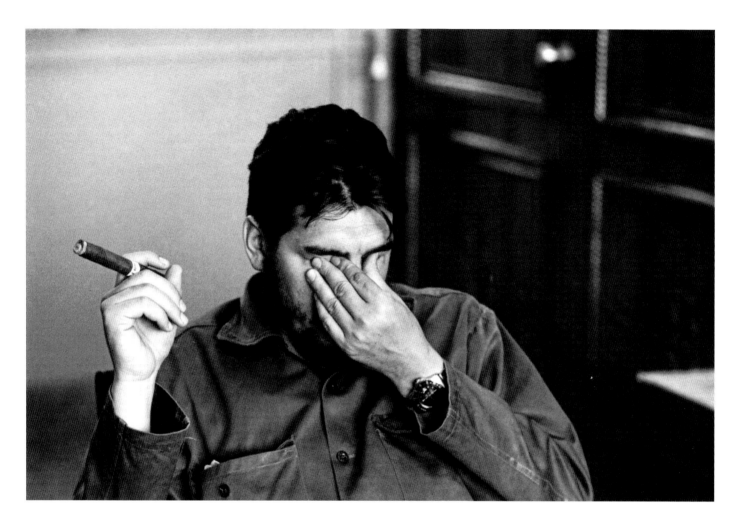

"I arrived with the US reporter Laura Berquist from *Look* magazine. Che had invited her when they met at the end of 1962 in New York. I immediately realized that the blinds were closed. Since this posed a technical problem, I asked him, 'May I open the blinds?' And he said, 'No, it's not necessary.' Only later did I realize that he was so focused on what he was doing that he didn't want to see what was going on outside.

The interview began right away, and after a while they simply ignored me. The conversation became heated. Sometimes he would speak with a certain charm, but sometimes he would grab some papers. I have a photo of him jotting down figures. From time to time he would get up and leave, and he would always come back wearing his officer's boots and combat fatigues. I remember that when he bit off the tip of his cigar, I expected him to offer me one, but he was so immersed in the discussion, which was lucky for me because

I was simply ignored for two whole hours. He never once looked at me, which was extraordinary. I was moving all around him, and there isn't a single photograph in which he appears looking at the camera.

Magnum distributed the story all over the world. In 1966, some friends asked me, 'René, can we make a poster?' And they made a huge poster framed exactly like Che's photograph. And from that moment on, it all began. People wanted to have the photo. The real boom was in Paris, in May 1968, when the photo appeared on flags. Later, when I returned to Havana, I saw my photo on T-shirts at the Ministry of Information, and I even bought some for my children. I told the salesperson, 'That photo is mine!' And I bought my T-shirts.

I regret not having seen Che again. To me what really matters is to preserve his image as a visionary, as a man who was willing to go to the very end. I believe the struggle continues."

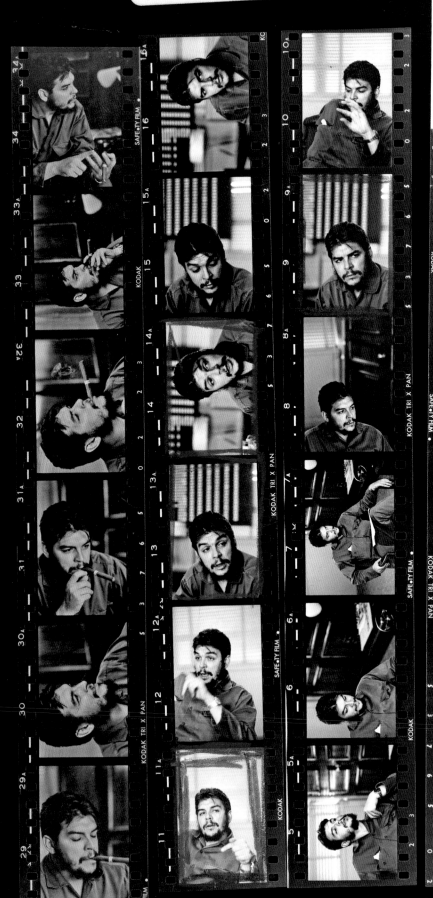

63.1.74

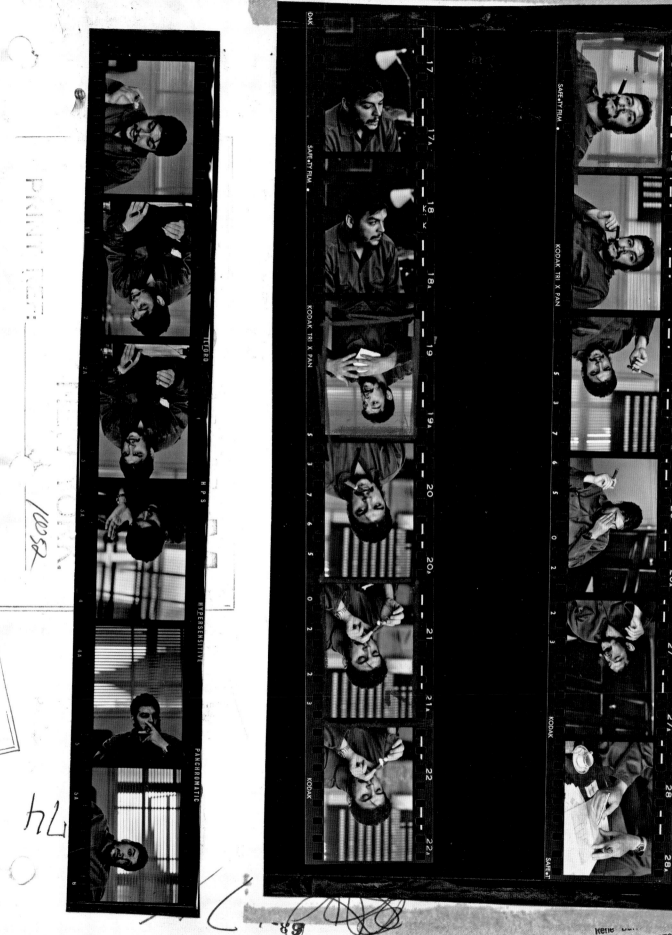

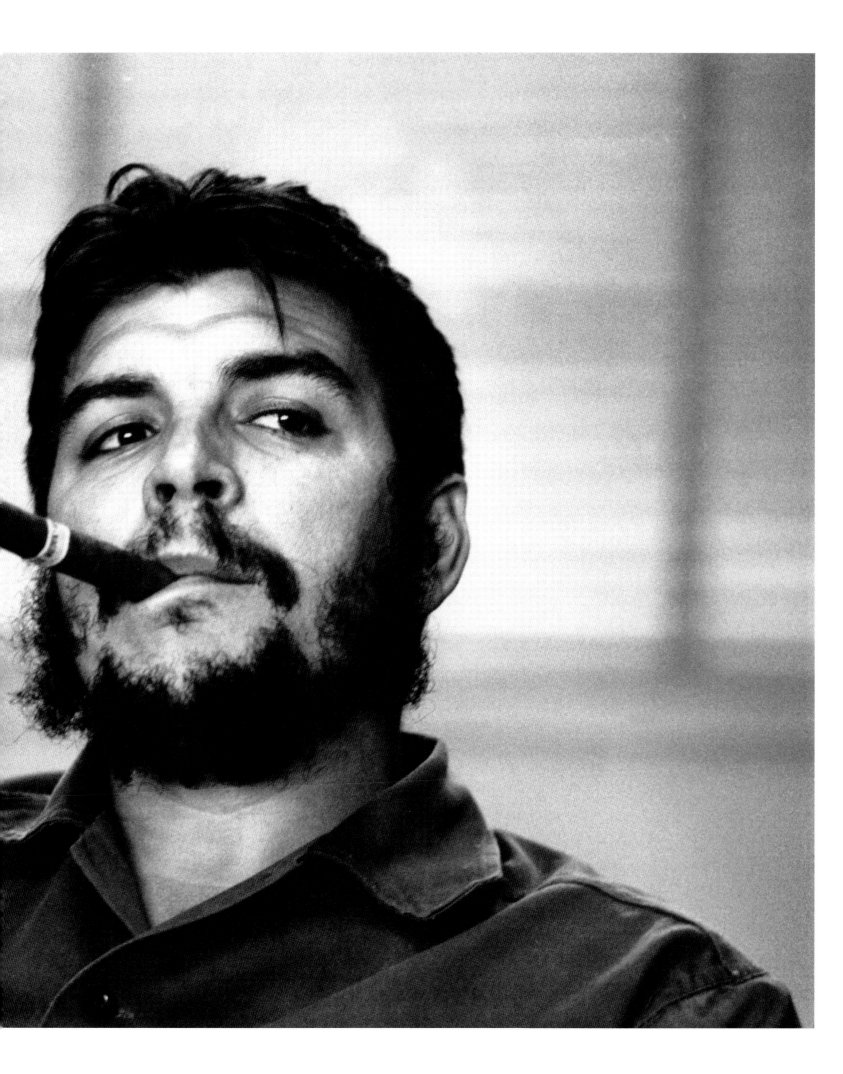

Baltimore, USA
October 1964

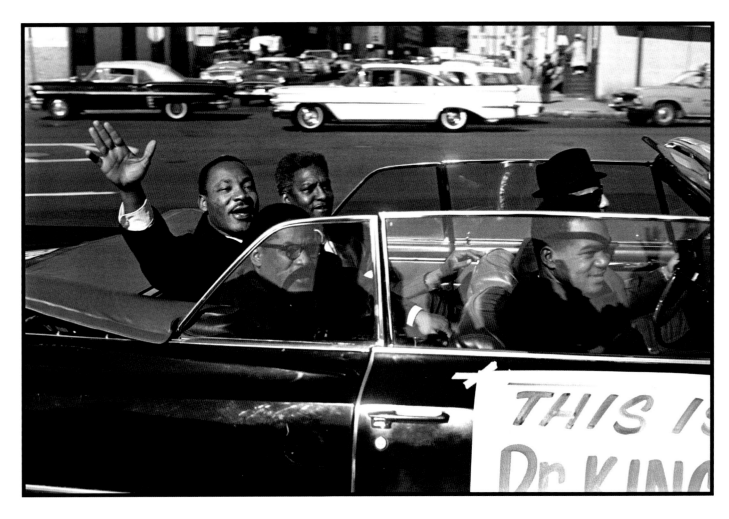

A pioneer of socially conscious photography, Leonard Freed spent most of the 1960s documenting the civil rights movement as it unfolded in small daily encounters in American streets and homes. Collected as a visual diary in his monograph *Black in White America*, Freed's images from this period avoid the iconic; rather, they quietly show the power and grace contained within a community oppressed by racism. As he explains: 'Most of the stories I do are of my own initiative. I choose the issues to explore, the photographs to make, the pictures to publish... I was never interested in photographing celebrities, I was interested in people. Take the Martin Luther King photograph. He is an icon, people want to touch him, he is not a human being anymore, he is totally surrounded by the arms, he is protected. Look at the eyes. I was more interested in the people, in their hands, than I was in Martin Luther King himself.' On this sheet,

Dr King is seen being greeted on his return to the US after receiving the Nobel Peace Prize.

Of photojournalism, Freed states: 'I am trying to get faces in relationship to the city, to the environment. Photojournalism has to be specific. It needs factual photographs. Basically I think that there are informational photographs and emotional photographs. I don't make informational photographs. I am not a journalist. I am an author. I am not interested in facts. I want to show atmosphere.' He notes, with regard to editing the contact sheet, 'It can be difficult to make a decision because you can like this frame for this reason, and that frame for that reason. Each photograph has its particular strength. But you only pick one. One has to represent all. So I am always trying to put everything into one image: the statement, the foundation, the composition, the story, the individual personality – all of that together into one image...'

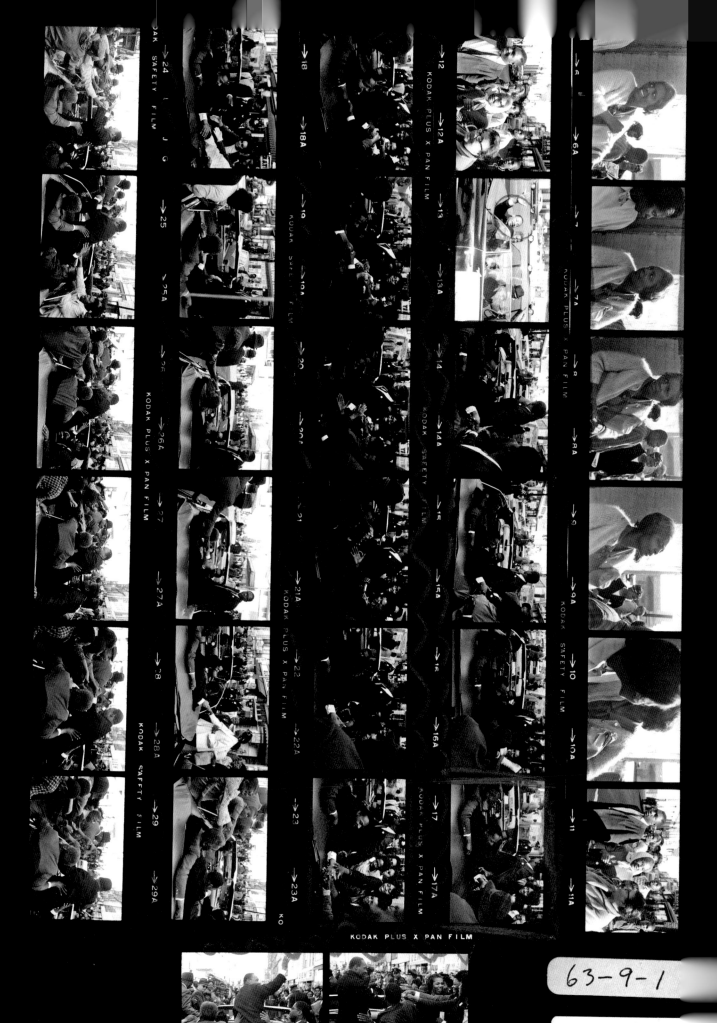

63-9-1

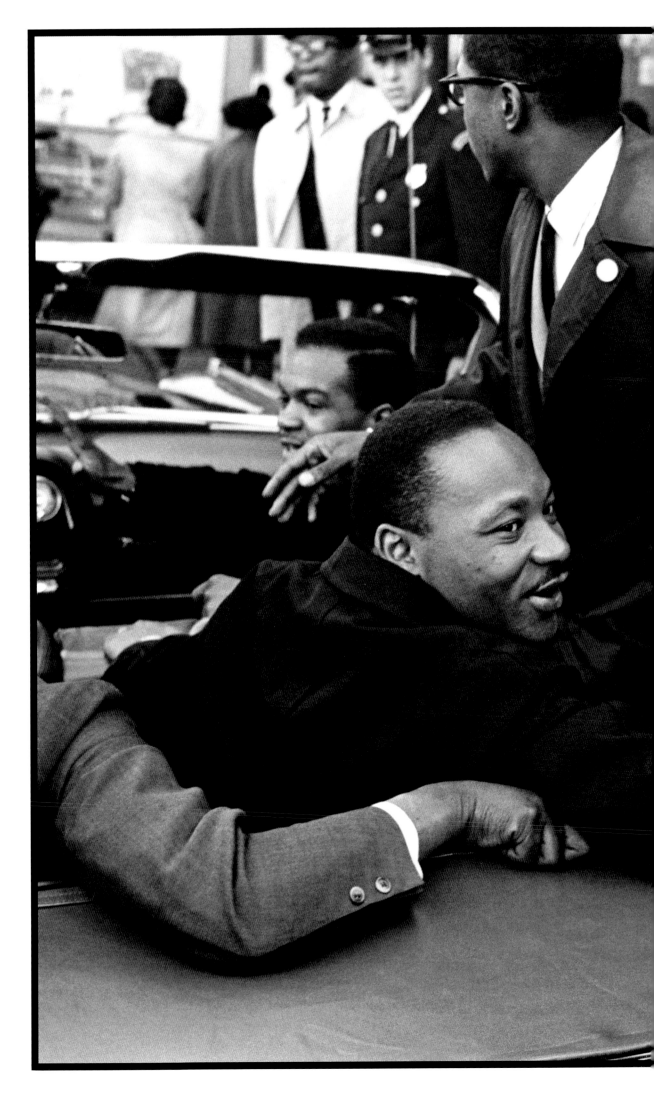

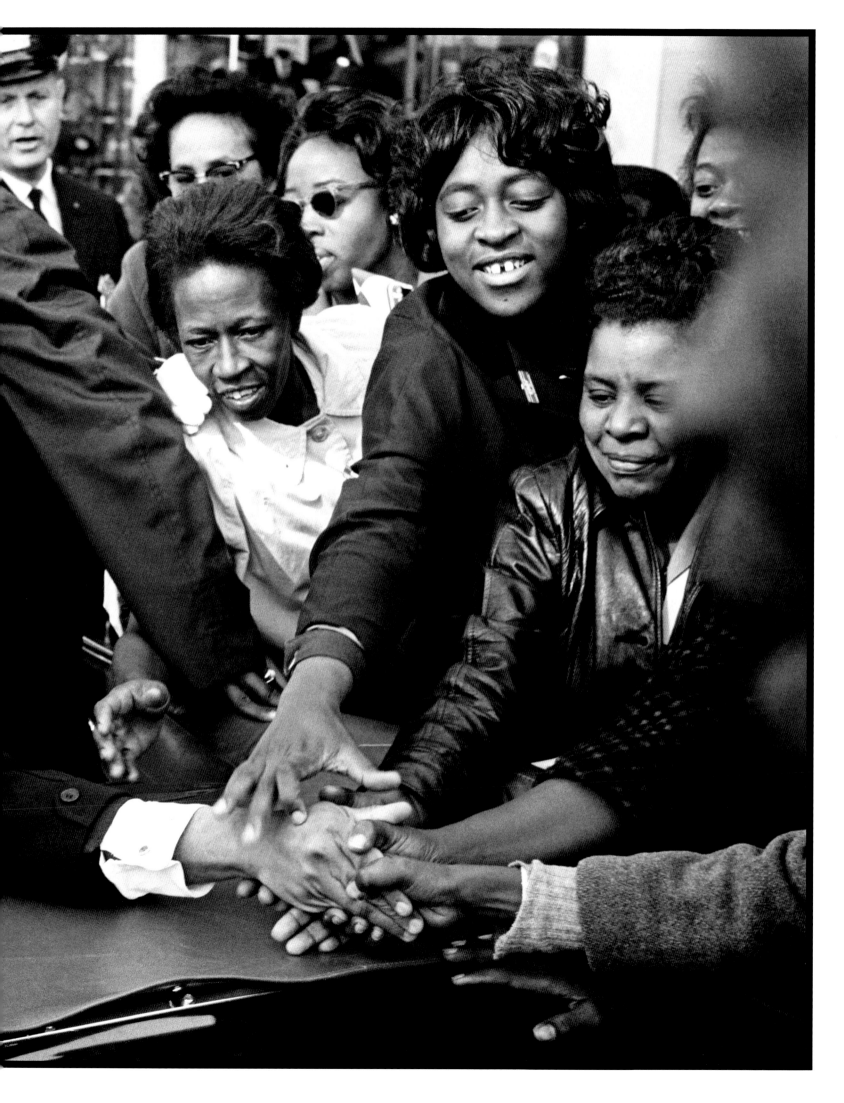

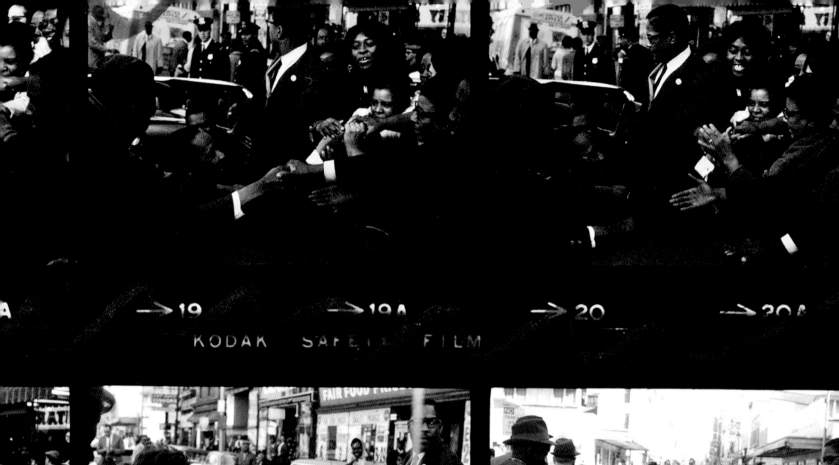

→19 →19A →20 →30A

KODAK SAFETY FILM

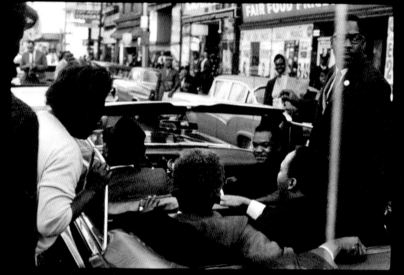

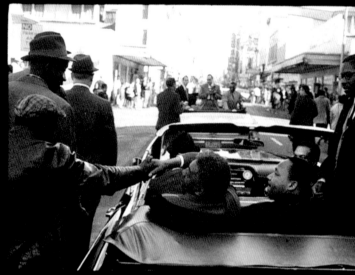

G →25 →25A →26 →26A

KODAK PLUS

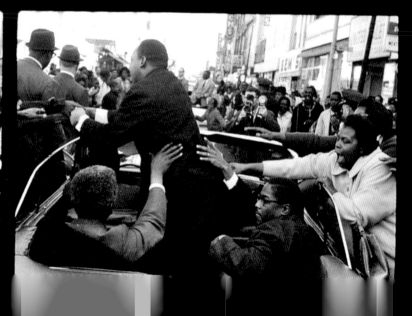

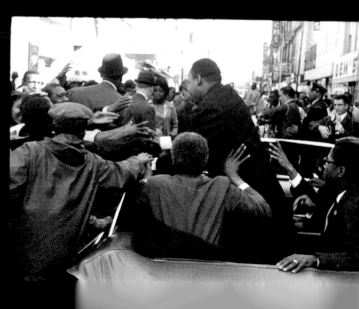

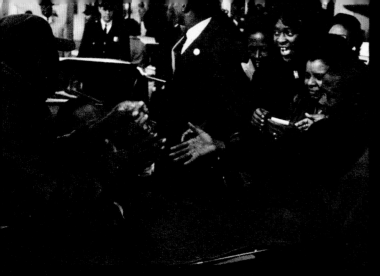
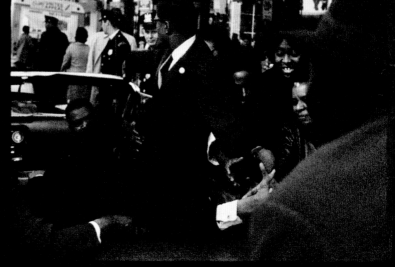

→21 →21A →22 →22A

KODAK PLUS X PAN FILM

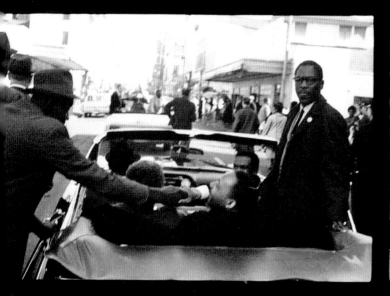
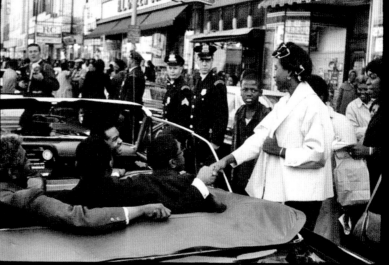

→27 →27A →28 →28A

N FILM

KODAK SAFETY

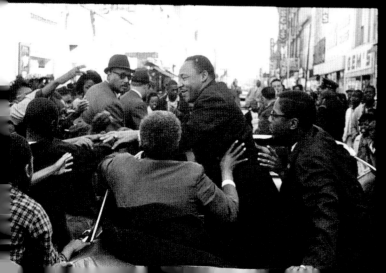
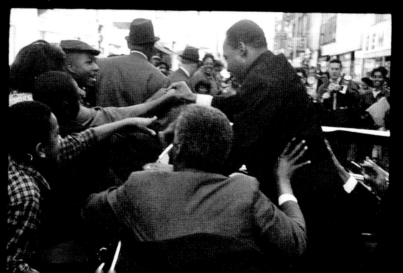

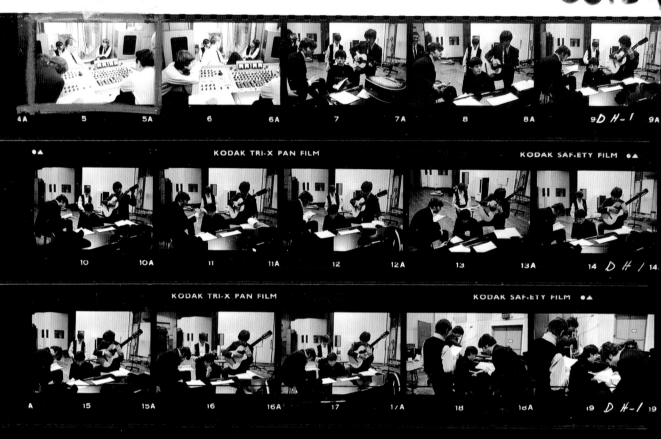

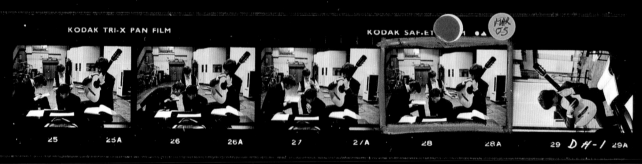

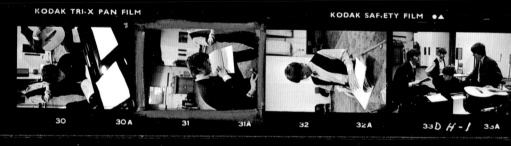

London, England
March 1964

"Most of the photo stories series produced by Magnum photographers come directly from their own ideas and initiatives. Networking in one's own particular area is vital, and the address book is very important. In this case, the chain consisted of a best friend, writer John Antrobus, who worked with Spike Milligan and Peter Sellers, who were directed by Richard Lester, who asked me to work on *A Hard Day's Night*, a film he was directing, which is where I met the Beatles.

The joy of being a photographer is that you actually have to be there to take the pictures. If you shoot portraits of people, you not only meet them but you often get to know them well. Through working on the film, I became very acquainted with 'the famous four'. At the time of roll 154, we were all working in the Abbey Road Studios in London. When you are in such a privileged position, it is imperative you get the best pictures possible. If all four musicians are to be in the picture, it is important that in at least one picture you can recognize each individual.

This can be more difficult than it seems, particularly when the subjects are being observed rather than directed. If you are working towards a magazine feature, you have to cover your subject at various distances: close, medium and more general views. Usually the clearest pictures only become obvious from the contact sheet after the event.

The contact sheet is a valuable instructor. Presumably, when a photographer releases the shutter, it is because he believes the image worthwhile. It rarely is. If the photographer is self-critical, he can attempt to analyze the reasons for the gap between expectation and actuality. How does one think? Could the image be improved by moving backwards or forwards, by moving to the right or left? What would have been the result if the shutter were released a moment earlier or later? Ruthless examination of the contact sheet, whether one's own or another's, is one of the best teaching methods."

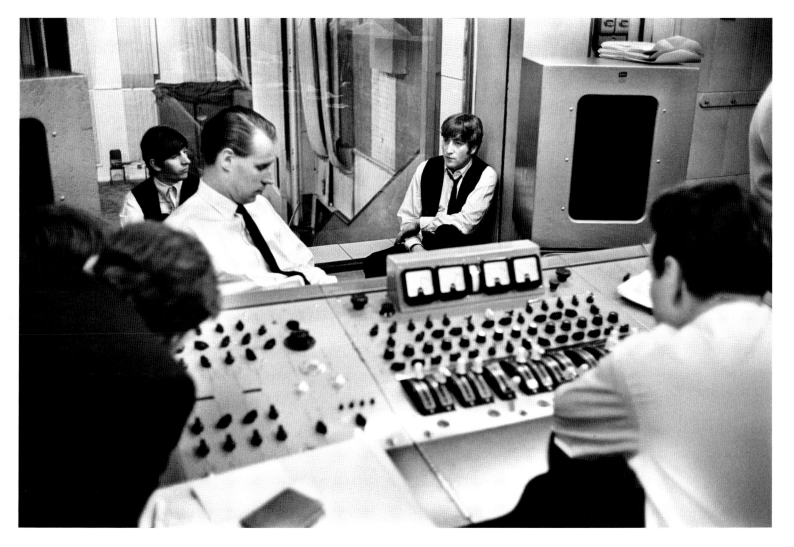

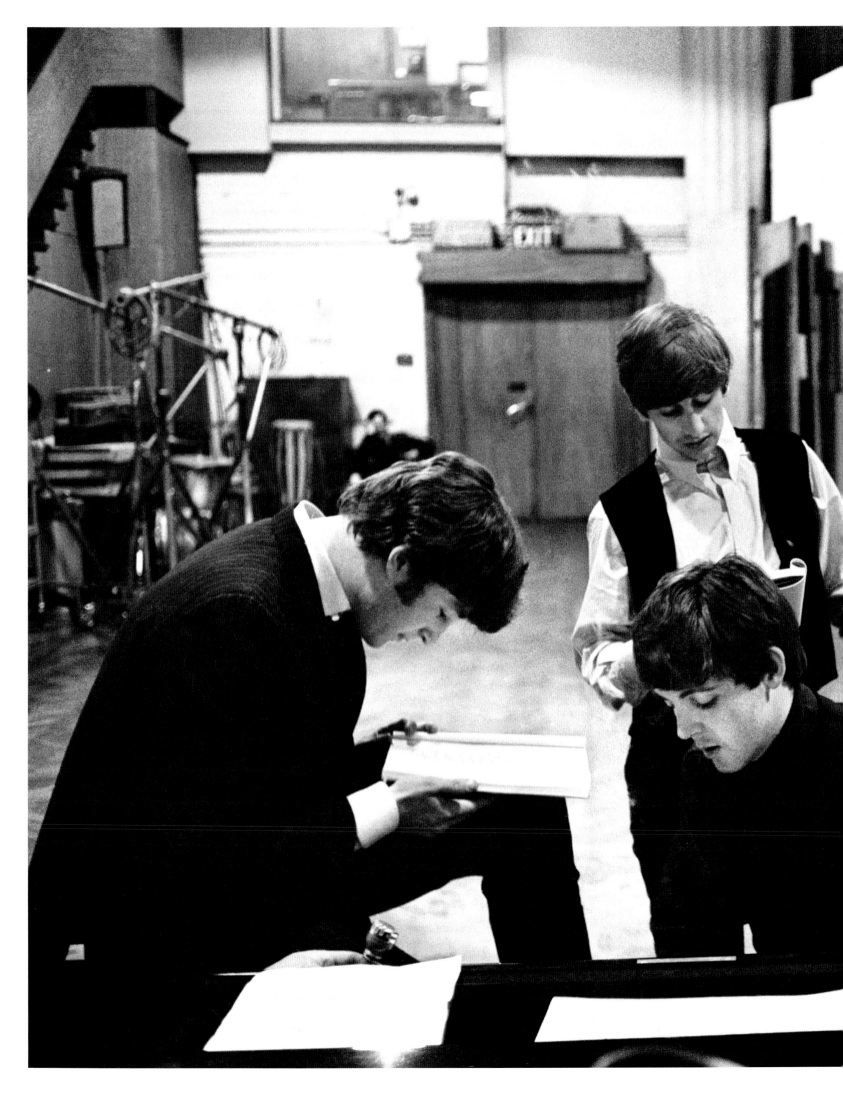

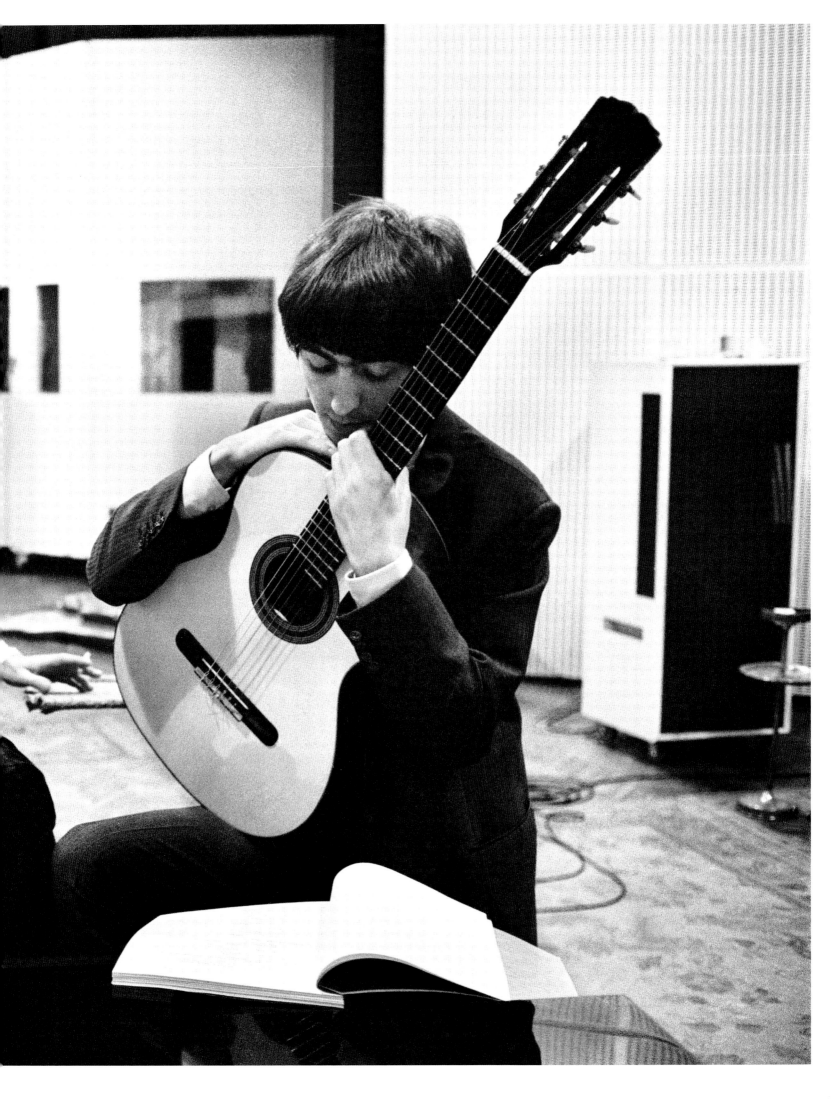

London, England
Summer 1965

"In contrast to the Beatles (see pp. 158–61), Jean Straker was already a friend when I started photographing him. During the Second World War, Straker, a conscientious objector, worked as a photographer of surgical procedures. Abandoning commercial photography in 1951, he set up the Visual Arts Club at Studio House, 12 Soho Square, for 'artists and photographers, amateur and professional, studying the female nude'. For me it was a convenient place, in the middle of London, to meet friends for afternoon tea and cakes.

Straker gave lecture-demonstrations, and members could shoot pictures and had access to exhibition space. The club was populated by a strange mixture of mainly men, with seemingly broad interests. What continually intrigued me was the voluptuous size of the women, who by and large were the models. Straker seemed to have a preference for very grandiose women, whom he would coax into extraordinary contortions for his pictures.

Straker's stated ideals and photography were concerned with visual freedom, but he was later arrested for producing pornography and stood trial for obscenity in 1962. He was a very intelligent man and he fought his own case in the courts of law. He argued that his photographs were of 'artistic value'. His case ultimately went to the House of Lords, where he was vindicated, and changes were made to the censorship acts in 1965. That this eccentric man, taking these bizarre pictures, could force a change in British law was, to me, wonderful. I later invited him to give a talk in my Bayswater flat, where he very eloquently put forward his views to a mass

of young photographers. Over the years I shot many portraits of him. This particular contact sheet shows him during one of his typical flamboyant photography sessions at the club.

The beauty about shooting on film is that looking at the contact sheet allows you to 'authenticate' a picture. You can see what's been shot immediately before, and you can see what's shot after, and your picture is clearly shown as part of a sequence. There can be no prefabrication, no faking. It's difficult to show the same with digital photography because there's basically no way of saying, 'These are the before and after pictures'. In an age of very easy manipulation, the possibility of authentication becomes very, very important. The history of photography tells us that many of the great pictures were re-edited many years later from re-examining contact sheets, sometimes finding something that was actually more historically significant than the original spur-of-the-moment selection.

Looking at other people's contact sheets allows one to understand their methods of working and their thinking processes. When I first came into Magnum, I learned an enormous amount by perusing shelves of books of contacts from Henri Cartier-Bresson, Marc Riboud, René Burri, Elliott Erwitt, etc. A feast to be absorbed, night after night, in the Paris office on rue du Faubourg Saint-Honoré. What was a revelation to me was that I could see a similar working pattern in virtually all the photographers I admired. Little sequences which show the photographer seemingly stalking the image."

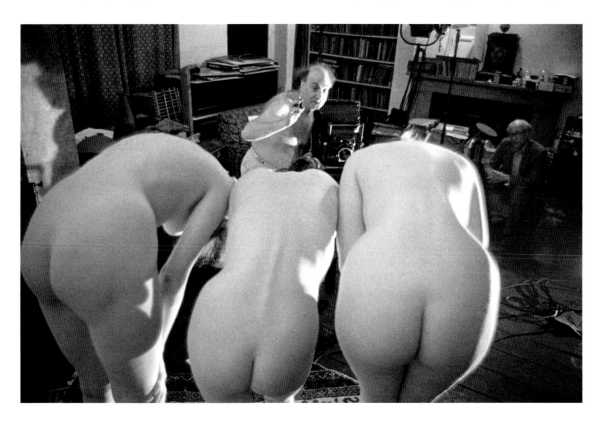

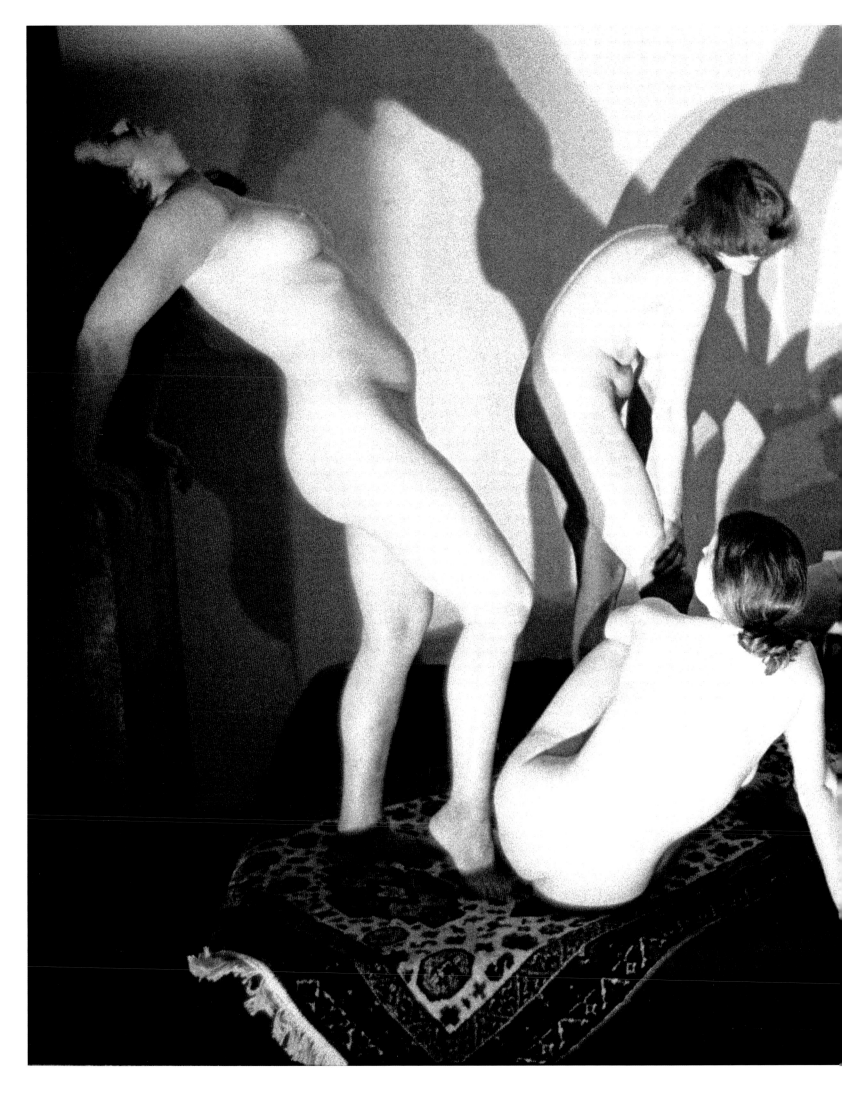

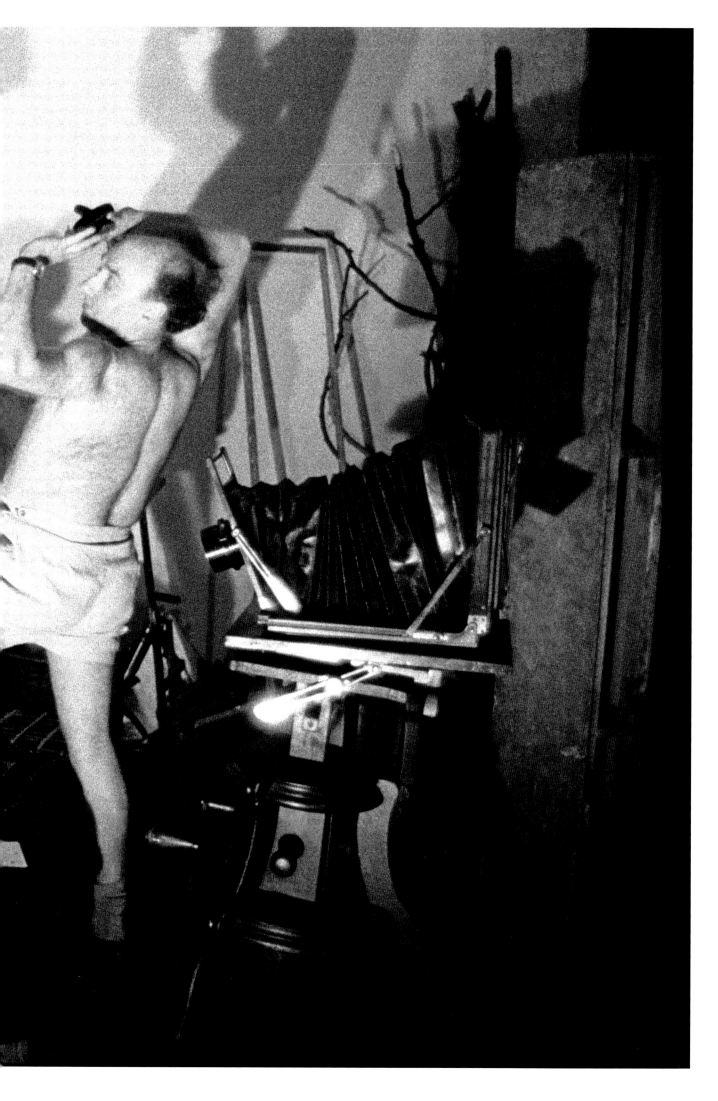

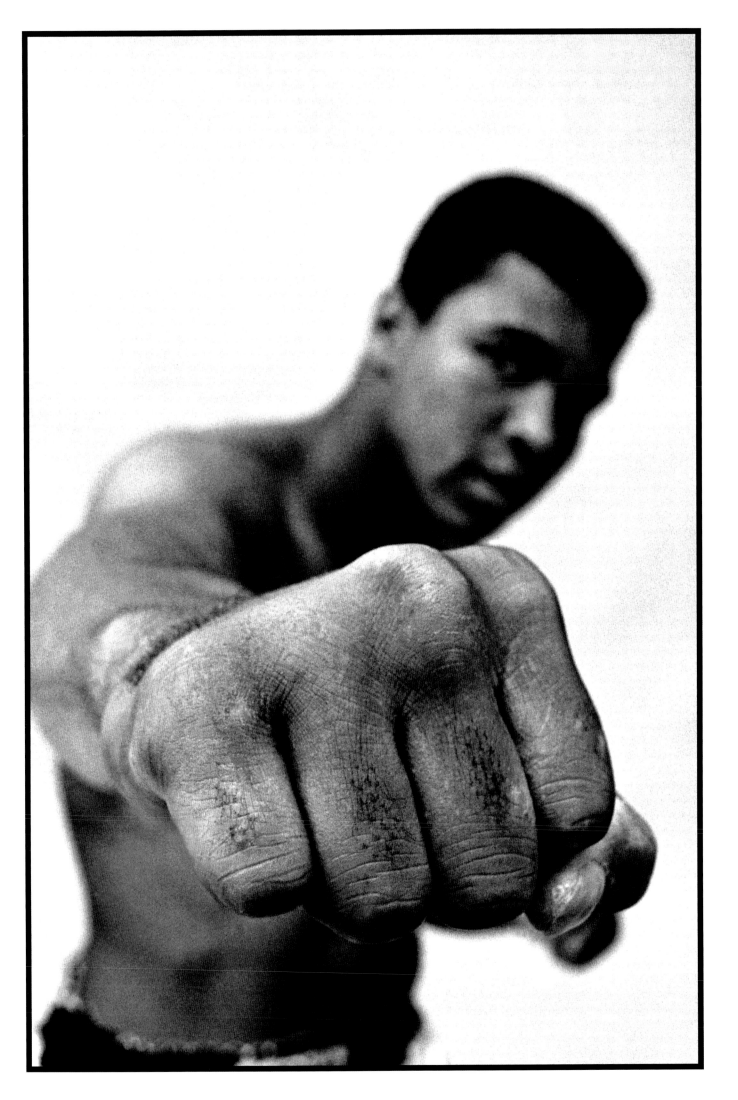

Illinois, USA
August 1966

"In 1966, *Stern* magazine asked me to photograph the heavyweight boxing world champion, Muhammad Ali, who had recently become a Muslim and changed his name from Cassius Clay. I met the 'champ' in London and followed him around town for a few days, before and after a title fight against Brian London, the British champion. I didn't know a thing about boxing, but I was fascinated by Ali's multifaceted personality – charming, witty, sometimes moody, quite street-smart and inscrutable.

At the time we had a simple rule: if you meet an interesting person, just stay with him/her ... until he/she throws you out. I persuaded the editor of *Stern* to let me follow Ali to his home in Chicago. I shadowed him, followed him around town, to the gym, to a lunch with friends, and to a doughnut shop on Chicago's South Side, where he flirted heavily with the baker's pretty daughter (she later became his second wife). Sometimes I went to his house in the mornings, and if Ali didn't show up or

was in a bad mood I tried to find him in his favourite diner at lunchtime.

One sunny day we drove around town in Ali's limo. Crossing a bridge over the Chicago River with a good view of the skyline, I asked him to stop for a moment. Ali spontaneously climbed up on the railing, took off his shirt, and shouted, 'Look at me, I'm the greatest!' Then he jumped towards me and my Leica. I got just one shot of the scene.

Another evening at the gym, the champ sees me standing in the shadows. He comes over, sticks his fist into my wide-angle lens – left, 'boom', right, 'boom', left! The light is dim, really bad. I try to focus on the fist, squeeze off three shots, then Ali dances back to his speed bag. Another missed opportunity, I think. Years later, one grainy shot from that sequence becomes the signature image of the whole story on Muhammad Ali, is used on magazine and book covers, hangs huge above museum doors, sells in galleries and photo auctions..."

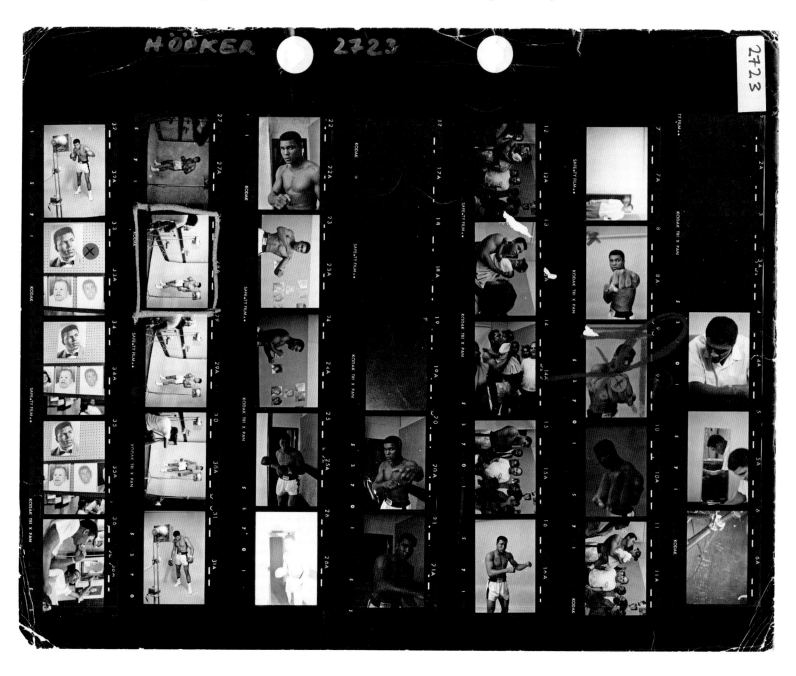

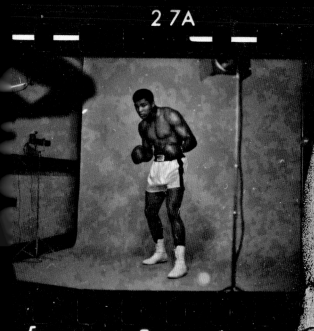
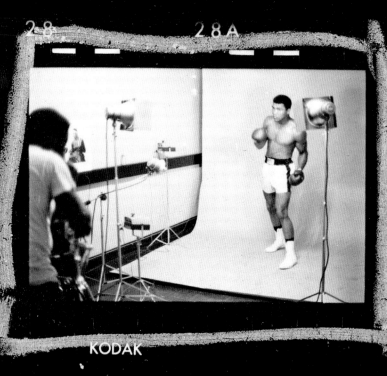

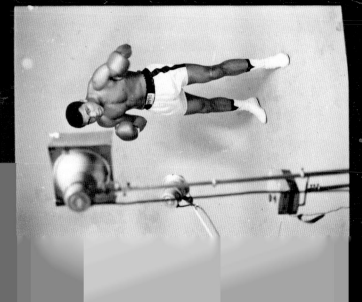

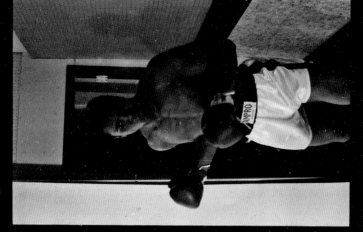

KODAK TRI X PAN 5 3 7 0 1

A 30 30A 31 31A

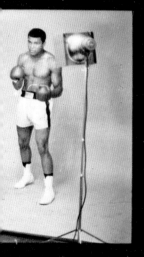
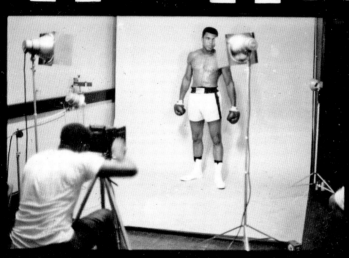
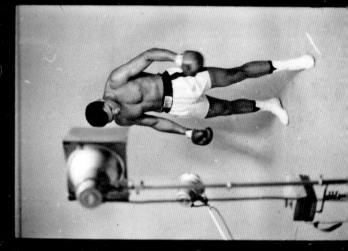

KODAK TRI X PAN 5 3 7 0

4A 35 35A 36 30A

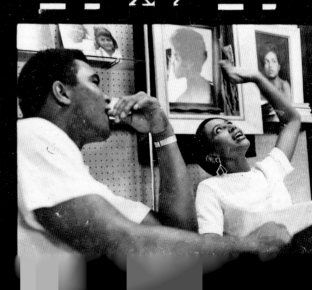

PHILIP JONES GRIFFITHS Civilian Victim, Vietnam

Vietnam
1967

'I discovered very early on that, if you want to change the world, you've got this amazing little box around your neck,' said Philip Jones Griffiths. *Vietnam Inc.*, the book he published in 1971, is cited as being one of the few bodies of work that have had a direct influence on the politics of the time.

Jones Griffiths took photographs in Vietnam and Cambodia, initially during the war but then also for decades afterwards. The writer John Pilger remembers how at the end of their first assignment together in Saigon, Jones Griffiths handed him 'not a bundle of rolls of film, but a huge brown envelope containing six photographs… I was aghast – until I looked. Each print was exquisite in its symbolism and true to everything we had seen in Vietnam.' For one of the shots, 'Philip had waited for days on the balcony of the Hotel Royale …

his war-weary Leica expending less than a single roll of film.'

The caption for 'Civilian Victim, Vietnam' – the shot with which Jones Griffiths closed his retrospective book, *Recollections*, reads: 'This woman was tagged, probably by a sympathetic corpsman, with the designation VNC (Vietnamese civilian). This was unusual. Wounded civilians were normally tagged VCS (Vietcong suspect) and all dead peasants were posthumously elevated to the rank of VCC (Vietcong confirmed).'

'The great thing about photography,' Jones Griffiths noted, 'is you have to be there. I've got the negatives – I've got the originals – that prove I was there. I didn't make up the pictures. I didn't fake them in any way. Are they opinionated? Well, of course. When you look through a viewfinder, what you decide to look at is a subjective action.'

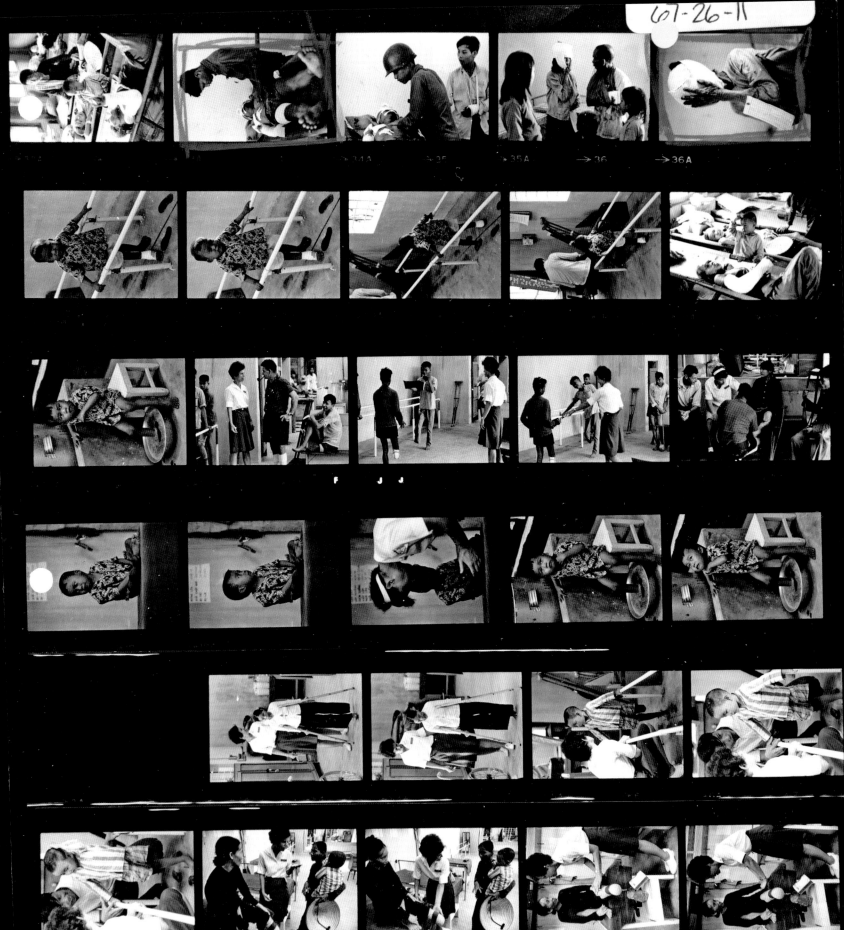

France
May 1968

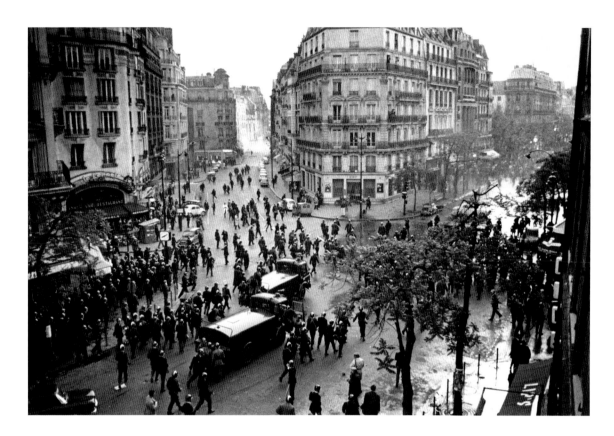

"During May 1968, I was on constant alert. I never had time to edit my photos properly. When the demonstrators went to sleep, I had to go back to the agency for my film to be developed so that I could edit. It was an atrocious rhythm to live by. There was no digital technology. You simply had to wait for the film to be developed. The contact sheets weren't usually that great. They were often very dense, and too dark, so I couldn't see all the images properly. I just quickly chose whatever seemed most interesting at first glance. It was only on the occasion of the fortieth anniversary of May '68 that we took time to re-edit because we were preparing two books and various exhibitions. We found a lot of photos I'd never really laid eyes on before. My wife, Caroline, made a film called *May 68* with the new picture edit.

In those days there were practically no movie cameras. I remember only William Klein filming, and some foreign television crews; French television was on strike. So the fixed image ruled the day. Photography really had a role to play, and a central importance. This is not the case today, as television footage and digital images are seen immediately.

A small group of filmmakers had organized themselves into a collective. There was Louis Malle, Alain Resnais, Jean-Luc Godard, Chris Marker and others. I joined them with my photographs. Chris Marker took the idea practised by the Soviet filmmaker Alexandre Medvedkine: during the 1920s he filmed an event in a town, travelled by train, developing his images and editing at night, then showed his work in the next town over the following days. I gave my photos to the collective and they were turned into short films. I also made one. I guess, in total, there were more than thirty of these made. The photos were used anonymously; the filmmakers didn't credit themselves; the films were *cinetracs*, or newsreels. They were sent to the provinces to show what was going on in Paris."

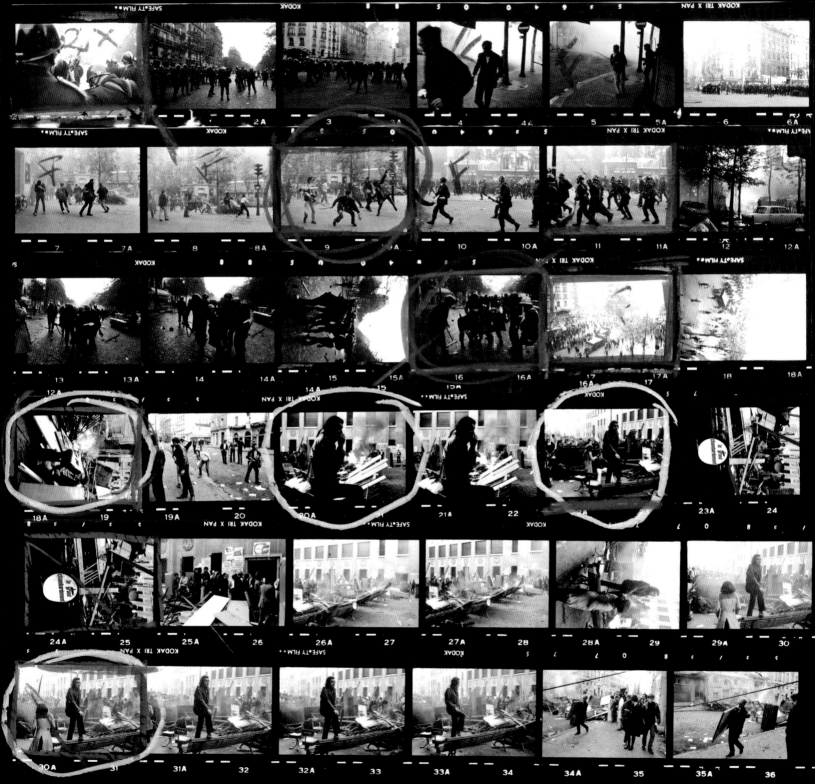

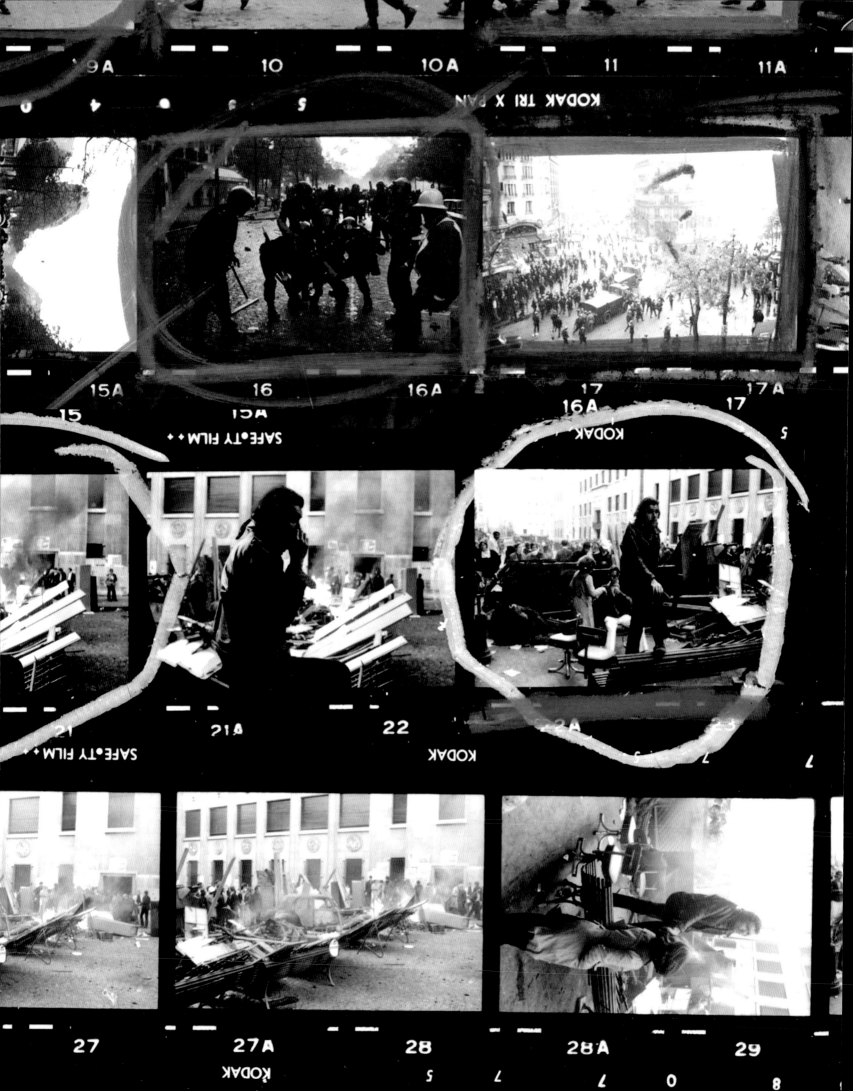

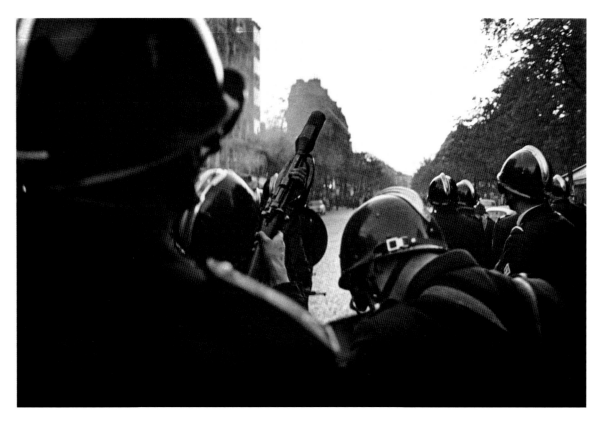

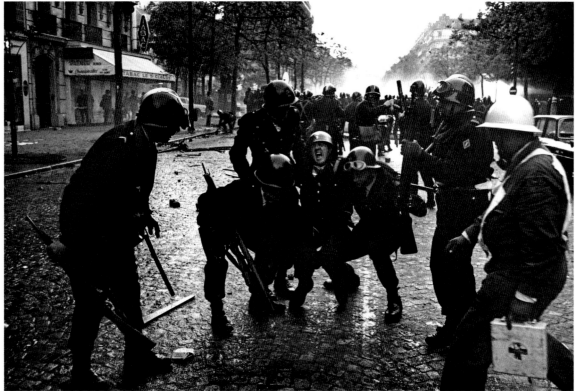

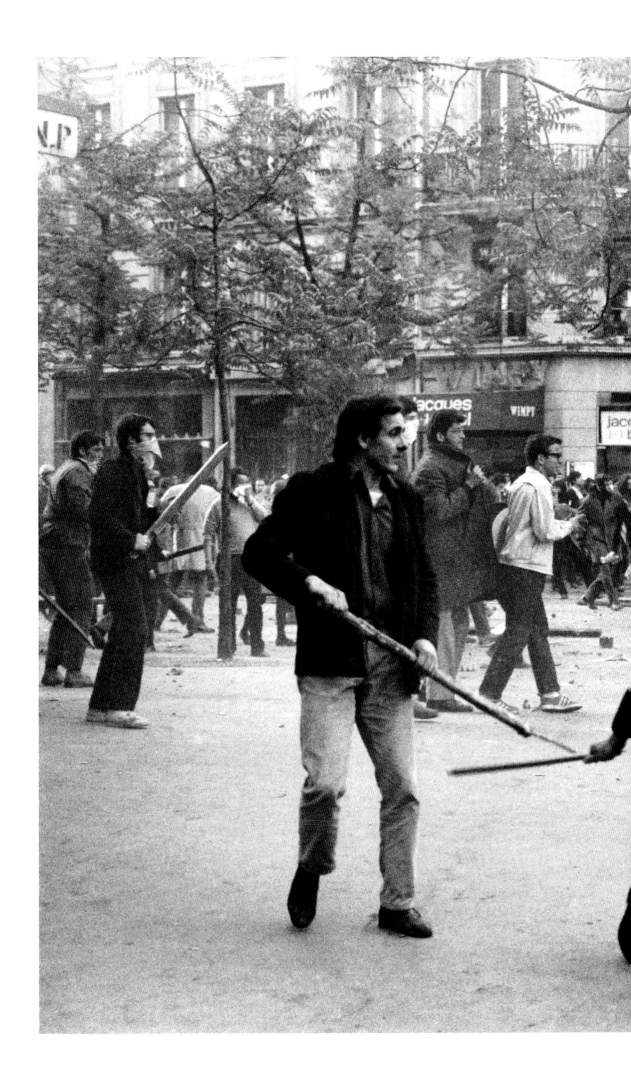

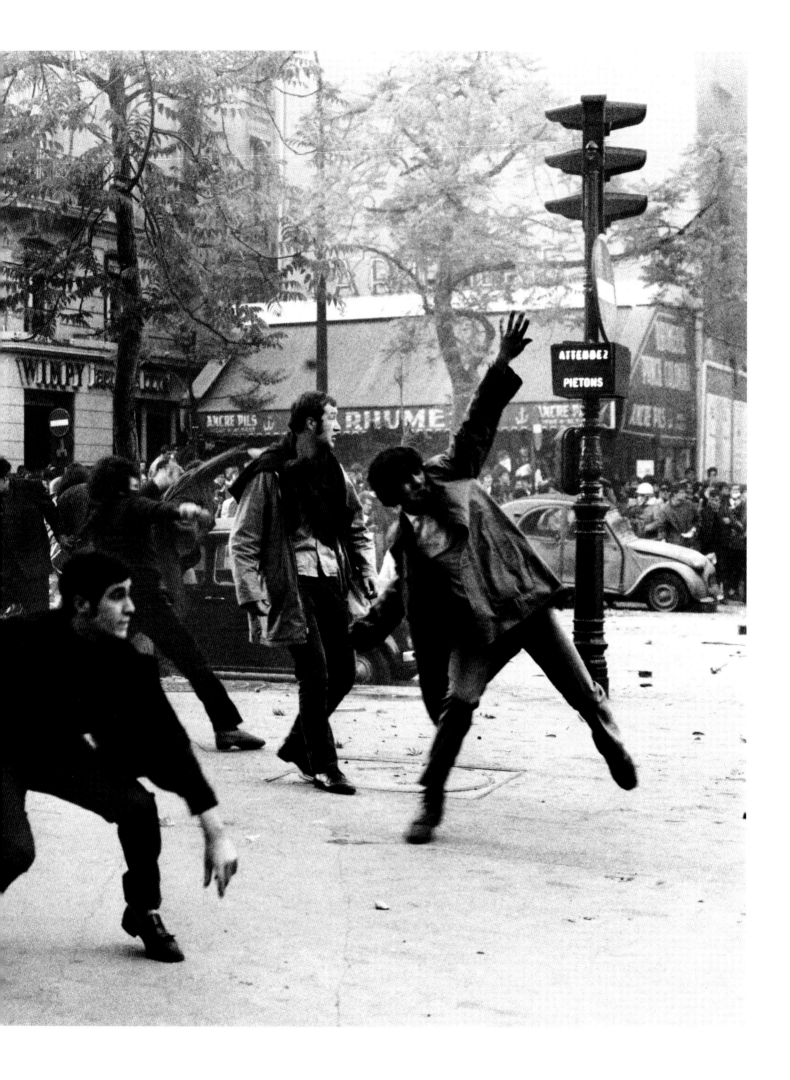

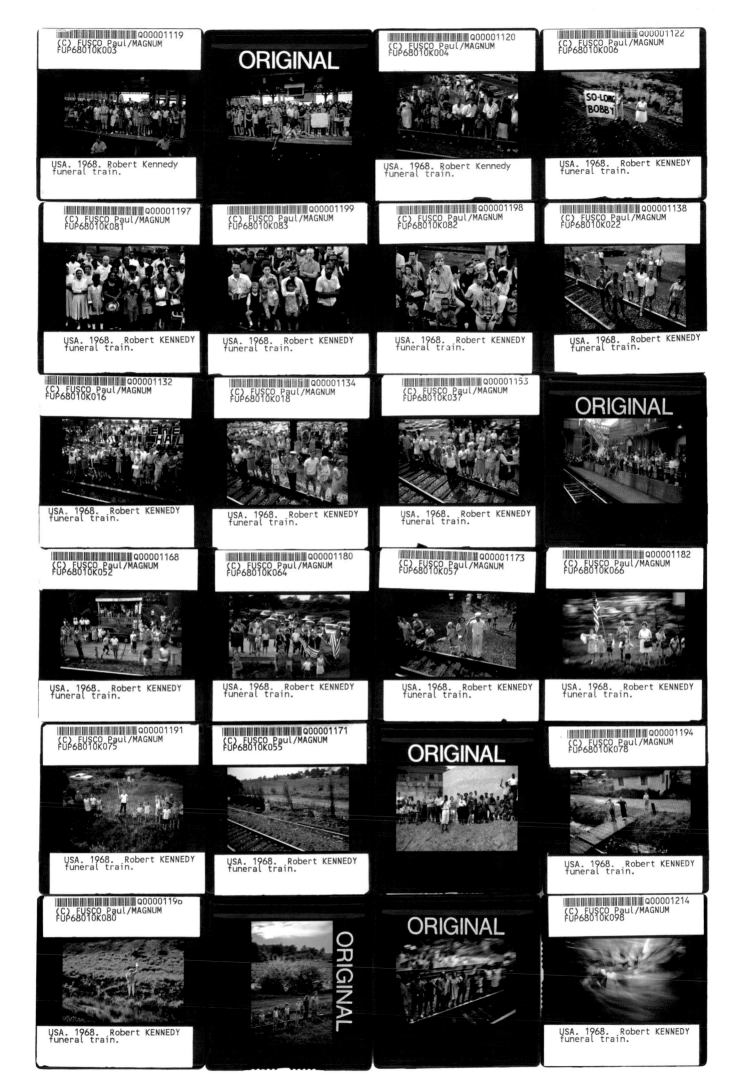

USA
June 1968

"In 1968 I was a staff photographer with *Look* magazine in New York City, where I was living when Bobby Kennedy was assassinated in Los Angeles. On the morning of the funeral mass, I walked into the editor's office to say hello. He looked up from his desk and said, 'There's a High Mass for Bobby at St Pat's. They're going to put his coffin on a train at Penn Station for Washington. *Get on that train.*' That's all he said. I went to the photographers' room, grabbed my cameras and lots of film, and headed for Penn Station. *Look* was only one block from St Patrick's Cathedral and I had to walk by it to get to the station. When I saw the surging crowd of mourners, I began photographing the story. I eventually worked my way into the cathedral. It was densely crowded and confining and intense. I reluctantly left to make sure I would be on that train.

At the station a security guard checked my press credentials and pointed towards an open door in a car, saying, 'OK, get in that car, sit down and don't move.' I was early. I was alone. My thoughts turned to Washington and the burial and the crowds and the press. Slowly people filled the car: no famous people, no press or TV, one other photographer. The doors closed. The train moved through the dark tunnels under New York. Suddenly, unexpectedly, it broke out into daylight, and I was astonished. There were hundreds of mourners crowding together on platforms, almost leaning into the train to get close to Bobby. I jumped up to a window, slammed the top panel down, claimed it as my space and photographed everything I saw. The train moved

very slowly, and even stopped a few times so that the countless thousands of mourners that stretched from New York to Washington were able to display and proclaim their loss, pain and love for Bobby. Hunched over the window, I photographed mourners constantly from early afternoon until night fell and the train pulled into Union Station in the dark.

I usually worked with three cameras, two Leica M rangefinder cameras and one Nikon single-lens reflex camera. The film was all colour, mostly Kodachrome 64 and a few rolls of Ektachrome 400. I never learned to print colour. As the light of day began to ebb, my anxiety began to shoot up. I was using low-speed colour film, I was on a moving train, I was photographing moving subjects, my shutter speeds were getting lower and lower, and there were still endless numbers of mourners I was trying to photograph.

Once I started to edit back in New York, it didn't take long to get very strong emotional reactions. As I kept editing from well exposed to darker and darker photos, I realized that the themes of the story were from light to dark, hope to loss, love to tragedy and pain. I really got a hit from the final photo the moment I saw it. The mourning believer caught in a maelstrom that is shattering her life: face raised, beseeching; arms spread, accepting her fate or asking to accept Bobby to bring him peace. For me it brings up a lot of questions about life that we really don't have any answers for. The photo hasn't received any special or extraordinary attention that I am aware of."

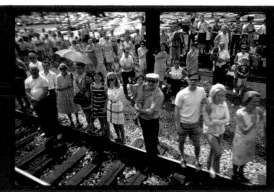
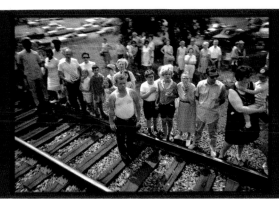

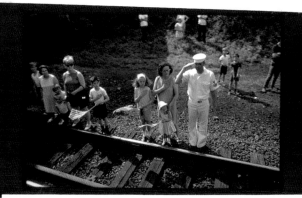

ORIGINAL

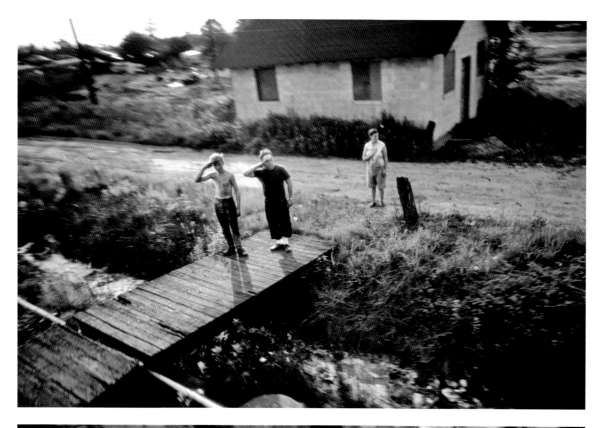

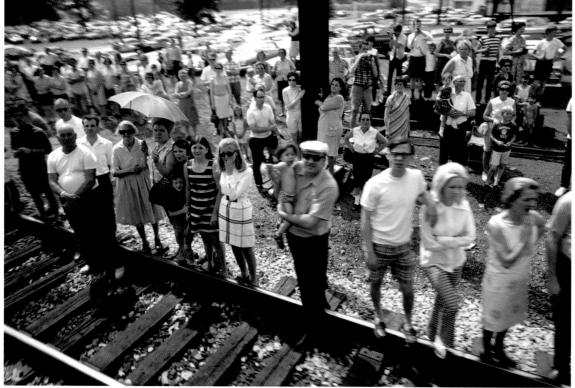

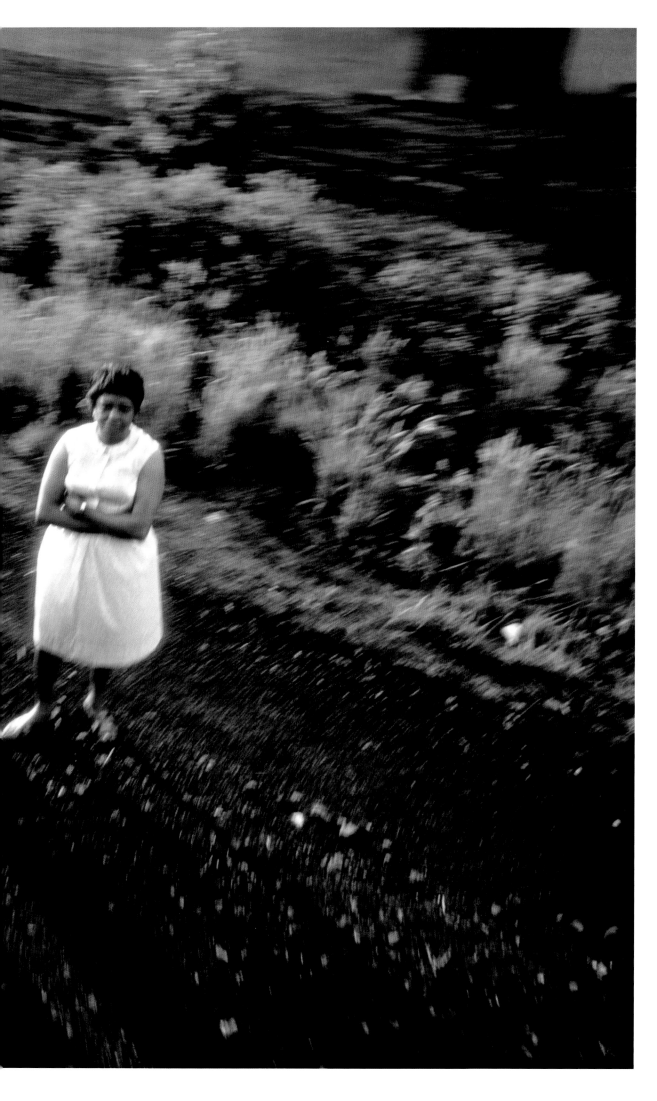

JOSEF KOUDELKA Prague Invasion

Czechoslovakia
August 1968

"During the night of 21 August 1968, my girlfriend called to tell me that Russian troops were entering Prague. It was about three or four o'clock in the morning. I got up, took my two Exakta cameras, one with a 25mm lens and the other 35mm, went outside and started to take pictures. It was like that for a week. I was using motion picture film at the time, because it was cheaper. That's why the contact sheets weren't numbered, other than by hand. I can't say for sure that these strips follow the correct chronological order, because they were put together in New York a year later, in 1969. These contact sheets are the ones I've always used, and I've kept them as they were, without making another set. What is certain is that this specific sheet was taken during the most violent part of the confrontation, which took place on the morning of the first day of the invasion, close to the headquarters of Czechoslovak Radio, on Vinohradská Avenue. One of the priorities of the Russians was to silence the radio. The crowd was protecting the radio headquarters building, but afterwards the tanks arrived and the soldiers were able to get in.

Five photos marked on this contact sheet were used in my book, *Invasion Prague 68*, published in eleven countries forty years after the invasion. It contains 250 photographs, most of them taken in the centre of Prague during the first seven days of the invasion. The pictures numbered 1 and 2 are two of the best photographs I took in that period, and I took them one immediately after the other – a stroke of luck that's only ever happened to me once.

What was happening in Czechoslovakia concerned my life directly: it was my country, my problem. That's what made the difference between me and the other photographers who came there from abroad. I was not a reporter. I didn't know anything about photojournalism. I never photograph 'news'. I photographed gypsies and theatre. Suddenly, for the first time in my life, I was confronted with that kind of situation, and I responded to it. I knew it was important to photograph, so I photographed. I took these pictures for myself, with no intention of publishing them.

By chance, someone in Prague noticed the pictures. Some of them were taken secretly out of Czechoslovakia several months later and ended up in New York on the desk of Elliott Erwitt, who was president of Magnum at the time. He immediately asked for more. Jimmy Fox, who was in charge of picture editing, couldn't believe that all these images had been taken by the same photographer! I didn't publish them under my own name for sixteen years, so as not to endanger my family; there could have been trouble. They were simply credited 'Copyright Magnum PP' for 'Prague Photographer'."

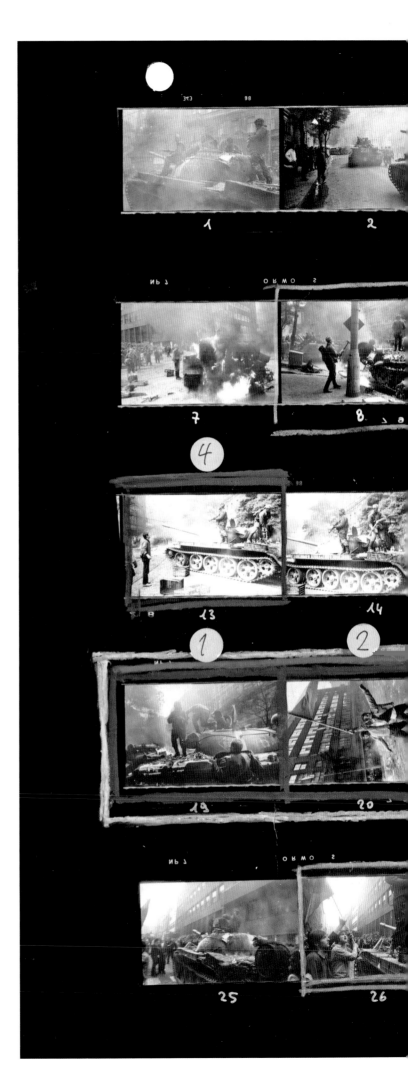

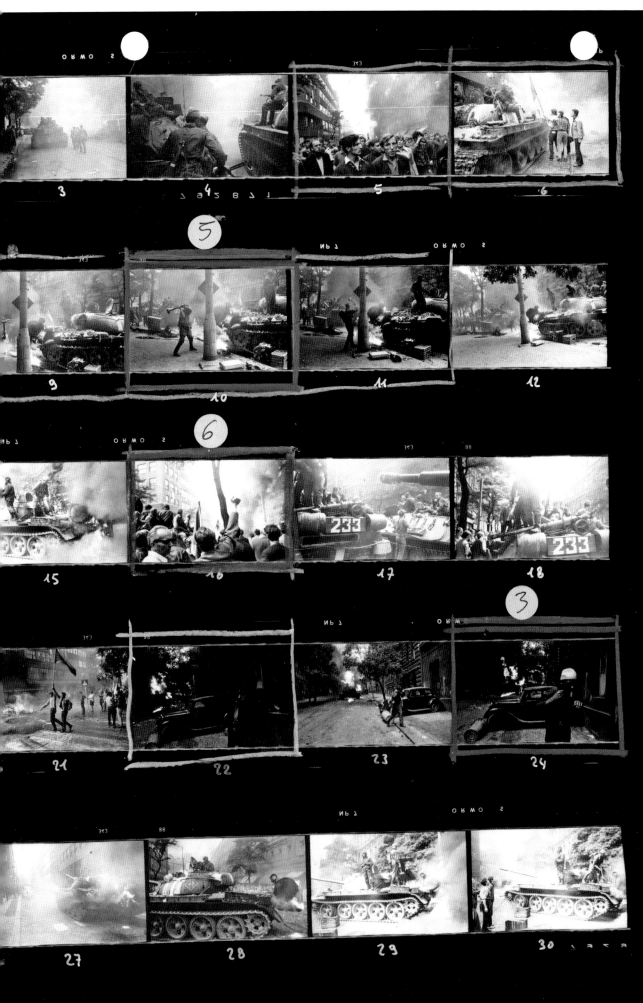

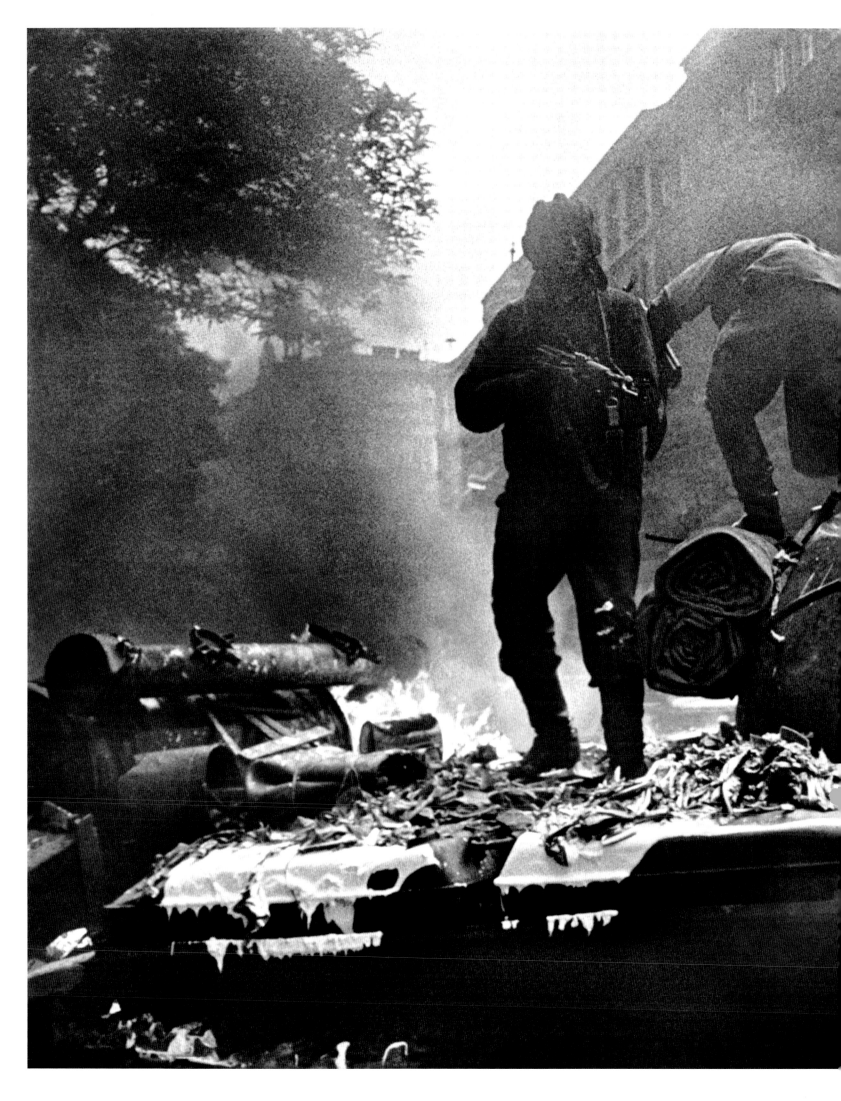

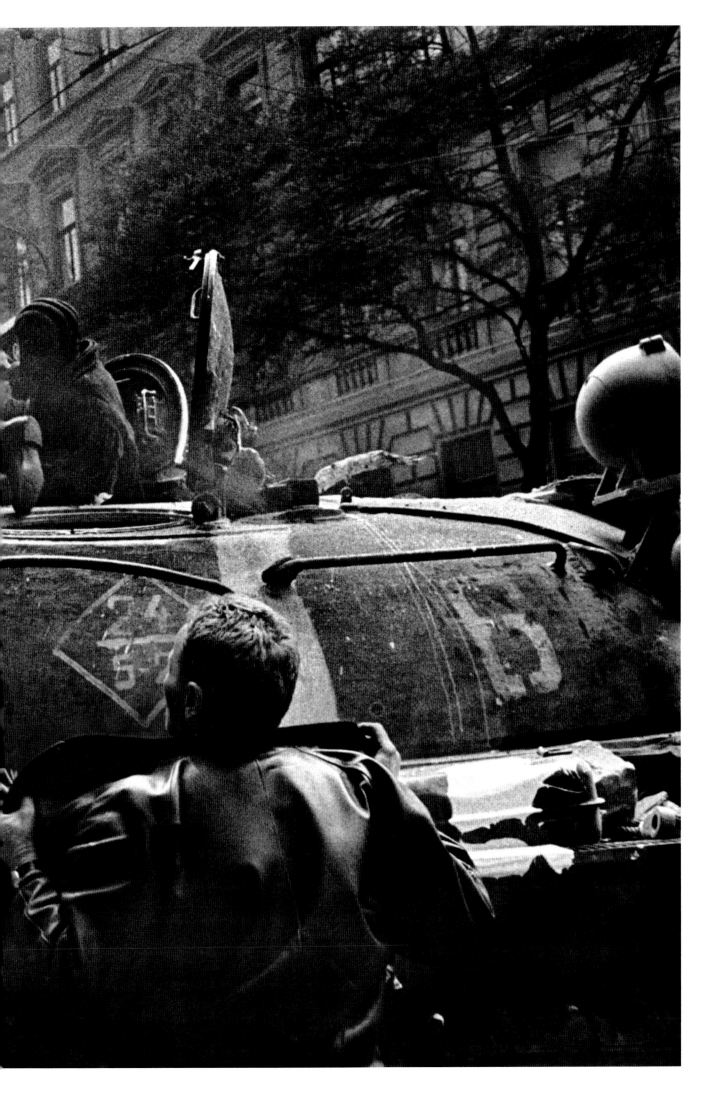

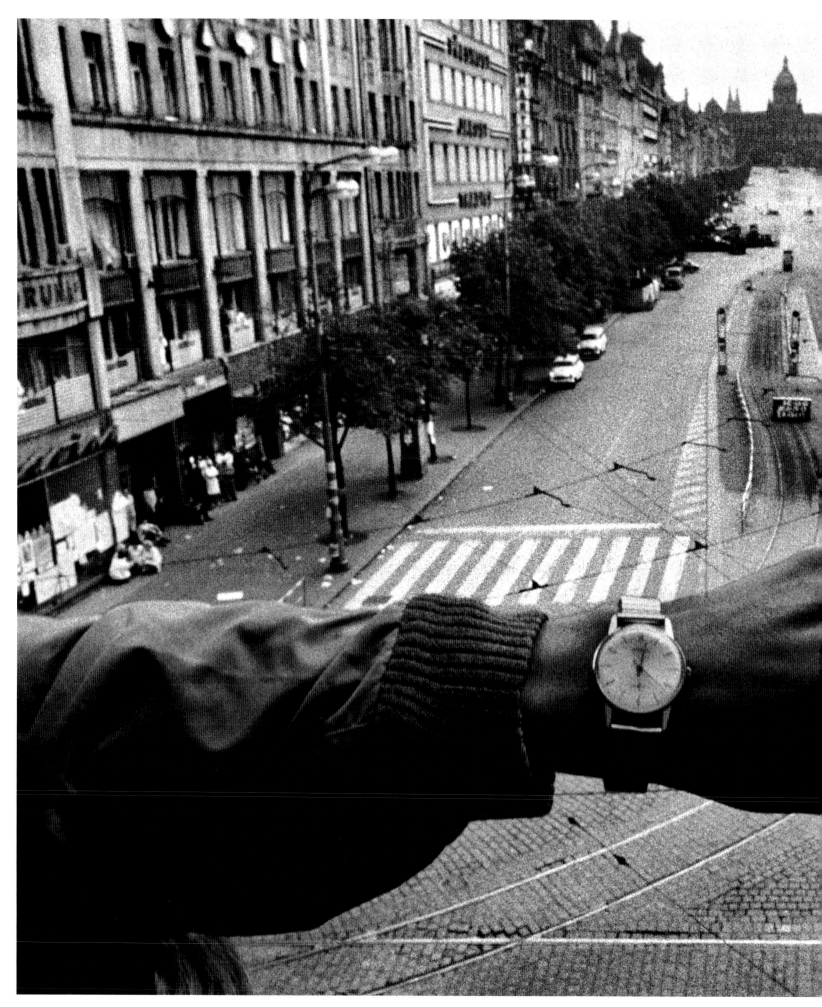

Wenceslas Square cleared of people, Prague, August 1968. The ambiguity and sense of expectation in this, the most reproduced photograph from the series, turned it into an enduring symbol of invasion. By contrast, the featured contact sheet depicts direct confrontation.

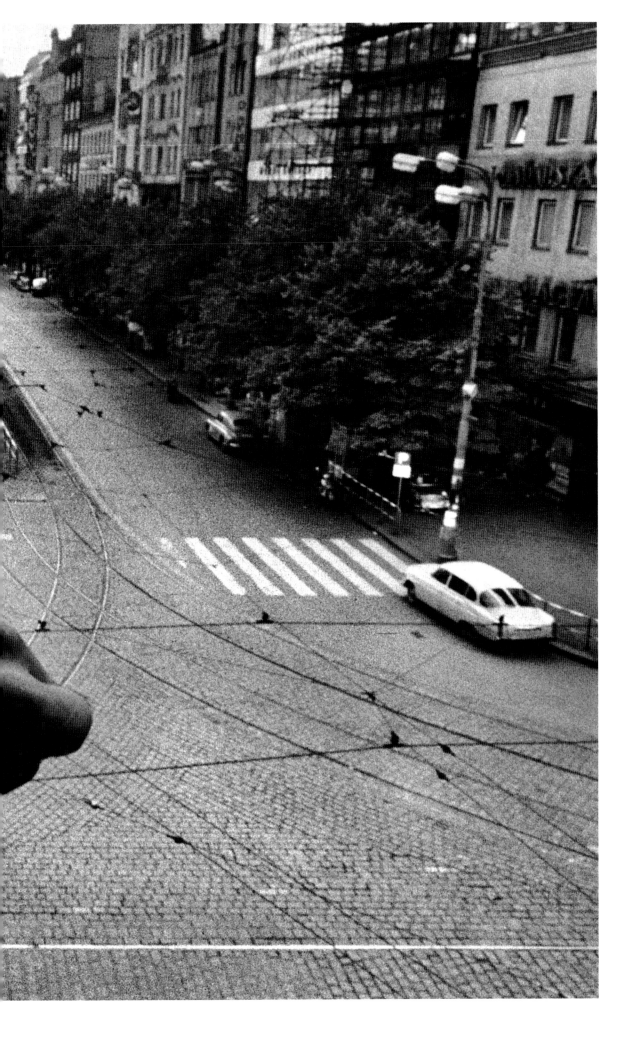

Venice Beach, California, USA
1968

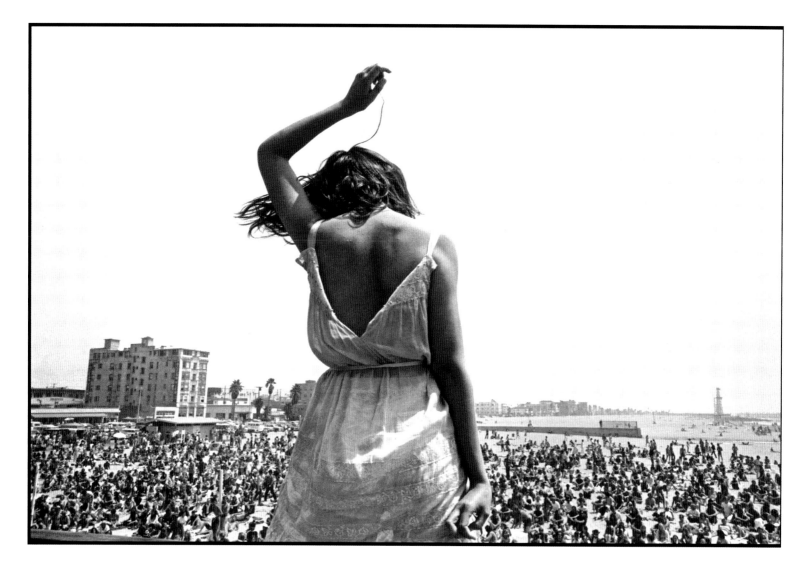

"I explored California in 1968 because there was a
transformation taking place in America. A surreal cultural
wave was spreading its currents from west to east, so I
self-assigned the state of California as my project, before
its eccentricity became too commonplace nationwide.
I was particularly attracted by the hippie movement,
which was defined by two main principles: caring about
others, and a taste for adventure. My pictures of hippies
are about the search for a better life. I was drawn by
what they tried to achieve. The hippie instinct was
countercultural. It said, 'Let's try to go back to basics.'

I turned up at a free rock festival in Venice Beach,
and I climbed onto the stage. A young lady, who seemed
to be high, was gyrating in front of the musicians. In
what were very tight quarters, the woman danced and
I shot. This picture became a symbol of the hippie times
and has appeared in poster form, on book covers and
in many periodicals. In essence, it's a vivid high moment
of the 1960s."

KODAK SAFETY FILM KODAK TRI X PAN FIL

→34A →35 →35A →36 →36A

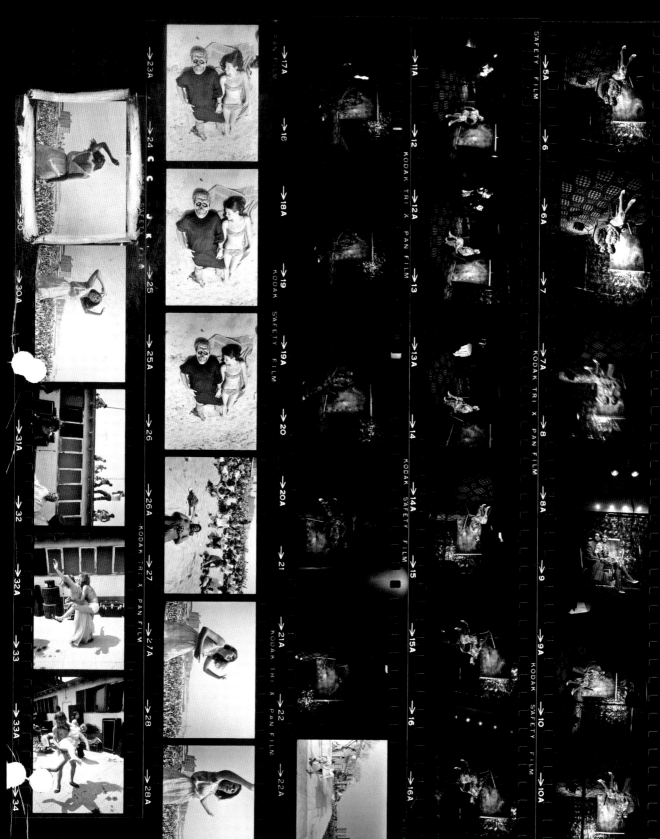
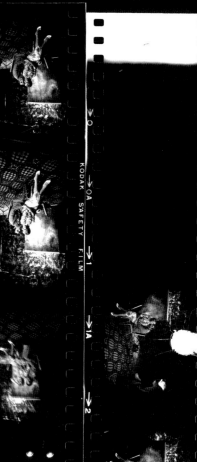

1968 **DENNIS STOCK** Playa del Rey

California, USA
1968

"While driving in the vicinity of the Los Angeles airport,
I noticed a restricted hillside that would possibly give me
a good angle for a beach shot in the distance. As I drove
to the top of the hill, planes were rising from their take-off
positions, their shadows momentarily sweeping across
the beach below. It became a considerable challenge
to catch these very fast-moving shadows on the distant
shore. With my 300mm telephoto lens, I could see a
couple laid out in the area where the planes' shadows
momentarily appeared. Everything that took place was
in split seconds. The contact sheet tells the rest of the
tale. The frame I chose is self-evident: this picture is a
very well composed, unusual moment … good enough
for me to take pride in.
 At the conclusion of my one-month survey of California,
I returned to my home base, which was New York, and
started to develop and print. I liked what I saw because
it supported my vision and surreal sense of humour."

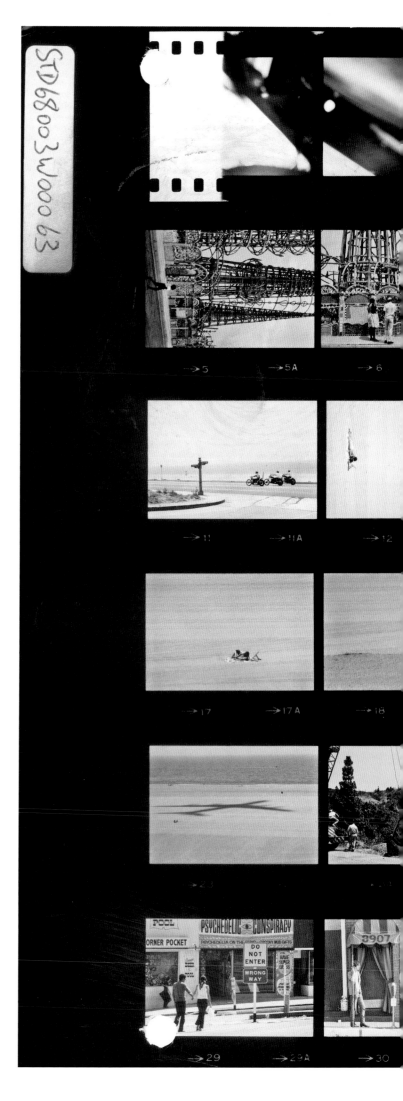

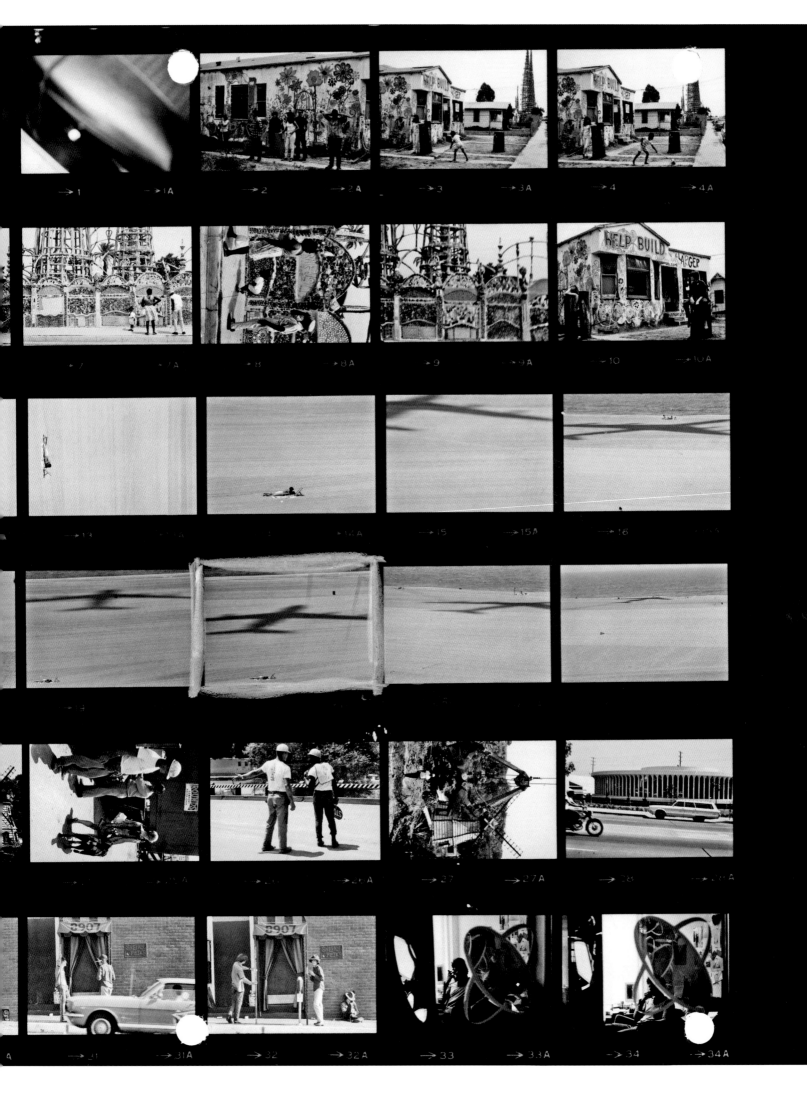

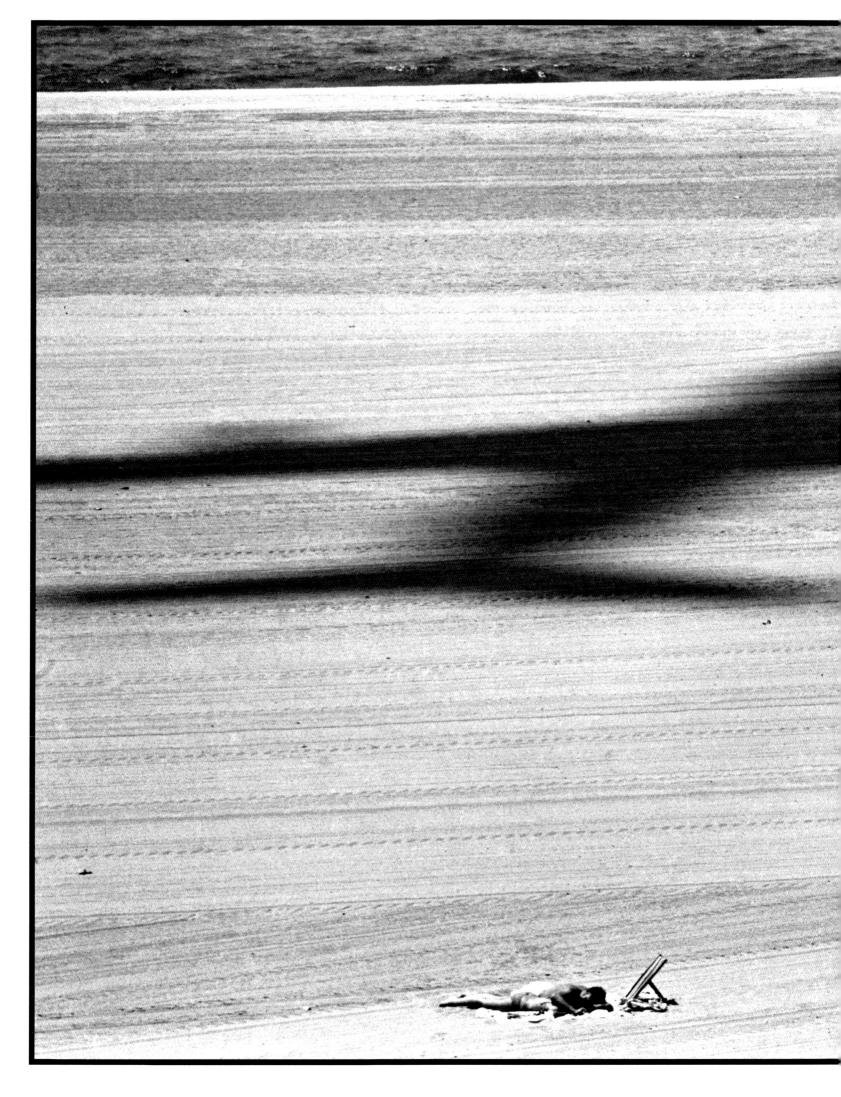

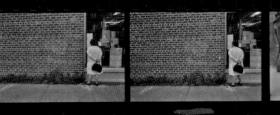

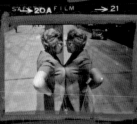
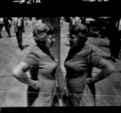
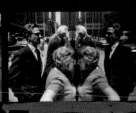
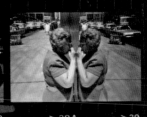

321 F1

New York, USA
1969

"As a young photographer, I spent my waking hours exploring my home town of New York. Sometimes you're unconsciously and unintentionally drawn to the same kind of subject all day. This was apparently a 'store window' day. As I walked up Madison Avenue, my eye was caught by a man staring intently through a store window on a side street. It was a stockbroker's office and a blown-up view of the New York Stock Exchange ticker tape was projected onto a screen inside, opposite the window. The noonday sun was strong, and the man had to put his face very close to the window in order to block out the reflection of the bright street with his shadow. I sneaked up and started to take a few pictures, but I couldn't really make it work. Frames 7A and 8A were OK, sort of, but 'sort of' wasn't good enough: too many reflections, too much going on inside the window. I tried changing the angle, but then I couldn't see the man's face. But the ridiculous idea of the man looking at himself, touching hands with his double, began to enter my consciousness.

I noticed the people in the background, also looking through the window, and I edged up to the woman. This was much better. The messy street had become less cluttered, and its reflection masked the busy interior. And the woman! What a magnificent specimen. Seeing her press her ample bosom against the window, giving the impression that she was confronting her likeness, made me understand what I was looking for. I wanted to lose all connection with the context, with stock market results and streets and other people, and isolate this woman shamelessly staring at and touching a stranger who was in fact herself. And then bang! My persistence was rewarded when everything came together in frame 25A. I took a few more pictures, but they were mere aftershocks to the big earthquake.

If I had wanted a funny little photograph of people looking through a window, frame 27A would have fit the bill. But what has always excited me in photography is to step out of 'real' reality and enter a world of frozen dreams, abstracted from the ordinary. The merely amusing is a temptation I struggle to avoid."

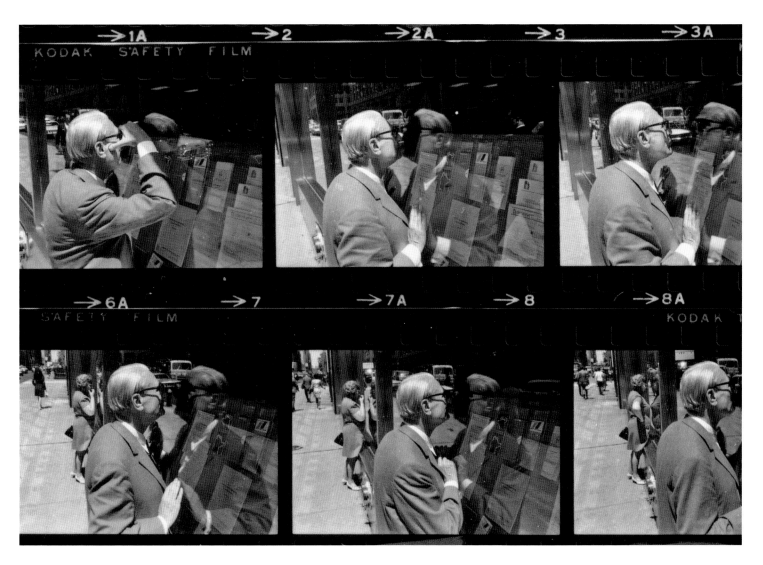

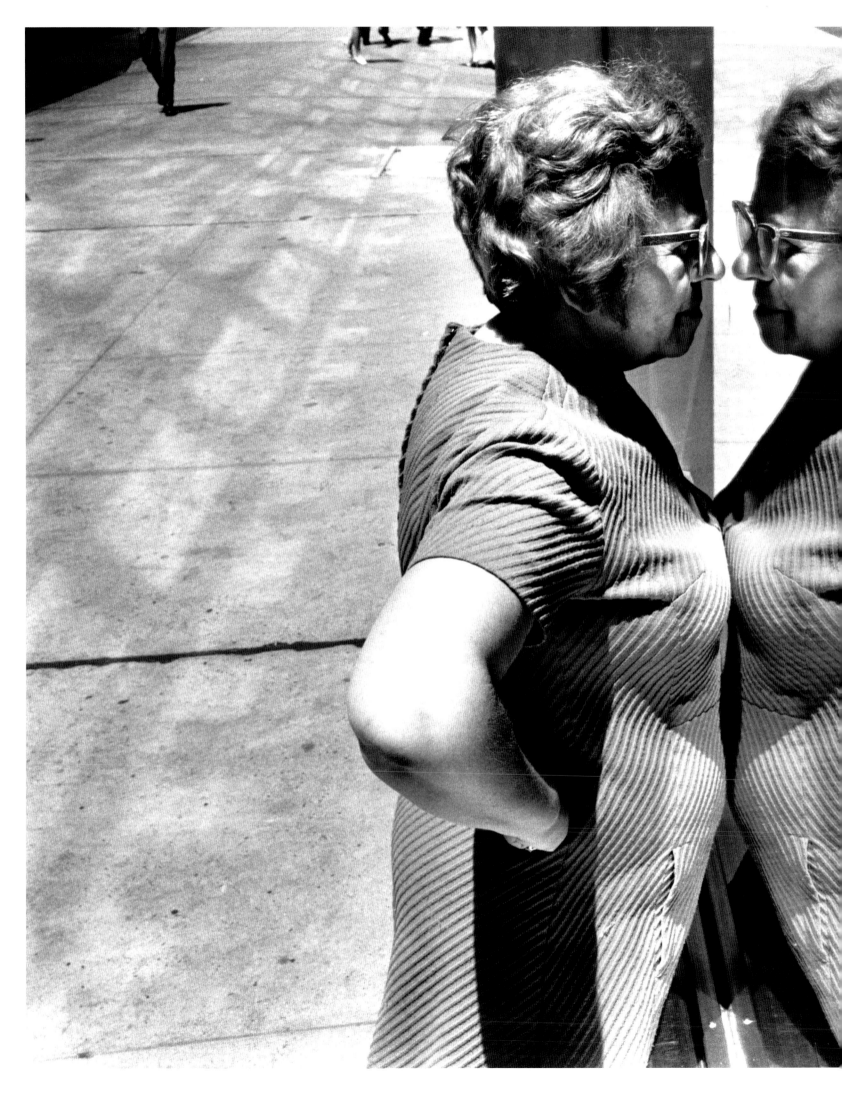

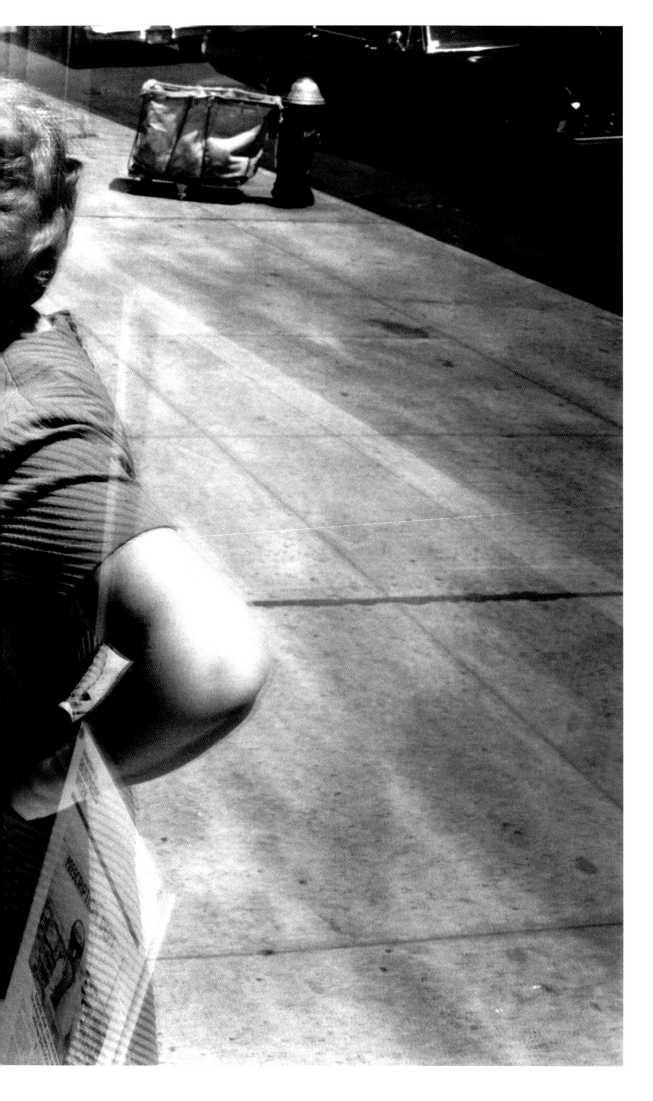

GUY LE QUERREC Miles Davis

Paris, France
November 1969

"After a concert by Duke Ellington and his orchestra on 1 November 1969, the organizers of the 6th Paris Jazz Festival had scheduled a double concert in the Salle Pleyel for 3 November at 7.30pm and again at 10.30pm. Miles Davis's quintet, with Wayne Shorter on sax, Chick Corea on keyboards, Dave Holland on double bass and Jack DeJohnette on drums, was to appear on stage before Cecil Taylor's quartet. I had decided to photograph all the concerts. By now I was working as head of the photo department at the Paris-based weekly magazine *Jeune Afrique*, so I also did regular reports in Africa, but I continued to photograph jazz as often as I could.

This was the second time that Miles Davis had entered my viewfinder, the first time being at the 1st Paris Jazz Festival in October 1964. I was still an amateur then. In those days, stages were brighter and the technical conditions were easier than they are today. Back then I took fewer photos, too. This was doubtless due to the need to be economical, but it was also because, being able to leave fewer things to chance, I had to concentrate harder in a given situation. This was certainly the case during the 10.30pm concert.

Although live music is always a visually dramatic art form, this concert was particularly noteworthy. As happened from time to time throughout the gig, Miles wandered away from the centre of the stage and the microphones to let his musicians take turns improvising. I had a premonition of the move he was going to make. Anticipating it, I was in just the right place when he stopped for an instant in a beam of light that was emanating from the floor, illuminating him in my low-angle shot and throwing a shadow on the curtain at the back. Miles passed without transition from the full uniform lights of the show into a single sophisticated, sculptural light. It accentuated his strange, enigmatic, fascinating beauty and emphasized the depth of his gaze – the same qualities found in his music."

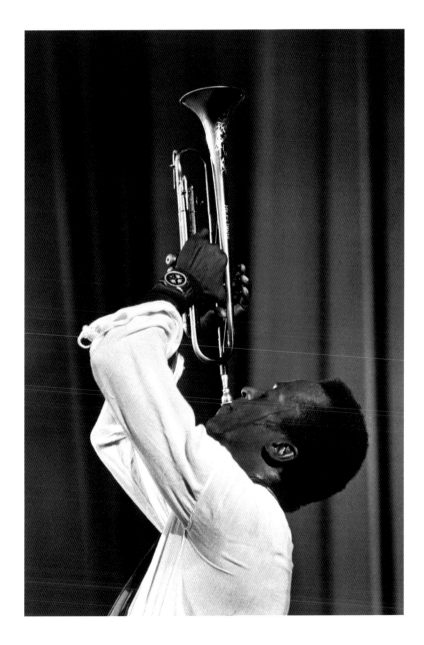

story
G L Q **69 0 9 2 W**

n° **01105**

date
lundi 3 novembre 1969

dist. K

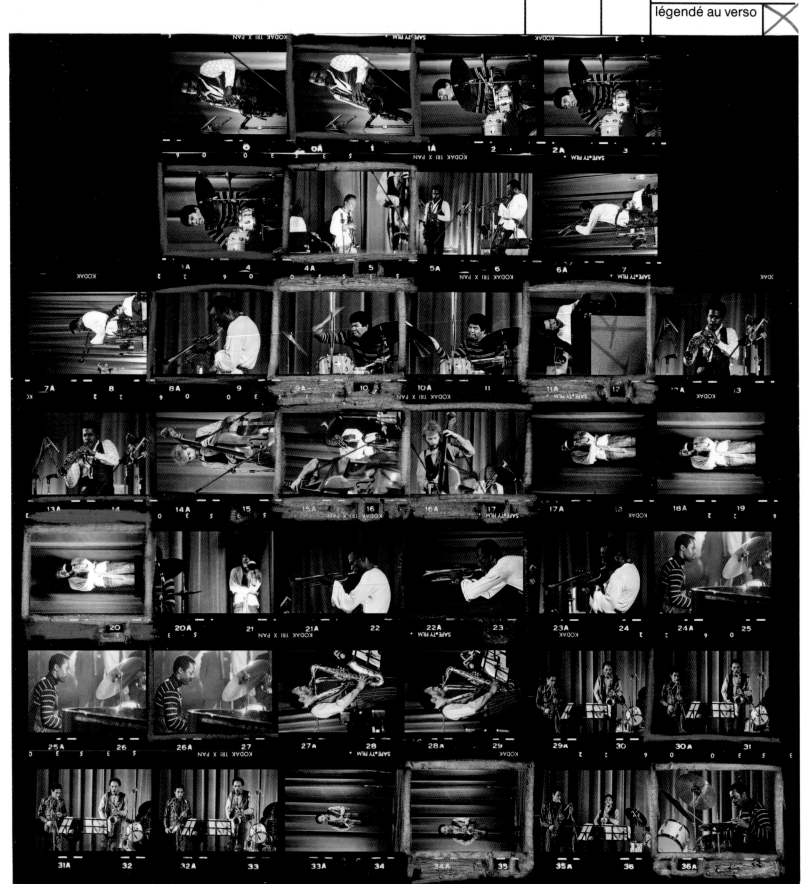

4ᵉ PARIS JAZZ FESTIVAL (ex – n° 1119-A)

(puis ex n° 01103)

0→24- MILES DAVIS QUINTET

Miles DAVIS (trompette)

Wayne SHORTER (saxo ténor)

Chick COREA (piano Fender)

Dave HOLLAND (contrebasse)

Jack DeJOHNETTE (batterie)

le concert de 22ʰ30 (en 1ère partie) leur 2ᵉ concert de la soirée.
[pendant le 2ᵉ concert Chick COREA jouera aussi de la batterie sur
le matériel d'Andrew CYRILLE (voir ci-dessous) et Jack
DeJOHNETTE du piano)

24ᴬ→36ᴬ- CECIL TAYLOR QUARTET

Cecil TAYLOR (piano)

Jimmy LYONS (saxo alto)

Sam RIVERS (saxos, flûte) - p ex. n° 28+29

Andrew CYRILLE (batterie) - p ex. n° 36ᴬ

le concert de 22ʰ30 (en 2ᵉ partie) leur 2ᵉ concert de la soirée

Salle Pleyel, 252 rue du Faubourg Saint-Honoré, Paris 8ᵉ

lundi 3 novembre 1969

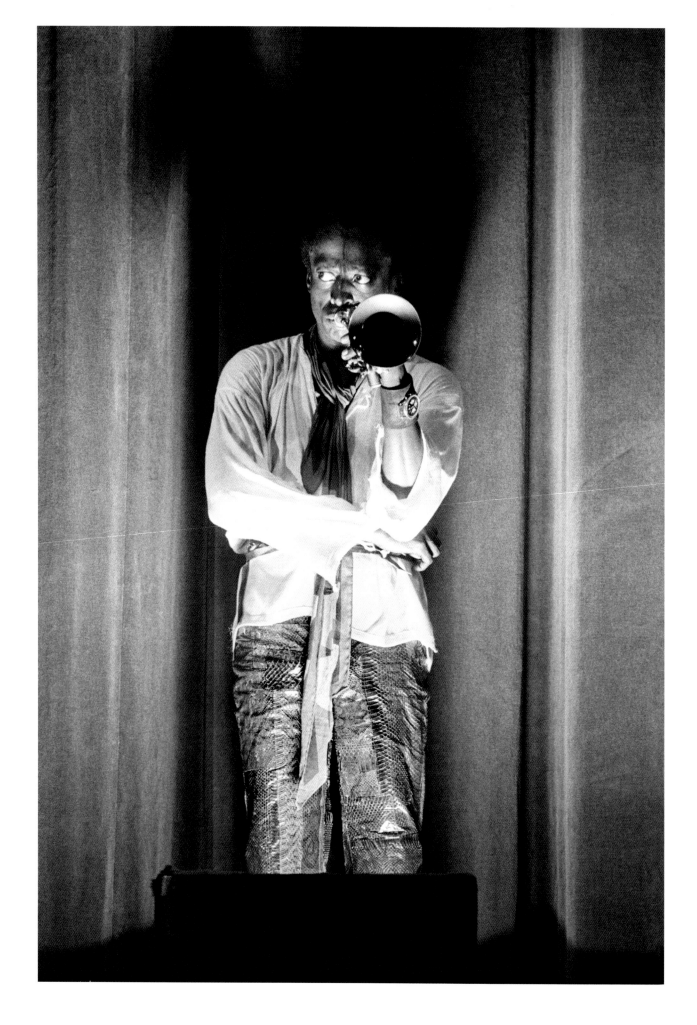

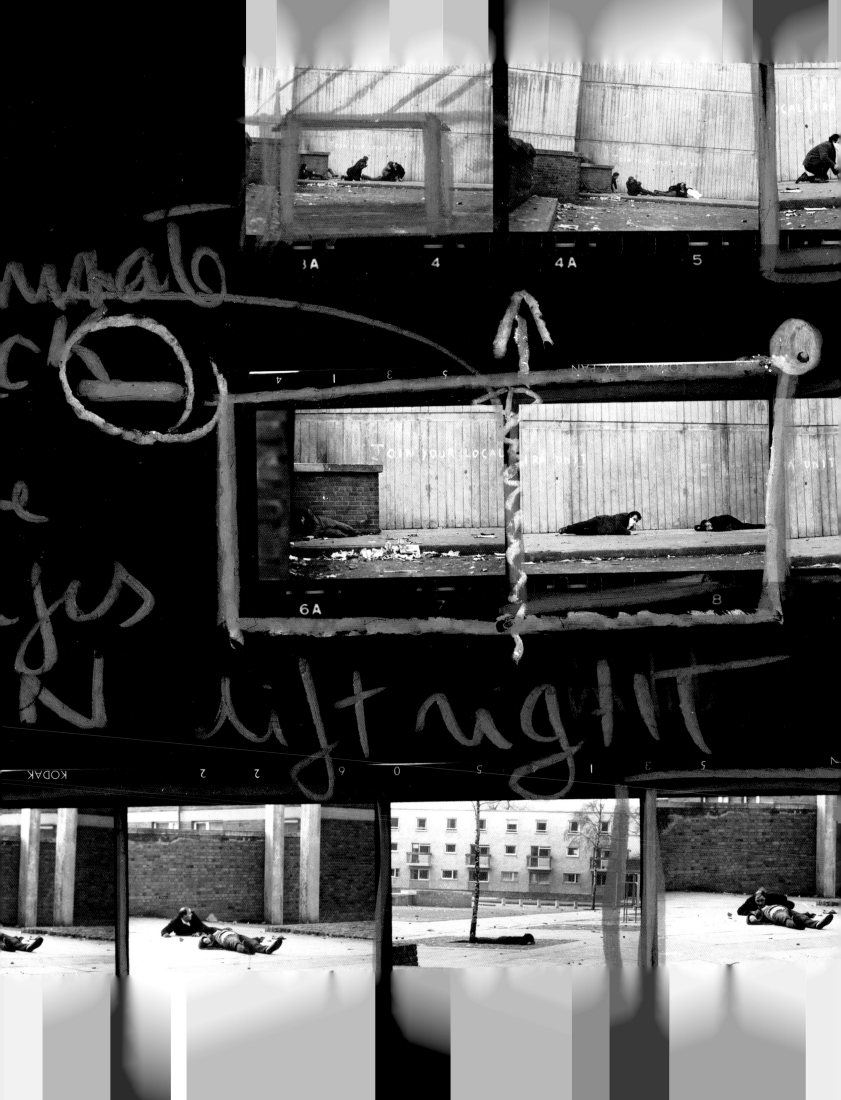

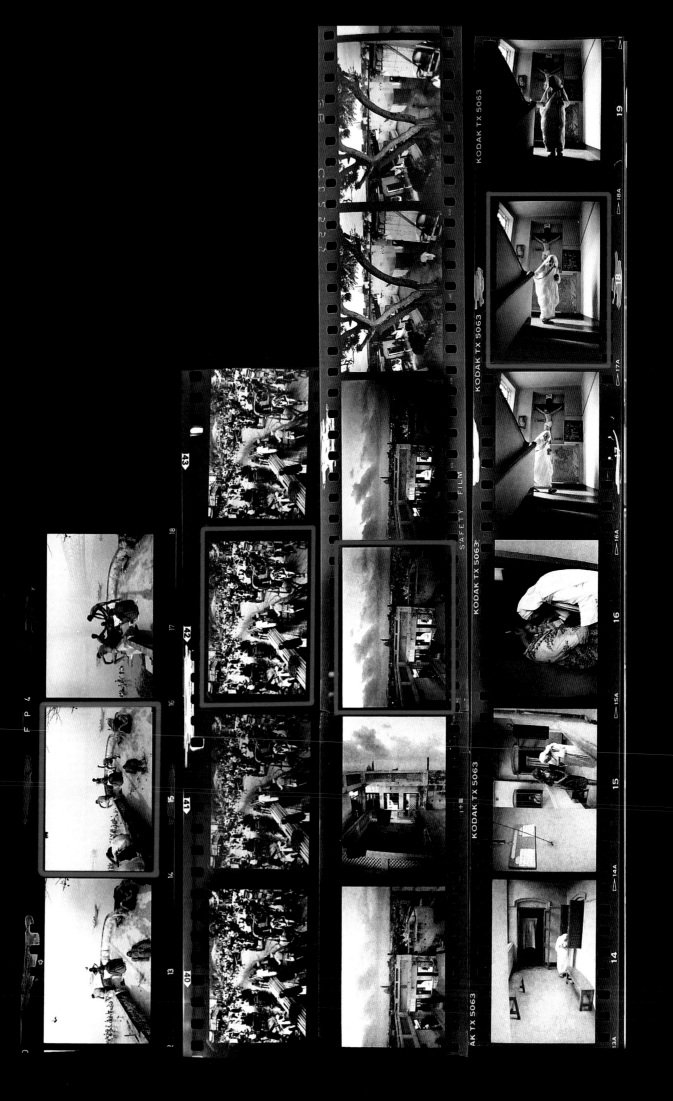

Calcutta, India
March 1970

"I started photographing Mother Teresa in 1970, when she was not so well known. After four days of shooting, she told me not to come the next day because it was Easter Sunday and 'I don't want anyone to be walking around and disturbing the peace'. This was upsetting, but I explained: 'Mother, you say when Christ was suffering you were not there to nurse him, so all those suffering human beings are your Christ, whom you serve with compassion and love. That's half of the story I have done so far. The other half is when you sit in prayer and connect with the Lord to rejuvenate yourself. I have never seen Him, but when you sit in prayer He seems to land in your eyes, and if I don't photograph the second part my story will be incomplete, and how will I share the glory of His grace?' 'You can come tomorrow at 6am,' she said, 'only with the commitment that you will sit in one place and take pictures.' I accepted willingly.

Mother took me into the chapel on the first floor, made me sit next to her, and went into prayer and then into meditation. I needed a frontal position to capture that moment of connectivity. Despite my commitment, I was restless, so I walked around and took all the required photographs, then the prayers were over and I came down the steps and waited for Mother… Here she arrives, Christ in the background and sunshine touching her feet. I took some more pictures of her coming down. And then it was a moment of reckoning. I folded my hands. 'Mother, forgive me for not being able to keep my promise.' She held both my hands, looked into my eyes, and said, 'God has given you this assignment. You must do it well.' And in that moment I was blessed."

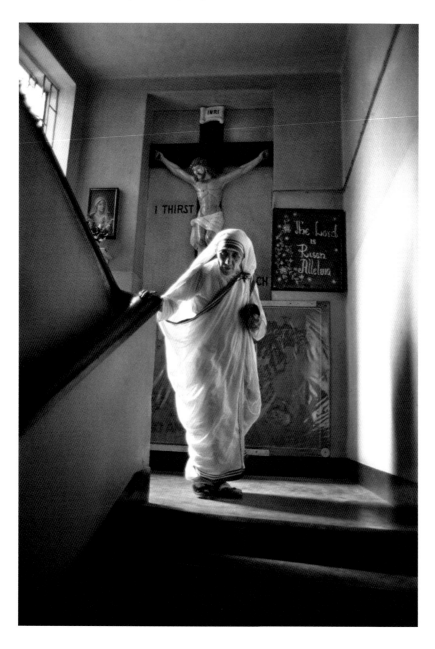

OPPOSITE Composite of film strips, marked with Raghu Rai's digital selection.

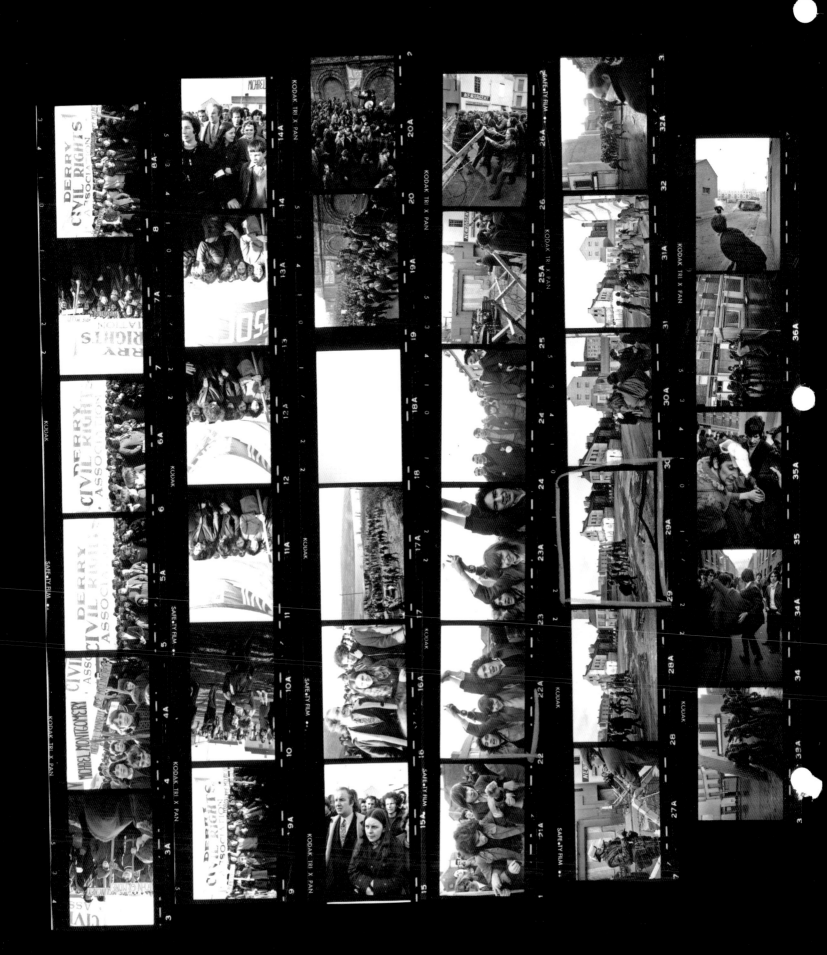

Derry, Northern Ireland
January 1972

On his first professional assignment, in July 1970, Gilles
Peress went to work in Northern Ireland; his involvement
in the region's struggle was to continue for the next
twenty-five years. He was photographing Catholic
activists, who, influenced by the American civil rights
movement, were marching in Derry on 30 January 1972,
when British paratroopers opened fire on the unarmed
protestors. Peress photographed events as they unfolded
– a tragedy that came to be known as the 'Bloody Sunday'
massacre. The day became a turning point in the
Troubles, as well as in the young photographer's
involvement.

He recalls: 'The paratroopers had established two
barricades. As the march passed on towards the city
centre down William Street, a mini-riot started. By the
time the army brought out its water cannon, things had
begun to cool down. I have this picture of the crowd
at the corner of William Street and Chamberlain Street
under a rain of purple dye. One of the young people
[Jim Wray] sitting down in protest was killed moments
later. Suddenly, from the corner of my eye, from James
Street across William Street, I saw the first paras in their
Saracens move towards Free Derry Corner, towards the
Rossville Flats. Then the shooting started. Then everybody
started running… I followed.'

On arrival at the corner of Chamberlain Street and Eden
Place, Peress recalls: 'I peeked around a corner and saw a
soldier. When he saw me, I shouted "Press" and I raised my
arms above my head to show him the cameras. But then
he shot at me from the hip, missing me by a few inches.

'I'm trying to remember my emotions. I know that at
one point I was shooting and crying at the same time.
I think it must have been when I saw Barney McGuigan
dead. By the time I'd reached him, people were still
huddling by the telephone box, protecting themselves
from the shooting. He was alone. Then a priest [Father
Tom O'Hara] arrived and started to give him the Last
Rites. I remember taking a few pictures then. I also
remember that I didn't want to intrude too much,
but at the same time I felt this obligation to shoot,
to document. It's always the same fucked-up situation:
you are damned if you do and damned if you don't…'

The pictures were published the following weekend
by the London *Sunday Times* (the paper was able to run
the photographs because they were not perceived as
editorializing in the same way that a text would have
been; staff journalist Murray Sayle's report – which
blamed the army, whose first statement was that they
had shot at armed rioters – was censored). 'I remember

[Magnum Paris bureau chief] Russ [Melcher] on the
phone asking me, "Did you see anybody armed?"
because that was the immediate issue. "No," I said.
"Look carefully on the contact sheets. I didn't see any
civilians with weapons." So Russ started to look at the
contact sheets very, very, very carefully. I had not realized
at the time that I had shot pictures of Paddy Doherty
alive and then later dead, but Russ did. "It's the same
jacket, it's the same man," he told me on the phone.
"I have these pictures of this guy alive and then dead;
the images clearly show he has no weapons."'

Peress's photographs went on to be used as key
evidence in the official inquiries. In June 2010, the Saville
Commission presented the findings of their twelve-year-
long inquiry, overturning the whitewashed results of the
previous Widgery tribunal that had reported eleven
weeks after the killings. As British Prime Minister David
Cameron noted, the Saville report found the killing of
fourteen civilians by soldiers of the elite First Battalion
of the Parachute Regiment 'unjustified and unjustifiable'.

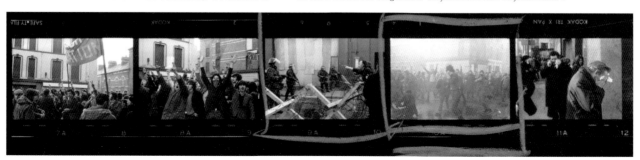

TOP Map drawn by Gilles Peress as part of his statement for the Widgery inquiry, 25 February 1972.

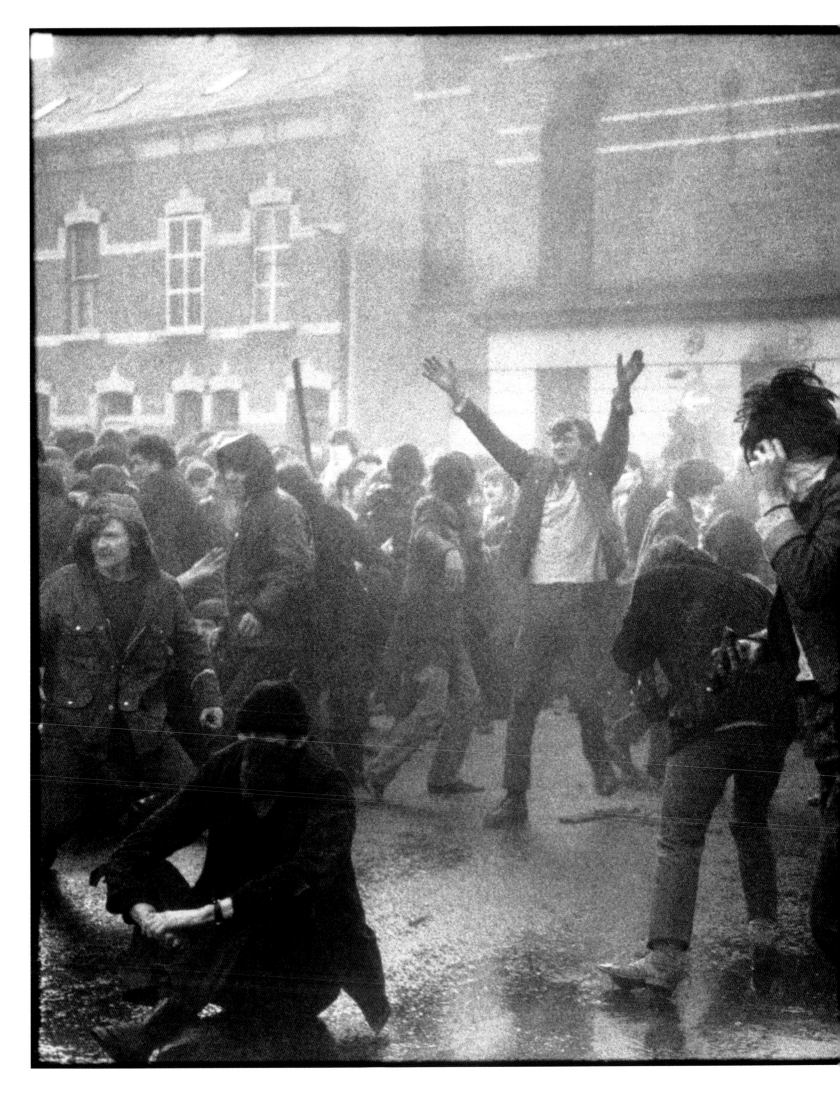

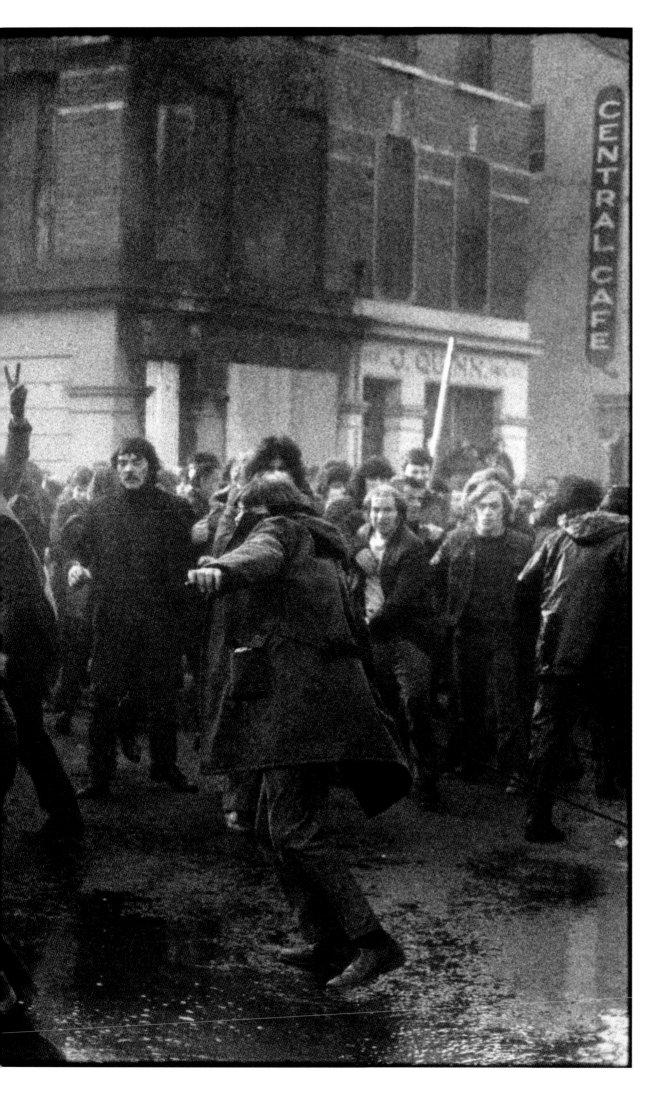

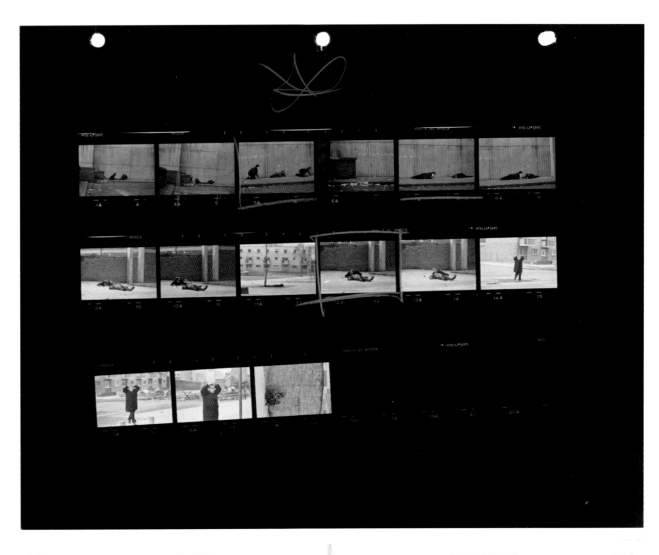

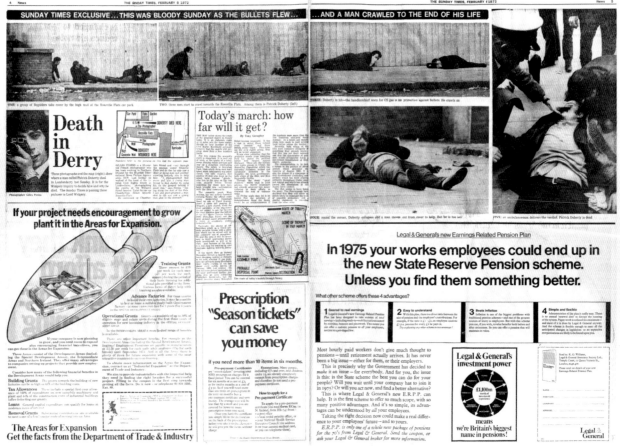

ABOVE *The Sunday Times*, 6 February 1972: 'This was Bloody Sunday as the bullets flew ... and a man crawled to the end of his life.'
PAGE 206 First page of Gilles Peress's statement, in which he records the sequence of events as documented in his photographs.

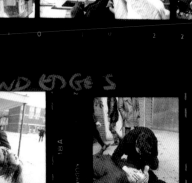
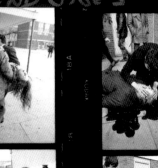
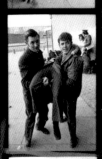

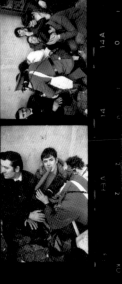
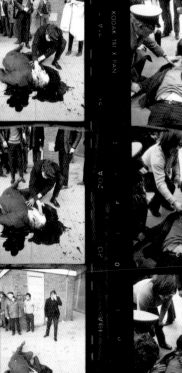
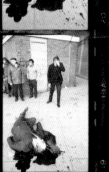

CONTRAST PRINT
FULL FRAME
PRINT BLACK AROUND EDGES

Gilles Peress of Magnum Photos,

1. I am a freelance photographer. On 30 January I went with the Civil Rights march and took photographs. On sheet 72-1-7, pictures 3-24 inclusive are of the march up to the barricades. On 72-1-5, 16A-32A are of the march. These were taken with different cameras - I had 3 that day. On 72-1-8, 1A to 8A inclusive are of the march up to the barricade in William Street.

2. On 72-1-8 pictures 9A-11A show the barricades and the dye and the gas being used. 72-1-7, 25A to 36A show stone throwing at the barricades at James Street and William Street. 25A to 27A were taken about 20 minutes before the shooting. 28A to 31A were about 10 minutes before the shooting. 32A was about 5 minutes before the shooting. 33A, 34A, 35A and 36A were taken at short intervals until the shooting period begins. 37 (unnumbered on the proof, but next to 36A) was taken just as the shooting begins. This was taken at the corner of Chamberlain Street and Eden Street. The Saracen is on Rossville Street beyond the burned out car.

3. On 72-1-5, 33A-35A show stone throwing. They were taken with the long lens when the photographs previously mentioned were bring taken.

4. After taking the picture of the Saracen (72-1-7 No. 37) shooting was going on in Rossville Street. I went carefully down Chamberlain Street and at the Eden Street corner I held up my cameras saying "Press". There was a soldier at the corner of the buildings on Eden Place. He was kneeling. After saying "Press" I turned and crossed the street very slowly. As I got to the footpath the soldier shot at me from the hip. The bullet smashed the second window of No. 6 missing me by a few inches.

5. I ran down Chamberlain Street to the end. I got to the end and saw a body in Rossville Square - there was a priest waving a handkerchief. I took picture 72-1-5, No. 37 with the long lens (135 mm).

6. There was a lot of shooting in this area. Most people were hiding by Chamberlain Street or running to the flats. I went over towards the centre block taking cover along the wall past Chamberlain Street. I went to the end of the small wall in the centre of the centre block but the body had been taken away. From here I took 72-1-9, No. 1A. I then went back a few yards towards the big concrete wall between

M65 - 1

- 1 -

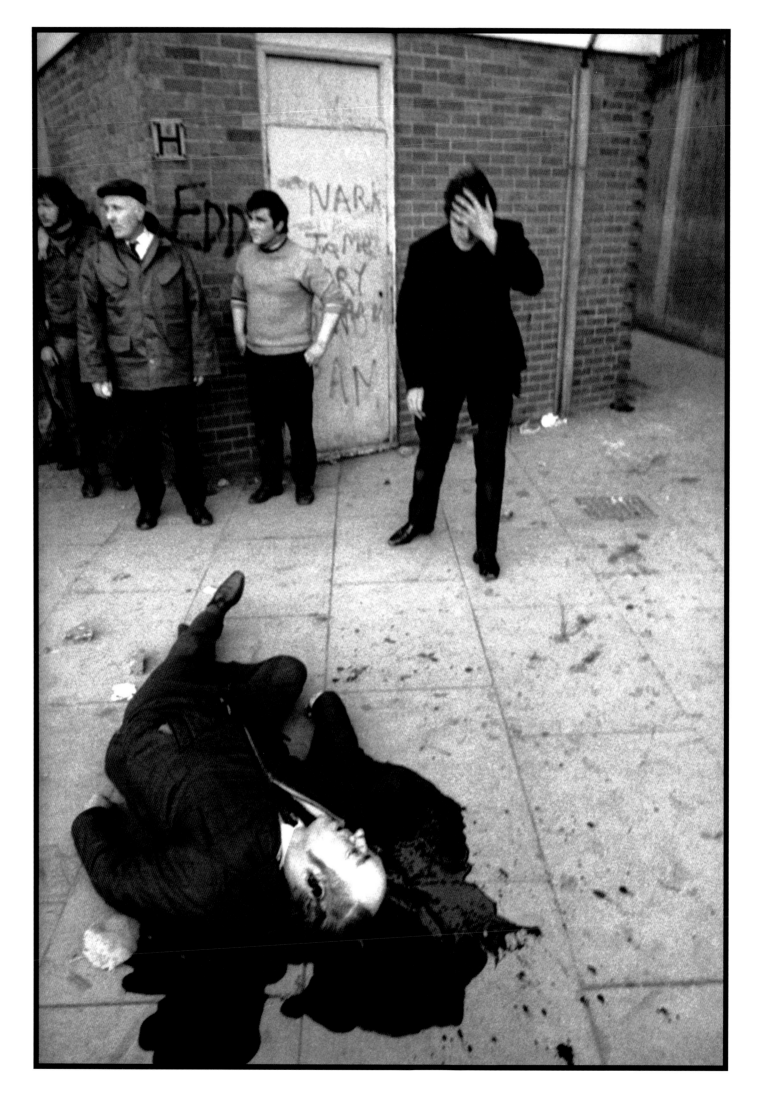

72·8·37

Benares, India
1972

"In effect, a contact sheet reflects the conscious and unconscious mind of the photographer. Often even the photographer cannot interpret it correctly. Nonetheless, it is through the analysis of contact sheets – a form of self-analysis – that a photographer can try to grasp the direction or meaning that lies behind his own images. This process can be long, but it can also be fascinating.

This is the contact sheet for one of my relatively well-known images. It is a photograph I hold dear: I chose it as the cover of my book, *Le Forme Del Caos* ('Forms of Chaos'). It symbolizes the necessity of chance in my work, and the way in which chance and necessity encapsulate the whole issue of taking photographs – of the kind that

interest me, at least. The photograph shows a dog chasing its own tail in Benares, India.

It seems to be an example of something quite simple: one shot when you see the thing, another to get the form right. And yet I could have added another contact sheet I shot a few days earlier, also in Benares. A completely different photograph, but with a dog in an identical position. In other words, images sometimes build over time, and in a sense they can be foreseen, like a premonition. It was just a few days earlier, but it could have turned this image into an entire tale of premonitions, or the archaeology of an obsession with form that began decades earlier."

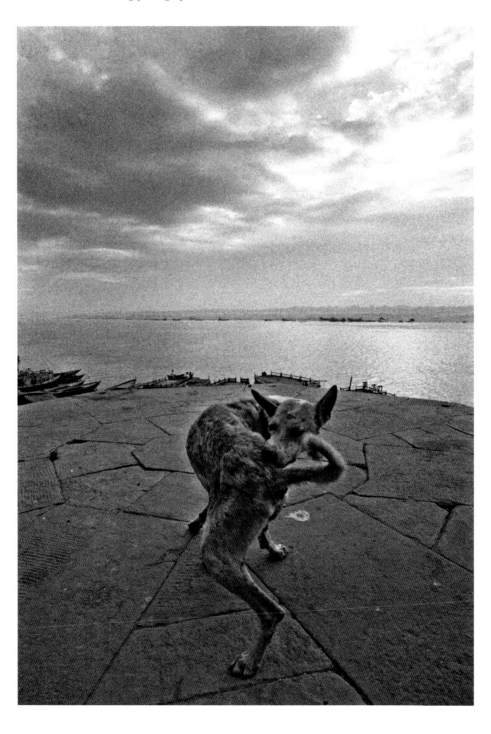

GUY LE QUERREC Artichoke Harvest

Brittany, France
June 1973

"In the early 1970s, a French publishing company called Réalités-Hachette produced a series of books on European countries and regions of France. To illustrate them, in addition to using a few archive images, the company sent various photographers out on assignment. I was one of them, in particular for the book *Voir la Bretagne*. The assignment suited me well because it gave me the opportunity to work for almost a month in the province from which my own family comes. Over the previous years, I had of course photographed Brittany on several occasions, and my hectic schedule had included a variety of agricultural, maritime and industrial shoots as well as the traditional Breton celebrations…

On Saturday, 2 June, I decided to follow the artichokes – cultivated mainly to the north of Finistère, around Saint-Pol-de-Léon – from harvest to cooperative. I had already observed the work in the fields, the efficient and skilful action of the farm labourers, cutting the artichoke heads without slowing down, and throwing them without looking so they fell into the basket carried on the back. I was impressed by the speed and dexterity of the work. I tried to capture the artichoke suspended in the air. I moved parallel to the farmer, and at the same speed. To increase my chances, I took one shot after another.

In the end, the photograph wasn't selected by the publisher. But the main thing is that it existed. It appeared in my first book, *Quelque part*, in 1977, and in 1986 it was published as a postcard.

The story does not end there. One evening a few years later, I received a phone call from a journalist working at *Ouest-France*, Brittany's regional newspaper, and the biggest selling daily in France. He told me that somebody had sent the mayor of Saint-Pol-de-Léon a copy of the artichoke postcard all the way from Washington. Proud and flattered that this local farm worker had appeared in the United States, the mayor organized a reception at the town hall to congratulate him. So the 'famous' artichoke cutter – a man known as 'Lomic' – was interviewed by *Ouest-France*, and I was interviewed by telephone, to give our versions of 2 June 1973. The photo and our stories were published in the newspaper. A few months later, the radio station France Culture decided to dedicate five programmes about Brittany to me, from my origins to my photographs of the region. I obviously chose to speak about the 'flying artichoke', and to find Lomic. The two of us exchanged our memories on air."

ABOVE 'The beautiful story of a postcard. "Lomic": known throughout the world.' Feature published in *Ouest-France*, 28 December 1989, sixteen years after the story was first photographed.

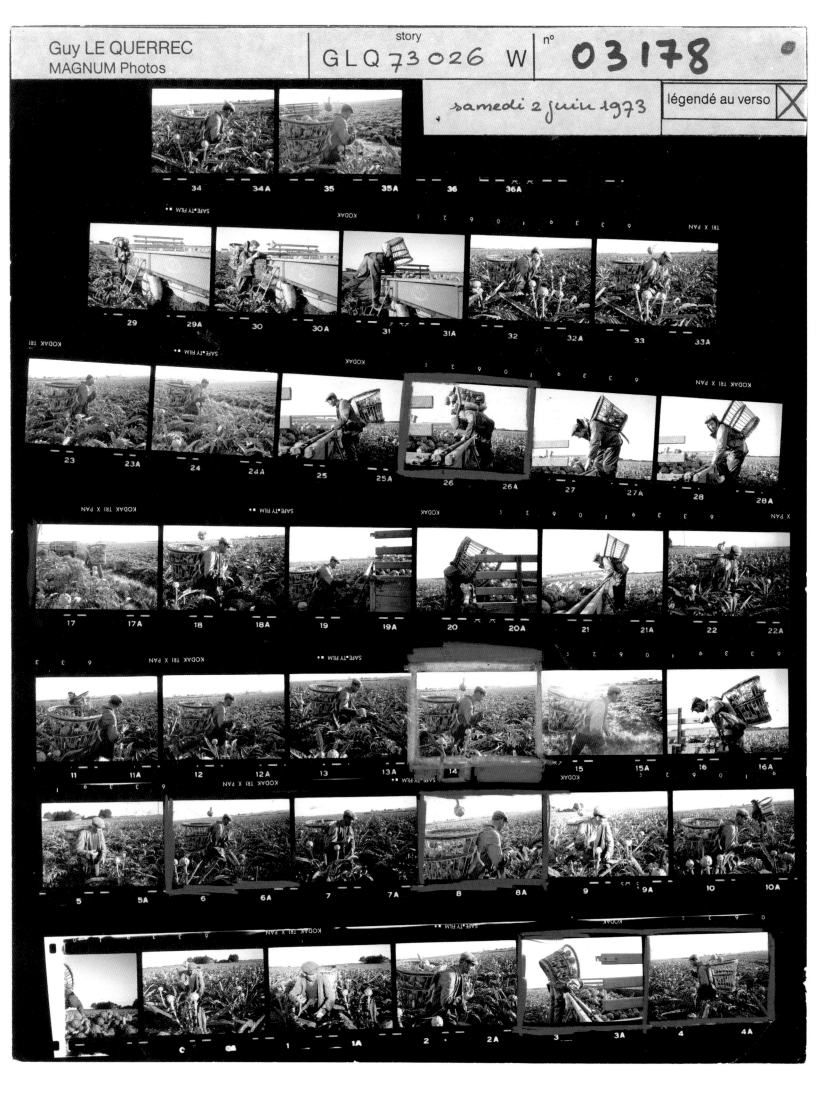

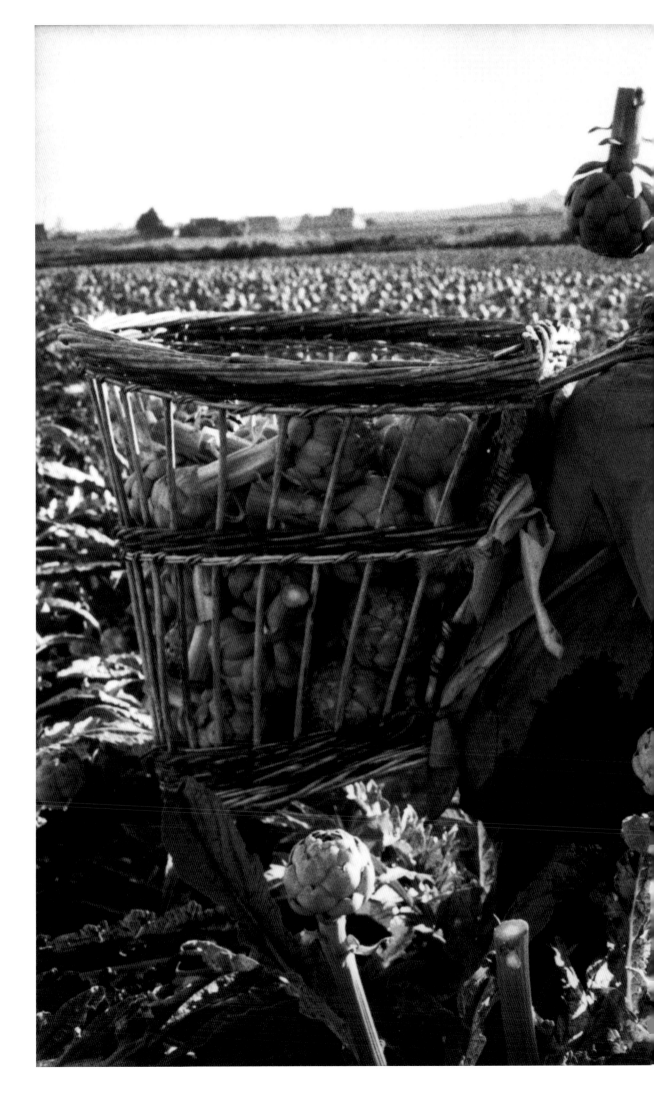

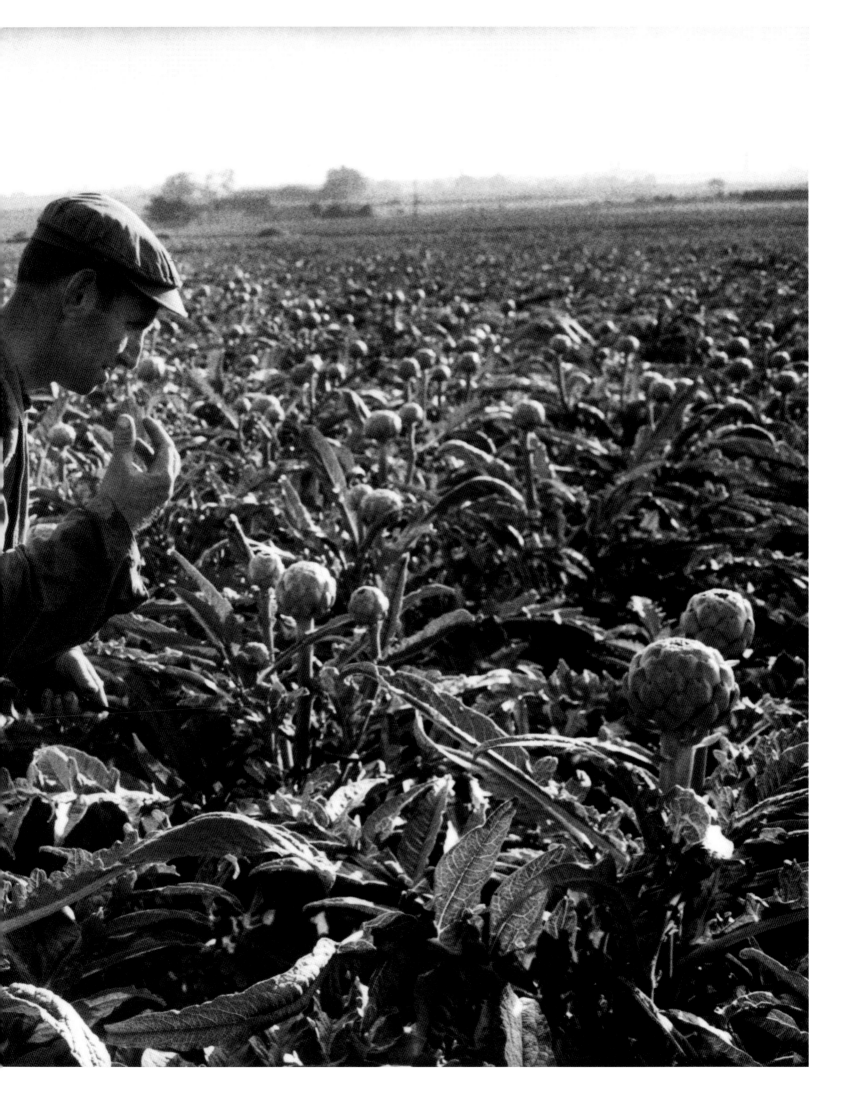

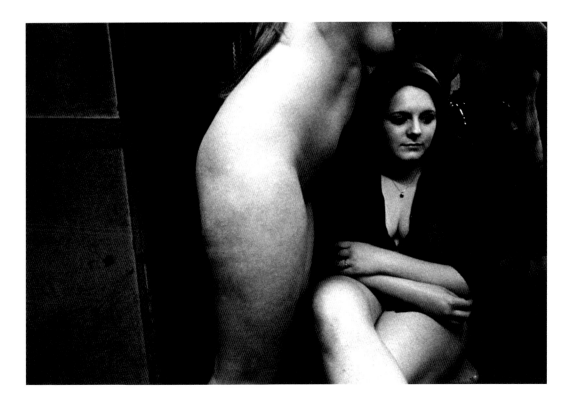

"In 1972, my partner Dick and I spent our first summer together and wanted to take a road trip. We decided to follow small circuses in the Midwest and ended up at state fairs and then carnivals in New England. I wasn't looking for the girl shows, until I found them.

The work was done over three summers, each one building off the last. A publication called *Variety* would list the fair dates before the season began. I figured out which carnivals were carrying girl shows and who would be where. Weekend to weekend, the shows travelled from Maine, through New Hampshire, to Vermont. The first summer I photographed from the fairgrounds, I was like everyone else walking by and watching. When I decided to return the second summer and follow the full route of the show, starting in Maine, I began to forge relationships and eventually it was through the women's invitations that the managers allowed me into the dressing rooms. Each weekend some girls rotated out, but enough of them – or at least one – would feel comfortable enough to invite me inside. I chose the classic fly-on-the-wall approach. I'm sure the girls were very aware of my presence, but I felt invisible. I made these photographs with a handheld Leica, no flash, and instead a long shutter speed and wide-open lens. The weeks of being with the women, changing locations each week, setting up the show, enduring long rainy nights, hoping there would be an audience, standing by them in difficult moments – all were factors in gaining their trust.

Issues of continuity were very problematic. I would sometimes take a portrait of a woman, bring the photograph back the following week, and she would have disappeared to go off with a boyfriend or just quit.

Still, I processed the film weekly so that the girls could see the contact sheets if they returned to the show or if I could find the show when it travelled to the next spot. Sometimes I would bring a few prints, but mostly the contact sheets. The value of that was the dialogue: they essentially saw all that I was shooting. They would mark with an initial if there was a particular picture they wanted, but most of the time they chose portraits, which is really why I began to shoot formal, medium-format portraits in addition to the backstage 35mm. In some shots they really performed for the camera with a pose. I felt awkward directing them in any way. I think you can feel that in the portrait encounters; they simply performed themselves or perhaps presented what they thought showgirls should look like for me.

I met Lena on the first day she arrived to get a job at the girl show near her home town in Damariscotta, Maine. The second portrait shown here is long after that 'first day'. She'd worked the shows for three summers; her body revealed the wear of those years. She was astoundingly articulate and open to sharing her feelings. She at times expressed alienation or sudden ecstasy. She was defiant. She challenged the managers, both male and female, and was erratic in her moods when performing. I wanted my photographs of her to convey her complexity. We knew each other over many years. When her mother sent me a letter saying she had died of an overdose, it was just after I'd been photographing the insurrection in Nicaragua (1978–9). There I had seen a very different kind of death. The idealistic Sandinista slogan was *Patria libre o Morir* ('a free country or death'). I was in the midst of covering this phenomenally collective, enveloping movement, and in contrast Lena seemed so isolated and alone."

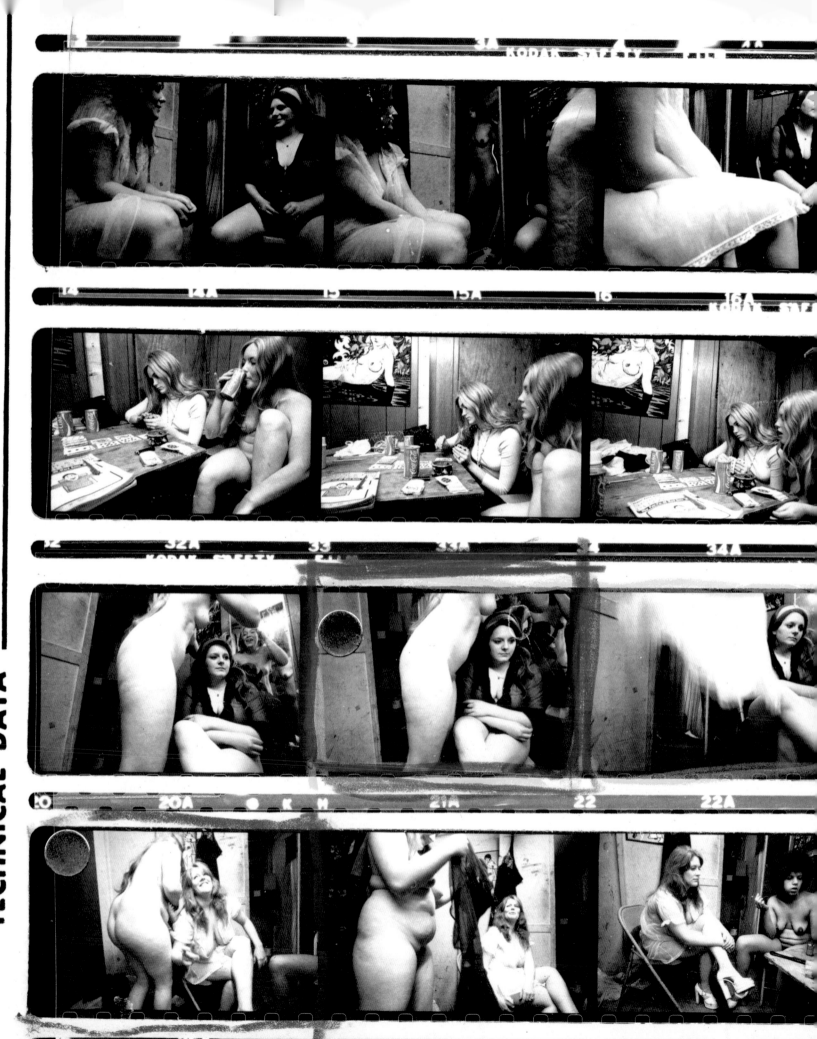

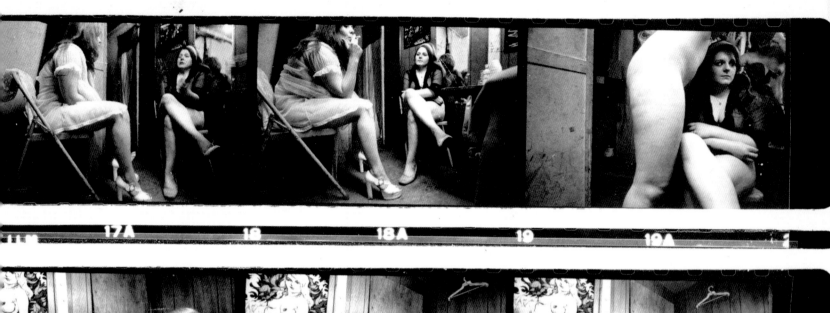
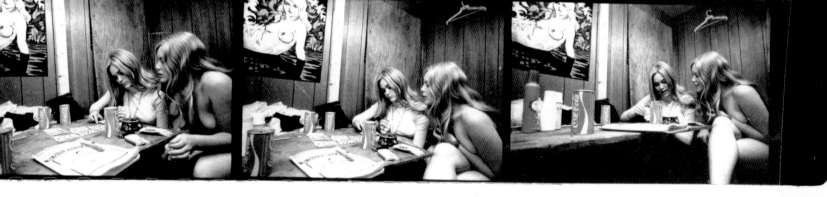
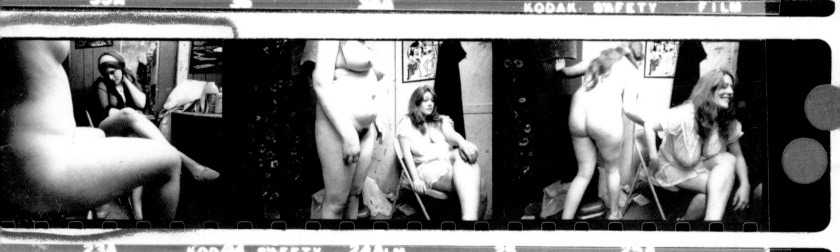
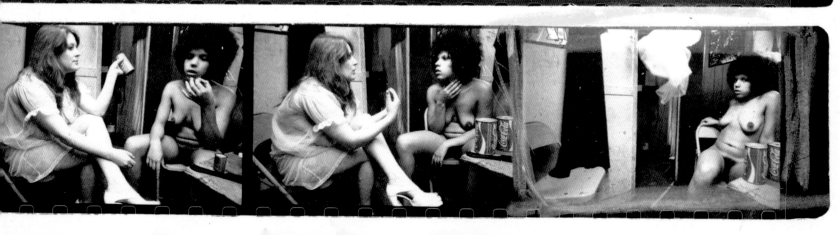

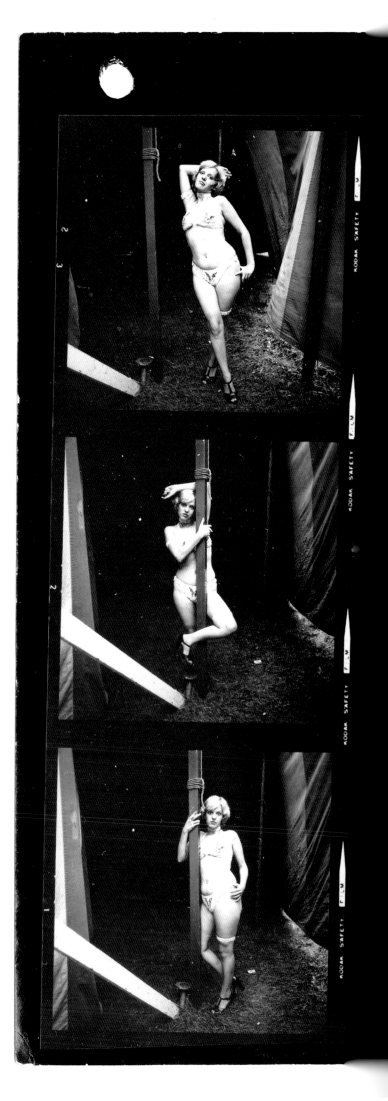

TOP Handwritten note by Lena, describing her life as a carnival stripper.
ABOVE Handwritten notes by Susan Meiselas, recording conversations with Lena.

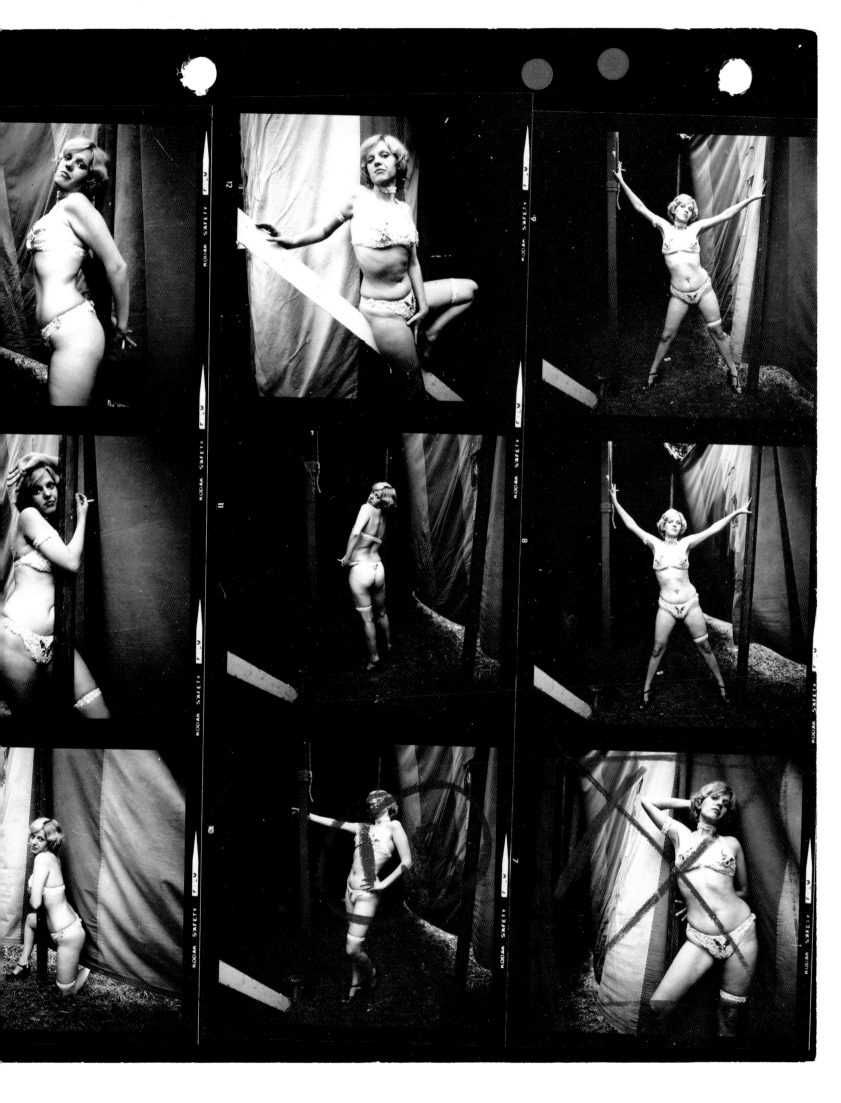

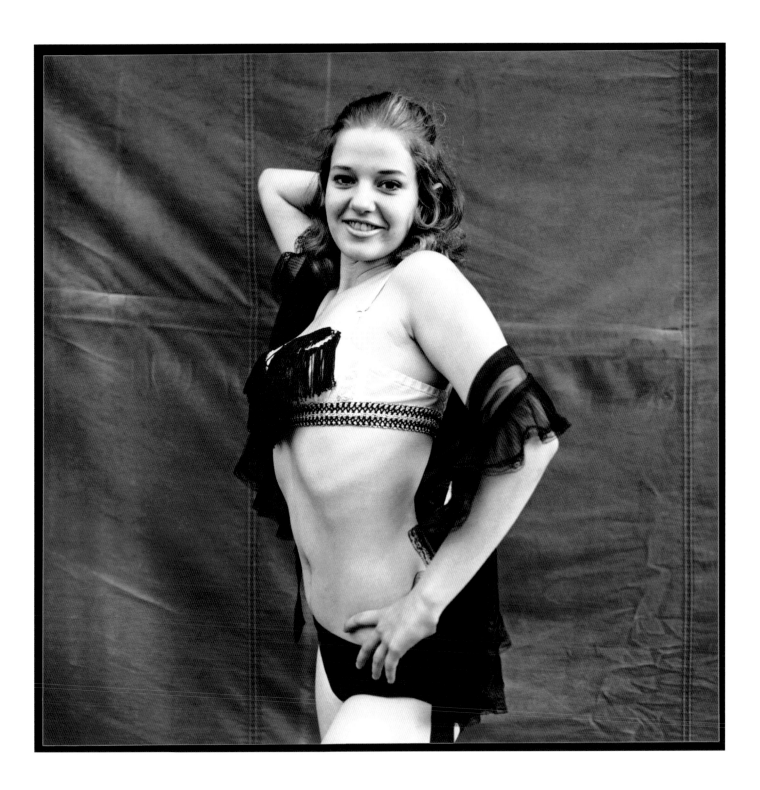

Lena on her first day, Essex Junction, Vermont, 1973.

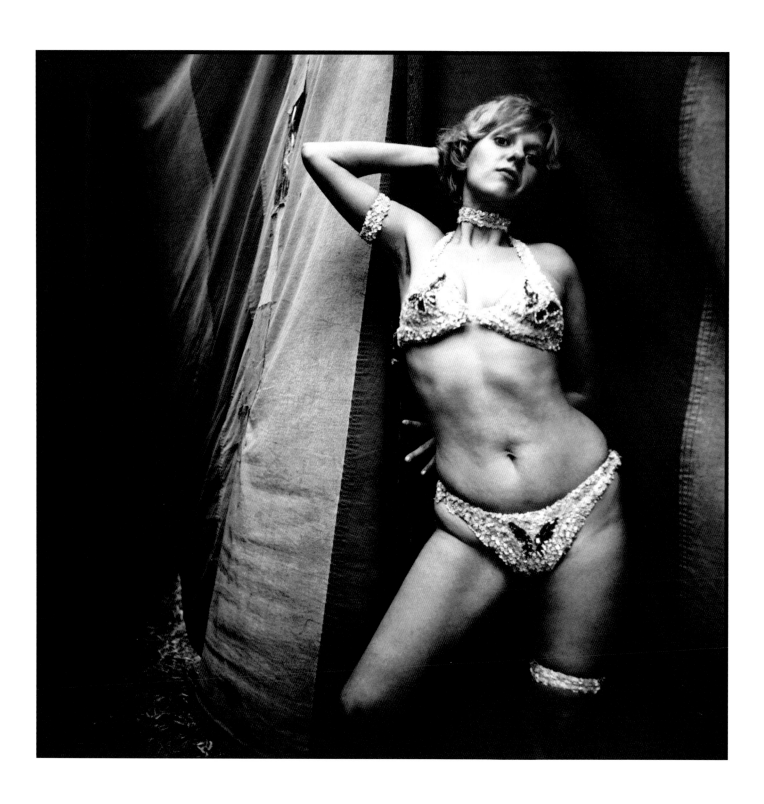

Lena, third season, Lehighton, Pennsylvania, 1975.

Yorkshire, England
1974

"This photograph [overleaf] was taken shortly after I
was awarded an Arts Council grant to photograph 'the
English'. Because of the grant, the BBC asked me to
join with them in making a film about Frank Meadow
Sutcliffe, a photographer who had lived and worked in
Whitby at the turn of the nineteenth century. The idea
was to have a contemporary photographer look at Whitby
today, and to compare the work of the two.

Initially I wasn't too enthusiastic about having a
TV crew following me around all the time. Happily, the
cameraman was sympathetic, and proved in fact to be
on occasion a help. In this picture his tripod can just be
seen in the far distance, and on other occasions, in bars
and nightclubs, the crew drew attention away from me
and I was able to shoot discreetly.

The man in the tweed cap first drew me to this
scene at a time when such caps were already becoming
unfashionable, and, as I approached, I realized the younger
man lying down with the straw in his mouth would make
the image, leaving only the need to put them into the
context of Whitby harbour. The two men were pretty
oblivious to the world on a sunny Sunday afternoon,
and I was able to shoot several images on two Leicas
with 35mm and 50mm lenses without disturbing them
or them being aware of me. I realized in retrospect that
this picture symbolized for me the passing of a gentler,
less aggressive age in England. In fact, it became the
front cover of my book, *The English*."

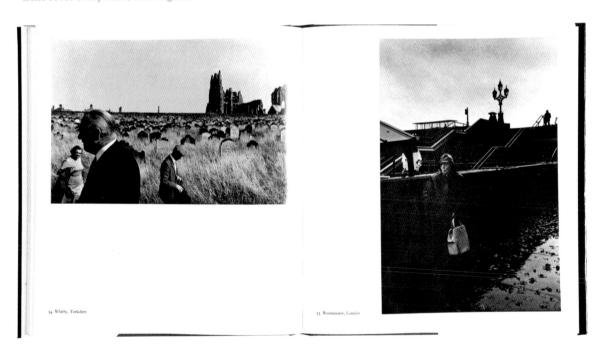

54. Whitby, Yorkshire 55. Westminster, London

 ABOVE Spread from Ian Berry's *The English*, published in 1978.

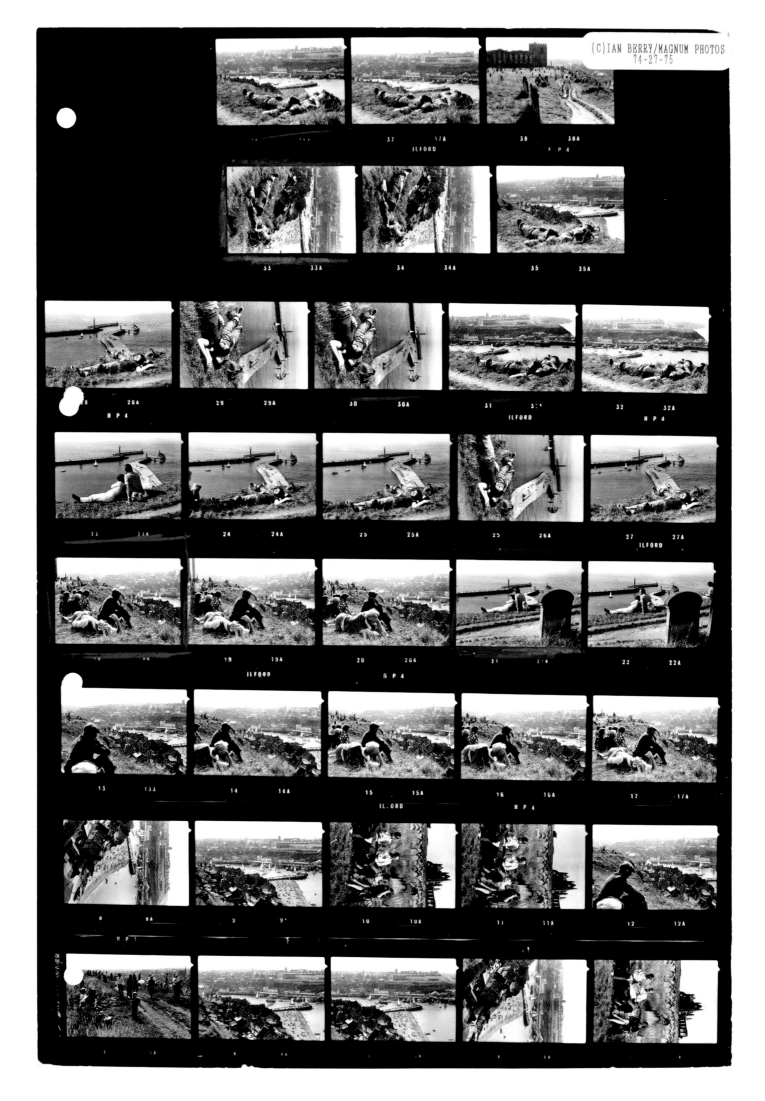

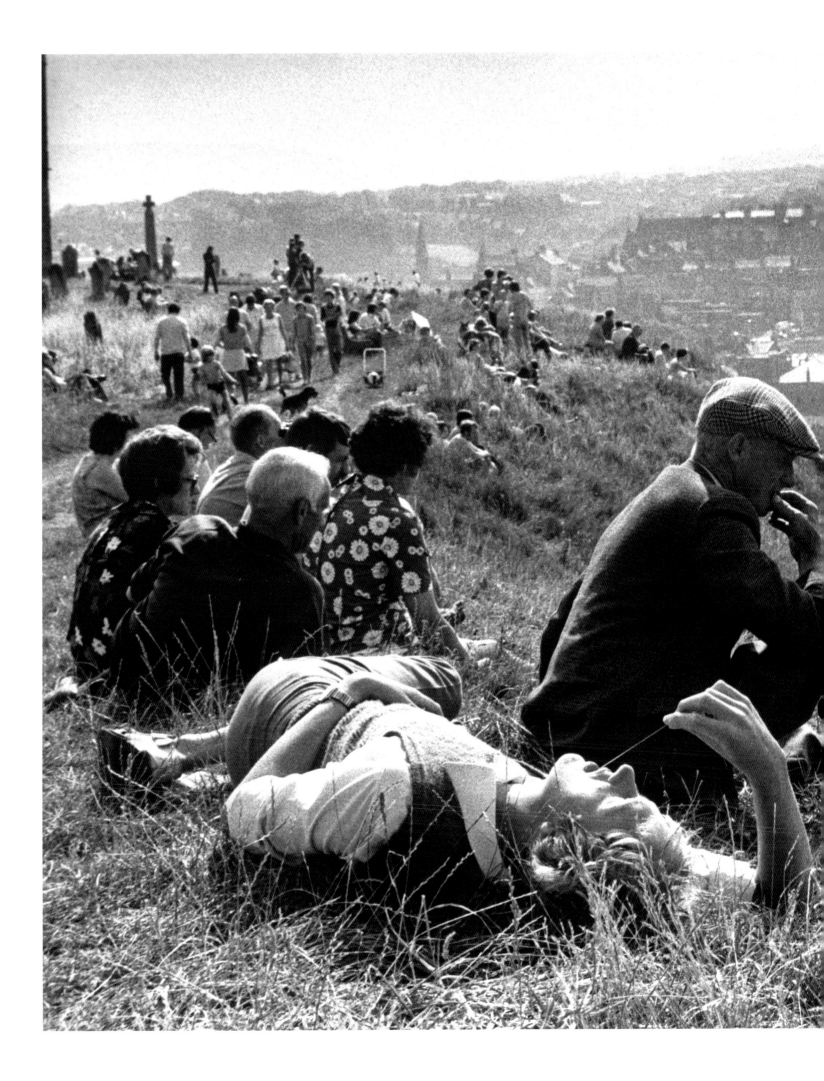

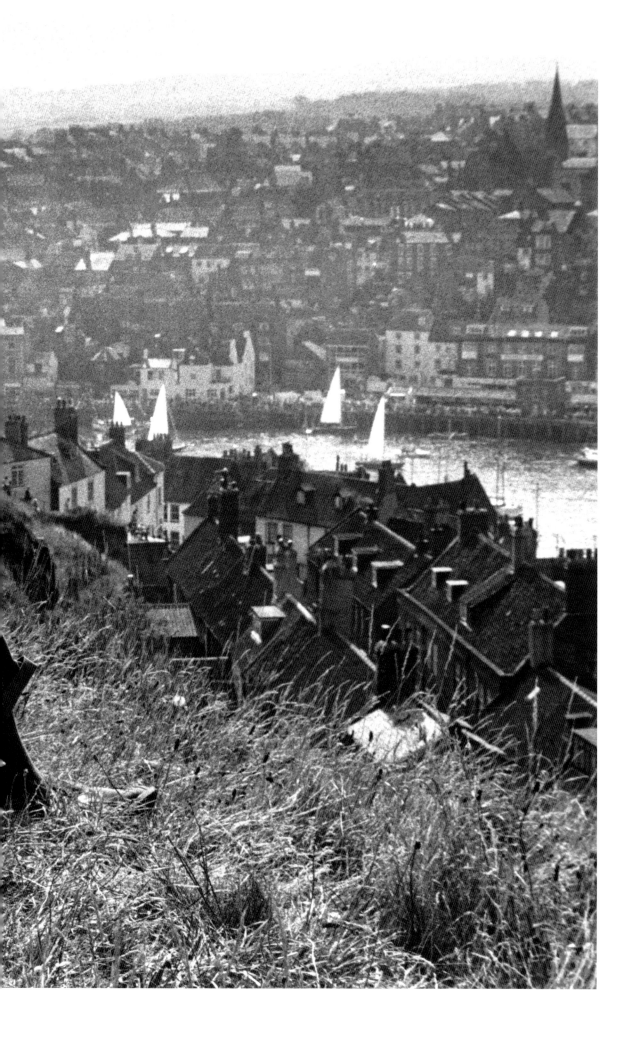

BAM 76 006 שלוש 293A

MICHA BAR-AM
P.O.B. 923-1000
Ramat-Chen, Ramat-Gan

HIJACKED HOSTAGES RETURN FROM ENTEBBE, JULY 1976

האירוע

ההנחיה

עבודה

מ"נ בנה עם
ד. ת. 923 — 1000
רמת-חן, רמת-גן

Near Tel Aviv, Israel
July 1976

"One of the most dramatic moments in my professional life – a peak of emotional outburst and release of tension – was the morning of 4 July 1976, when the rear doors of a heavy Hercules plane opened at an airforce base next to Ben Gurion Airport and a group of freed hostages returned to the arms of their waiting families.

The story had begun a few days earlier, when an Air France plane flying from Tel Aviv to Paris was hijacked by Palestinian terrorists and diverted to Entebbe, near Kampala, in Uganda, with 248 passengers on board and 12 crew members. The hijackers were welcomed by the Ugandan dictator, Idi Amin. They demanded the release of their colleagues in Israeli and other jails, and threatened to harm the hostages. The Israeli cabinet was unsure how to act. Due to the great distance – 2,500 miles from home base – a military rescue operation seemed too risky. Nevertheless a swift decision was taken and Israeli commandos on board six airplanes, including an airborne hospital, left on what was codenamed 'Operation Thunderbolt', later renamed 'Operation Yonatan' after

Yoni Netanyahu, the Israeli commander who was killed during the rescue operation.

Like everyone else, I was glued to the radio. When it became known that the planes were on their way home, I rushed to the air base, where an anxious crowd of families and wellwishers had gathered to await the freed passengers and the commando soldiers, members of an elite unit whose faces could not be revealed. Everyone wanted to be part of the story. When the rear doors of the freight planes opened, the commotion was huge, with everyone looking eagerly for their loved one. It was almost impossible to get a clear frame.

After I developed the films and printed the contact sheets, it was possible to edit and get to the core image that showed the raw emotion and not too many other photographers in the frame. I chose a cropped version of frame 26 as most representative of the most dramatic moment. I now think that a triptych sequence with the many hands holding the returnee would probably be more effective, without even the faces."

Micha Bar-Am's tightly cropped photograph appeared in several newspapers, and was included in this profile in the *Salzburger Nachrichten*.

235

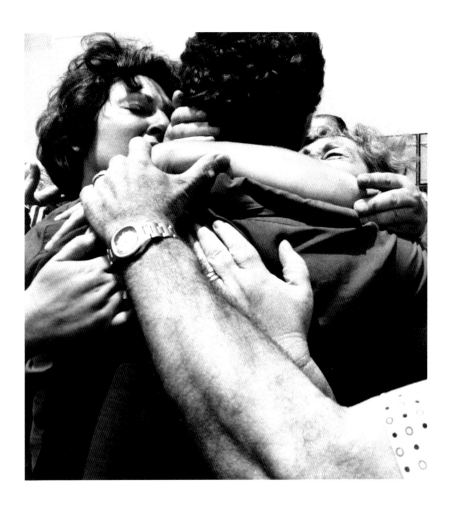

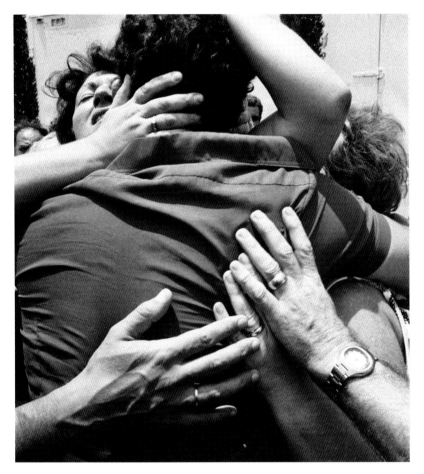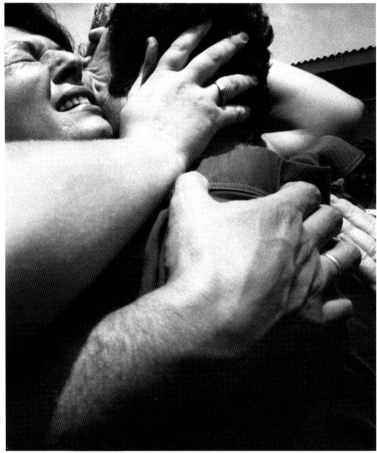

Le Brusc. Piscine conçue par Alain
Capeillères.

"Vacances des Français" pour Fondation de la Photo.

9⅜ to 6¾

#38119

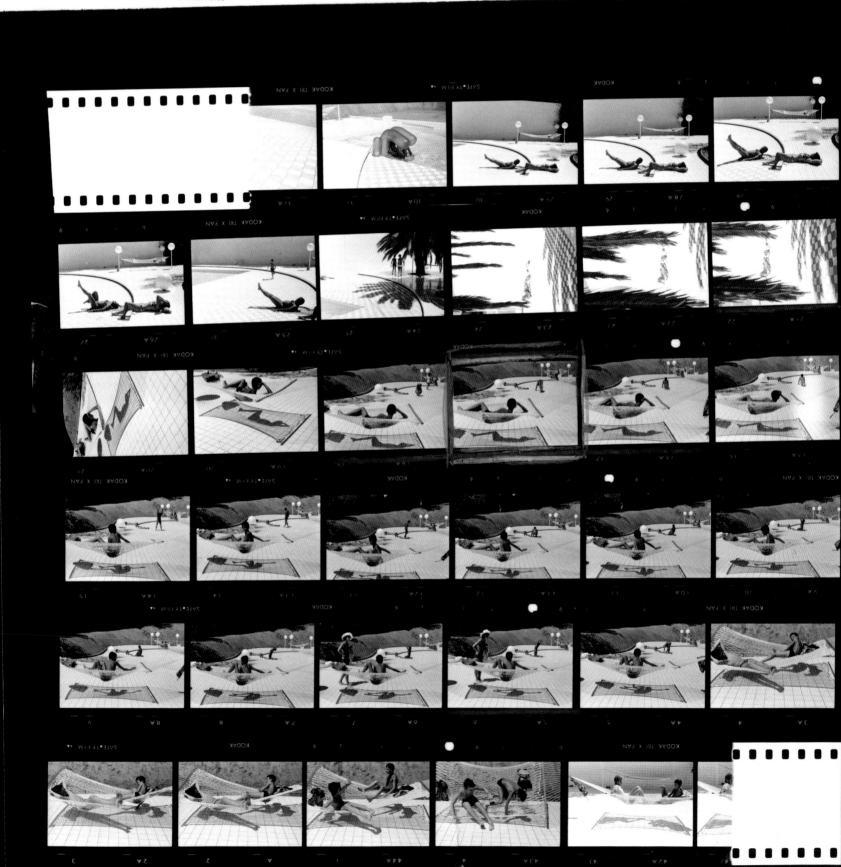

Provence, France
Summer 1976

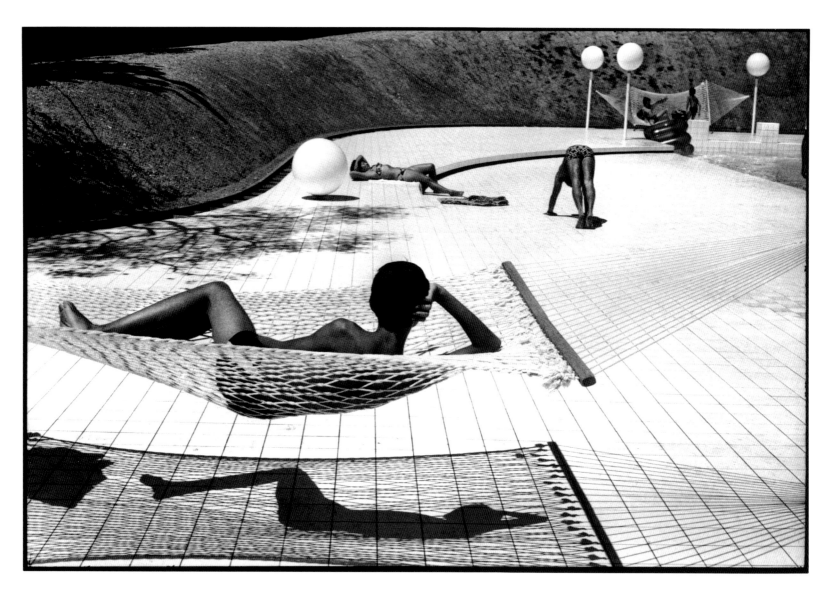

"I had been commissioned by the newly created Fondation Nationale de la Photographie, then directed by Pierre de Fenoyl, to take a look at the French on holiday. My friend, the architect Alain Capeillères, asked me to photograph his recently completed swimming pool, which he had designed for his wife Lucie.

I distinctly remember running to get the image, while changing the exposure on my Leica M3 (I used a 50mm lens and Tri X Kodak film), wondering if shutting down to f.16 at a 1,000th of a second would be sufficient. The sunlight on the white tiles was so intense and almost blinding. I remember the man in the background doing his push-ups and waiting for him to be in a taut position. I only had time to take four shots and then the young boy in the hammock turned around and saw me, and the picture was gone.

That is the excitement of taking photographs on the spot. Intuitively one grabs the image, and an instant later the perfect composition has broken up and is no longer to be seen. It's only when you go back to your contact sheets that you can see how the scene developed in time, which is why contact sheets are a neverending source of fascination to those interested in photography. I chose this precise image because all the elements were in place. There was no second choice possible. It was evident from the start which image should be printed, and there was only one image."

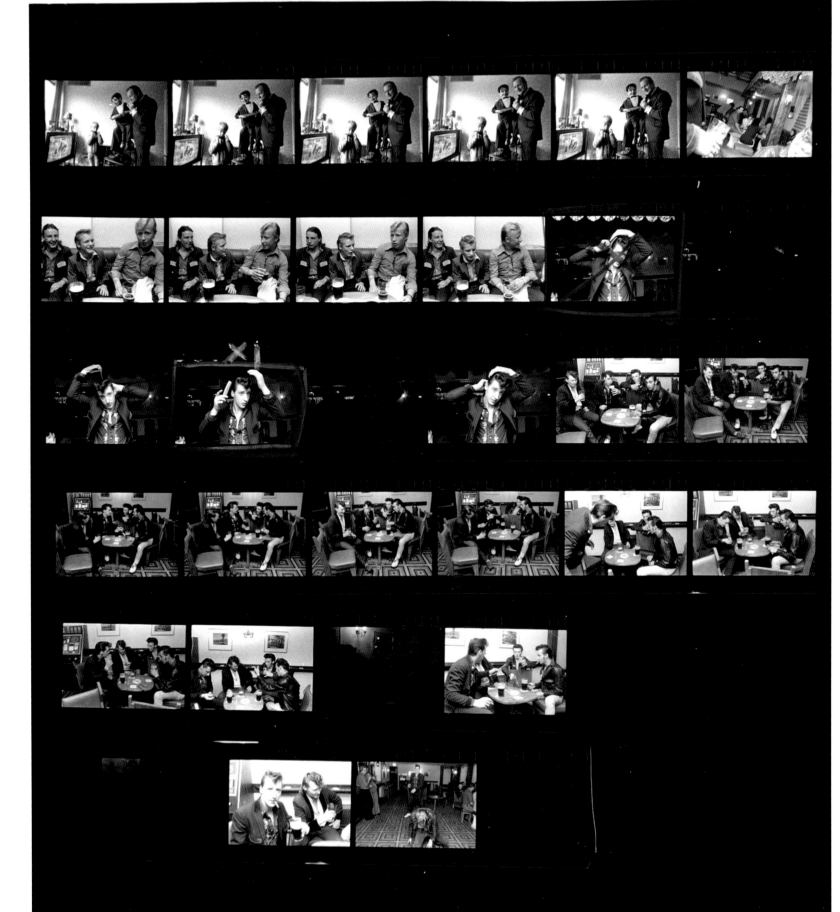

Bradford, England
1976

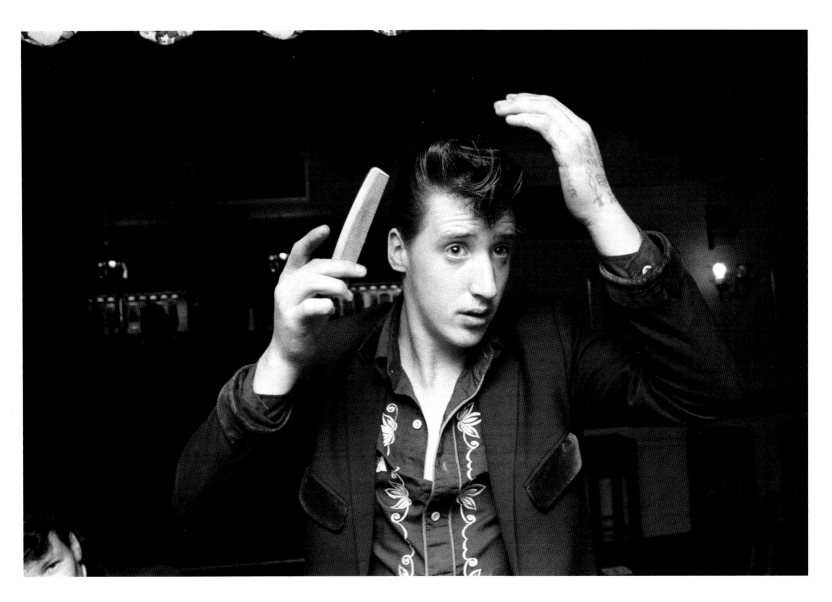

"In the mid-1950s the Teddy Boys were the first mass expression of British youth culture: a tribal clique dressed in Edwardian style and determined to strut, threaten, amaze, entertain and define the aspirations and imagination of post-war, working-class youth. *New Society* magazine asked me to photograph the Teddy Boy revival in the 1970s. I teamed up with my friend, the writer Richard Smith. I wasn't a Ted, but it was easy enough to fit in. I was the bloke who took photographs. Our book, *The Teds*, came out in 1979 and it's become a bit of a cult.

You can see here that the start of the roll is another situation entirely. It's a portrait job of a ventriloquist that I had, I think, for *The Listener* magazine. I guess I must have gone out later that night and decided to use up the roll shooting some photographs for my Teds project.

The picture of the Ted combing his hair is a little strange because you think that I'm shooting into a mirror … so, where's my reflection? The first frame is probably the one that grabs you immediately, as it's quite decisive, but I preferred the later one because it's of that moment when something is about to happen, yet is suspended, unresolved in time, and that injects a little tension into the image. I also wanted the eye.

The rest of the roll is pretty boring – the kinds of shots you sometimes take just to establish that you're there, working as a photographer, so people get used to you and ease up on the posing."

San Francisco, USA
1977

"I met TJ through Dorothy Geiger in Room 30 at the
Albert Hotel. I never knew her real name, since she told
me that she had lost it along the way. She was a bit older
than me, but close enough in age that our life-paths were
overlapping at that moment. She was an amputee who
had lost her right hand in a fight with another prostitute.
She worked the low-rent district of the Mission, doing
what she had to do in order to numb her mind afterward.
Our friendship grew beyond my standard documentary
practice. It was 1977, and most of my women friends
were emboldened by the times: they were becoming
'strong' women. It was problematic for me to see TJ
just as conscious and aware of her situation as my
women friends were, but, unlike them, stuck in a life
she didn't want and unable to do anything about it.

TJ was in her room most afternoons. She worked at
night, and when these pictures were taken there wasn't
much business because of her black eye, so during that
time she was willing to work with me. I would bring my
contact sheets for her to edit, and use her choices as a
guide. I'd return with a pile of 5×7s as gifts. I'd ask her
a few questions, such as: 'If this was the last picture ever
taken of you and put on your door as a remembrance of
yourself, what would you say?' I'd have her write down
the answers on the 11×14" prints I had made for myself.
TJ practised her writing on a piece of paper that I have
saved and cherished ever since.

About six months after these photos were taken,
TJ disappeared from the hotel and was not seen until
I ran into her at the intersection of 6th Street and Natoma
in the Tenderloin. Long-haired and dirty, eyes swollen,
her battle-scarred face cut and bashed-in, she was with
four guys who were fucking her for a drink. She could
barely speak, but was so upset with me seeing her
this way that she asked her friends to beat me up.
I left quickly, expecting never to see her again. A few
months later, I received a call from the emergency room
of San Francisco General Hospital, where she had been
admitted for being 'absent of mind and unable to function
on her own'. I tried – perhaps foolishly – to become her
guardian in order to help her avoid ending up in San
Francisco's home for the indigent and the elderly. I was
unsuccessful. To my best knowledge, TJ lived there until
she passed shortly after. She would have been around
thirty-four."

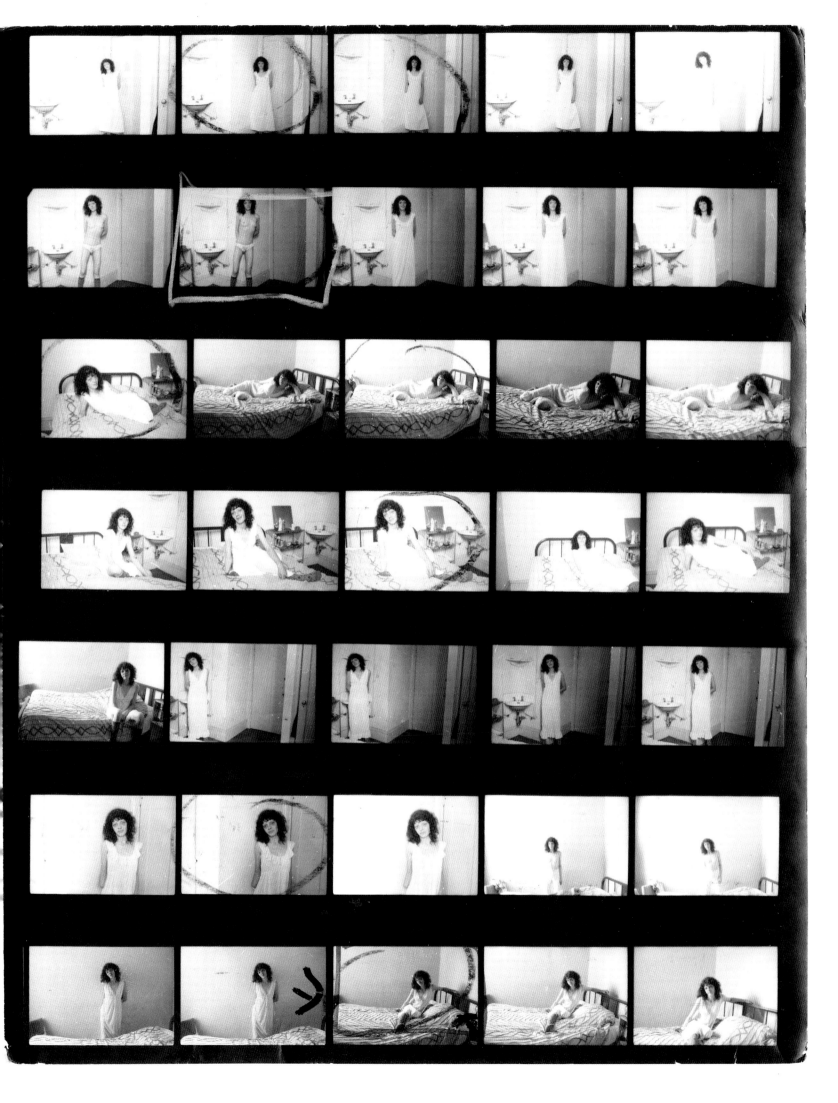

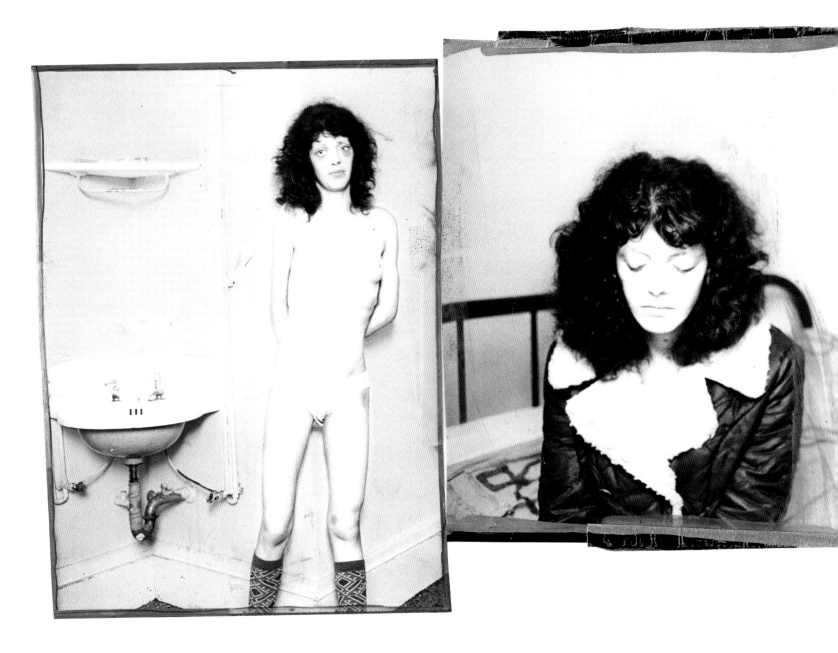

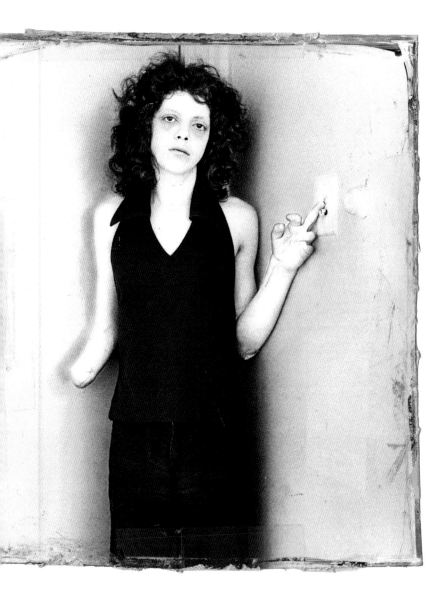

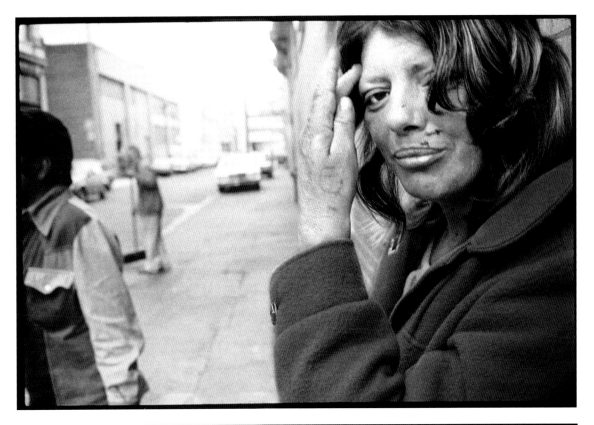

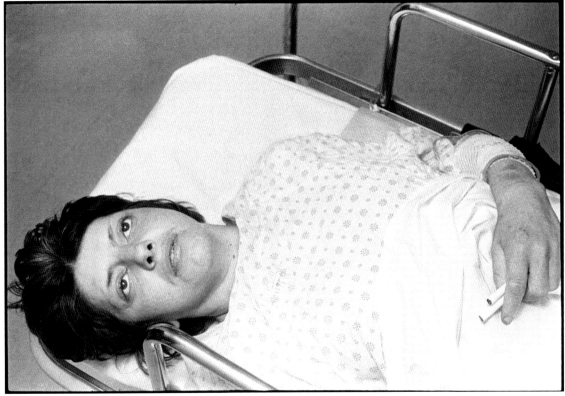

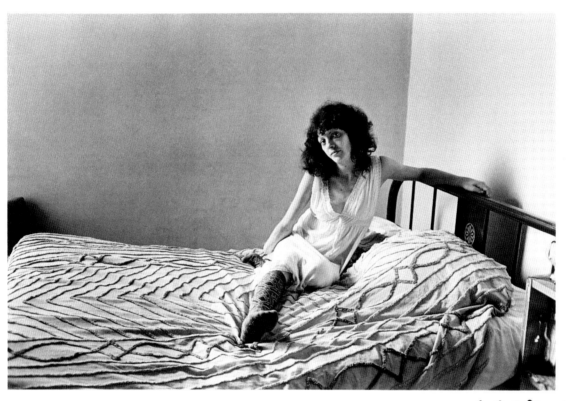

To me Life seems so messed up
But Liltter And Liltter i AM
TRYing to over come that.
Because it is haRd Being
a woMeN And to accept me
As i AM.

T.J.

Chad-Libya border
1978

"These pictures were taken in 1978 on the border of Chad and Libya. From 1975, I was spending all my time in Libya, doing a lot of coverage of 'the Claustre affair' (the French archaeologist Françoise Claustre had been kept hostage by Chadian rebels in Tibesti, to the north, for over a thousand days). Chad was a no-go zone, and very difficult to access: you had to pass through Algeria and Libya.

In 1978, the rebels were heading south in the direction of the capital. I was making a round-trip between Chad and Libya, and at one point I passed a van. The driver had been obliged to pick up all the passengers on his route, and they had hung their own luggage from the top with rope. When I passed the van, I was in a 4×4 car with the rebels, on my way back to Libya. But I've been

on that kind of transport myself, doing round-trips between Faya-Largeau and Sheba. There's a wonderful atmosphere up there. Everyone sits on the roof, and the women sing. I adapted very well to the desert. It was like being home.

I took the photo of the van with a 28mm Nikon reflex. It's been published as a postcard but it hasn't been in the papers much. I shoot essentially in analogue and in every format: 135mm, medium-format, large-format. My background as a photojournalist allows me to be open-minded about things, even if I don't necessarily shoot for the news. Looking at a contact sheet is, I find, like reconstructing your own human path. It's a beautiful moment. It's perhaps even more beautiful – more enjoyable – than taking the picture."

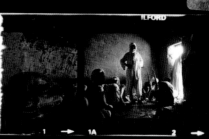

1 1A 2

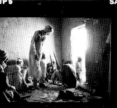
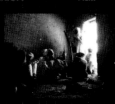
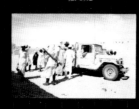
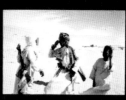
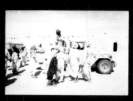
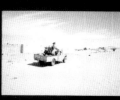

2A 3 3A 4 4A 5 5A 6 6A 7 7A 8

8A 9 9A 10 10A 11 11A 12 12A 13 13A 14

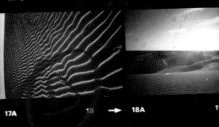
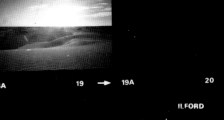

14A 15 15A 16 16A 17 17A 18 18A 19 19A 20

20A 21 21A 22 22A 23 23A 24 24A 25 25A 26

26A 27 27A 28 28A 29 29A 30 30A 31 31A 32

32A 33 33A 34 34A 35 35A 36 36A 37 37A 38

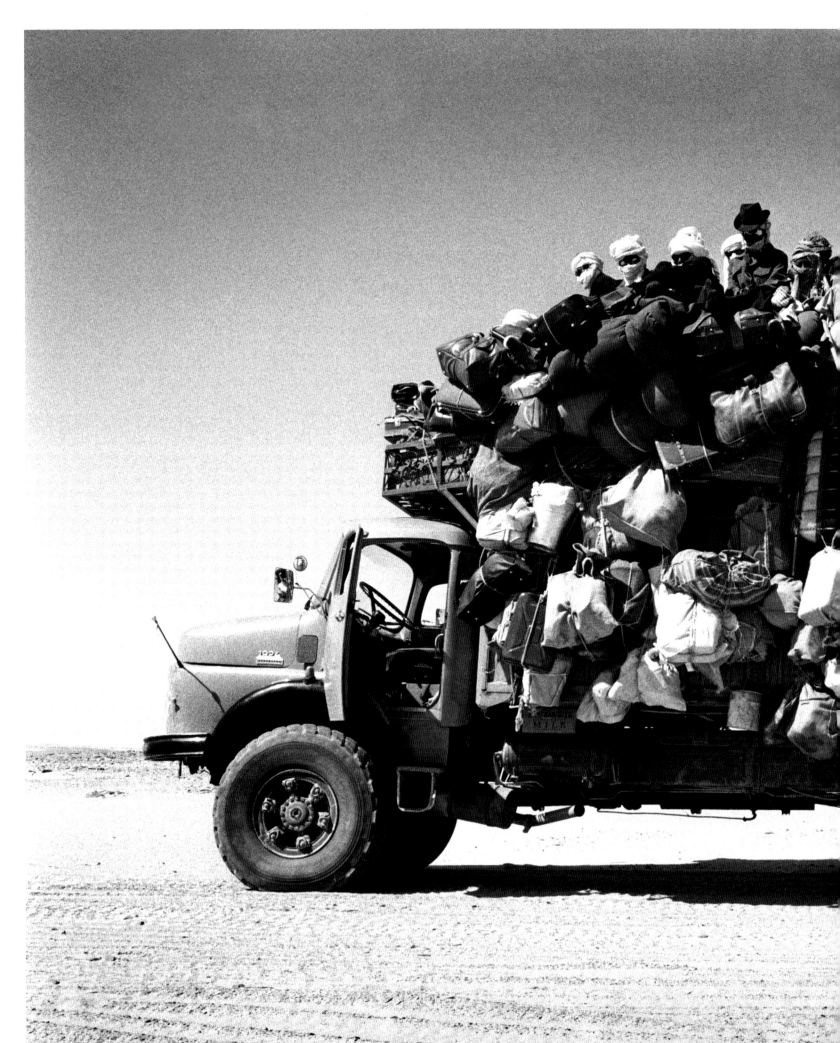

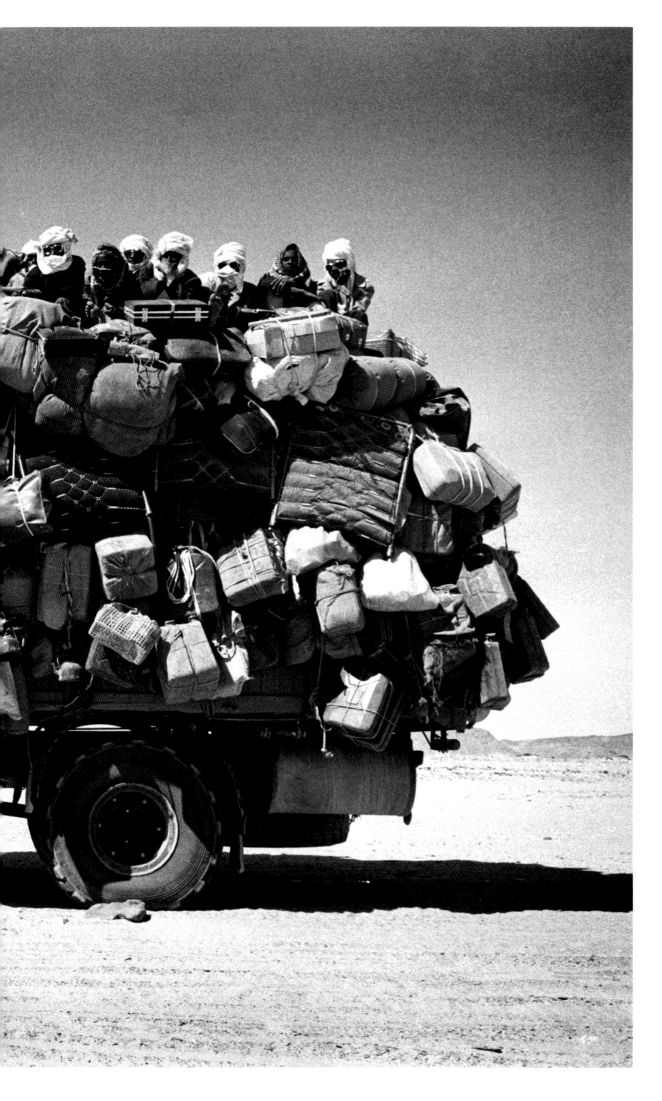

78-9-
9

New York, USA
1978

"The London *Sunday Times* asked me to do a story on violence. I photographed what I thought violence meant to me. If I couldn't open a window because of pollution, that was violence to the person, I thought. And graffiti was a violence to the eyes, and a lack of trees in the city was a violence to the mind. Anyway, that was the story I sent to London. Afterwards they sent me a telegram from London, saying 'Great, loved the story, but needed more blood and gore.' I then went out and photographed over fifty homicides. They just loved it.

I was more interested in who the police were. I wanted to understand what they do, why we cannot do without them. It was a sociological study related to what I felt about the police. I assigned myself to do this project. I wanted to get involved in their lives; to see why some people could call them 'pigs'. What do people know about brutality? Policemen are working-class people. They're not psychiatrists, they're not lawyers, they're not doctors. They are blue-collar workers. I look at them from the point of view of the working class, not the ruling class. I am very conscious that I come from a working-class family myself. My father was a working man. I can identify myself with these people. But I am not romantic about working-class people… So this is why I tried to understand the police, to have contact with them, be sympathetic, talk to them, understand their problems. Police don't talk to other people; they never talk to anyone about their experiences. They are not educated to talk; they are supposed to be strong, silent types. I literally spent days with policemen. Some didn't want to work with me; some agreed. I didn't want to be against them, to show brutality. I was not a spy…

Contact sheets are mostly a waste of money, I find. 99.9 per cent of the frames on the contact sheet are mistakes one makes while photographing. Because it is a waste of money, I love them. There are things in life we must do just because we find them unprofitable. Also, contact sheets are private: they belong to me, whereas photographs, once they are out of my hands, take on a life of their own."

ABOVE Captions by Leonard Freed, handwritten by his wife Brigitte on the back of prints in preparation for Freed's book, *Police Work*, published in 1980.

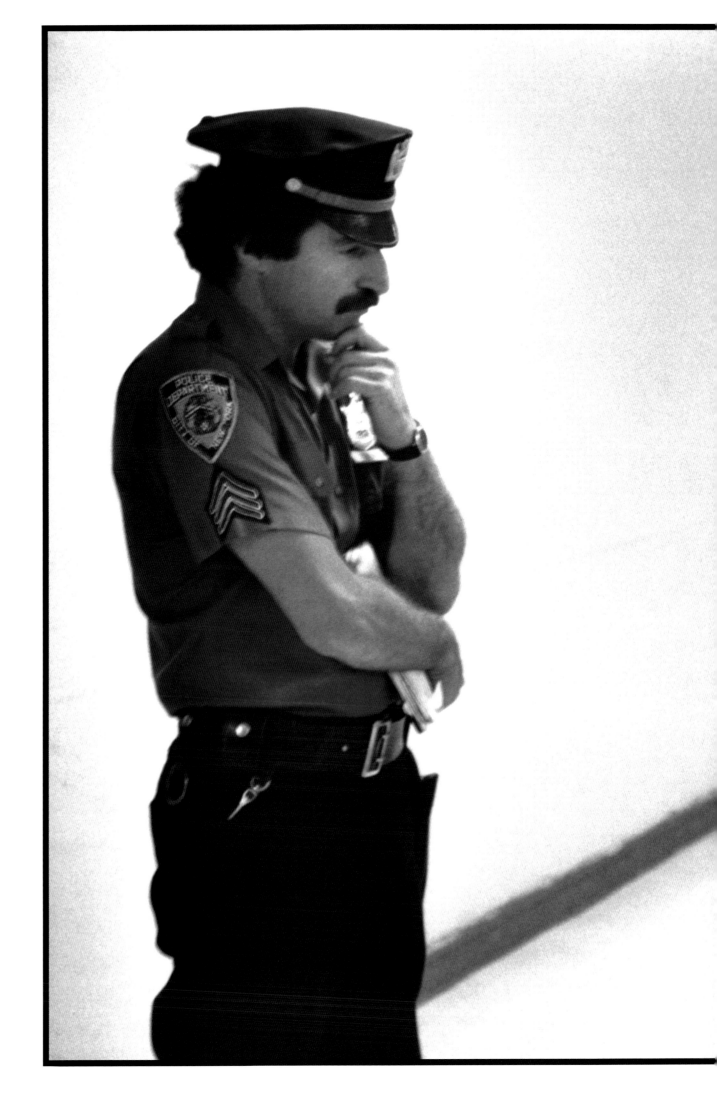

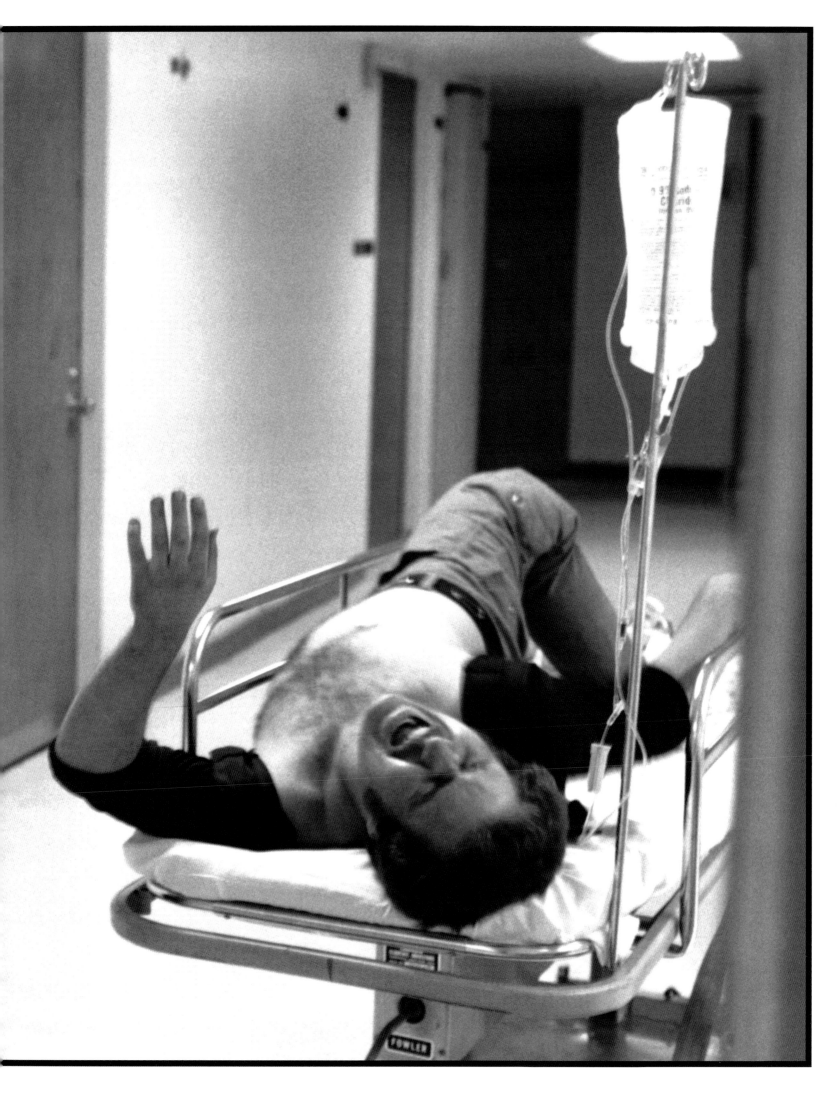

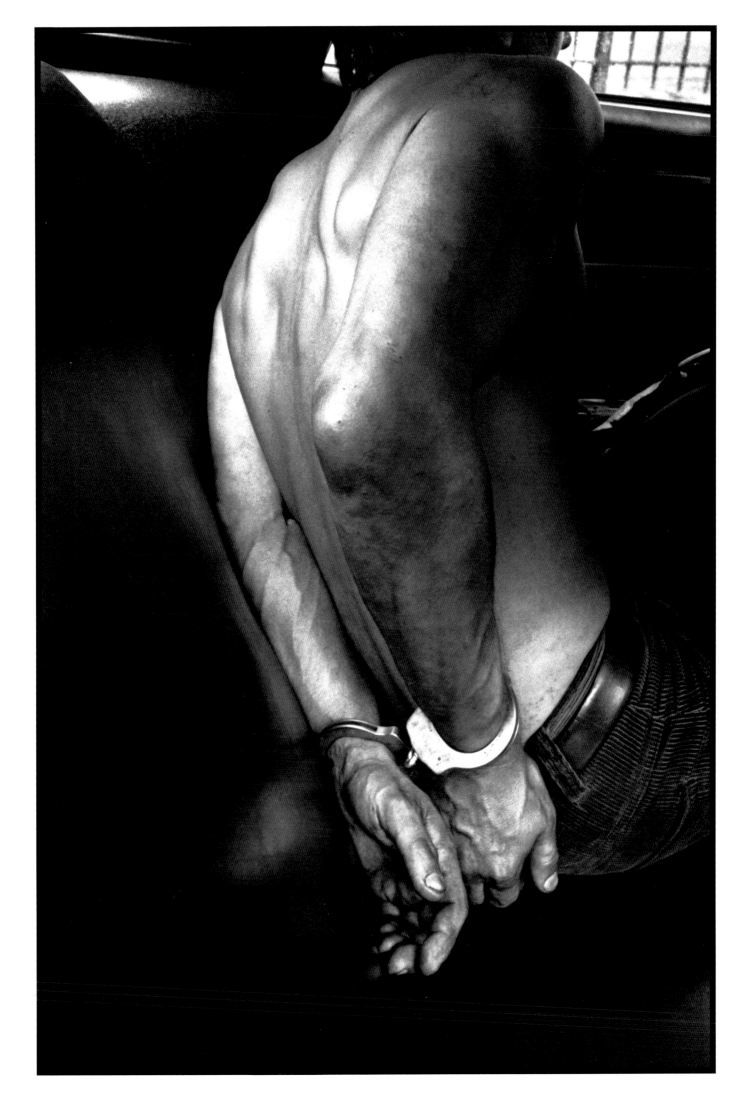

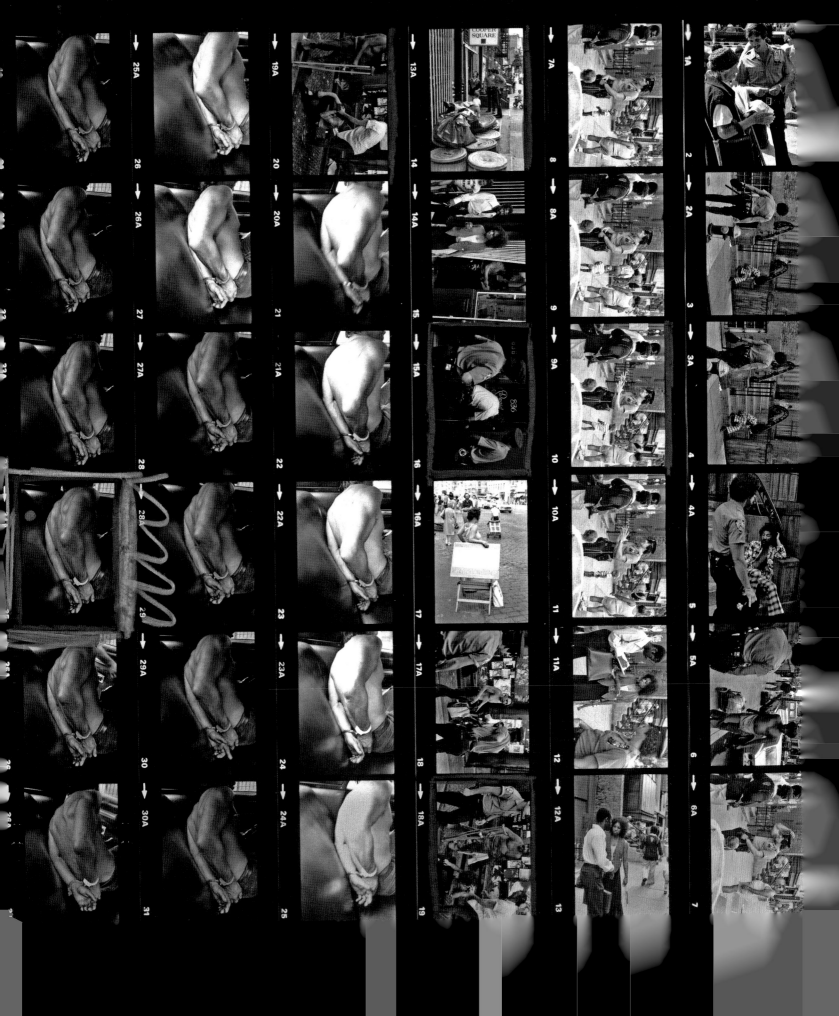

1978　　**HIROJI KUBOTA**　The Golden Rock

Kyaiktiyo, Burma
Spring 1978

"In 1969, I spent time in Okinawa, then still under American occupation, at a time when the Vietnam War was at its peak. This gave me a strong desire to photograph an Asian country that stood in complete contrast to America. That was Burma.

Burma had been one of the richest countries in Southeast Asia, but after the 1962 coup it became one of the poorest, with freedom of speech muzzled by the military dictatorship. However, I was completely charmed by the Burmese people, who were always kind and generous, despite their hardship. This was a mystery to me until I became aware that it was their faith that brought them these qualities.

I had frequently visited the Buddhist sacred land of Sagaing, but now decided to go to Kyaiktiyo, where the famous 'Golden Rock' was situated. The trip consisted of a three-hour ride on a packed train from Rangoon, followed by a couple of hours of mountain climbing. Naturally, you couldn't return on the same day, plus the region was known for Mon insurgents kidnapping foreigners for ransom. I therefore wore a native loincloth called a 'longyi', and pretended that I was on a pilgrimage. I was accompanied by my local friend and didn't utter a word throughout the trip.

Unfortunately, when we got there, the rock was entirely covered with bamboo matting because its gold foil was being restored. I had no choice but to spend the night at the lodge on the mountaintop and leave for Rangoon in disappointment. After two or three months I was told that the restoration work was over, so, with much enthusiasm, I went back for my second visit. Would you believe it, most of the matting was still there! A few months later, my friend assured me that this time there would be no problem. Third time lucky, I told myself … and, lo and behold, the rock was glistening in pure blinding gold. The weather was clear and the deep blue sky perfect. In spite of this, the pagoda placed on top of the rock was not yet uncovered. As I wondered what to do, some serious-looking monks approached the rock and began to pray. The setting was so beautiful that I began clicking away, irreverently cropping out the pagoda and its enshrined Buddha's hair. I can't help but believe that it was the soul of my grandmother, who'd died that spring, who guided me to this sublime scene."

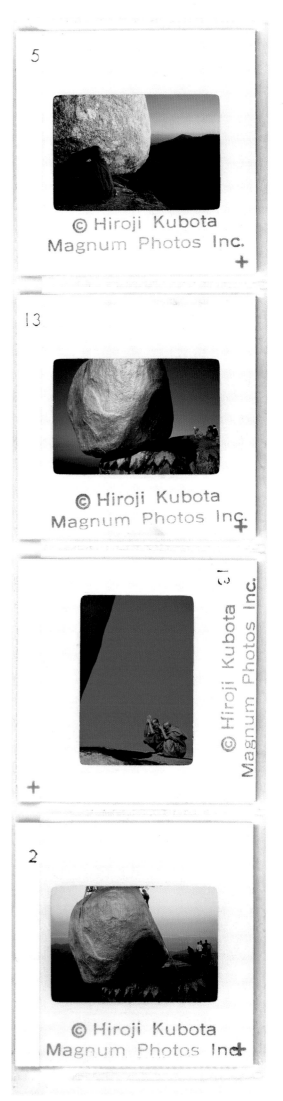

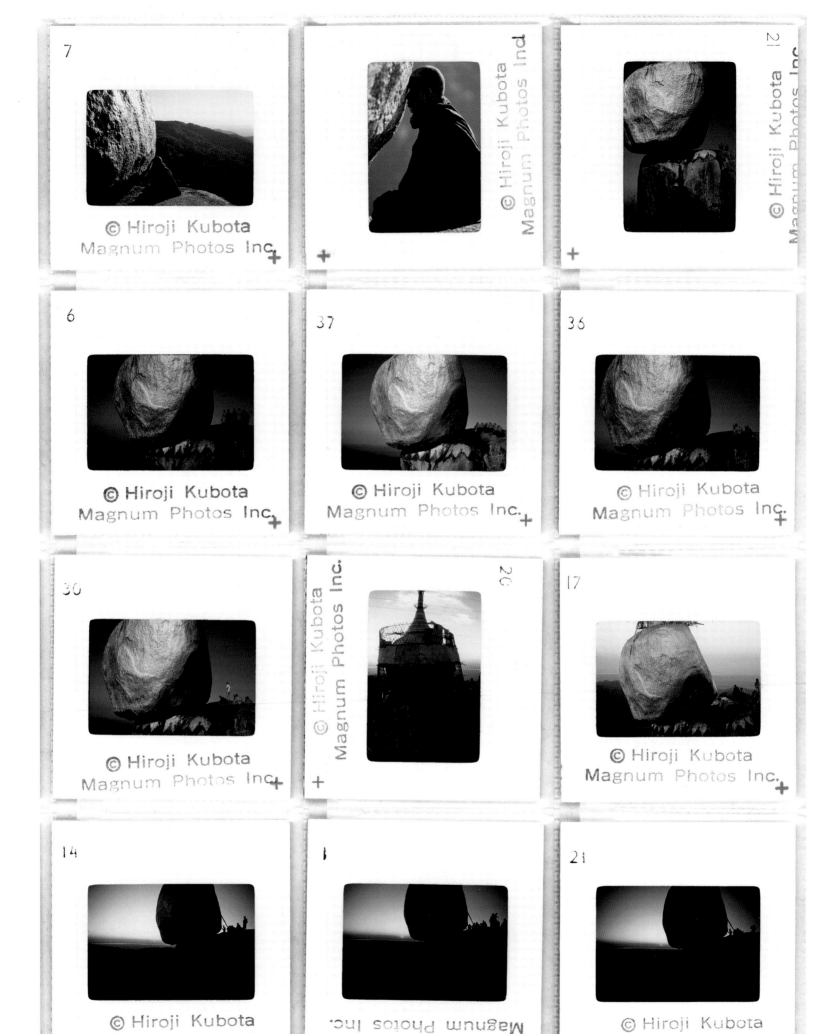

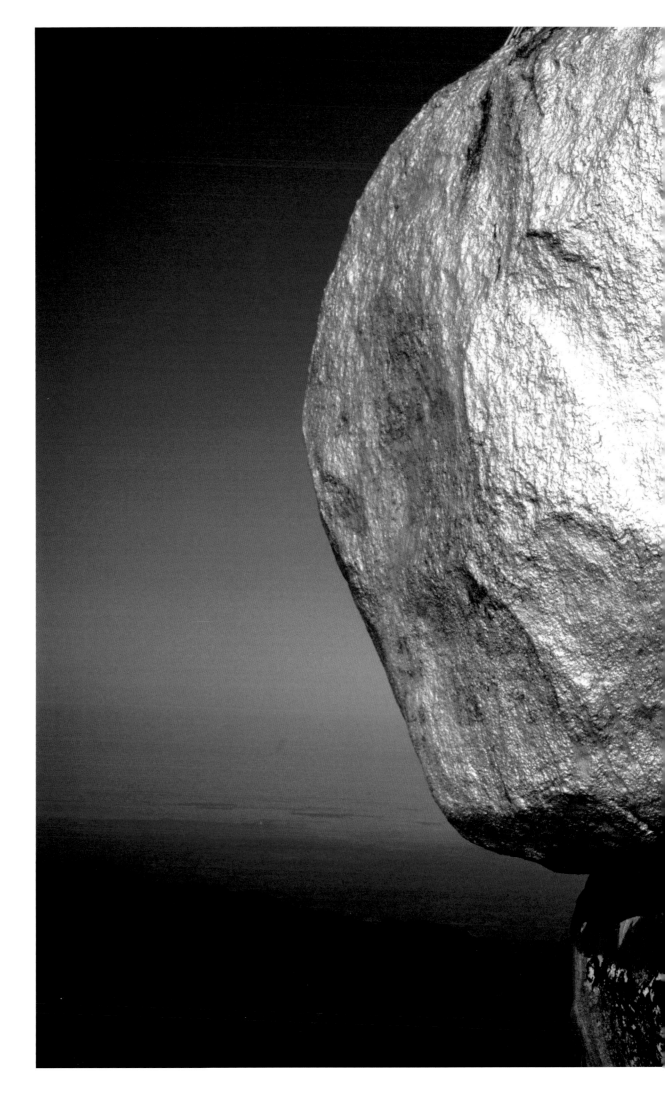

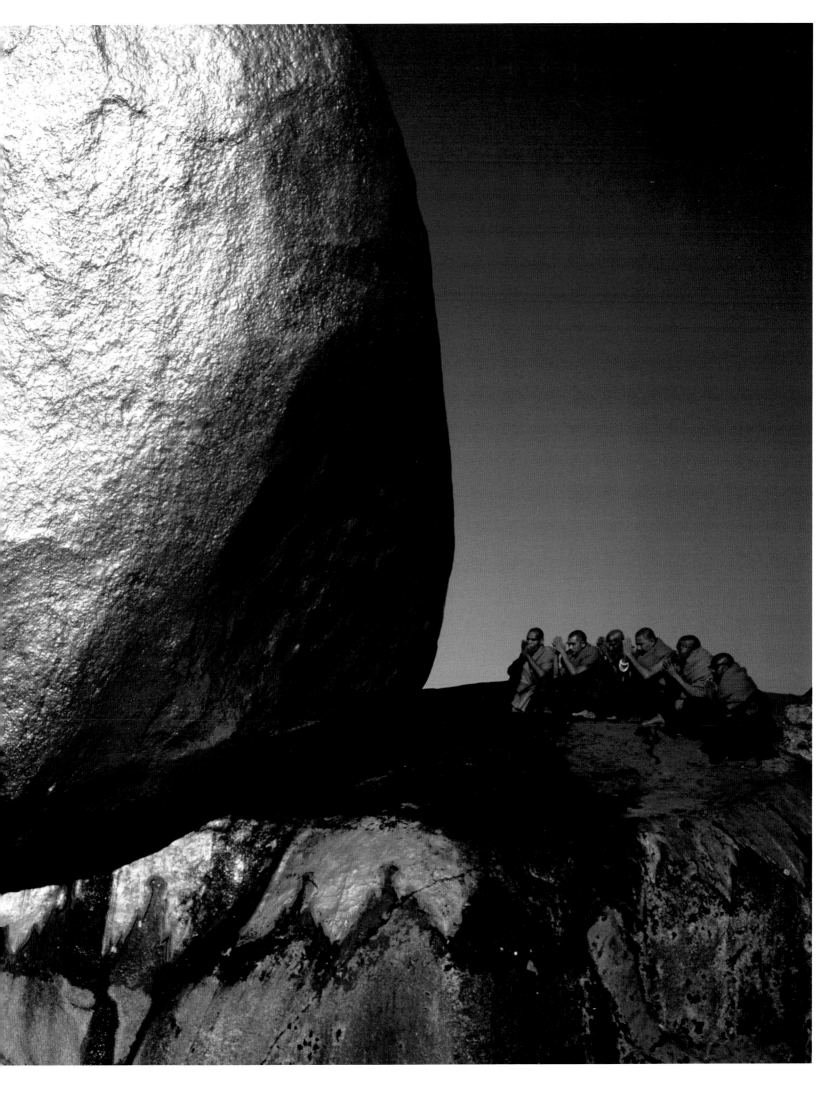

Masai Mara, Kenya
Summer 1978

"It was only by chance that I met again the Masai I had known so long ago in Africa … a thousand to one chance … for I found him, inexplicably, in a Belgian hospital! Several weeks later we met again, by prearrangement this time, in Kenya. 'Would you like to photograph the Masai?' he asked. 'Some ceremony perhaps?' I couldn't believe it. On fifteen different trips to East Africa I had tried to photograph the Masai and got no further than the polite offer of a long-bladed spear between the ribs.

At first light, two days later, we drove out of Nairobi. After hours of bush whacking, my friend said we had arrived. It was one o'clock in the morning. We had to leave again at four because the Masai settlement was still another hour away, and the ceremony had to start early because there was a belief that 'there was less bleeding before sunrise'. Wrapped in a Masai blanket I was soon asleep but up again at four.

A tall Masai ran ahead of the Land Rover to show the way. Some young Moran came to greet us and then formed a tight circle, jumping up and down, and singing in the half light. Inside the circle was a dazed young man, completely naked. It was only then that I realized the 'ceremony' I was about to see was a circumcision ceremony … a very rare privilege indeed. The young Moran taunted the hapless initiate. I pushed my way through the circle and cursed the lack of light. The naked youth looked bewildered. A small boy poured water over him – the cleansing ceremony. Suddenly he leapt to his feet and attacked the boy, knocking him down. Then he rushed at me. It was very fast and I got no pictures of it. There was no anger in this display. It was a gesture to show disdain for what was to come.

With another quick rush he threw himself onto a cow hide and he leaned back against an 'uncle', who held him tightly. He spread his legs to await the knife. The mocking cries ceased. There was complete silence and the pale orange light, coming now from the east, added a touch of drama. Nobody took exception to my camera and so, when presently the 'doctor' came, whetting an ordinary clasp knife on the horny palm of his hand, I moved in with him and knelt on the ground by his side.

The 'doctor' splashed the white sap of some shrub over his hands and knife, which I presume was an antiseptic. Then he took the first cut. The young initiate's expression never changed. Neither did he flinch. A second cut was made, and then a third. The whole operation took more than a quarter of an hour and it seemed to me it was prolonged intentionally to test the initiate's fortitude. I photographed the whole operation step by step. But, as yet, there was very little light, and a man leaning on my back made it difficult to steady the camera for a 1/4-second exposure. The initiate was raised, semi-

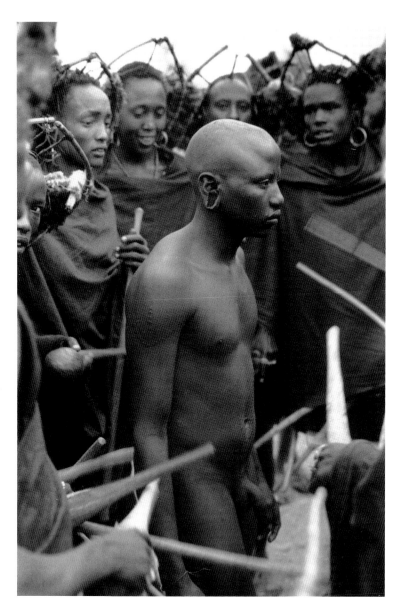

conscious, by his 'uncle' and trundled to his mother's hut. He had no strength to stand and hardly sufficient to move one foot after the other.

I could never have got my Masai pictures if handling my camera hadn't become second nature to me, a matter of reflexes as instinctive as opening one's mouth to bite an apple. But in such situations the technical side is the least part of it; what's vital is the contact you make with the people you're among. Basically this is a matter of the respect and liking you feel for them, and which somehow they understand and feel towards you in return."

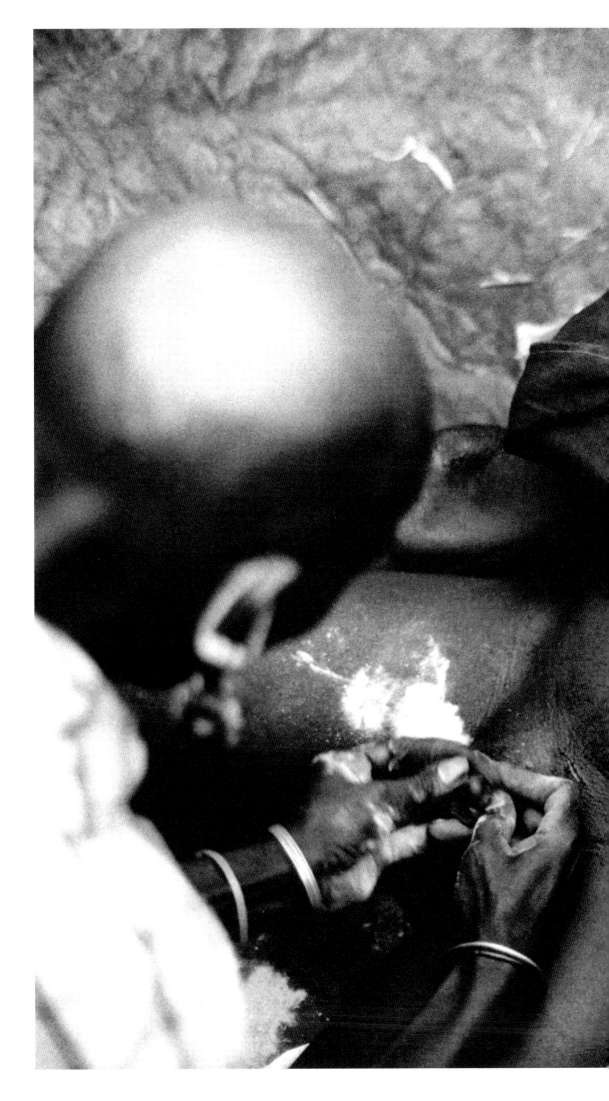

Tehran, Iran
November 1979

"On 4 November 1979, a group of 'student' revolutionaries took over the US embassy in Tehran and held its diplomats hostage. I had been covering events surrounding the Iranian revolution for almost two years, but this time I didn't rush to Tehran because an earlier occupation of the embassy, which I had witnessed, had been sorted out within a few hours. This one, however, lasted 444 days.

When I arrived in front of the embassy a few days after the occupation had begun, what I found didn't look like a world-changing geopolitical event; it looked more like a festival. Around the crowd of curious onlookers, travelling stallholders had set up shop, banners were unfurled and photos were pinned to trees. Groups of students, workers, farmers, soldiers, schoolchildren and mothers with babies were taking it in turns to stand in front of the embassy gates to yell out their hatred of the

US and to chant verses – what a nation of poets this was! – in support of the revolution.

A contact sheet reflects not only what the photographer sees and chooses to capture in time for all eternity, but also their moods, their hesitations, their failures. It is pitiless.

My films were sent to Paris to be developed and edited, and my reports were sent around the world. It was only when I got home that I noticed that behind the armed militants chanting slogans, with their fists in the air, behind a banner denouncing imperialism and promoting democracy, a silhouette of the Statue of Liberty could be seen, also with her arm seemingly facetiously raised. A statue from the same country whose diplomats were being held hostage just a few metres away. An example perhaps of history on a small scale being playful with History?"

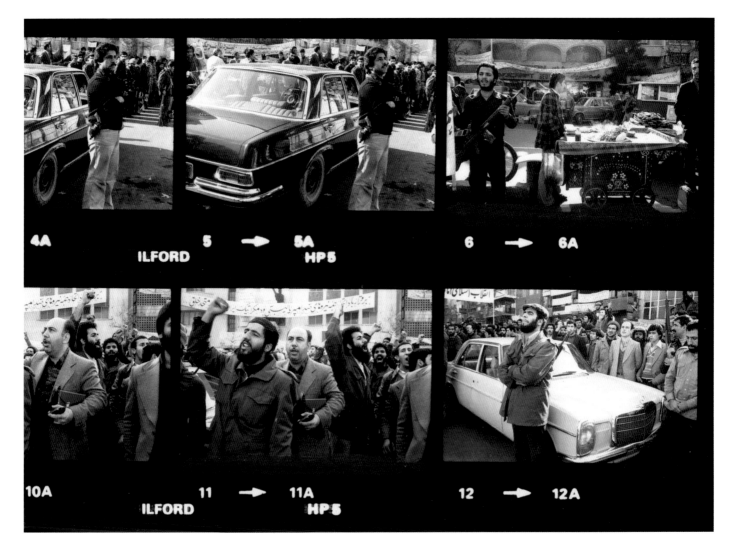

270

Tehran - Nov.

ABA 1979022 W00031

- In front of US embassy where diplomats are kept
hostage. Street vendors (6-8) Big shot + car (9-12)
Armed militants in uniform - future Revolutionary
Guards (?) - Foreign journalist

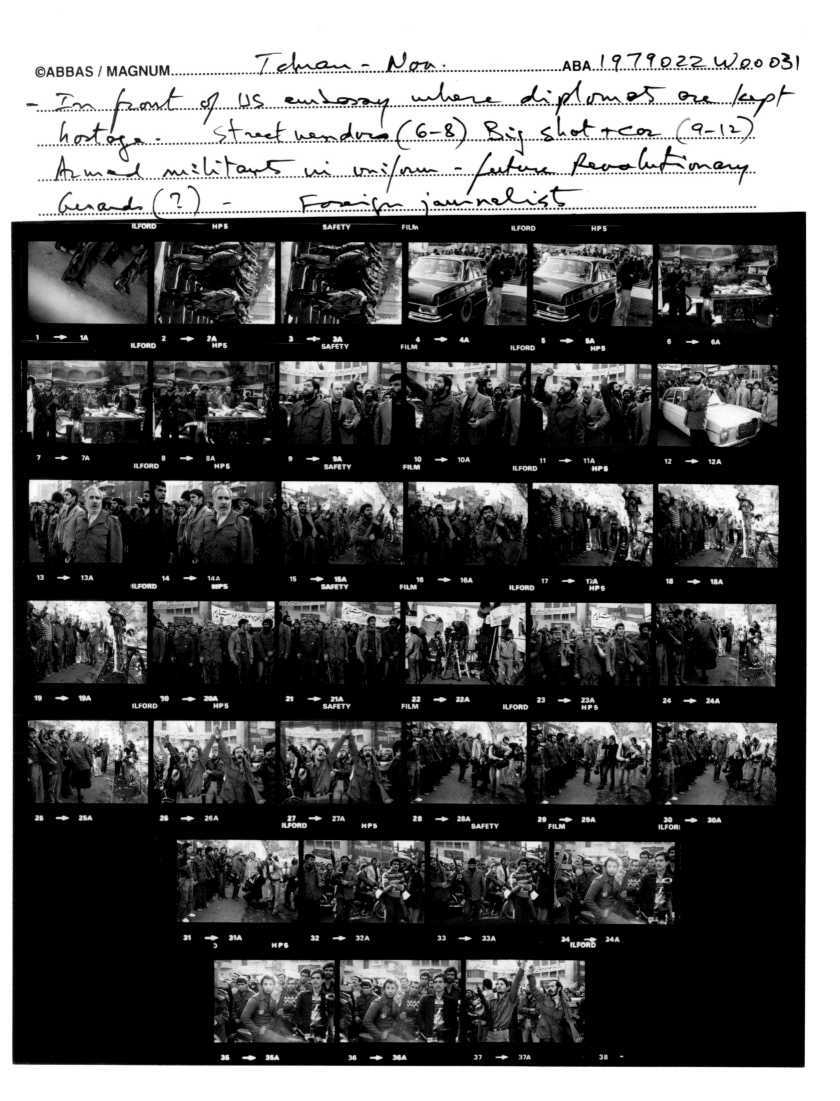

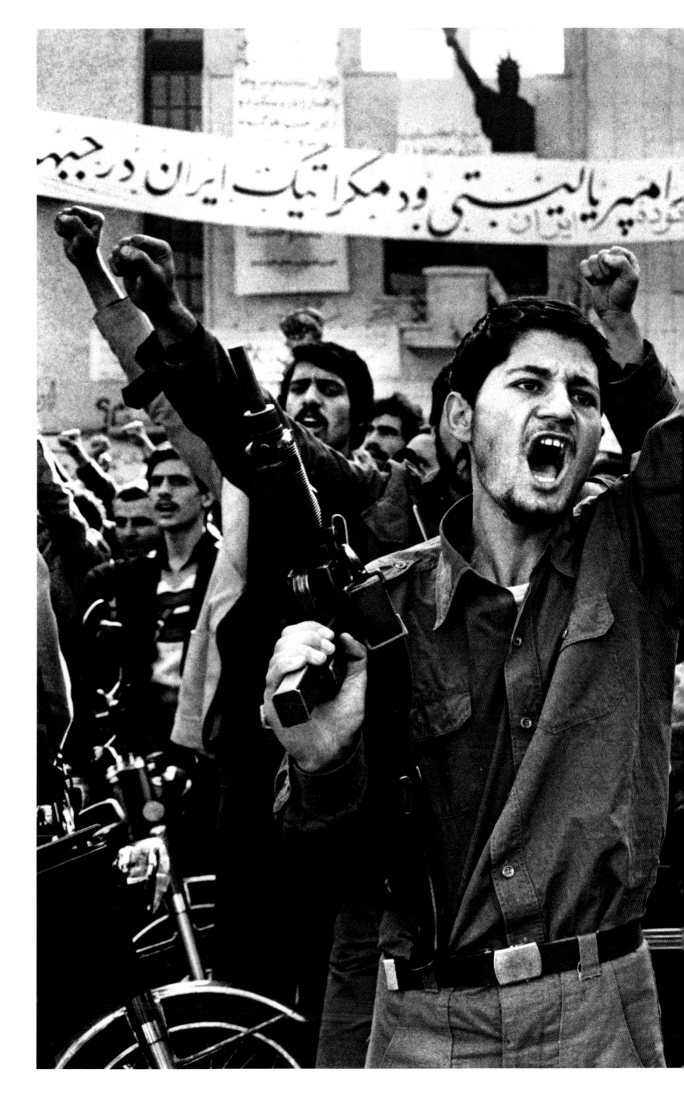

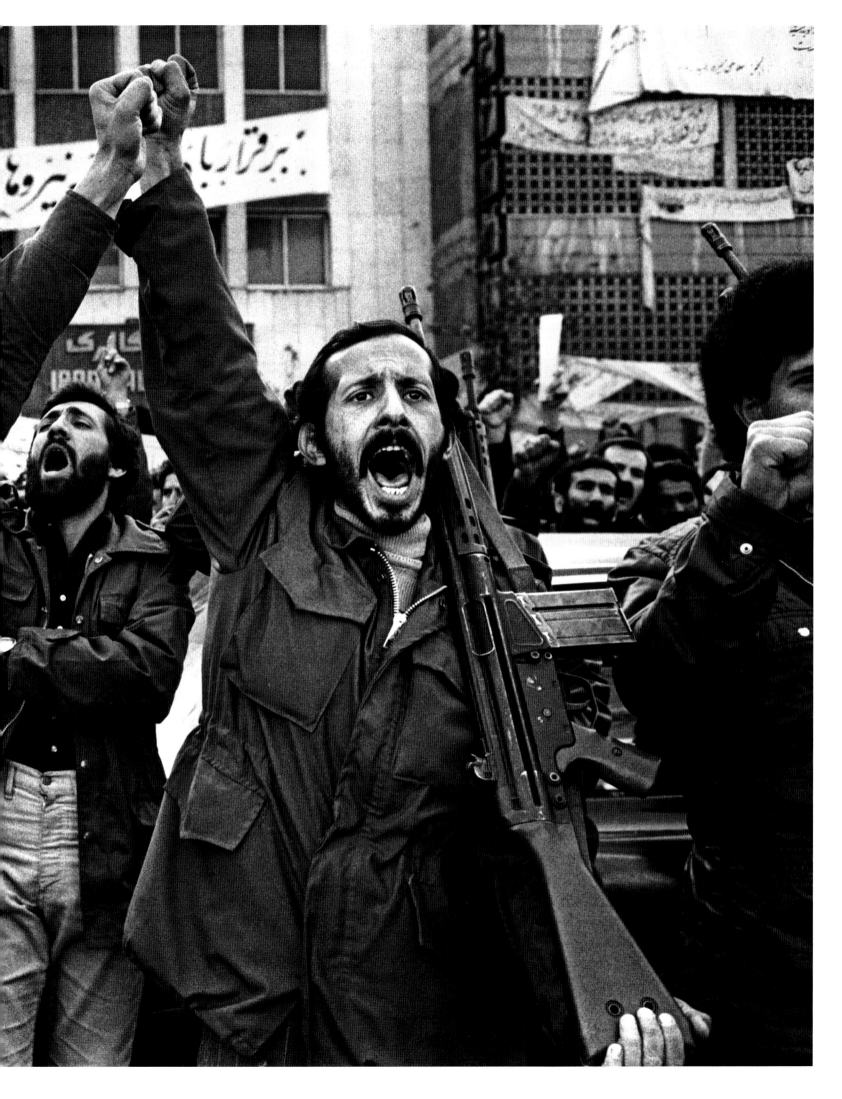

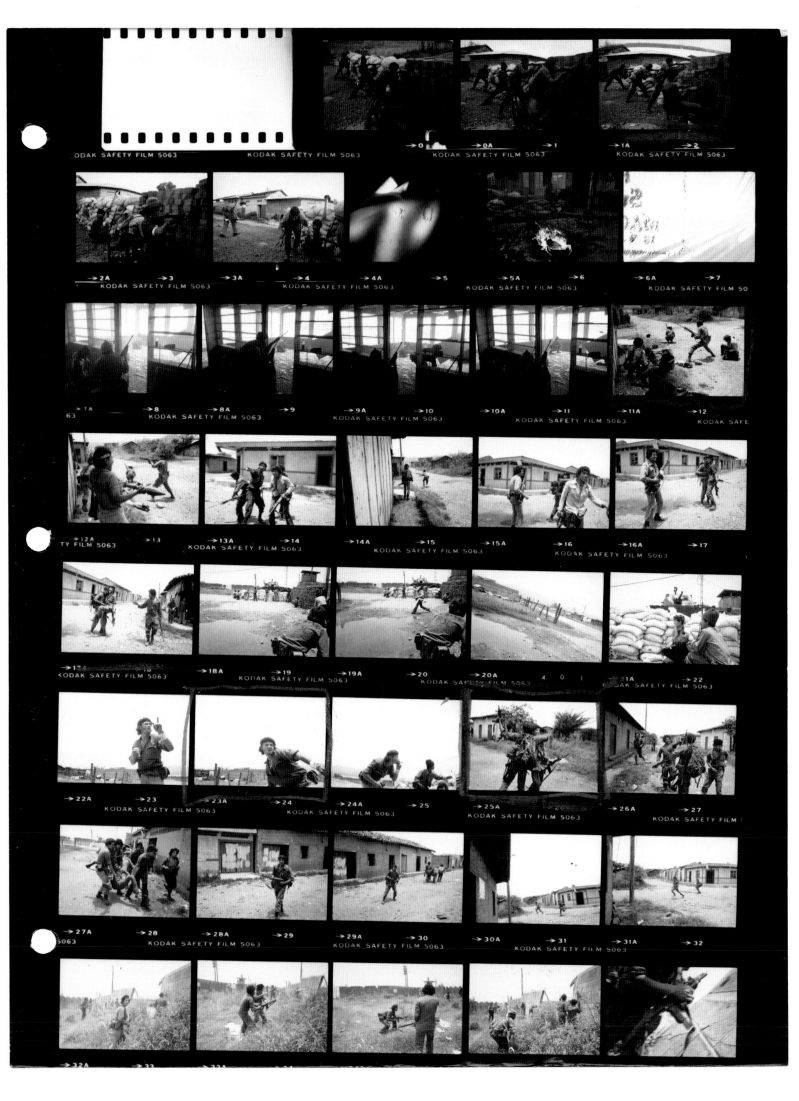

Estelí, Nicaragua
July 1979

"I went to Nicaragua on 1 June 1978. In my early weeks there, I was frustrated because I knew things were happening that I couldn't find a way to photograph. I would go out early every morning, often without a plan, though sometimes hearing the radio would draw me in one direction or another. In the first weeks it was mostly exploratory, getting to know the roads, the *barrios*, sometimes encountering people who later became friends, such as Justo Gonzales, whom I've seen every time I've been to Nicaragua over the last thirty years.

I initially worked with two cameras, one with black-and-white film and the other with colour. Increasingly, I came to feel that colour did a better job of capturing what I was seeing. The vibrancy and optimism of the resistance, as well as the physical feel of the place, came through better in colour. This was at a time when photographs in newspapers were still in black and white, as was traditional documentary and war photography. Colour was associated with commercial photography, and some critics thought that it romanticized the young Sandinistas and glamorized the conflict. For me, the black and white became more like a sketchbook, because I could process it locally. Though I didn't always know what I had, it helped me caption my material in the field. It was my own reference with which I could advise Magnum about the material I was sending.

The unprocessed colour film had to be shipped via trusted couriers, which was an elaborate operation at that time, and meeting deadlines was critical to reproduction. All the airplanes stopped when the war intensified, and you had to be sure that on the day you shipped your film there would be someone to hand-carry it from Managua, and someone to pick it up in Miami, who could then send it on to New York. Once it was safely in New York, Magnum would pick it up, take it to the lab, process it, edit a selection and deliver it by hand to the magazines.

However, at times I felt very isolated from the editing process – in a vacuum. Magnum's support allowed me to stay an extended time in the field. There was always an element of doubt and the question of: how do you know that the material you have is important? But that's also what kept me shooting – not knowing what I really had. That not knowing is totally different now with digital cameras. We've lost that sense of surprise.

I never used a motor drive, so, as you can see with the picture of the 'Molotov Man' (whose real name I now know is Pablo Araúz; his pseudonym was 'Bareta'), I nearly missed the dramatic moment, between the frames of the two Leicas I was using at the time. One was loaded with colour film, the other with black-and-white. This single frame became an iconic image, a young Sandinista during the final days before the Triumph over Somoza, and is still a symbol of the revolution thirty years later."

TOP AND ABOVE Susan Meiselas's iconic photograph appropriated for a Christian publication and a matchbox cover celebrating the first anniversary of the Sandinista Triumph.

LEFT AND OVERLEAF Meiselas worked with two cameras simultaneously, one containing black-and-white film (note contact sheet frames 23-25), one containing colour film (see the selected colour frame overleaf).

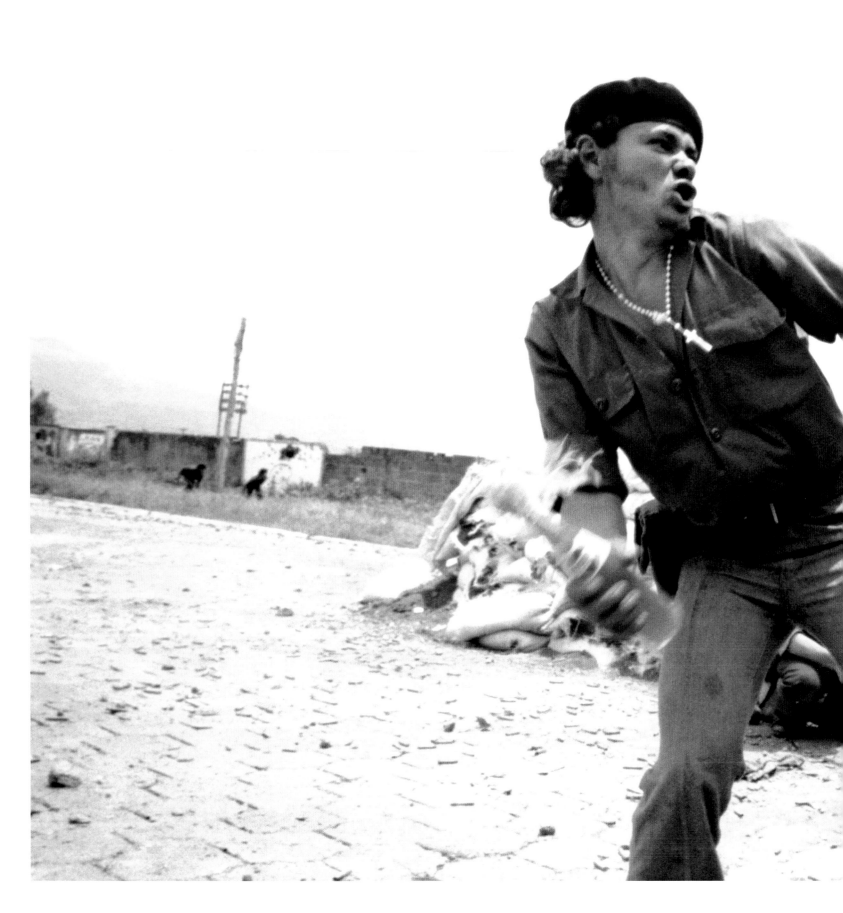

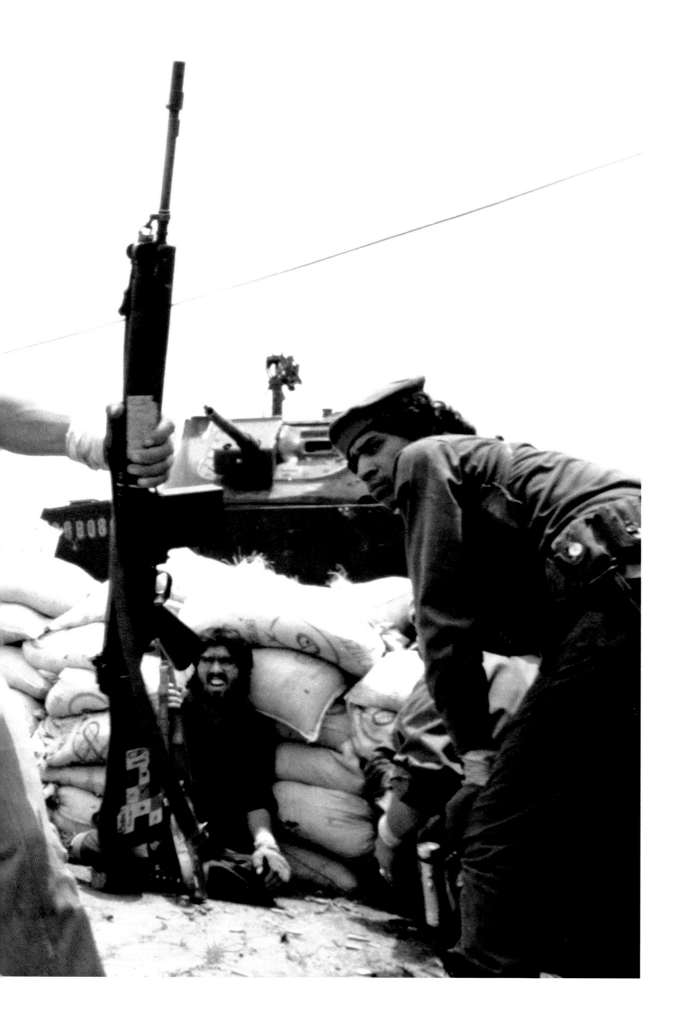

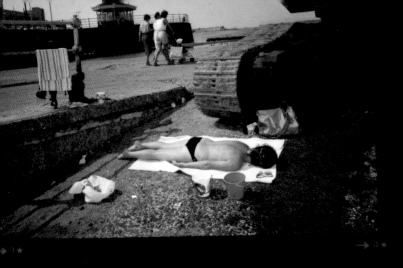
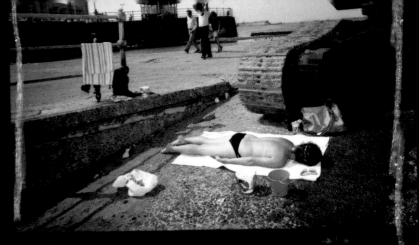
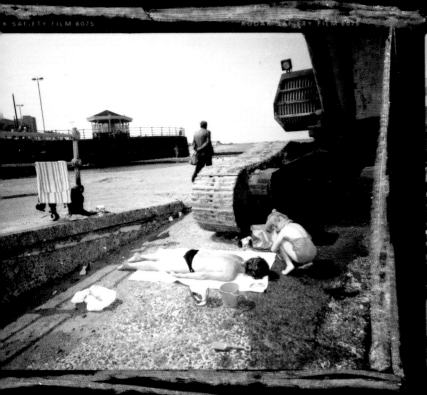
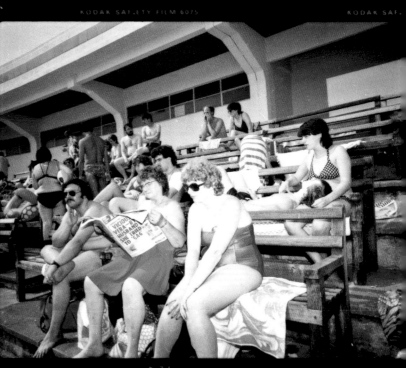
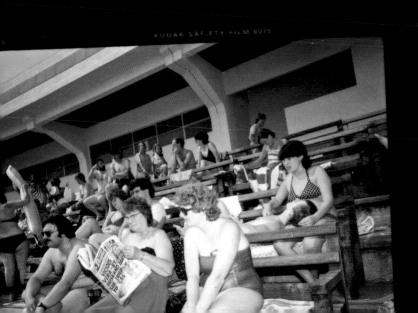
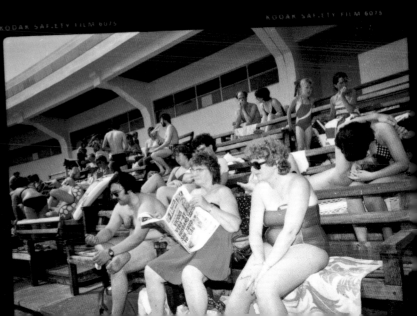

MAGNUM photos

Captions

© Richard KALVAR magnum

Remarques

Story Nº	80-2-36
Roll Nº	
Dist Nº	
Color	

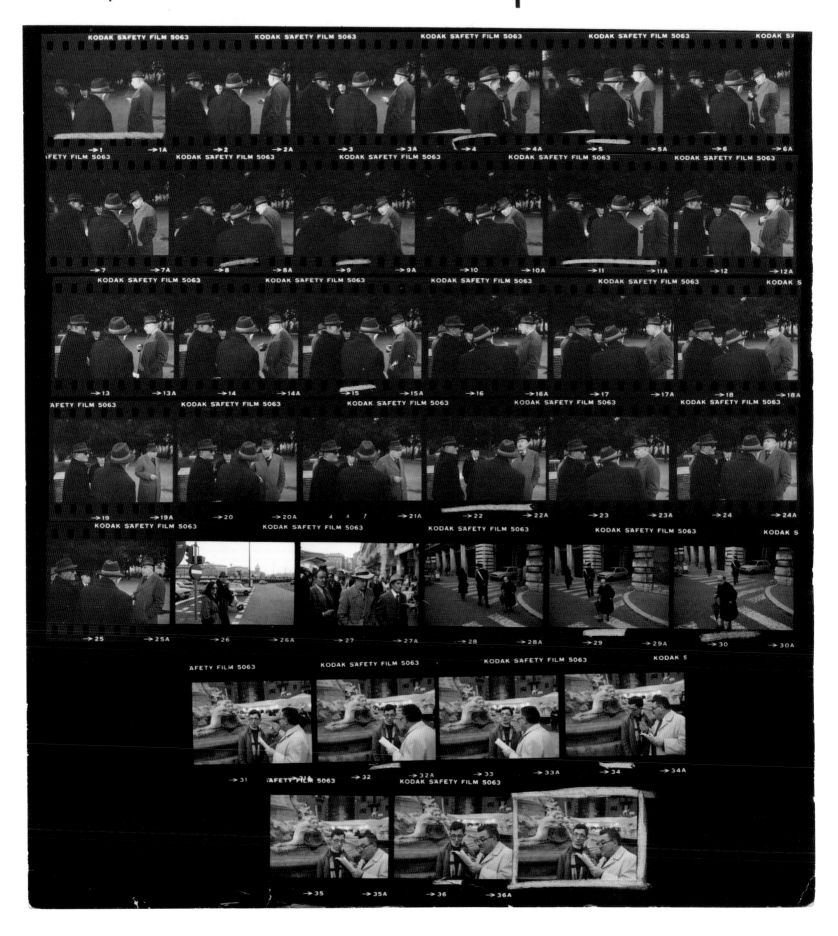

Rome, Italy
1980

"In 1978 I went to Rome for *Newsweek* to cover the funeral of Pope Paul VI and the election of his successor. I had never been to the city before, and I immediately fell in love with it. My first opportunity to return came two years later. I wound up at the Albergo del Sole, said to be the oldest hotel in Rome, on the Piazza della Rotonda, just in front of the Pantheon. Every day my walks would begin and end near the magnificent fountain in the middle of the piazza.

One day I came across my favourite raw material – people in conversation – just next to the fountain. An older man was speaking to a younger one (father and son, probably) in French, and reading out of a Michelin guide. The younger man apparently had weak eyes, and he wore thick glasses. I started my little dance, moving nearer and nearer, looking all around the place and pretending to photograph the fountain or the surrounding buildings. It's generally not very easy to photograph people close up without their noticing (and getting suspicious or angry, or at least modifying their behaviour), and ruses are necessary. I like to be almost on top of my subjects, partly because I'm nosy (or eyesy and earsy) and want to hear what they're saying; partly because I want my slightly wide-angle lens (35mm) to embrace them; and partly because I don't crop my pictures so I try to control the composition, limiting what's in the background.

I kept working the two guys, the spitting gargoyle and the background, grabbing pictures when I thought I wasn't being seen. I started picking up on the water jet seeming to hit the young man in the neck, and I was ready when the *miracolo* occurred and he suddenly turned his head up with that look that seemed to show surprise. I had my picture, but that's not why I stopped; I had reached the end of the roll!"

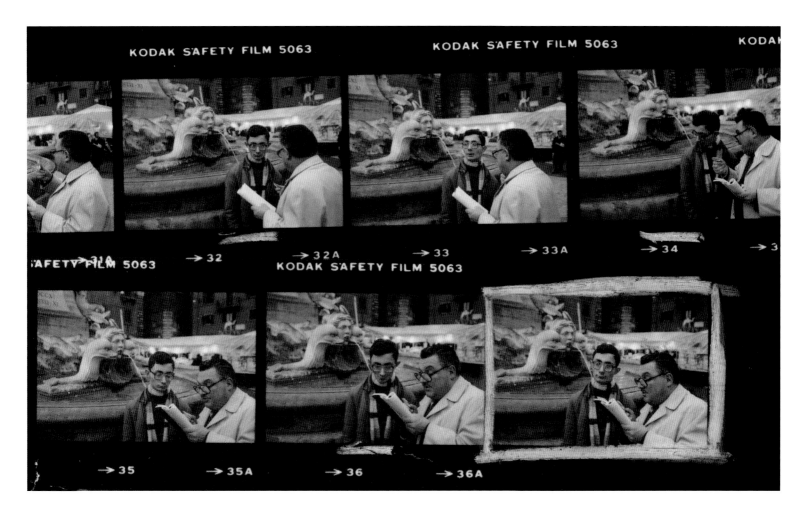

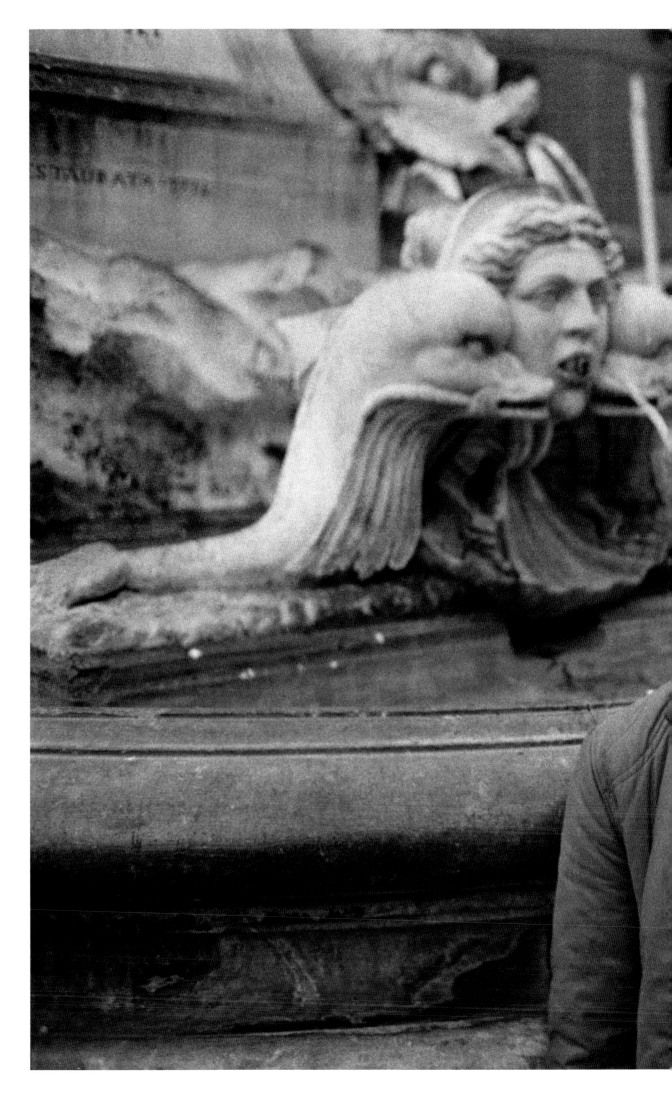

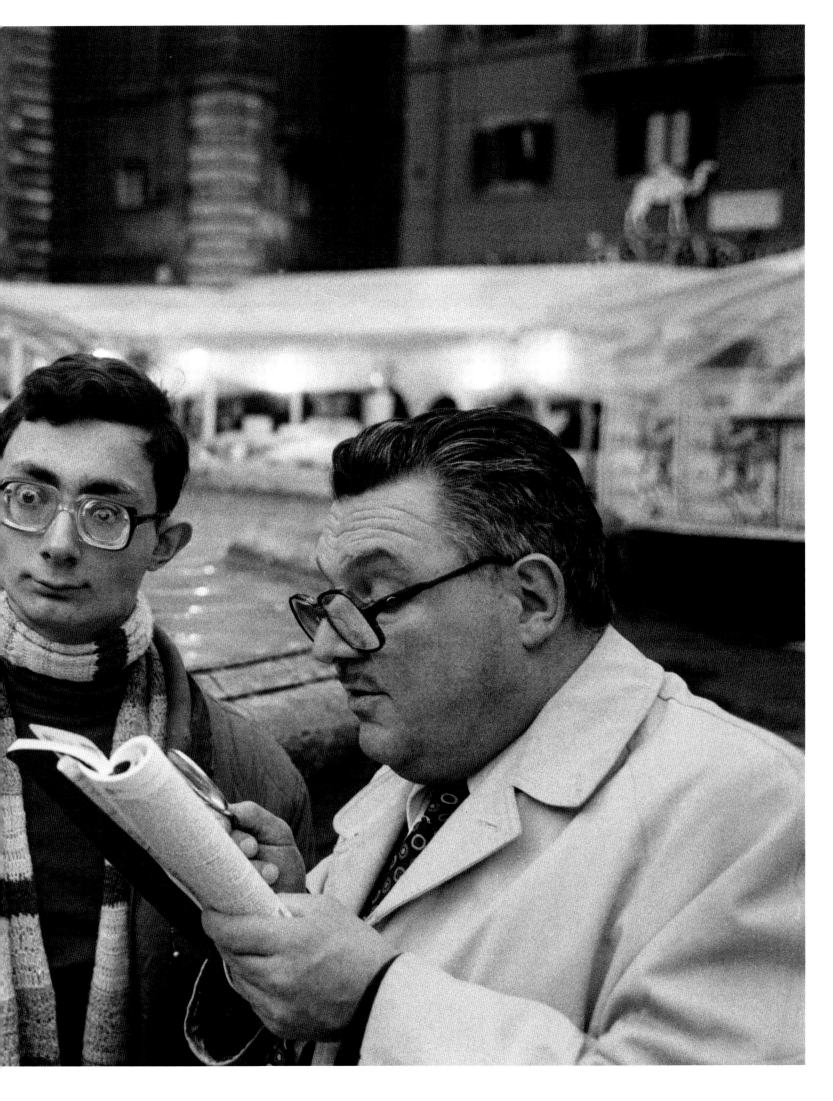

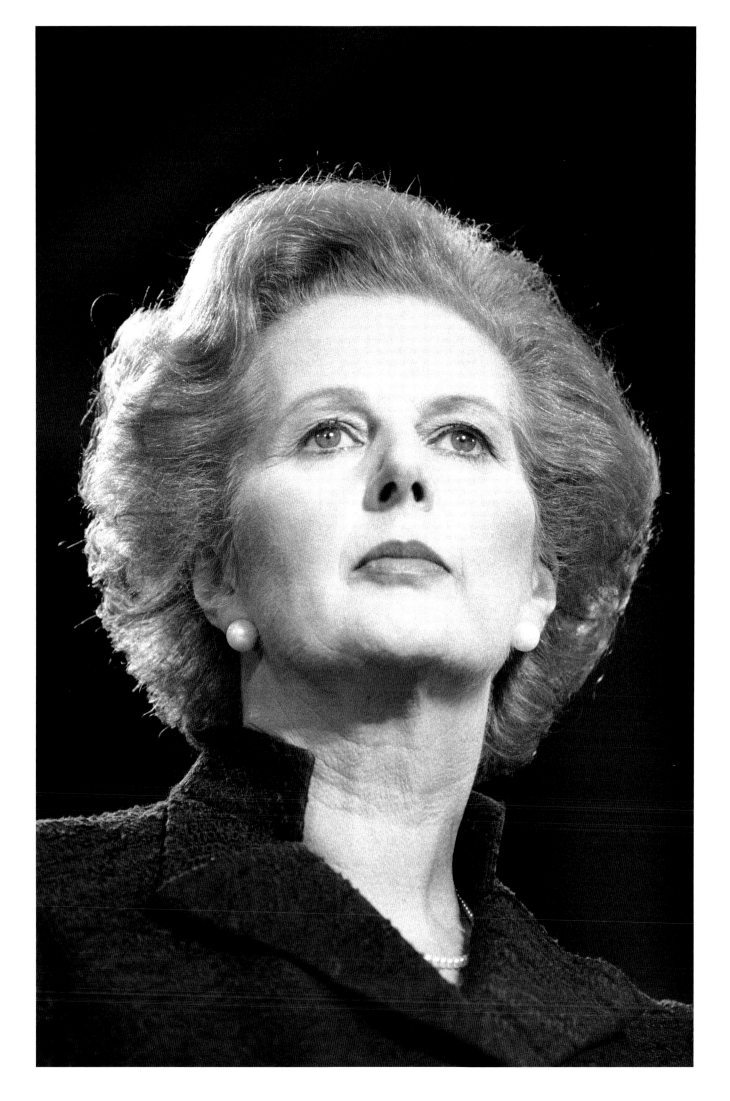

Blackpool, England
October 1981

"'You turn if you want to,' Margaret Thatcher said at the 1980 Conservative Party conference, when there were calls for her to change her policies, adding, 'The lady's not for turning.' This pun on Christopher Fry's play *The Lady's Not For Burning* was typical of the polish that Thatcher and her advisor Gordon Reece gave to her conference addresses. Now, a year later and two years into being Prime Minister, she was developing her status as the 'Iron Lady'.

I was a youngish photographer on assignment for *Newsweek*, working for the French news agency Sygma. We had a policy in those days, with our Nikon motor drives, of making what were called 'in camera dupes'. This was so there was always an original slide, rather

than a copy, to send out to the magazine network. I had a large Rollei flash on my Nikon F2 and simply blasted away during Thatcher's speech, hoping to get that one shot which would end up on the cover of the international edition of *Newsweek*.

The photos may give the impression that I was the only one there to watch the speech, but there were in fact more than ten other, mostly male photographers shooting away. It was fascinating to be a first-hand witness of the early days under Britain's first woman prime minister. Forgetting the politics, she was always friendly and open to the photographers who were with her, in a way that would be hard to imagine today."

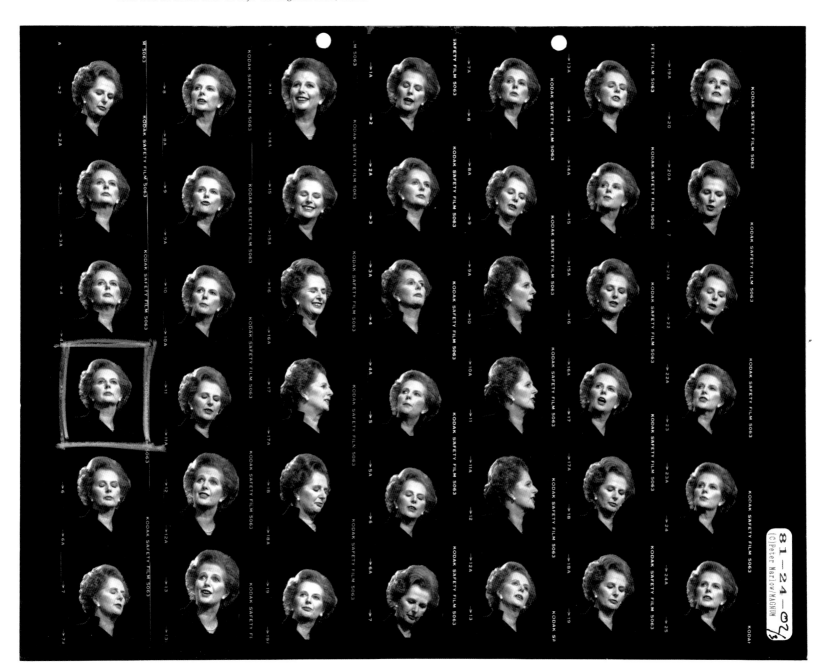

PETER MARLOW Northern Ireland

Derry, Northern Ireland
April 1981

"In April 1981, the hunger strikes led by Bobby Sands, Provisional IRA volunteer and Maze Prison inmate, had been in progress for one month. Protests and riots were rife. On Easter Sunday, 19 April, 19-year-old Gary English died, having been struck by a British Army Land Rover under attack from petrol bombs. As English lay on the ground unconscious, the vehicle was reversed over his body. Another young man, Jim Brown, had moments earlier been killed by the same Land Rover. The soldiers were not charged with murder, but rather a lesser offence of reckless driving. Both were acquitted at trial.

I was covering the riots following these deaths. As I stood in a doorway of a terraced house in the Bogside area of Derry, out of the line of fire of plastic bullets which were winging down the narrow street, I was photographing the very incongruous sight of a lady in her housecoat, watching the riot unfold on her doorstep. Looking down the street towards the British Saracen armoured car, known locally as a 'Pig', I saw a young Catholic boy creep along the wall, unseen by the soldiers waiting with their shields, to hurl a petrol bomb.

The pictures were shot on Kodachrome colour transparency film, which was processed in New York, as I was on assignment for Time-Life that day. Unlike negative film, which stays in an intact sequence, slides are notoriously difficult to keep safe: they are small and easily lost, and, without completely removing the paper mounts and reading the numbers on each frame, it's virtually impossible to rebuild the order. *Life* edited the work and published a double spread in their August edition. The slides were then returned to the Paris office, where they were edited again and duplicated in multiple sets to create a 'package' to distribute to other magazines in Europe and the rest of the world. Eventually they were returned to me in London. The sequence here is what can only be a rough reconstruction of the order. Though I believe it is accurate, there are very likely to be images missing due to all the handling and editing of the work. Looking back thirty years later, I feel that the best image was not used by *Life*. My feeling is that the image before – K038 – better describes the energy and narrative of the event as it unfolded."

'The Troubles' This Time

Molotov cocktail poised, a Catholic youth surprises two British soldiers barricaded behind their riot shields in Londonderry. It was but one such incident in the violent days of April that marked yet another round in the unending civil war in Northern Ireland. The riots this time were sparked when two Catholic demonstrators were run over by a British Army Land Rover in the tense period preceding the death of jailed Irish Republican Army hunger striker Bobby Sands. The latest chapter in the bloody saga that has cost more than 2,000 lives in the last 12 years has intensified anti-British sentiment among Northern Ireland's Catholic minority and diminished hope among Catholic and Protestant moderates for conciliation. Historic animosity between Catholics and Protestants, heightened emotion following the deaths of other IRA hunger strikers, high unemployment and Britain's unbending attitude toward prisoners who claim their law-breaking is political – all work against a solution to what the Irish for decades have called 'the troubles.'

105

ABOVE Spread from *Life* magazine, August 1981.

MAP1981011K046
D#81-81/

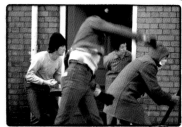

MAP1981011K043
D#81-81/

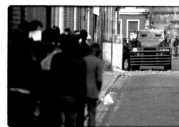

ORIGINAL DISC.

MAP1981011K053
81 - 81 - 7

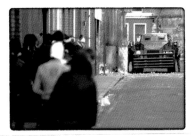

1

MAP1981011K045
D#81-81/

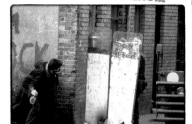

2

ORIGINAL DISC.

MAP1981011K054
81 - 81 - 2

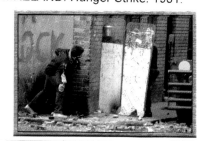

3

MAP1981011K038
D#81-81/

4

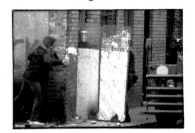

4

ORIGINAL

MAP1981011K040
D#81-81/0B
*

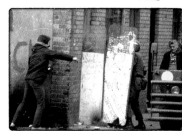

5

ORIGINAL DISC.

MAP1981011K055
81 - 81 - 4

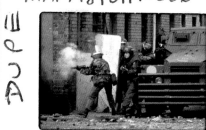

27 20/11/84 6

MAP1981011K006

DUPE

LOST ORIGINAL?

81 - 81/6
● N. IRELAND

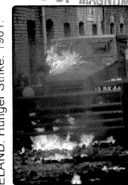

PA 29.4

7

I00026015
© Peter Marlow / Magnum Photos
MAP1981011 K039
N.IRELAND. Hunger Strike. 1981.

MAP1981011K039
D#81-81/

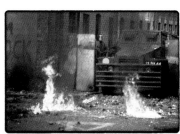

8

ORIGINAL DISC.

MAP1981011K056
81 - 81 - 5

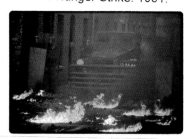

9

MAP1981011K041
D#81-81/

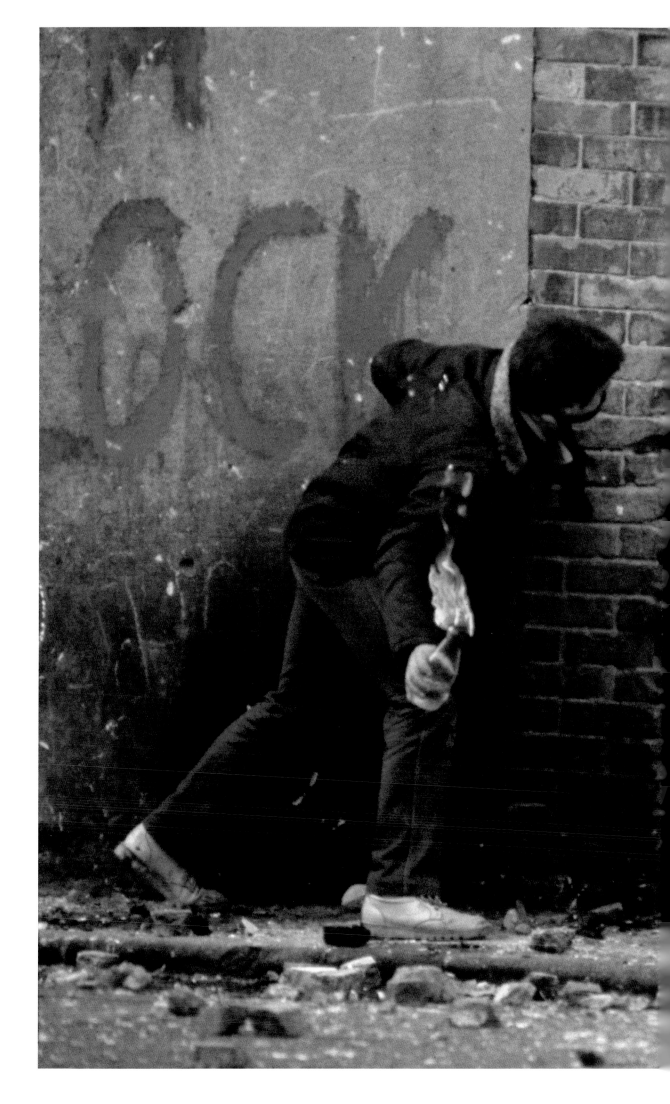

MARTIN PARR Bad Weather

Dublin, Ireland
1981

"After shooting for many years in Hebden Bridge, a small
town in West Yorkshire, I was keen to find a project that
gave me more freedom. *Bad Weather* was the one that
pushed me into new territories of discovery. I liked the
idea of picking up on a national obsession in the British
Isles – namely, discussing the usual dismal state of our
weather – and turning this into subject matter.

　　This particular roll, taken in Dublin in 1981, was where
the new sense of discovery around shooting with a camera
and flash in the magic hour all came together. That dizzy
combination of the burst of flash, some rain on the lens and
a slow shutter speed all combined to produce this quite
particular language. You didn't really know how the
photograph would look until the film was processed, so
poring over this contact was very exciting. I would learn how
the process manifested itself in images, and this particular
shoot was where all the elements first worked together.

　　I had positioned myself around O'Connell Bridge and
the famous Ha'penny Bridge in the centre of Dublin. Sure
enough, it was busy, as people scuttled through the wet,
being startled by this lanky guy and his strange flash.
There were the usual umbrellas, but the ever resourceful
Irish also wore boxes and even newspapers on their heads:
all good material for me. Within the shoot, this was the
roll that produced two images that made the project, and
indeed the cover image of my book, *Bad Weather*. Seeing
it reminds me of that exhilaration: the essential process
of finetuning one's palette by studying, and learning
from, the contact sheet."

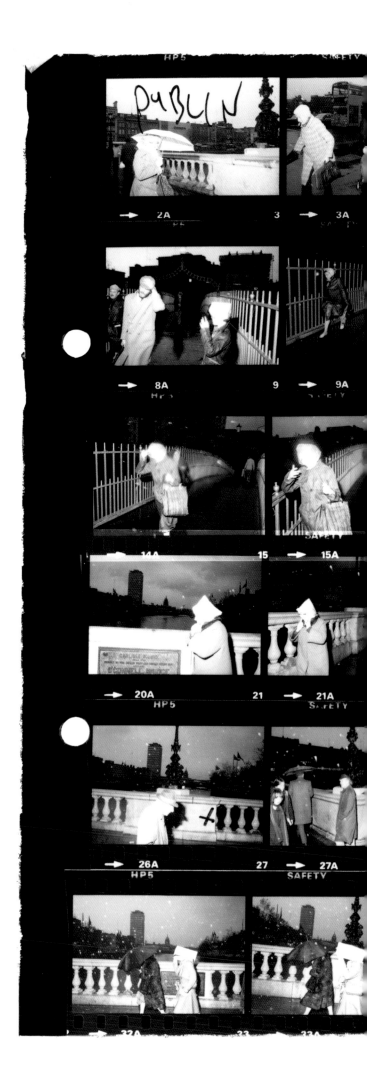

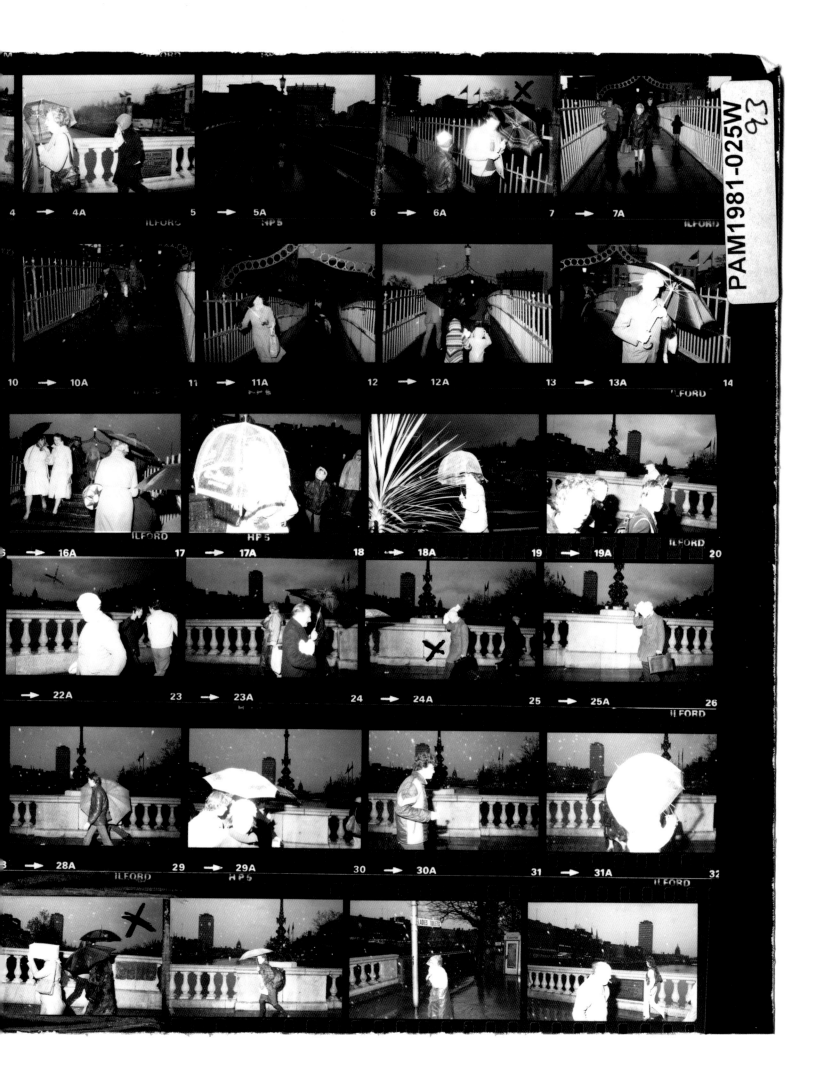

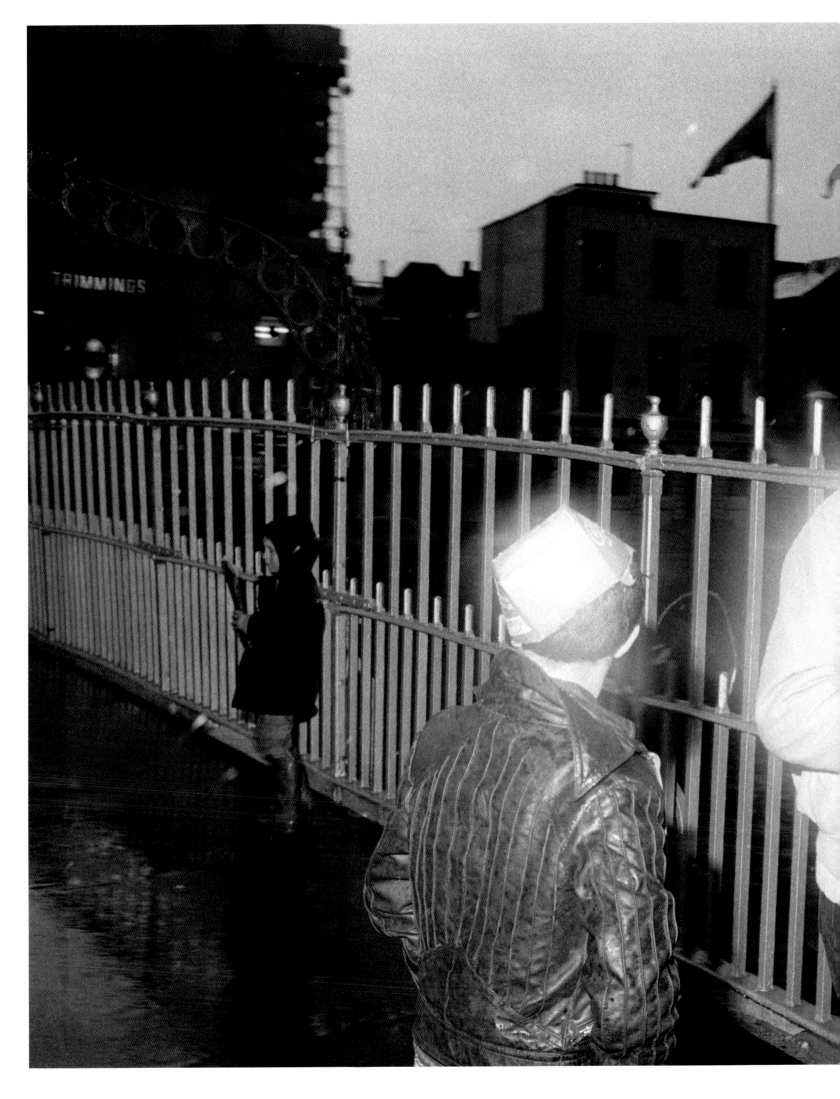

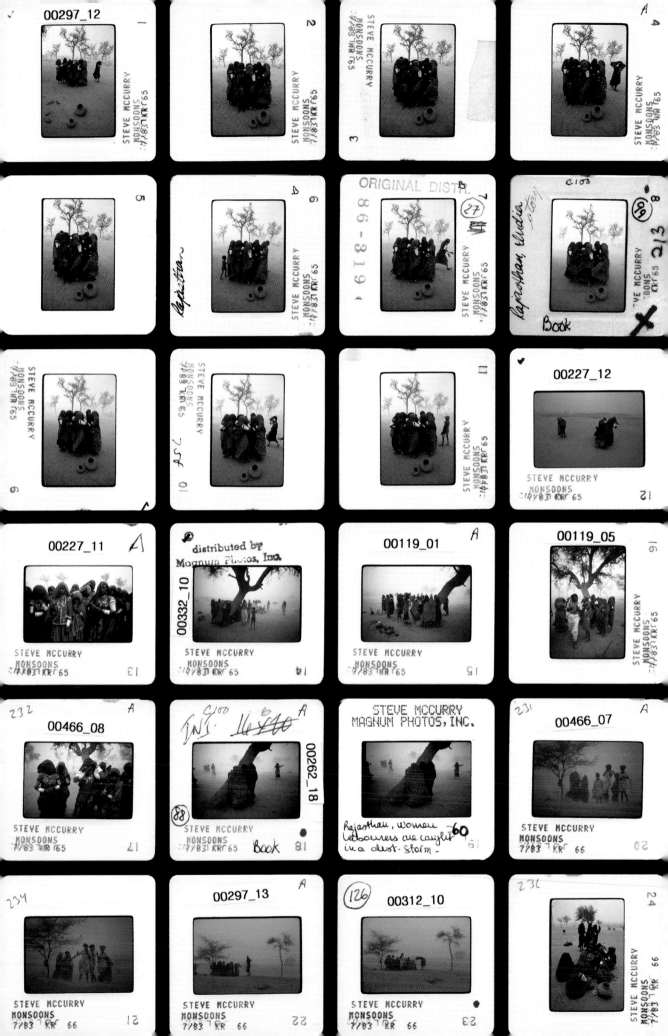

Rajasthan, India
June 1983

"I was in a beat-up taxi, travelling through the desert to a town called Jaisalmer on the India-Pakistan border. It was June, and as hot as the planet ever gets. I was doing a story on the monsoon. The rains had failed in this part of Rajasthan for the past thirteen years, and I wanted to capture something of the mood of anticipation before the monsoon.

As we drove down the road, we saw a dust storm grow, a typical event before the monsoon breaks. The weather instantly changed from being sunny and clear to dark and dusty, with a very strong wind. It was hard to breathe, and difficult to see through the wall of dust that was moving like a tidal wave and sounded like a deafening roar. The light turned a dark orange colour and the temperature suddenly dropped.

Women and children had been working on the road, something they are driven to do when the crops fail.

Now they were barely able to stand in the fierce wind, clustered together to shield themselves from the sand and dust. Life and death seemed to hang in a precarious balance. The women were singing, which was a way of praying for rain.

My first instinct was to try to protect my camera from the swirling dust, but then I realized that I could always buy a new camera but the opportunity to shoot this group of women was priceless. They were dressed in textiles that are no longer produced, and I thought they looked quite beautiful.

The final image that I chose from the edit seemed to capture the spirit of this moment. It is important to me because it reminds me of the part of the world that I have explored for thirty years.

You can't be hung up on what you think your 'real' destination is. The journey is just as important."

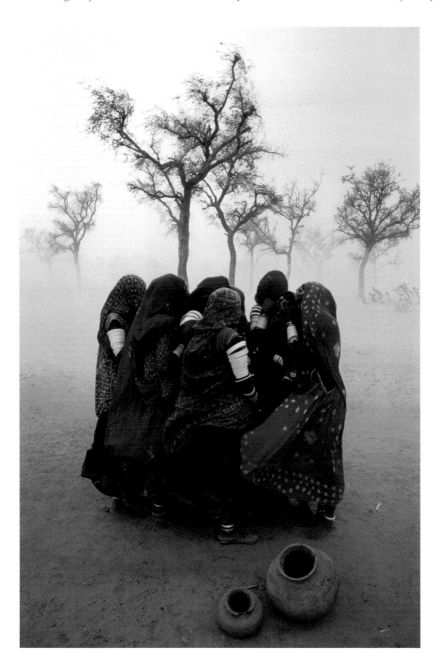

Rajasthan

86-319

ORIGINAL DISTR.

27

Rajasthan, India
story

Book

00227_12

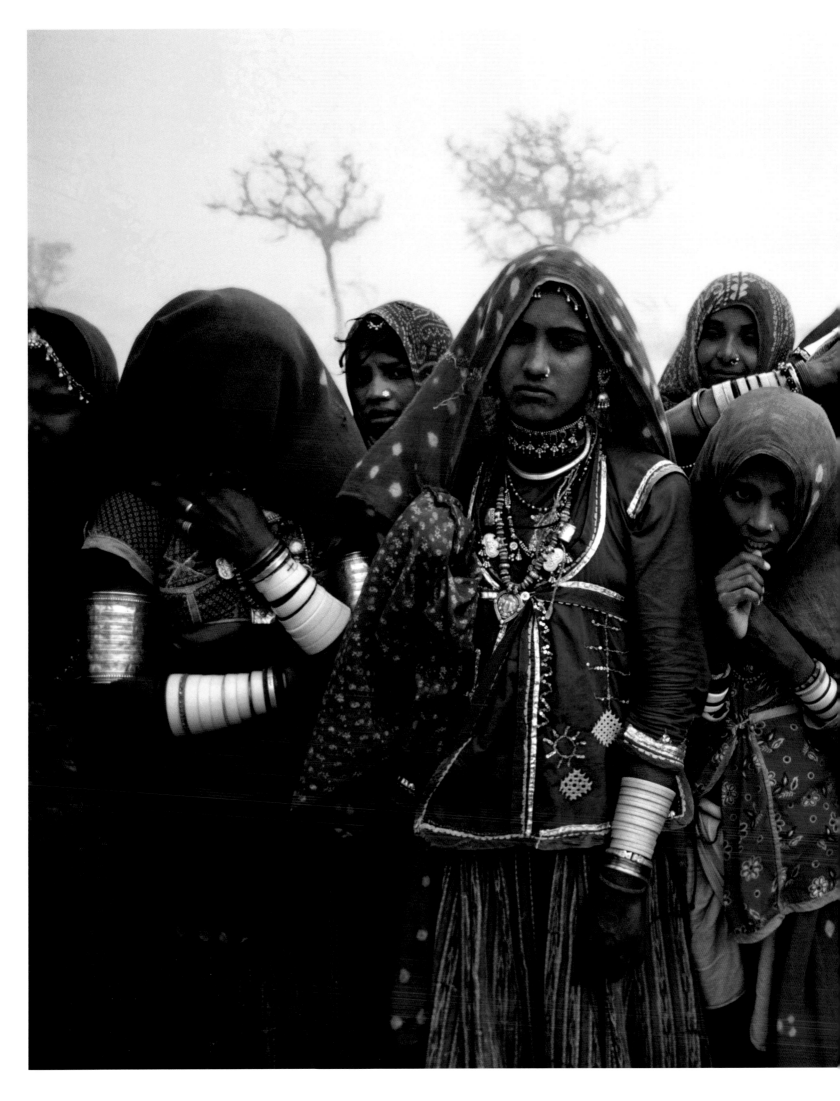

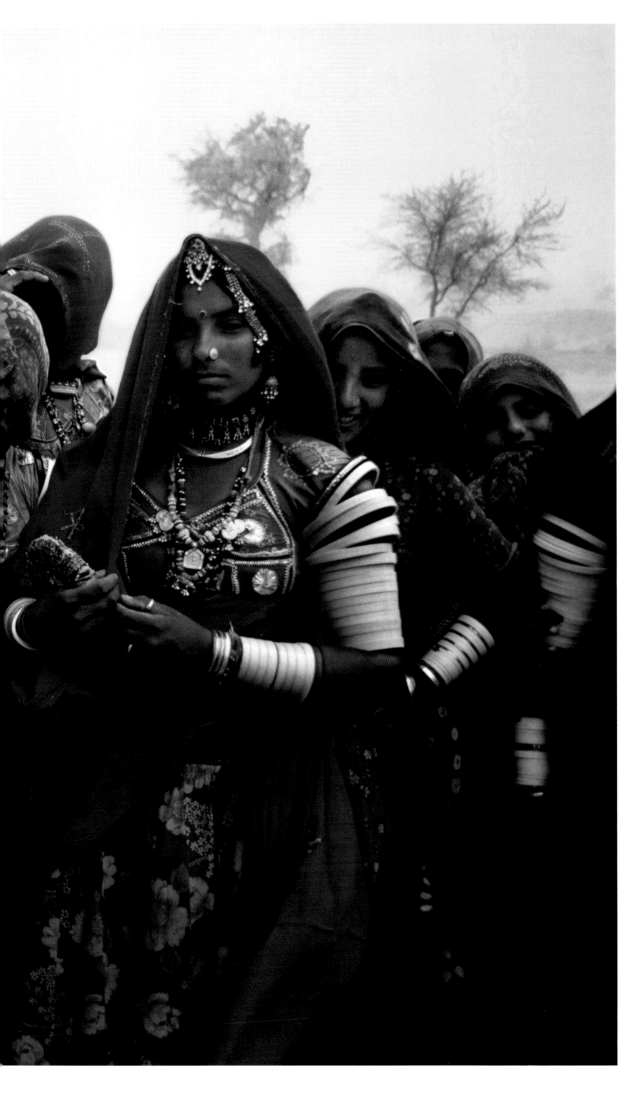

New York, USA
September 1984

"My lifetime's work is the streets of New York. I've been photographing them since 1980, and I think I am the epitome of a New York street photographer. The reason I started using flash in the early 1980s was because I had previously shot six hundred rolls and wasn't satisfied. When I added flash, I found out that it highlighted the subject in the foreground of my photos, and it allowed me to show the speed, stress, anxiety and energy of the city. The streets in New York are difficult to photograph because there's a lot going on and there are many interferences, so you have to make quick decisions.

These two images were taken at the San Gennaro Festival, a yearly street fair that takes place in mid-September in Little Italy, an event that I love to photograph. The streets are narrow, and there are crowds of people packed in like sardines in a can. They can't move too fast, so it's an excellent situation in which to take photos.

On frame 20A, when I saw the little boy on the man's shoulders, I saw a living collage of New York. I think it works perfectly because the whole frame is filled, everything is positioned quite right, and what makes it a genuine New York photograph is the signature Egg Cream sign behind.

On frame 24A, I responded to the two ladies in the forefront. One is smoking a cigarette with the ash about to fall off, completely oblivious of her surroundings, and the other one is staring at something. But what was going on behind the women? Anything is possible in New York! I think that for a photograph to work, there has to be some connection between the foreground and the background, and to me there was a connection between the men behind the two women in the front, even though I assume they didn't know each other.

I am a tough editor of my work, and usually when I look at my contacts I find that I can go as many as fifty rolls without getting a good photo. But when I looked at this roll, I had not one but two of my best images ever of New York City. What a coup!"

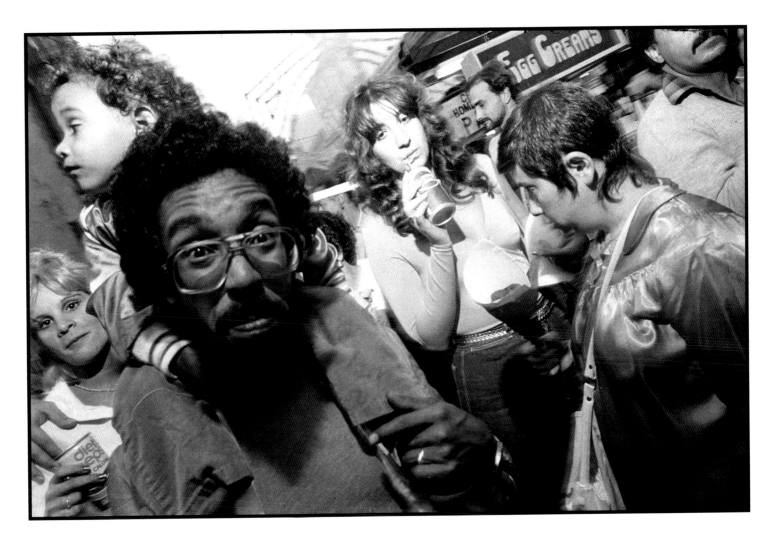

→12A →13 →13A →14
KODAK S'AFETY FILM 5063 KODAK S'AFETY F

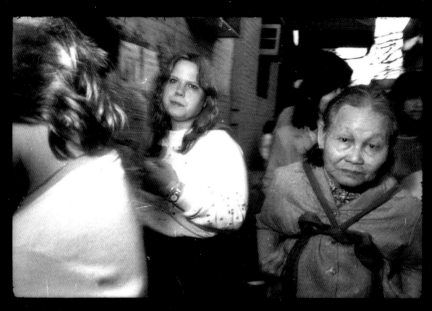

→18A →19 →19A →20
.M 5063 KODAK S'AFETY FILM 5063

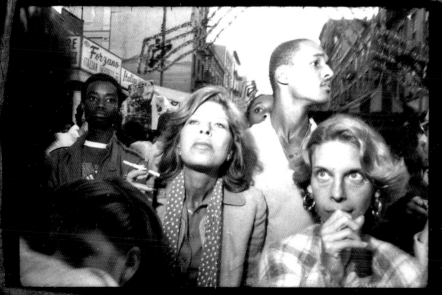

→24A →25 →25A →26
KODAK S'AFETY FILM 5063

→14A →15 →15A →16

5063 KODAK SAFETY FILM 5063

→20A →21A →22

KODAK SAFETY FILM 5063 KODAK SAFETY FILM

→26A →27 →27A →28

SAFETY FILM 5063 KODAK SAFETY FILM 5063

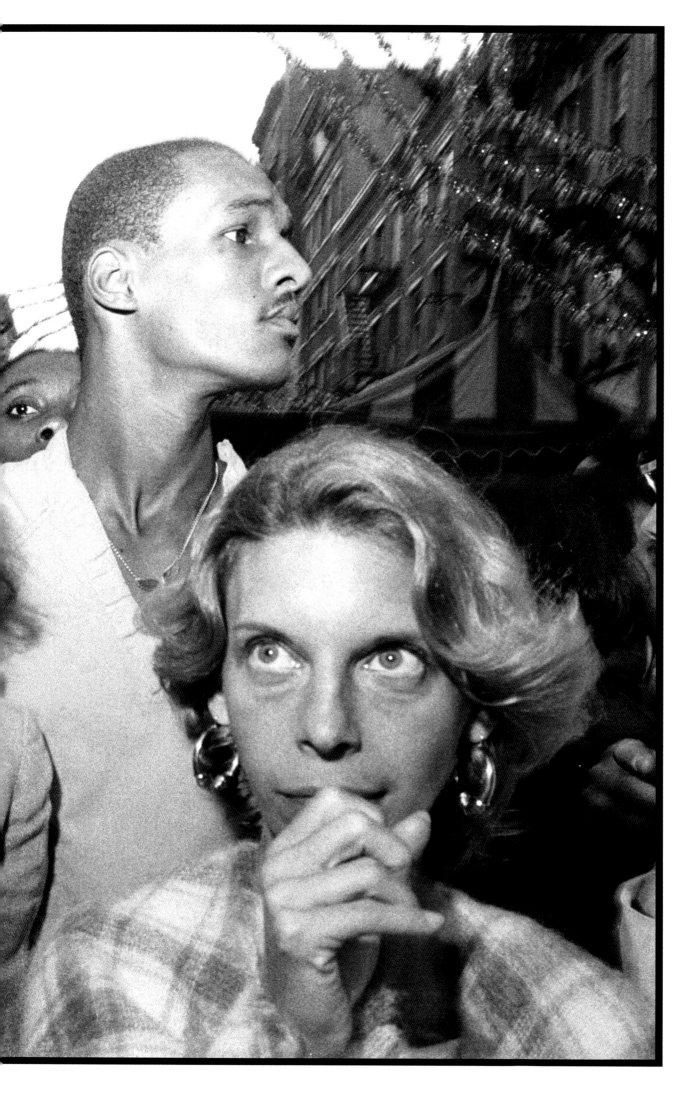

Transvaal, South Africa
1985

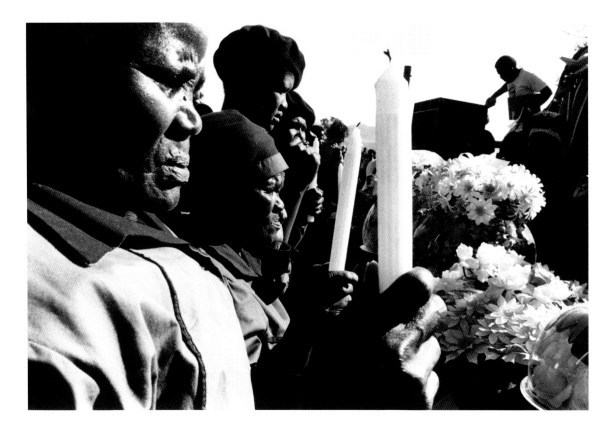

"My interest in South Africa started when I went to work with a magazine for Africans called *Drum*. Tom Hopkinson, ex-editor of *Picture Post*, became the editor and I wanted to learn about magazine photography from a man whose reputation had preceded him. Only then did I get the chance to understand both sides of the African apartheid line. I was working with African reporters and couldn't even have a cup of tea with them in the same cafe. When I'd go on a shoot I stayed in a hotel, while they'd have to find a bed in a township or sleep in the car.

Later I worked as a freelance photographer and no longer lived in South Africa. I would travel back once every two or three years to document what was going on until I was finally banned, shortly before Mandela came out of jail. I would generally be working on assignments for magazines such as the *Telegraph*, *GEO* and *Paris Match*.

As tensions rose in South Africa before the fall of the apartheid government, there were frequent shootings of black African civilian protestors by the police. It became a cycle. A protestor would be shot, the funeral would be politicized, and almost inevitably more violence would follow. On occasion Archbishop Tutu (then Bishop Tutu) would turn up to try to maintain the peace between the police and demonstrators. It became obvious that every time there was a funeral there would be further violence.

I came to have many contacts with African photographers. I would go into the South African *Sunday Times* office in Johannesburg, knowing some of the reporters there who would keep me abreast of events. In this case a fourteen-year-old schoolgirl had been shot by the police and I attended her funeral. I went alone to such events, shooting on a Leica 35mm. My appearance worked for me: long-haired and slim, I didn't look like a South African. In fact, I was always in more danger from the white cops than from the South African blacks. I think the Africans sensed I was sympathetic. I was relatively familiar with the situation and I had people looking out for me.

I would either process my film in South Africa or travel back to the UK with all my rolls. The image on the contact chosen by the magazine I was working for was the picture of the strong faces of the elderly ANC women supporters carrying candles. However, I preferred the pallbearers who walked to the graveside giving the ANC clenched fist salute. It shows just how politicized these funerals had become."

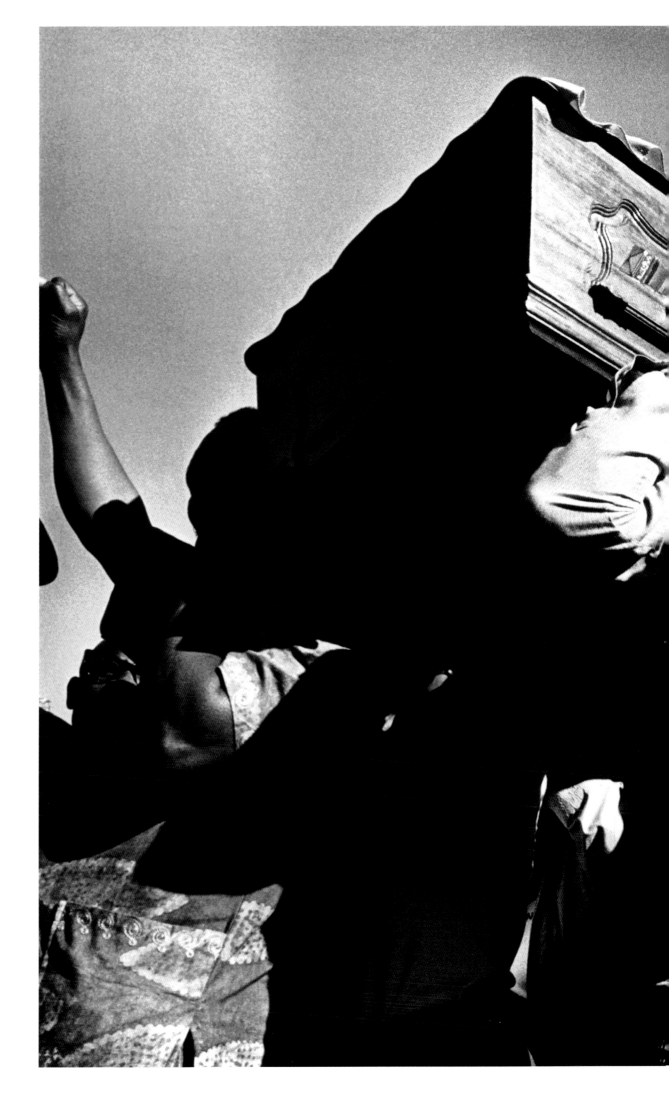

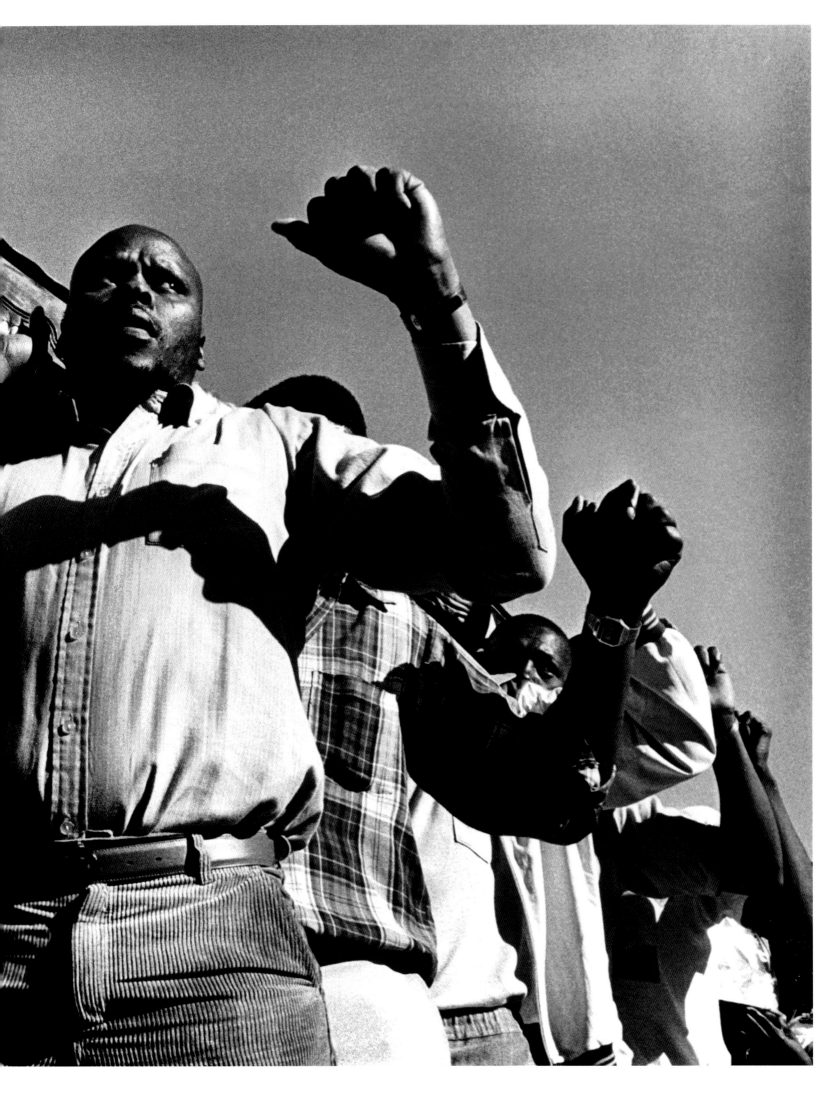

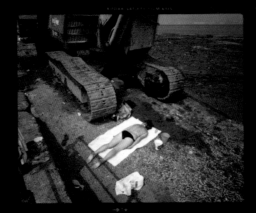
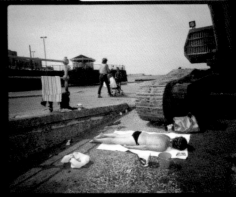
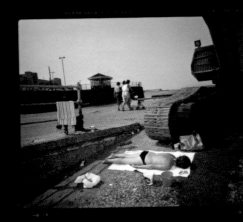
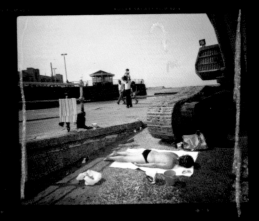
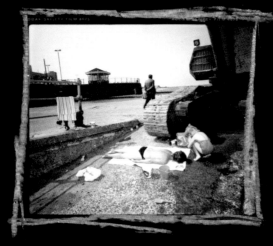
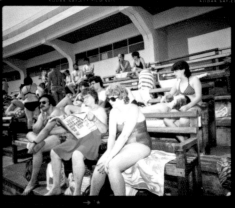
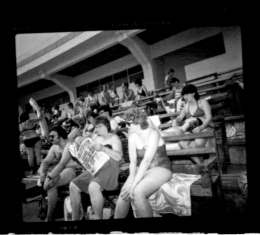
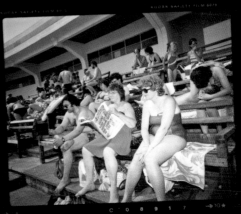

Merseyside, England
Summer 1985

"This project, started in 1982, was a three-year exploration of a decaying seaside resort on the Wirral estuary, near Liverpool. The idea was to contrast domestic activity with a backdrop of run-down Britain, so perfectly expressed through the shabbiness of New Brighton. On busy weekends the place was thronging and every available space was utilized for sunbathing. When I turned the corner and found this excavator, with a mother and daughter sunbathing and playing, I could hardly believe my luck. I was aware of how the machine would set up the ambiguity perfectly. I shot a few and here you can

see the final image working, as the rest lead up to that moment. The young girl is perfectly positioned, looking at her mother, and there's even the strange man walking away in the background.

The original contact sheet was printed in black and white, the reason being that I couldn't afford to print these in colour. This one was made more recently. How strange to assess my first substantial colour project in black and white, but the idea was the colour would look after itself and the action was what I had to edit."

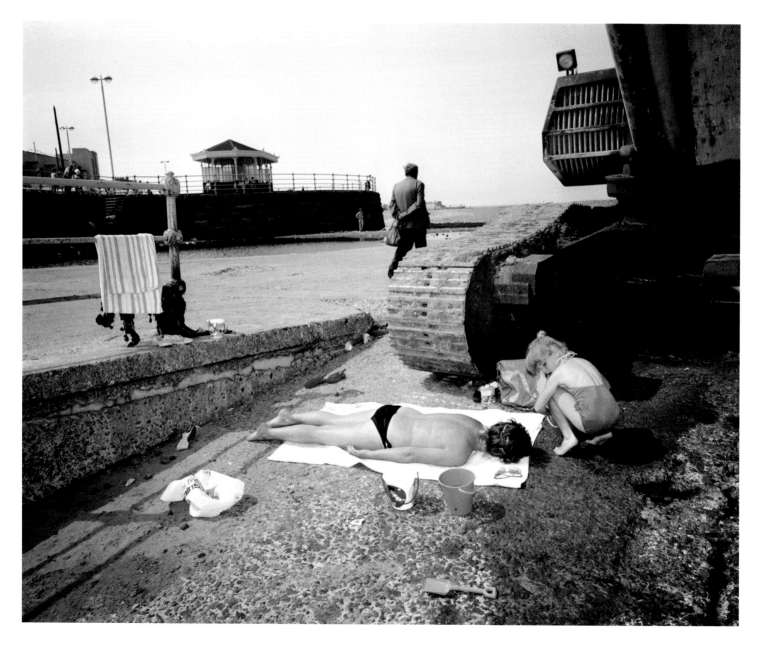

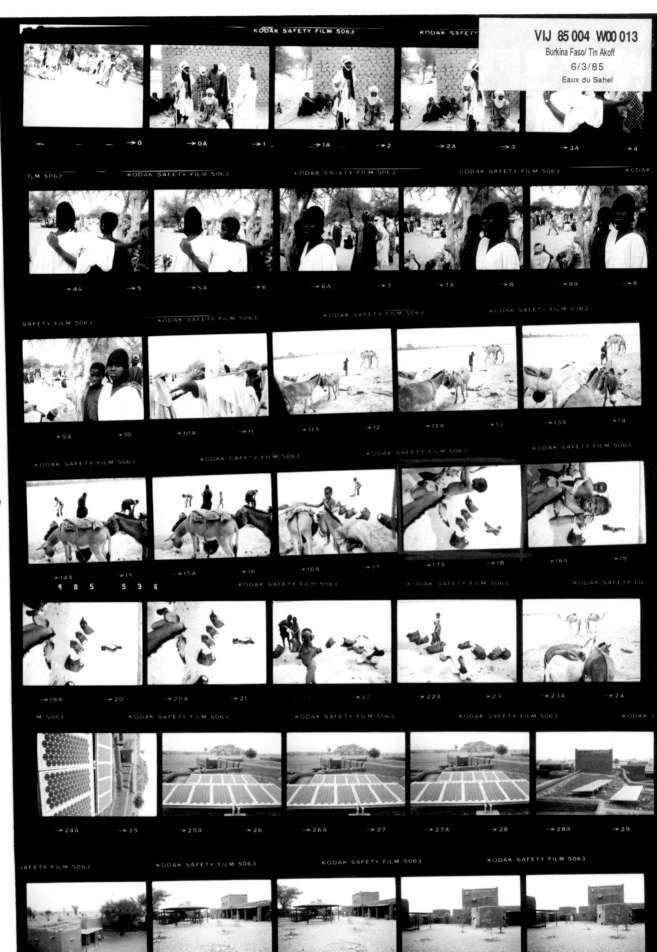

199
Tin Akoff
26 s: Goron
6/5/85

Tin Akoff, Burkina Faso
March 1985

"I had covered the Paris-Dakar race the year before and been seduced by the light and the space. Now I just wanted to roam around the Sahel, and a flight to Ouagadougou was the cheapest I could find. My first real trip to the real Africa ensued: 54 hours on top of a truck overloaded with bags of rice, heading to the north of Burkina Faso; destination Gorom Gorom. I was told it means 'sit down so that we can sit down', and that seemed appealing enough to go there. I didn't have a particular plan or a story to work on.

Arriving in Gorom Gorom was a relief: a nice room in an adobe house, clean water, some electricity from solar panels, and people who were knowledgeable about development issues in the area. The Sahel was under threat of desertification, and a few NGOs were working on the issue. Nobody was talking about global warming at the time.

There was a well, and I photographed some nomadic families collecting water in goatskins tied to the belly of their donkey and disappearing in the dust once they were finished. I immediately realized that that was the story I wanted to tell: the management of water in Sahel. Not the famine, not the drought, not the crisis, but what was being done to try and avoid it.

The next day the guy who ran the project took me to the Tin Akoff pond, driving several hours on sandy tracks. We stayed an hour or so before we had to go back. It was a muddy pool, and there were a few camels. Some children were filling guerbas, loading them underneath and on top of their donkeys. The little miracle of an interesting photograph happened just by switching from horizontal on frame 17 to vertical on frame 18.

That trip to the Sahel somehow contained and defined what I would be working on nearly exclusively for the next twenty-five years: aftermath situations, threats to cultural identity, development issues, the uprooted, the voiceless..."

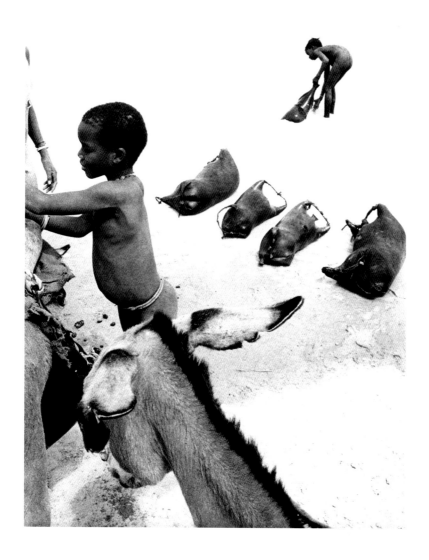

1986 **STUART FRANKLIN** Moss Side Estate

Manchester, England
1986

"These photographs were taken at a time when I was exploring the unemployment crisis in the north of England. I had come from Teesside, where I had seen the launching of the last ship to be built at Smith's Dock. In Manchester I was looking at some of the housing estates around the edge of the city, in Moss Side and Salford. This project made me question any definition of 'Third World' that excluded areas such as Moss Side.

I had spent a lot of time inside the buildings, photographing single-parent families, and was pleased to get outside, away from the depressing stench of urine. Here I'm in the place where children from the estate had made a playground out of an old container. I waited around, taking a lot of pictures, trying to find a moment that made sense of the spirit of the place.

A contact sheet is a record of a journey, of a pursuit. It carries all the wanderings around an idea – or, as some would have it, a vision. Some of these wanderings are purely technical: what would happen if I changed the aperture? Did I mess up the exposure? Some are aesthetic: about composition, or a moment in time. These days I work both in analogue and digital photography. In the process of making a selection from digital files, what is often lost is the chance to go back, to retrace one's steps – to follow the original journey."

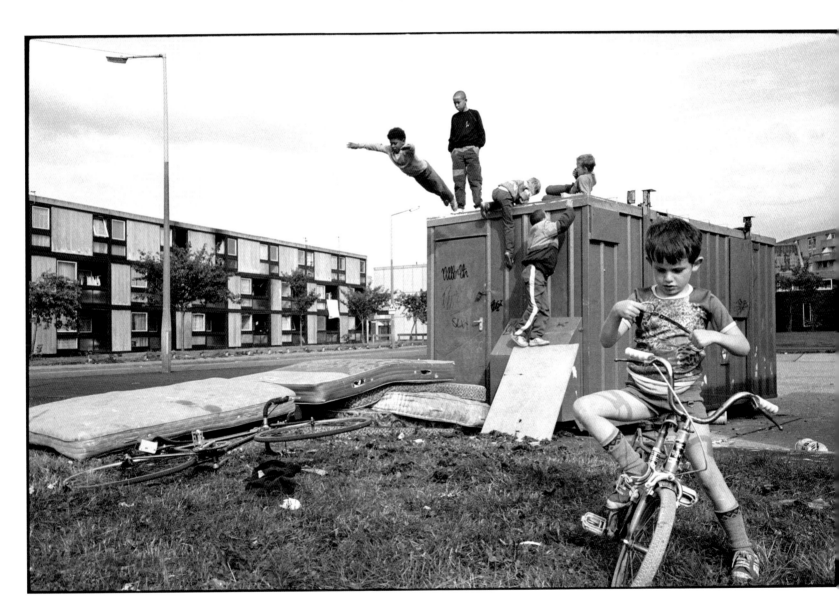

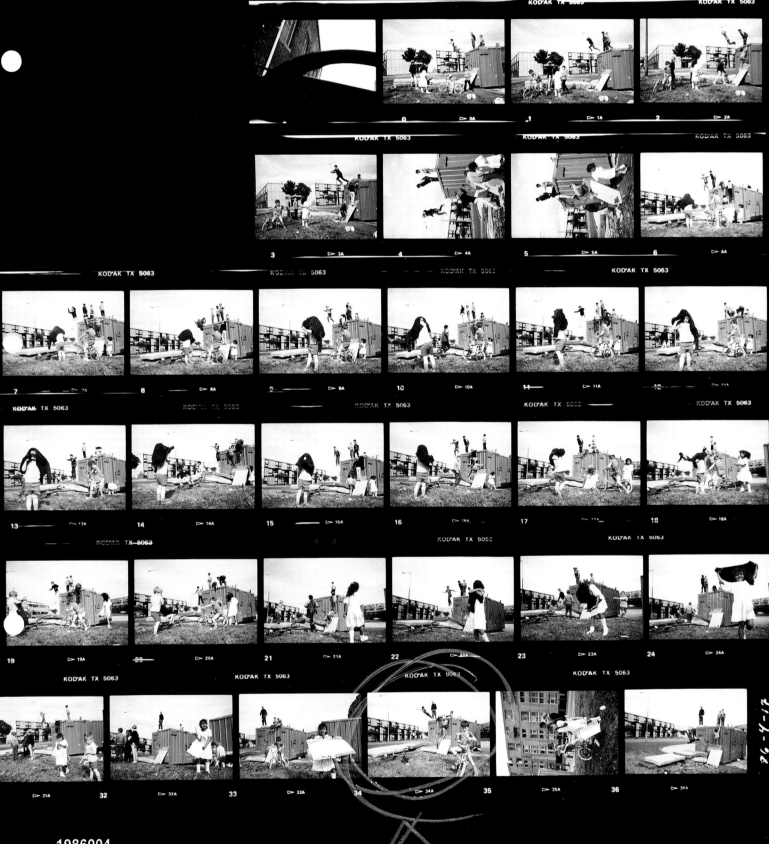

1986004
28/07/05
FRS - 17

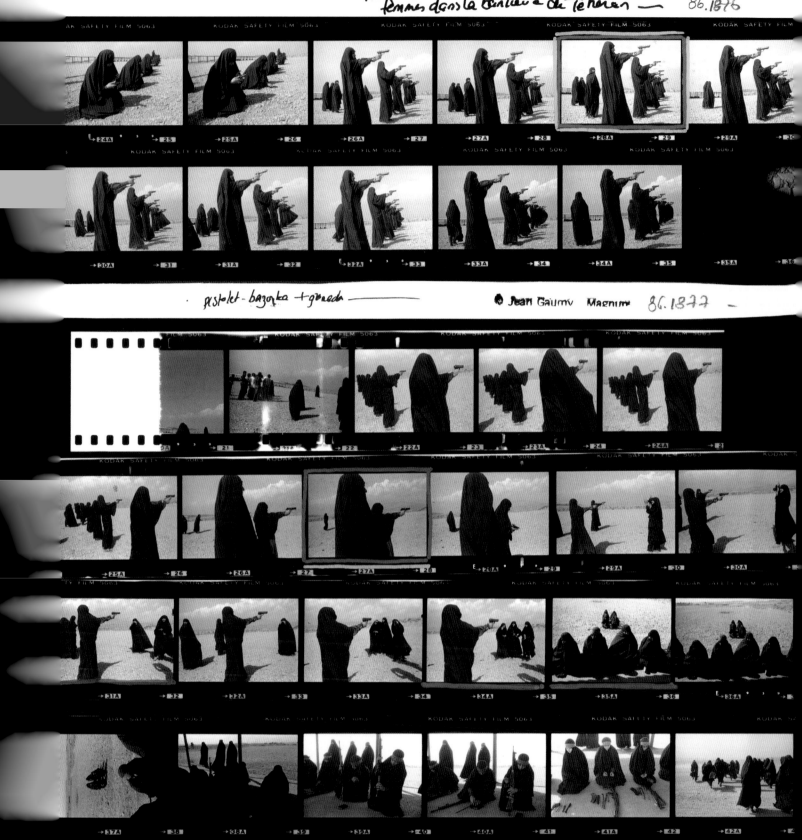

© JEAN GAUMY
MAGNUM PHOTOS

86 010 W 01876 et 01877

Iran - Tehran. 1986 — entrainement des
femmes dans la banlieue de Teheran — 86.1876

pistolet - bazooka + grenade © Jean Gaumy Magnum 86.1877

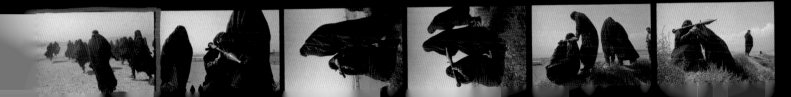

Tehran, Iran
October 1986

"It was my third trip to Iran during the post-Revolution period. I was one of the very few Westerners to enter the country, the eye of the storm. As is usual in this kind of situation, the Ministry of Communications knew that I was there and wanted to keep me under constant control. However, in countries as complicated as Iran, where everything seems impossible, paradoxically lots of things turn out to be possible in the end. For example, the Ministry told me that I would be permitted to go to a place that had never before been open to the Western press: a training camp for a female *Basij* (paramilitary volunteer militia) on the outskirts of Tehran. Journalist friends had made the same request a year earlier and been denied. I realized that the Iranians were testing the waters.

I found myself accompanied by two or three Iranian photographers, who were working with Western newspapers. I remember that it took us a very long time to find the exact location of the camp. When we finally got there, the trainers wanted us to work from a distance, using telephoto lenses. I refused to do this. After a good half-hour of negotiations, I was able to work among the women quite naturally. Through the viewfinder of my little analogue Olympus with its 35mm lens, I soon grasped how powerful the scene was, and one image in particular reminded me of a shot from a film I'd seen in the 1960s of an Ancient Greek tragedy.

The series was published in *Time* magazine, and the shot was seen around the world. Of course, I understood that with this work I was in no way providing what Western readers would perceive as a positive picture of Iran. But the Iranian authorities surely knew this. For them, it was a way of saying, 'Look, even our women are determined to defend our country.' They must also have foreseen that the photographs would be published in *Time*, for which I was then working, or in similar international magazines, and therefore in a sense 'exported' to countries that already supported Iran or could potentially be won over. There the images would inevitably be perceived very differently. The Iranians wanted to be the spearhead of the Islamic revolution, and Iranians are extremely pragmatic.

Some time after *Time* had published the series, a right-wing US senator made an official complaint about the photo of the women because – according to his far-right logic – it misrepresented Iran. He claimed that the picture could not have been taken in the country, and therefore must be a fake. What's more, he thought that the woman in the foreground looked much too 'masculine' to be a real woman. *Time* magazine asked me to confirm what I'd seen, and I duly verified where I was and what I saw. I hope that I also managed to put the senator's mind at rest about the nature of the sexes in Iran."

TOP Jean Gaumy's press pass, issued by the Iranian authorities.
ABOVE Cover of Gaumy's notebook, documenting his stay in Iran.

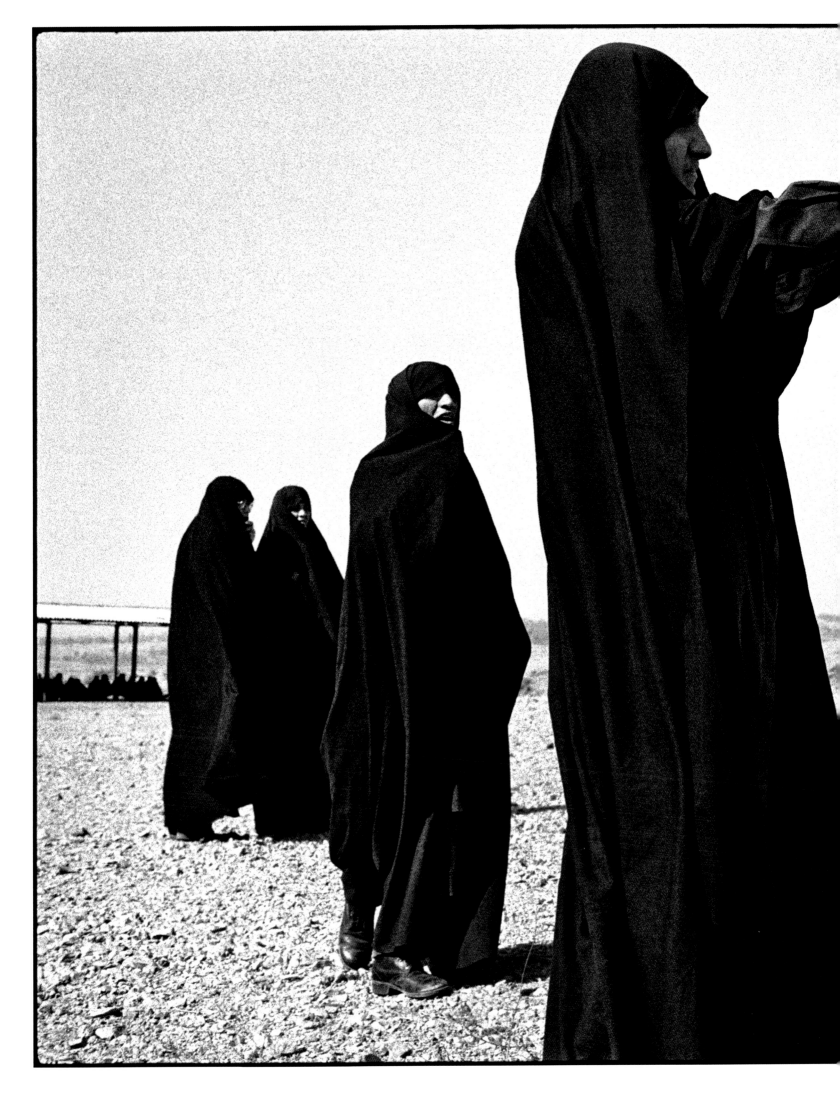

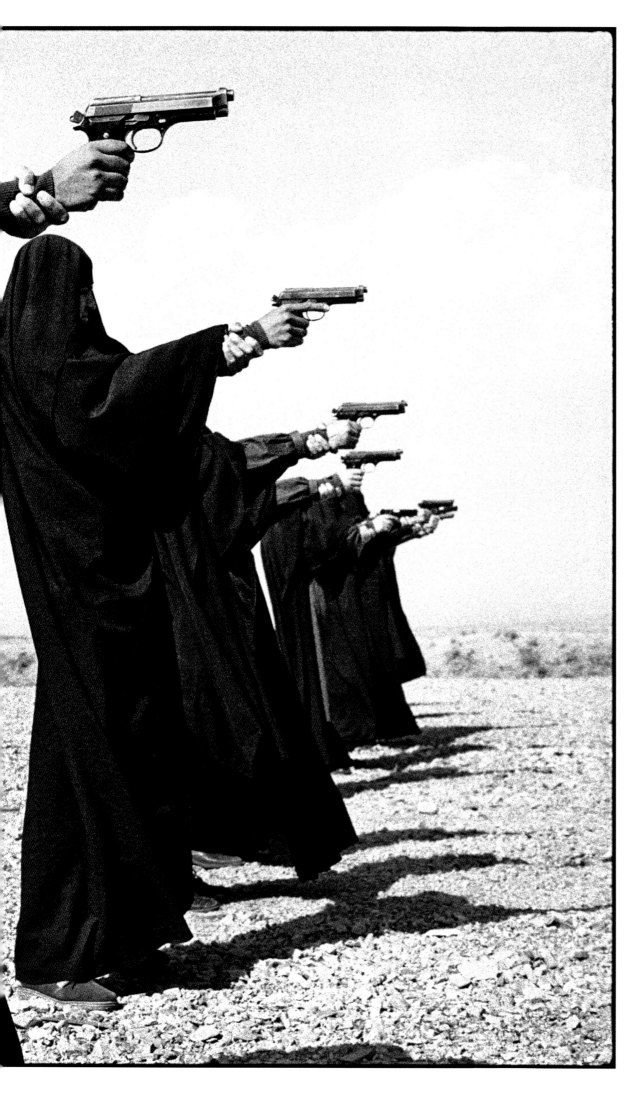

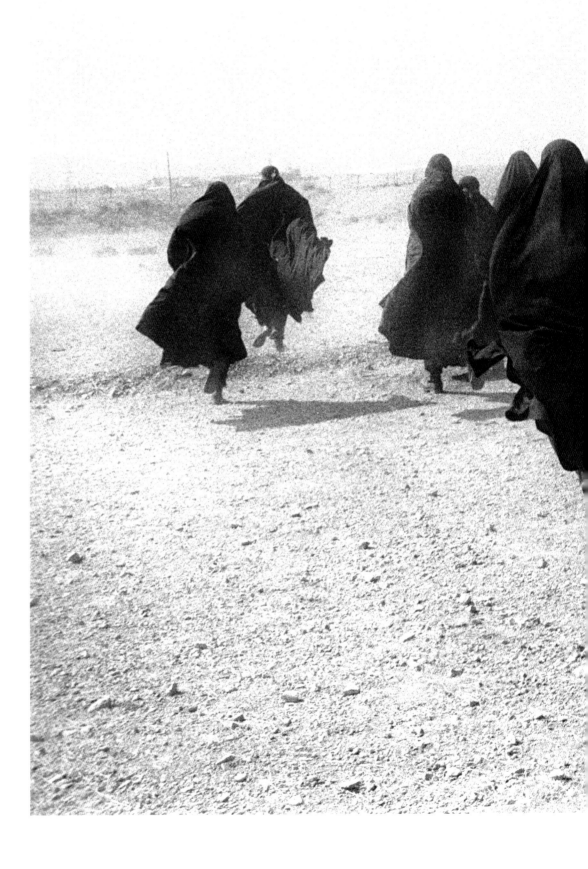

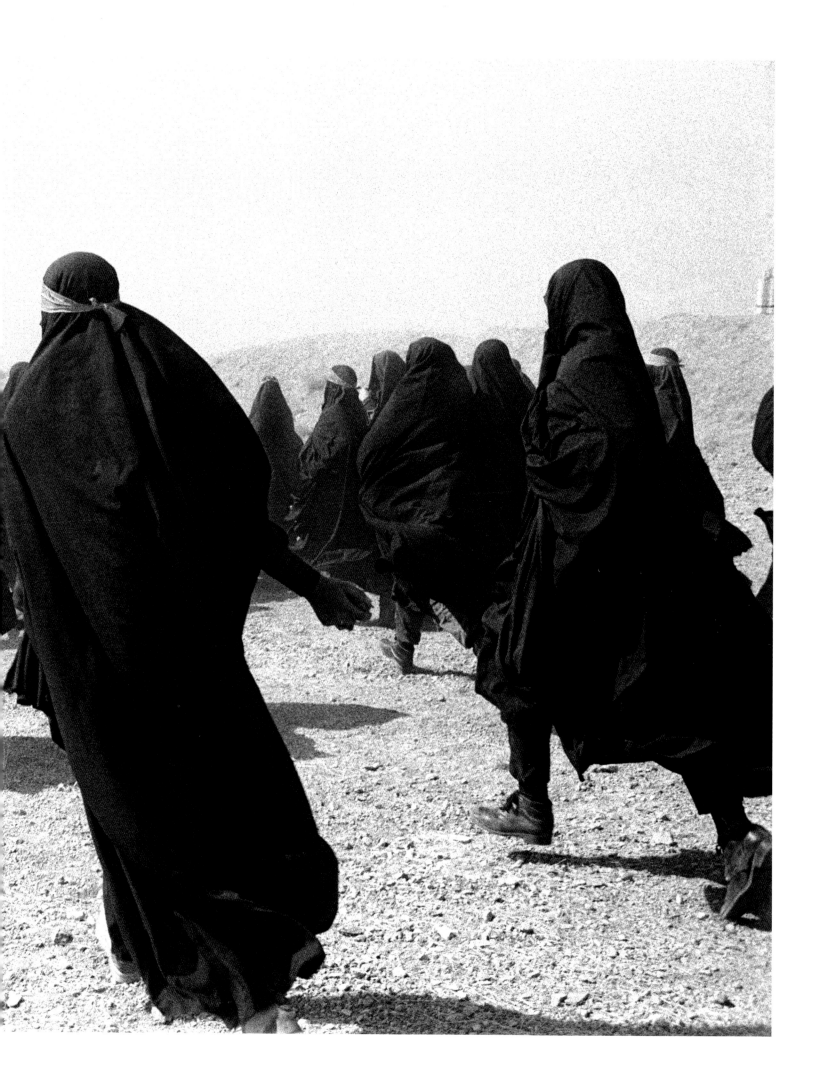

2353

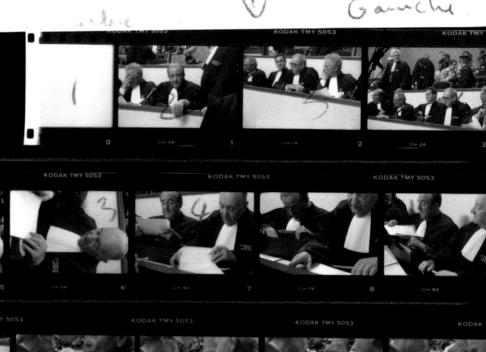

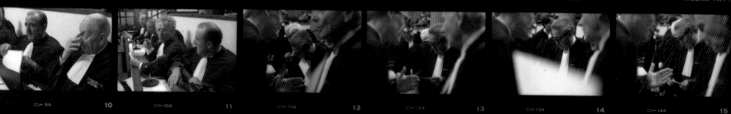

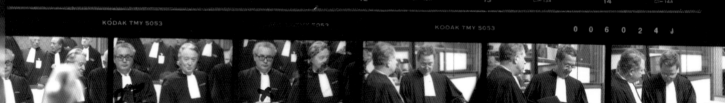

Lyon, France
May 1987

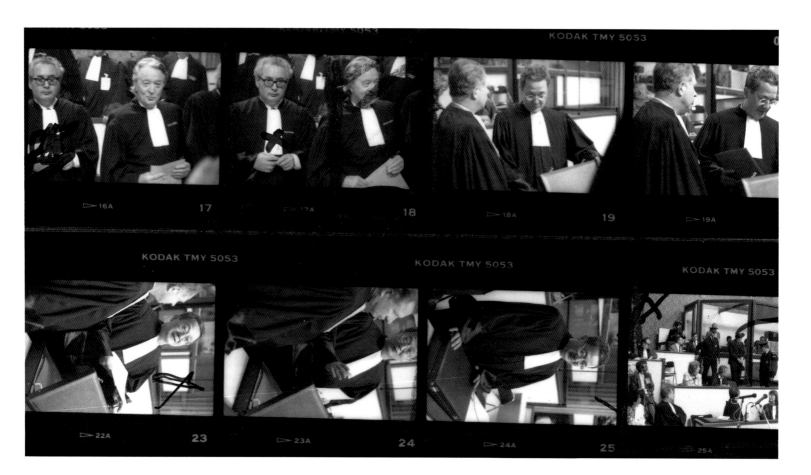

As a native of Lyon who served in the French Resistance, Marc Riboud approached his assignment to photograph the war crimes trial of former Gestapo head Klaus Barbie with a dual focus that encompassed his role as both witness and participant: 'On 12 May 1987, at 1pm sharp, millions of television viewers wait for Klaus Barbie to appear. In the Lyon Palais de Justice, the lawyers wait, too. Suddenly, Barbie appears in my viewfinder. I know he's a torturer and a killer. My camera has never been a more effective shield. I press tensely on the shutter release. Forty-four years before, here in Lyon, so many members of the Resistance, comrades and close relatives were tortured and shot by the Butcher of Lyon. Now, he is only a few feet away. He looks like a gentleman, courteous, reserved; almost vulnerable. You'd trust him with your children. But can the picture be trusted? That evening, in the laboratory, I discover something on the contact sheet that I hadn't seen before: the respectful looks centering on the accused as if he were a star.

'During the trial I met another person, Julien Favet, the only surviving witness of the Izieu round-up ordered by Barbie. Forty-three children, aged from five to fifteen, were thrown alive into the flames at Auschwitz. Favet is a former farmhand, illiterate. With his deformed eye and twisted mouth, he could be frightening, and yet he's a gentle and sensitive man, obsessed by the truth and revolted by injustice. One really must beware of judging by appearances.'

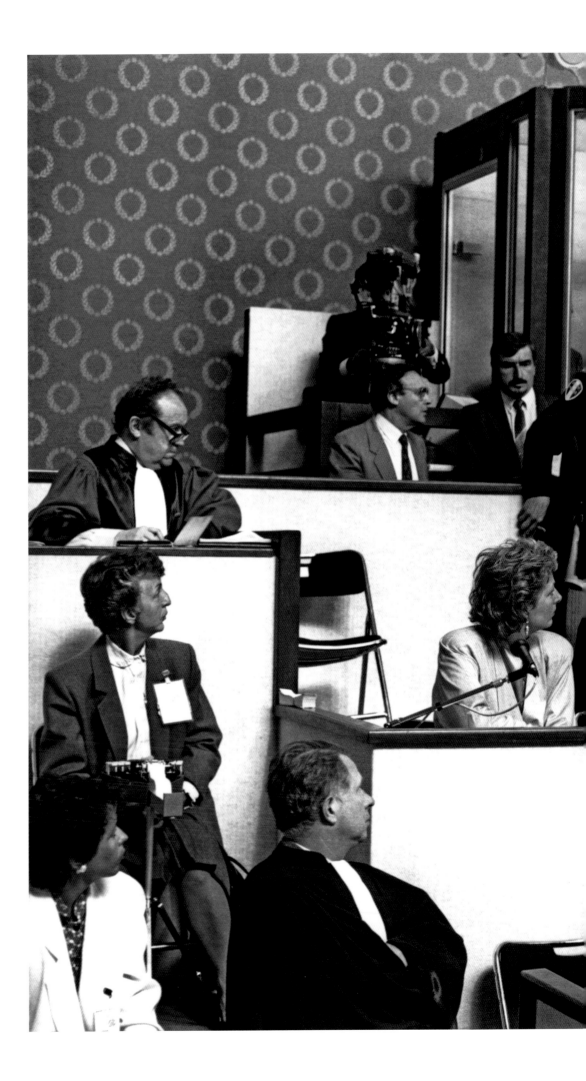

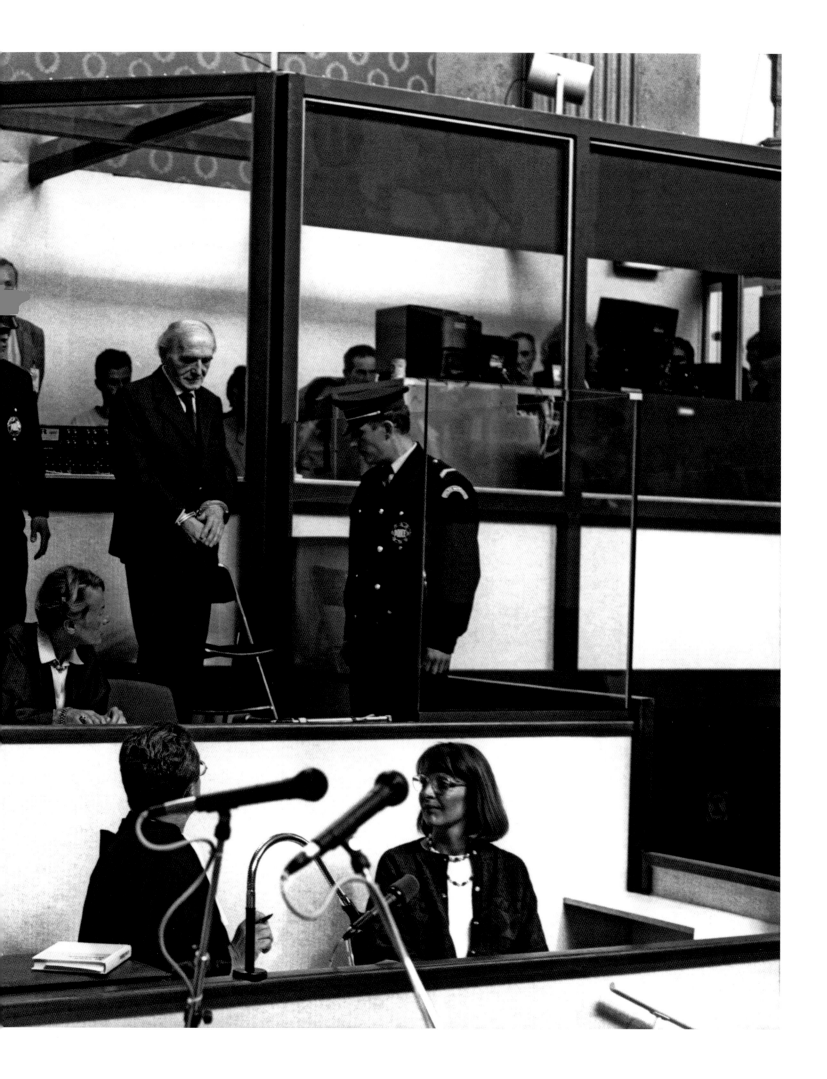

FERDINANDO SCIANNA Marpessa

Bagheria, Sicily
Spring 1987

"I was in Bagheria, in Sicily, the land where I was born. It was the spring of 1987. Two little-known designers called Domenico Dolce and Stefano Gabbana had asked me to take photographs for one of their fashion catalogues. I had never done any fashion photography before. I felt a little guilty, but happy. We were at the Villa Palagonia, a baroque palace filled with sandstone monsters. The model, Marpessa, was amazing. The dress was very sexy: close-fitting, black, transparent, with a rose at the waist. The light was fading.

Trying to find an image, I began with the face. Marpessa's beauty hypnotized me. Then I began to explore the outfit. Ultimately, that was what I was there to capture. I asked Marpessa to move her hands closer to the rose. At the start, she had her hands crossed, and they looked too compact. Then she stretched them out. The elegance of the pose, the contrast between her pale hands and the dark transparent fabric seemed perfect to me. I no longer needed her face in the shot, so I pulled in close and cropped it out. That crop was too close, so

I moved back a little and cropped at collar height. There they were: three shots, almost identical. Then I tried something else. Out of all the images I took for that catalogue, and in the few years that I spent on my unusual and exciting venture into fashion photography, this is perhaps the one that is most often discussed and remembered.

I continued to work with Marpessa, and our collaboration was turned into a book. The subheading was 'A Story' – the story of the photographer and his model, which, strangely, in seventy years of fashion photography, hadn't yet been done. In 1989 I made my application to become a member of Magnum, and I did something that at the time was seen as scandalous. It wouldn't be now, but back then it provoked a great deal of discussion. There were my classic Magnum-style photos – committed social photography with a gritty realism – but I also took along my fashion photography, which had this ambiguity to it. 'Oh! Fashion!' A lot of people were appalled, but I got in."

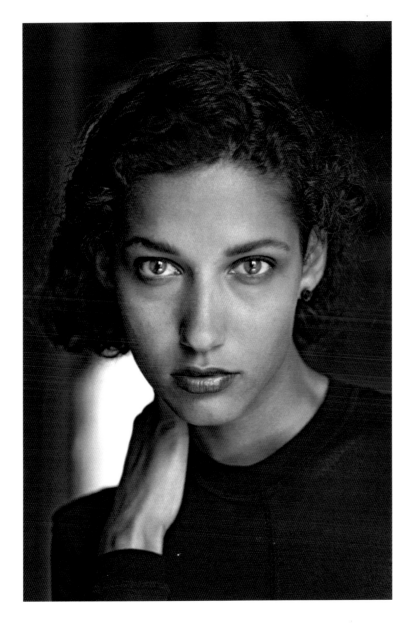

87-9-40

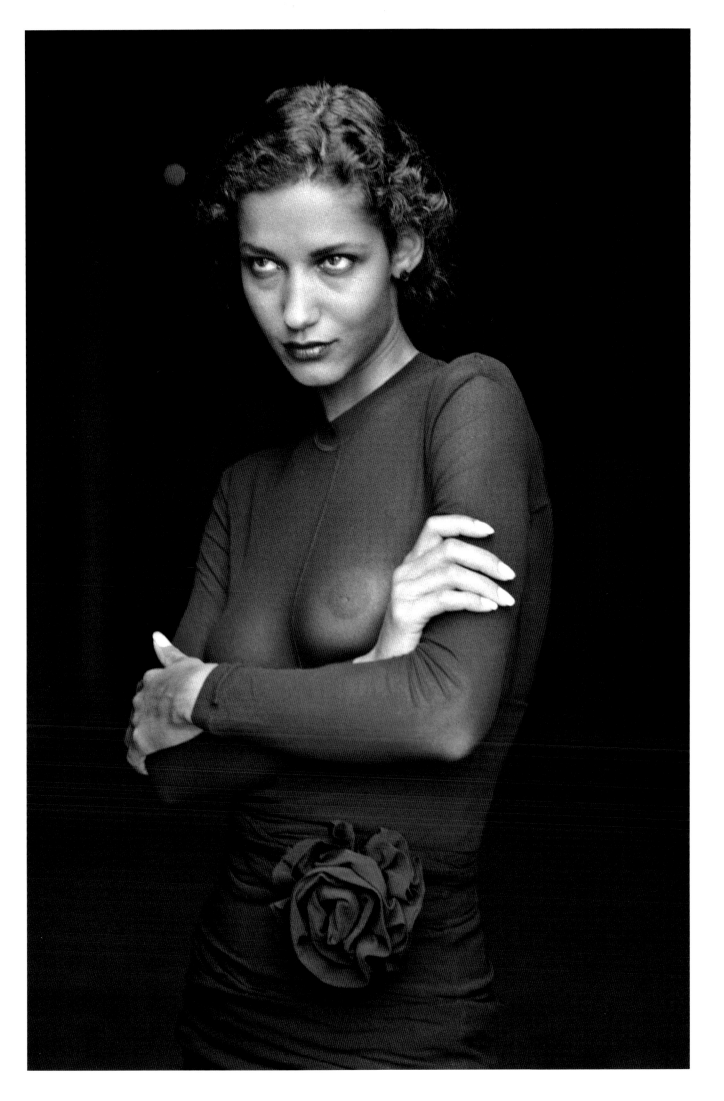

Kowloon, Hong Kong
1988

"I was working on a personal project on the Chinese diaspora, *W., or the Eye of a Long-Nose*. W. was a Chinese-French Cambodian friend, who'd initiated me into Chinese culture, codes, ways of thinking and secret societies. I wanted to go and photograph in Kowloon City, the 'Walled City', which was an amazing place. It was right in the middle of then British Hong Kong, but it belonged to Communist China, so the police weren't allowed in. A whole underworld had developed there, away from controls. All kinds of illegal practices flourished, including child labour, prostitution, drug smuggling, illegal immigration from China, unlicensed dentistry and so on. Of course the triad gangs were usually behind these activities.

Daylight never penetrated Kowloon City, even though outside it might be sunny. People carried umbrellas because it was constantly 'raining' from all the leaking pipes. W. called some of his friends to find somebody who belonged to the triads to guide us to a local godfather and let me photograph. That's how I got in the first time in 1987. I came back in 1988, having proposed a story on the triads to *GEO* magazine. This time I went through an association run by a British woman, Jacky Pullinger, working with addicts. Through Jacky I met Ah Sai, who is on the contact sheet, photographed on the roof of the Walled City. Ah Sai was a member of the Sun Yee On triad, but had become drug-addicted. He was frightened because triads don't usually allow addicts among their members.

The contact sheet shows my progress before the whole image is set up 'perfectly'. I was working with two Leicas, one M4 and one M5. I usually work with a 35mm lens, but also occasionally with a 28mm. Initially, Ah Sai is at some distance, standing up and looking at me (frames 6–7), then he sits down but is still posing for the camera (frames 8–18). Perhaps I felt that something wasn't natural and asked him to stand up again (frames 19–23). Then a natural position came by itself. He sat down, the way the Chinese do, started to lose his self-consciousness and looked to the front, while I was composing the frame and waiting for planes that were coming in (frames 24–30). Little by little, Ah Sai forgot about me. I came closer and asked him to look at me for a while. Then the magic moment arrived, with a plane framed just between the TV cables and Ah Sai looking down, suddenly expressing feelings of fear and tension (frame 34A). I stopped shooting at that point, feeling I'd got the right picture. Kowloon Airport has now been replaced by a larger one that is further away; and, after the Chinese took over Hong Kong, they destroyed the Walled City."

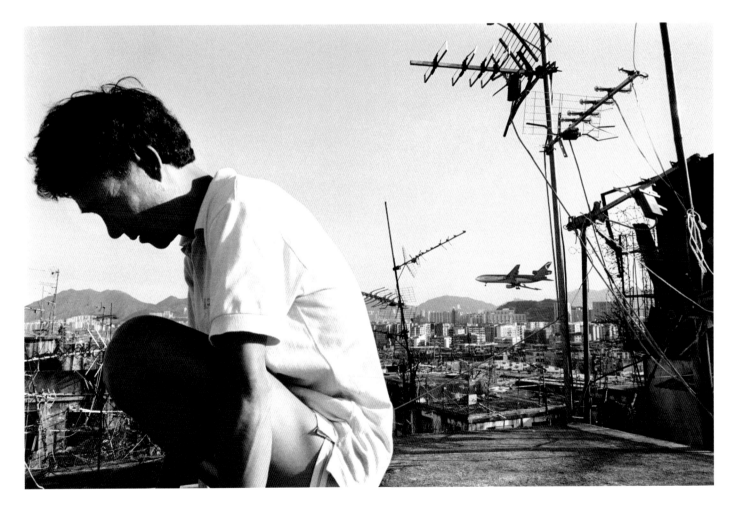

Hong Kong, 1988.
Kowloon city - Ah Sai, toscicomane et ex-membre de la triade Sun Yee On.

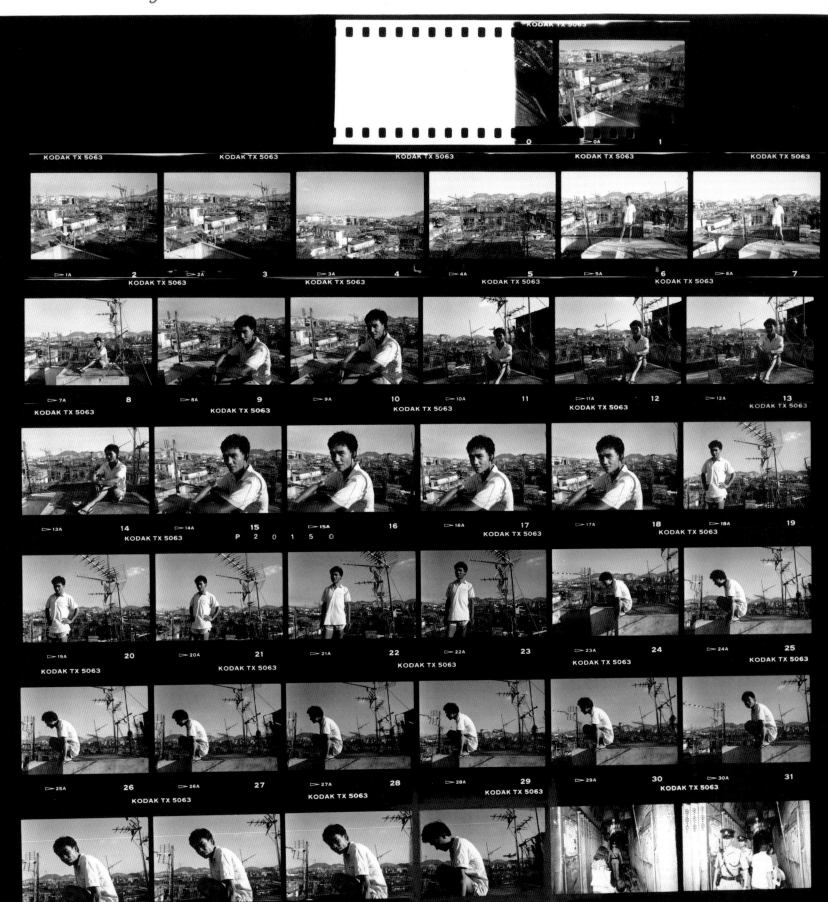

ILFORD HP5 2 4 5 5 ILFORD HP5 ILFORD HP5

0A 1 1A 2 2A 3 3A 4 4A 5 5A

2 4 5 5 ILFORD HP5 ILFORD HP5 2 4 5 5 ILFORD HP5

6 6A 7 7A 8 8A 9 9A 10 10A 11 11A

ILFORD HP5 2 4 5 5 ILFORD HP5 ILFORD HP5 2 4 5 5 ILFORD HP5

12 12A 13 13A 14 14A 15 15A 16 16A 17 17A

ILFORD HP5 2 4 5 5 ILFORD HP5 2 4 5 5

18 18A 19 19A 20 20A 21 21A 22 22A 23 23A ILFOR

5 ILFORD HP5 ILFORD HP5 2 4 5 5 ILFORD HP5

24 24A 25 25A 26 26A 27 27A 28 28A 29 29A

D HP5 2 4 5 5 ILFORD HP5 ILFORD HP5

30 30A 31 31A 32 32A 33 33A

2 4 5 5 ILFORD HP5 ILFORD HP5

34 34A 35 35A 36 36A

Berlin, Germany
November 1989

"Back in 1961, when I was nineteen years old, I was sent to Berlin to take pictures of Robert Kennedy. It was at the time when the Berlin Wall was being constructed. I've therefore ended up covering its construction in 1961 and its deconstruction in 1989.

These pictures were taken in Berlin, at the Potsdamer Platz, near the Brandenburg Gate. Jean-Pierre Montagne, manager of the photo department at the newspaper *Libération*, had contacted me to tell me that the wall had fallen. He asked me to go there immediately to cover the event. Back then it was a 'no man's land'. The wall fell on the night of 9 November 1989, but all the photographers arrived on 10 November. The pictures of the young man on the wall were taken on 11 November. The wall had fallen, but not completely. Its symbolic remains were still there.

As you can see on the contact sheet, in the middle of the roll I started to focus on the young man on the wall. He was a punk from the West, and he suddenly screamed very loudly. That's how he got my attention. He screamed and I grabbed my Leica and I shot. The power of the image is made by this rebel yell. It's a cry of freedom, anger and pleasure. The scream symbolized the fall of the wall at the time. The picture appeared on the front page of the *Financial Times* and *Le Monde*, but it took a while before it became known as a good picture. I think it's getting even more symbolic with time.

There are always pictures that we forget about, or don't appreciate, or are disappointed by when we first see them. But, as time goes by, pictures become transformed. They gain in value, both sentimental and visual. I like to be on my own when I look at my contact sheets, because I'm often disappointed when I first look at them. For me it's an intimate moment that I don't like to share. But, as years go by, we become proud of our old contact sheets. They are a tool that allow us to fight against time."

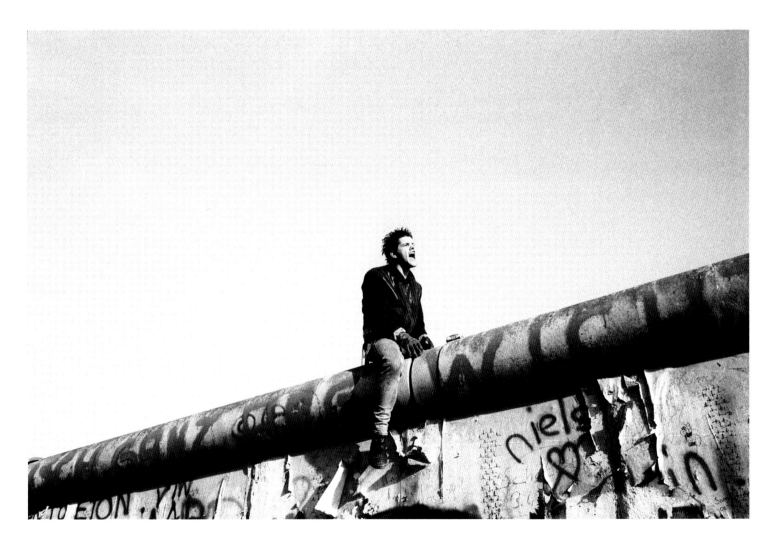

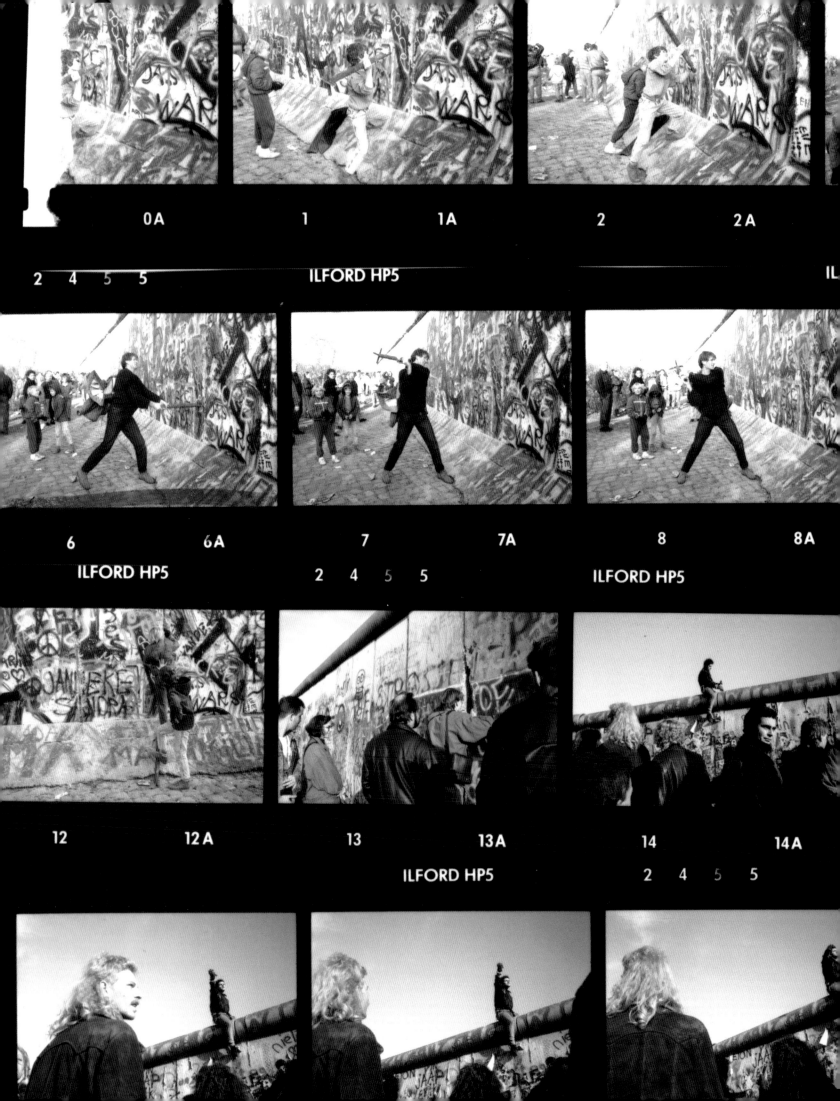

ILFORD HP5

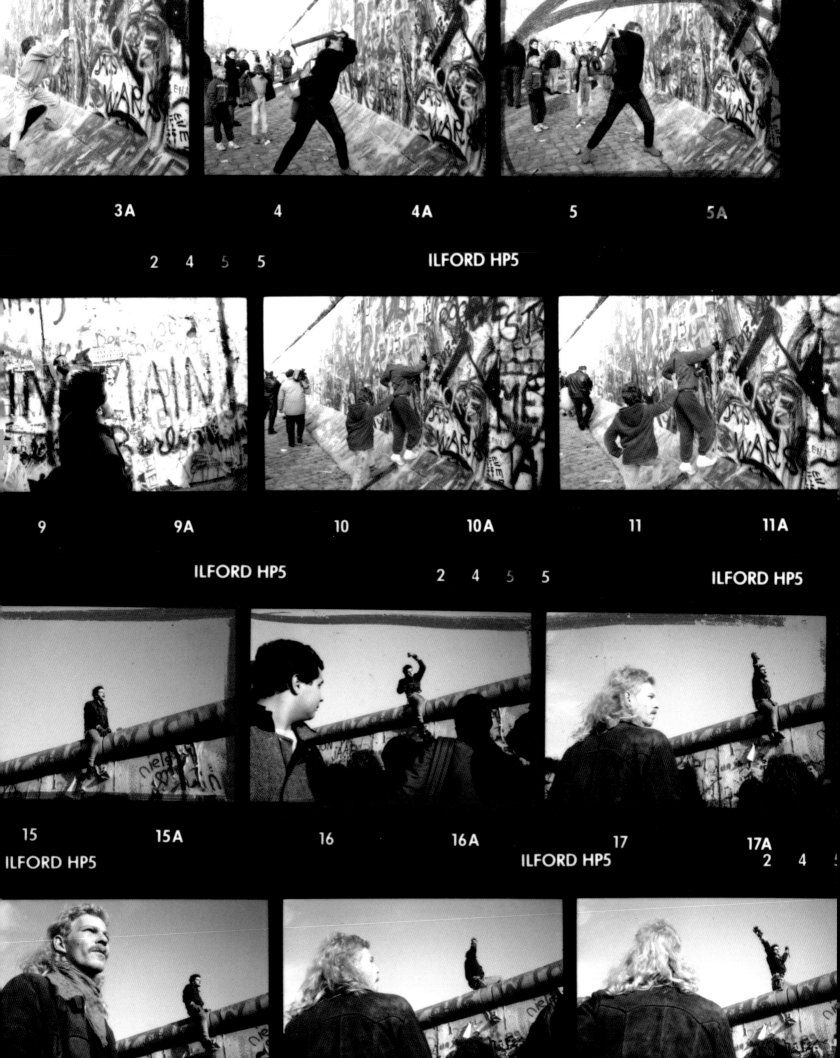

Beijing, China
June 1989

"This is not a contact sheet, strictly speaking. It's an assemblage of photographs in more or less chronological order, taken during the morning of 4 June 1989. This was the morning after the terrible crackdown on demonstrators around Tiananmen Square. The square had been cleared overnight and we were trapped in our quarters, the Beijing Hotel. All the photographs were taken from the hotel balcony looking down Chang'an Avenue towards the square.

When I started taking these photographs, I had no idea what was going to happen, but I did see people in the distance continuing to demonstrate, to form a line in front of a row of soldiers. I heard shots fired but couldn't confirm who, if anyone, had been hit. Finally the tanks started to roll up the avenue, and the whole *ballade* began between them and the lone protestor.

As I have often said, I was always frustrated with my photographs: I was too far away. But after the television footage moved the whole world, I guess the photograph of defiance became iconic and at the same time symbolic of the whole juggernaut of the Chinese state being challenged by its people. In this sequence I at least try to place the work in context, in space and time."

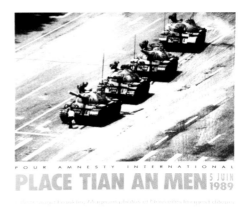

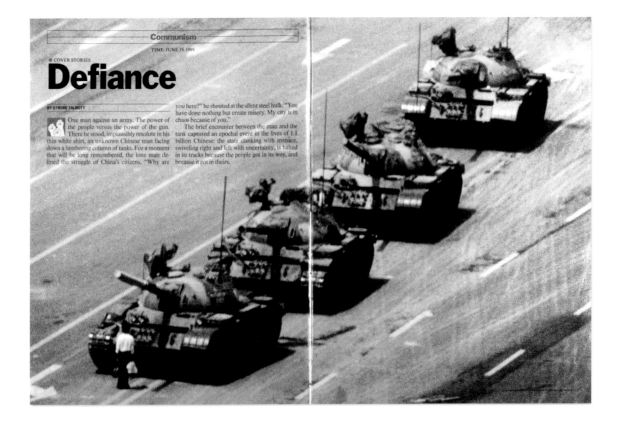

TOP AND ABOVE An Amnesty poster and a spread in *Time* magazine, featuring Stuart Franklin's iconic image.

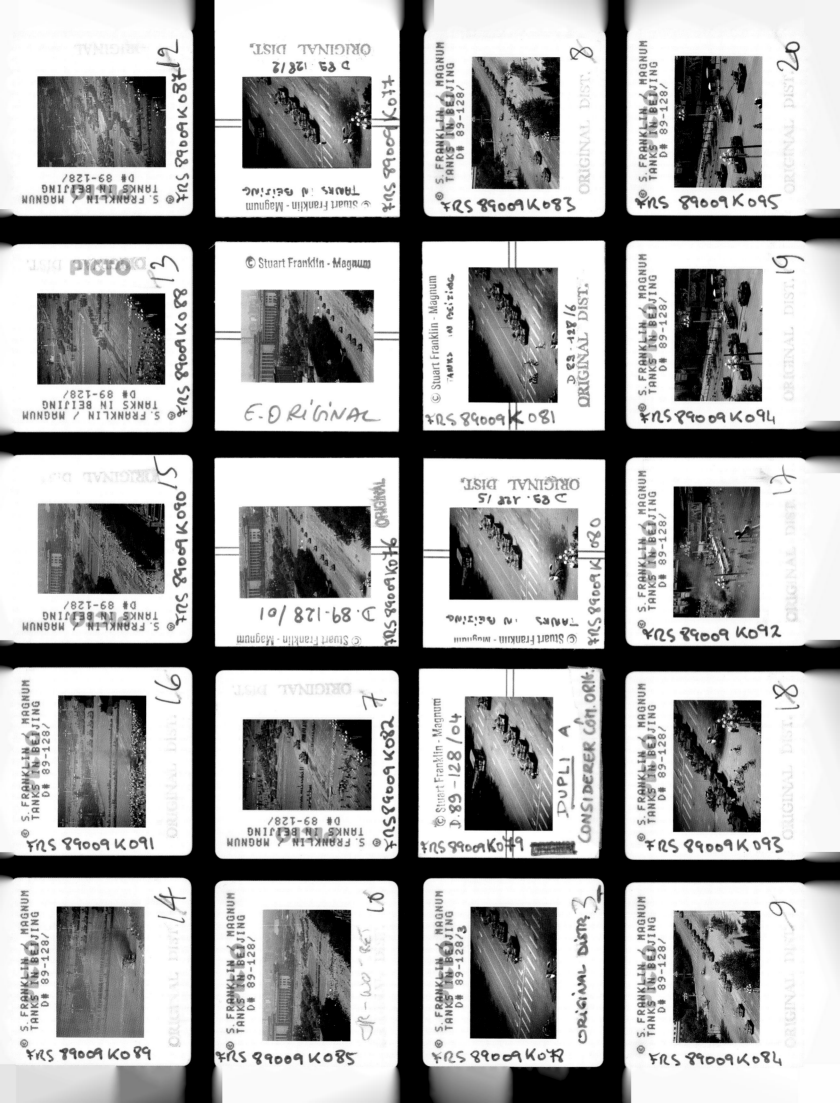

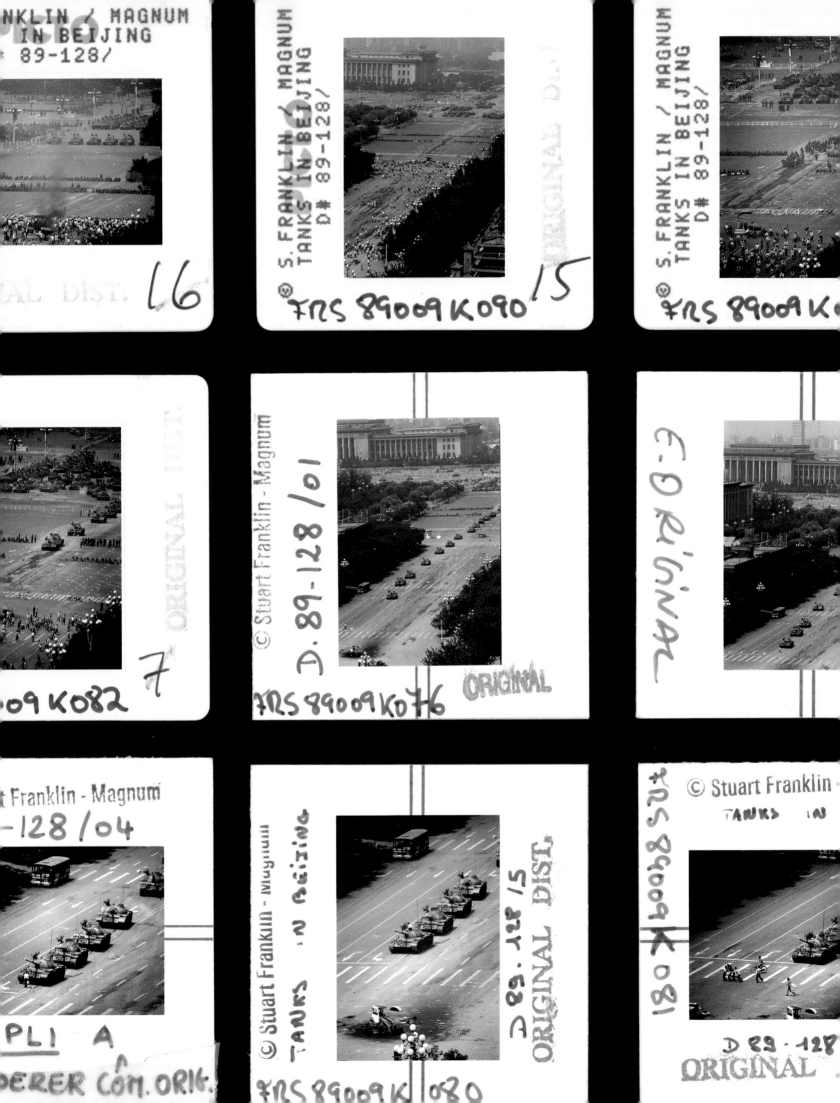

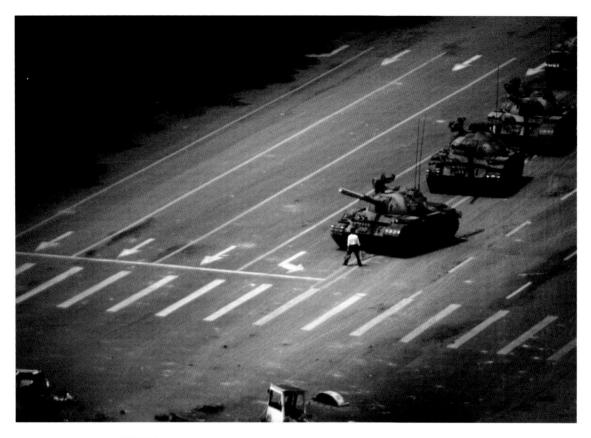

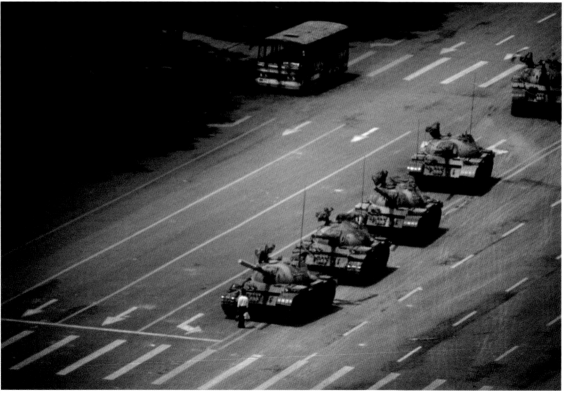

California, USA
1989

"At the time I thought it couldn't get worse than this. They were two young kids, she from a wealthy southern Californian family and he from the other side of the tracks and country. Fuelled by the cheques her parents sent her in the mail, they drank all day, every day. They were endlessly abusive and violent, calling each other Mommy and Daddy amid constant but abortive attempts at sex, only to puke some more and then pass out. As exciting as it was in the moment to be in a place as intimate as this … immediately afterwards my stomach would seize, and I became sickened as a depressive state settled in.

I thought hard as to whether I could use these images or not. After looking at the first proofs I was unhappy with their descriptive sharpness, so I decided to work directly with the contact sheets by cutting them up and pasting together the pieces into a collaged artifact. Although this new contact sheet succeeded in becoming a dense, distilled encapsulation of what I had experienced, it was still too clear and graphic. I then tried to selectively hide parts, using paint and scratches. However, the more I tried to hide and the more markings I made, the more the violence and voyeuristic nature revealed itself. So I decided to hide everything behind photos of a TV set. This came from thinking about the hotel rooms where these children often stayed – transient shelters for their tangled lives.

I imagined being in one of these rooms, with the kids passed out from too much of something, and the TV going, and it's 3am and the station is going off the air and the American anthem is playing and a flag is waving, and then it signs off to static… I used words to describe what you couldn't see. They were typed out and taped underneath the contact sheet to complete the story."

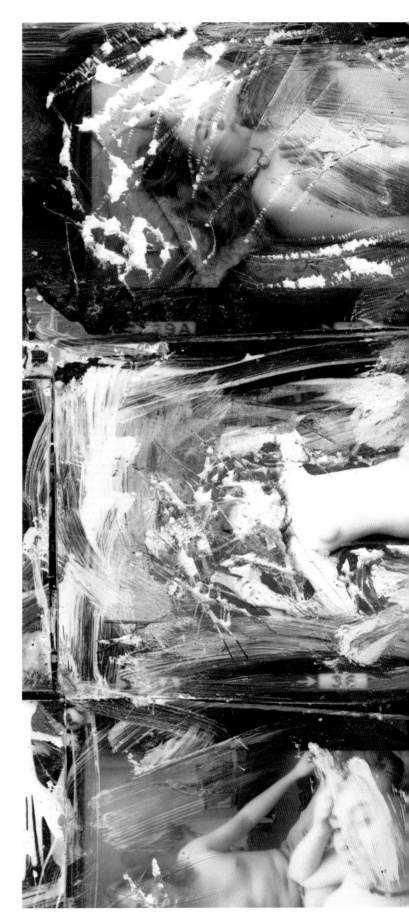

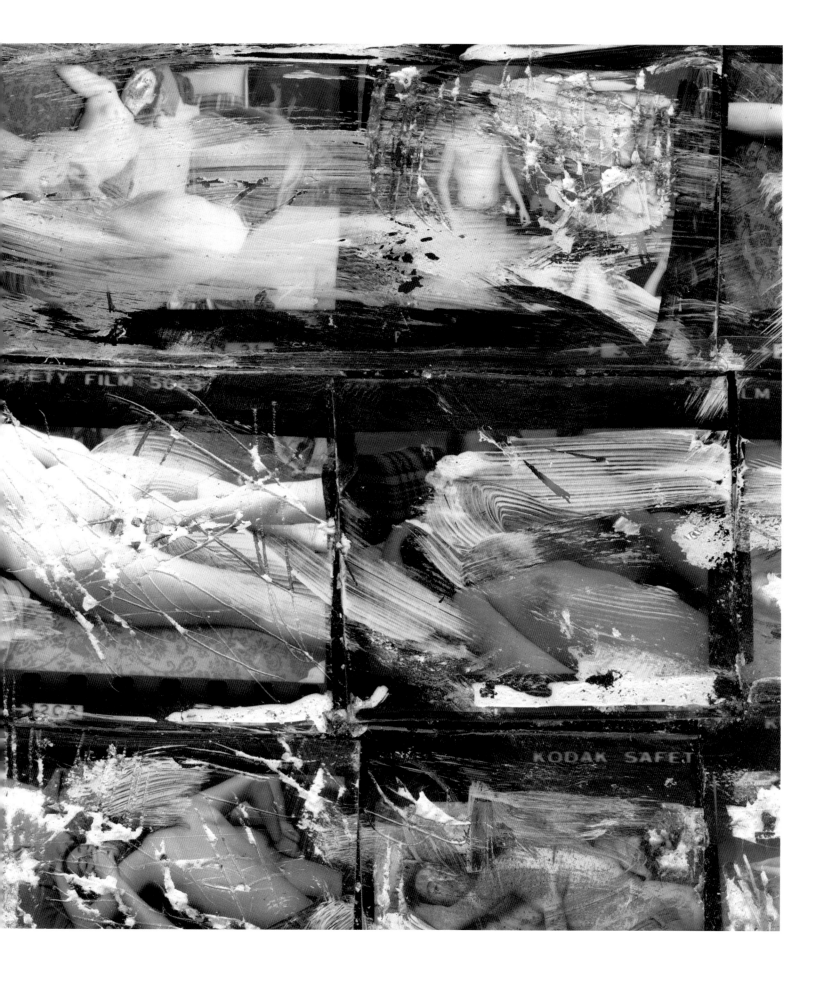

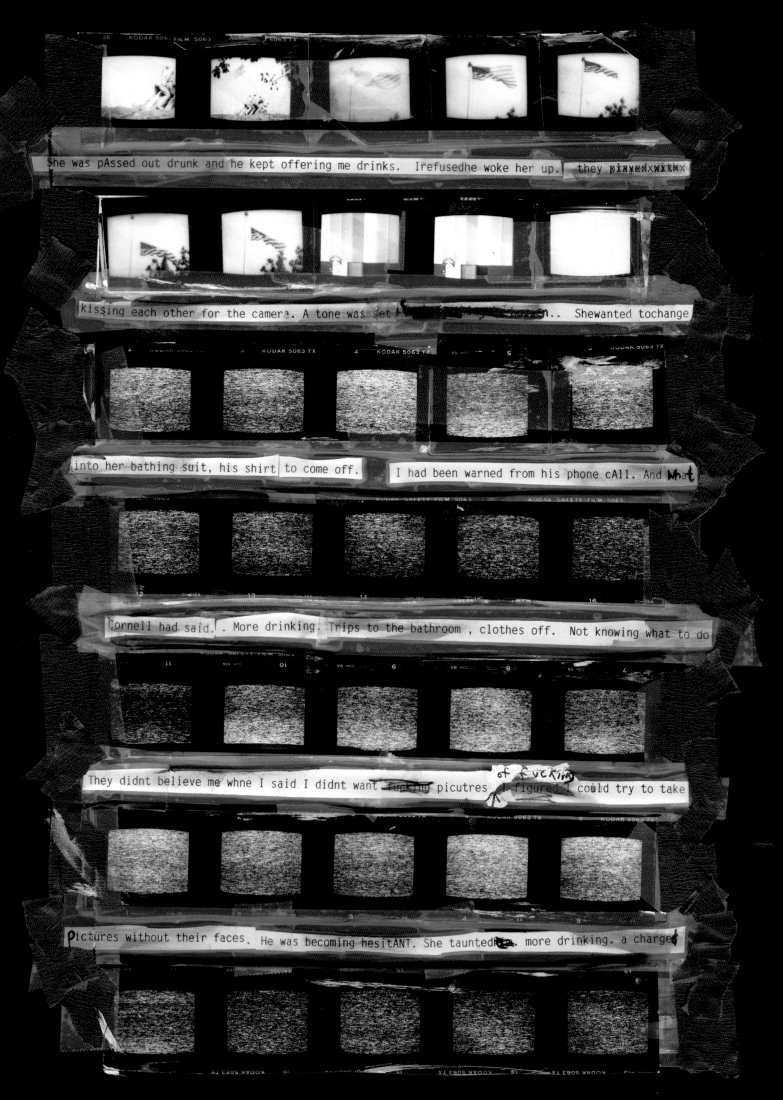

She was pAssed out drunk and he kept offering me drinks. Irefusedhe woke her up. they played xxxxxx

kissing each other for the camera. A tone was set ~~xxxxxxxxxx~~.. Shewanted tochange

into her bathing suit, his shirt to come off. I had been warned from his phone cAll. And What

Cornell had said. . More drinking. Trips to the bathroom , clothes off. Not knowing what to do

They didnt believe me whne I said I didnt want fucking picutres *of fucking* I figured I could try to take

pictures without their faces. He was becoming hesitANT. She taunted ~~him~~ more drinking. a charged

parental tome filled her voice. He became the "dumb" little brother. ~~She seemed to enjoy her new~~ they

would argue and then before I knew it back trying biting to fuck. He couldnt get it up. More out of control

Cigarettes and drinking poking He hurt ~~~~ emotionally too. ~~filling with~~ anger. finally

ha he so frustrated and taut he started slapping. A smile. She hit back. ~~kissing again.~~ sloppykissingsmoking. drinking More

nits ~~and and a threshold of screaMing and then~~ during it all calling each other Mommy and DAddy

I HID these picutres for years.

Calais, France
1989

Silent and monumental, Josef Koudelka's panorama of
the new harbour in the northern French city of Calais is
simultaneously a document of a specific location and an
abstraction of an industrial 'non-place'. Created using a
large-format panoramic camera, the scene is evocative
of a post-apocalyptic world and forcefully heralds the
end of a romantic, idyllic conception of the landscape.
The image – one of the earliest examples of Koudelka's
ongoing series of panoramas – resulted from a French
government commission from DATAR to record the French
landscape at the end of the twentieth century. Although
the work is visually a radical departure from his earlier,
well-known photographs of gypsies or the events of the
Prague Spring (see pp. 184–89), the uniting factor is an
interest in 'what is ending; what will soon no longer
exist'.

As Koudelka notes: 'This photograph was taken
for my first book of panoramic photographs, *Mission
Photographique Transmanche*, published in 1989, and
later used on the cover of my book, *Chaos*. It's become
one of my best-known panoramics. I chose the top image
as my final selection because it has the best composition,
and I crop it a little.

'I spend a lot of time studying my contact sheets.
I use a very specific visual code to label my pictures,
with different colours to indicate their importance.
First, I frame in white all the pictures that appeal to me,
to make them stand out. Images marked with yellow are
all the ones that Magnum may use. The ones marked
red are the next selection – for books, for example.
A blue mark means that those pictures are part of my
"exhibition drawer", where I keep negatives of my best
photographs. These are the images I publish and exhibit
under my full name; the others, usable for the agency as
press illustrations, are signed only with my initials, J.K.
I've made this distinction among my works – for me and
others – since I first came to Magnum in 1970.'

ABOVE Cover of *Chaos*, published in 1999.

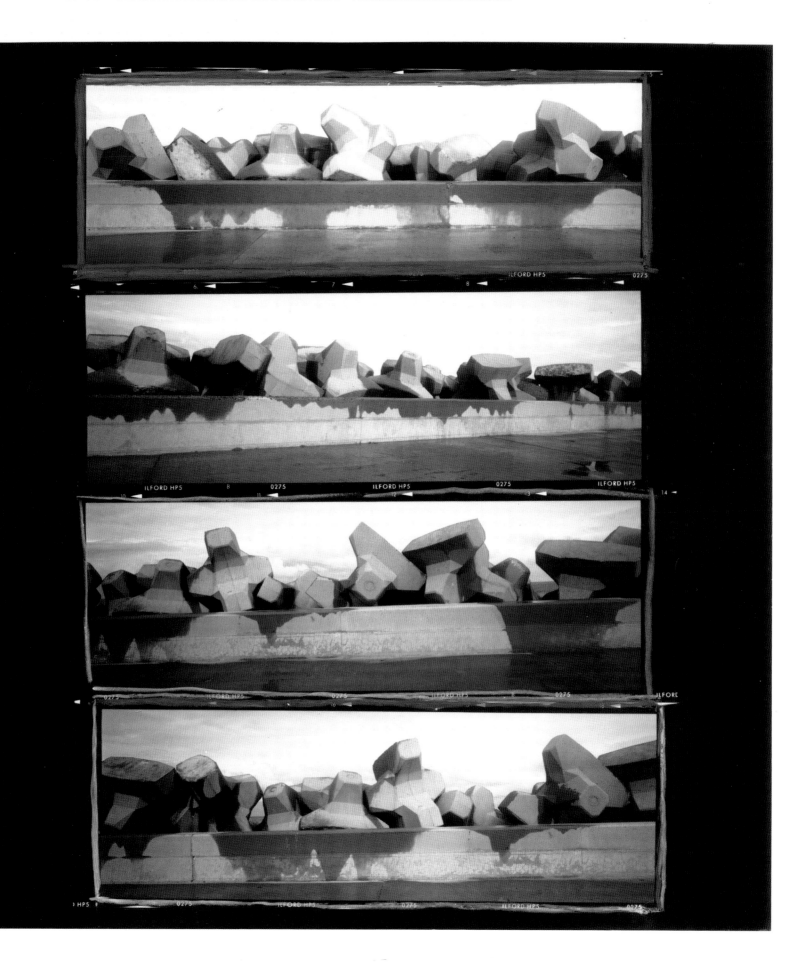

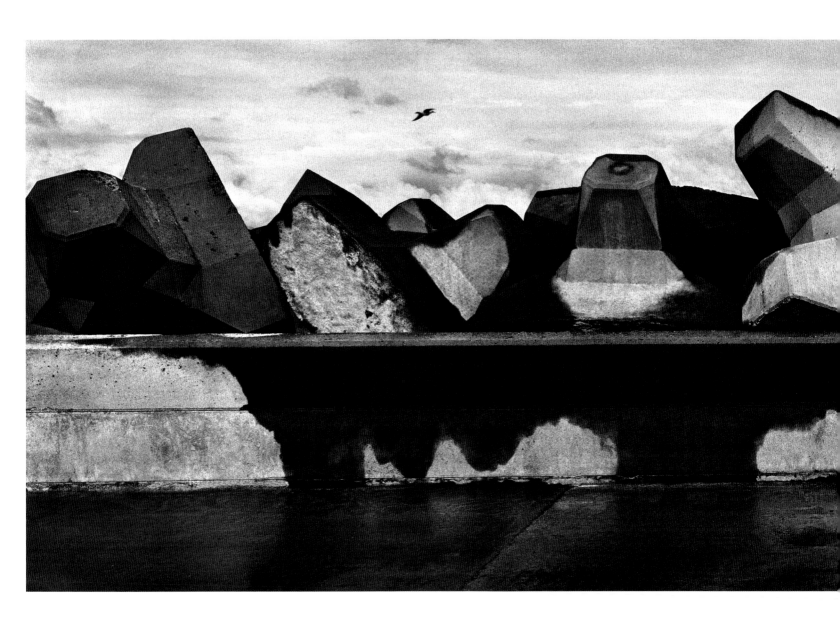

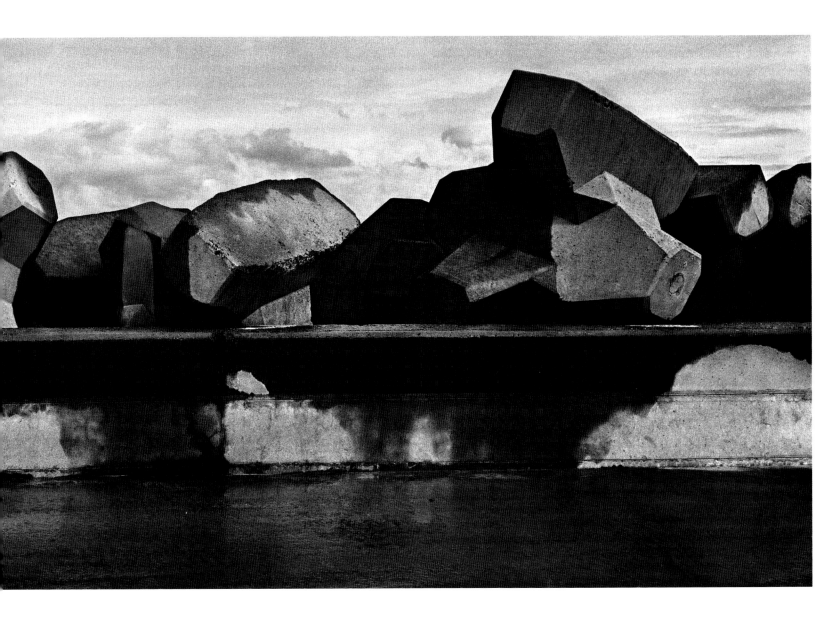

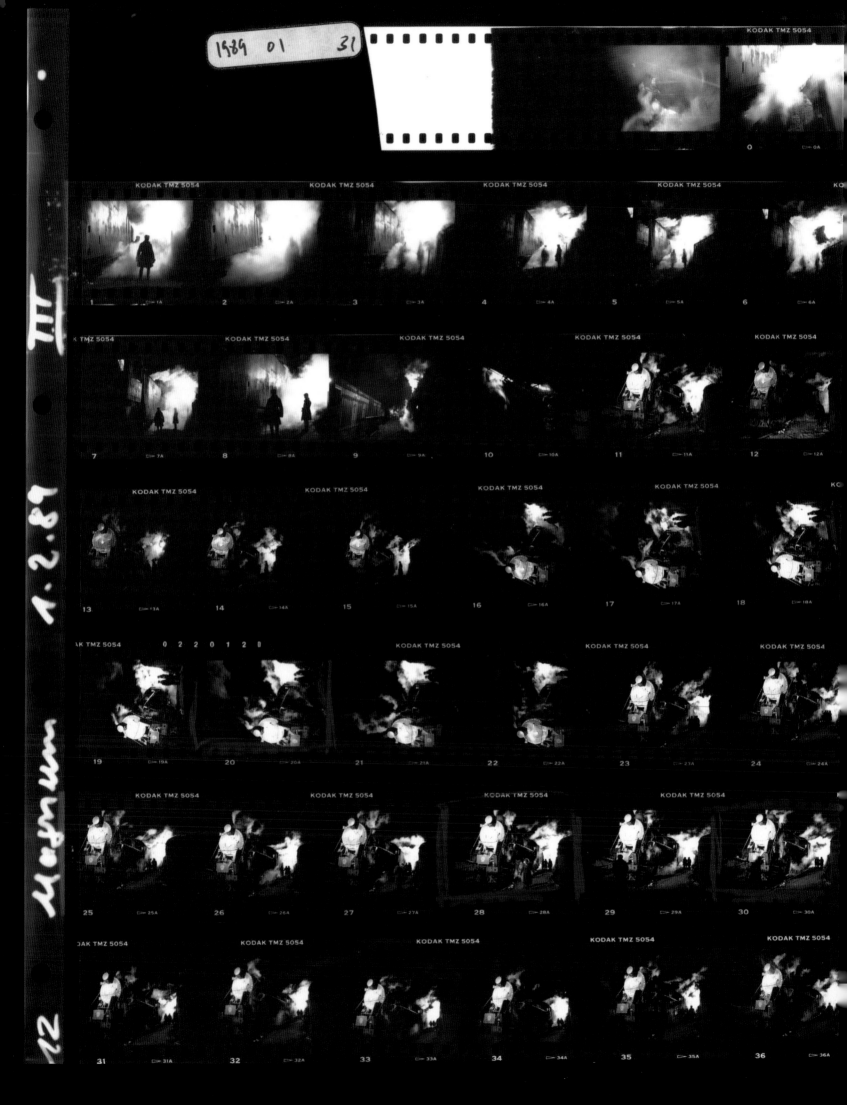

Leninakan, Armenia
January 1989

"I arrived in Armenia after the New Year. Leninakan
and Spitak were completely destroyed. I had never seen
anything like it. There was not a building left standing in
its entirety. The initial shockwave of emotions had already
passed. People were living in ruins and tents. Women,
children and the elderly were being evacuated. Of course,
the cities were almost entirely blacked out as well.

Two special trains were dispatched to the towns.
They were trains that were kept in case of war or
catastrophe, with steam-driven engines that generated
their own power in order to be autonomous. The particular
train photographed here brought these poor folk bathing
and laundry services, which ran round the clock. I took
these pictures one night when people were coming back
from the baths. I could take them in the dead of night
thanks to a new type of film that had just come onto the
market – 3200, which I pushed up to 6400."

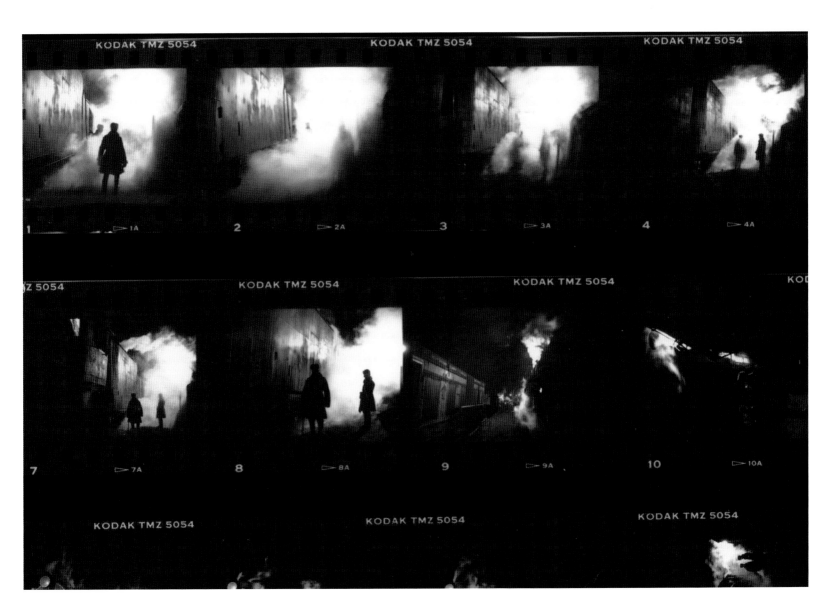

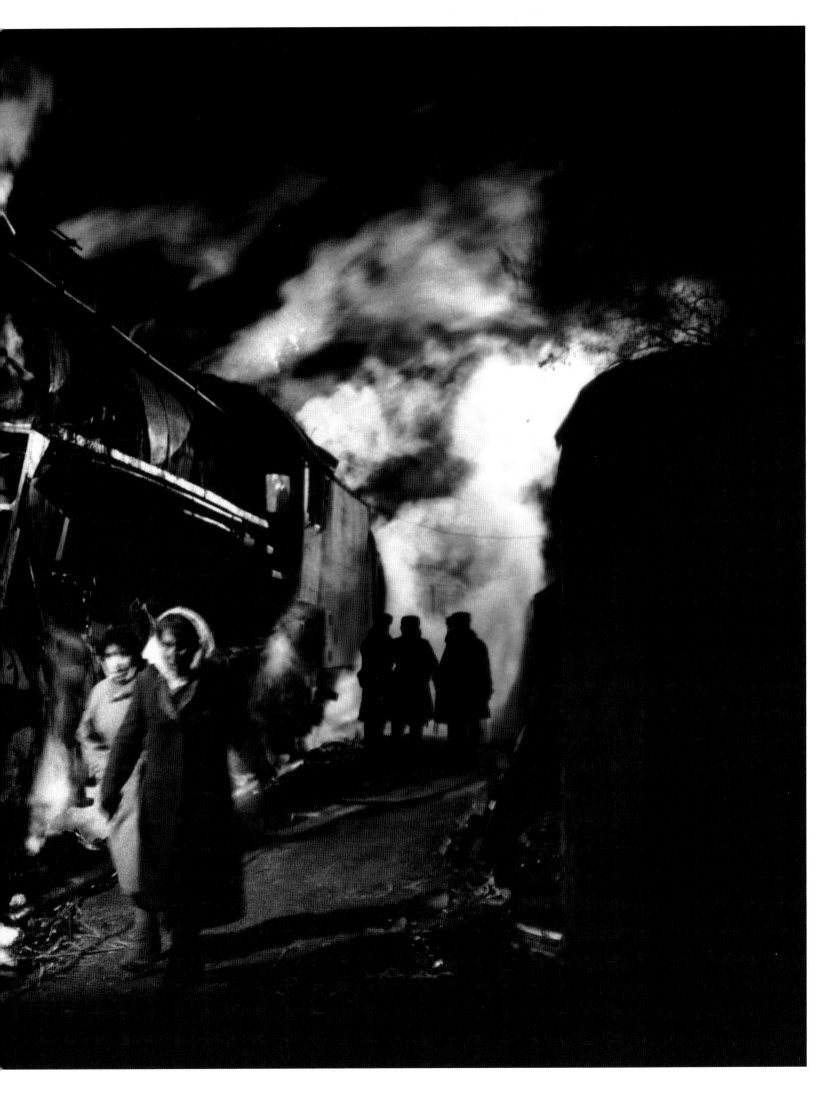

1990-99

90-02-19/2276

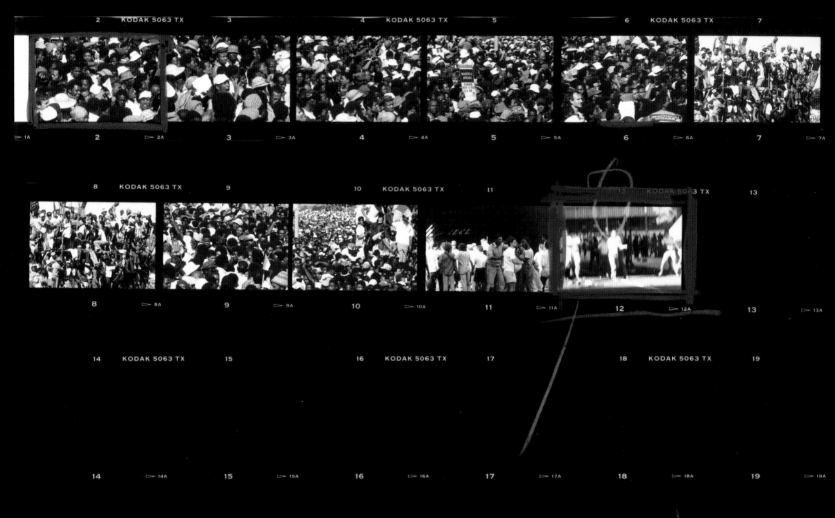

Cape Town, South Africa
February 1990

"It was the day of Nelson Mandela's release from prison. The beginning of the contact sheet shows the crowd gathering to wait for him in the square where he was expected to make his first speech to his people. The 11th frame shows the chaotic situation that ensued. The 12th, the only frame that is out of focus, was the last shot I could take of the riot and the police running and shooting. At the very moment that I took this photograph, one of the white policemen in it was firing at me with birdshot. I collapsed, while he shot me a second time with lead bullets. I got about thirty in my legs, arms and chest. Two also hit my Leicas. The photograph has subsequently often been used to illustrate the fight for freedom of the press.

For three months I was immobilized and had no income. When you are assigned by a magazine, you may be insured, but when you go without any assignment or guarantee, it's at your own risk. After the incident was reported in the press, the French photographers' corporation ANJRPC-FreeLens fought to find a way to protect independent photographers. As for myself, I learned to evaluate risks better and to be more careful on the field. I always ask myself now if a picture would justify getting killed or in serious trouble. I also learned compassion for the person on the other side of the lens. As I was lying on the ground, covered in blood and with my left arm swelling hugely, I hoped that somebody would take care of me and take me away (the police were still shooting).

When the incident happened, there were three of us photographers present. None of us knew each other. The Gamma photographer disappeared, but the Reuters one came over. I am very grateful to him, but his first reflex was to 'shoot' me! He took several pictures of me down, then he and a black guy took me to a nearby square, where all the injured people were laid out on the ground. I have often thought about that photographer's reflex and asked myself what I would have done. I'm not sure that I would have taken the pictures first, but I understand his professional attitude as a news photographer, and I think he had the right to do it. Before taking pictures of suffering people, or even before going to those kinds of places, I always ask myself now if it's really justified, and if it might actually help the people or the situation. It's crucial that news reporters, or assigned photographers, take risks in order to convey information, but I am not that type of photographer and I no longer feel any obligation to take those kinds of pictures."

TOP Postcard from Henri Cartier-Bresson: 'I hope everything has healed well; they opened fire on you with bullets, but just think of your camera as a flamethrower, and a lot more effective.'

ABOVE Postcard from Guy Le Querrec: 'And to think I've quite often felt my life was going down the drain! … Here's hoping Mandela will lend you a hand, since you need one.'

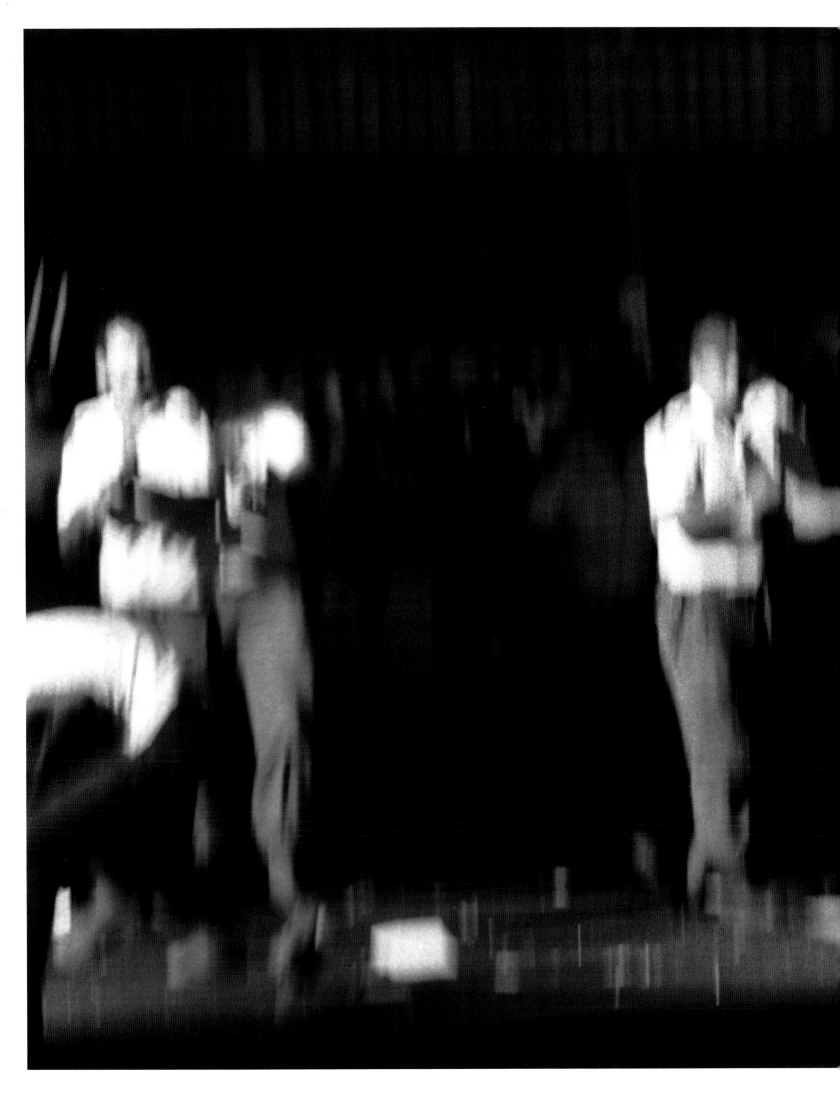

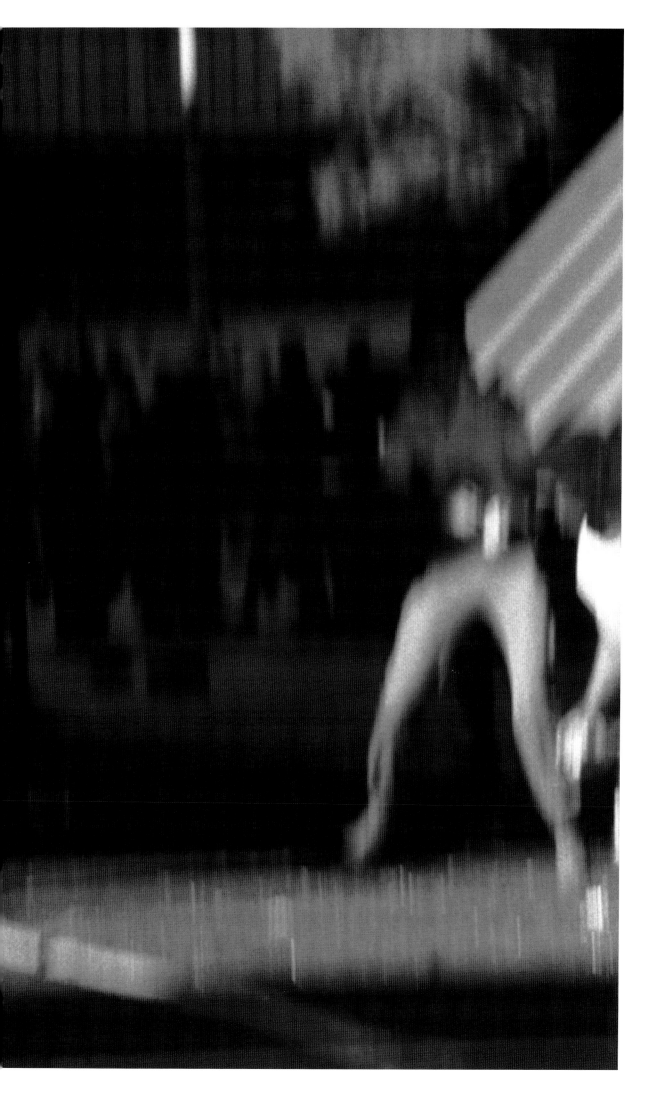

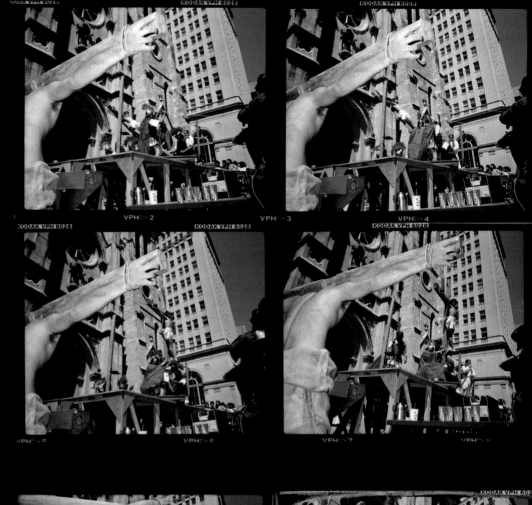
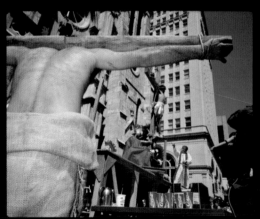

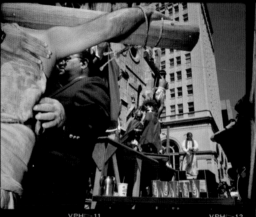

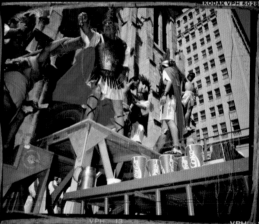
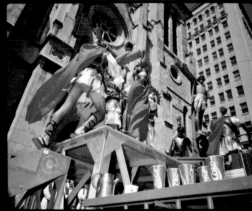
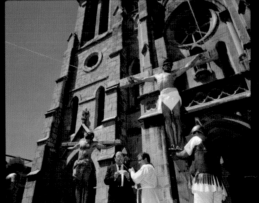

Texas, USA
April 1991

"The *God, Inc.* project took 13 months of travel in the
US; 50,000 kilometres, 32 different states, 150 different
churches and religious communities; a 1972 Winnebago
RV and a VW diesel car; 1,200 rolls of black-and-white
120 film; and 1 roll of colour film. That last roll was a
mistake. This is the contact sheet.

I had done an assignment for the American *GEO*
magazine – in colour – while travelling in the US.
So when I followed the procession of the Hispanic
community in San Antonio on Good Friday from their
little church to the rented stage, sponsored by Coca
Cola, in front of the cathedral, I put a colour film in my
camera by mistake. It happened during the climax of
the procession: Christ on the cross, people cheering,
other press pushing my back. I liked the image a lot,
but in the days before Photoshop and decent negative
scanners, I couldn't convert it into black and white
without losing too much quality. So one of my best
images did not end up in my book.

The *God, Inc.* exhibition was shown in 1992 at the
Canon Image Centre in Amsterdam. Kodak had a big
billboard on the façade, and an image from the show –
if in colour – was usually featured there. The San Antonio
colour picture was used and started to lead a new life.
Hanging 4 by 5 metres in size, the monumental image
reminded me of the old religious paintings I saw so
often in old cathedrals. The mistake I made started me
on *Trinity*, a 15-year-long project about the relationship
between photography and historical painting."

ABOVE Poster for the *God, Inc.* exhibition at the Canon Image Centre, Amsterdam, 1992.

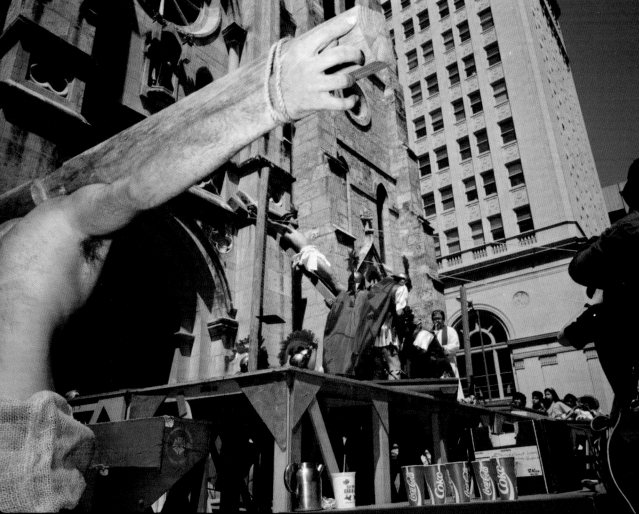

VPH ▷ 3

VPH ▷ 4

VPH 6028 KODAK VPH 6028

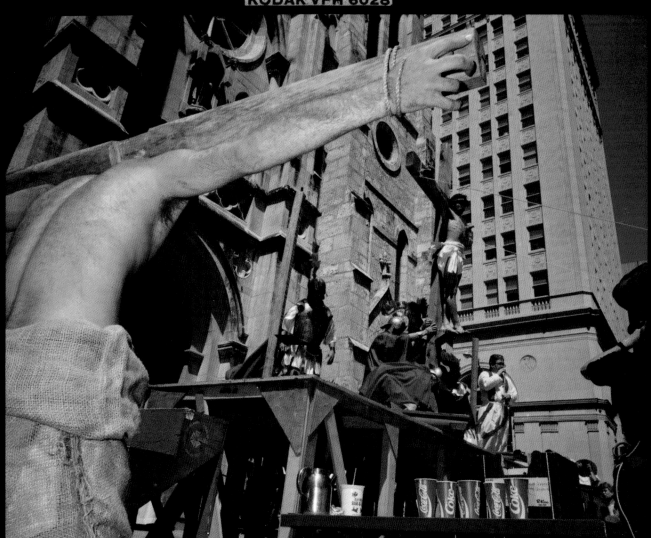

Hico, Texas, USA
June 1991

"This was the last subject for my *God, Inc.* project: it simply took a long time to find a Ku Klux Klan rally. But then Grand Wizard Tom Robb told me where and when they would have one of their rare cross burnings, or rather 'cross lightings', as the cross is a shining beacon for a world astray. So I arrived in Hico, a small town in the heart of Texas. The rally was to be held in some fields on private property. A large 'KKK Rally' sign served as entry, and a thirty-foot-high cross wrapped in burlap lay on a hilltop. Later, I got into some trouble with the Grand Dragon of Texas, who felt I was making too many pictures of the public during the speeches. He wanted to smash my camera and take out the film. Fortunately Grand Wizard Tom Robb intervened.

At dusk a few campers and motor-homes drove up the field. After a while, Klansmen got out, clad in white gowns with pointed caps. The cross was pulled upright with a tractor and all the gowned Klansmen entered the woods. After waiting half an hour in complete darkness, I saw them – there were about a hundred – returning in groups from the woods, every one of them in white with pointed cap (only the Grand Wizard and Grand Dragon wear black). Torches were drenched with gasoline and fire was passed in a circle around the cross. I wasn't allowed to photograph the final cross lighting with a flash, but I did it anyway, since I'd travelled so far to get to Hico.

The Grand Wizard lit the cross and set the group moving in a large circle around the mighty torch. The ceremony was simple but fairly impressive. The circle changed directions a few times, and once in a while torches were waved. A quarter of an hour later the cross had almost gone. Then they all turned towards me and I feared the worst, as I had flashed a lot during the ceremony. But instead of knocking my camera away, they gave me their own pocket-size cameras and posed before the cross. All the Klansmen's left arms were raised – not the right arm like the Nazis; the left one is closer to the heart – and they remained upright until all the pictures were taken. I took about twenty for them, and my own camera was the last I used. My shot was a single handheld Metz 60 flash on a Plaubel Makina 6×7, with a longer, 1/4-second exposure for the cross fire."

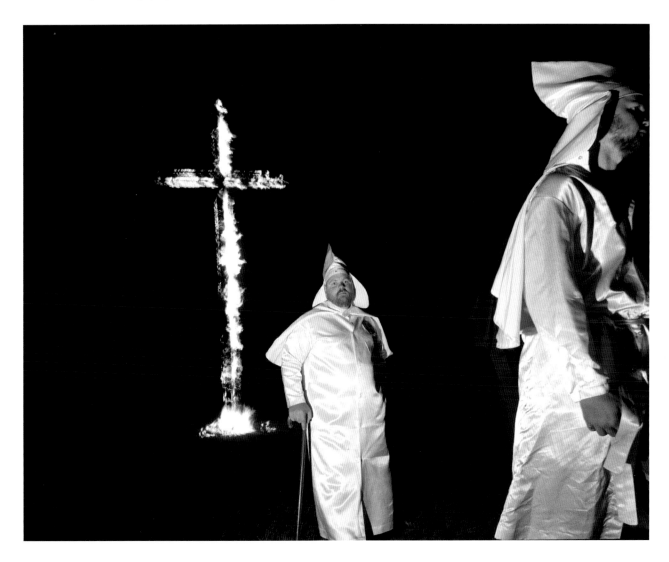

KEC 90 001 W 1201 HICO / TX USA
 KU KLUX KLAN RALLY

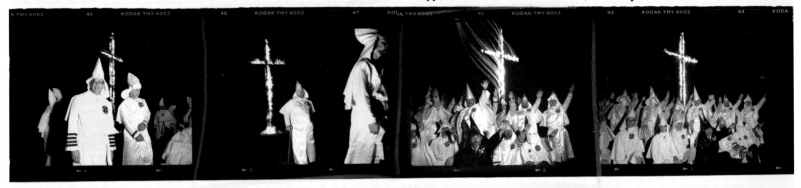

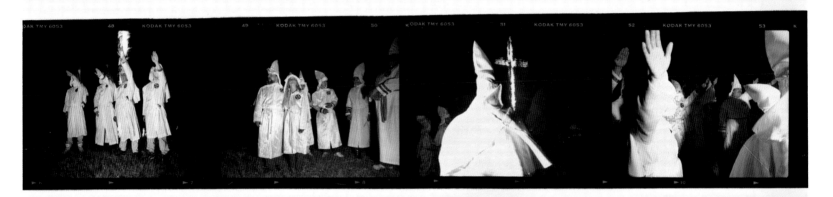

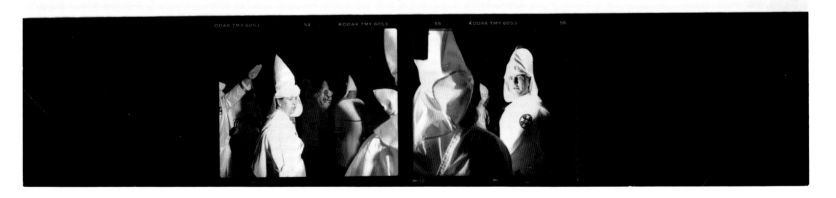

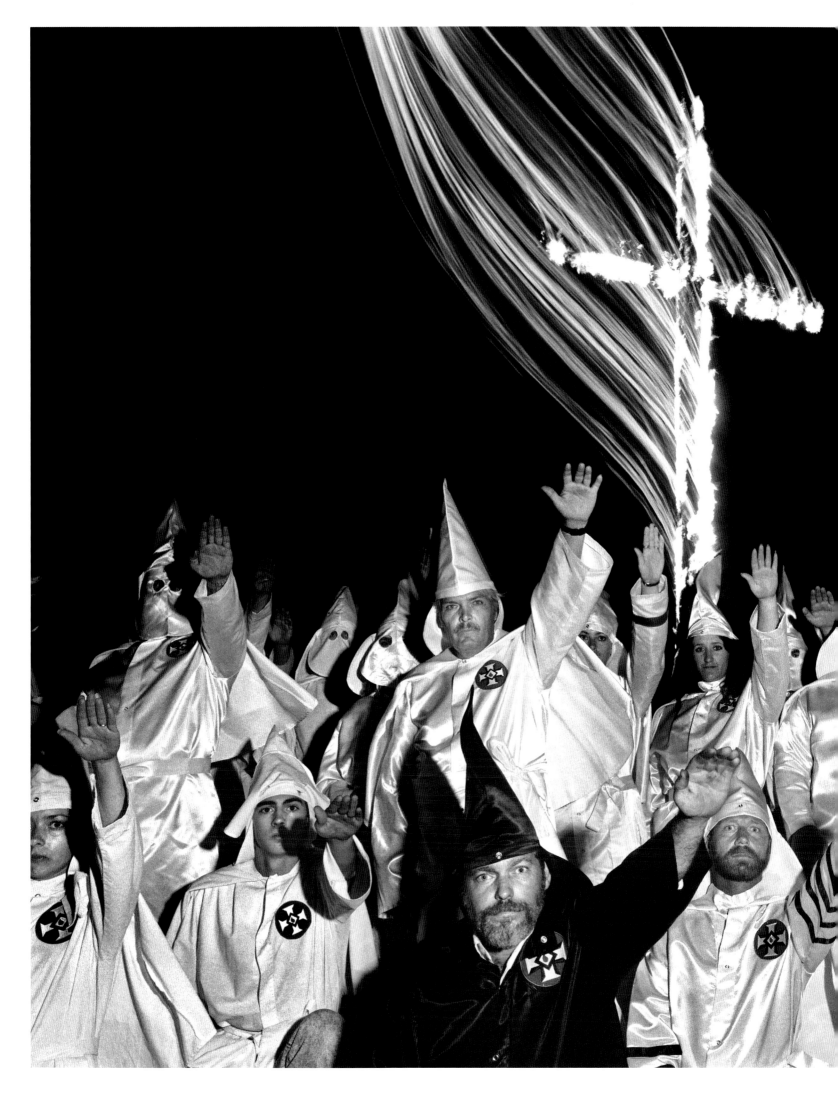

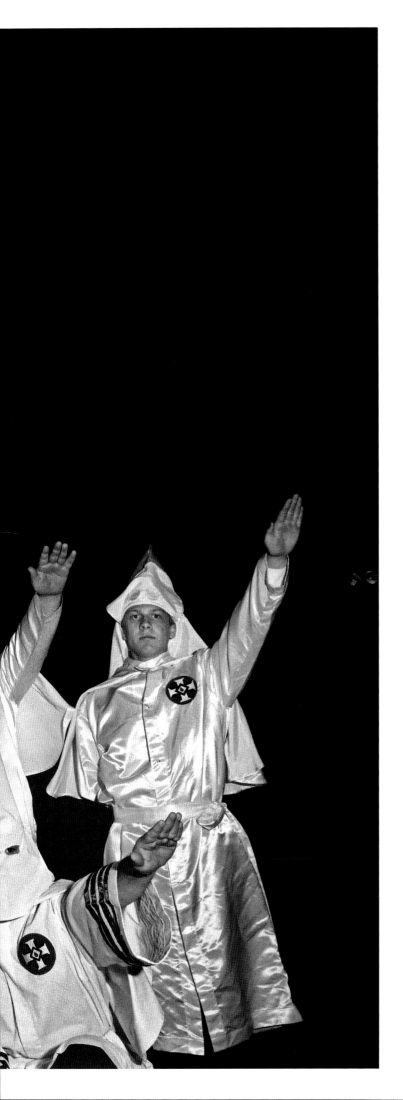

NIKOS ECONOMOPOULOS Central Railway Station

Tirana, Albania
1991

"This photo was taken at the central railway station in Tirana in 1991, a time when the whole country wanted to migrate. Mobility was greater than ever. People had started discovering their country, the places around it, the villages, the cities. They were feeling free and moving around. Trains were one of the few means of transport. I'm not sure if the man in the photo was one of the thousands who was leaving the country or just a villager arriving at the station. In that sense, it's not a documentary photograph. Despite that, this solitary figure encapsulates the whole current of outward mobility that characterized the Balkans at the end of the twentieth century.

I often hung around at the station. I remember standing beneath the shelter of a shed as the man approached me in the rain. Choosing to take the photo was done mostly with photographic criteria in mind.

One always has subject matter; it's a matter of selecting the form that works the best. Usually one element strikes me initially, and then I start building around it. The rest of the elements are fluid, and it is in this fluidity that I try to capture and understand what I see. The man with luggage walking between the two trains is the shifting element; what interests me is his relationship with the surrounding context and the changing scale.

The rest of the contacts on the sheet portray similar scenes: everyday life around a station, a place buzzing with newfound mobility. That was what I was trying to capture, without ever thinking that this man's face would come to symbolize what it did. Nor did it occur to me then that the commonplace scenes of a normal day at a train station would capture the spirit of the great escape that marked contemporary Albania."

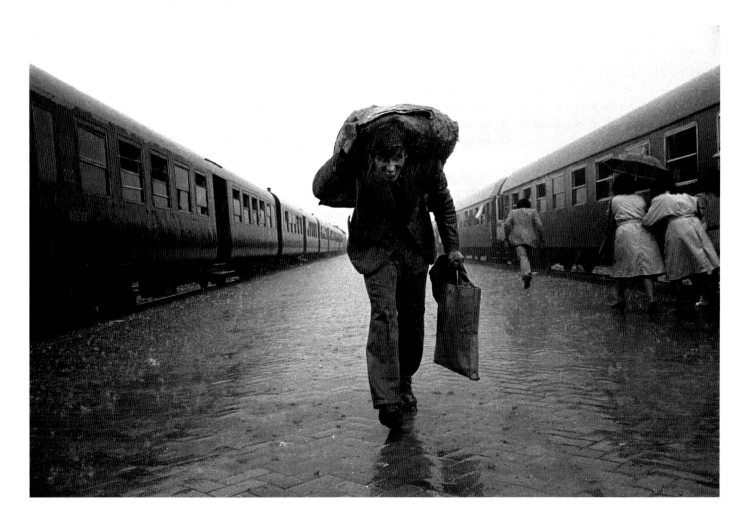

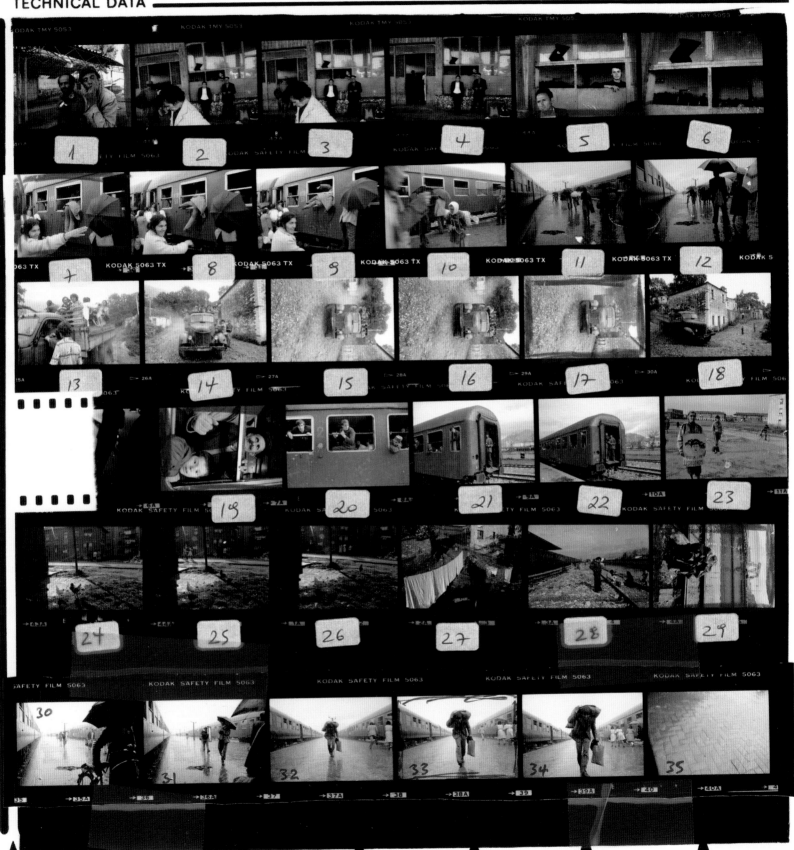

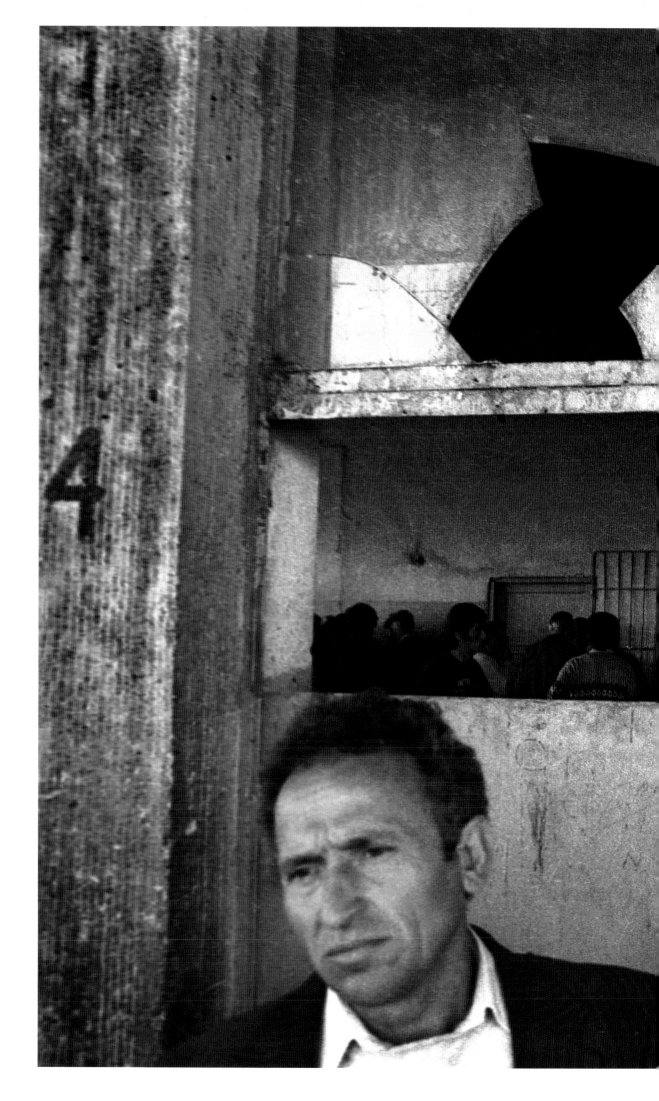

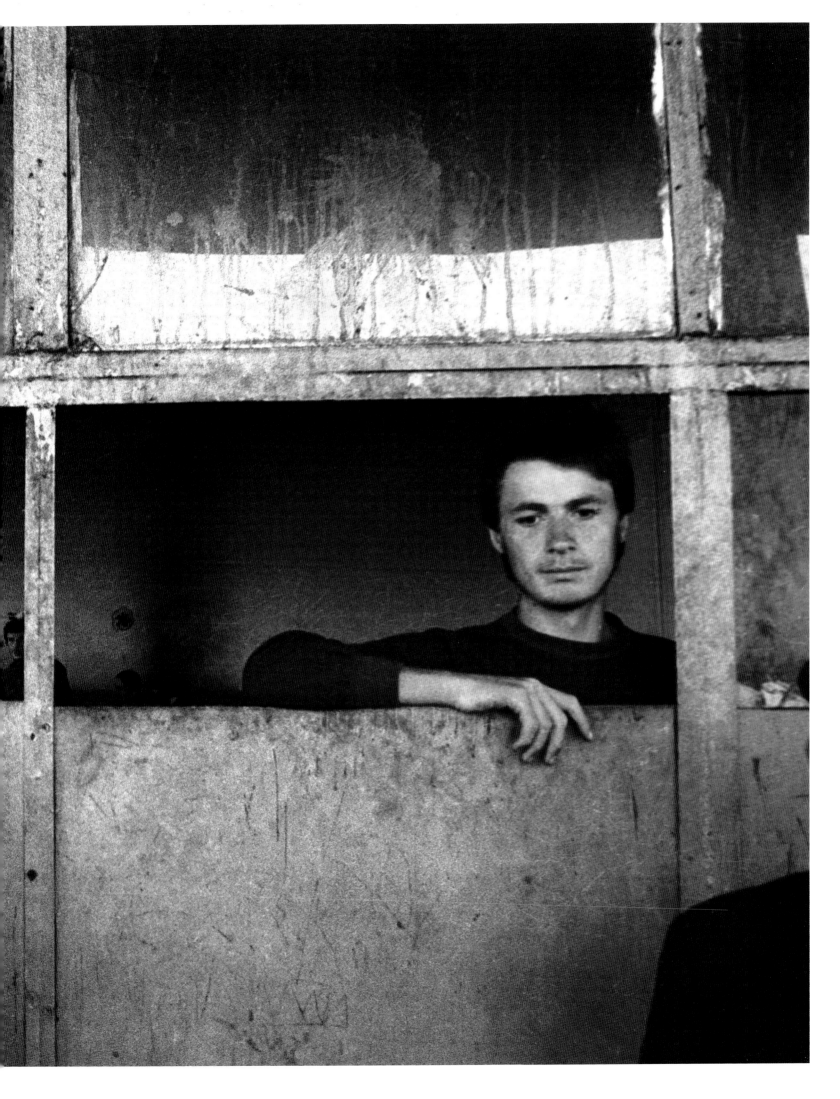

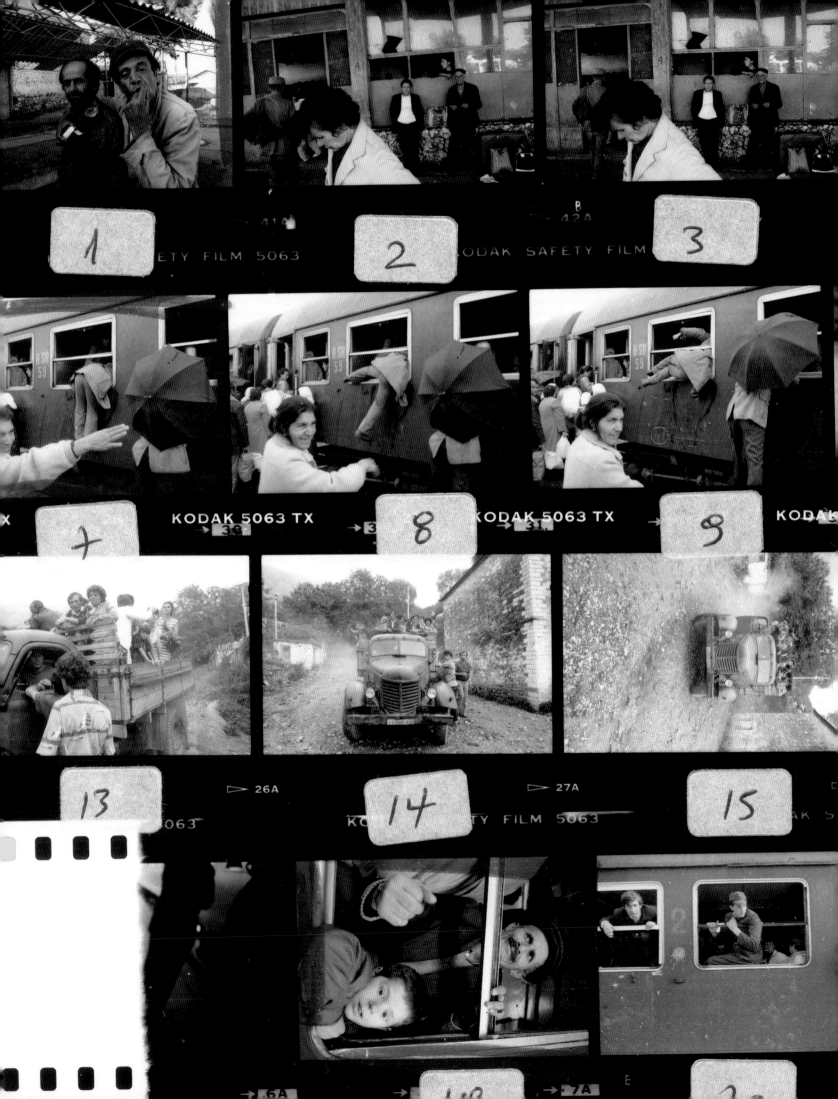

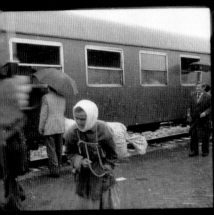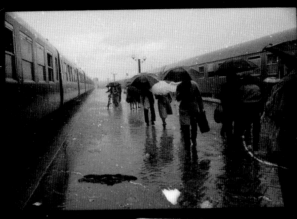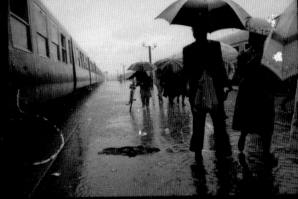

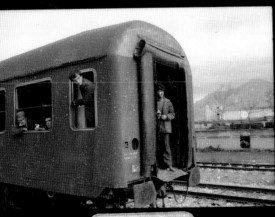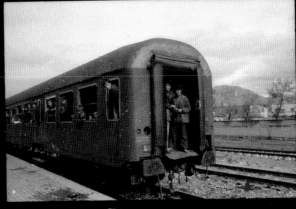

Morazán, El Salvador
1991

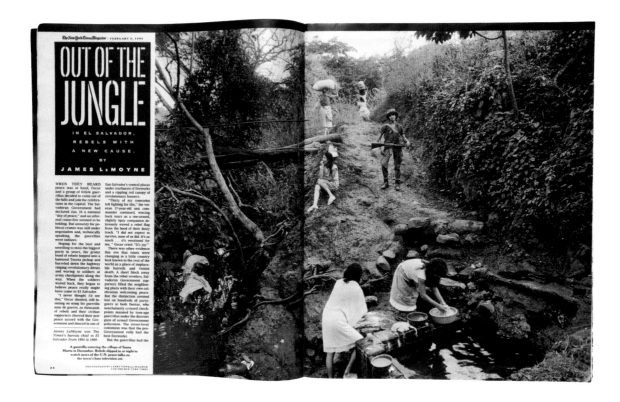

"This series was taken a year before the war in El Salvador ended. I passed into the guerrilla zone on the roof of a bus by laying flat at army checkpoints. Everyone inside knew I was up there, but said nothing. Once you crossed the Torolla River you were safe; you were in their promised land.

I got off at Segundo Montes, a village of repatriated refugees who'd fled the massacres of the 1980s and had just re-established a new community in what was still an active war zone. They'd named the town after one of the six Jesuits executed by death squads during the November '89 offensive in the capital. The government really resented the name they chose. To cut a long story short, I went to Perquín, a village frequented by combatants, just down the road from Montes. I let them know I wanted to visit an encampment, and, as I had good contacts, one of them took me into the mountains.

Within an hour, we were at a camp and I could photograph freely.

I attached myself to a group of kids from Montes, two boys and three girls between fourteen and sixteen years old. Good thing I'd brought a blanket, because we slept on the ground and it was cold. The kids were being given military training. The girls would become *brigadistas*, basic medical workers caring for the wounded.

It was Sunday morning, their day off. We got up. They bathed. They had to keep their guns within reach all the time. Then they went picking wild flowers. Later, everyone was called to formation. A lot of government soldiers were in the area so the commander decided to get on the run and asked me to go back to Perquín with some of the recruits. I remember the girl in the picture crying because she wanted to stay with her friends. But she was not yet trained for what would probably happen."

ABOVE Spread from *New York Times* magazine, 9 February 1992.

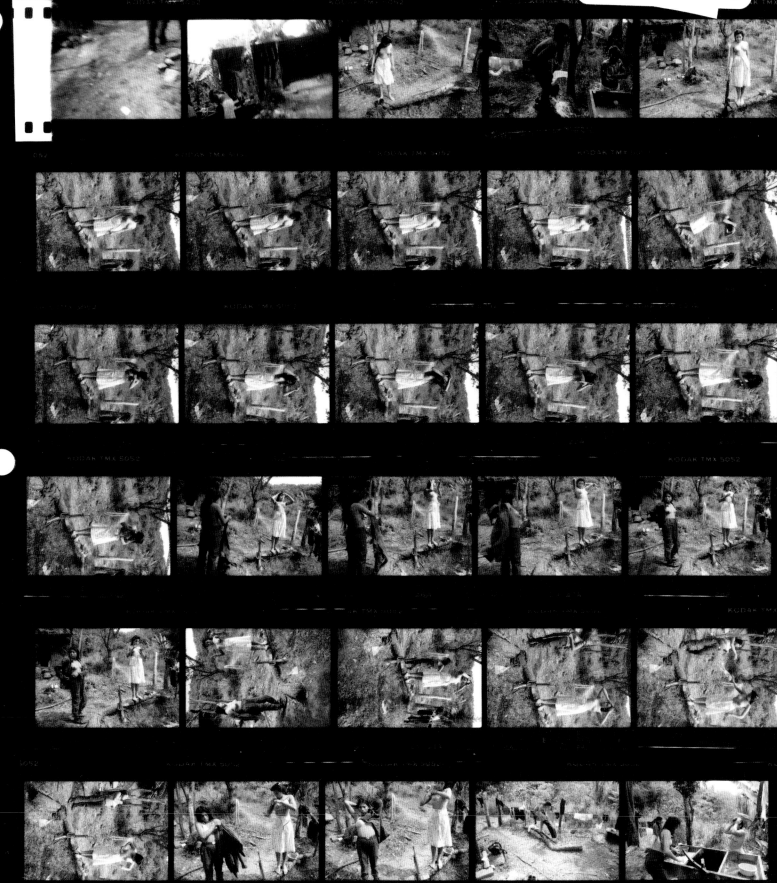

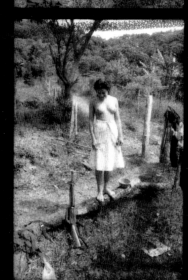
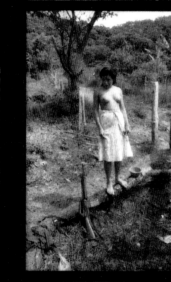

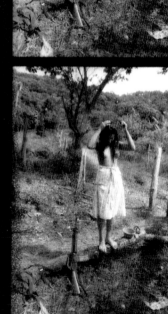

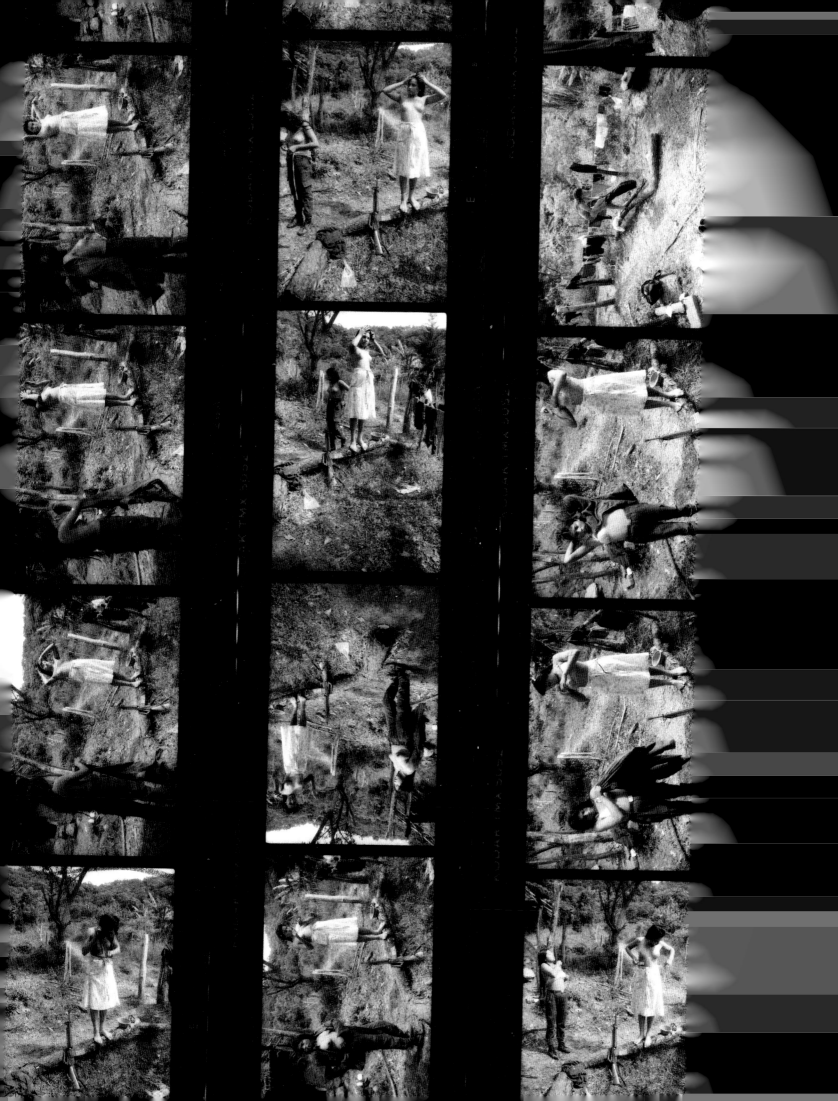

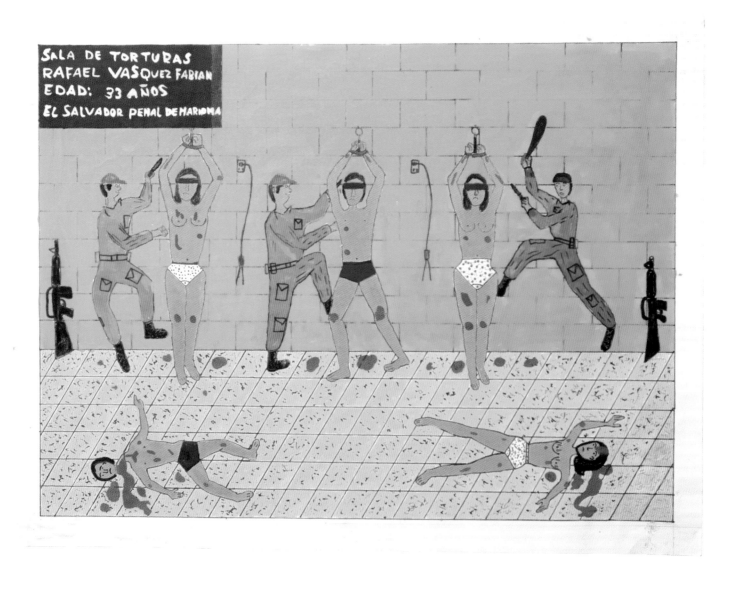

ABOVE Drawing of a torture chamber by Rafael Vasquez Fabian, aged 33, Mariona Prison, El Salvador.

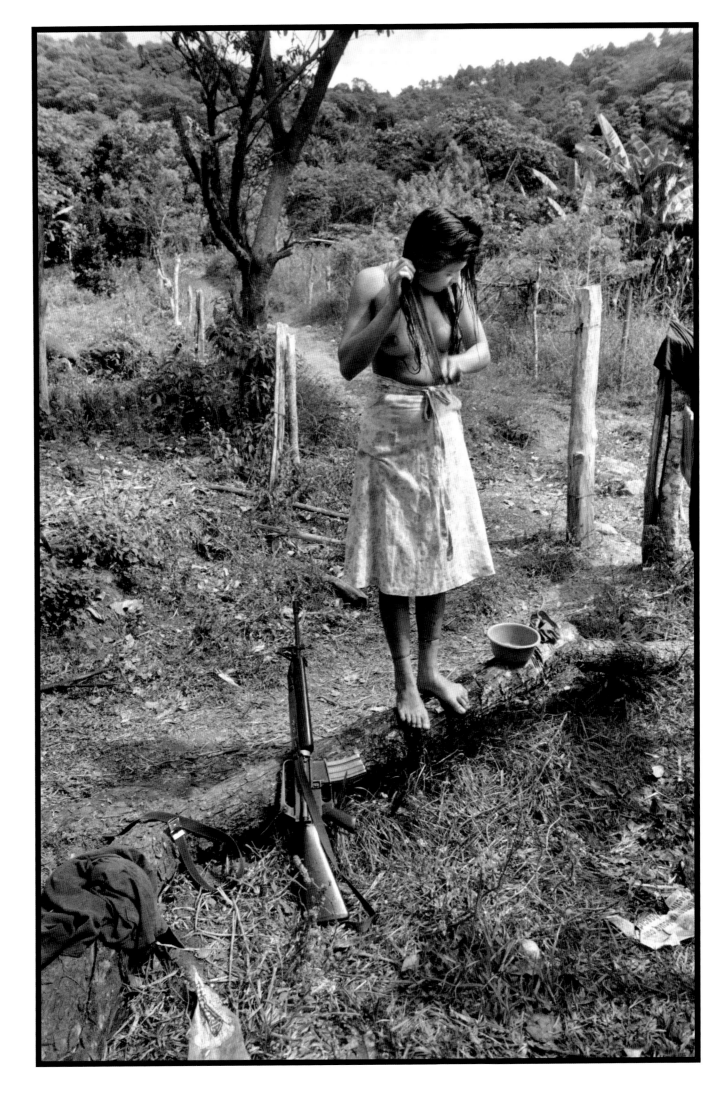

Espagne. 21 mai au 3 Juin 92
Almadraba de Zahara de los atunes
(27 mai)

92-015-W-03514

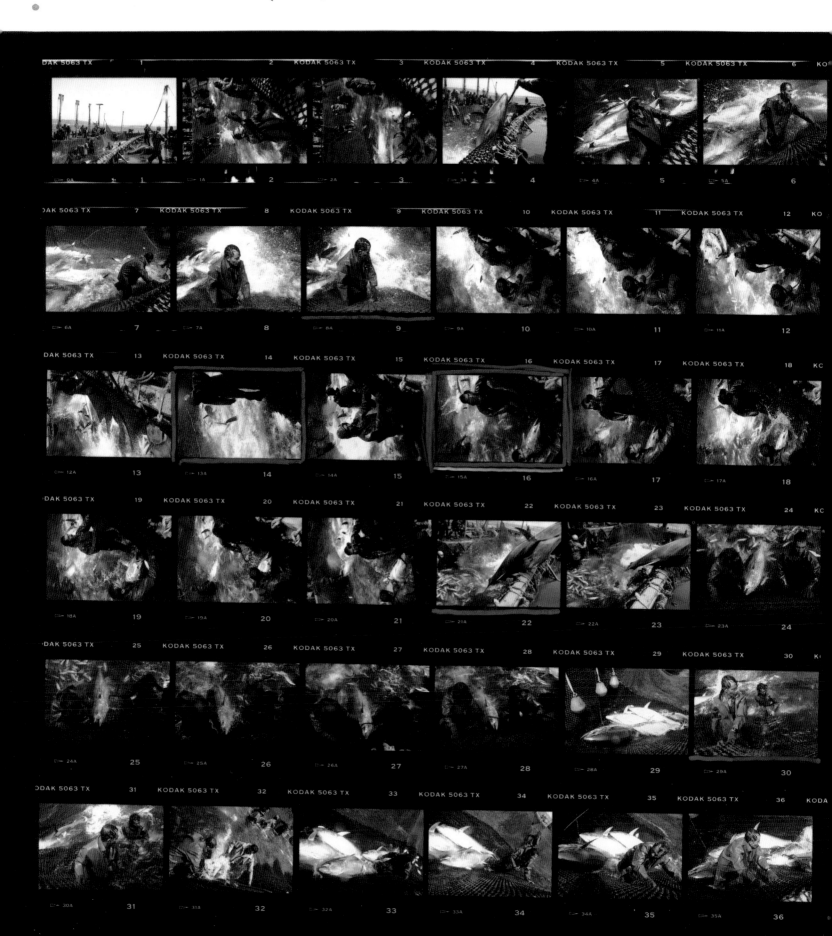

Zahara de los Atunes, Barbate de Franco, Spain
June 1992

"These photos were taken in the far south of Spain, in the Strait of Gibraltar that connects the Atlantic to the Mediterranean. This type of fishing has often been photographed, but most often in Sicily. It was featured in Roberto Rossellini's film *Stromboli* in 1950.

I had visited these fishing sites once before, in May 1982. The village of Zahara de los Atunes, close to Barbate de Franco, was a charming place then, amazingly unspoiled. Since then, urban development has had a catastrophic effect. I went back ten years later, having promised myself that I would return to the place that was the setting for what seemed to me to be one of the most time-honoured and beautiful encounters between man and fish. I had also maintained a few links with some of the fishing teams.

Known as *almadraba*, the form of static-net fishing that was practised for centuries before the devastating post-war boom in industrial fishing methods was a very sustainable process. Once the large nets had been fixed in position, the fishermen depended on the vagaries of the weather and the movements of the fish, which swam closer to or further away from the coast according to changes in the wind. A healthy uncertainty – albeit offset by centuries of observation – meant that the game was a relatively fair one, in harmony with nature. But since then, technology and the interests of the human race have changed the rules to a terrible extent.

I remember the first time I saw the hauling-in of the big fish caught in the central net. I found it unbelievably emotional. I was alone with the big team of fishermen – some fifty of them – as they slowly raised the bottom of the net in which dozens and dozens of fish had been caught. The men were chanting to create a rhythm for their repetitive motions, just as men have done since the earliest days of humanity. Panic overwhelmed the fish when there was very little water left between their bodies and the surface. An incredible maelstrom of bodies and seawater exploded. The fishermen stopped pulling up the net and fell silent. For long minutes, there was nothing but the churning water and the thrashing of the tuna as they ricocheted against each other like shrapnel. Juan, one of the fishermen, saw me watching. In the way that only the Spanish know how, spellbound and proud, he softly said to me: 'That's death.'"

TOP Page from Jean Gaumy's notebook, dated 1 June 1992: 'A lot of rain and hardly any photos. I'd thought about going into the water with the Fuji – not enough tuna...'

ABOVE Annotated plan of fishing nets in Gaumy's notebook.

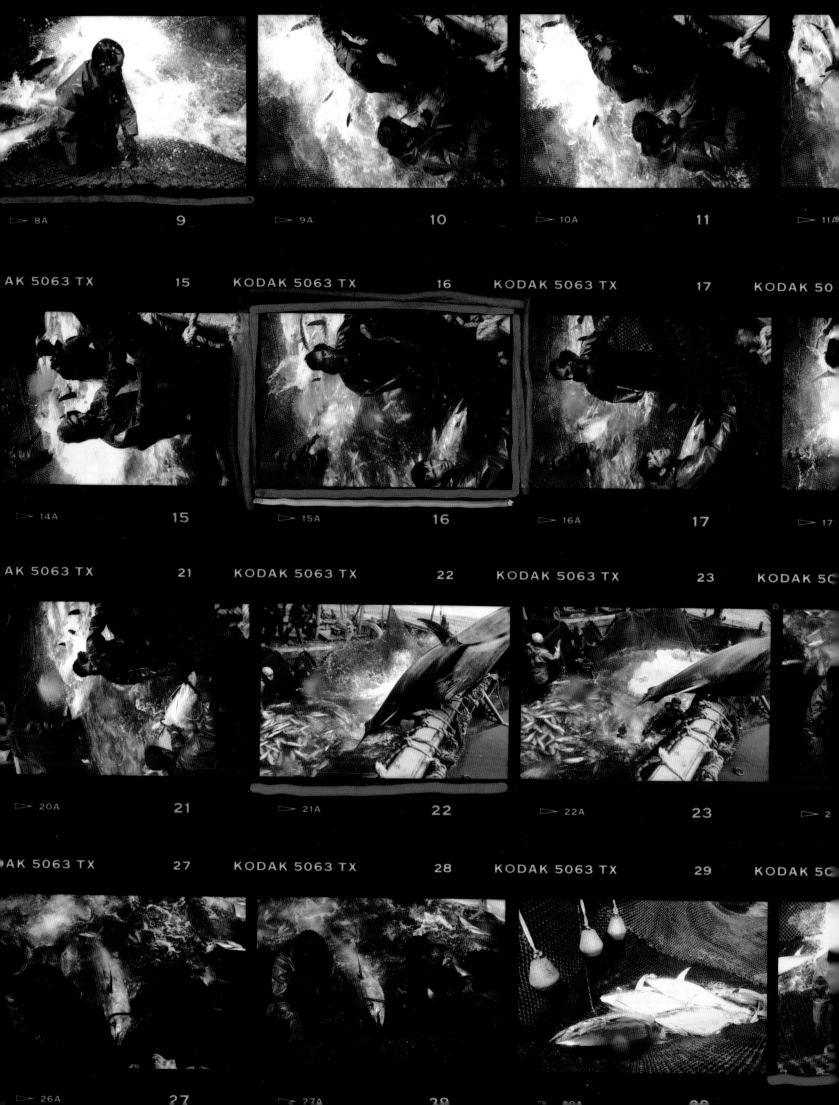

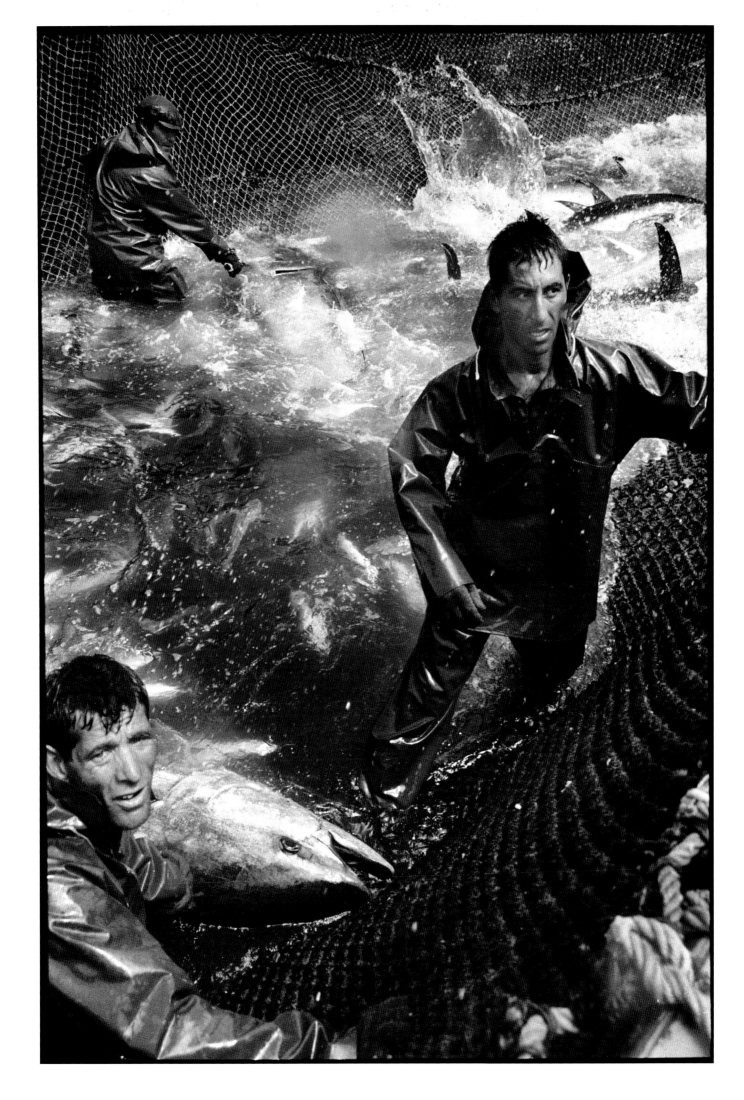

Scarborough, England
July 1993

"The idea for *The Shipping Forecast* came from a tea towel I bought in Great Yarmouth in 1992. On it was printed a map of the sea areas featured in the BBC radio broadcast of the same name. The forecast had formed an aural backdrop to my childhood, and now, for the first time, I could see where all those places with such strange but beautiful names – Dogger, Fisher, German Bight – actually were. Soon afterwards, I set out to visit all 31 areas to see if the reality of what I found bore any resemblance to the imaginary landscapes that had built up in my mind over all those years.

I spent the summer of 1993 slowly working my way around the coast of Britain, still trying to work out exactly what sort of pictures I was looking for. In a sense, the contact sheets shown here are very much a part of that thought process. By the end of July I'd reached Scarborough, a Yorkshire coastal town in a particularly dramatic setting: two large, sandy beaches nestling beneath dark imposing cliffs and some impressive Victorian architecture. The weather was changeable all day. I remember the dense dark clouds building from the southwest before dumping a short shower of torrential rain on the holidaymakers as they ran for cover. Thankfully I've never been too worried about keeping my camera equipment in perfect condition and I frequently photograph in the most appalling conditions, simply because it often produces interesting results.

During the four years spent making *The Shipping Forecast* I exposed nearly 1,200 rolls of film, which amounts to 14,000 individual pictures. Editing this down to a manageable number was a major exercise. I had advice from several people whose opinion I respected, but this only served to confuse me more. So instead I asked myself what the work was really about, and the answer was far clearer: it was about my childhood. The short series of pictures shown here reminds me so much of those wet, very British family holidays of the 1960s. Deckchairs, windbreakers and donkey rides were all part of the experience, and of course the weather didn't matter at all. Like everyone else, we'd make for the beach, for there was little else to do.

In the end, *The Shipping Forecast* doesn't depend on outstanding individual pictures, but instead on its collective strength. All the pictures are annotated with a caption in three parts – crucial to the conceptual framework of the project. First is the name of the specific sea area; next, the date on which the picture was made; finally, the forecast for that sea area, as broadcast at 6am the same day. The strange, esoteric, mantra-like language is wonderfully poetic, and is what maintained my interest in the project for all those years. For while the forecast primarily exists to warn those at sea of inclement weather, to most British radio listeners it is much more than this. Part of our cultural heritage, it reinforces a romantic notion of our island nation, battered by wind, waves and rain."

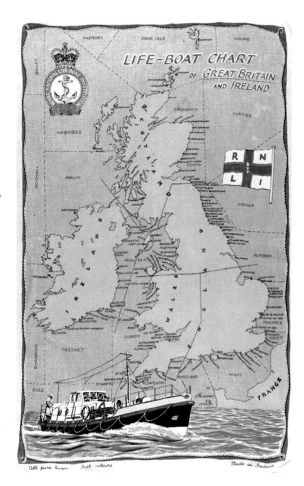

Tea towel, purchased by Mark Power in 1992, illustrated with key sea areas, and a source of inspiration for *The Shipping Forecast* series.

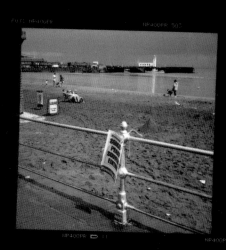
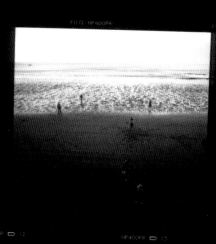

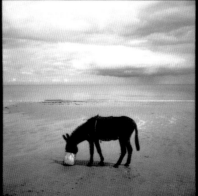

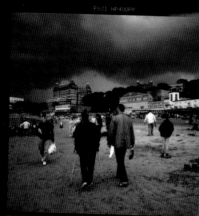

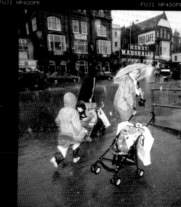
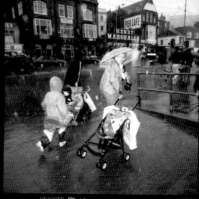
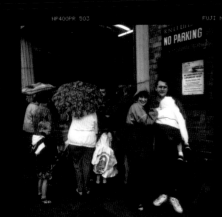
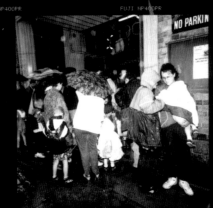
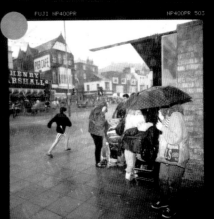

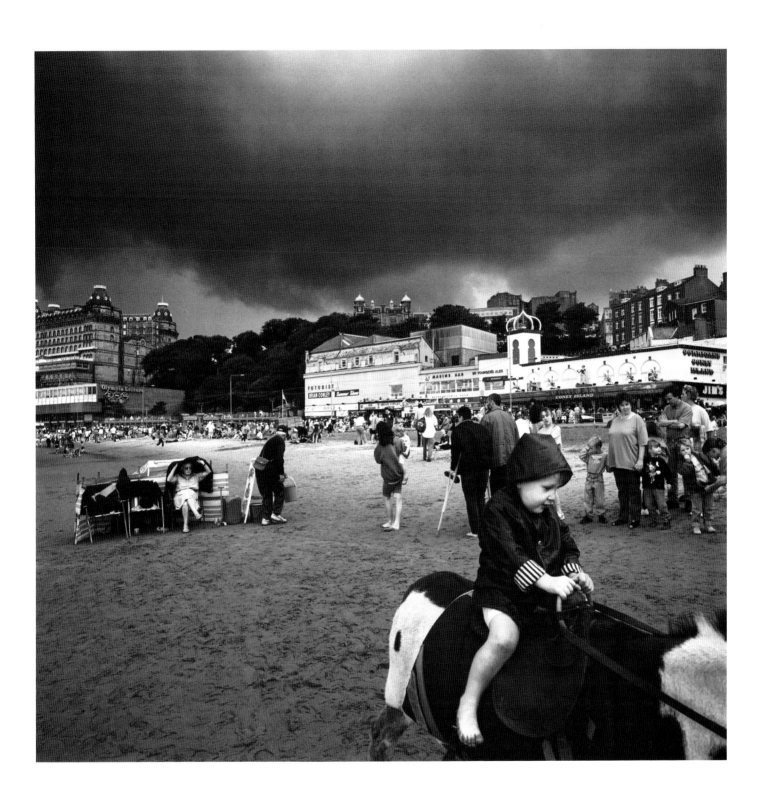

Tyne

Sunday 25 July 1993

West or southwest 3 or 4 increasing 5 or 6. Showers. Good.

LARRY TOWELL Kids with Toy Guns

Gaza
Spring 1993

"I first went to Palestine in 1993 during Ramadan, just before the Oslo Accords were signed. I thought documenting the birth of a nation would be important. Like everybody, I was naïve. I was sleeping at the house of Dr Eyad El Sarraj, the only psychiatrist for thousands of traumatically scarred human beings.

It was my second or third day in Gaza and I was sharing a ride with a French photographer who'd come in from Jerusalem. We saw these kids playing with toy guns, the same way I used to play cowboys and Indians, only they were re-enacting Israeli soldiers shooting Palestinians. The other photographer took some frames. I walked into the crowd and the kids surrounded me. I saw this swirl of toy guns while I was focusing on the graffiti behind them, trying to make sense of the black blobs. Then I got back into the car and drove away.

That night I walked the beach. Shati Refugee Camp smelled like sewage. An Israeli spotlight swirled from a watchtower like a cyclops' eye. A soldier yelled through his loudspeaker. I don't know what he was saying. I just ignored him, but I photographed my shadow in the spotlight. Then I went to the UN Beach Club, the only place you could get a beer. They kicked me out because I wasn't UN, so I walked back to Eyad's and went to bed.

The next morning, on the way to Eyad's treatment centre, Israeli soldiers were processing Palestinian families for visitation to Ansar II, Israel's notorious prison. One soldier was swaggering, smoking a big cigar in order to offend the families during Ramadan. Then he ordered them around, making them move here and there, just for the fun of it … the same stuff they do at checkpoints today. One soldier was nice to me. He said he was a leftist and was there to make sure his friends didn't shoot children. He said, 'There aren't many like me here.'

Later on, I sent one image, and some other new work, to World Press Photo. I won the 1994 Picture of the Year, as well as first place in both the 'General News' and 'Daily Life' categories for stories on Gaza and on the Mennonites. Until then, I didn't have much of a name as a photojournalist. After that, I could go into any editor's office and they had time for me. The Gaza picture launched my career."

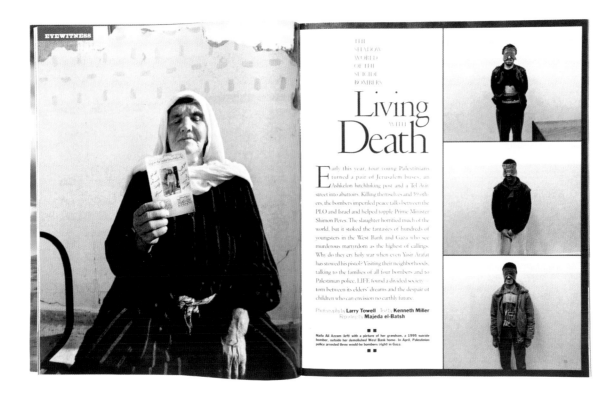

ABOVE Spread from *Life* magazine, July 1996.

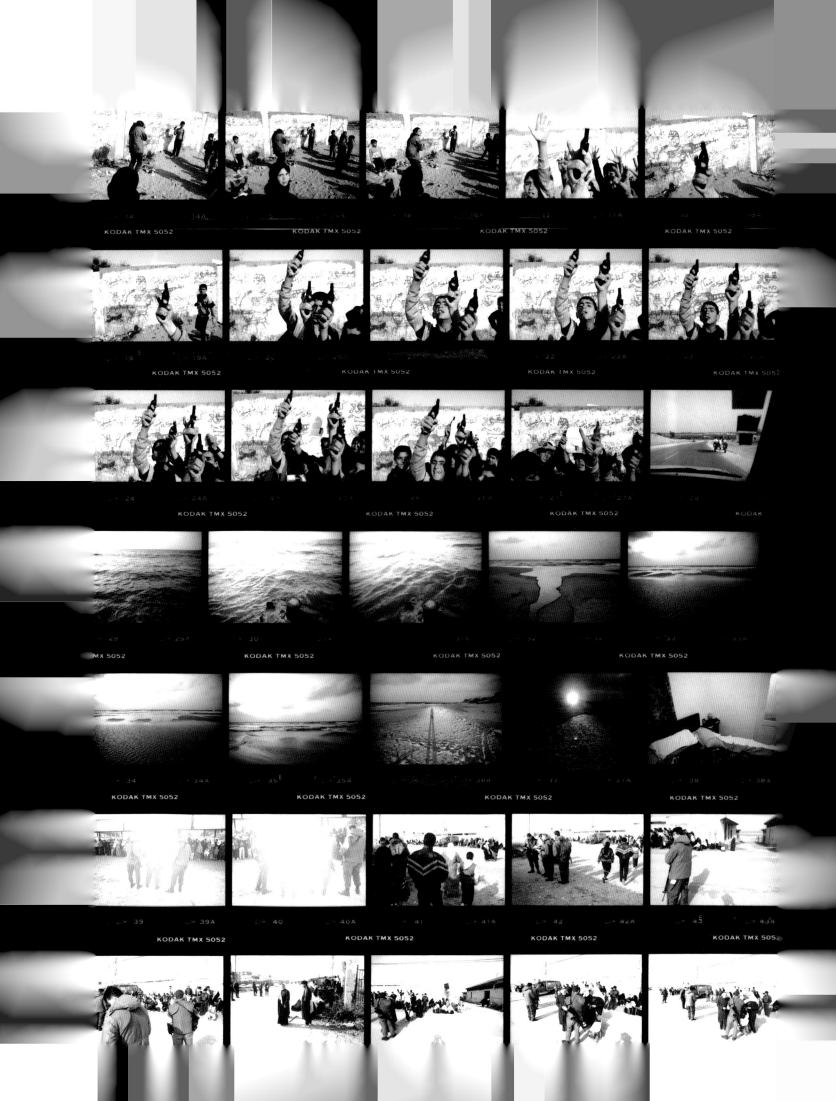

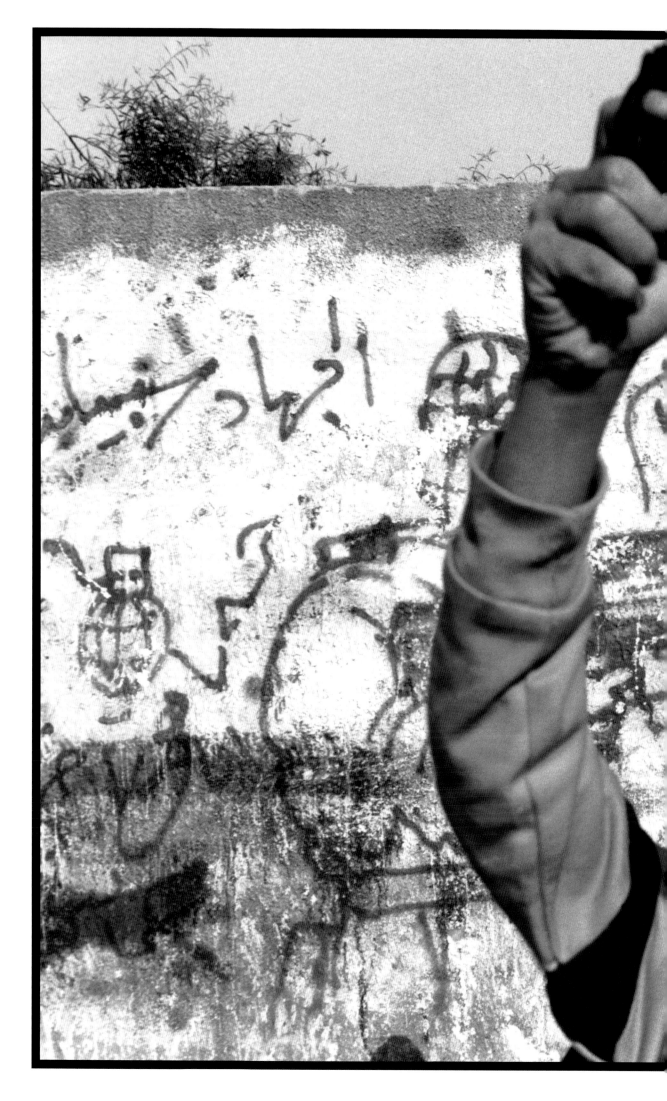

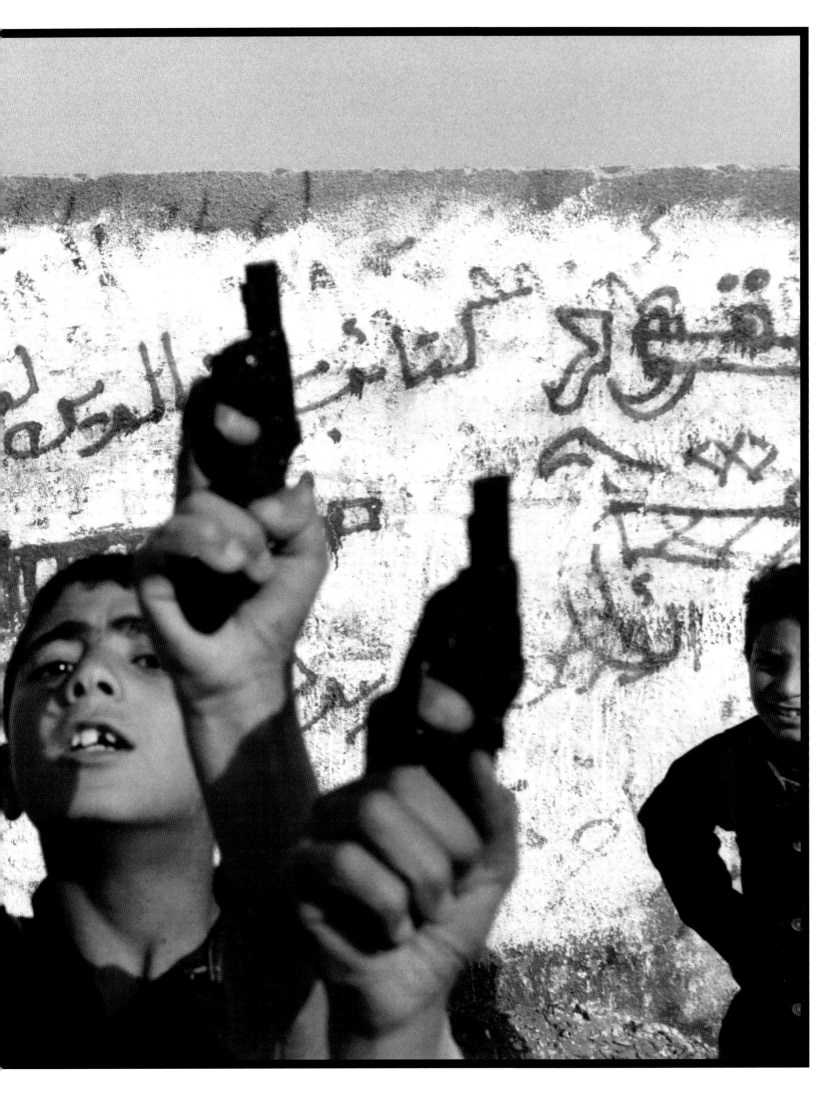

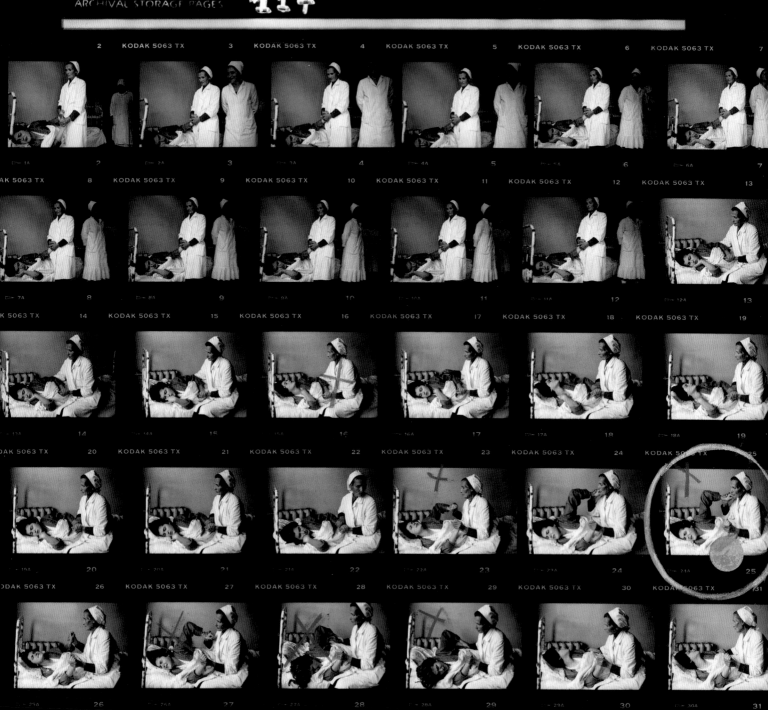

Georgia
Autumn 1995

"These photographs were taken in Georgia in September–October 1995, under the auspices of Doctors Without Borders, who were marking the anniversary of their founding. Georgia was in a bad way due to the recent civil war, caused by ethnic conflicts in the breakaway regions of Southern Ossetia and Abkhazia.

I went to the local hospital and, on arrival, made my way to the maternity ward. While photographing the babies there, I heard some screams that made a strong impression on me. I asked what was happening and, with the use of sign language, was made to understand that someone was about to give birth. I asked for permission to photograph, which was kindly given, although my interest was not understood.

When I went into the room, I found a girl – practically a child – about to deliver. I was very moved by the generosity and humanity of one of the nurses, who stood for a long time holding hands with the young mother in the throes of labour, comforting, helping and reassuring her. The main memory that has stayed with me is of that thin woman, with her taut skin, high cheekbones and deep-set eyes of a transparent, cold-looking blue, wearing a simple white coat; but she was all humanity, her warmth making up for the enormous technical shortcomings of the hospital. The young first-time mother – so pretty, lying on the bed in her nightgown and robe – was shouting out the name of her own mother with every contraction.

I lost all sense of time. In order to be at the height of the bed, I was bent over in a corner of the room. There was no more space. From time to time other nurses came in to see if we were finished, or to check what was happening, and they smiled – without understanding – at my concentration and my focus on these two women, united by pain and by joy at the coming of new life."

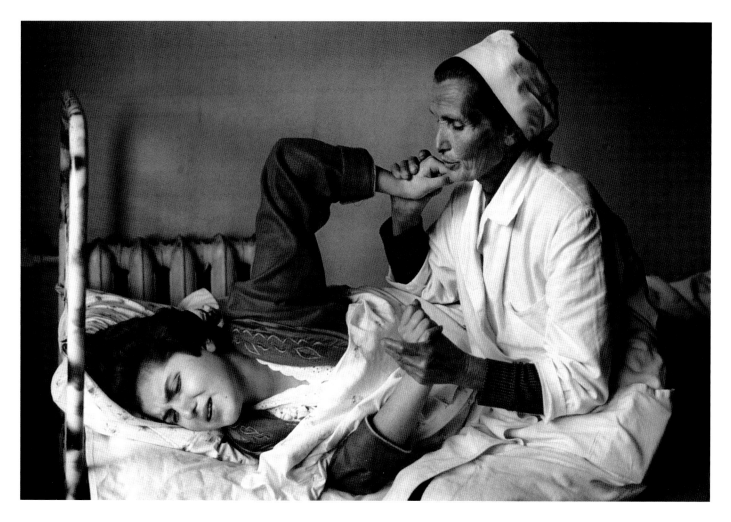

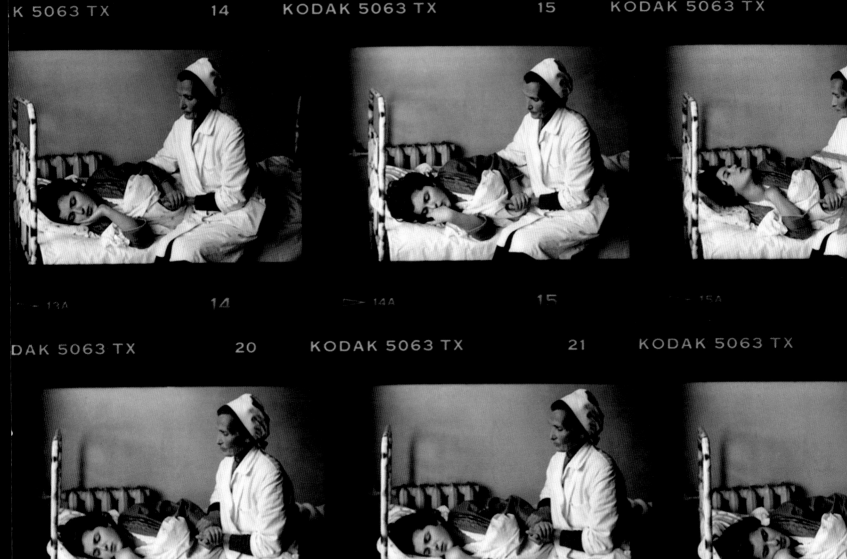

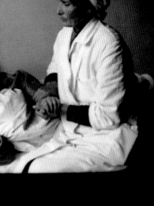

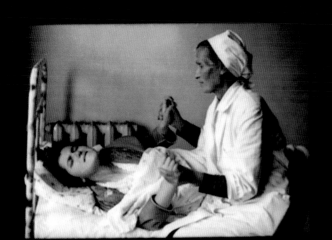
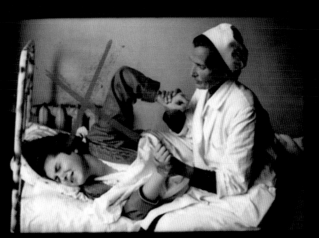

K 5063 TX 14 KODAK 5063 TX 15 KODAK 5063 TX

13A 14 14A 15 15A

DAK 5063 TX 20 KODAK 5063 TX 21 KODAK 5063 TX

19A 20 20A 21 21A

DAK 5063 TX 26 KODAK 5063 TX 27 KODAK 5063 TX

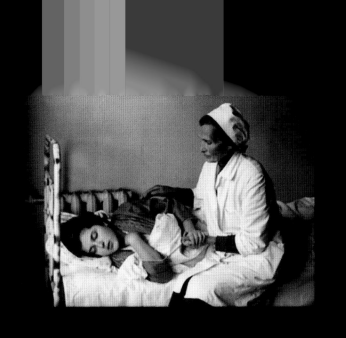
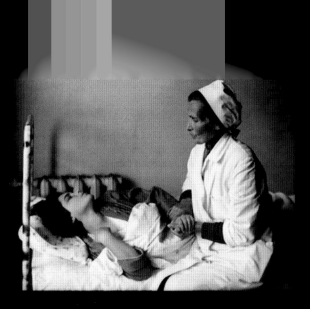

▷ 16A 17 ▷ 17A 18 ▷ 18A

KODAK 5063 TX 23 KODAK 5063 TX 24 KODAK 50

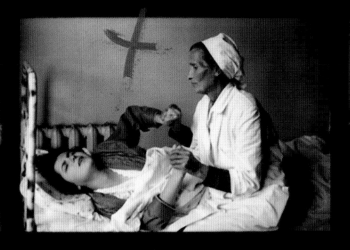

▷ 22A 23 ▷ 23A 24 ▷ 24A

KODAK 5063 TX 29 KODAK 5063 TX 30 KODAK 5063

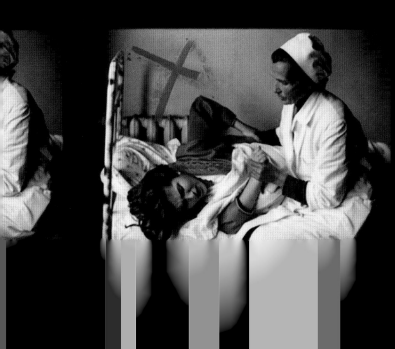
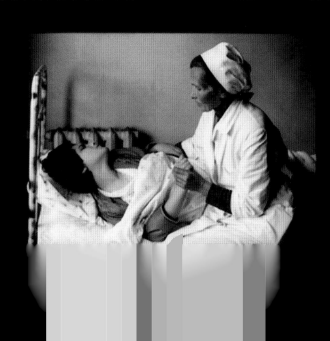

Benaco, Tanzania
Winter 1995

"This assignment was for a Magnum book project on refugees, with other photographers assigned on stories all over the world. Paul Fusco was supposed to have done this story, but he was out of commission for a while so I basically took his place. The picture in frame 33 of this sheet ended up on the cover of the book.

I was in Tanzania for only a few days, working with the Spanish arm of Doctors Without Borders. Everything was in short supply, and with refugees coming in from Rwanda it was a noticeably hostile situation at times, with the different groups creating some violence in the camps. Doctors Without Borders were amazing; so relaxed, despite the situation. I realized that it was important that I focused and worked fast. It was dangerous, and I'd sometimes have to move quickly to get the images I wanted. At times I had to stay near my transport so I could leave quickly. There were also domestic moments within the chaos, which I tried to capture. For me it was important to value the normal humanity in the situation: the feeling a mother has for her child, for example.

The two cameras I worked with at the time were an Olympus and a Leica, and I'd use a 28mm, 35mm or 50mm lens, depending on the circumstances. This sheet is one camera, but it starts with a 35mm and it looks as if

I switched to a frame 28mm further down. Over three or four days I shot something like forty rolls of film. When I edit, I go for a gut, instinctual feeling. I started editing when I got the film back a day or two after I returned to the States. You are so aware of what you saw; the experiences that reflect in your mind. You don't really forget the people and what they are going through. So I wanted to work on it immediately. Like anything else, when you're trying to put down what you witnessed, you go for the pictures that speak to you.

Because of time constraints, I edited on the sheets themselves. The first stage was with a red chinagraph pencil, marking the images that would make the final cut. Then the yellow marks are for my favourites and the final edit. Depending on the project I'd sometimes do work prints, but in this case I didn't have much time, so was efficient and edited quickly. I always go back through sheets – and you find images where you wonder how the hell you missed them, but you often don't have the time to see everything the first time around. I also look back and wonder about the people in these images, and what happened to them. Somehow, because you can hold contact sheets in your hand, they stay with you longer; the images don't go away."

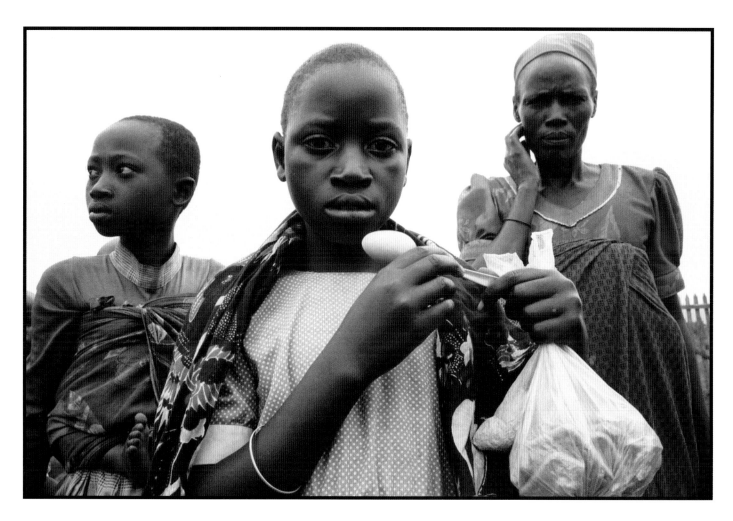

95-2-24

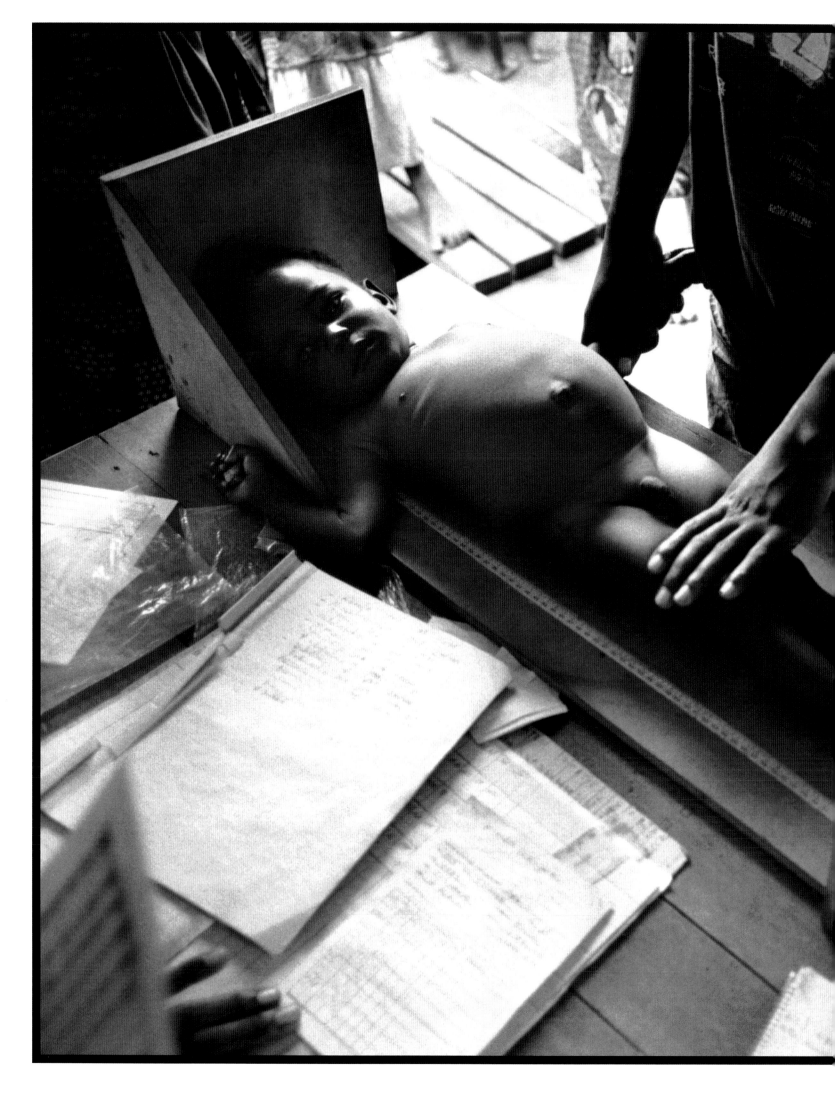

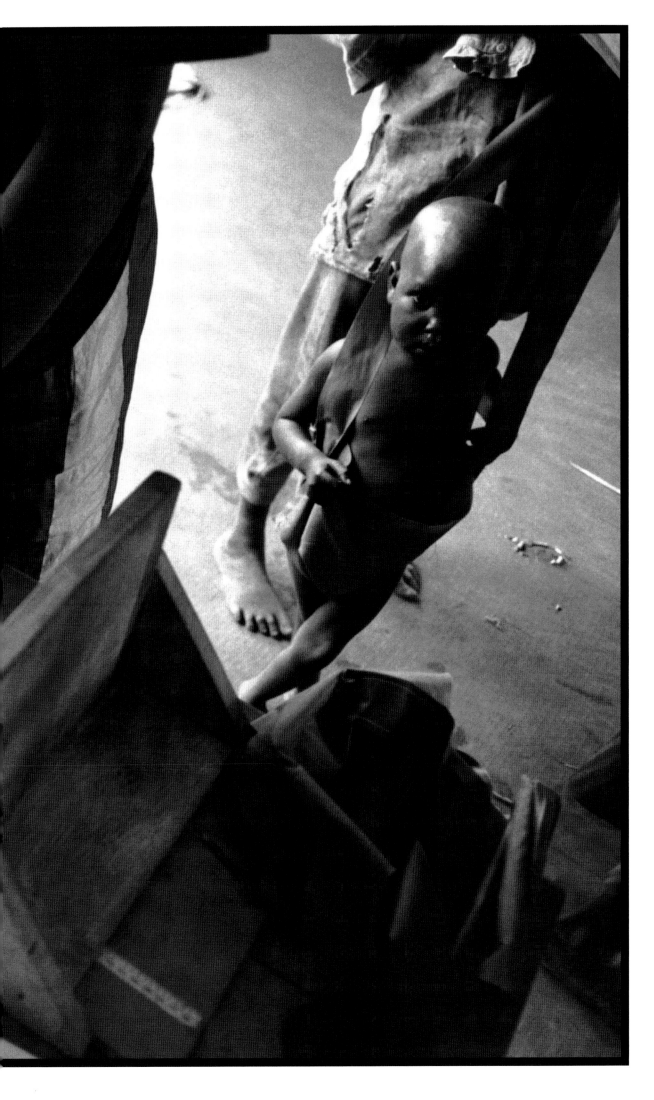

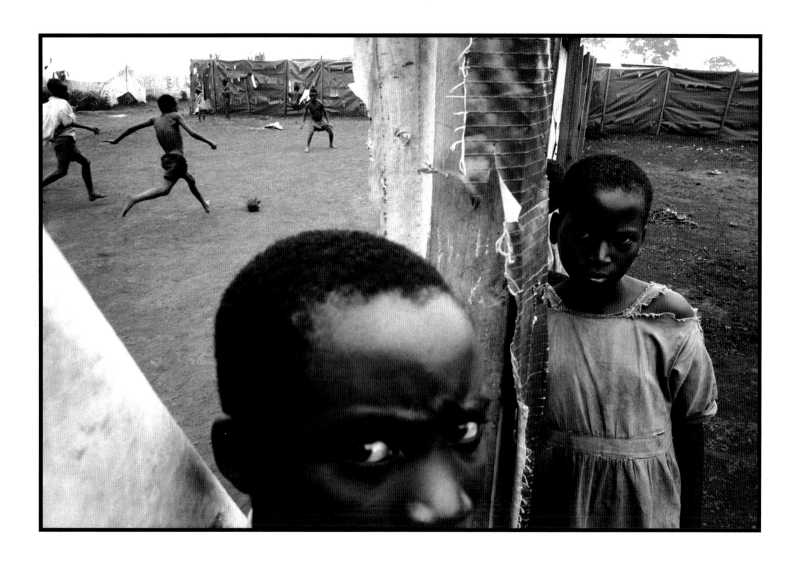

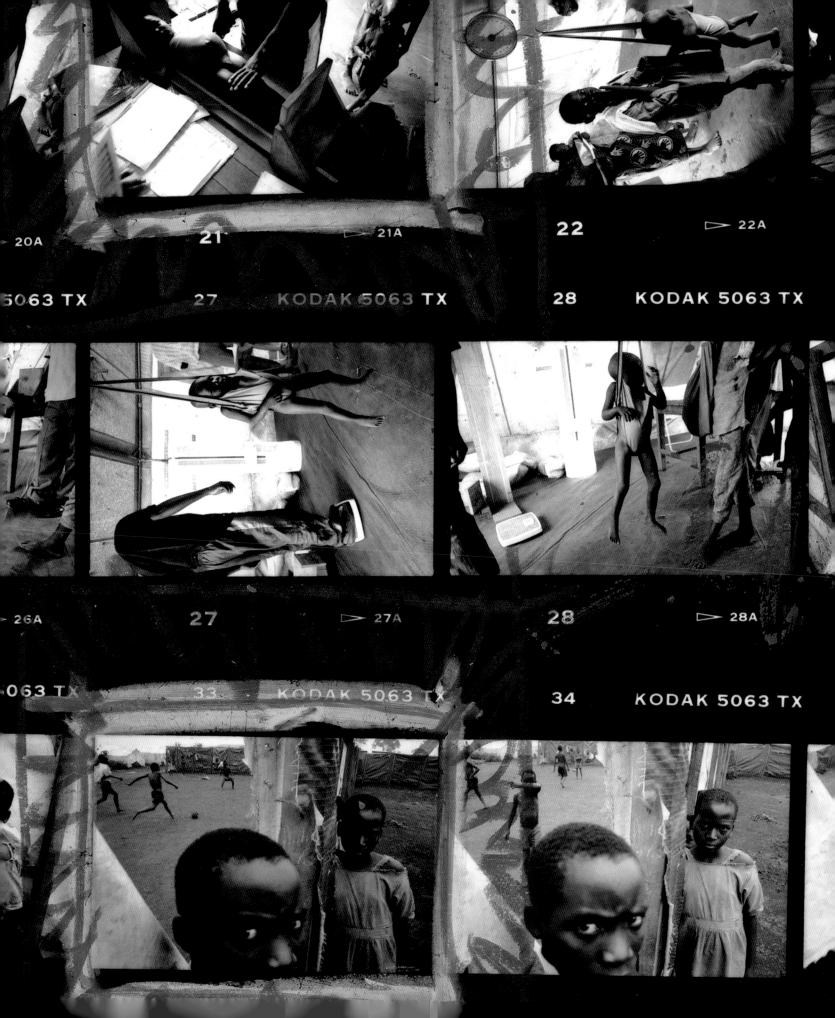

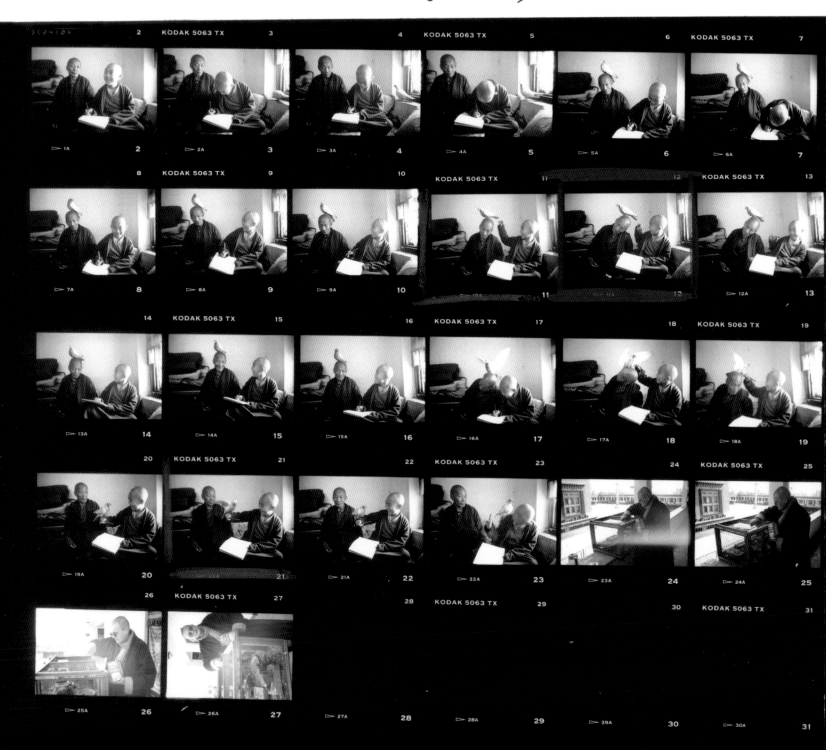

Shechen Monastery, Bodnath, Nepal
1996

"In 1996 I had just started getting interested in documenting the lives of Tibetan *tulkus*, children who have been recognized as the reincarnations of important lamas. I was keen to see how they were educated and what sort of lives they led. I travelled to Shechen monastery in Bodnath, Nepal, to visit ex-Magnum photographer Marilyn Silverstone, who had become a Tibetan Buddhist nun. She was living in the monastery and, among her many other duties, she took care of the young monks.

On the first day I arrived, Marilyn took me to visit Tulku Khentrul Lodro Rabsel. He was twelve years old and had been recognized as a tulku at the age of five, when he was brought to the monastery to be educated. I went into his room, where he was studying with his tutor, Lhagyel. I crouched in a corner in order to be as inconspicuous as possible. All of a sudden, to my delight and to the delight of the young tulku, a pigeon landed on his tutor's head. Of course, we all burst out laughing. The situation lasted just a few seconds, but it happened that I was in the right place at the right moment and that I knew I had my 35mm lens on one of my two Leicas and grabbed the right lens.

I knew I had taken a memorable photograph, but I had to wait three weeks before I returned to Paris and developed my film and contact sheet. It was a great relief to see that the image was not blurred and the exposure was alright. The image has since become one of my most popular. When Josef Koudelka saw it, he told me, 'Martine, it was worth your while travelling to Nepal just to get this one picture. If you manage to get ten more, you'll be a good photographer.' I don't know if I have made the ten, but I am still pursuing the unexpected. I have always thought it essential for a photographer to be ready to capture what cannot be foreseen."

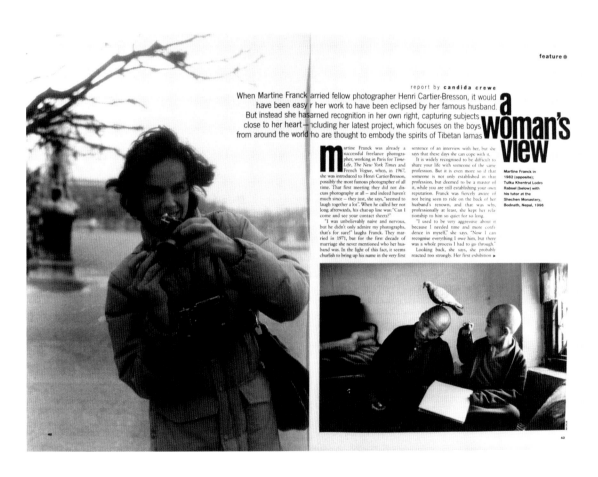

ABOVE Spread from *The Times* magazine, November 2000, written in association with Martine Franck's exhibition, *Tibetan Tulkus: Images of Continuity*, at Rossi & Rossi, London, 9 November–2 December 2000.

403

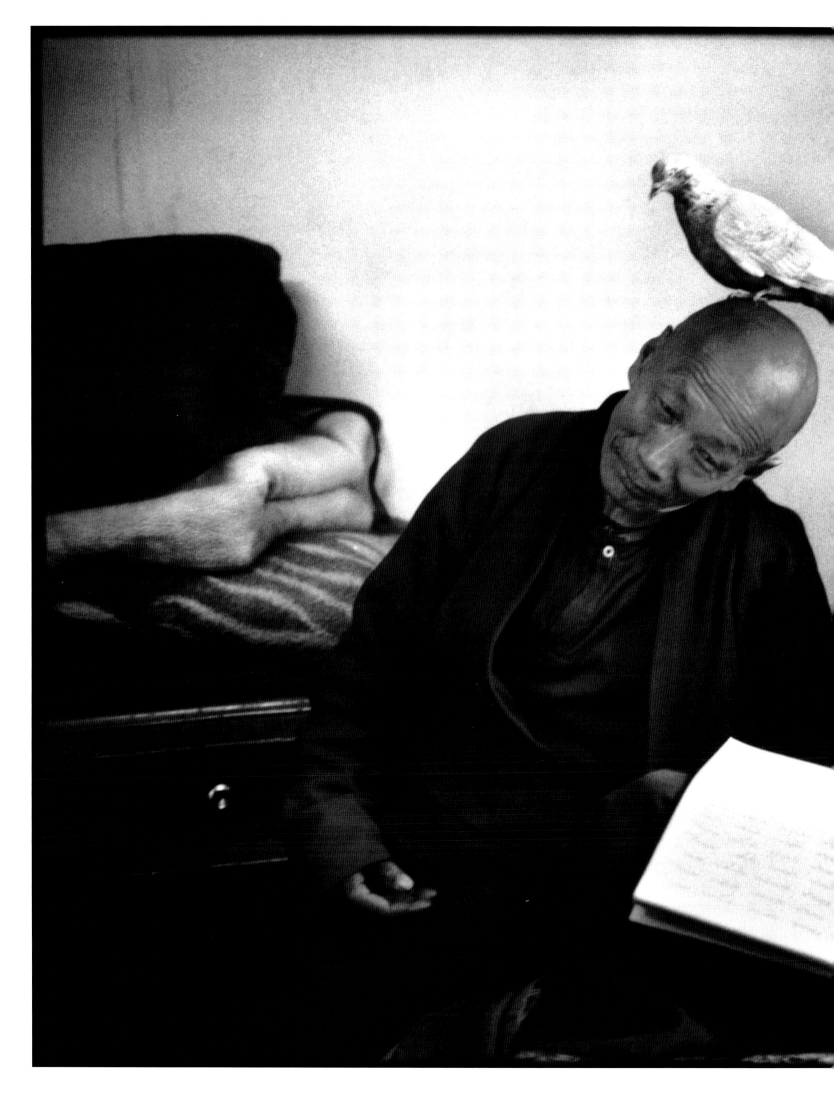

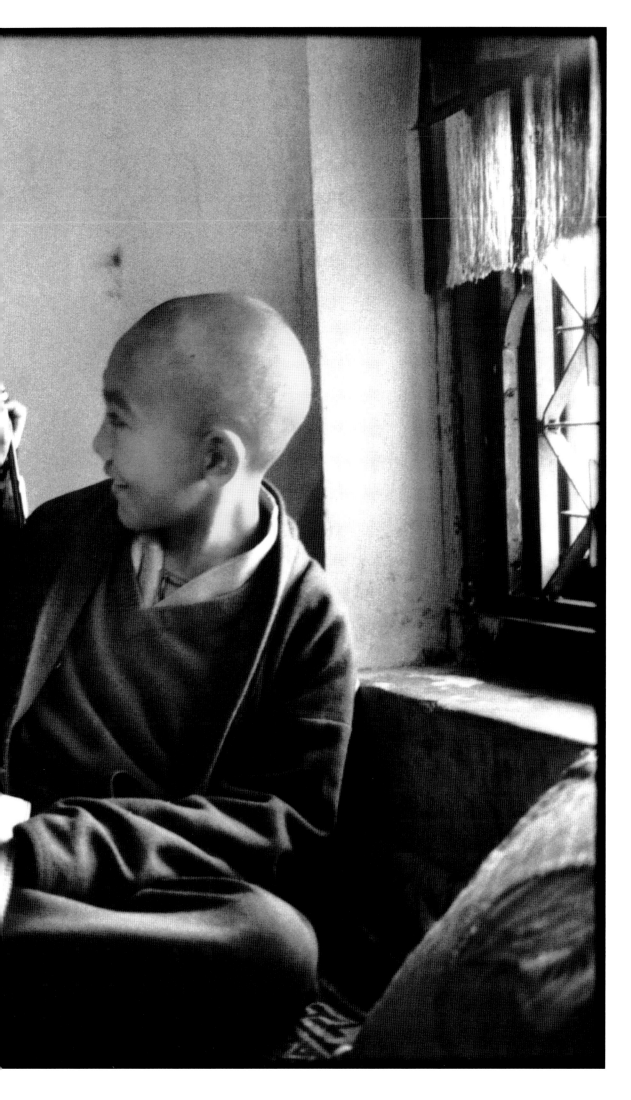

Kent County, Ontario, Canada
Summer 1996

"The Mennonites had begun drifting back to Canada, driven by poverty and landlessness, and still dressed the way they'd left in the 1920s. I live in rural southwestern Ontario, where I'd spend summers in the vegetable fields with the Old Colony Mennonites. In the fall, we'd cross America in a dilapidated truck, or in a van full of kids, ending up in one of their isolated Mexican colonies. They were now doing our manual field labour as migrants. That's when I started photographing them.

When I shot off this roll of film, I'd already been documenting them for four years. In the process, I grew to love them, their awkwardness and backwardness, their stubbornness, and their unwillingness to compromise with the devil of modernism. They had no education. Most were illiterate, and all were poor. Dirt poor. Land hungry. Dirt poor. It also made them vulnerable to

exploitation by employers. But the family was one unit; one cohesive, integrated whole.

This was Bernard and Elizabeth Peters's family. Bernard was from La Honda Colony, but wasn't there that day. Elizabeth was riding the cucumber machine with some of their nine children. I saw the baby sleeping on the coat, her pants soiled and soaked with urine because her mom didn't have time. Elizabeth and her children picked as fast as their hands could move. If they were sharecropping, they'd average about $2 an hour.

When I look at a contact sheet, I try to remember the feeling I had when I took the frame. The memory of feeling helps me edit. Art for me is really simple. It's when a feeling overcomes you and you convey your feeling with symbols. In photography the symbols are the thing itself."

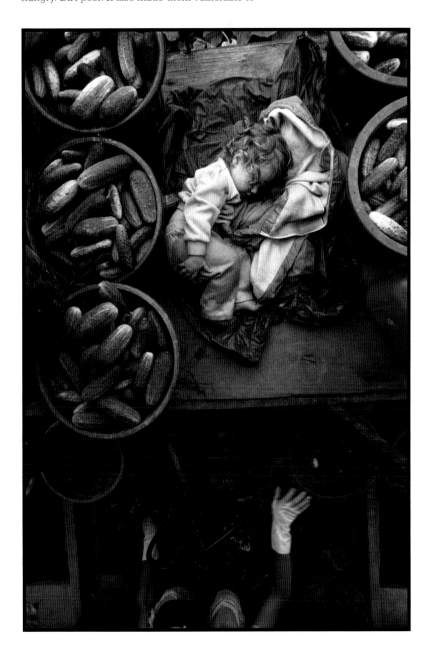

2 KODAK 5052 TMX 3 KODAK 5052 TMX 4 KODAK 5052 TMX 5 KODAK 5052 TMX 6 KODAK

1A 2 2A 3 3A 4 4A 5 5A 6

5052 TMX 7 KODAK 5052 TMX 8 KODAK 5052 TMX 9 KODAK 5052 TMX 10 KODAK 5052 TMX 11 KODA

 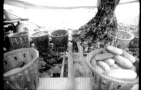 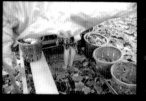 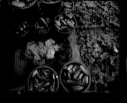 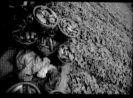

6A 7 7A 8 8A 9 9A 10 10A 11

K 5052 TMX 12 KODAK 5052 TMX 13 KODAK 5052 TMX 14 KODAK 5052 TMX 15 KODAK 5052 TMX 16 KODAK

11A 12 13A 13 14A 14 14A 15 15A 16

5052 TMX 17 KODAK 5052 TMX 18 KODAK 5052 TMX 19 KODAK 5052 TMX 20 KODAK 5052 TMX 21 KODA

16A 17 17A 18 18A 19 19A 20 20A 21

K 5052 TMX 22 KODAK 5052 TMX 23 KODAK 5052 TMX 24 KODAK 5052 TMX 25 KODAK 5052 TMX 26 KODAK

21A 22 22A 23 23A 24 24A 25 25A 26

5052 TMX 27 KODAK 5052 TMX 28 KODAK 5052 TMX 29 KODAK 5052 TMX 30 KODAK 5052 TMX 31 KODA

26A 27 27A 28 28A 29 29A 30 30A 31

K 5052 TMX 32 KODAK 5052 TMX 33 KODAK 5052 TMX 34 KODAK 5052 TMX 35 KODAK 5052 TMX 36 KODAK

31A 32 32A 33 33A 34 34A 35 35A 36

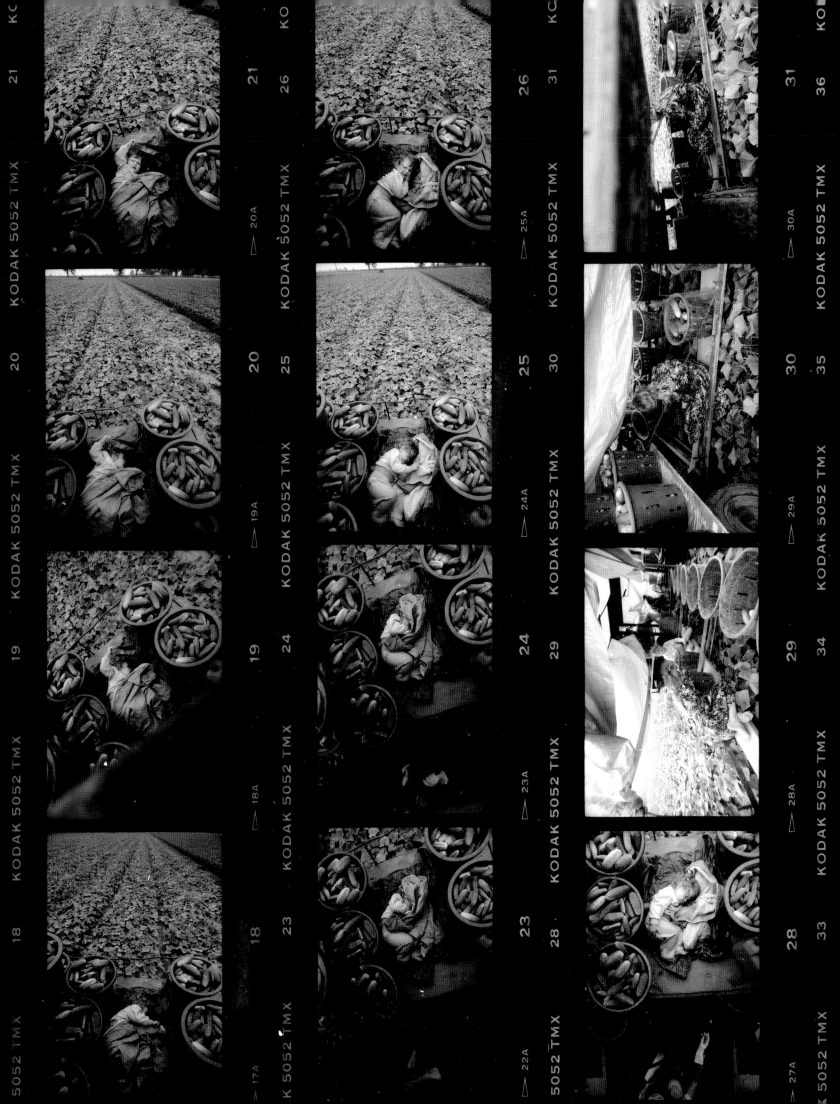

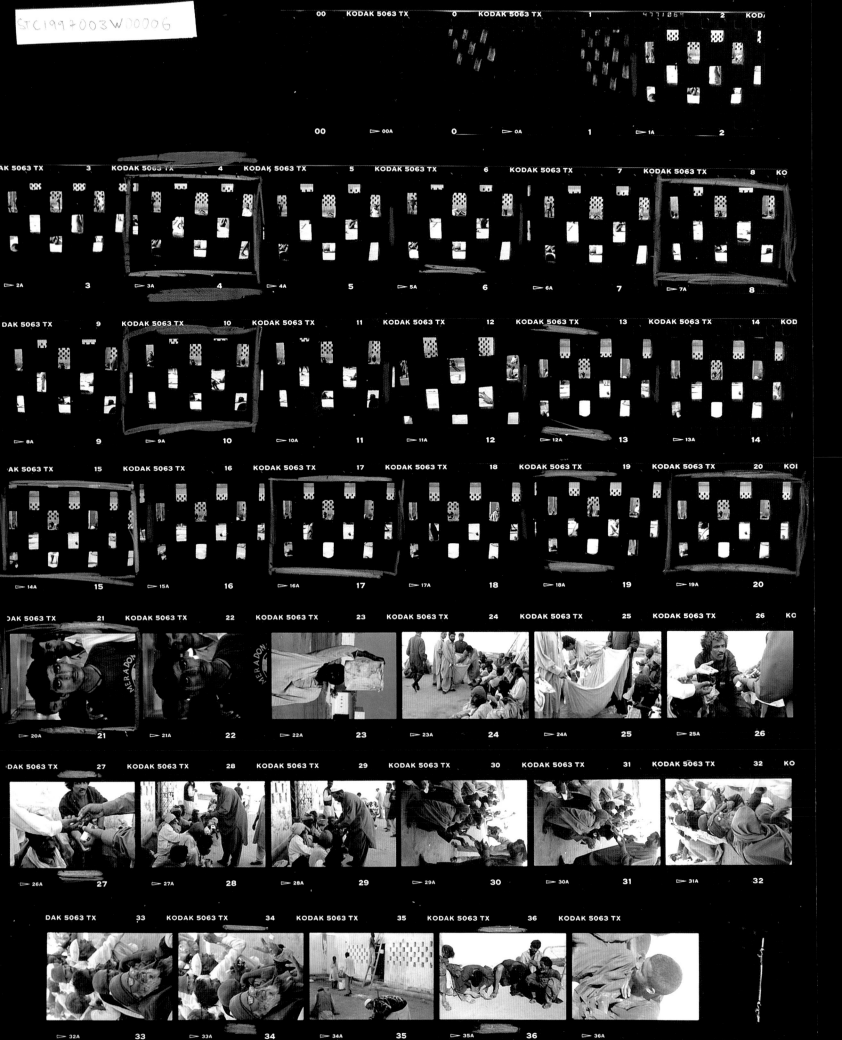

Karachi, Pakistan
1997

"I was working on a story about the charitable work done by the Pakistani philanthropist Abdul Sattar Edhi, an extremely modest man and one of the few people I have met who truly wore the mantle of greatness. One aspect of his work involved the running of a mental home in Karachi. This was somewhere where those with broken minds could live out their lives without being kicked and abused in a harsh world.

Walking past a wall, looking into the courtyard of the mental home, I was immediately struck by how each window seemed to hold a different world. There was an interesting photograph to be taken, but there were practical considerations, which are worth mentioning precisely because they are so prosaic. At first I couldn't get the right perspective as I was too short, so I had to find some bricks to stand on to get the best angle through the gaps. Also, I normally use a 35mm lens, but this rendered a perspective where the black was out of proportion to the white; in addition, the windows were too small, so I had to use a 50mm lens to get the right balance.

The picture was obvious. Each window had to hold an interesting fragment, and all the fragments needed to be different. The requirements of the composition and of the metaphor – fragmented lives imprisoned in darkness – were in sync. The problem was to concentrate hard enough to take the photograph that actually delivered."

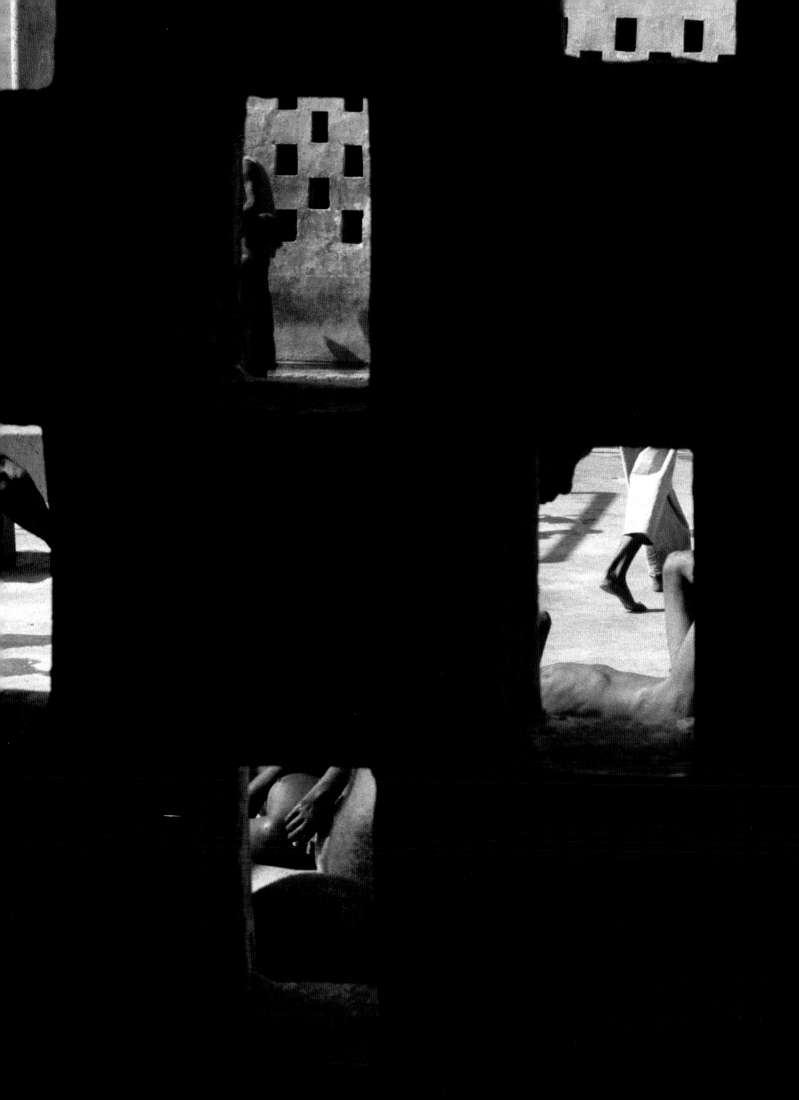

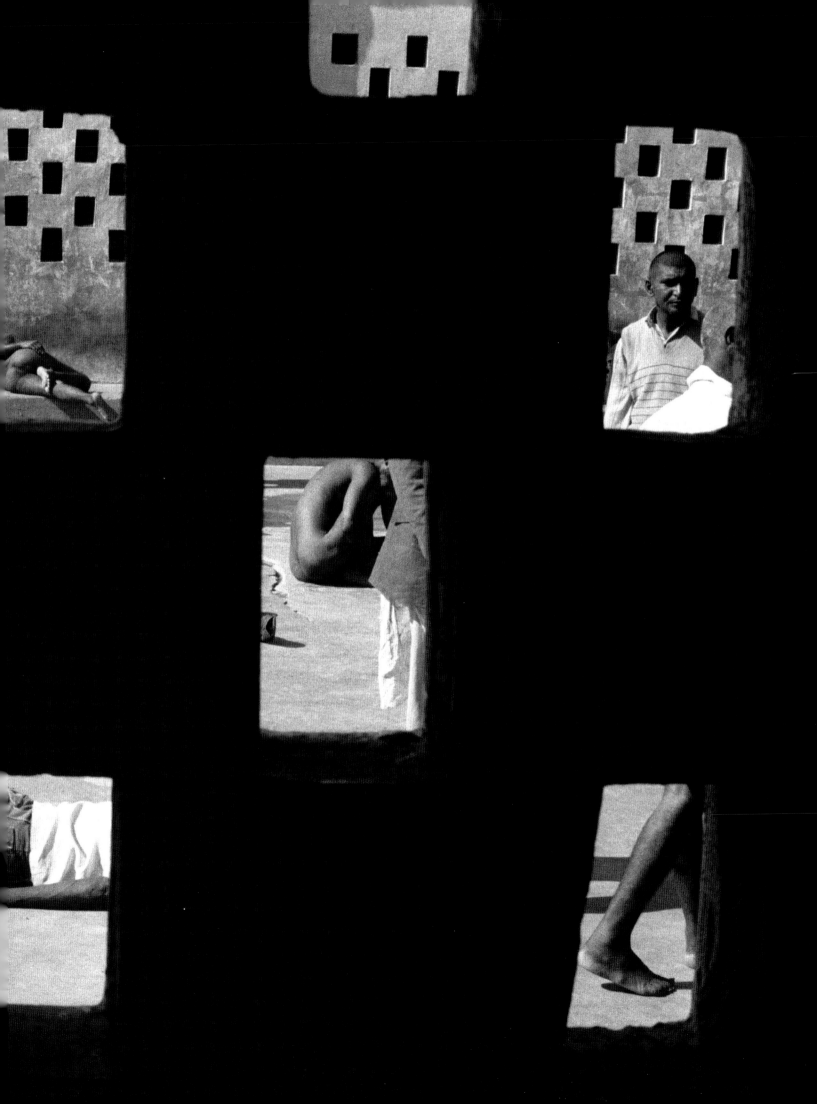

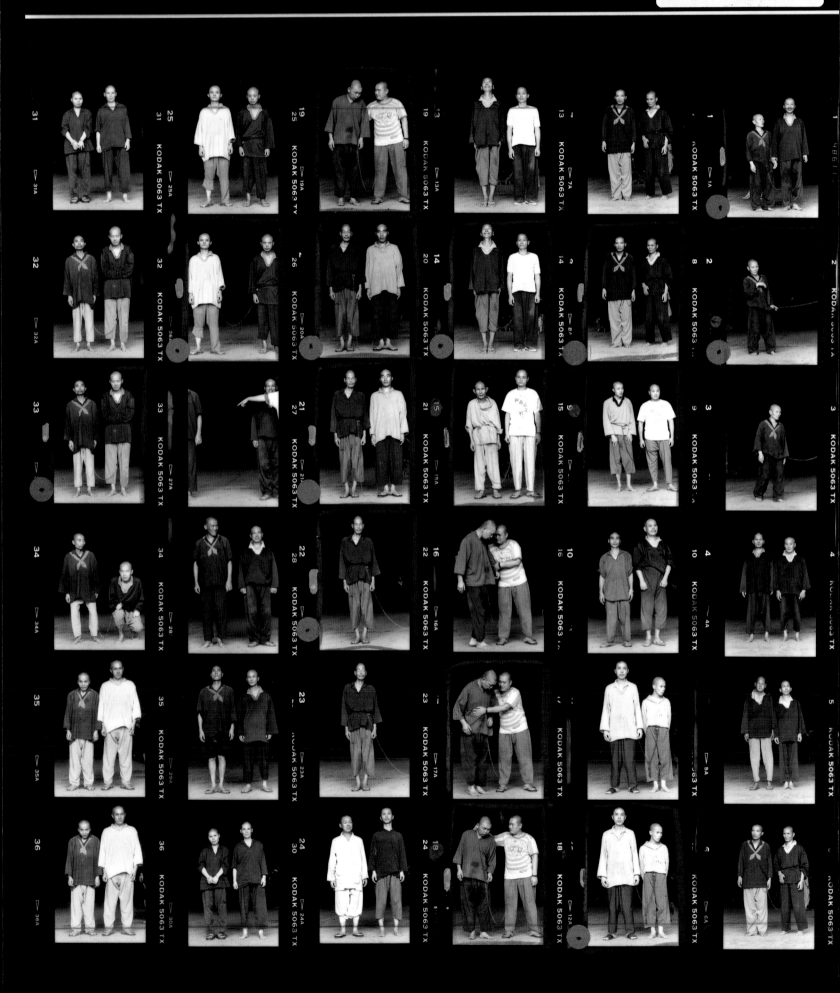

Kaohsiung, Taiwan
October 1998

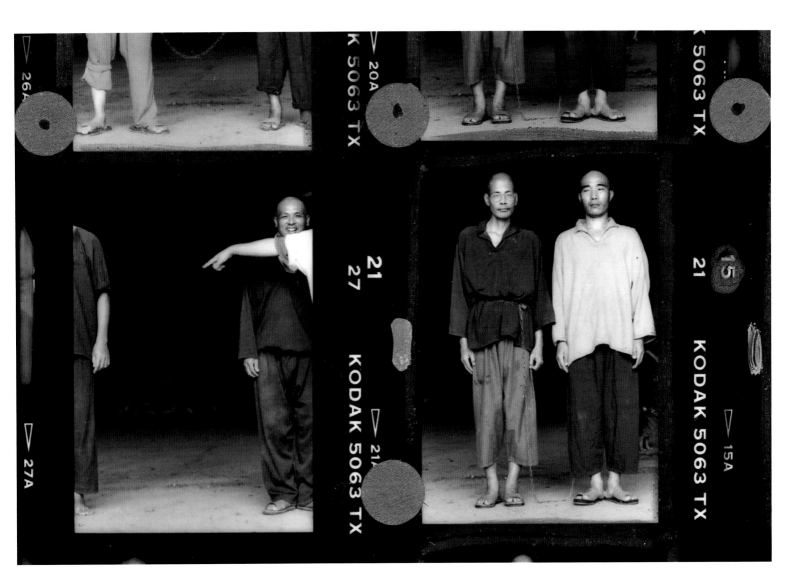

"I had been asking for permission to photograph at the Long Fa Tang temple for six years before the authorities finally agreed. The temple was both a sanctuary and a prison for seven hundred mental patients. They worked on the temple's chicken farm, Taiwan's largest, and I set myself up in the warehouse, my camera mounted on a tripod. The patients had a break for lunch at noon. Then, led by their supervisor, they came down from the canteen, in pairs, to the warehouse. I was perspiring profusely. In October, in Kaohsiung, southern Taiwan, it is hot. In addition, the situation that I took in through my viewfinder was very intense.

Most of the patients had been left at Long Fa Tang by their families. The temple provided no medication or treatment, but instead used 'therapeutic' chains. A more lucid patient was chained to a less lucid one. Sometimes it was obvious who was leading whom. Sometimes it wasn't.

Things happened very quickly. The supervisor adjusted the patients' clothing, then 'click, click', two shots and it was over. There's the interaction between the two patients, between them and their supervisor, and between them and me and my camera. All these dynamics at the same time, repeated with every pair. When I pressed the shutter, I thought I was in control. But, looking back, they were, too. When they wanted to walk off, they walked. In some frames, you can see one partner tugging at the chain to rein in the other.

The light reflected off the cement ground. It changes across the sheet because the clouds and sun moved in the course of the two or so hours I was there, shooting nine and a half rolls of film. My interaction with the patients as I shot them was for just a few seconds, but my interaction with them, as frozen on my contact sheet, has been for so much longer, and it continues to grow."

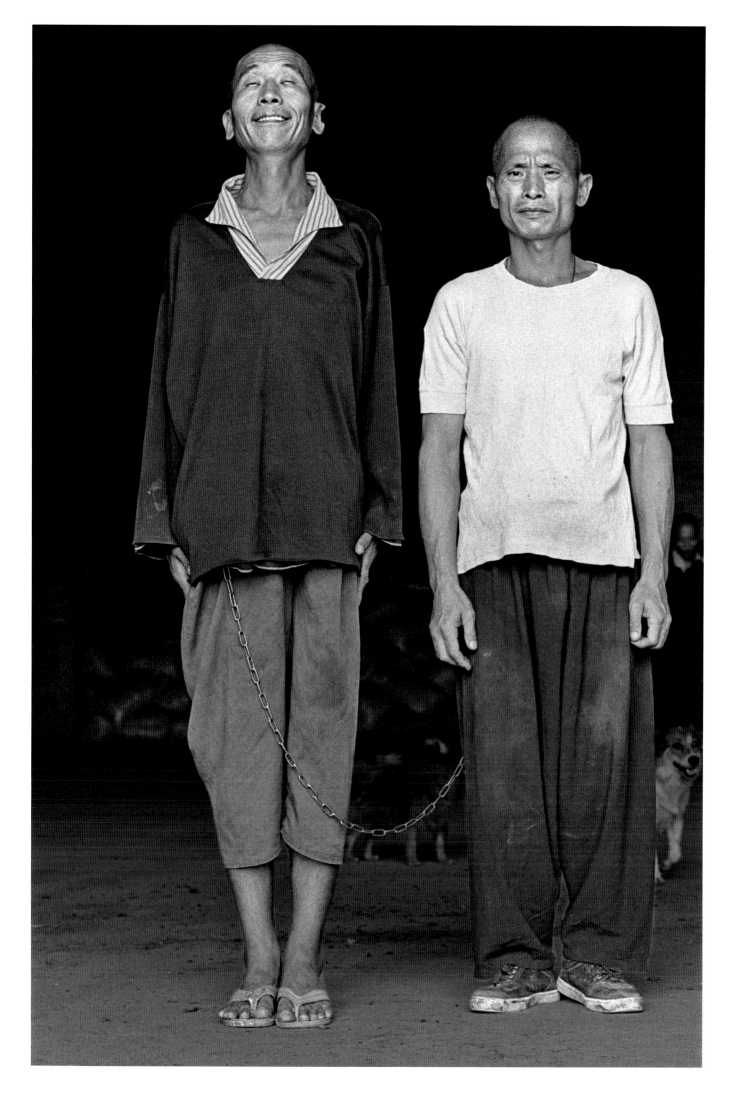

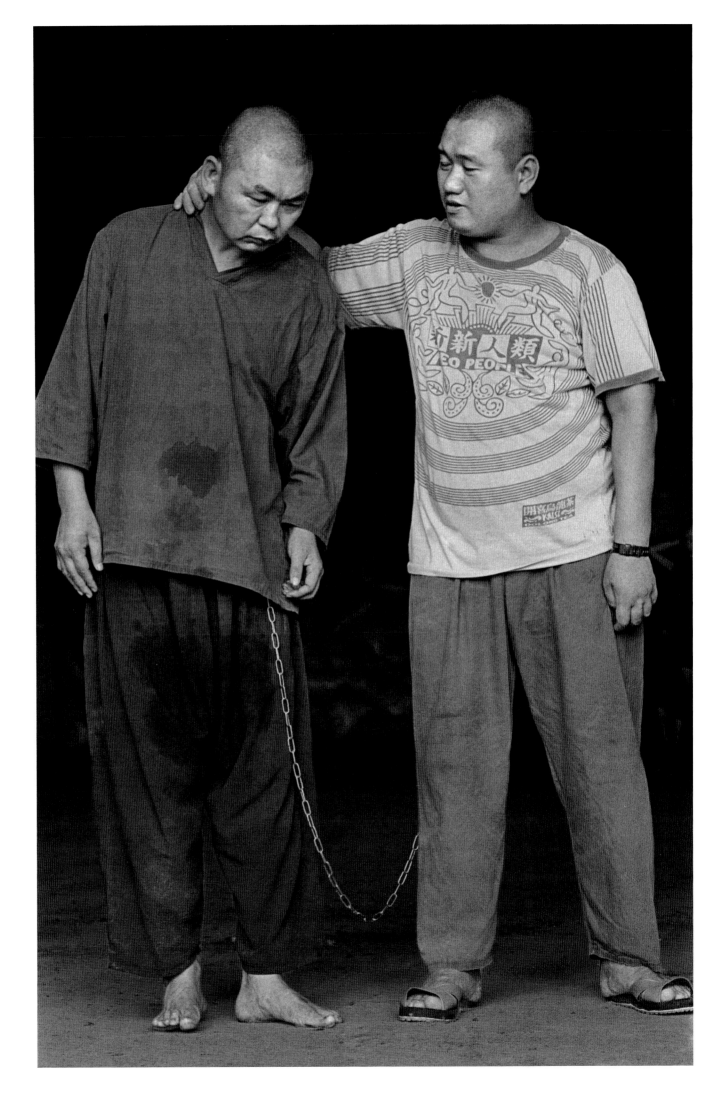

Tokyo, Japan
1998

"Ever since seeing the 'New Japanese Photography' show at MoMA in 1974, I had wanted to go to Japan. I figured that if they could do good photographs there, why couldn't I? Of course, when I got to Tokyo for the first time in 1994, it had changed a lot. I spent ten months photographing in the city, and my work culminated in the 2000 publication of my book, *Go*.

In 1998, I was in Tokyo on a Japan Foundation grant, working on the dark side of life in the city. Through a journalist friend, I was introduced to some Yakuza, members of the Japanese mafia. An image I took then became one of my favourites from the Japan series. It was taken early on in the evening at a coffee shop in the Ginza area of Tokyo. As we were talking, the gentleman at the rear lit the other yakuza's cigarette. I like bad guys, and cigarettes are one of my favourite photographic props. So at that moment, right there in front of me, I was offered a great combination of three elements that attract me visually: cigarettes, smoke and underworld characters. The scene looked wonderful, so I asked through my translator if they could do it again, and they agreed. I thanked them and I went on photographing. The lighting of the cigarette lasted at most another minute.

When I look at a contact sheet, I go in order from No. 1 to No. 36. I mark the ones I like and, unless something really jumps off the page at me, I go over them again to see which is the best one. With my personal work, I only print what I think is good. When something jumps off the page, it's easy. That photograph jumped off the page. It worked, form-wise and emotionally. To me, the photograph says a lot about the hierarchy in Japanese society, with the underling lighting the cigarette of the person above him, and I like the wary eye that the 'boss' gives the photographer."

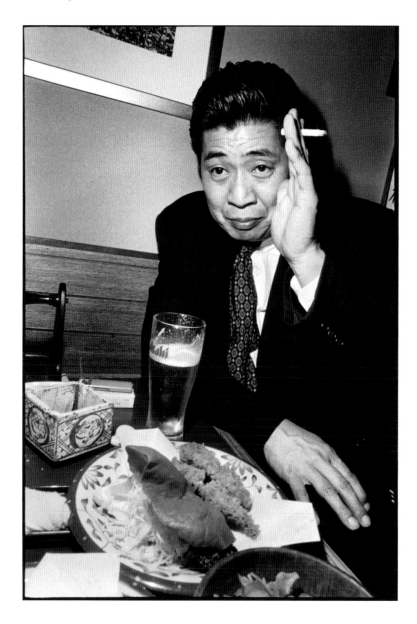

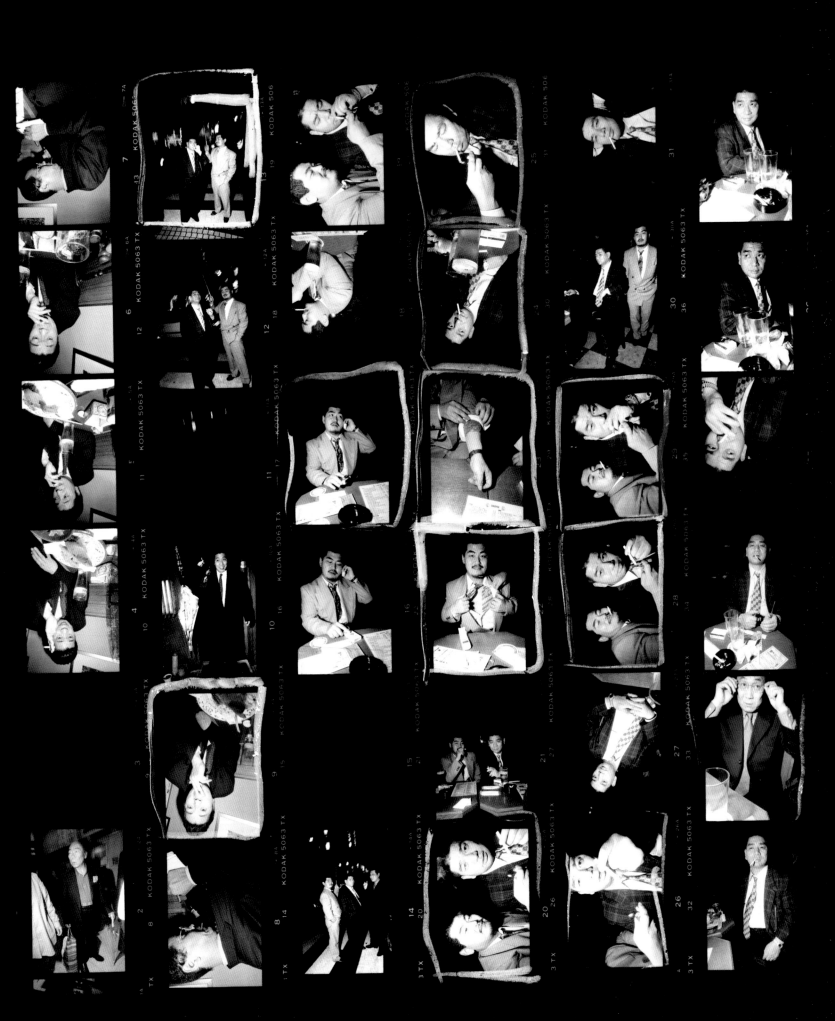

98-3-6

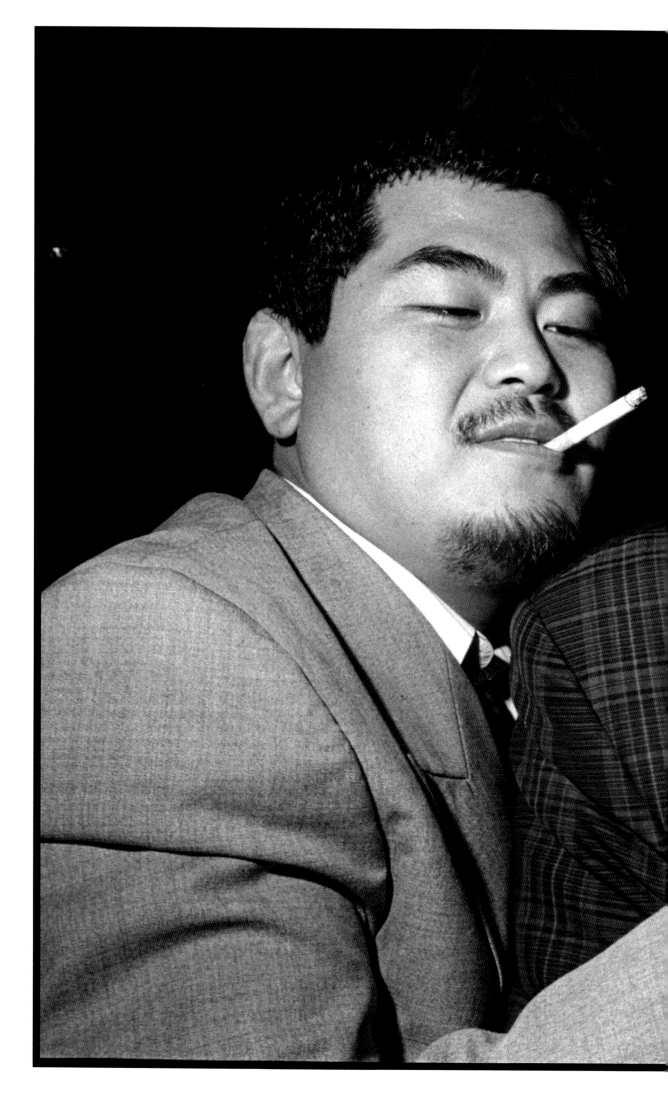

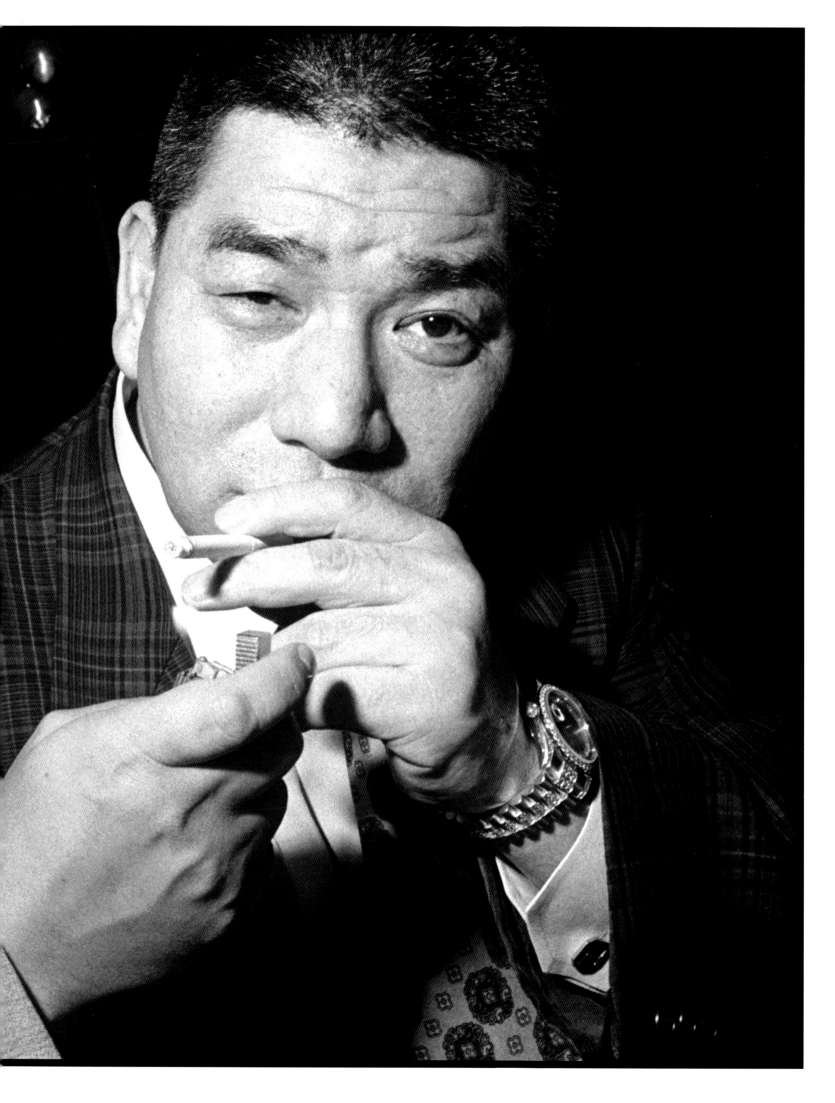

1998 **TRENT PARKE** Summer Rain

Sydney, Australia
Summer 1998

"For ten years I roamed the streets of Sydney, exploring photography and the city I had moved to. This contact sheet, typically, starts with some pictures taken from my bedroom window in the apartment I lived in in Kirribilli (a man sunbakes as the ferry arrives). I was always looking out of the window across the harbour, waiting for the right ferry to catch; always leaving it until the very last minute before racing downstairs and along the ferry's gangplank. The ferry would take me across Sydney Harbour to Circular Quay and the city.

By the time I reached the city on this particular day, an incoming summer storm had quickly taken the light from the sky. I was just about to catch the ferry back home again when I had one of those gut feelings. It started to rain. I literally ran the length of George Street to the Queen Victoria Building – a place where, if the sun did happen to come out, I would have a backlit, dark background. The sun came out for a very short period. It happened to coincide with the heaviest part of the thunderstorm's downpour. The man in the photograph had obviously been running to escape the rain, as his tie had swept back over his shoulder. He has since been commonly mistaken for a child with a backpack.

The photograph came to symbolize my time in Sydney: ten years of always standing, watching and waiting on street corners for something magical to happen. It also appeared on the cover of my first book, *Dream/Life*."

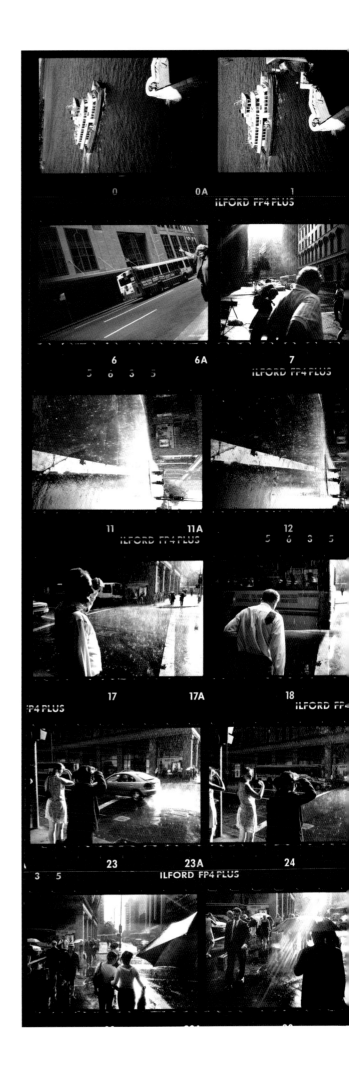

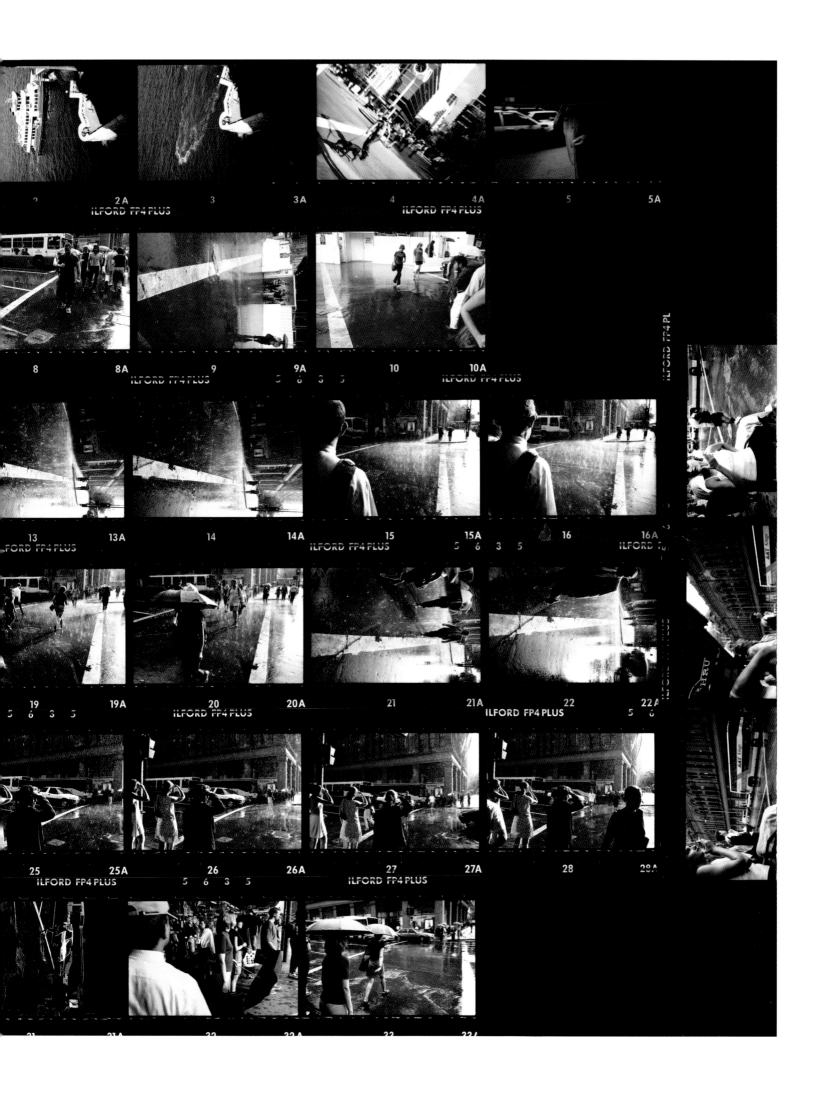

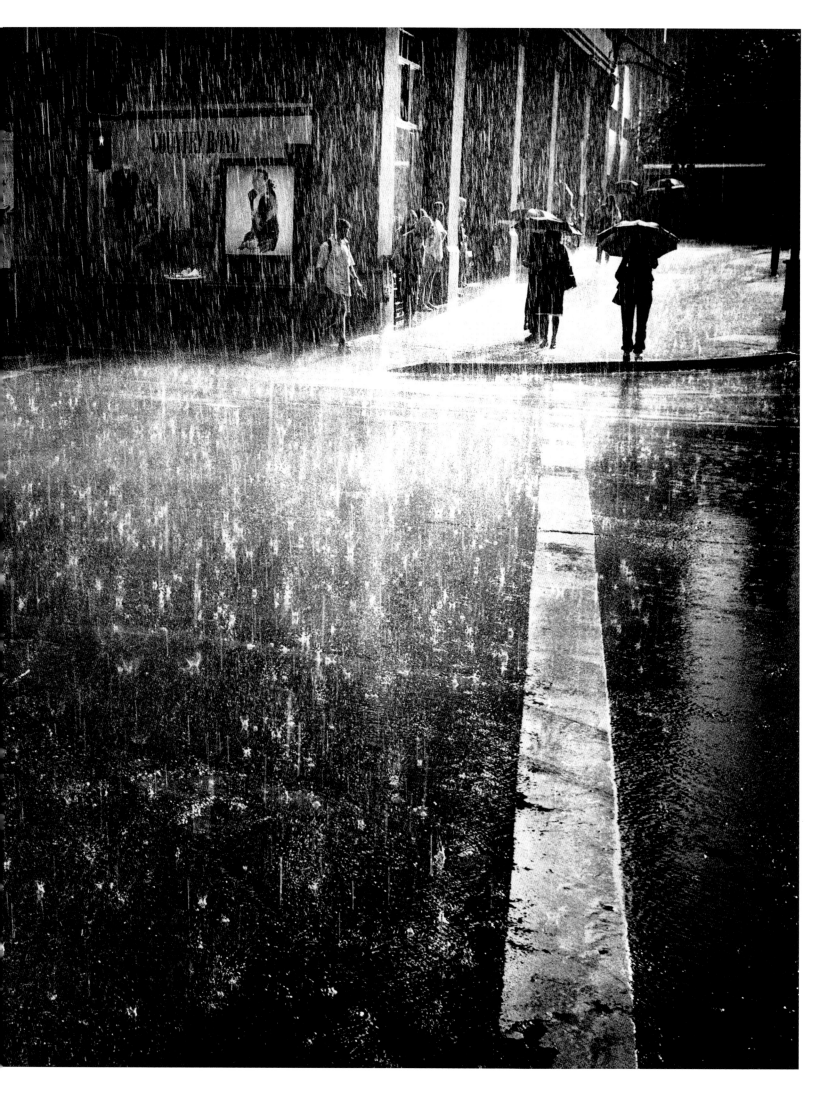

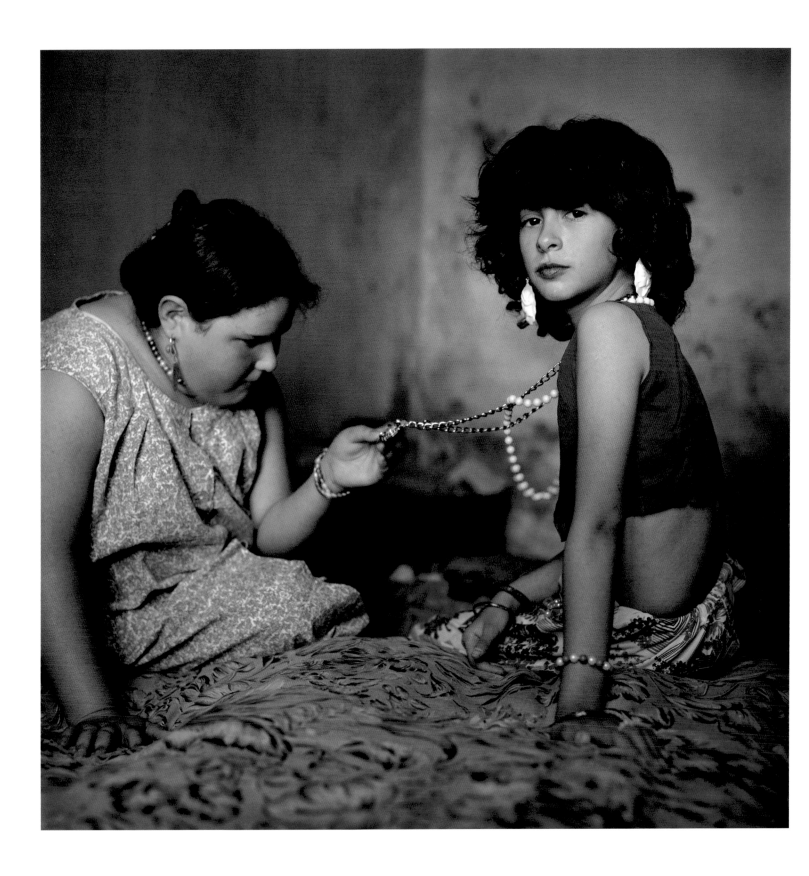

Argentina
January 1999

"It was January 1999. I was in the countryside 300
kilometres away from Buenos Aires, trying to continue
work on my *On the Sixth Day* project, but in reality,
spending my days with Guillermina and her cousin
Belinda. They were the granddaughters of Juana, a
woman whose farm animals I'd been photographing
since 1993, and to whom I'd grown close.

It was mid-summer there, Guille and Beli were out
of school, and I'd recently quit my editing job at *Clarín*,
an Argentine newspaper, so I had the luxury of time that
only a child has. I spent the mornings walking in the fields
and the afternoons at Juana's, sitting for hours outside by
the dirt road, drinking *mate*, listening to gossip, watching
out for any interesting animal happenings, and offhandedly
filming and photographing Guille and Beli, always feeling
guilty for not doing 'real work'.

This particular day we drove to an abandoned
farmhouse, where Guille's other grandmother had once
lived. To get there, we had to go through three bumpy
fields until we reached a dense patch of overgrown
everything. Guille and Beli used branches as machetes
and their feet to sweep away the anthills by the doorway.
After making their way in, they raided a closet, where,
among the moth-eaten dresses, Beli found the necklace.
As she sat on the bed to show it off, I forced open the
blinds and this beautiful clear light poured in.

After shooting four frames in black and white, I
stopped. Something wasn't right. Beli's red lips and
Guille's crazy skin colour were lost in grey; their delight
– normally a high-pitched string of silliness – was muted,
but their disputes over the used-up lipstick were
wonderfully solemn. So I put down the camera and I
started to videotape them. After a few minutes of video,
I changed the film to colour and photographed them
some more (this is when I shot 'The Necklace'), then
I switched back to video, and went back and forth in
this way from that afternoon until about three years later.
Whenever I filmed I felt I was missing a wonderful still
moment, and whenever I photographed I felt I was
missing an unrepeatable conversation; never really
catching up…"

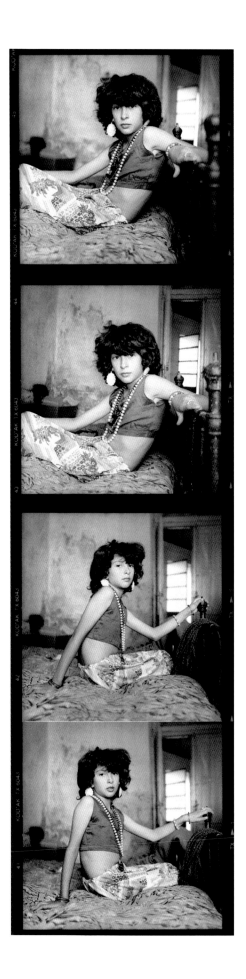

Fuji City, Japan
1999

"The first images on this contact sheet are taken from a footbridge in a part of Fuji City where my wife's father had a restaurant. My wife, Miyako, and I were having dinner with him that evening. The light was good when I shot from the bridge, so we decided to go back to Tokyo the long way round, in a big loop around Mount Fuji. At a certain point, Miyako pointed to the view we had of the mountain. It wasn't terribly exciting until I came across some roadworks, and I knew I'd get something interesting from their flickering, artificial light. Because we were on a road and it was a long exposure, I had to jump in front of the camera with my coat open whenever cars drove past, in order to block out their lights. I basically guessed the exposures. The final one was about three minutes. People always ask if I used Photoshop, but I didn't. The red is from the safety lights and the green from fluorescent lights in Fuji City behind the mountain. Two pictures from this roll of film made it into my Fuji book.

The idea for the project started when Miyako gave me a book of Hokusai's prints, *36 Views of Mount Fuji*. I was struck by the documentary nature of his images, which depict views of ordinary life, with the mountain as a presence in the background. The first view a foreigner usually gets of Fuji is on the bullet train out of Tokyo, when the mountain rises out of the surrounding industrial landscape. This is the unromantic reality, and yet in most photographic representations there is hardly any sign of human activity. I wanted to depict contemporary Japan in the shadow of Fuji as I really found it, and in so doing discover the country.

As the project progressed, I would get several rolls contacted together, from which I would then make proof prints of the images I liked. The contact sheet is interesting, as you carry in your head what you think you've photographed, but sometimes the actual picture doesn't quite come up to scratch. On this sheet, for example, I didn't realize that I'd messed up the exposures in the initial images of Fuji at the roadworks as much as I had done.

In Japan, 'Red Fuji' – meaning 'Fuji tinged by evening light' – is considered to be especially beautiful. People refer to this photo as my 'Red Fuji' picture, even though in the photo the mountain itself is not actually red. I like that apparent confusion, and this image ended up on the cover of my book, because it's the sort of picture that you don't interpret immediately; you look at it and wonder, 'What is it? What's going on?' I want that. It's ambiguous, and hopefully it draws people in."

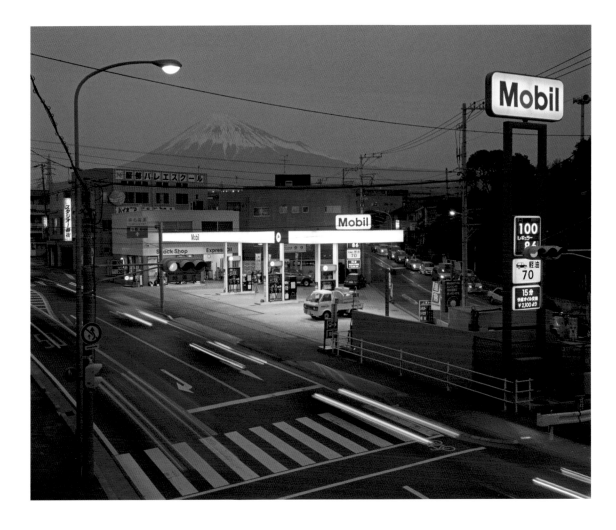

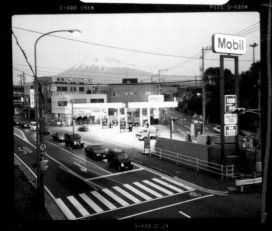
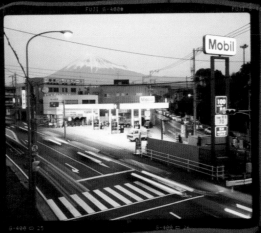
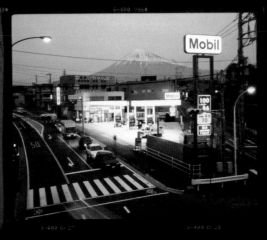
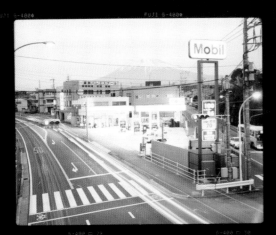
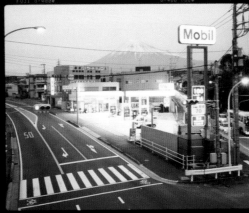
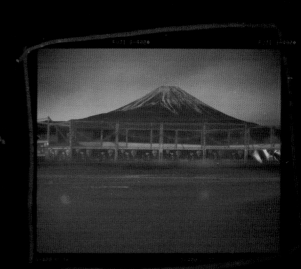

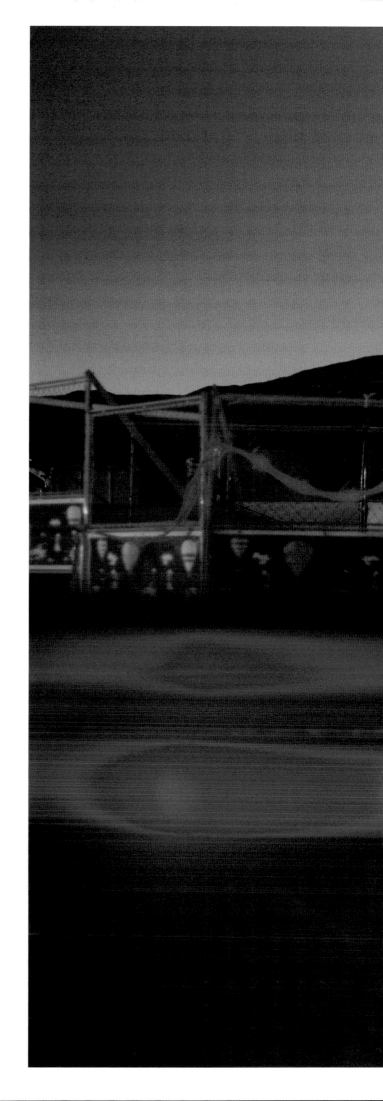

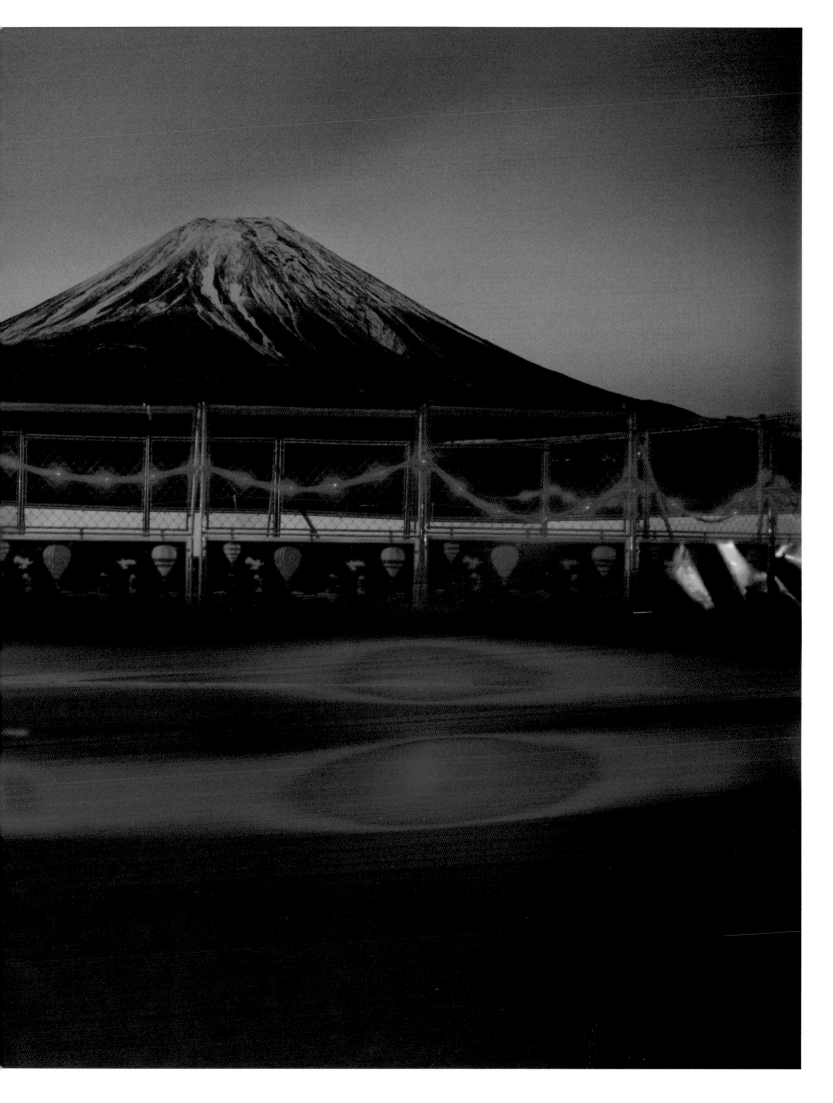

Haiti/USA
2000

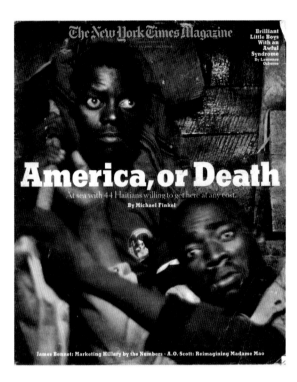

"In 2000, I managed my way on board a 23-foot homemade wooden boat with 44 clandestine Haitians who were trying to sail to the United States. A couple of days into our journey, the boat began to sink. We were doomed and we knew it. We started saying goodbye to one another. Strangely, it was quite calm on the boat. There was not much to do except resign oneself to the inevitability of it all. Up to that point, I had not taken many pictures. Everyone on the boat knew I was a photographer, but it somehow had not felt right … it's difficult to explain. But as the boat sank, David, the Haitian whom I had followed on this journey, said to me, 'Chris, you'd better start making pictures. We only have an hour to live.' And so, without much thought, I began making pictures.

We were saved at the last moment by a US Coast Guard cutter that happened upon us, but that's another story. Much later on, back home safe, I reflected on this question: why make pictures that no one will ever see? The only explanation for me was that the act of photographing had more to do with explaining the world to myself than explaining something to someone else. The pictures were about communicating something about my experience, not about reporting literal information. This would be the single most transformative moment of my photographic life."

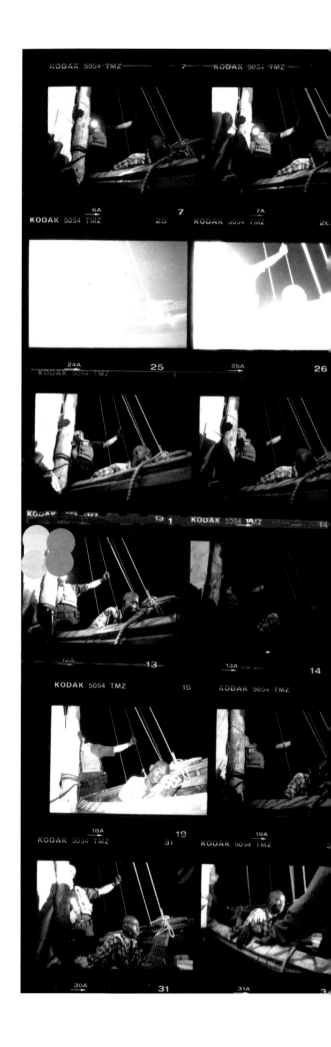

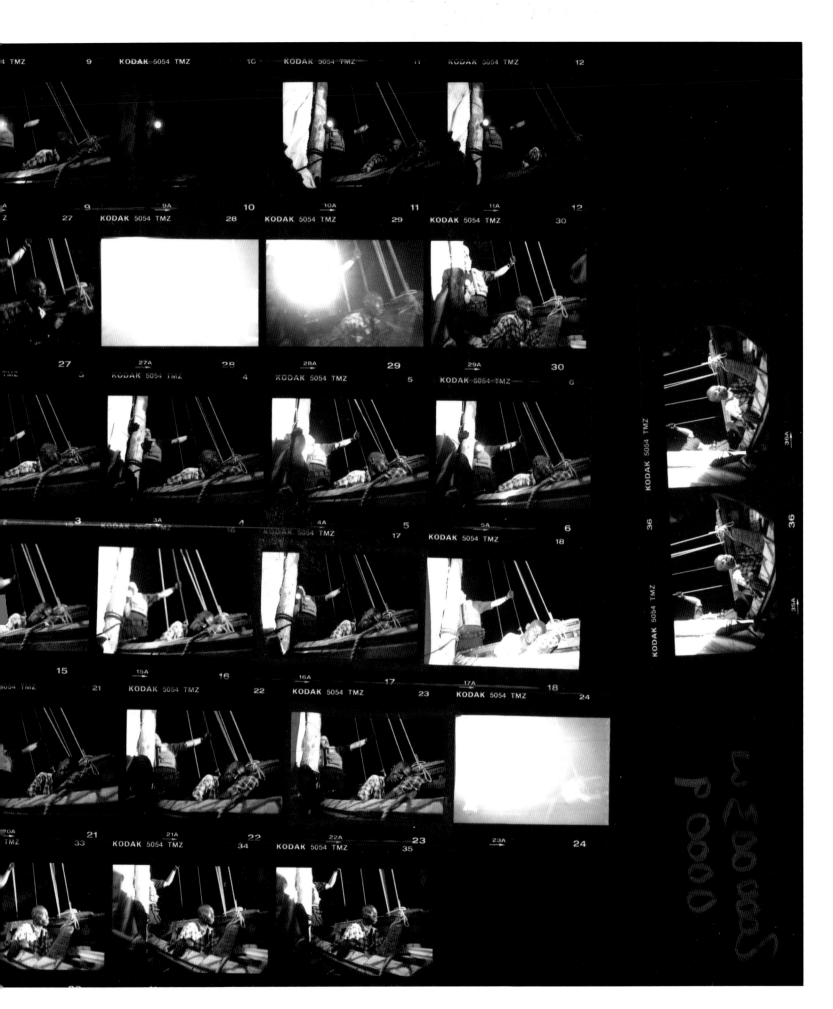

435

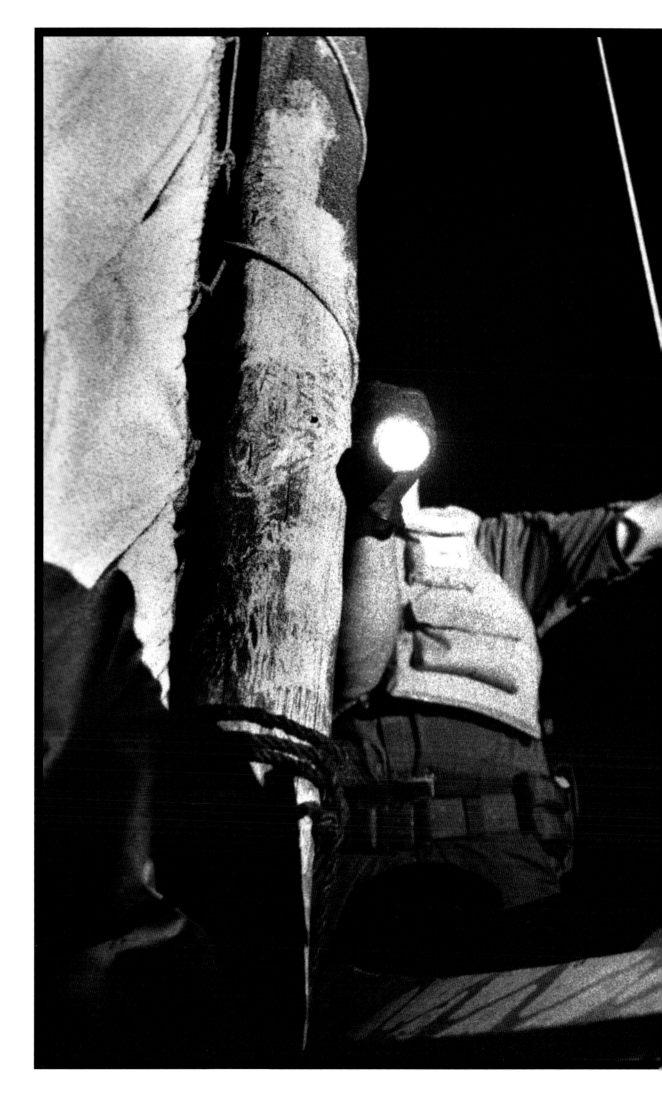

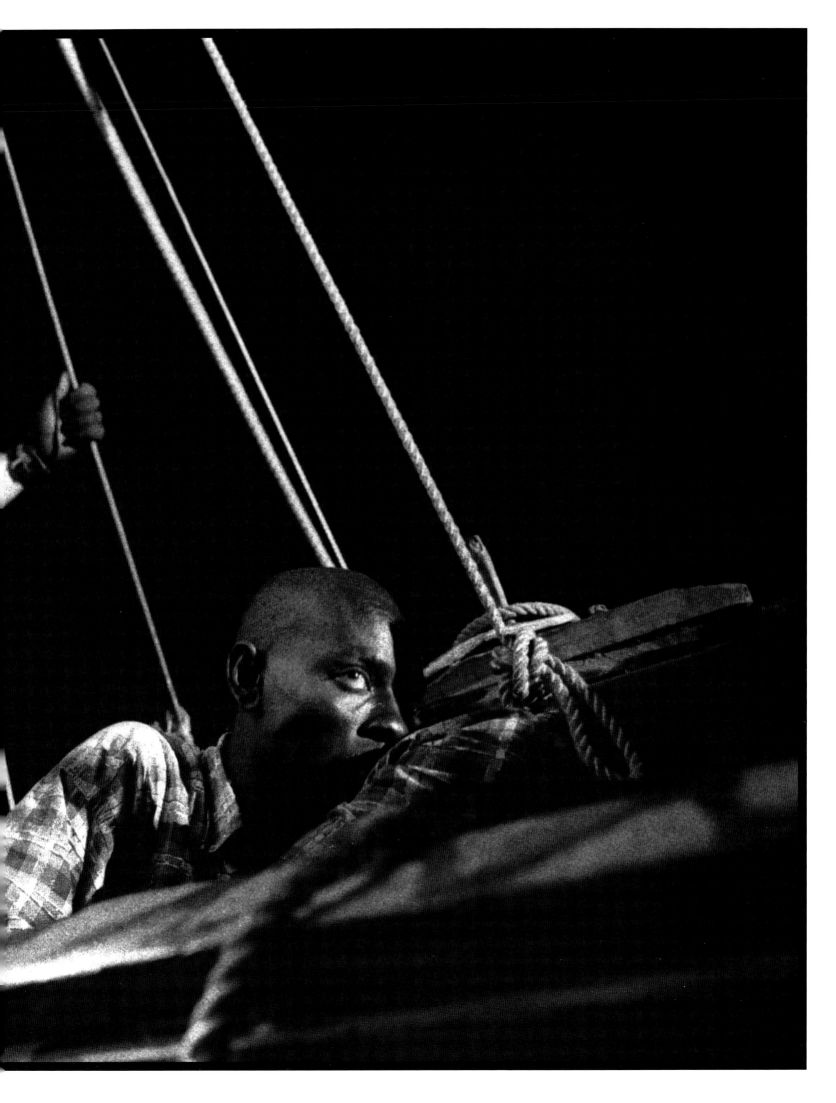

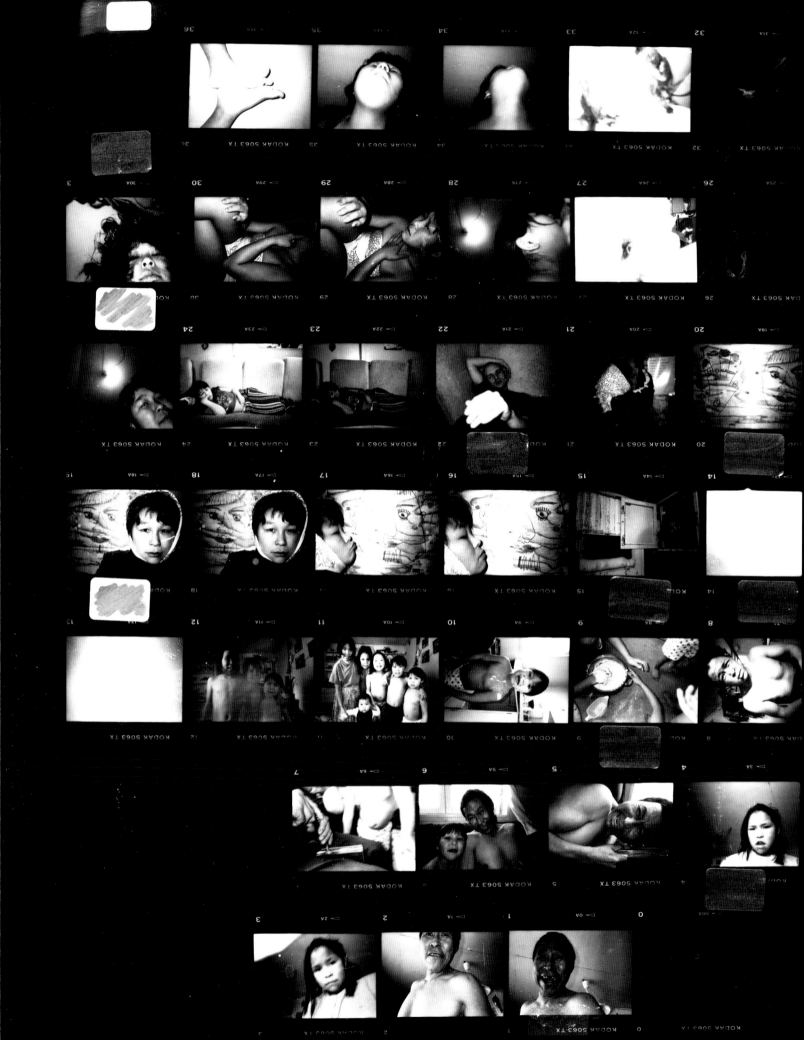

Tiniteqilaaq, Greenland
2000–02

"Early in the morning – just before dawn – I go fishing for cod. I do that every morning in January with the other fishermen in the settlement. I hand my catch to Sabine's mother in the kitchen. She smiles and starts to prepare our breakfast: boiled cod with dark bread. January is dark and cold in Eastern Greenland. The sun doesn't rise.

I crawl back to bed and start to photograph Sabine's feet, her chin and her throat as she sits on top of me. She looks at me. I am in love. After four months of leaving photography alone, I start to take pictures with a small pocket camera. My images are unpredictable and playful – like Sabine.

In our bedroom there is ice on the inside of the window, but Sabine has lit a row of candles on the windowsill to melt the ice and keep us warm. We are sleeping on two thin foam mattresses. Next to the bed stands the rifle, ready to shoot the next seal when the weather allows us to go hunting again. The windows are thin and during storms the wind whistles through all the cracks and crevices. When I return from fishing this morning, Sabine has started to cram our socks and underwear into the cracks. '*Pilarngar-lerpoq.* Here comes the *Piteraq*,' she says. I call the weather service and they tell me the storm will arrive with a wind speed of up to 45 m/s.

We decide to visit my friend James and his nine children before the storm hits the settlement and isolates everyone in their houses. On the way we pass the notice board, where the 148 inhabitants put up notes. A kid has made a drawing. I photograph the drawing, then Sabine and the drawing.

When we arrive at James's house, one of his kids welcomes us through the open window. '*Kulaaaa Jaaku.* Hello Jacob,' she salutes. Behind her the hallway is packed with jackets and shoes in all sizes. My camera steams up. Outside it is -30. Inside +15. The kids are baking bread. In the kitchen Louisa and Martha are skinning a seal. '*Kaappid*? Are you hungry?' James asks. I call him *Kammaaji* – my mate.

In 2004 I published my book, *Sabine*, and ended up using the three pictures that are marked in red (two on a contact sheet from 2000; one from 2002). While I was living in Greenland, I never saw the material I was recording. It was only when Sabine and I visited Denmark that I would develop the film in my mother's bathroom and print the contact sheets. To me they became more than an editing tool; they were like looking through a diary.

After two and a half years, our relationship ended. I later realized that printing and looking through the contact sheets over and over again was a way for me to stay with Sabine and maintain the love we shared."

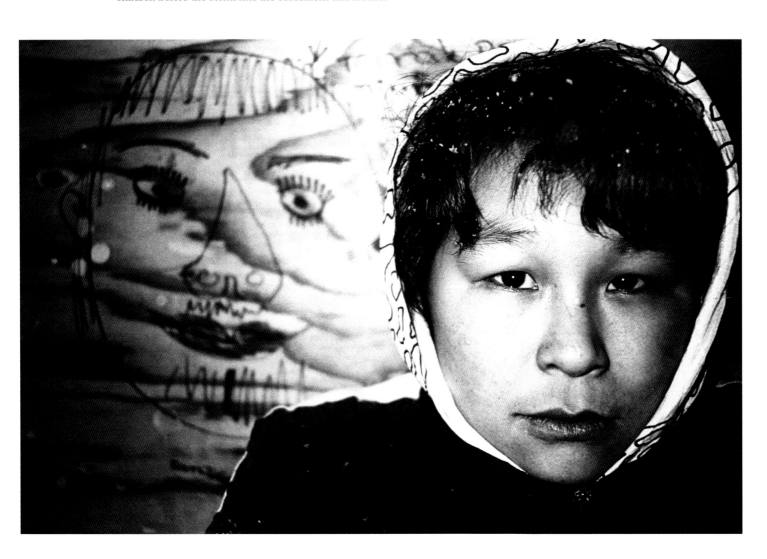

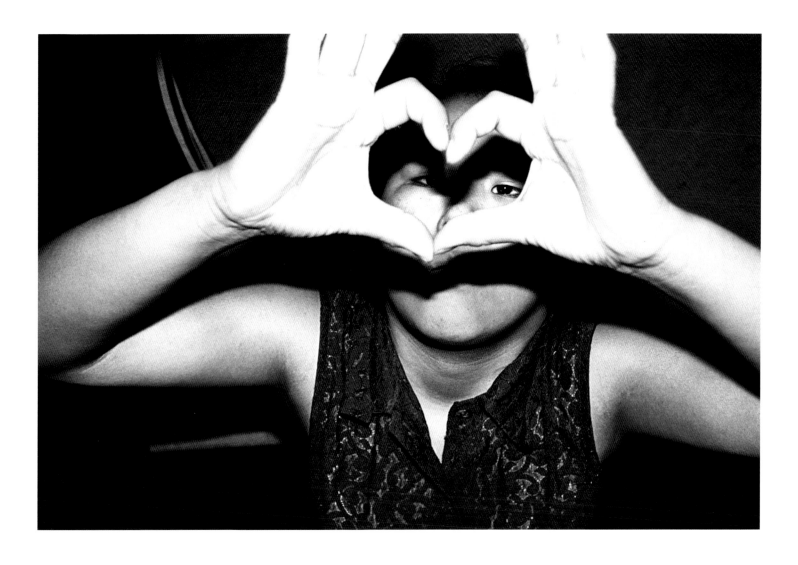

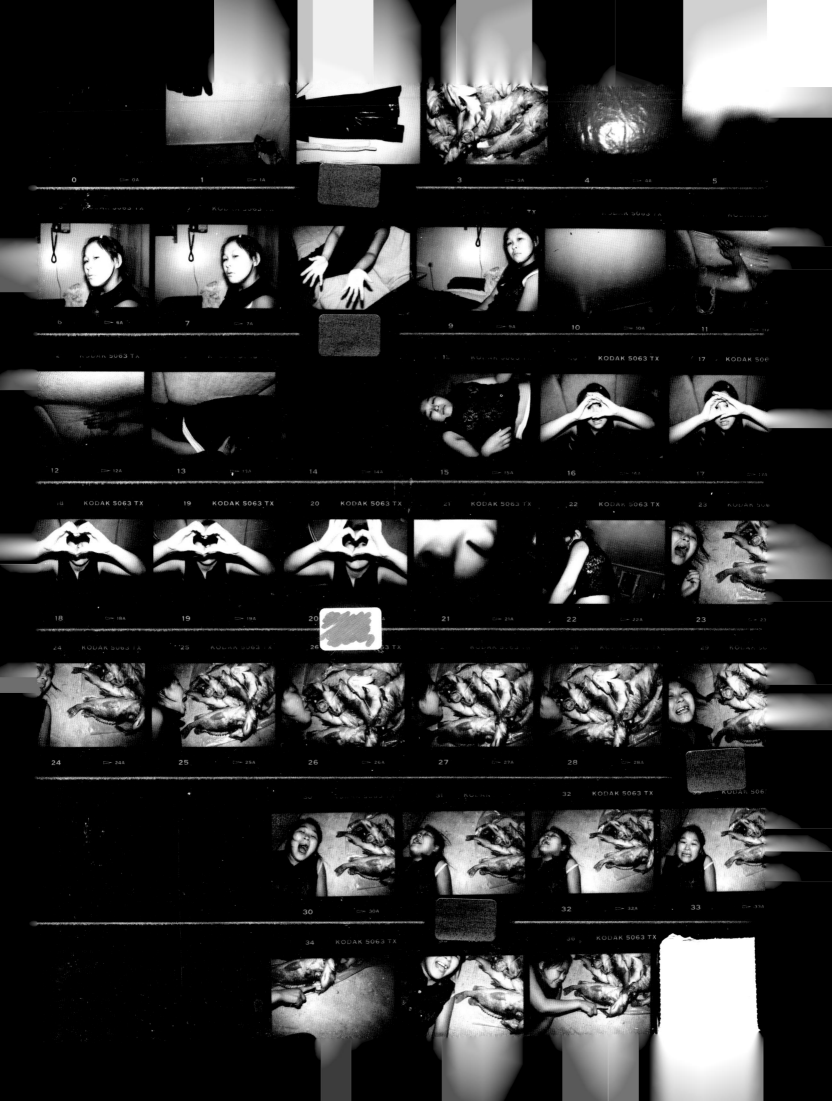

BRUNO BARBEY Morocco

Near Rissani, Morocco
2000

"I was born in Morocco. I grew up in Salé, Rabat, Marrakech and Tangier. When I was very young, Salé was my kingdom: its austere medersa, the call of the muezzin mingling with the ever-present song of the sea, the waves beating against the cliffs, the beauty of the cemetery out beyond the city walls. In Rabat, even as a small boy, I was entranced by the Oudaia kasbah and the Chellah necropolis, the Bou Regreg river lapping softly against the boats. Later I lived in Marrakech, the Red City at the foot of the Atlas mountains, and later still in Tangier, on the Straits of Gibraltar, with Andalusia not far away. In half a day you can move from the desert sands to the Atlas mountains, and from the Atlantic coast to the shore of the Mediterranean. Cultures and civilizations overlap in unlikely combinations: Umayyad culture, Andalusian influences, Berber traditions, Jewish traces. The Moroccans have so far succeeded in preserving their sense of human solidarity and harmony with nature. They have adapted to the 'modern' world, while retaining their own culture.

I began to photograph Morocco forty years ago, when I returned to my homeland with my wife Caroline in the early 1970s. I have been going back there to work ever since, and perhaps I would not have been crazy enough to continue for so long if my childhood memories had not remained so vivid. What might have been nothing more than an aesthetic interest elsewhere takes on a unique dimension, a humanity, in Morocco, land of tradition.

As everywhere, globalization is now underway, but Morocco remains – though for how much longer? – a strangely still, almost timeless land. Look at Delacroix's notebooks: skill notwithstanding, you could still sketch the same scenes today on the street corners of the souk. How many painters, photographers and writers that have stayed in Morocco have allowed themselves to be carried away by its light, its substance, its colours? Perhaps the most famous among them, Matisse, admitted that the country had forced him to totally rethink his palette.

Here, it is sometimes so difficult for a photographer to do his work that he must learn to merge into the walls. Photos must either be taken swiftly, with all the attendant risks, or after long periods of infinite patience. Such was the price of these images. The memory of Morocco can only be captured with respect."

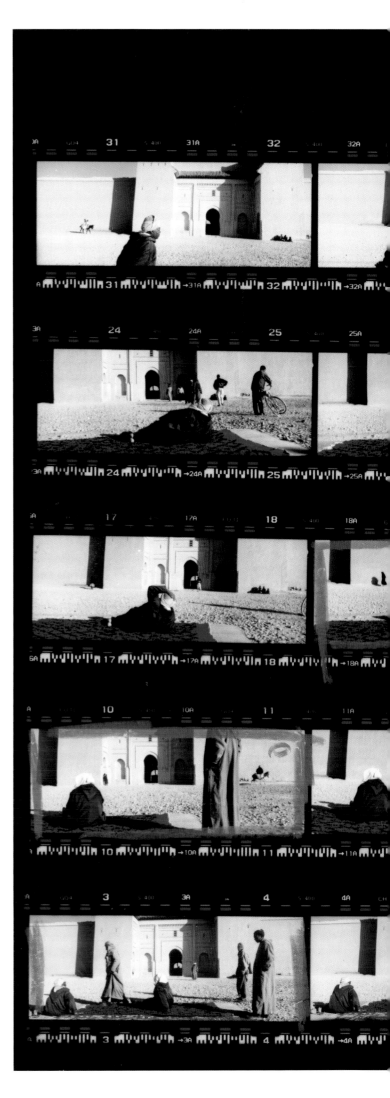

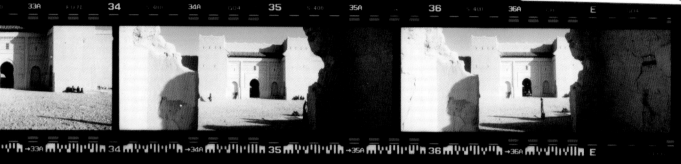

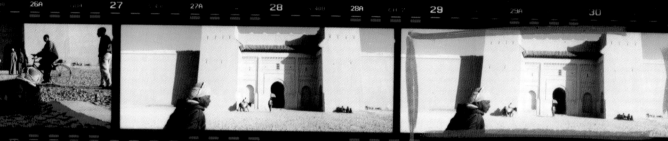

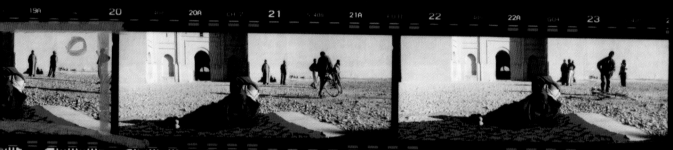

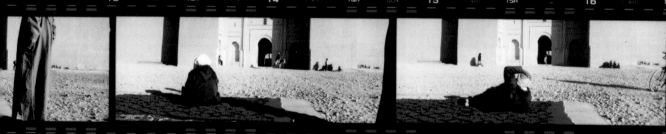

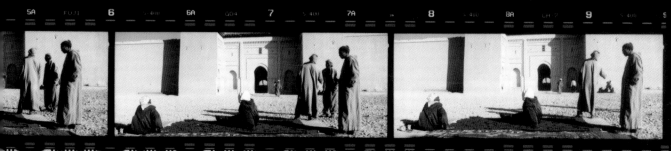

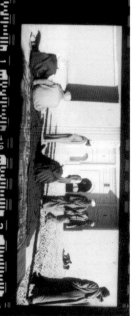

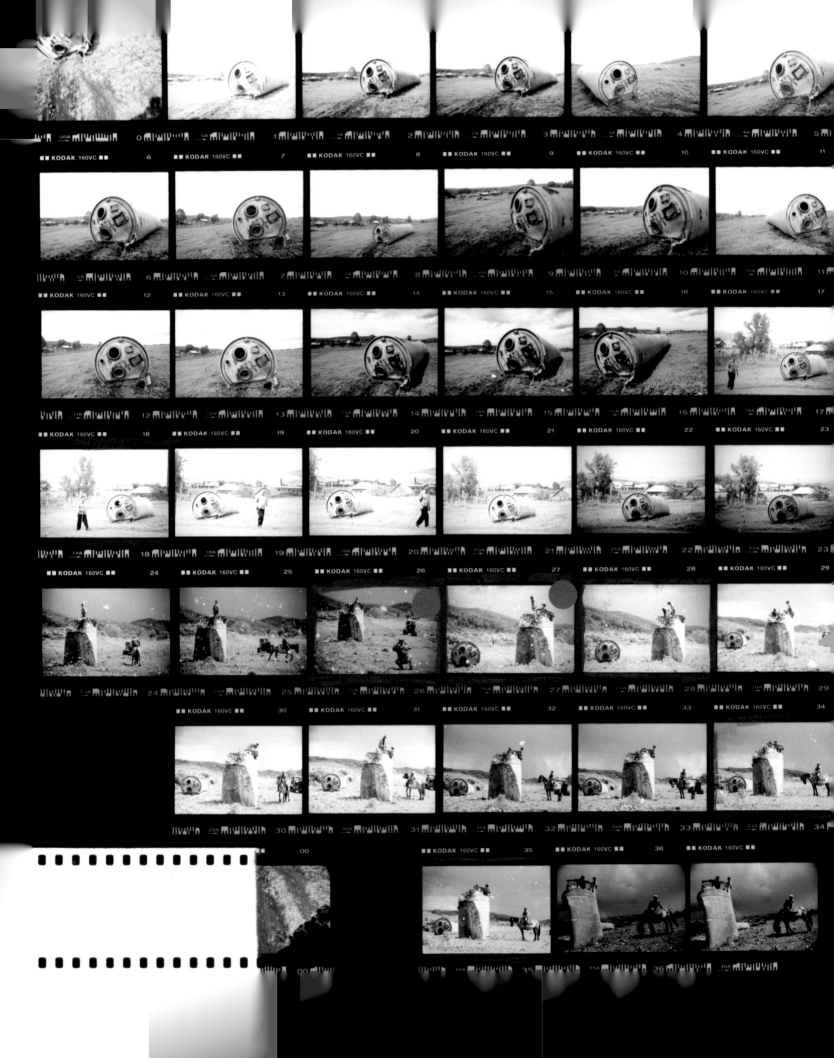

Altai Territory, Russia
2000

"The image that became the cover of my *Satellites* book was one of the few I ever shot on negative film. Normally I would use transparencies. However, I think I had probably run out of slide film on that day, and was going on whatever I had in the bottom of my camera bag. The image was shot in 2000 in the Altai Territory of Russia. My wife Laara and I, then living in Moscow, were doing a story about the people who lived downwind from Russia's main spaceport, Baikonur.

I hadn't looked at this contact sheet in years, as I'd cut out the chosen frame and left the rest in an archival box I hardly ever accessed. Once I dug it out, I couldn't help laughing aloud. I was shocked, but thrilled, at what it showed – a complete unawareness of the magic that was swirling around me. Or perhaps it was the last breath of the save-your-film-you've-only-got-36-shots era? In any case, here we were in a cloud of white butterflies circling the remains of a Soyuz space rocket's second stage, while local farm boys were gutting it for usable scrap metal. In total, I shot less than half a roll of film. From the basic angle and composition from which I got the final select, I clicked the shutter three times. That would not have happened today.

In a sense, it makes me a little wistful to look at this sheet ten years later. When this was shot, I was just at the beginning of my career and was doing everything for the first time. I wonder if I can ever recapture the rawness of those first years of photographing – when everything was so fresh to look at that I didn't seem to think a freshly crashed spaceship with farmers on top of it was anything that far out of the ordinary; nothing worth a couple more rolls of film."

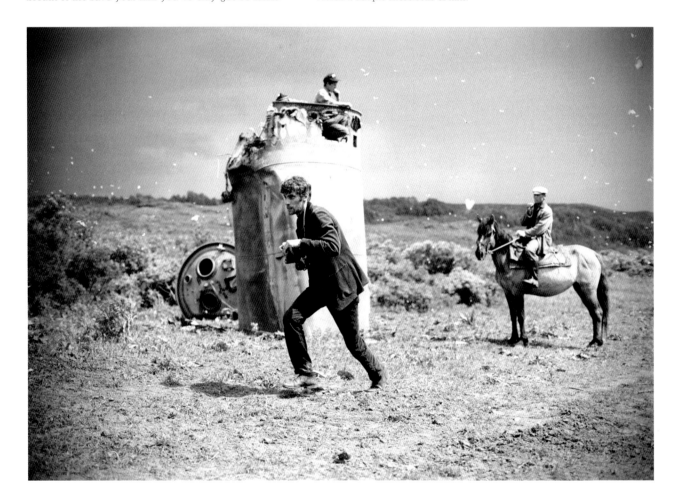

ABOVE Jonas Bendiksen on location, photographed by his wife Laara Matsen.

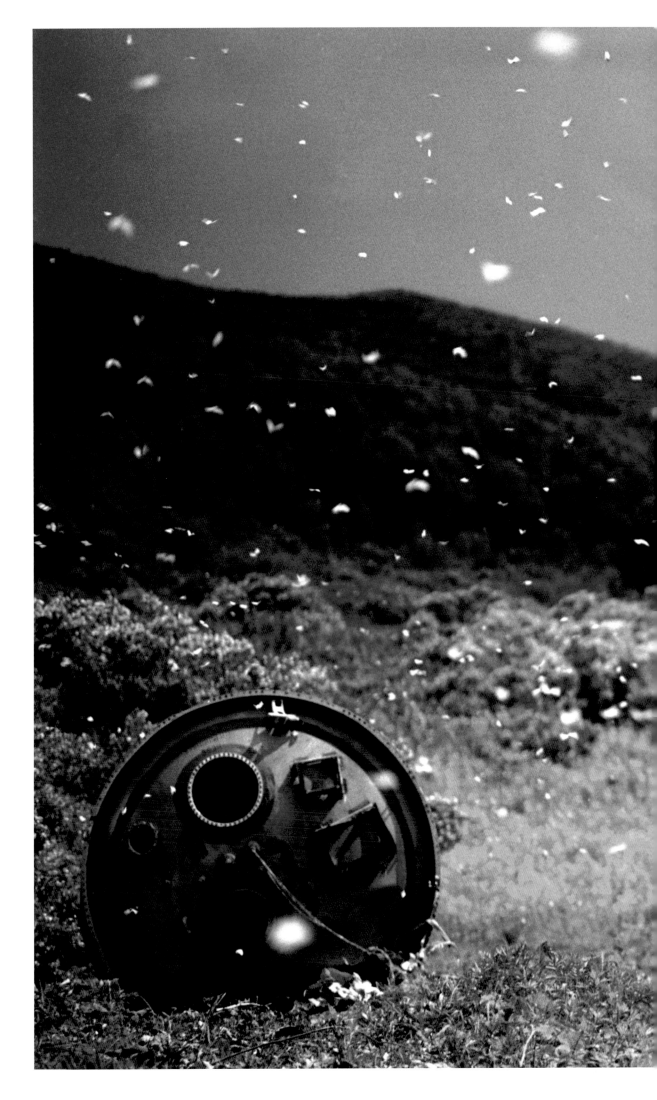

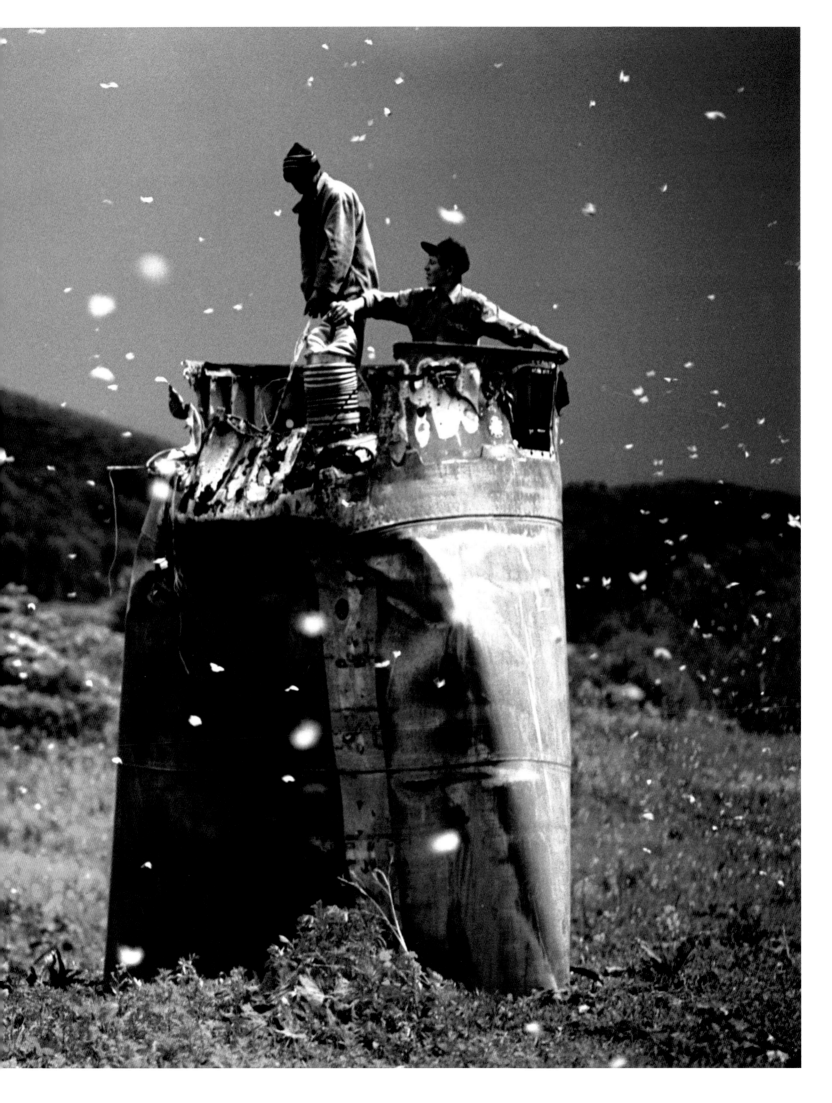

Alkhan-Kala, Chechnya
February 2000

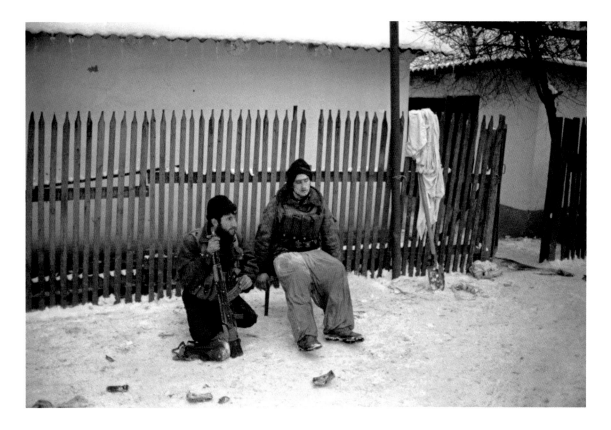

"This work was taken during the second war in Chechnya, which started in the autumn of 1999. I travelled into the country from Georgia, as it was complicated for me to travel via Russia because I'd been associated with the Chechen side. By the end of January I'd gone in four or five times, but it hadn't been very rewarding in terms of pictures. I had no more money, but, as luck would have it, I got a job as a fixer and translator, helping a female journalist get into Chechnya.

We came to the village of Alkhan-Kala and, by pure chance, encountered the Chechen troops withdrawing from Grozny. Four thousand fighters had started moving out, in two columns, from the city they'd given up. It was very difficult to shoot, as the troops were in bad shape, and angry because they didn't like being photographed in retreat. I took very few pictures – only three and a half rolls – and was very gentle about my approach. A lot of the pictures are taken in low light, as the troops ushered me away when the light came up. Out of everything I've photographed, this is probably the most spectacular from the fewest number of pictures. I wasn't even photographing on a professional camera: it was a Hexar.

The next day the Russians started shelling the village. The surrounding area was also under bombardment, so we moved out to the neighbouring republic, Ingushetia. I knew a guy there who had a 24-hour photo lab, and so, three days after the event, that's where I first saw the pictures. I viewed the work as colour negative and edited off the strips against the window. This was the way I worked with film at that time – editing fast when you remember what you've shot. I'd shot so little and didn't shoot sequences, so my contact sheet has two or three subjects on one page. The actual contact sheet was made later in Moscow, but by then the pictures had come out. They were shown first in the *Sunday Times* and then *Paris Match*. In total, it was two weeks between shooting and the story breaking. This contact sheet represents some of the last days of my working with analogue: in 2001 I changed to digital."

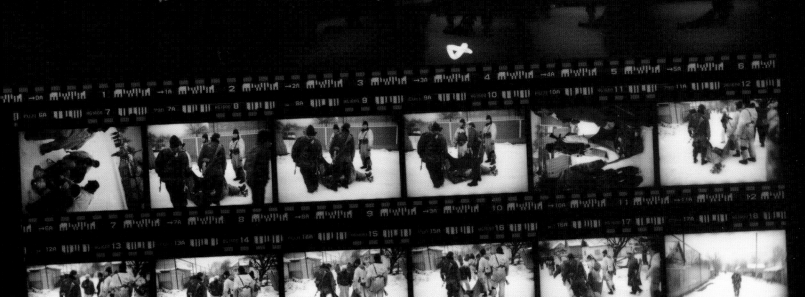

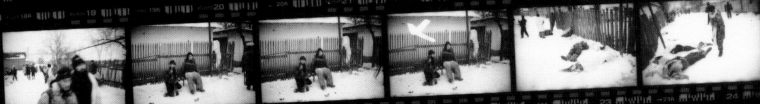

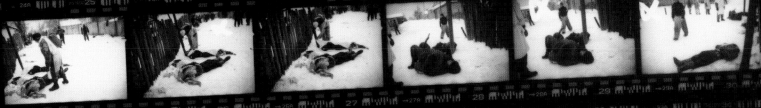

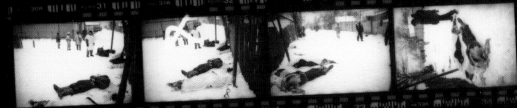

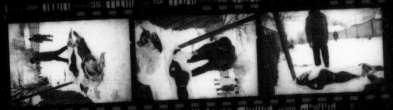

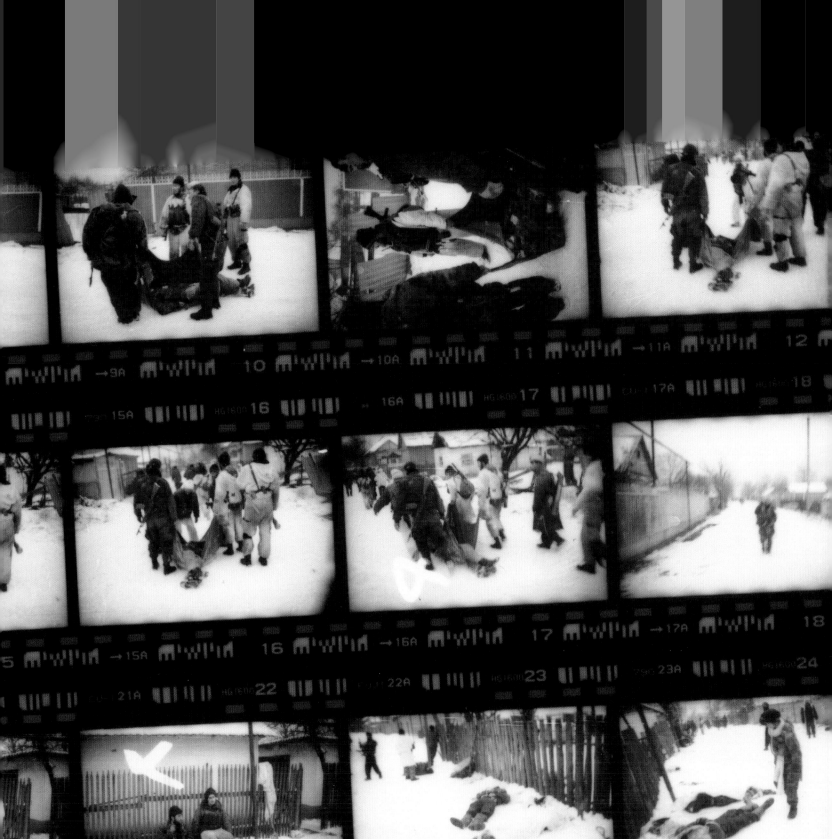
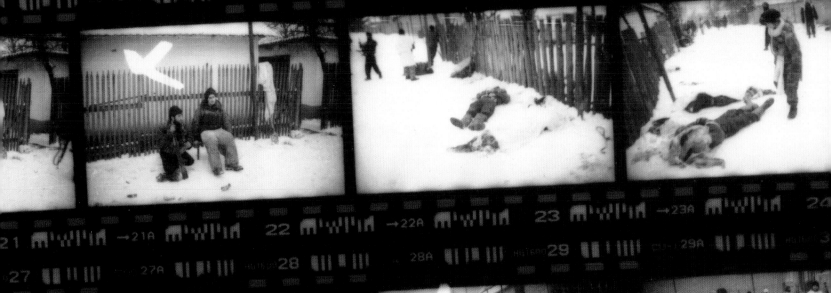

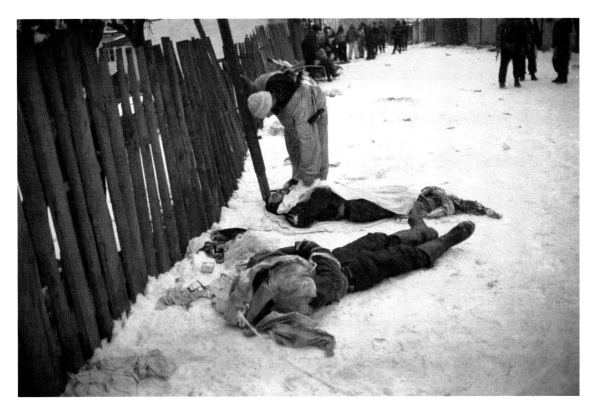

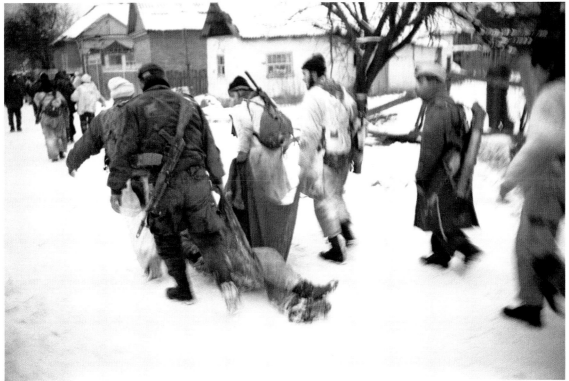

New York, USA
2000

Elliott Erwitt's comical photograph of the bulldog sitting on its owner's lap exemplifies the adage that dogs really do look like their owners. Well known for his dog images, Erwitt captures the precise moment when, framed by the stoop of a New York City building, the head and body of the dog are in perfect alignment with the arms and legs of its owner. Somewhat fantastical, the superimposed head highlights what Erwitt calls the 'visual contradictions that are a photographer's dream'.

As Erwitt recounts: 'I was out walking with my friend Hiroji [Kubota] around the corner from my studio on the Upper West Side of Manhattan, and I didn't have my camera. I saw the situation and I said, "Could I borrow your camera?" And I borrowed his Leica. He was very generous and let me use it and I shot the whole roll of film on it.'

By the very last picture on the roll, all the compositional and conceptual elements are in place, the absurdity of the image further supported by a second dog on the left sitting in exactly the same pose as the surreal dog-man composite. The contact shows Erwitt's patience, shooting around an image methodically until he has all the elements synchronized for maximum effect. As he says, 'It's a lot of pictures getting to the good one.'

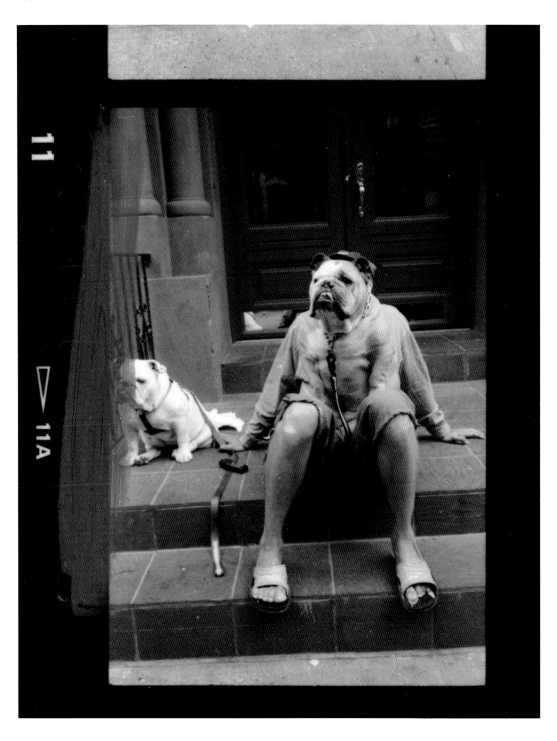

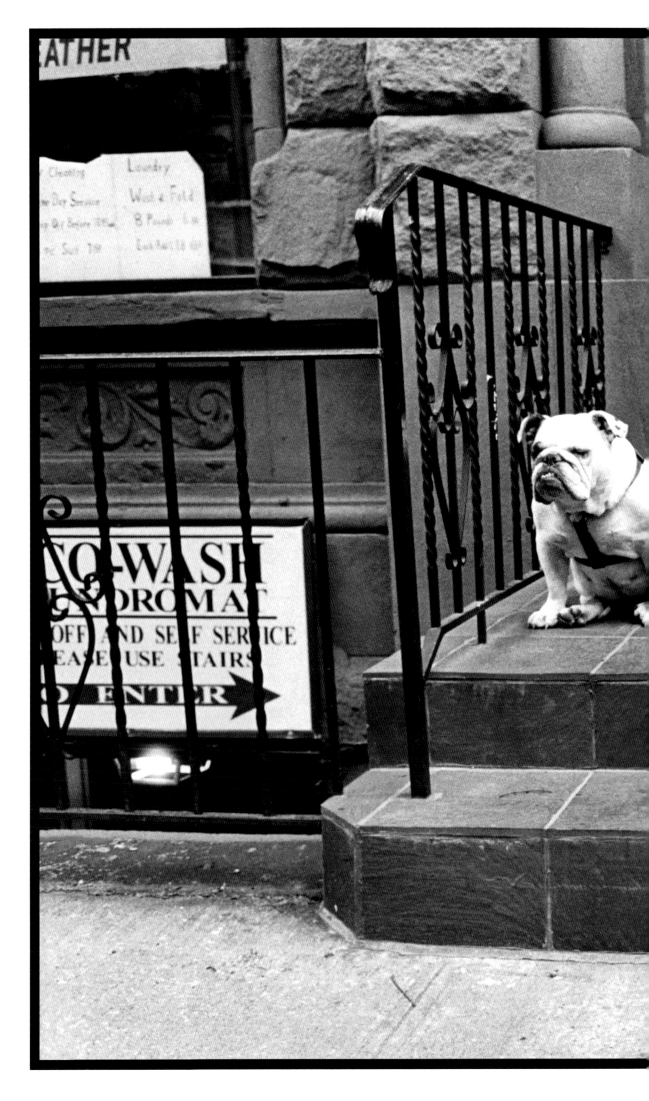

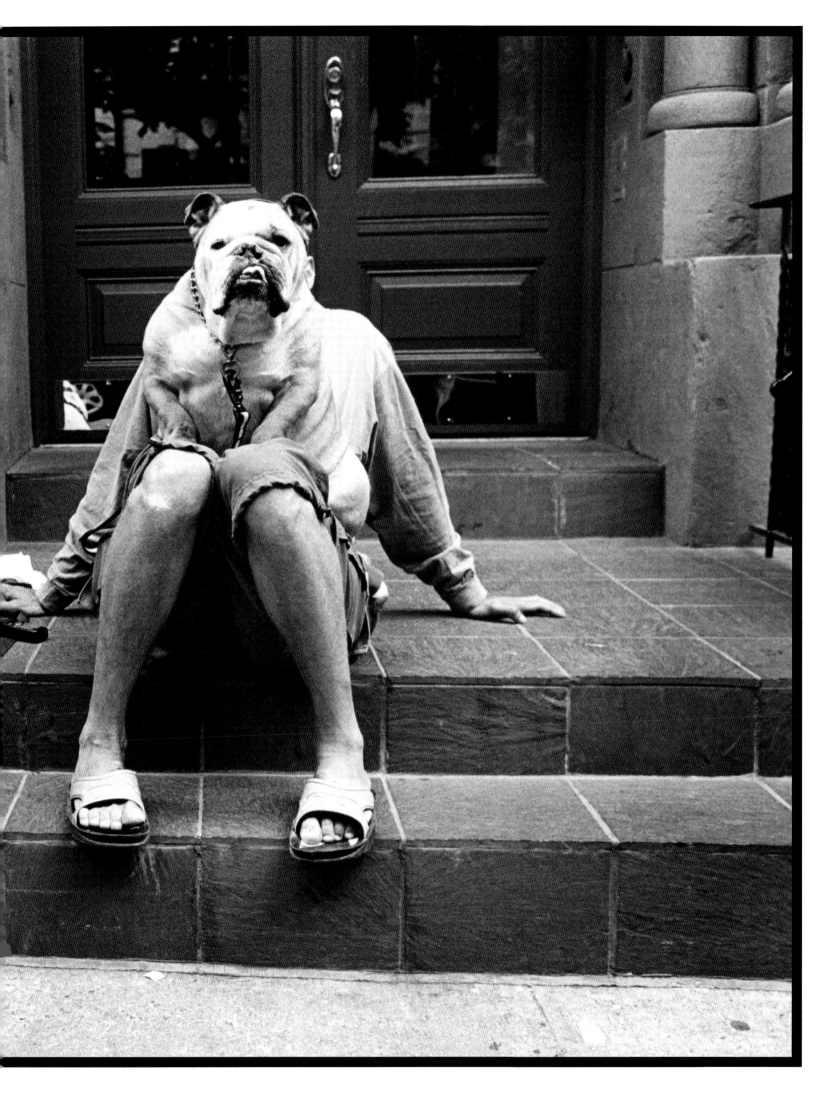

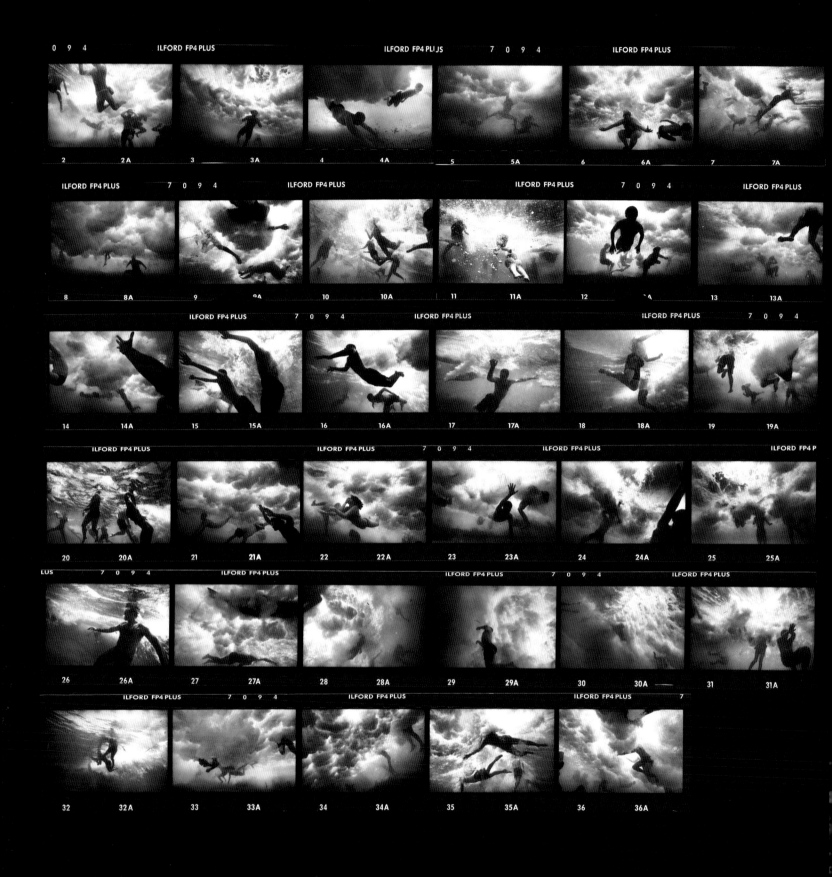

Sydney, Australia
January 2000

"For two years my partner, Narelle Autio, and I worked on a book called *The Seventh Wave*. Every weekend we would be at the mercy of the weather, hoping for hot sunny days and packed beaches. We would also rely on rainless weekdays in the lead-up, so that the water was clear. The surf would dictate the outcome of the pictures, as big gnarly surf meant that the swimming flags were posted closer together and this had the effect of positioning more people in a confined area.

During the whole two years, no one saw us photographing beneath the surface of the waves. We shot the photographs on a breath of air, swimming with one hand and battling the surf. The ocean controlled the photographs to an extent. We were also just trying to survive, like the majority of the swimmers. We never knew what we were getting, as we would hold one arm out, point and shoot. This was always the most exciting part.

Developing the negatives at the end of the day always revealed some surprises and some disappointments. This particular roll was one of the last I shot for the project. The surf at Bondi beach was huge. It was a few days after New Year's Eve, and the beach was packed with holidaymakers. The day was clear. After two years of battling the waves, this was my day."

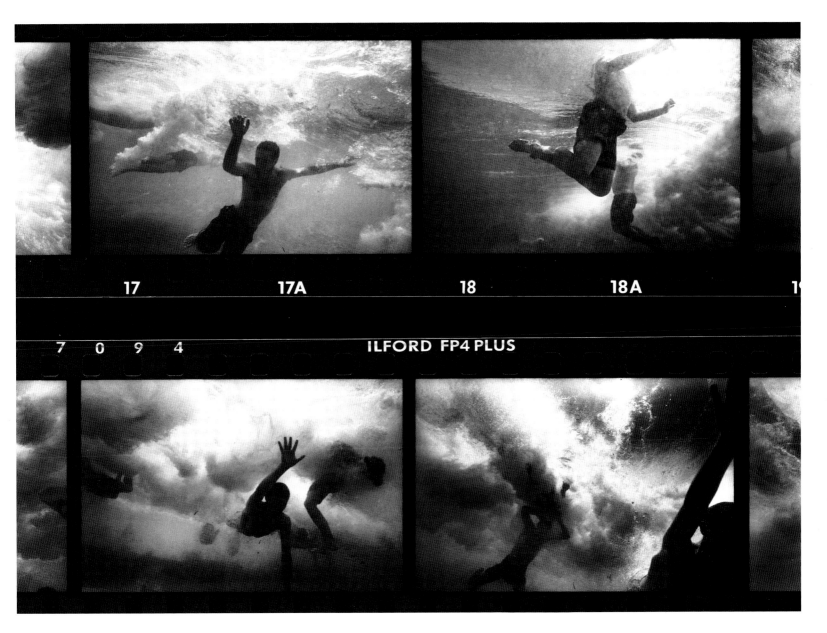

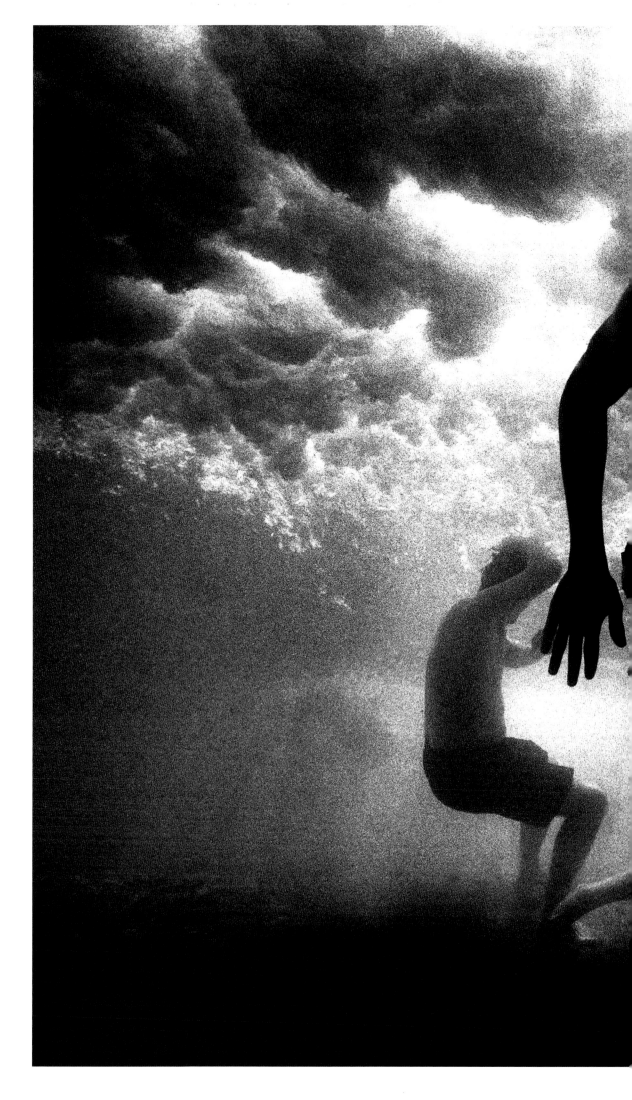

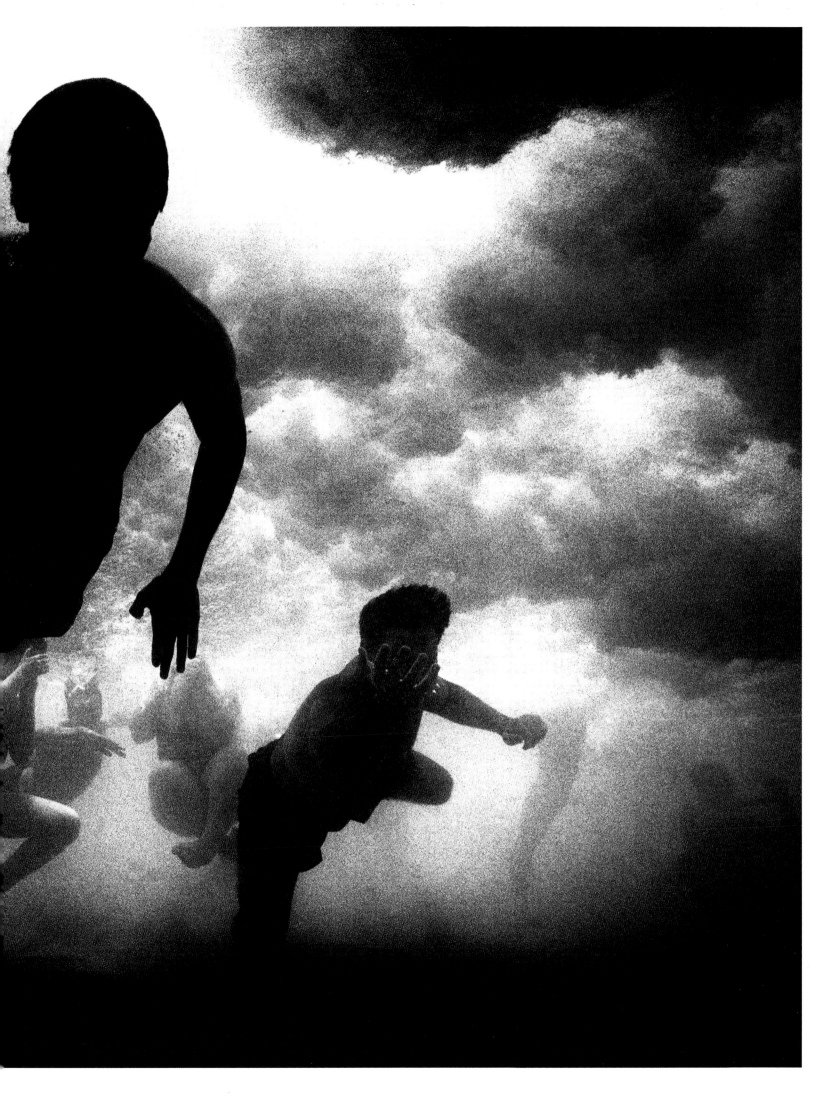

2000 PAOLO PELLEGRIN Serb Funeral

Obilić, Kosovo
2000

"The Balkans have been a site of conflict since the turn
of the twentieth century. This particular European war
was taking place only 100 kilometres from the Italian
border, a vestige of the decades of tension spilling into
violence in the late 1990s. In 1999 NATO troops had
entered Kosovo to discover mass graves, the sites of
execution by Serbian troops. The Serbs, now a minority,
were to be found in enclaves guarded by NATO forces
against revenge killings.

This story was taken in a town close to a battleground
that was historic for the Serbs (they had battled the Turks
there in the fifteenth century). I had been spending a lot
of time in Kosovo, documenting the ongoing situation.
The Serbian peasant whose funeral it was had been a
victim of a revenge killing.

In the contact sheet, you never see the body. It's
all about the faces. When I look at it, I have in mind a
painting by Brueghel. These women in black are quite
extraordinary. I spent the day with them, and it took a
long time to convince them to be photographed. As with
many conflict situations, it's often easier to work with
the victims (in this case the Albanians). Perhaps they
were more open to the opportunity to raise awareness
of their plight. The Serbs were understandably more
difficult – anti-Western and suspicious of what they saw
as a partisan press. With subjects like these, I don't want
to intrude too much. I try to respect their feelings, while
at the same time I feel it's important to document them,
so there's a tension. Each time I approach a subject like
this I have to convince myself that it is reasonable to
photograph – something that is actually getting harder
for me, the older and more exposed to these sorts of
situation I become."

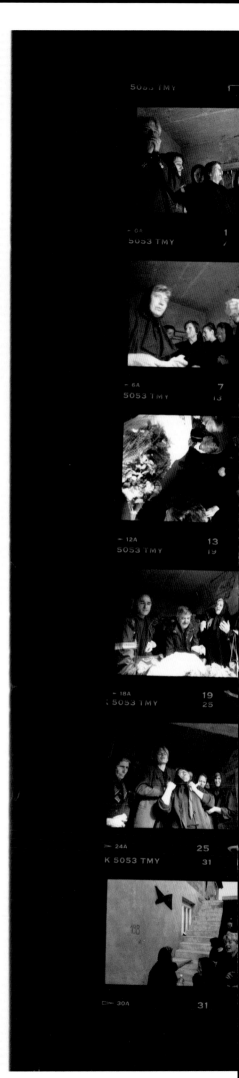

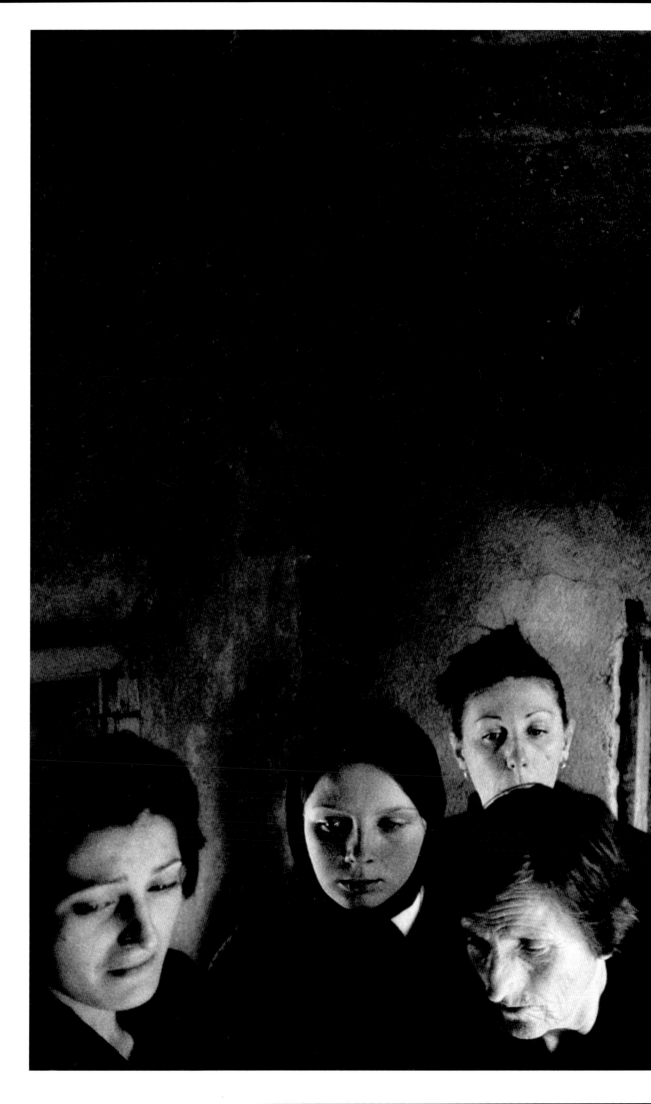

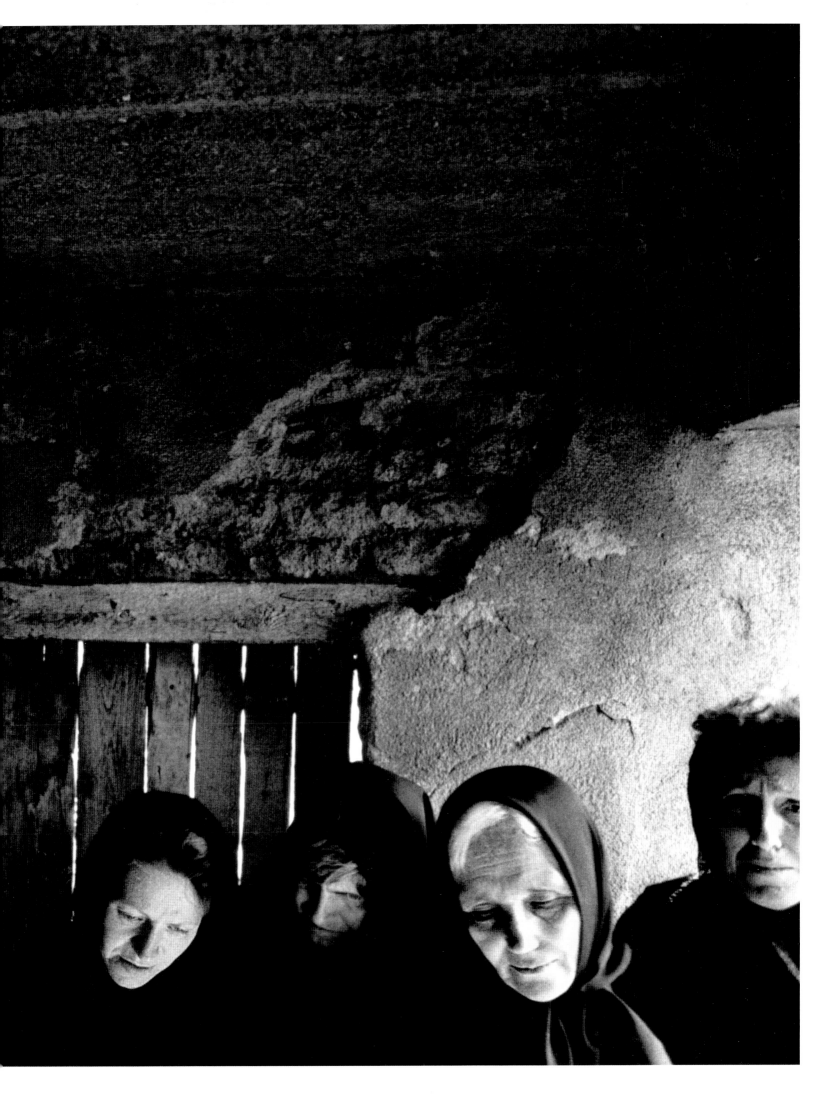

Nom

Sujet

#2A, 14A, 25A, 27A, 8

Date

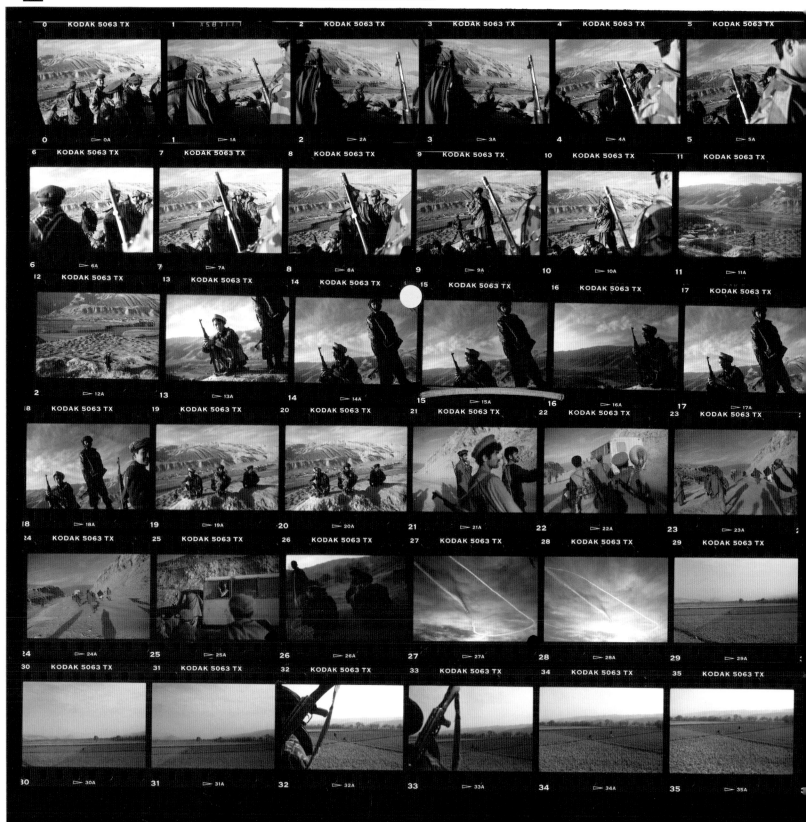

Afghanistan
Winter 2001

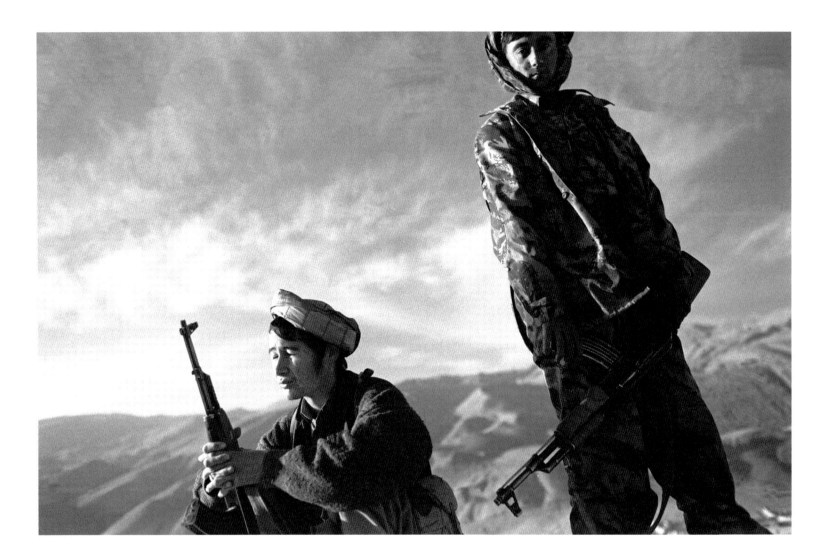

"Six days after September 11, 2001, I went to Pakistan and Afghanistan, where I spent the next four months photographing the war. I wouldn't see this contact sheet until much later. There were some decent pictures on it, but nothing that I thought was great. I made a print of 15A, which was included in my larger edit of Afghanistan material. But it was really just a quiet picture – the kind that sits in an archive, and maybe gets published now and again, but not one that I would ever pay much attention to.

A couple of years ago, I looked back at the contact sheet. Frame 27 jumped out at me. The photograph shows the contrails of an American bomber that has just dropped its payload on a Taliban position and made the arcing turn back to wherever it came from. I don't know why I didn't see this picture before: a picture of something so deadly and yet so beautiful. How far did the pilot fly that plane before pushing the button? What was his name? How many men died as he made that turn against the sunset? What were their names? Did they know the plane was coming for them, when they first saw it in the sky? I am now sure that this is the most interesting picture I will ever make of war."

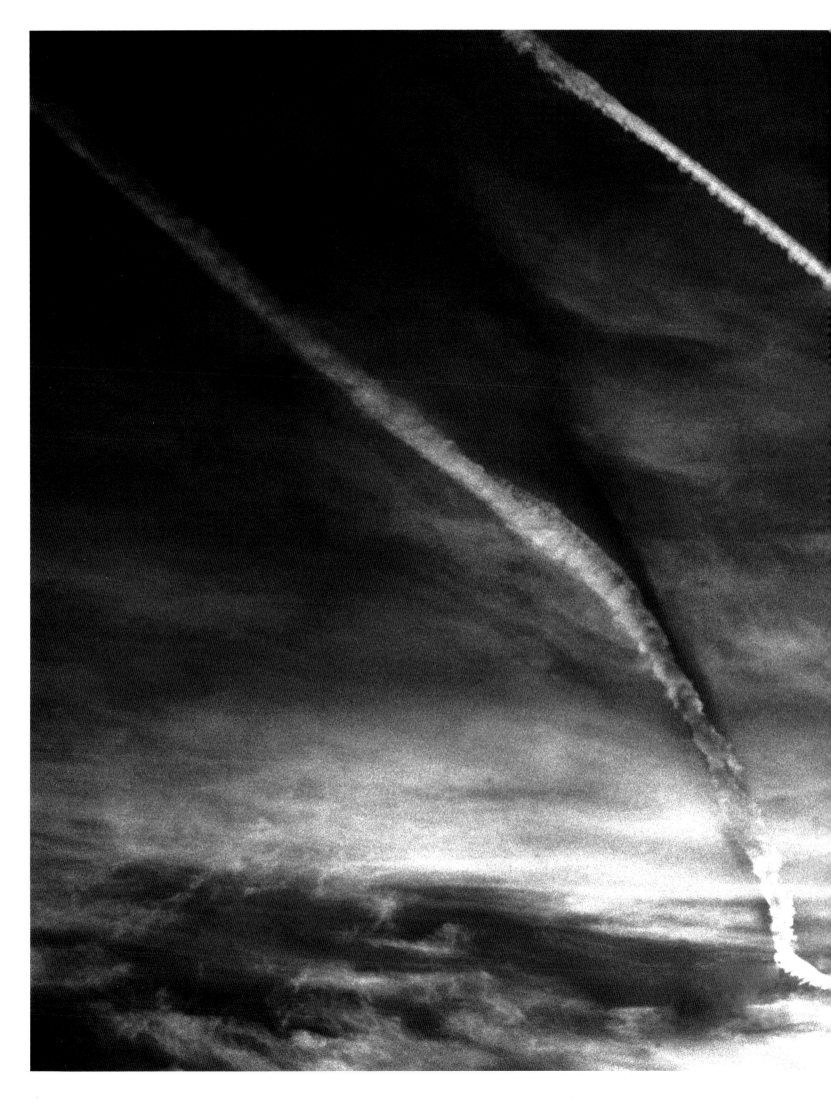

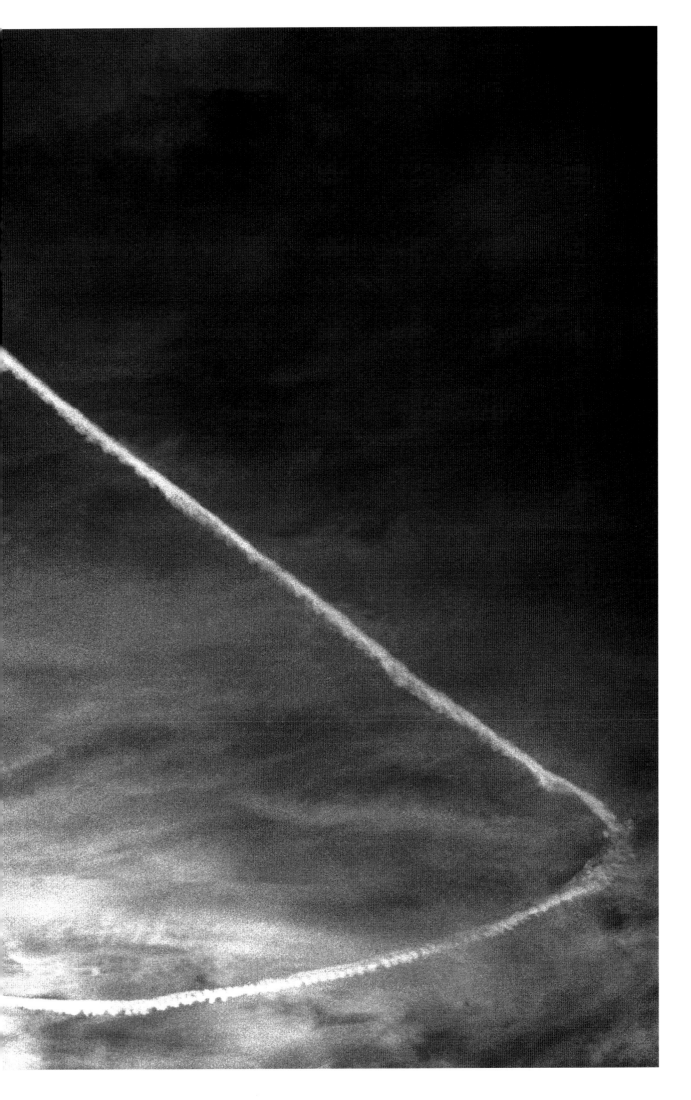

Bahia, Brazil
Spring 2001

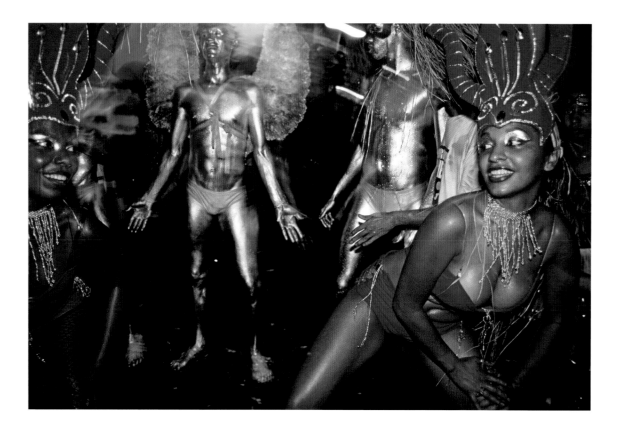

"This slide sheet comes from a long-term interest in photographing the diaspora of the Iberian peninsula. I thought I'd go to Bahia, as that is where the original slave ships went (it was sugar cane that took them there). I knew I didn't want to photograph in a linear way. The work is all based on history, even though my pictures are very contemporary. I was interested in the carnival and the African culture in Bahia. You see more African culture there than in Africa. It's an isolated spot, and you can see certain tribes and traditions that only exist there and have died out in West Africa.

This series of images was taken at night in the middle of carnival. Obviously carnival is very, very visual. It's very sexual and anything goes, as it's the last party before Lent. This particular group was one of the more popular ones in Salvador. The silver body paint and the girls in their costumes drew my attention. Most photographers were at the official carnival but I broke away from the pack and saw this smaller group, which for me was the most interesting. The silver was amazing. I have a little flash, which I put on top of my Leica, with which I was shooting on a slightly wide lens, a 35mm or 28mm. I knew that the flash would play on the black/silver skin and that it would be interesting.

My relationship with my subjects consists of the look, the history – and then there's my visceral connection. I get very involved. I feel I have to participate, to be part of a scene, in order to take a natural picture. I can take a photograph with my camera in my right hand and a cold beer in the other.

I got to Bahia on assignment for *National Geographic*, but I also had a book in mind. This picture didn't get into the magazine, as it was probably a bit racy, so it went in the book. My editing process – for colour as for black and white – is about looking for a good picture. Here, I was in the location for an hour. I stuck with the same characters: I varied it a little but I stayed with the same visual components, the two girls and two guys. I knew I got about two to four good pictures, so when I edited I looked for nuance. Usually I get the best picture right away. I won't come back in thirty years and find it, but then I'll find others."

DAVID ALAN HARVEY
BAHIA, SALVADOR
2 RVP 03/01 IR2070

DAVID ALAN HARVEY
BAHIA, SALVADOR
RVP 03/01 IR2070

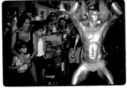

DAVID ALAN HARVEY
BAHIA, SALVADOR
RVP 03/01 IR2070

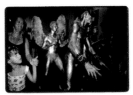

DAVID ALAN HARVEY
BAHIA, SALVADOR
RVP 03/01 IR2070

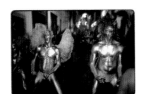

DAVID ALAN HARVEY
BAHIA, SALVADOR
2 RVP 03/01 IR2070

DAVID ALAN HARVEY
BAHIA, SALVADOR
2 RVP 03/01 IR2070

DAVID ALAN HARVEY
BAHIA, SALVADOR
RVP 03/01 IR2070

DAVID ALAN HARVEY
BAHIA, SALVADOR
RVP 03/01 IR2070

DAVID ALAN HARVEY
BAHIA, SALVADOR
2 RVP 03/01 IR2070

DAVID ALAN HARVEY
BAHIA, SALVADOR
2 RVP 03/01 IR2070

DAVID ALAN HARVEY
BAHIA, SALVADOR
RVP 03/01 IR2070

DAVID ALAN HARVEY
BAHIA, SALVADOR
RVP 03/01 IR2070

53

DAVID ALAN HARVEY
BAHIA, SALVADOR
2 RVP 03/01 IR2070

DAVID ALAN HARVEY
BAHIA, SALVADOR
3 RVP 03/01 IR2070

DAVID ALAN HARVEY
BAHIA, SALVADOR
25 RVP 03/01 IR2070

DAVID ALAN HARVEY
BAHIA, SALVADOR
RVP 03/01 IR2070

DAVID ALAN HARVEY
BAHIA, SALVADOR
66 RVP 03/01 IR2070

DAVID ALAN HARVEY
BAHIA, SALVADOR
66 RVP 03/01 IR2070

DAVID ALAN HARVEY
BAHIA, SALVADOR
66 RVP 03/01 IR2070

DAVID ALAN HARVEY
BAHIA, SALVADOR
RVP 03/01 IR2070

30 HOT2001009K007
9-11-01

© Thomas Hoepker - MAGNUM
New York Sept.11 HOT2001009K007
View from Queens towards lower
Manahattan

24

© Thomas Hoepker - MAGNUM
New York Sept.11 HOT2001009K158
View from Brooklyn towards lower Manhattan
with Brooklyn Bridge

34 HOT2001009K006
9-11-01

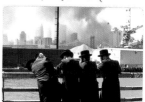

© Thomas Hoepker - MAGNUM
New York Sept.11 HOT2001009K006
View from Willamsburg/Brooklyn towards
lower Manhattan

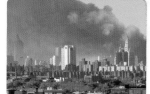

© Thomas Hoepker - MAGNUM
New York Sept.11 HOT2001009K003
View over Queens cemeteries towards lower
Manahattan

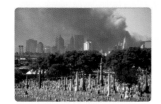

9-11-01

9-11-01

3

© Thomas Hoepker - MAGNUM
New York Sept.11 HOT2001009K122
View from Williamsburg/Brooklyn towards
lower Manhattan

© Thomas Hoepker - MAGNUM
New York Sept.11 HOT2001009K004
View from Willamsburg/Brooklyn towards
lower Manahattan

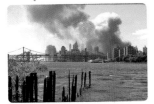

10

© Thomas Hoepker - MAGNUM
New York Sept.11 HOT2001009K151
View from Brooklyn towards lower Manhattan
with Brooklyn Bridge

police line

HOT2001 009 K008

© Thomas Hoepker - MAGNUM
New York Sept.11 HOT2001009K008
sign on FDR drive in lower Manhattan

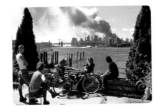

8

© Thomas Hoepker - MAGNUM
New York Sept.11 HOT2001009K131
View from Brooklyn towards lower Manhattan
with Brooklyn Bridge

© Thomas Hoepker - MAGNUM
New York Sept.11 HOT2001009K001
View from the Manhattan bridge at noontime
to Brooklyn Bridge and lower Manhattan

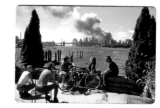

© Thomas Hoepker - MAGNUM
New York Sept.11 HOT2001009K002
View from the Mahnattan bridge at noontime
to Brooklyn Bridge and lower Manahattan

15

9-11-01

© Thomas Hoepker - MAGNUM
New York Sept.11 HOT2001009K128
View from Brooklyn towards lower Manhattan
with Brooklyn Bridge

9-11-01

© Thomas Hoepker - MAGNUM
New York Sept.11 HOT2001009K130
View from Brooklyn towards lower Manhattan
with Brooklyn Bridge

33

© Thomas Hoepker
Magnum Photos, Inc.

© Thomas Hoepker - MAGNUM
New York Sept.11 HOT2001009K043
Writing and mementos on Union Square,
sponteneaous memorial site

©Thomas Hoepker
Magnum Photos, Inc. 96

© Thomas Hoepker - MAGNUM
New York Sept.11 HOT2001009K096
Memorial to Father Judge at firehouse on
West 31 Street

TO REPORT A FIRE
DIAL 911

11

©Thomas Hoepker
Magnum Photos, Inc.

© Thomas Hoepker - MAGNUM
New York Sept.11 HOT2001009K069
Flags, banners and billboards on Times
Square

35

Q00010779

© Thomas Hoepker / Magnum
HOT2001009 K075
USA. NYC. World Trade Center

the victims...

attack
27/

HOT2001009K064

© Thomas Hoepker - MAGNUM
New York Sept.11 HOT2001009K064
People with images of missing family at 26
Street Armory

2

© Thomas Hoepker
Magnum Photos, Inc.

© Thomas Hoepker - MAGNUM
New York Sept.11 HOT2001009K051
Writing and mementos on Union Square,
sponteneaous memorial site

New York, USA
September 2001

"On the morning of 11 September 2001, a call from the Magnum office alerted me to the World Trade Center attacks. Horrified and paralyzed, I watched TV in my Manhattan apartment. Finally, I made up my mind to get in the car. Driving through Queens and Brooklyn, I took some pictures of the plume of smoke on the horizon, behind a cemetery. Eventually I came to a spot on the East River with a good view of lower Manhattan and a group of young people sitting between trees. I snapped three images, instinctively, then drove on and forgot about the scene. Later, still in a daze, I walked across the Manhattan Bridge, getting some shots of the smoke-filled sky, but I never made it to Ground Zero: the police had cordoned off the area.

The next day I went to the office and saw all the great, shocking, touching pictures my Magnum friends had taken, close to the rubble and the fires. I felt I had done a pretty bad job in comparison. I chose some of my images, taken from the bridge, but dropped the slides of the five relaxed-looking people into my 'B-edit' box. There they stayed for over three years.

In 2005, I began work on a retrospective exhibition and a book, together with Ulrich Pohlmann, curator of the Foto-Museum in my home town, Munich. He looked in my B-boxes and unearthed the colour slide that has now become my most published and most discussed picture. Strangely, its popularity contradicts the famous adage of Robert Capa, one of Magnum's founders, who preached: 'If your pictures aren't good enough, you aren't close enough.'

Commentators, writers and bloggers have asked whether the group in the photograph really knew what had happened behind their backs. Why do they look so relaxed? The slides in my archive prove that in the first frame they had actually watched the event across the river, before turning around and discussing the catastrophe. So does the image tell a lie? Maybe it is deceiving, but for many it has become the ultimate symbol of a peaceful world, which is suddenly shattered by a horrific act of terrorism, on a sunny day that changed the world."

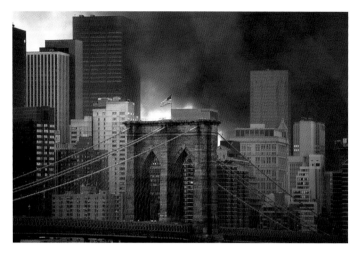

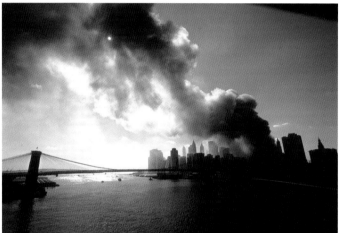

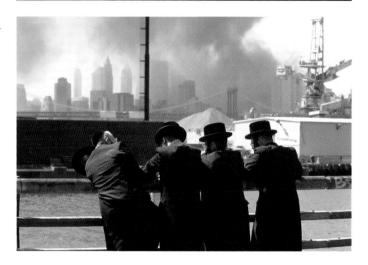

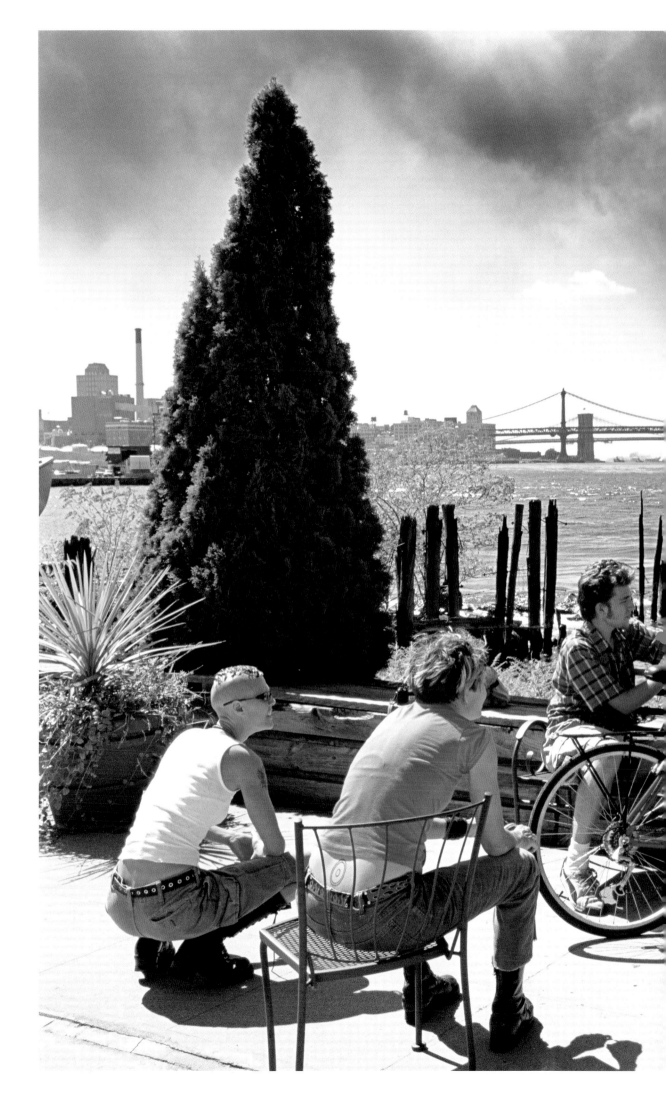

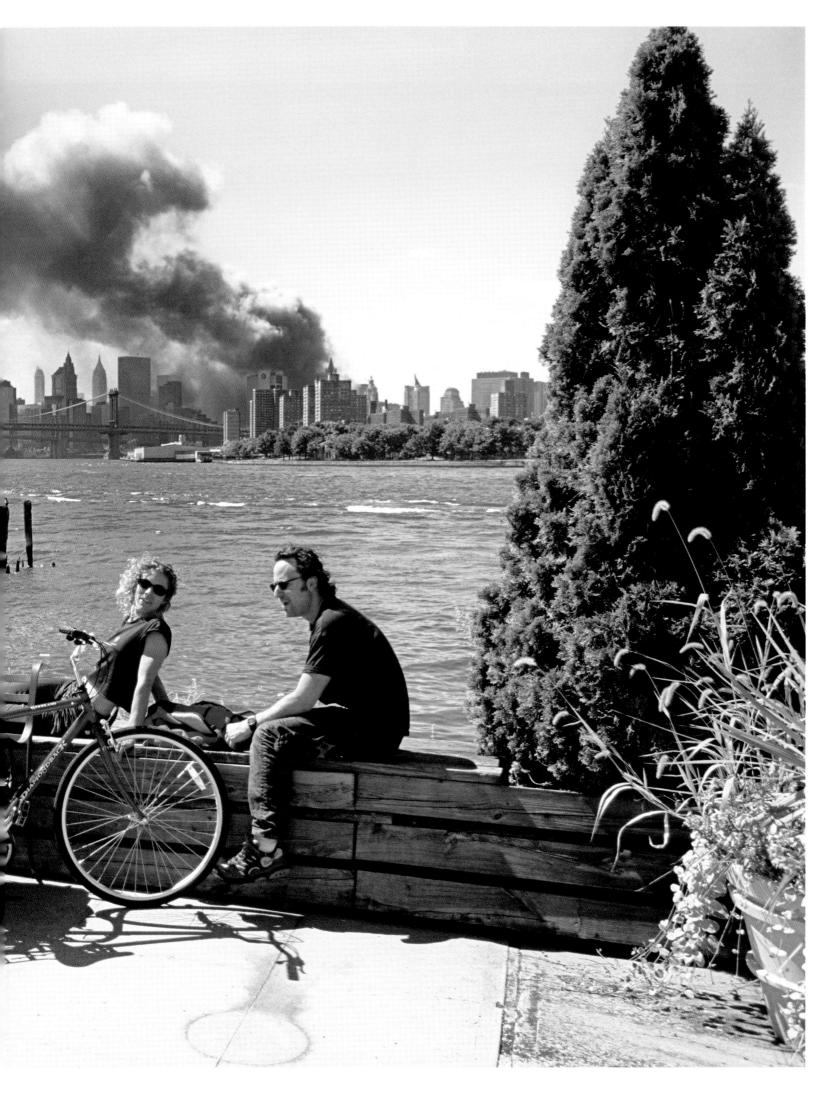

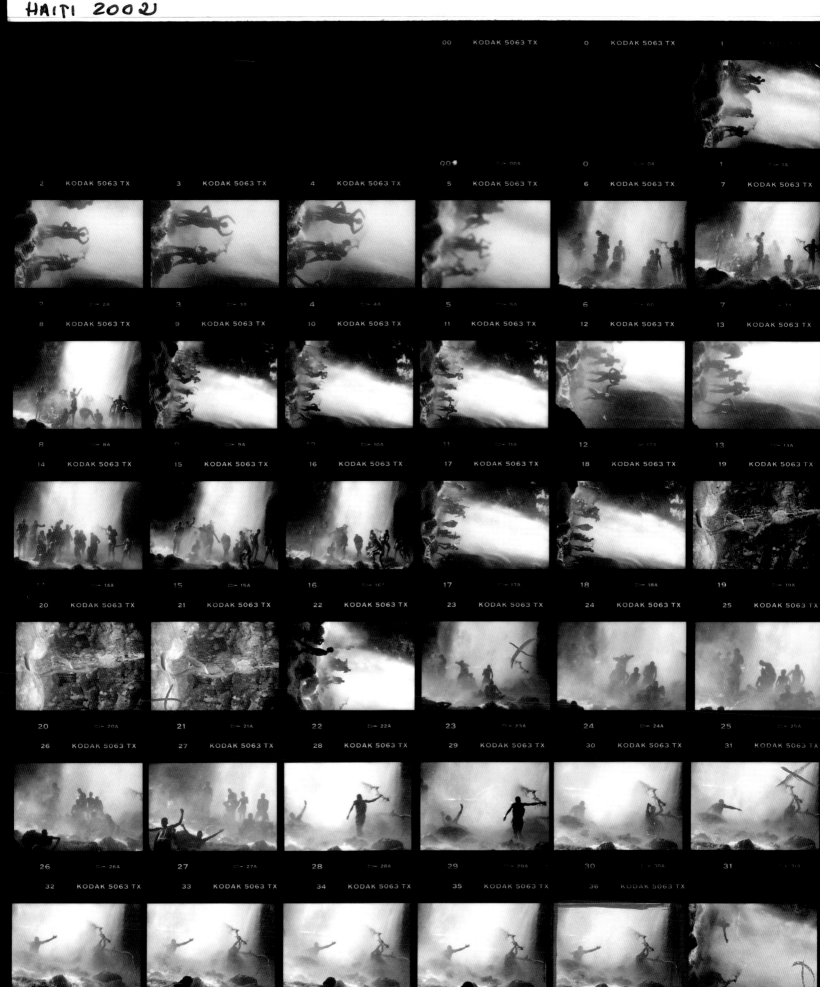

Mirebalais, Haiti
July 2002

"On the feast day of Our Lady of Mount Carmel, tens of thousands of pilgrims make their way to the town of Mirebalais in the central plateau, in order to commemorate the apparition of the Virgin Mary in a palm tree at the foot of the waterfall, where voodoo gods are said to reside. In 1849, when Faustin Soulouque, the president of Haiti, was crowned emperor, a church was built on the site in honour of the Virgin, celebrating her appearance at the waterfall, but also venerating Lwa Ezili Fréda and Lwa Dambala-Wedo, water-dwelling voodoo gods with the power to grant material wealth to their followers. The pilgrims gather at the waterfall – locus of mystical forces and a symbol of inexhaustible life – to pray for love, marriage, children and the cure of illnesses, offering candles and oblations, and praying for an end to suffering and ill fortune.

I went to Saut d'Eau on several occasions because I was interested in anything to do with water, particularly the rituals of cleansing and purification. Saut d'Eau is a magical place, full of power and hope, where people cleanse their naked bodies with aromatic herbs. The mountain opens up and the water falls from a great height to rush down over the stones. At its highest point, it falls with such force that it can bring trees down. In the face of the torrent pounding over their bodies, people cry out, pray or sing and try to remain upright, withstanding the pressure. Some go into a trance and are helped so that they don't hurt themselves.

I have tried to photograph everything that happens, not only in the waterfall but also in the town, the church, the market, on the streets, in the places where animals were once sacrificed, but there is no doubt that the highest point of the waterfall is where the power of the water is most impressive. Here people go, on their own or in groups, to receive a 'bath of luck', and their cries and chants can be heard as the water comes into contact with their bodies, especially when musicians enter the sacred space and everyone spontaneously dances and raises their arms to the sound of trumpets. Some do it perched on impossibly high, tiny rocks. A whole mass of people moving in unison, from one side to the other, with a contagious desire to enjoy the experience."

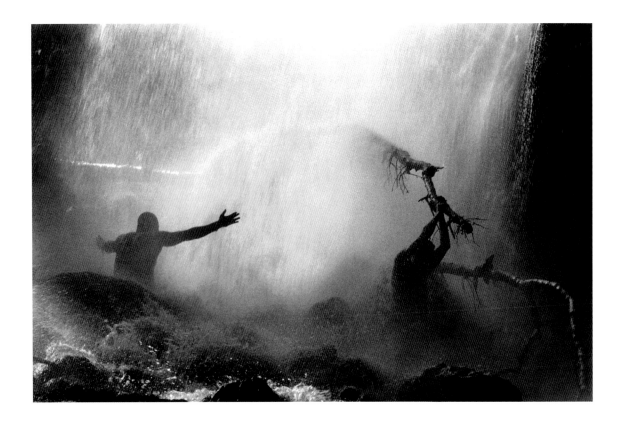

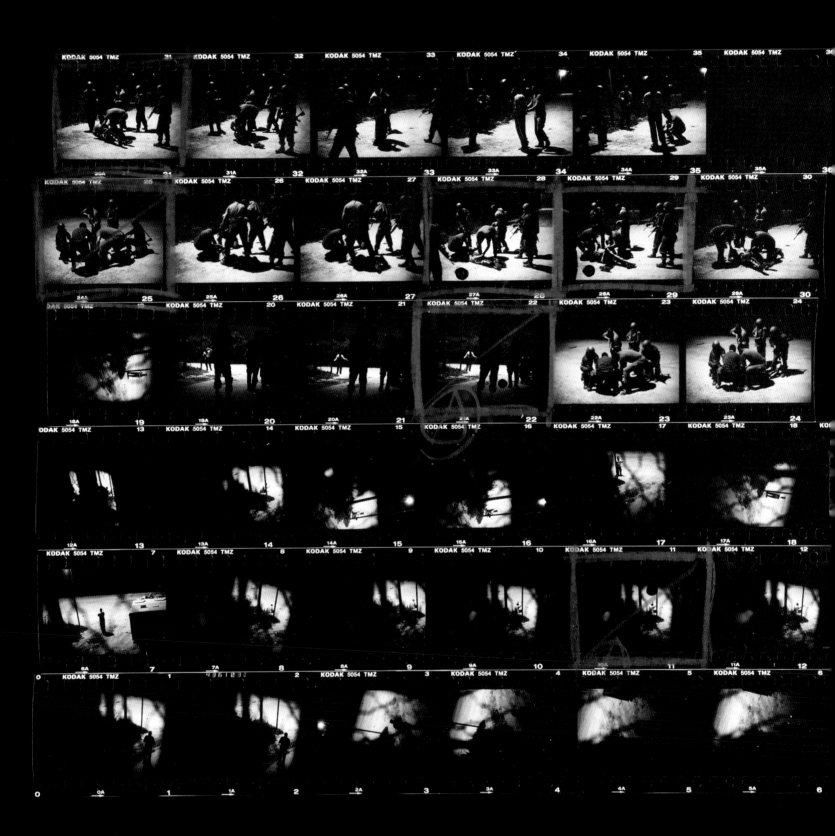

Palestine
2002

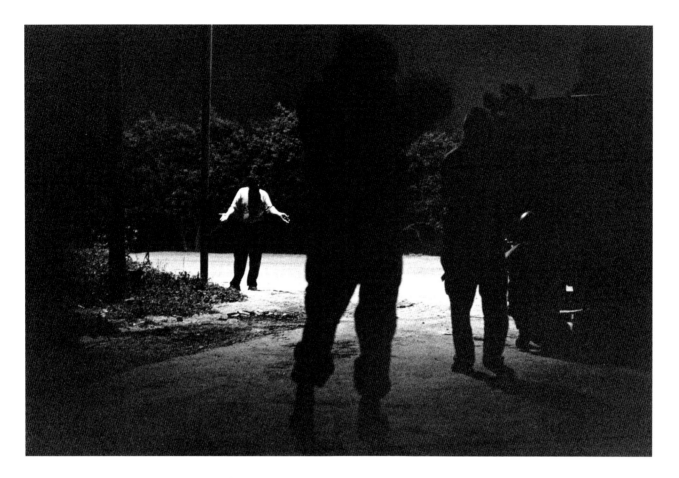

"I had travelled to Israel and Palestine a couple of times
during the 1990s, then in 2002 I was assigned by the
New York Times magazine to work on a story with the
writer Scott Anderson. It was the beginning of the
second Intifada, and we were commissioned to spend
some time with a special unit of the Israeli army, running
operations in the West Bank. This story was the start
of a long relationship with Israel and Palestine. Every
year I've been back two or three times, and over the
last ten years it has become the place where I've spent
the most time and have felt the most politically and
emotionally engaged.

This sheet is significant because it's an example of
how the photographer's presence might have changed
the course of the story. I try as much as possible to limit
my effect as an 'agent of modification'. However, in this
instance, I'm pretty sure that the presence of both myself
and my colleague prevented the death of the Palestinian.
He had approached us, gesturing wildly and shouting,
and did not respond to the Israelis' commands to stop
and turn back. He was eventually roughed up and arrested,
but he wasn't shot, as the commander of the Israeli
group we were with told me later was according to
their rules of engagement."

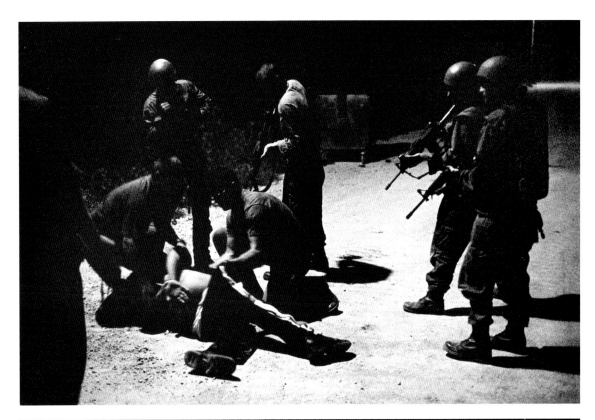

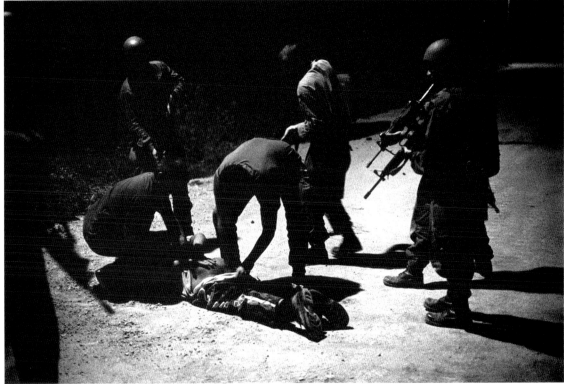

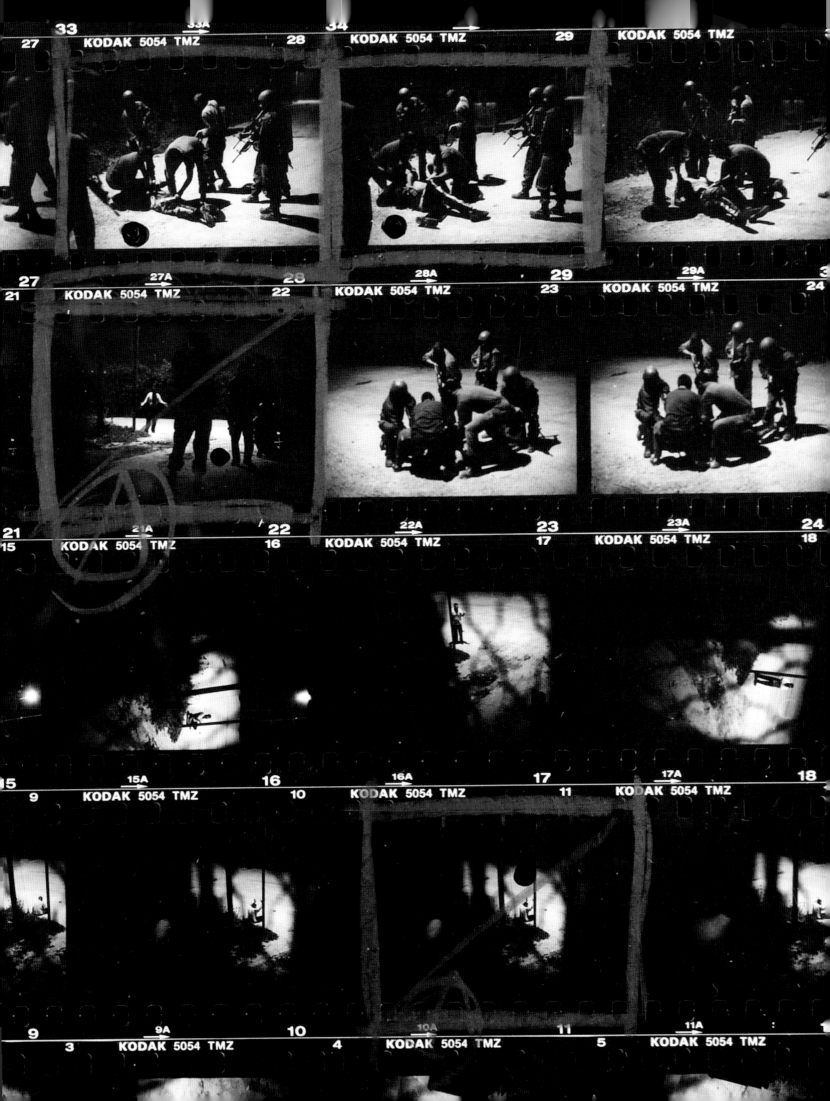

Davenport, Iowa, USA
2002

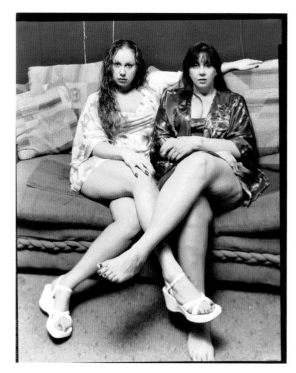

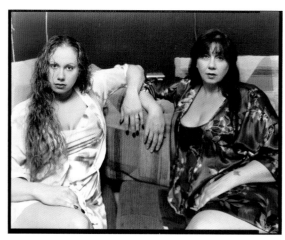

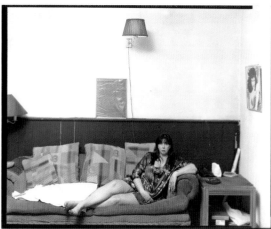

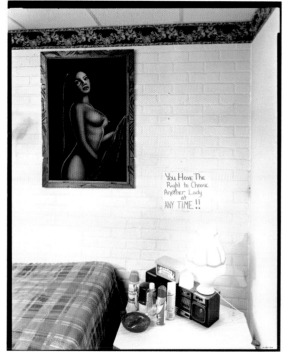

"I was working on *Sleeping by the Mississippi* – a project along the entire Mississippi River. While I was in Davenport, Iowa, I saw a building that clearly looked like a brothel. I was just curious. I got up my nerve and went inside. A little old lady worked the front desk. I told her that I was a photographer and that I would pay to take pictures. She said, 'No need to pay. It's good advertising.' I spent hours there. I photographed the various rooms. I photographed several clients. And I photographed a variety of women, including this mother and daughter.

I was working with an 8×10-inch view camera, which is a slow process and also expensive, so I wouldn't shoot much. But when something was really juicy, I'd take a few more exposures. It's impossible to explain why I chose the final frame. It's like asking a painter, why did

you choose that stroke? It just felt right. It's incredible how subtle and intuitive these decisions can be.

The portrait turned out to be one of the key pictures in *Sleeping by the Mississippi*, and it's been exhibited around the world. There's a toughness and a vulnerability to it. A couple of years ago a newspaper in Iowa contacted me. They wanted to meet and interview the women, but I didn't give him their information. I once sent them a copy of the picture, but I have no idea what they thought of it. I don't know if they even know about the book.

When I was working on the project, I used to have the models write down their 'dream' on a sheet of paper. The mother didn't do it: 'I'm too old for dreams,' she said. But the daughter did write on the sheet. She said her dream was to be a registered nurse."

OPPOSITE Finished 8x10-inch negative contact print with notes (negative number and information for darkroom printing).

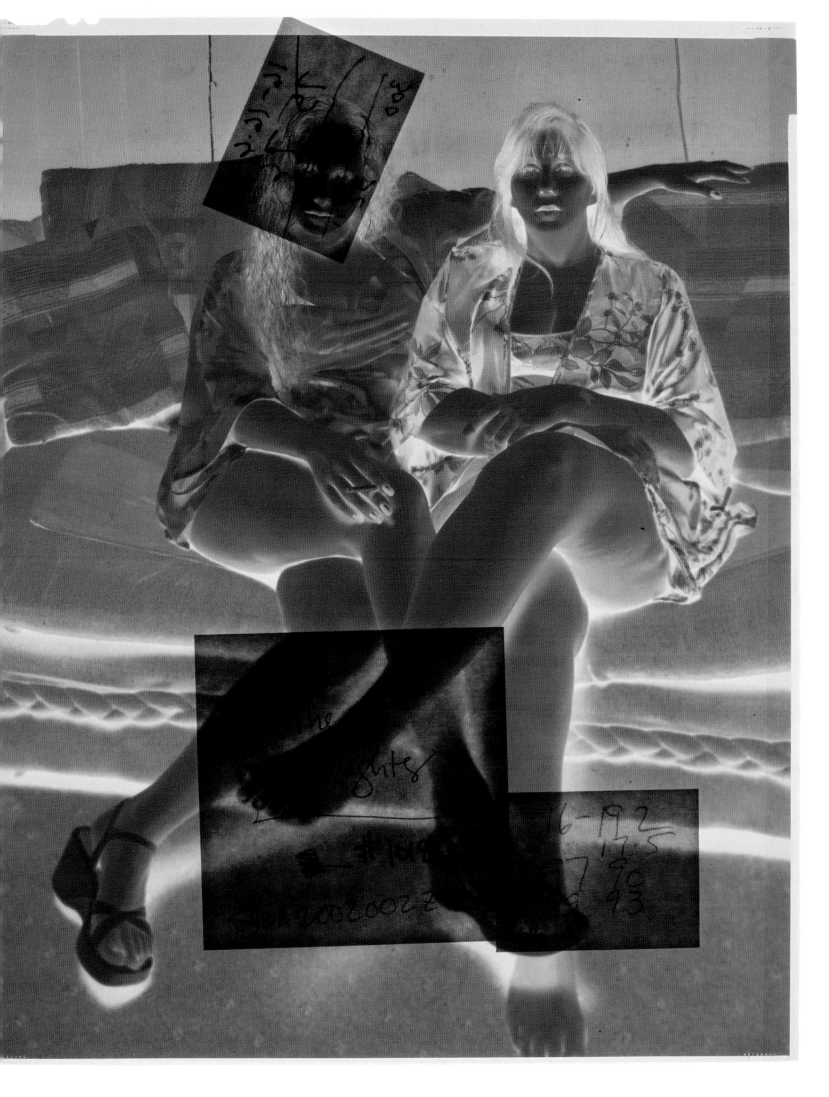

Fronts ↗

County Down, Northern Ireland
2002

"This contact sheet is from the very first shoot I did at the Maze Prison in Northern Ireland in 2002. The Maze was notorious for housing republican and loyalist paramilitary prisoners during the Troubles, and had a violent history of protests, hunger strikes and escapes. I was granted exclusive and unlimited access to the site so that I could systematically document its decommission and demolition. Between 2002 and 2003 I spent almost a hundred days inside the prison. At the time I hadn't used a 5×4-inch camera for some years. The camera I used – an old MPP – was one I'd bought for cheap as a teenager in a bomb-damage sale in Belfast. It was funny to bring this old machine into the prison where the person or people who made the bomb that enabled me to buy the camera cheap must have spent their time.

In fact, this is one of the last contact sheets I ever had done, maybe actually the last, for after this specific shoot I had all my negatives digitally scanned and never returned to contacts again. As a young photographer, I could never afford contact sheets, so did all my editing just looking at the negative in daylight. When, a little later, I could afford contact sheets, I loved them. I loved spending hours studying them and drawing on them with chinagraph pencil, and finally cutting them up. This contact sheet is one of the few I did not cut up … which means I didn't think much of the photographs."

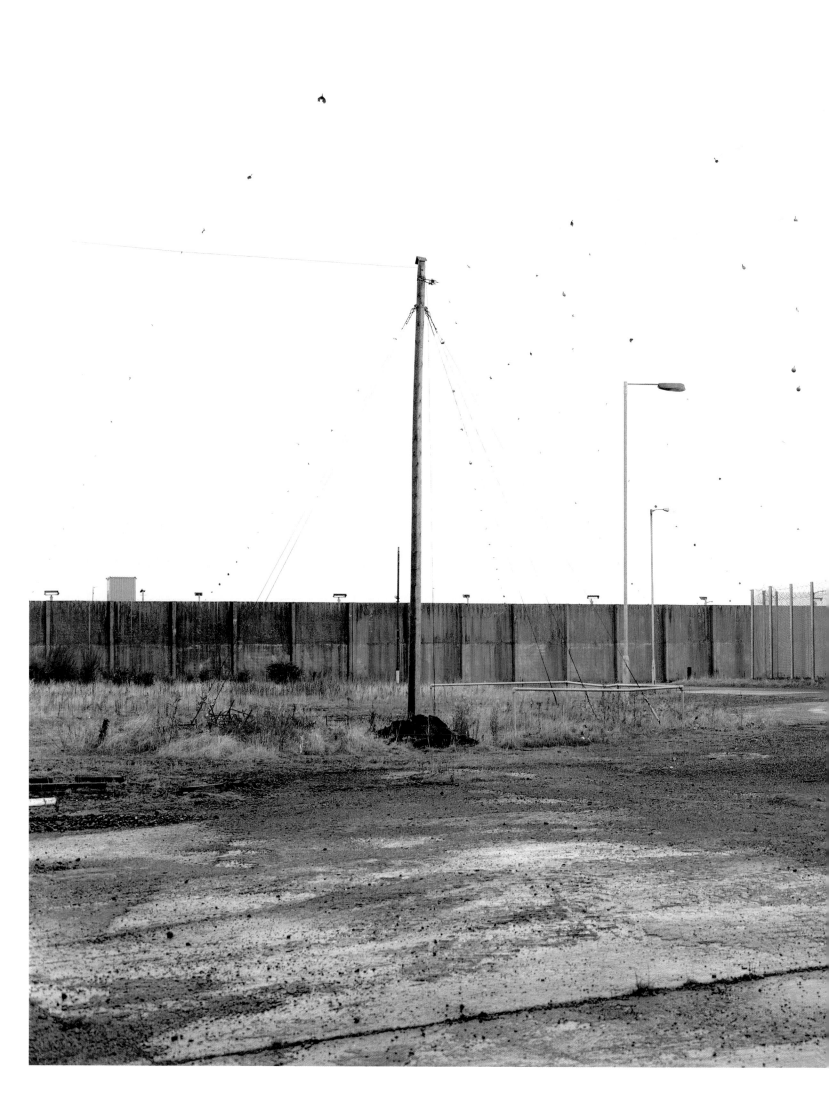

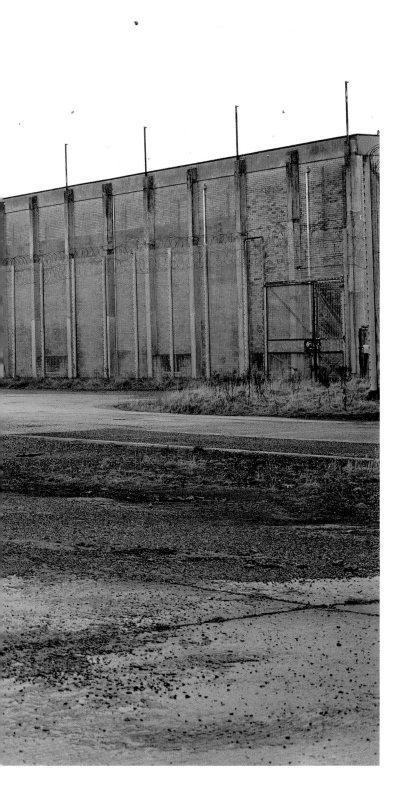

Abu Dis, Palestine
2003

"This sheet is part of a much bigger story encompassing my long relationship with Israel and Palestine (see pp. 480–83). The narrative here is about the time before the separation wall. Once the wall was approved, the Israelis traced a line and started putting preliminary forms of separation in place. This one divided a location in East Jerusalem, which had been occupied since 1967 and separated from the rest of the West Bank. It's a town called Abu Dis – a busy place, with lots of activity. The preliminary wall was made of blocks three metres high, which meant that people – albeit with great difficulty – could find ways to go across it. In this sheet we're looking at young men jumping over the wall, but often one would see elderly people going over, helped by others. The wall really disrupted the life of the neighbourhood.

I used to go to this location quite a lot at different times of the day – early morning or, in this case, late in the day – to document the difficulties imposed on the population (it felt to me like a manifestation of a kind of collective punishment). In place of the preliminary wall, there is now an 8-metre monster, with military roads running alongside it and watchtowers.

I don't shoot that much in panoramic, but I'm interested in landscape and the relationship between men and landscape. I feel that in a way this defines the character of a people. I often try to introduce an idea of the environment in my work: in this case, it's a manmade landscape – the wall.

I try to work as lightly as possible. I think it's the same for most documentary photographers: there's a constant search to travel light and be unobtrusive. For many years I had a Leica. Now with digital it's a little different, as cameras are unfortunately bigger. At the time of this shoot, I'd probably have been there with a 35mm body and a couple of different lenses in my pocket.

The other 50% of the shoot is the editing process, where you look for an aesthetic quality and perhaps a sense of narrative. It's a complex process in which many things come together. Here in this contact sheet the information is on one surface, and the process is about how these shapes and silhouettes are positioned in the frame. It's purely aesthetic."

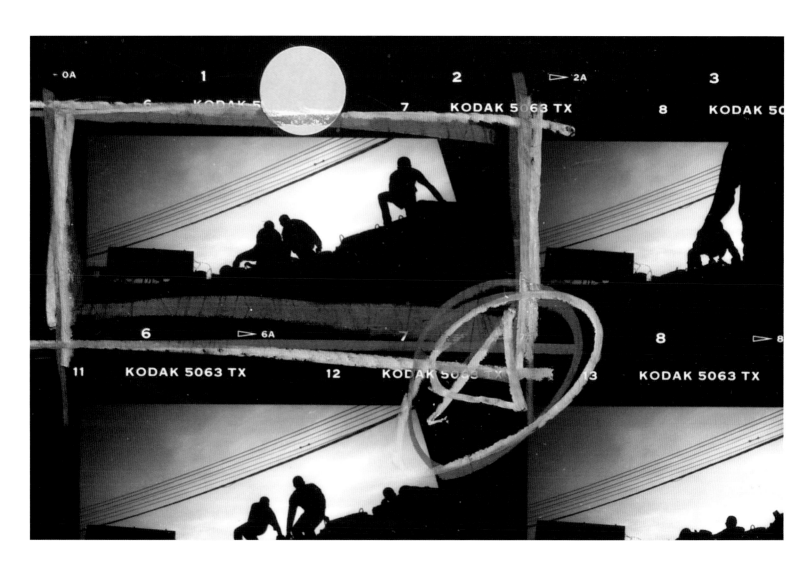

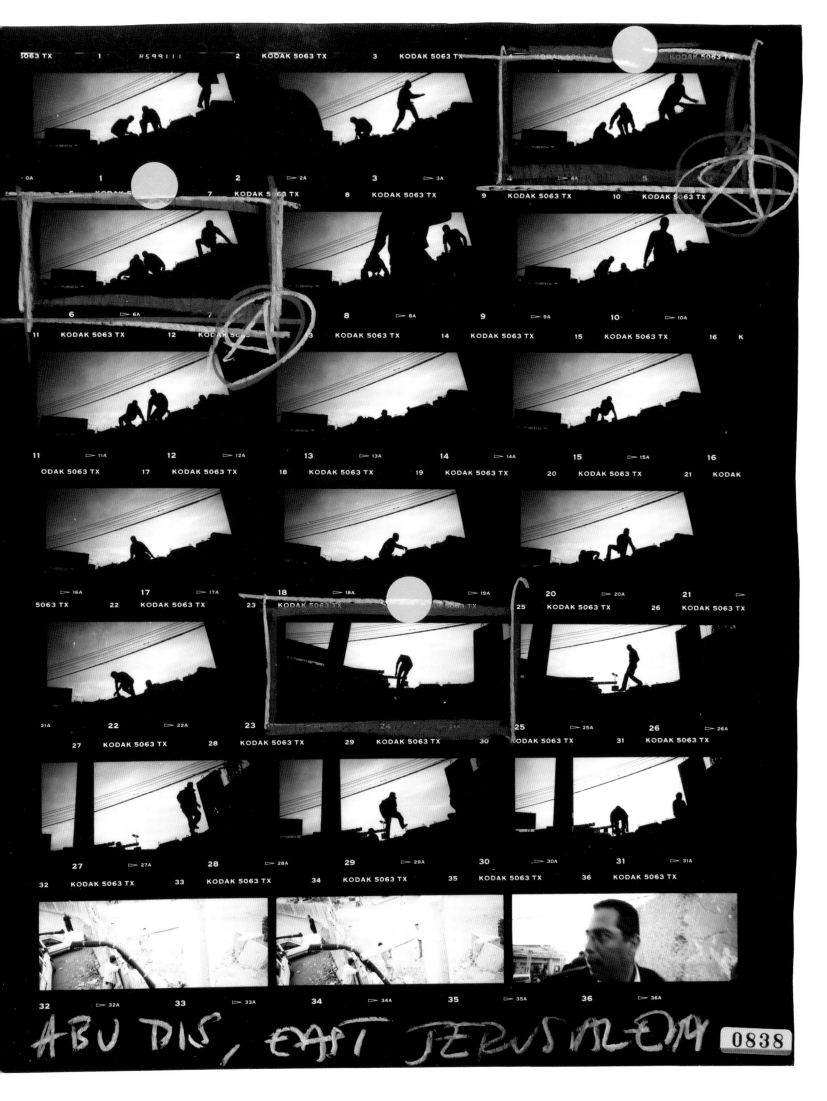

ABU DIS, EAST JERUSALEM

0838

New South Wales, Australia
October 2004

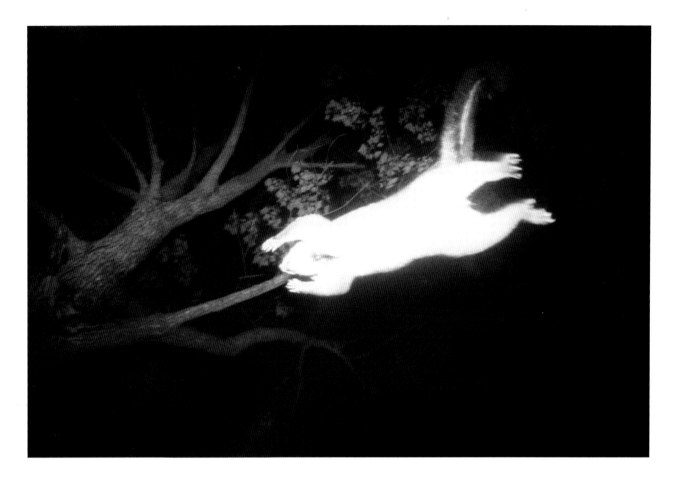

"When my partner Narelle and I returned from our trip around Australia working on our *Minutes to Midnight* project, we stayed at my parents' place in Newcastle. Narelle was seven and a half months pregnant and was having trouble sleeping at night. Our first unborn son, Jem, was (and still is) constantly doing somersaults.

Every night the resident possum would jump onto the tin roof of the deck and bang its way along until it reached the other side. Between Narelle and the possum, I couldn't sleep. I knew I couldn't stop the possum (Dad had tried), so I decided to photograph it. The possum would always run along the same path on the roof before jumping to the nearest tree, and then to the bird-seed feeder in the backyard. I photographed it once a night for the last month of the pregnancy. Sitting in the dark of the deck, I would wait for the possum to arrive. Sometimes it was just after lights out. Other times it was well into the

early hours of the morning (one night I even sat up on the roof). One thing was for certain: the possum always came. On one occasion it miscalculated the jump and landed squarely on my face (maybe it calculated the jump perfectly). We both wrestled in the backyard for a second, before scurrying off in different directions.

I bulkloaded all my film. For some reason the numbers on the roll are very faint and, once printed, they disappear because I overexpose. The possum was eventually printed as a large lightbox in the *Minutes to Midnight* installation and hung directly overhead in the blackness above the show, jumping above the crowd.

Years later, Dad cut down the tree near the roof, but the possum still found a way. It ended up walking the tightrope along the telephone wire that joined the telegraph pole with the house. To this day he still lands on the roof with a thundering clap."

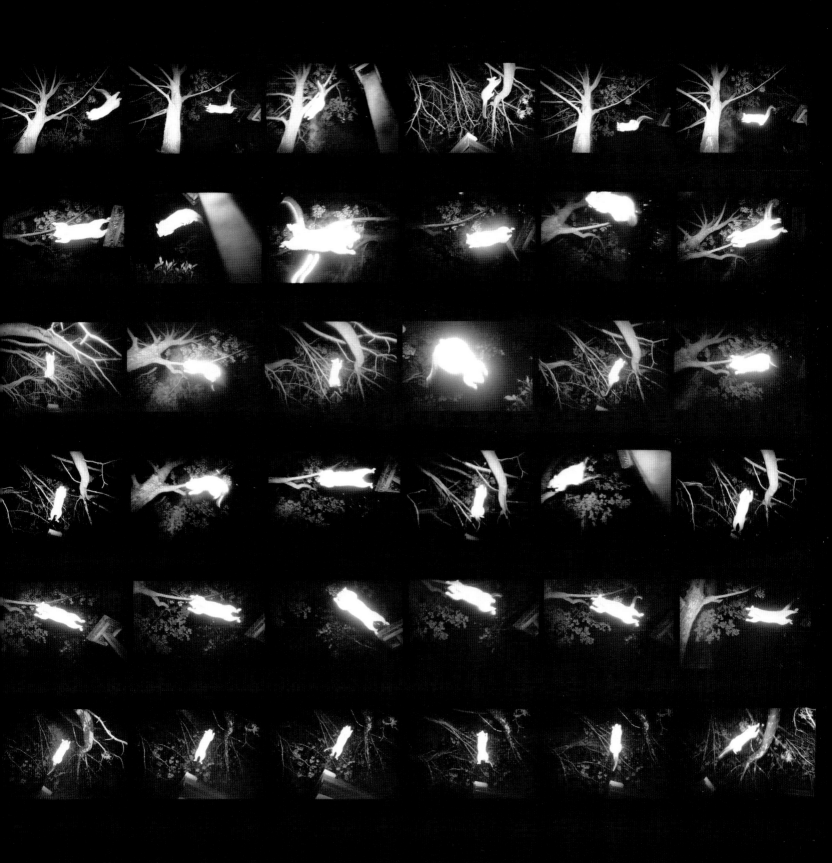

Kaboul - Sept ABA 2005012W00024

U.S GI's on patrol around King Nader' tomb, on a hill
which dominates city

Kabul, Afghanistan
September 2005

"In 2005 I went back to Kabul. The US army authorized me to accompany some of its troops on a dawn patrol of the capital. Five big guys from Mississippi and I piled into one of their two Humvees. They were decent men, but after two hours in their company I'd seen enough to know that President Bush and the neo-conservatives may have been pursuing a worthwhile goal in seeking to bring democracy to this part of the world, but America was not the best country to do the job.

The only point of contact these soldiers had with the Afghans was through their interpreters, and they lived in what can only be described as a bunker. The result was that they knew absolutely nothing about the local culture. Negotiating the Kabul traffic, they behaved like total idiots – hurtling around, ignoring the lights, driving down one-way streets and abusing the other drivers. They may have been crassly insensitive towards a nation they'd come to liberate and to help, but there was one attenuating factor: the knowledge that in Iraq their convoys were being attacked on a daily basis, and that their routes were the target for remote-controlled bombs and suicide missions.

We went up one of the hills that overlooks the city. It was scattered with tombs, some old, like the tomb of Nader Shah, and others more recent. Which invisible enemy is this lone US soldier standing guard against?

Are the ruins that surround him historical, or was this destruction caused by more recent conflict between rival factions, fighting over the city after the departure of the Soviet forces? Is the valley enveloped in morning mist, or are those clouds of dust from a bombardment?

When I look at the contact sheet, I'm surprised to see that I've only taken one shot of this scene. Nonetheless – could we call it happy coincidence? – it's a good summary of the US intervention in Afghanistan."

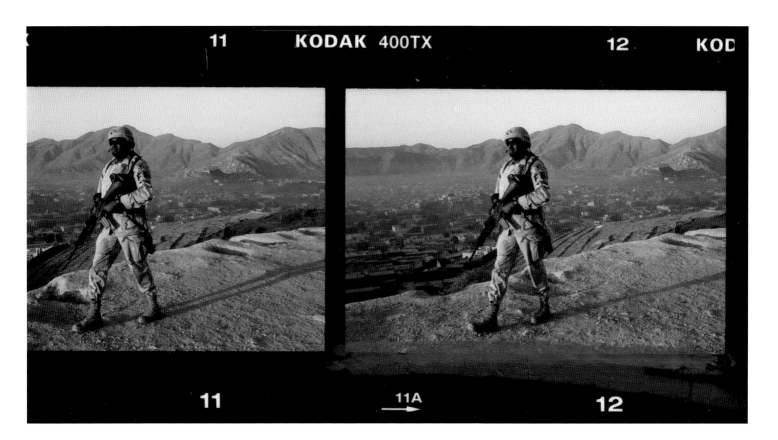

TOP Spread from Abbas's notebook.

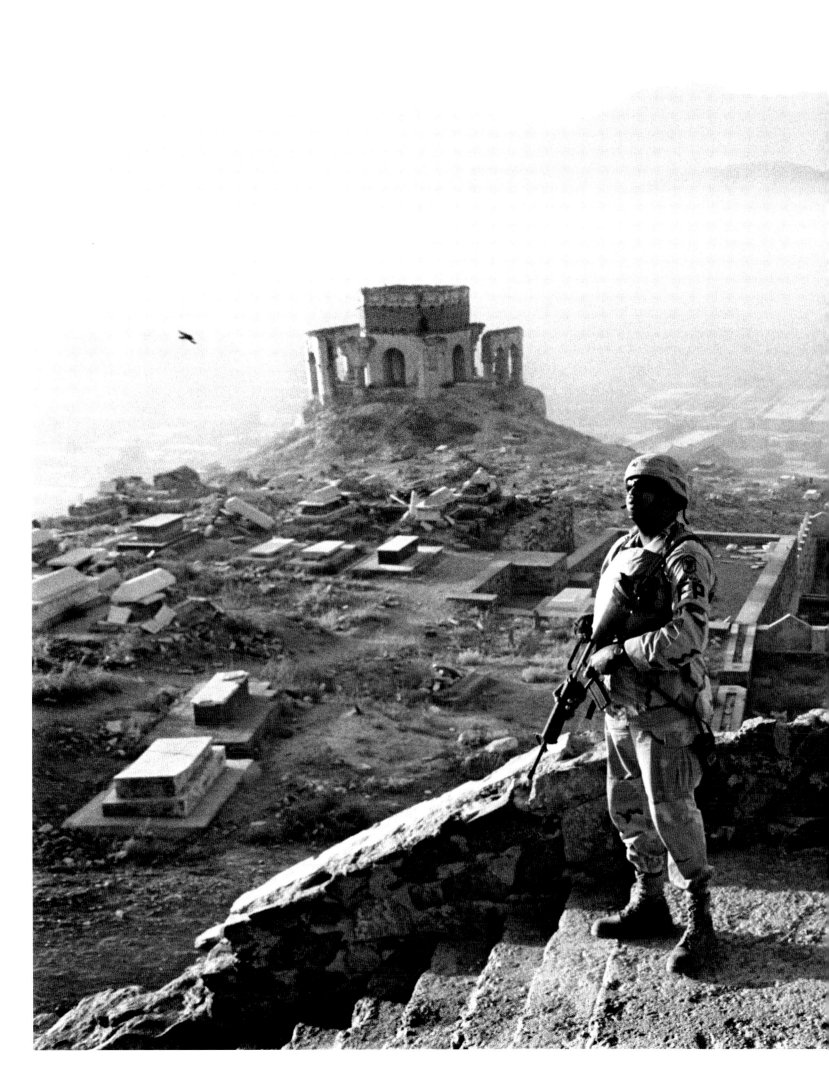

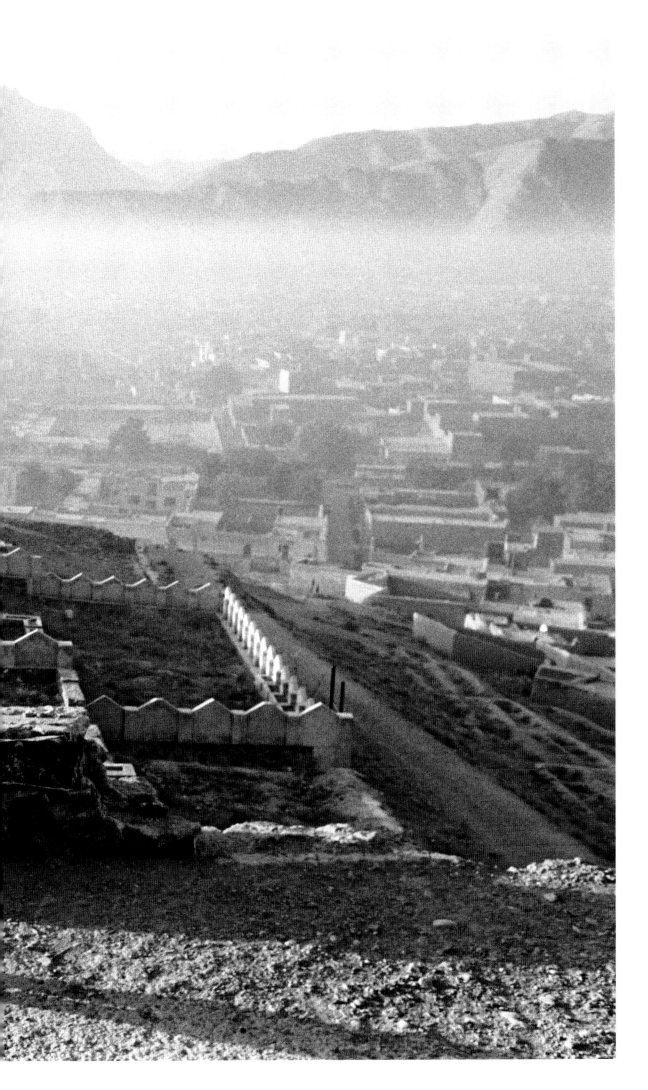

685

686

687

688

Warsaw, Poland
February 2005

"I had begun to work in Poland in September 2004, as part of Magnum's *Eurovisions* project – ten photographers each visiting one of the ten new members of the European Union. My work there continued beyond that initial assignment, however, and I made a further twenty-five visits, amassing a much larger body of work over a period of five years.

This contact sheet contains my 'Dalmatian' picture, perhaps the most recognizable photograph from the series. It was a remarkable slice of good fortune. I had recently broken a lens, and Konrad (my guide, driver and assistant) had taken it to a man with a workshop deep in a forest somewhere on the outskirts of Warsaw. After the lens was fixed, it was picked up – by mistake – by someone who lived on the housing estate you see here. Early one Saturday morning Konrad and I set out to get it back.

In the middle of the estate was a small hill, down which several people were sledding. We were a little early, so I set up my tripod to take a picture. You can see two of the people on sleds in frame 687. I then noticed, over to my right, a Dalmatian that appeared to be walking straight into the view. It was quite dark, and the exposure would be one second, so, as it wandered across

in front of me, I knew that unless it stopped there would be no picture. But stop it did, and in the right place, too. Looking at it now, I've no idea why it should have rested there: it hadn't reached a tree or any specific landmark. Perhaps it just felt my strength of will and did it just for me.

So there it was: right dog, right place, right time. I pressed the cable release and prayed the dog would stay rigid for the whole second. Right at the end of the exposure it wagged its tail, so, in a big print, it's possible to see a slight blur in its nether regions. But otherwise it's pin-sharp. On the right you can see the owner just beginning to walk into the frame. She's blurred, and in the print I always crop her out. Mist had descended since the previous picture, and the hill had lost its definition, but it's still there … just. It's also unfortunate that the sleds had disappeared. But no matter; it was still a remarkable piece of luck.

The picture perhaps marks the time when my work in Poland stopped trying to be about politics and economics and became more about photography instead. For this picture isn't about anything more than that. It doesn't mean anything. It is just what it is. And I rather like it for that. We got my lens back, too."

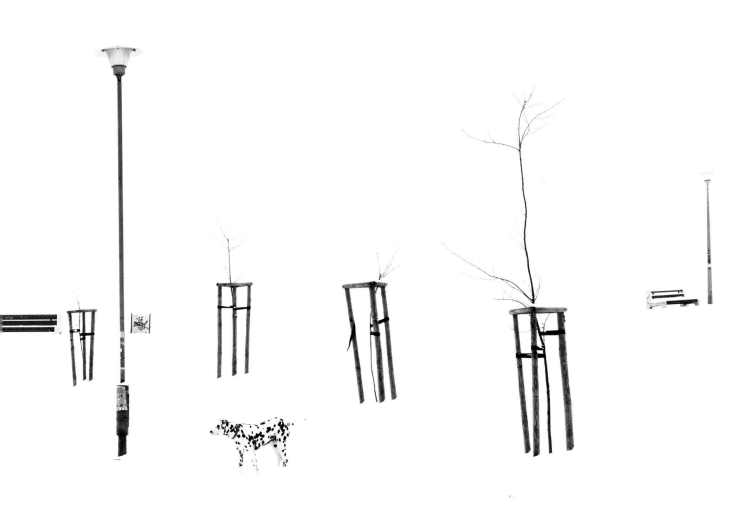

Nuevo Laredo, Mexico
November 2006

"Footage taken in Mexico in 2006. These video stills
are extracts from a sequence, presented without any
particular logic. She wanted to feel. Filming her was
the only way in which I could capture, with immediacy,
the chaotic mixture of fear and pleasure experienced
during her frenzy. The *danse macabre* of a merchandised
body that worships pure consumption and is driven to
extremes by the violence exerted on it by crack. The
attraction of a prostituted, drug-addicted body towards
the void, beyond the reach of reason or language. This
brutal, random geometry resists any attempt at narration
or confinement to an arbitrarily imposed form or sense.
I had no need to make a selection, or to believe that a
single image should be privileged. Randomness is the
only way out: a repertoire of elusive rhythms, perspectives,
poses; from photographic idea to cinematic action.
Through one's own actions, no matter how great the
temptation of inertia. Scattered fragments, unfinished
snippets of absurd interactions with the world,
manifestations that defy any possible hierarchy of
meaning or perspective. A language less inclined to
aesthetic lyricism, more porous and capable of capturing
the violence suffered and generated by the drive for
pleasure at any price. The promise of photography,
a language inextricably bound up with the experiences
from which it is derived, boils down to this possibility
of living one's own fictions to the full, in crazed forms
of intercourse with the world."

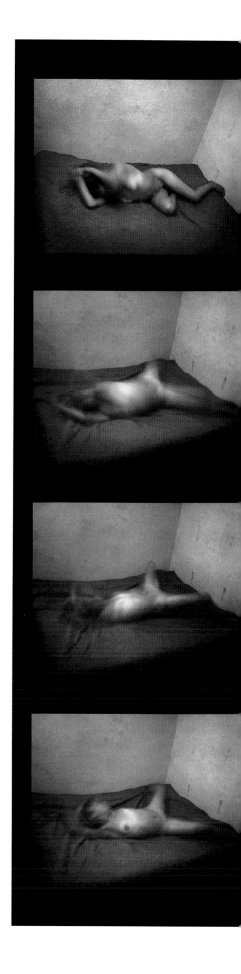

504 Series of stills from the short film *El Cielo del muerto*, made on the US-Mexico border.

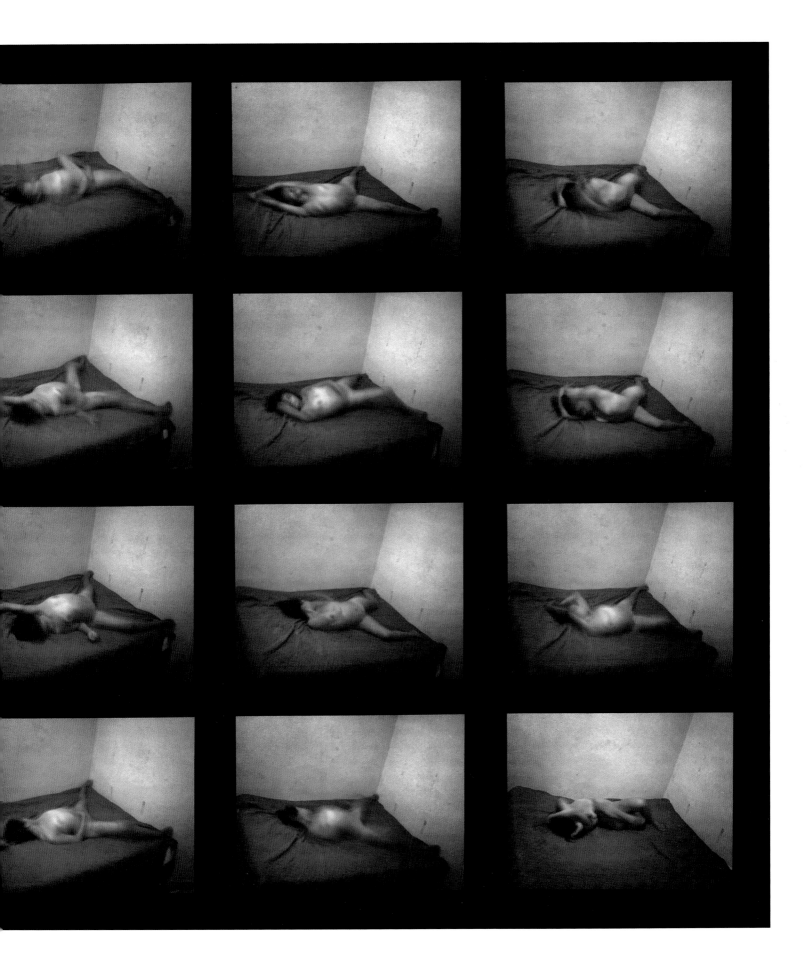

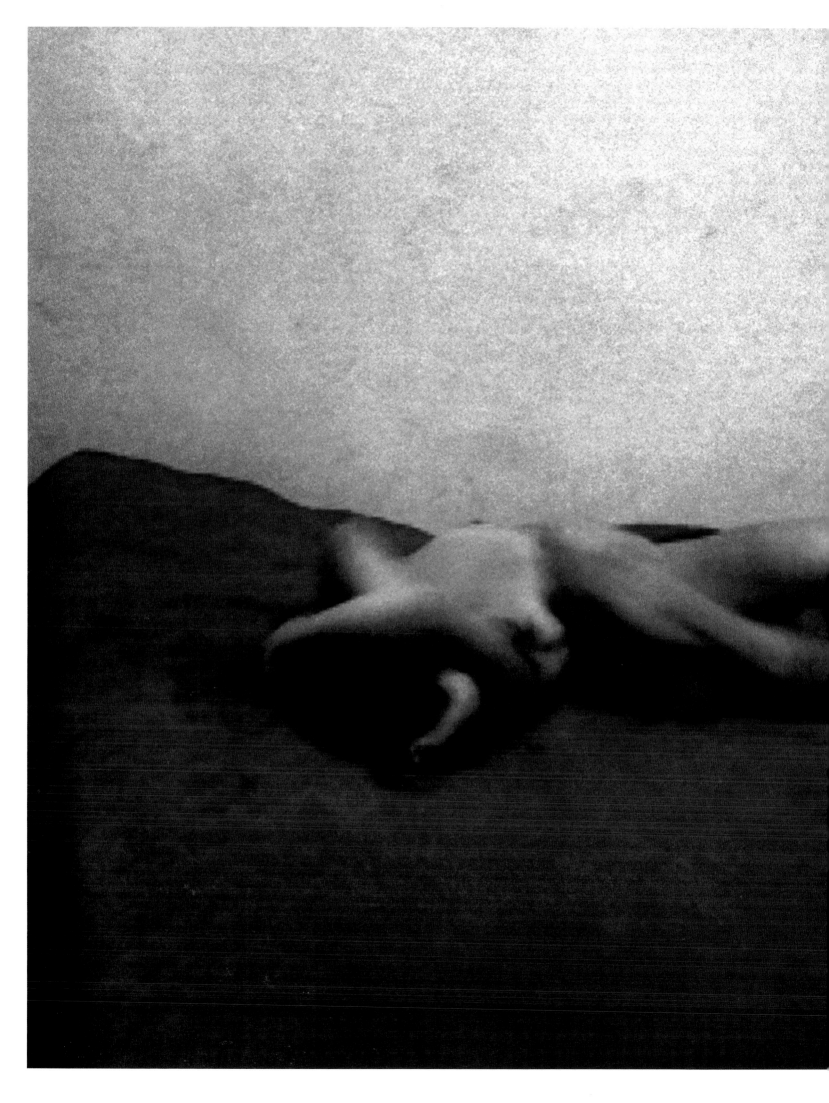

Western Cape, South Africa
2006

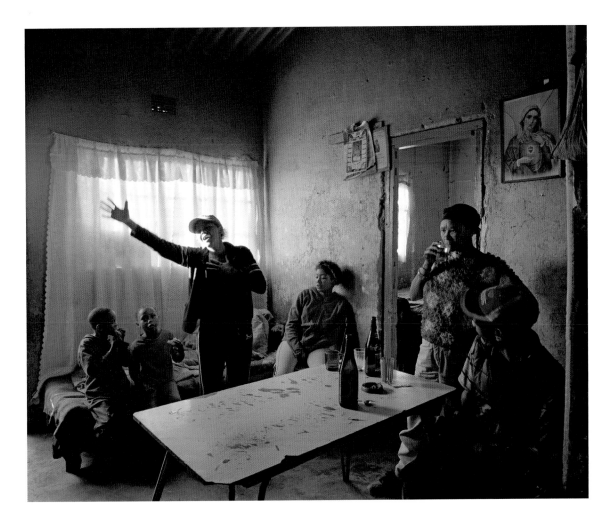

"When I was a student, I worked with both 35mm film and digital cameras. I would edit the black-and-white 35mm work on handmade contact sheets, and the digital colour work on the computer. In the darkroom, I was struck by how one's 'gut feeling' about an image changed as it revealed itself – at first glance in the processed negatives, on the contact sheet, and then in a larger work print. I was often fooled into thinking that a negative looked like a better image than it actually was, and that an image on a contact sheet was worse than it actually was. Editing digital work on the computer was like going straight to a work print for each frame – a fully formed image that can be looked at with two eyes. Despite the distorting effects of the backlit screen, I preferred this approach to editing tiny images through a magnifier. Later I returned to working exclusively with colour film, but found it easier to replicate the digital editing process by scanning every frame I shot in low resolution.

These contact sheets are from the *Beaufort West* series, which was made over three years. They demonstrate the approach I developed in the series towards my own position and movement within a situation.

The images in the rubbish-dump contact sheet were taken after I jumped on the back of a truck that had just dumped a load of rubbish. This had been happening throughout the morning but I had been struggling to find a composition that had enough height and distance to satisfactorily represent the way in which the people were urgently crowding around the recently dumped rubbish.

The contact sheet from the Mallies household shows how I worked in domestic situations. I would sit in a corner of the room with my camera on the tripod with a cable release, and roughly set a composition and focus. I would then sit and chat with the family, and only look through the camera occasionally to adjust the composition. As Bonita started singing, I began photographing more intensely, and moved positions in the room a couple of times. The chosen image (number 3) is the one I thought was the most successful, both in describing the situation and in bringing together many elements of interest. Looking at the rest of the frames, it feels as if they are details from this all-encompassing image. What surprises me is that each detail is actually better in the chosen shot: there is not any element of the other frames that I prefer to those which came together in frame 3. It feels as if I managed to express in one photograph so much of the dynamic of this family that I had experienced in three years of knowing them and photographing them."

OPPOSITE Screenshots of digital contacts, with colour-coded filenames (red the initial selection, green the next level, and purple the final choice).

509

Taiwan and Myanmar
August 2010

"I started doing my single-frame project in 2006. At the time, I had two Mamiya 7s, and I set one aside for this. Now I only use the format for this series, and I shoot about fifty to sixty contact sheets a year. Usually when you shoot, you work the image. You shoot a strip of film and pick the best. I work it, too, but in my heart or mind. I see the process, but I press the shutter when I feel connected. I don't really care about the 'before' and 'after' anymore. I feel that one shot is enough. Sometimes I might feel I'm missing the so-called 'decisive moment', but when you accept that you're going to shoot this way, you accept that you'll be missing something: you win some, you lose some. I take pictures increasingly slowly, trying to make every frame count even more. I spend time watching, observing, interacting. Sometimes I feel, 'enough', and I put down the camera and have a bowl of tea.

When I first started out, I was quite deliberate in thinking through the contact sheet. I made sketches in my notebook, I'd refer to it, and try to make a juxtaposition, a correlation: so, when I was shooting frame 2, I might already be thinking about frame 5, or the rest of the contact sheet. It was insane. Now I don't push it. If it happens, it happens.

I sketch as soon as possible after taking a shot, usually at the scene itself. Otherwise, I might forget. Later, when I look at the contact sheets, I'm often surprised at how selective the eye is. But the lens isn't. It captures whatever is before it within the frame. At the back of my mind, I have a sense of what I've photographed, but there are many things I don't and can't anticipate. Sometimes, there are days, or even weeks, between frames. Sometimes, the people or the locations in my frames are repeated, but years apart.

When you're channel-surfing, what you see on one TV channel is totally unrelated to what's on the next. These frames are stand-alones, but there's also a kind of narrative. There's a shift in time and place, plus I'm constantly on the road. Regarding the massage parlour in Myanmar: I'd tried so many times to get access to it over two years. Finally, I was allowed in. I only wanted to shoot one frame, but there were police outside to collect protection money from the owners, and I think I might have been a bit excited and nervous and scared. I spent ten to twenty minutes there and I shot two frames, but only because I thought the shutter speed had accidentally fired on the first one.

With digital, there's always the temptation to view off the back of the camera. With this, I shoot and then I see the contacts perhaps two months later, and all I have is my sketchbook. These contacts are full of imperfections and incompleteness, but they are part of a whole set; they are part of my diary and my journey."

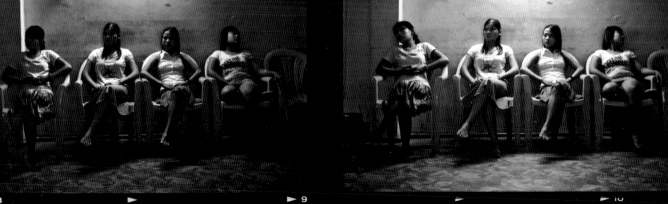

ABOVE Page from Chien-Chi Chang's sketchbook, showing drawings of his single-frame series.

513

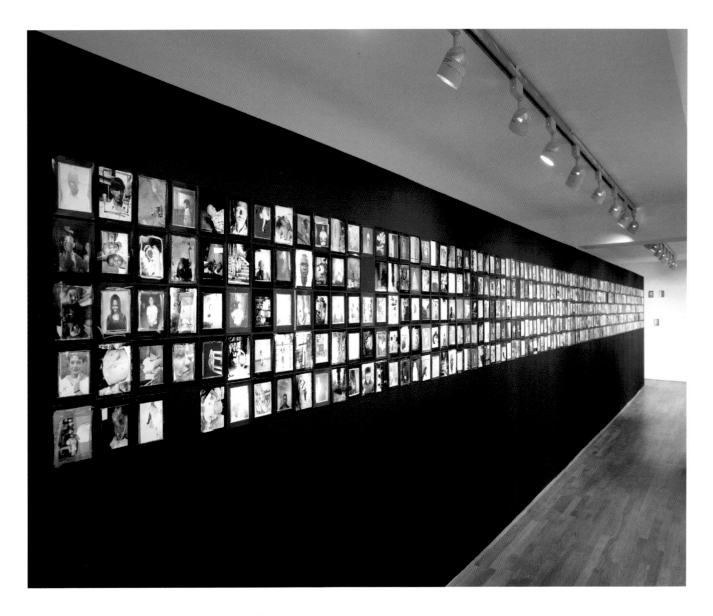

"*In 1971, he began 'Variable Piece #70 (In Process)
Global' for which he proposed his intention 'to
photographically document the existence of everyone
alive…'* (from Douglas Huebler's Wikipedia page).

'Proof' is my attempt to assemble a 'family album';
a catalogue raisonné of all my photographic encounters
during the past nine years of this project. What started
as a nine-image collage titled 'Contact' has grown into
an archive of over 650 images. On one level, this piece
illuminates my working/editing process and how I use
markings and notes to make sense of what I've shot.
On another level, it describes the way in which I
conceptually address my subject. While both the words
'contact' and 'proof' are technical photographic terms
used to describe a set number of images or quickly made
prints, I use them to illustrate that these are people with
whom I have had *contact*, and my work perhaps acts as
proof, certifying the existence of these individuals who
would otherwise be invisible."

ABOVE Wall installation of Jim Goldberg's 'Proof', Foam Fotografiemuseum Amsterdam, November 2010.

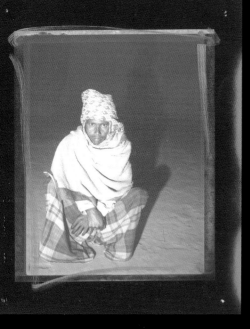

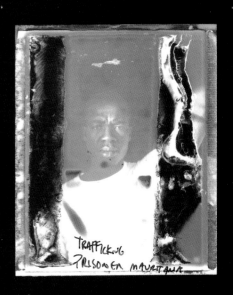

TRAFFICKING
PRISONER MAURITANIA

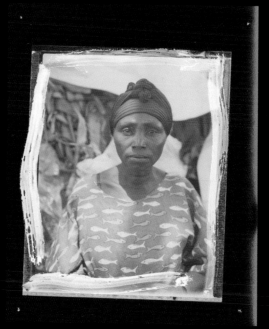

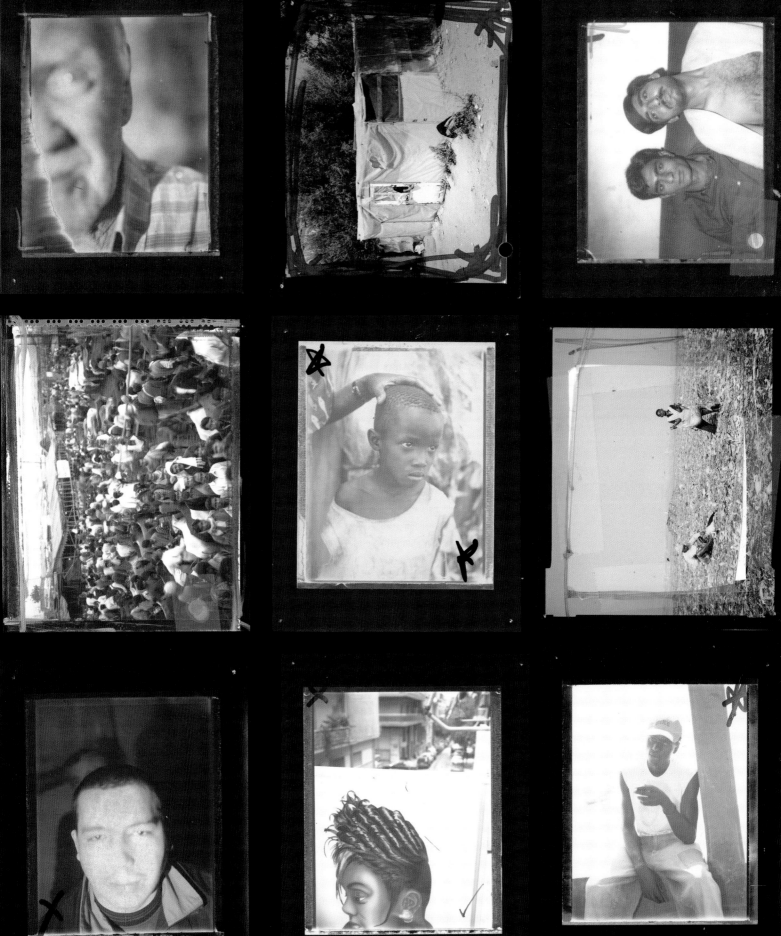

NOTES

NOTE ON THE AUTHORS

MARCO BISCHOF is the son of the late Werner Bischof. He works as a filmmaker and multimedia director, and is involved in the Magnum Foundation as well as the Werner Bischof Estate.

JAMES A. FOX was Editor-in-Chief of the New York and Paris offices of Magnum Photos for some thirty years. An author, photographer and lecturer, he picture-edited *Israel: 50 Years, As Seen by Magnum Photographers* (New York: Aperture, 1998) and published *Ringside* (London: Thames & Hudson, 2001) as well as several books on Robert Capa. The film *James A. Fox – The Eye of Magnum* came out in 2000. Fox has led numerous photojournalism workshops, worked on many Magnum estate collections and is on the advisory committee for the *Magnum Time* project for the Magnum Foundation. He is currently Curator of the Marilyn Silverstone Estate Collection.

JOHN JACOB is Director of the Inge Morath Foundation and Director of Legacy Programs for the Magnum Foundation, both in New York City. He was Director of the Photographic Resource Center at Boston University from 1992 to 2000, and an independent curator before that. His recent publications include *Inge Morath: First Color* (Göttingen: Steidl, 2009) and *Man Ray: Trees + Flowers – Insects Animals* (Göttingen: Steidl, 2009).

BRIGITTE LARDINOIS is Associate Director of the Photography and the Archive Research Centre at the University of the Arts in London. She worked for ten years as an Exhibition Organizer and Curator at the Barbican Art Gallery, where she specialized in the curation of photography exhibitions. In 1995 she joined the staff of Magnum Photos, where she set up and headed the Cultural Department in London. In 2006 she moved to the London College of Communication as a Senior Research Fellow. In that capacity she edited *Magnum Magnum*, Magnum's 60th anniversary book (London: Thames & Hudson, 2007), and *Eve Arnold's People* (London: Thames & Hudson, 2009).

CAROLE NAGGAR has worked as a poet, artist, curator, educator and photography historian since 1971. She is a co-founder and Special Projects Editor of PixelPress. A regular contributor to *Aperture* magazine since 1988, she is currently at work on a biography of Chim (David Seymour), co-founder of Magnum Photos; a book based on Hungarian-American photographer Marion Palfi's 1949 unpublished essay on racism, 'There Is No More Time: An American Tragedy'; and a book on Swedish photographer Christer Strömholm. Among her recent publications are biographies of George Rodger and Werner Bischof and a Photopoche volume on Chim. She is also a consultant on Marco Bischof's upcoming film, *Lives of Chim*.

PEER-OLAF RICHTER is the director of two photographers' estates in Hamburg, Germany. Along with the artistic heritage of Herbert List, he takes care of the estate of former Magnum contributor Max Scheler. Richter's most recent publications are *Herbert List: Lo sguardo sulla bellezza* (Rome: Contrasto, 2007) and *Max Scheler: Von Konrad A. bis Jackie O.* (Munich: Schirmer Mosel, 2009). He also curated the affiliated exhibitions at the Musei Capitolini in Rome and the Haus der Photographie in Hamburg and Fotomuseum in Munich.

CYNTHIA YOUNG manages the Robert Capa and Cornell Capa Archive at the International Center of Photography, New York. With Richard Whelan, she organized the exhibition *This Is War! Robert Capa at Work* (2007). She was also the editor of *The Mexican Suitcase: The Rediscovered Spanish Civil War Negatives of Capa, Chim and Taro* (New York and Göttingen: ICP/Steidl, 2010) and curator of the eponymous exhibition. Other exhibitions and publications for ICP include *Ralph Eugene Meatyard* (New York and Göttingen: ICP/Steidl, 2004) and *Unknown Weegee* (New York and Göttingen: ICP/Steidl, 2006).

NOTE ON SOURCES

All the texts in the book were provided by the photographers or the editor, unless otherwise credited.

HENRI CARTIER-BRESSON Seville
pp. 18–23 Text supplied by the Fondation Henri Cartier-Bresson, established in 2000 by Cartier-Bresson, Martine Franck and their daughter Mélanie to preserve the independence and legacy of his work and to provide a permanent home for his collected works, as well as an exhibition space open to other artists. 'When the war came' quotation from a conversation with Gilles Mora, cited in *Cahiers de la photographie*, no. 18, 1986, p. 121; 'A contact sheet is a little like a psychoanalyst's casebook' quotation from the film *Contacts: Henri Cartier-Bresson*, Centre National de la Photographie, Paris, 1994; 'A contact sheet is full of erasures' statement made by Henri Cartier-Bresson, 3 December 1991; 'Pulling a good picture' quotation from an undated letter to René Burri; 'No plans, no projects' quotation taken from Pierre Assouline, in *L'œil du siècle*, Paris: Gallimard, 2006, p. 108. Contact sheet supplied by the Fondation Henri Cartier-Bresson.

CHIM (DAVID SEYMOUR)
Woman in the Crowd
pp. 24–25 Text supplied by Carole Naggar. Contact sheet supplied by the International Center of Photography, New York.

HERBERT LIST Man and Dog
pp. 26–27 Text supplied by Peer-Olaf Richter. Contact sheet supplied by the Herbert List Estate.

ROBERT CAPA The Battle of Rio Segre
pp. 28–35 Text supplied by Cynthia Young. Contact sheet and contact print notebook supplied by the International Center of Photography, New York; page from *Picture Post*, © Time Inc., used with permission; page from *Life* magazine, © Time Inc., used with permission.

WERNER BISCHOF Mountains
pp. 36–39 Text supplied by Marco Bischof. 'Ascent of the Ochsen from the Strahlegghütte', diary of Werner Bischof, 19 August 1940. Contact sheet supplied by the Werner Bischof Estate.

GEORGE RODGER The Blitz
pp. 40–45 'Thursday 14 November was the night' quotation from George Rodger, *The Blitz: The Photography of George Rodger*, London: Penguin, 1990, p. 37; 'In the 1940s George had been the victim' quotation from an interview between Pierre Gassman and Carole Naggar in Paris, 4 May 1997. Contact sheet supplied by the George Rodger Estate.

GEORGE RODGER Western Desert
pp. 46–49 'I had already been four days in the desert' and 'The editors of *Life*' quotations, plus picture spread, taken from George Rodger, *Desert Journey*, London: Cresset Press, 1944. Contact sheet supplied by the George Rodger Estate.

ROBERT CAPA D-Day
pp. 50–55 Text supplied by Cynthia Young. Contact sheet supplied by the International Center of Photography, New York; pages from *Life* magazine, © Time Inc., used with permission.

ROBERT CAPA Leipzig
pp. 56–59 Text supplied by Cynthia Young. Contact sheet supplied by the International Center of Photography, New York; spread from *Life* magazine, © Time Inc., used with permission.

HERBERT LIST
Plaster Casts at the Academy
pp. 60–61 Text supplied by Peer-Olaf Richter. Contact sheet supplied by the Herbert List Estate.

CHIM (DAVID SEYMOUR) Girls Sewing
pp. 62–63 Text supplied by Carole Naggar. Contact sheet supplied by Magnum New York.

PHILIPPE HALSMAN Dalí Atomicus
pp. 64–65 'If the photograph of a human being' quotation from Philippe Halsman, Cornell Capa and Owen Edwards, *Halsman © 79*, New York: International Center of Photography, 1979 (unpaginated); 'Six hours and twenty-eight throws later' quotation from Philippe Halsman, *Halsman on the Creation of Photographic Ideas*, New York: A. S. Barnes and Company, 1963, p. 55. Contact sheet supplied by the Philippe Halsman Estate.

WERNER BISCHOF
Courtyard of the Meiji Temple
pp. 68–69 Text supplied by Marco Bischof. Contact sheet supplied by the Werner Bischof Estate.

ELLIOTT ERWITT Mother and Child
pp. 70–73 Text drawn from an interview between Elliott Erwitt and Kristen Lubben, New York, 25 October 2010. Contact sheet supplied by the photographer.

MARC RIBOUD Eiffel Tower Painter
pp. 74–77 'In 1953 I leave Lyon for Paris … to see them more closely' and 'Hanging onto the little spiral staircase … good geometry' quotations from *Contacts.1: The Great Tradition of Photojournalism*, dir. Robert Delpire, Alain Taieb, Elliott Erwitt et al, perf. Henri Cartier-Bresson, Elliott Erwitt, Leonard Freed, Josef Koudelka, Marc Riboud et al, 1988–2000, Arte France Développement with the participation of the Ministry of Foreign Affairs, 2000, DVD; 'I [walk] up the tower, maybe one hour of walking' quotation, and second paragraph, from 'Man Painting the Eiffel Tower, 1953: Marc Riboud, photographer of the "golden era",' SF Gate, *San Francisco Chronicle*. Web. Accessed 24 January 2011: http://www.sfgate.com/cgi-bin/object/article?f=/c/a/ 2010/03/15/DDKN1CED97. DTL&object=/c/pictures/2010/ 03/12/dd-riboud16_eiff_0501313792.jpg; 'the rhymes and rhythms in my viewfinder' quotation cited by John A. Benigno, in 'Masters of Photography: Marc Riboud', 26 December 2010. Web. Accessed 24 January 2011: http:// mastersofphotography.blogspot.com/2010/12/ marc-riboud.html. Contact sheet supplied by the photographer.

CORNELL CAPA Fall of Perón
pp. 78–81 Text supplied by Cynthia Young. Contact sheet supplied by the International Center of Photography, New York.

ERICH LESSING Budapest
pp. 82–87 Text drawn from an interview between Erich Lessing and Sophie Wright, Magnum London, 17 February 2010. Contact sheets supplied by the photographer.

BURT GLINN Little Rock, Arkansas
pp. 88–91 Text source 'USA. 1957. Integration at Little Rock High School', Magnum Photos. Web. Accessed 4 January 2011: http://www. magnumphotos.com/Archive/c.aspxVP= XSpecific_MAG.StoryDetail_VPage&pid= 2K7O3R1W2YNQ; caption list, 'Photographs by Burton Glinn – Magnum: Soldiers & School Children in Little Rock' (preliminary roll captions), supplied by Elena Glinn, 5 January 2011. Contact sheet supplied by Magnum New York.

INGE MORATH A Llama in Times Square
pp. 92–95 Text supplied by John Jacob. Contact sheet supplied by the Inge Morath Foundation; page from *Life* magazine, © Time Inc., used with permission; p. 88 photographer unknown.

EVE ARNOLD Joan Crawford
pp. 96–99 Text contains edited excerpts from *Eve Arnold: In Retrospect*, New York: Alfred A. Knopf, 1995. Contact sheet supplied by Magnum London.

ELLIOTT ERWITT Kitchen Debate
pp. 100–03 Text drawn from an interview between Elliott Erwitt and Kristen Lubben, New York, 25 October 2010. Contact sheet supplied by the photographer; 'America Needs Nixon' campaign poster, Republican Party of Wisconsin, Offset, 1960, Madison, Wisconsin.

BURT GLINN Fidel Castro
pp. 104–07 Text edited excerpt from *Cigar Aficionado*, Winter 1996/97 issue, by kind permission of *Cigar Aficionado*. Contact sheet supplied by Magnum New York.

MARILYN SILVERSTONE The Dalai Lama
pp. 108–11 Text supplied by James A. Fox. Contact sheet supplied by Magnum Paris.

RENÉ BURRI Ministry of Health
pp. 114–17 Text drawn from an interview between René Burri and Sophie Wright, Magnum London, 30 March 2010; 'The room, with its criss-crossing shafts of light' quotation cited in René Burri and Hans-Michael Koetzle, *René Burri Photographs*, London: Phaidon, 2004, pp. 212–13. Contact sheet supplied by Magnum New York.

INGE MORATH Refugee Camps
pp. 118–21 Text supplied by John Jacob. Slide contact sheet supplied by the Inge Morath Foundation; Yul Brynner and Inge Morath, *Bring Forth The Children: A Journey to the Forgotten People of Europe and the Middle East*, The McGraw-Hill Companies, Inc.

EVE ARNOLD Malcolm X
pp. 122–23 Text edited excerpt from *Eve Arnold: In Retrospect*, New York: Alfred A. Knopf, 1995, pp. 60–66. Contact sheet supplied by Magnum New York.

CORNELL CAPA The White House
pp. 124–29 Text supplied by Cynthia Young. Contact sheet supplied by the International Center of Photography, New York; spread (and LP) for *Let Us Begin: The First 100 Days of the Kennedy Administration*, commentary by Martin Agronsky, Eric F. Goldman, Sidney Hyman, Barbara Ward and Ira Wolfert, photographs by Magnum: Cornell Capa, Henri Cartier-Bresson, Elliott Erwitt, Burt Glinn, Constantine Manos, Inge Morath, Marc Riboud, Dennis Stock and Nicolas Tikhomiroff, reproduced by permission of Simon & Schuster, Inc.

BRUCE DAVIDSON Civil Rights Movement
pp. 130–37 Contact sheets supplied by the photographer.

PHILIP JONES GRIFFITHS
Boy Destroying Piano
pp. 138–41 Text supplied by Brigitte Lardinois; 'This place, Pant-Y-Waen' quotation from Philip Jones Griffiths, *Dark Odyssey*, New York: Aperture Foundation, 1996, caption to picture p. 3. Contact sheet supplied by the Philip Jones Griffiths Foundation.

CONSTANTINE MANOS
Women at Graveside
pp. 142–45 Contact sheet supplied by the photographer; cover of *A Greek Portfolio*, courtesy W. W. Norton & Company, Inc.

RENÉ BURRI Ernesto 'Che' Guevara
pp. 146–51 Text extracted from *Cuba in Revolution*, dir. Roberto Chile, International Art Heritage Foundation, DVD. Contact sheets supplied by Magnum New York.

LEONARD FREED Martin Luther King
pp. 152–57 Quotations from an interview between Leonard Freed and Nathalie Herschdorfer, in William A. Ewing, Nathalie Herschdorfer and Wim van Sinderen, *Worldview: Leonard Freed*, Göttingen: Steidl, 2007, pp. 206, 215. Contact sheet supplied by the Leonard Freed Estate.

DAVID HURN The Beatles
pp. 158–61 Text drawn from an interview between David Hurn and Kristen Lubben, New York, June 2010. Contact sheet supplied by Magnum London.

DAVID HURN Jean Straker
pp. 162–65 Contact sheet supplied by Magnum London.

THOMAS HOEPKER Muhammad Ali
pp. 166–69 Contact sheet supplied by the photographer.

PHILIP JONES GRIFFITHS
Civilian Victim, Vietnam
pp. 170–71 Text supplied by Brigitte Lardinois. 'I discovered very early on' quotation from an interview between Philip Jones Griffiths and his daughters Fanny Ferrato and Katherine Holden; 'not a bundle

of rolls of film' quotation from *Reporting the World: John Pilger's Great Eyewitness Photographers*, London: 21 Publishing, 2001, p. 10; 'This woman was tagged' quotation from Philip Jones Griffiths, *Dark Odyssey*, New York: Aperture Foundation, 1996, caption to picture p. 181. Contact sheet supplied by the Philip Jones Griffiths Foundation.

BRUNO BARBEY Paris Riots
pp. 172–77 Contact sheet supplied by Magnum Paris.

PAUL FUSCO
Robert Kennedy Funeral Train
pp. 178–83 Slide contact sheet assembled by Magnum New York.

JOSEF KOUDELKA Prague Invasion
pp. 184–89 Contact sheet supplied by Magnum Paris.

DENNIS STOCK California Rock Concert
pp. 190–91 Contact sheet supplied by Magnum New York.

DENNIS STOCK Playa del Rey
pp. 192–95 Contact sheet supplied by Magnum New York.

RICHARD KALVAR Woman in Window
pp. 196–99 Contact sheet supplied by Magnum Paris.

GUY LE QUERREC Miles Davis
pp. 200–03 Contact sheet supplied by the photographer.

RAGHU RAI Mother Teresa
pp. 206–07 Contact sheet supplied by the photographer.

GILLES PERESS Bloody Sunday
pp. 208–15 Text extracted from an interview with Trisha Ziff in *Hidden Truths: Bloody Sunday 1972*, Santa Monica, CA: Smart Art Press, 1998, pp. 71–82. Contact sheets supplied by the photographer; Widgery inquiry map and statement, © Crown copyright 2011; spread from *Sunday Times*, courtesy The Sunday Times / NI Syndication.

FERDINANDO SCIANNA Dog on the Ghat
pp. 216–17 Contact sheet supplied by the photographer.

GUY LE QUERREC Artichoke Harvest
pp. 218–21 Contact sheet supplied by the photographer; spread from *Ouest-France*, courtesy Archives Ouest-France.

SUSAN MEISELAS Carnival Strippers
pp. 222–29 Contact sheets supplied by the photographer.

IAN BERRY The English
pp. 230–33 Contact sheet supplied by the photographer; spread from *The English*, reproduced by permission of Penguin Books Ltd.

MICHA BAR-AM The Return from Entebbe
pp. 234–37 Contact sheet supplied by the photographer; page from *Salzburger Nachrichten*, courtesy *Salzburger Nachrichten*.

MARTINE FRANCK Le Brusc
pp. 238–39 Contact sheet supplied by Magnum Paris.

CHRIS STEELE-PERKINS The Teds
pp. 240–41 First paragraph drawn from Chris Steele-Perkins, 'Father Teds', *The Observer*, 26 January 2003. Web. Accessed 28 February 2011: http://www.guardian.co.uk/theobserver/2003/jan/26/features.magazine47. Contact sheet supplied by Magnum London.

JIM GOLDBERG TJ
pp. 242–47 Contact sheet supplied by the photographer.

RAYMOND DEPARDON Chad
pp. 248–51 Contact sheet supplied by the photographer.

LEONARD FREED Police Work
pp. 252–57 Text compiled of edited extracts from an interview between Leonard Freed and Nathalie Herschdorfer, in William A. Ewing, Nathalie Herschdorfer and Wim van Sinderen, *Worldview: Leonard Freed*, Göttingen: Steidl, 2007, p. 213, and *Contacts.1: The Great Tradition of Photojournalism*, dir. Robert Delpire, Alain Taieb, Elliott Erwitt et al, perf. Henri Cartier-Bresson, Elliott Erwitt, Leonard Freed, Josef Koudelka, Marc Riboud et al, 1988–2000, Arte France Développement with the participation of the Ministry of Foreign Affairs, 2000, DVD. Contact sheets supplied by the Leonard Freed Estate.

HIROJI KUBOTA The Golden Rock
pp. 258–61 Slide contact sheet supplied by Magnum New York.

GEORGE RODGER Circumcision Ceremony
pp. 262–65 Final paragraph taken from an unpublished interview between George Rodger and Sir Tom Hopkinson. Contact sheet supplied by the George Rodger Estate.

ALEX WEBB Boystown
pp. 266–69 Contact sheet supplied by the photographer.

ABBAS
Armed Militants outside the US Embassy
pp. 270–73 Contact sheet supplied by Magnum Paris.

SUSAN MEISELAS Sandinista
pp. 274–77 Contact sheet supplied by the photographer.

RICHARD KALVAR Piazza della Rotonda
pp. 280–83 Contact sheet supplied by Magnum Paris.

PETER MARLOW Margaret Thatcher
pp. 284–85 Contact sheet supplied by Magnum London.

PETER MARLOW Northern Ireland
pp. 286–89 Slide contact sheet supplied by Magnum London; spread from *Life* magazine, © Time Inc., used with permission.

MARTIN PARR Bad Weather
pp. 290–95 Contact sheet supplied by the photographer.

STEVE MCCURRY Dust Storm
pp. 296–301 Slide contact sheet supplied by the photographer.

BRUCE GILDEN
San Gennaro Street Festival
pp. 302–07 Contact sheet supplied by Magnum New York.

IAN BERRY Apartheid Funeral
pp. 308–11 Text drawn from an interview between Ian Berry and Sophie Wright, Magnum London, 10 March 2011. Contact sheet supplied by the photographer.

MARTIN PARR Last Resort
pp. 312–13 Contact sheet supplied by the photographer.

JOHN VINK Filling Guerbas with Water
pp. 314–15 Contact sheet supplied by the photographer.

STUART FRANKLIN Moss Side Estate
pp. 316–17 Contact sheet supplied by Magnum London.

JEAN GAUMY Shooting Practice
pp. 318–23 Contact sheet supplied by Magnum Paris.

MARC RIBOUD Klaus Barbie's Trial
pp. 324–27 Text drawn from *Contacts.1: The Great Tradition of Photojournalism*, dir. Robert Delpire, Alain Taieb, Elliott Erwitt et al, perf. Henri Cartier-Bresson, Elliott Erwitt, Leonard Freed, Josef Koudelka, Marc Riboud et al, 1988–2000, Arte France Développement with the participation of the Ministry of Foreign Affairs, 2000, DVD. Contact sheet supplied by the photographer.

FERDINANDO SCIANNA Marpessa
pp. 328–31 Final paragraph drawn from *Fotografia Italiana: 5 film 5 grandi fotografi: Ferdinando Scianna*, dir. Giampiero D'Angeli, Giart – Visioni d'arte, Cineteca Bologna and Contrasto, 2009, DVD. Contact sheet supplied by the photographer.

PATRICK ZACHMANN The 'Walled City'
pp. 332–33 Contact sheet supplied by the photographer.

RAYMOND DEPARDON The Wall
pp. 334–37 Contact sheet supplied by the photographer.

STUART FRANKLIN Tiananmen Square
pp. 338–41 Slide contact sheet supplied by Magnum London; poster commissioned by Amnesty International France for the 1989 Tiananmen campaign, © Amnesty International; spread from *Time* magazine, © Time Inc., used with permission.

JIM GOLDBERG Signing Off
pp. 342–45 Contact sheets supplied by the photographer.

JOSEF KOUDELKA Nord-Pas-de-Calais
pp. 346–49 Contact sheet supplied by Magnum Paris; *Chaos*, published by Phaidon Press Limited, 1999, © Phaidon Press Limited, www.phaidon.com.

ACKNOWLEDGMENTS

This book, like Magnum itself, was a collective effort that involved the good work of many people. I would first like to extend my sincere thanks to all of the photographers, who braved the challenge of sharing their intimate working processes through their contact sheets, and contributed thoughtful, challenging and wonderfully varied ideas to the overall project. I would also like to thank Sophie Wright, cultural director of the Magnum London office, who was a fantastic partner at each stage of the process. Her extensive knowledge of the photographers' work, smart judgment and unflagging enthusiasm were essential throughout. Martin Parr was our trusted sounding-board and reliably incisive and good-natured advisor, and I was honoured and pleased to have this opportunity to work with someone whose knowledge of photographic books is unparalleled. Russet Lederman's assistance was invaluable in researching and writing a number of the photographers' texts; her intelligence and dedication to the project was much appreciated. Maggie Innes undertook extensive research on the subject of the contact sheet that was creative and thought-provoking, and helped the ideas explored here take form. The Thames & Hudson team, undaunted by the challenge of refining over a hundred disparate texts in many voices and languages, was sure-handed, energetic and enthusiastic from start to finish. From the outset, we knew we wanted a design worthy of the subject matter, one that revealed the richness and tactility of the contact; Smith Design exceeded our expectations. I am grateful for the experience and engagement that Stuart Smith and Victoria Forrest brought to the book.

I would like to extend special thanks to a number of photographers who generously shared their time and ideas with me. Susan Meiselas, friend and ally through all endeavours, encouraged the project and pushed my thinking on the subject. I am grateful to Jim Goldberg, Elliott Erwitt, Gilles Peress, Josef Koudelka, David Hurn, Abbas, Bruce Davidson, Richard Kalvar and Ian Berry for speaking with me about their work and their thoughts on the contact sheet. In addition to the photographers, writers for the estates lent their intelligence and expertise to the book: thanks to Cynthia Young, curator of the Robert and Cornell Capa Archive at the International Center of Photography; Carole Naggar, writer and specialist on Chim and George Rodger; Agnès Sire and Aude Raimbault from the Fondation Henri Cartier-Bresson; Peer-Olaf Richter from the Herbert List Estate; John Jacob from the Inge Morath Foundation; Marco Bischof from the Werner Bischof Estate; and Brigitte Lardinois on behalf of the Philip Jones Griffiths Estate.

Jimmy Fox, longtime editor and archivist in the Magnum Paris office and invaluable resource on Magnum history, was extremely generous with his time and knowledge. John Morris, legendary photo editor and former Magnum director, also kindly spent time with me, explaining the advent of photo editing. I am also grateful to Inge Bondi, Jinx Rodger and Liz Gallen for speaking with me about the function of contact sheets within Magnum over the years. Mark Lubell, former New York director, was a helpful supporter of the project, and extended conversation with Julien Frydman, former Paris director, was appreciated and constructive. I also extend my thanks to Paul Hayward, Eva Eicker, Matt Murphy, Véronique Sutra, Sophie Marcilhacy, Chloé Jafé, Diana Saldana and the production teams in the London, New York and Paris offices for their generous cooperation.

Sally Stein, Yael Lipschutz and Fred Ritchin offered smart and challenging ideas on the subject of contact sheets, as did Brian Wallis, whose advice and encouragement are always greatly appreciated. Pauline Vermare, Chi Yin Sim and Alexa Natanson generously contributed their time and ideas to the project. For their support and editorial intelligence, I am grateful to Jennifer Hoyden, Erin Barnett and, as always, Kathryn Trotter.

INDEX